The Emperors' Album

PUBLISHED WITH THE AID OF A GRANT FROM
The Hagop Kevorkian Fund, New York

THE EMPERORS' ALBUM

Images of Mughal India

STUART CARY WELCH

ANNEMARIE SCHIMMEL

MARIE L. SWIETOCHOWSKI

WHEELER M. THACKSTON

The Metropolitan Museum of Art

DISTRIBUTED BY *Harry N. Abrams, Inc.,* NEW YORK

This publication was issued in connection with the exhibition *The Emperors' Album: Images of Mughal India*, held at The Metropolitan Museum of Art from October 21, 1987, to February 14, 1988.

Published by The Metropolitan Museum of Art, New York
John P. O'Neill, Editor in Chief
Kathleen Howard, Editor
Peter Oldenburg, Designer
Gwen Roginsky, Production Manager

Chart of borders of album leaves by Wilhelmina Reyinga-Amrhein

Photographic credits: All MMA folios were photographed by the Metropolitan Museum's Photograph Studio and by Edward Gorn. The folios from the Freer Gallery are reproduced courtesy of the Freer Gallery of Art, Smithsonian Institution, Washington, D.C. The photographic credits for the comparative illustrations appear in their captions.

Type set by U.S. Lithograph, typographers, New York
Printed and bound by Arnoldo Mondadori Editore SPA, Verona, Italy

Library of Congress Cataloging-in-Publication Data

The Emperors' album.

 Catalog of an exhibition held at the Metropolitan Museum, fall, 1987.
 Bibliography: p.
 Includes index.
 1. Illumination of books and manuscripts, Mogul—India—Exhibitions. 2. Illumination of books and manuscripts, Islamic—India—Exhibitions. 3. Miniature painting, Mogul—India—Exhibitions. 4. Miniature painting, Islamic—India—Exhibitions. 5. Calligraphy, Mogul—India—Exhibitions. 6. Calligraphy, Islamic—India—Exhibitions. 7. India—Kings and rulers—Art patronage—Exhibitions. 8. Metropolitan Museum of Art (New York, N.Y.)—Exhibitions. I. Welch, Stuart Cary. II. Metropolitan Museum of Art (New York, N.Y.)
ND3247.E46 1987 745.6'7'095407401471
87–18647

ISBN 0–87099–499–9
ISBN 0–8109–0886–7 (Abrams)

CONTENTS

Foreword

The Mughal dynasty of India, descended from Tamerlane and Genghis Khan, is legendary for its wealth, power, and aristocratic grandeur, but the paintings commissioned by these great emperors have not met wide and continuous acclaim. Although Rembrandt drew copies of the Mughal portraits he collected, Mughal pictures have not until recent times been duly appreciated in the West, perhaps because Western connoisseurs regarded them as charming, but not quite "serious" creations of an exotic tradition. One need only turn, however, through the pages of this volume to grasp their great aesthetic worth and extraordinary appeal—from the majestic portraits and vibrant bird and animal studies to the superb calligraphy and magnificent ornaments.

Fortunately The Metropolitan Museum of Art acquired, and continues to acquire, Mughal art so discerningly—often through the wisdom and generosity of New York collectors—that we have assembled one of the world's richest Mughal collections. We cite a few especially fine examples: a floral carpet with trellis pattern made for Shahjahan (Bequest of Benjamin Altman, 1913); a very large, splendidly animated late sixteenth-century rug (Gift of J. Pierpont Morgan, 1917); magnificent miniatures of the same period from a manuscript of Amir Khusrau's Quintet (Gift of Alexander Smith Cochran, 1913); folios from *Dastan-i-Amir Hamzah*, painted for the emperor Akbar in the 1570s (Rogers Fund, 1918); Jahangir's jade inkpot, dated 1618–19 (Gift of George Coe Graves, 1929); many remarkable early Mughal miniatures (Theodore M. Davis Collection, Bequest of Theodore M. Davis, 1915, and Purchase, Edward C. Moore, Jr. Gift, 1928); a prayer rug made for Shahjahan (Bequest of Joseph V. McMullan, 1973); and a mid-seventeenth-century dagger with a jade hilt in the form of a nilgai and a stunning late sixteenth-century painting of a lion at rest (Gift of Alice Heeramaneck, in memory of Nasli Heeramaneck, 1985).

Outstanding among the Museum's Mughal holdings is the series of forty-one leaves from the Kevorkian Album (the other nine leaves are in the collection of the Freer Gallery of Art). This entire assemblage of miniatures, calligraphies, and illuminations is published here for the first time. The leaves we value most were made for the emperors Jahangir and Shahjahan to be enjoyed in the company of family and close friends; these thirty-nine seventeenth-century leaves were supplemented in the early nineteenth century with appealing but comparatively slight copies and variants of earlier compositions.

Although we do not know when or how the Kevorkian Album leaves left the imperial collections in the Red Fort in Delhi, their peregrinations took them to a Delhi art dealer who bound them with the later leaves; the resulting album made its way through obscure routes to Scotland, where it was discovered in 1929 in an antique shop by a sharp-eyed English couple. That same year, just before the Great Depression, the album was acquired from them through a London auction sale by Hagop Kevorkian to whose memory we dedicate this volume.

The art-loving founder of The Hagop Kevorkian Fund, which has so enriched the Museum on many occasions and which has generously supported this publication, Mr. Kevorkian also gave the Museum many of its magnificent miniatures, illuminations, and calligraphies.

Although our primary indebtedness for this publication is to Mr. Kevorkian and his Fund, we are also grateful to the authors who so thoroughly discuss the Kevorkian Album. The project was proposed several years ago—prior to his major undertaking, the watershed exhibition *India: Art and Culture, 1300–1900*—by Stuart Cary Welch, Special Consultant in Charge of the Department of Islamic Art from 1981 until 1987. For many years, both here and at Harvard University, he has shared his connoisseurly enthusiasm and scholarly devotion to Mughal art through teaching and writing and has inspired a new generation of impassioned Mughalists. This volume was planned by him, and he has contributed a lively introduction to Mughal painting and painters and many brief but insightful essays.

To introduce the art of calligraphy—ranked second to none in the Islamic world—and to describe the album's remarkable specimens of fine writing, we were fortunate in being able to call upon Dr. Annemarie Schimmel, another of our Special Consultants in Islamic Art, who is also Professor of Indo-Muslim Culture at Harvard University. Poet as well as scholar, Dr. Schimmel has broken new ground in her informative essay, which is enriched by her translations and paraphrases of many of the profound and witty verses that make the Kevorkian Album such a source of refreshment and renewal.

Incomprehensibly, in the past the extraordinary painted borders of Mughal album leaves were usually neglected—and even masked over when the miniatures were exhibited. Here they are analyzed by Marie L. Swietochowski, Associate Curator of Islamic Art. Most imperial Mughal albums have been scattered, if not destroyed or lost, and Mrs. Swietochowski earns our deep thanks for accepting the challenge of placing the Kevorkian leaves and a substantial number from other sources into coherent groups.

Dr. Wheeler M. Thackston, Senior Preceptor of Persian at Harvard University, deserves our gratitude for introducing the many remarkable men portrayed by the imperial artists. Read in conjunction with the artists' penetrating characterizations, his brief but authoritative biographies, based on primary sources, make a lively art yet livelier.

Finally we are grateful to Dr. Thomas Lawton, Director of the Freer Gallery of Art, and to Dr. Glenn D. Lowry, Curator of Near Eastern Art at the Freer, for their enthusiasm and generous cooperation, which made it possible to publish the Kevorkian Album in its entirety.

PHILIPPE DE MONTEBELLO
Director, The Metropolitan Museum of Art

Acknowledgments

IMMENSELY GRATEFUL AS WE ARE TO the long-departed Indians and Persians whose work we celebrate here, we are particularly indebted to those who helped create this book.

When the idea for this book first struck, it was warmly received by Philippe de Montebello, the Museum's Director, as well as by Bradford Kelleher, then Vice President and Publisher, and John P. O'Neill, Editor in Chief, who proposed it to Ralph Minasian and Stephen Chan of The Hagop Kevorkian Fund. All are due warmest gratitude, as are my three fellow authors, devotees of Mughal India and admired friends. I am particularly happy that Annemarie Schimmel, Marie L. Swietochowski, and Wheeler M. Thackston have shared this labor of love with such distinction.

I also wish to thank other friends within the Museum: Carolyn Kane, Helen Otis, Susan Salit, Hilda Feiring, and George Berard, without whose work and benevolence this publication would not exist.

I am also most grateful to many others: in India, O. P. Sharma of the National Museum of India, New Delhi, and Asok Kumar Das of the Maharaja Sawai Man Singh II Museum, Jaipur; in the German Democratic Republic, Volkmar Enderlein and Regina Hickmann of the Staatliche Museen zu Berlin; in the Federal Republic of Germany, Klaus Brisch and Jens Kröger of the Staatliche Museen Berlin, Dahlem, and Ekkehart Vesper of the Staatsbibliothek Preussischer Kulturbesitz, Berlin.

Without the help of valued colleagues in Great Britain and Ireland, little could have been accomplished. For information and inspiration, I give special thanks to Mildred Archer of the India Office Library; Robert Skelton of the Victoria and Albert Museum; Michael Rogers, Rachel Ward, and Robert Knox of the British Museum; and David James of the Chester Beatty Library, Dublin. My thanks also go to Rosemary Crill, Toby Falk, Nabil Saidi, Margaret Erskine, and Michael Goedhuis and to Margaret Tyler, Robert Alderman, and Mark Zebrowski.

In France I am grateful to Krishna Riboud, Marthe Bernus-Taylor of the Louvre, Vadime Elisseeff of the Musée Guimet, E. Isacco, and Stéphane Ipert.

I am profoundly indebted to two citizens of the world, Prince Sadruddin Aga Khan and John Goelet, whose unfailing generosity and kindness contributed once again to an exciting project.

I extend my warmest appreciation to Thomas Lawton and Glenn D. Lowry of the Freer Gallery of Art and to Milo Cleveland Beach of the Sackler Museum, Washington, D.C., all of whom were outstandingly generous in enabling us to publish the Freer folios.

For their many kindnesses I am grateful to Alice Heeramaneck and to Hossein and Maheste Ziai, as well as to Daniel Walker, Ellen Smart, Ralph and Catherine Benkaim, Terrence McInerney, Michael Brand, Pratapaditya Pal, Thomas Lentz, and Janice Leoshko.

John Rosenfield, Jane Montgomery, Marjorie Cohn, Craigen Bowen, Massumeh Farhad, Henri Zerner, and Dr. Ali Asani of the Harvard Art Museums have given, as always, unstinting help, often at short notice.

Without our enthusiastic, devoted, and tactful editor, Kathleen Howard, the text of this book would be less informative and readable; and were it not for Peter Oldenburg, our sensitively imaginative designer and typographer, the spirits of Jahangir and Shahjahan would have been far less pleased.

SCW

I am most grateful for the time and immense help given to me in the identification of the flowering plants by Dan Nicolson of the Botany Department, Natural History Museum, Smithsonian Institution; Larry Pardue of The New York Horticultural Society; and Frank Anderson of The New York Botanical Gardens.

I am also grateful for the generous assistance given to me in the identification of birds by Ben King and Mary LeCroy of the Department of Ornithology, American Museum of Natural History. Marie Lawrence of the Department of Mammals, American Museum of Natural History, was most helpful in identifying the

animals in both album leaf pictures and decoration.

I wish to thank Robert Skelton of the Victoria and Albert Museum for his many kindnesses in my study of the Wantage and Minto albums in the V&A and David James for his help, kindness, and advice while I was studying the Minto Album in the Chester Beatty Library. I would like to thank William Voekle of the Morgan Library for his help in looking at medieval manuscripts relevant to my study. I am grateful to Ebba Koch of Vienna for her helpful suggestions on the subjects of Shahjahan, gardens, and borders.

MLS

Note to the Reader

THE SEVENTEENTH-CENTURY and earlier illuminations, calligraphies, and miniatures of the Kevorkian Album were augmented, foliated, and rebound during the early nineteenth century. Inasmuch as their order was haphazard, we have rearranged them for this publication. Our book opens with a rosette (shamsa) bearing the imperial cipher of Shahjahan (pl. 1), which is followed by a double-page frontispiece (ʿunwan)(pls. 2 and 3) and a richly illuminated calligraphy folio (pl. 4). After a second shamsa with the seal of Aurangzeb, another ʿunwan, and an illuminated calligraphy folio (pls. 5–8), the extraordinary series of folios bearing portraits and calligraphy begins. As in the original royal albums, each miniature is backed by a calligraphy. The portrait miniatures are arranged according to the hierarchy of the imperial Mughal court. First is a posthumous likeness of Emperor Akbar (pl. 9), father of Emperor Jahangir, who was the initiator of the original album. The portraits of Jahangir—one of them with his father—come next (pls. 11, 13, and 16). Likenesses of members of the imperial family and of Jahangir's courtiers are next (pls. 18, 20, 21, 24, 26, 28, 29, and 32), followed by the sultan and dignitaries of Bijapur, a rival Indian principality (pls. 33, 35, and 38). The studies of birds and animals commissioned by Jahangir (pls. 40, 41, 44, 45, 47, and 50) precede two figural paintings, one from sixteenth-century Persia, retouched for Emperor Jahangir (pl. 52), the other by an émigré Persian working in seventeeth-century Persian style (pl. 53).

Portraits of the album's second great patron, Emperor Shahjahan, son of Jahangir, are next (pls. 55, 58, 59, and 62). These are followed by a portrait of one of his sons and by those of members of his court (pls. 63, 66, 67, and 71) and of a nobleman from the Deccan (pl. 74). Two studies of holy men follow (pls. 76 and 77).

Miniatures and calligraphies that were added to the original album in the early nineteenth century have been arranged according to the same system.

Each album leaf measures 15⁵/₁₆ in. × 10 in. (38.9 × 25.4 cm.)

The following abbreviations are used for institutions:
 CB Chester Beatty Library, Dublin
 MMA The Metropolitan Museum of Art
 V&A Victoria and Albert Museum, London.

The following abbreviations are used for authors' names:
 SCW Stuart Cary Welch, Special Consultant in Charge of the Department of Islamic Art, The Metropolitan Museum of Art
 AS Annemarie Schimmel, Special Consultant, Department of Islamic Art, The Metropolitan Museum of Art
 MLS Marie L. Swietochowski, Associate Curator, Department of Islamic Art, The Metropolitan Museum of Art
 WMT Wheeler M. Thackston, Senior Preceptor in Persian, Harvard University

Introduction

STUART CARY WELCH

THE FIRST FOLIOS IN THIS RE-markable album were initiated in about 1620 by Nuruddin Muhammad Jahangir (r. 1605–1627), the fourth Mughal emperor of Hindustan (Northern India). It appears that imperial albums were designed to bring together portraits of family, of friends, and of a few members of rival dynasties. For greater delight specimens of calligraphy (quit'a), other miniatures–including a series of extraordinary natural history studies—and illuminations were added, and all were set within magnificent borders decorated with flowers and arabesques.[1] The emperor inscribed many of the portraits in a hand of imperial aplomb. Intimate as one of our own family albums, it was intended to be contemplated in private or to be leafed through with family and very close friends. The mood is tranquil.

When Emperor Jahangir died in 1627, he was on his way to Lahore from Kashmir, his favorite retreat, noted for lakes, prospects of mountains, and flowers of the sort the emperor asked artists to paint. His albums were inherited by his son, Shahjahan (r. 1628–58), who enhanced them with further portraits, calligraphies, and illuminations, many of which bear his elegant nasta'liq script. They became the property of his third son, Abu'z-Zafar Muhyi'ddin Muhammad Aurangzeb, who imprisoned Shahjahan, seized the throne, and ruled as 'Alamgir I (1658–1707). He made a single addition to the Kevorkian Album: a small, black impression of his seal stamped at the center of one of his father's noble rosettes (shamsa) (MMA fol. 40r; pl. 5).

Many royal albums left the imperial library, probably in the early nineteenth century (see below, "The Royal Albums in the Nineteenth Century"). The Kevorkian Album itself was created in about 1820, pre sumably by a Delhi art dealer, who commissioned a number of miniatures and calligraphies to supplement the seventeenth-century originals he had obtained. The lustrous folios were edged in crimson silk then bound in papier-mâché decorated with floral arabesques and birds. The album, containing no owner's or librarian's comments tracing its history, was ready for the next stage of its peregrinations.

Hagop Kevorkian and the Album

On a summer day in 1929 Mr. and Mrs. Jack S. Rofe admired this extraordinary album while browsing in an antique shop in Scotland where they were on holiday. They bought it for less than one hundred pounds, far less than it would have cost a century or so before when some connoisseurly traveler or official of the East India Company bought it in Delhi.[2] Although the Rofes lived in Cairo, they were neither collectors nor more than vaguely aware of Islamic art. Later in London, they took it to Sotheby's, the auction house on New Bond Street, where they were told of its importance and value. The auctioneers convinced them to sell it, and it was catalogued for sale on December 12, 1929, as "Indian Miniatures—The Property of a Gentleman." In accordance with the arrangements between the sellers and Sotheby's, it would be offered as a single lot, but if there was no buyer, it would then be broken into forty-eight parts. The sale opened with a bid of three thousand pounds, more than the modest—now forgotten—reserve. There were two bidders: Hagop Kevorkian, the knowledgeable New York collector and art dealer who was later a major benefactor of The Metropolitan

11

Museum of Art and the founder of the Hagop Kevorkian Fund, and Mr. B. Maggs of Maggs Brothers, the London booksellers. Maggs represented A. Chester Beatty, the renowned American-born mining engineer who was assembling a magnificent collection of oriental manuscripts and miniatures, now established as the Chester Beatty Library in Dublin, Ireland. Mr. Beatty, who later received a knighthood for his benefactions, sat beside Mr. Maggs, whose final bid of £10,000 was raised by Mr. Kevorkian. He acquired the album which has since borne his name for £10,500.[3]

Mr. Kevorkian kept his imperial album in his stately New York house where he showed it to admiring specialists. In 1939 and 1948 a total of nine folios was offered to the Freer Gallery of Art, which added them to its splendid collection of imperial Mughal paintings.[4]

In 1955 Hagop Kevorkian generously provided the Metropolitan Museum with funds—supplemented by the Rogers Fund—for the purchase of the remaining forty-one folios. A special exhibition was mounted to display the new acquisition, and in the Museum *Bulletin* Marshall B. Davidson wrote that "the brilliance of Shah Jahan's court is reflected in a series of superb portraits and paintings of genre, bird, and animal subjects that were brought together in a single album as a royal treasure during his reign. The leaves from this album represent the climax of Mughal painting."[5]

Mughal Art and the West

During the 1950s Mughal miniature paintings—intimate little pictures that nevertheless fill the entire scope of one's vision—were beginning to emerge from many years of comparative neglect in the West. Valued by artists such as Rembrandt, Sir Joshua Reynolds, William Morris, and other pioneering tastemakers, they had long been collected in Europe and England by a few discerning amateurs, but even superb examples had not been ranked on a par with Western works. Empress Maria Theresa acquired miniatures from Rembrandt's collection (to which she added heaps of inferior pictures in the Mughal style, probably painted in the bazaars of Burhanpur). Many of these miniatures were pieced together and set in Rococo frames in the Millionenzimmer, an intimate salon in Schönbrunn Castle. (Many more—the overflow from Schönbrunn—are in albums in the Austrian National Library, Vienna.)

During the later eighteenth century, when the British replaced the Mughals as the dominant power in India, such enlightened officials as Warren Hastings and Richard Johnson found the sensitive naturalism of the Mughal style much to their taste. The harvest of their enthusiasm eventually enriched museums and libraries in England, Europe, and elsewhere.[6] By the end of the century institutions as well as individuals were collecting Mughal pictures more systematically, and by the later nineteenth century the taste for things Mughal had spread to America.

Mughal miniatures rose and fell in the eyes of scholars and in the marketplace. The few that reached the United States in the earlier nineteenth century—when American institutions and collectors gathered them not only for their intrinsic appeal but also to satisfy an appetite for works of art from the entire world—must have been acquired very cheaply. They were better appreciated, however, during the second half of the nineteenth century, when American designers and patrons discovered the arts of India as well as those of China, Japan, and the Near East. In the United States Biedermeier, Victorian, and Art Nouveau American mansions waxed exotic with Turkish Corners; Saracenic, Cairene, Ottoman, and Indian motifs jostled in smoking rooms like racehorses at the starting tape. Occasionally, as in the designs of Lockwood De Forest, and Louis Comfort Tiffany, greater harmony and purity of style were achieved; not surprisingly, some Persian and Indian miniature paintings of good quality, as well as metalwork, arms and armor, and other examples of the decorative arts, were bought to enhance the mise-en-scène.

Interest in lively miniature paintings continued to increase. American collectors followed the lead of discerning early twentieth-century European connoisseurs, of Edmond de Rothschild, Louis Cartier, and Henri Vever, who eagerly collected superb Mughal pictures at a time when few scholars appreciated the differences between the styles of major and minor Mughal artists. Before and after the First World War fine Indian, Persian, and Turkish miniatures, calligraphies, and bindings were offered by specialized dealers who combed the East for them at a time when most sultans, maharajas, and nawabs preferred European baubles to their own artistic heritage. American collectors—Henry Walters, Alexander Smith Cochran, Edward W. Forbes, and others—joined in the search, and by 1925 the Metropolitan Museum had assembled a notable collection by gift as well as by purchase.

The collectors' preferences conformed to the taste of the period. Affinities between Art Nouveau and later Safavid miniatures enhanced the desirability of seventeenth-century Persian pictures to the detriment of their starkly naturalistic Indian counterparts. To encourage the sale of slow-moving Mughal material, dealers re-

named it "Indo-Persian" but to little avail. Auction records from 1910 through 1930 reveal that only a few particularly discerning—or bargain-conscious—collectors sought the underpriced but occasionally extraordinary Mughal pictures. Even the Kevorkian Album, sold when the art market was very high on the eve of the Great Crash of 1929, brought a relatively modest sum.

Gradually a small number of scholars and collectors isolated and defined the changing idioms of Mughal art and gathered information about individual artists. During the 1920s and 1930s Percy Brown, Ivan Stchoukine, Sir Thomas Arnold, and a few others noted the names of major masters, listed their works, but made no attempt to define their styles. Although Wilhelm Staude wrote monographs on Basawan and Miskin, two leading early Mughal artists, in the later 1920s and 1930s, it was not until the 1950s and 1960s that individual painters were subjected to close scrutiny.[7] In the 1960s important Mughal pictures could still be bought from well-established art dealers in Paris, London, or New York for a few thousand dollars or less; the first major exhibition devoted solely to Mughal art ("The Art of Mughal India: Painting and Precious Objects") was held in New York at the Asia House Gallery during the winter of 1963–64.[8]

The Mughals

Few dynasties in history equal the Mughals in their enlightened, discerning patronage of the arts. The passion was inbred. Zahiruddin Muhammad Babur (1483–1530), the dynasty's charismatic first emperor, descended from both Timur (Tamerlane) and Genghis Khan, was a man of letters as well as a soldier. At the age of twelve, he inherited the small kingdom of Fergana (now in Soviet Turkistan) when his father fell from a pigeon tower and died. At fourteen, he attacked Samarkand, where he was defeated but not discouraged. He reestablished himself at Fergana in 1498, and in 1500–1501 he captured Samarkand, which he soon lost to the Uzbeks. But by 1504 he controlled Kabul and Ghazni, from which he made forays. Recalling his ancestor Timur's conquest of Hindustan, he set off for the Hindu Kush. Surviving terrible snowstorms, defeats in skirmishes, and demoralizing desertions (he was once reduced to a handful of followers), he persevered, leading five expeditions into the mountain passes between 1519 and 1525.

In 1526 Babur defeated the combined forces of the Muslim sultan of Delhi and the Hindu raja of Gwalior on the plains of Panipat near Delhi. He and his weary army were latecomers among the many invaders who since ancient times had penetrated one of India's few vulnerable points. Like earlier attackers, they faced worse trials upon arrival—battles against the descendants of the Aryans, Huns, Turks, and Afghans who had preceded them. Babur's triumph rested not only on his leadership but also on his artillery, previously unknown in India. So terrifying were its thundering booms and noxious smoke—more lethal than cannonballs—that his enemies' elephants ran amok, bringing panic and death to their masters' armies.

At Khanua in 1527 Babur consolidated his position by defeating an alliance of Rajput rajas led by the rana of Mewar, the proudest Rajput nobleman, whose descendants troubled the Mughals for the next century. By talent and determination he had established one of the world's great empires.

But those strong or crafty enough to enter India must adjust to Indian ways or ultimately leave or be destroyed. Hardy and sensitive, the Mughals survived. Babur was more intrigued than enchanted by India's land and people. In *Waqi'at-i Baburi*, his memoirs which were written in Chagatay Turkish and are the most informative and candid autobiography of any Muslim ruler, the homesick conqueror compared Hindustan unfavorably with Central Asia. But his eyes and ears were captivated by the extraordinary Indian landscape, flora, fauna, architecture, and people, which he described with lyric, enthusiastic accuracy.

Babur's account of India established the essence of Mughal artistic and literary thought at the empire's outset. Although no paintings commissioned by him are known, he wrote so insightfully of Timurid, Safavid, and Uzbek miniatures that his familiarity with and admiration of all three schools is evident.[9]

Mughal history abounds in poignant anecdote. The traditional account of Babur's death recalls the self-induced demises of Muslim or Buddhist saints. When his son Humayun (born ca. 1508; r. 1530–40 and 1555–56) was seriously ill in 1530, Babur offered God his own life if he would spare his son. Humayun survived, and the emperor soon weakened and died. Aristocratically aloof, elegant, and devoted to astrology, protocol, literature, painting, polo, and the martial arts, Humayun became the least appreciated and most mysterious of Mughal emperors. His character anticipates that of another underestimated emperor, Shahjahan, a major patron of the Kevorkian Album. Both Humayun and his great-grandson were reticent and somewhat introspective, coolly cerebral yet aesthetically inclined, and not always sufficiently ruthless in a dangerous world.

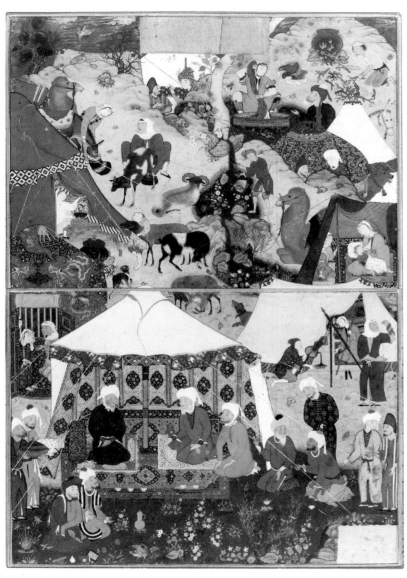

FIG. I Mir Sayyid-ʿAli, *Majnun Visits Layla's Camp.* Safavid, 1539–43. Fogg Art Museum, Gift of John Goelet, formerly in the Collection of Louis J. Cartier, 1958.75

Humayun's frailties, like those of several other Mughal rulers and princes, give a sympathetic dimension to his self-consciously imperial persona. After successful battles he did not press the enemy but instead rested, enjoying wine and opium, music and poetry. His foibles led to near disaster—or did they? If artistic rather than political history is emphasized, such episodes as Humayun's expulsion from Hindustan following defeat by the ambitious interloper Sher Shah Afghan and his period of exile in Iran at the court of the great patron Shah Tahmasp Safavi were immensely productive.

If Babur set the mood of Mughal painting, Humayun established its form, and this form was shaped by his stay at the Safavid court. For Mughal art the timing was extraordinarily propitious. As a young man, Shah Tahmasp (r. 1524–76) had not only painted but was also a major patron of painting. He assembled and guided one of the most brilliant ateliers in Iranian history, one that synthesized the traditions of Turkoman Tabriz and Timurid Herat.[10] But when Humayun visited the shah's court in 1544, the ruler's attention had recently turned from art to piety and statecraft. Humayun, whose passion for the arts of the book was on the rise, not only saw and admired the work of the shah's major masters but also met these artists; he even dared suggest—without offending his host—that several of them would be welcome at the Mughal court.

After Humayun had established himself at Kabul with Safavid support, several of the shah's master artists joined him there in 1549 and helped found the Mughal school. Humayun's choice of artists is not surprising. As Babur's son, he liked pictures showing the world, its people, flora, and fauna, with sensitive accuracy. At the same time, as an artistically aware sixteenth-century Turko-Iranian, he demanded exquisite workmanship, lively drawing, and a harmoniously jewel-like palette.

All these requirements were met in the work of Mir Sayyid-ʿAli, one of his émigré painters who had been apprenticed at Tabriz to two of the three major early Safavid masters, Sultan-Muhammad and Aqa-Mirak (pl. 52). He was the son of the third, Mir Musavvir, who followed him to the Mughal court and there painted three miniatures for Humayun's only surviving illustrated manuscript.[11] The most observantly naturalistic of Safavid artists, Mir Sayyid-ʿAli was also a bold designer whose brushwork stands out as eye-strainingly fine in a tradition noted for minuteness. At Tabriz he painted *Majnun Visits Layla's Camp* for Shah Tahmasp's manuscript of Nizami's Quintet, dated between 1539 and 1543 (fig. 1).[12] Its many highly individualized figures and animals, elaborate textiles, still-

life objects, and settings offer an encyclopedic survey of Safavid life and material culture.

Mir Sayyid-ʿAli was accompanied to the Mughal court by ʿAbd as-Samad, a less brilliant but also less troubled and erratic young painter, an aristocrat born and trained in Shiraz. During his long career ʿAbd as-Samad served not only Shah Tahmasp and Humayun but also Akbar, who appreciated his skills as an administrator as well as his talents as a painter.

A slightly later arrival at the Mughal court was the renowned Dust-Muhammad. Artist, calligrapher, and critic, he had worked in Herat for the last great Timurid patron, Sultan Husayn Mirza (r. 1468–1506), at the side of the illustrious artist Bihzad. With him, Dust-Muhammad emigrated to the Safavid court at Tabriz, where he helped illustrate Shah Tahmasp's great *Shahnama* (Book of Kings).[13] Admired as a critic and connoisseur, he was commissioned to assemble a magnificent album of miniatures, drawings, calligraphies, and illuminations for the shah's brother, Bahram Mirza.[14] Addicted to alcohol, this perceptive but troubled spirit painted a large, hallucinatory miniature of Humayun and his family in a landscape with cliffs and rocks inhabited by nightmarish grotesques that include a looming Indian elephant.[15]

The agitated landscape brings to mind not only the artist's inner torment but also the all-too-frequent bitter rivalries between princes vying for the throne which stain the pages of Mughal history. Seated near the emperor is his brother Kamran Mirza, remembered less for his poetry and connoisseurship than for his brutality and treachery. He rebelled against Humayun, who had entrusted him with the care of his infant son, Prince Akbar. When Humayun reluctantly besieged Kamran Mirza's fort, his perfidious brother exposed Akbar on the ramparts to his unwitting father's arrows.

In 1556, two years after Humayun's reconquest of Hindustan, a call to prayer from the mosque built in Delhi by his late enemy Sher Shah distracted him and brought his death. While descending the precipitous stairs of his library, the emperor tripped, fell, and cracked his skull. He died three days later, and at the age of fourteen Akbar inherited the throne.

Akbar, whose name aptly means "the Greatest," was born in 1542, at the darkest moment of his father's forced retreat from India. Although the "empire" he inherited was barely worthy of the name, he was well served by Bayram Khan, a regent chosen by Humayun; and he himself was rugged, decisive, charismatic, and creative. In effect, he refounded the Mughal state. Although Bayram Khan—the father of the Khankhanan (pl. 20) was effective militarily and politically, the boy king chafed under his domination as well as that of a faction of powerful ladies of the harem, both of which he soon overcame. Aggressive and constant military campaigns vastly increased the imperial territories and population. In order to unify the disparate peoples, religions, and castes of India, the young emperor brought members of virtually every community to his court. Skillful accountants and administrators were hired from the business caste, and he gained loyal officers for his expanding armies by marrying the daughters and sisters of great Rajput chiefs, which brought Indian blood and traditions into his household. His chosen companions, the *nauratan* (nine gems), included Muslims as well as Hindus of various sects, castes, and national origins.

With Emperor Aśoka (r. ca. 265–238 B.C.) of the Maurya dynasty, Akbar ranks as one of India's great philosopher-kings. Far more than a warrior and statesman, he was also a mystic, who experienced a vision in 1578 during the course of a *qamargah*, a hunt prepared by an army of beaters who drove assorted game from miles around into an enclosure. In the words of Abu'l-Fazl, his friend and biographer, "a sublime joy took possession of his bodily frame. The attraction of cognition of God cast its ray."[16] Akbar stopped the hunt; instead of killing animals, he distributed gold to the local poor and holy men. Increasingly curious about the world of the spirit, Akbar brought together holy men, philosophers, and theologians of all beliefs and

FIG. 2 *Krishna Slays the Demon Trinavarta*. Leaf from a *Bhagavata Purana*. Uttar Pradesh or Rajasthan, ca. 1525. Private collection

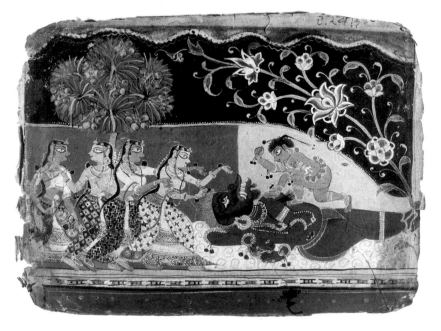

engaged them in searching all-night discussions.

A patron on a grand scale, Akbar attracted artists, intellectuals, men of letters, musicians, and craftsmen to his capitals at Agra, Fatehpur-Sikri, and Lahore. Through them he created a new cultural synthesis that permeated thought and art from statecraft to painting and gastronomy. Although he admired his father's émigré Safavid masters as well as those trained in the workshops of non-Mughal Muslim courts,[17] he was particularly moved by the work of the newly recruited Hindu masters—some of whom were drawn to his court by his repute as a patron, others of whom had come as spoils of victory[18]—who responded more sympathetically to his stimulating and innovative patronage.

Although it would be impossible to refer here to more than a few examples of the indigenous sources of the extraordinary, always evolving synthesis, all known works from this period were rooted in an ancient pan-Indian style from many areas encompassing most of India.[19] We cite a single example in which the qualities of the group are appealingly evident. *Krishna Slays the Demon Trinavarta* (fig. 2) is one of a hundred or so illustrations to a *Bhagavata Purana*, a Hindu epic about the god Krishna. It was painted in Uttar Pradesh or Rajasthan about 1525. Somewhat influenced—in its ornament and flat areas of background color—by the Indianized but originally imported idiom patronized by pre-Mughal Muslim sultans, it nevertheless retains many traditional characteristics which bring the incident to life with the utmost legibility and directness. Among these are its energetic rhythmic structure, strikingly bold composition, masterful outlines, and broad brushwork. Although faces, hands, and gestures were painted according to traditional formulas, the surging vitality and conviction of Krishna, of the four delighted ladies, and of the toothy demon with his tufts of hair more than compensate for the lack of portrait-like individuality. And if the magnificent peony silhouetted against the night sky has been transformed from a Chinese motif imported under the Muslims, the textiles of the ladies' costumes are block-printed with age-old Indian patterns, ones current to this day in a land where such good things are rarely discarded. Paradoxically, the seeming "un-Indian-ness" of the "foreign" patterns is profoundly Indian. From ancient times Indian culture welcomed foreigners and foreign ways —and transformed them with astonishing speed and thoroughness. Sharp eyes will find evidence of this in the flower's exultant leaves, which are shaped like peacock heads (complete with crests) and are thus symbolic of Krishna.

Under Akbar's direction the radiantly outgoing fan-

tasy seen in the Hindu picture met and merged with the exquisitely self-contained Safavid idiom represented by Mir Sayyid-ʿAli's *Majnun Visits Layla's Camp* (fig. 1). In the emperor's ateliers Mir Sayyid-ʿAli and ʿAbd as-Samad directed the new recruits and instructed them in Iranian finesse, without depriving them of the inbred verve and soaring imagination so admired by Akbar. But indigenous and Iranian modes were not the only ingredients of Akbar's varied and evolving school. A search through the thousands of pictures that have survived from his busy ateliers reveals many from Bukhara, Central Asia, Europe, Tibet, Nepal, and China. Exotic works of art interested Akbar as much as people; just as he staffed his administration, harem, and armies with people of every sort, so did he weave together a multiplicity of styles in creating a new artistic idiom.

Although Akbar never learned to read or write, he commissioned a vast library of books on a myriad of subjects, including mathematics, religion, anthropology, literature, and history. Many of his books were illustrated by the more than one hundred master artists of his atelier, whose work he inspected frequently.[20]

Akbar's pictures and other works of art are not only emblematic of his unification of Hindustan and of his broad view of the world but also of his own changing attitudes, interests, and moods. Those commissioned during the years of aggressive military aggrandizement, for example, are composed with explosive energy, while pictures created after the vision of his late thirties are more tranquil and reflective.

All reveal his enthusiasm for nature and people, one of Babur's traits that persisted in his dynasty until the end of Mughal rule in 1858. Akbar spurred his artists to characterize men and animals as profoundly and revealingly as possible. His interest in the human character and soul is reflected in the commission of a great portrait album (now scattered) so that, as Abuʾl-Fazl remarks, "Those that have passed away have received a new life, and those who are still alive have immortality promised them."[21] This album must have been feared as a powerful, even threatening catcher of souls. These likenesses—unlike the subtler, usually less biting portrayals of the Safavid masters or the impersonally generalized ones of indigenous traditions—are unidealized images that lay naked both the strengths and weaknesses of the sitters. Their importance to Akbar as a means of analyzing enemies as well as evoking absent friends encouraged artists to observe and paint ever more searchingly, a determining factor in the development of Mughal art.

If Akbar's soul-searching album portraits, usually of

courtiers standing at attention before the emperor, impressed his visitors, his illustrated histories must have astonished them. In them realistically characterized figures, including acquaintances and friends, were depicted waging war, participating in the pageantry of court ceremonies, or pleading for mercy. As immediate and dramatic as documentary films, these vital scenes make Persian, Turkish, and earlier Indian historical pictures seem undetailed and static. Imbued with the emperor's zest for life, many such pictures were painted by a corps of artists under his close supervision, and each scene was the work of several hands: a master to design or outline, a less accomplished painter to color, and often a third or fourth to execute "special portraits" or animals. The most immediate and compelling of these vital compositions, commissioned for the *Akbarnama*, the emperor's official history of his reign, were sketched by Basawan or Miskin, who often added finishing touches to the coloring of their assistants.

By the age of twenty-six the young emperor had succeeded in virtually every area of life—except in siring an heir. But he was determinedly persistent, and after making many pilgrimages he obtained the intercession of the Sufi saint, Shaykh Salim Chishti of Sikri. Prince Salim, named after the saint, was born to Maryam uz-zamani, the daughter of Raja Bihari Mal Kachhwaha, in 1569. A few years later the humble but auspicious village of Sikri was transformed into a new capital, Fatehpur-Sikri (City of Victory), and its great mosque was completed in 1572.

Growing up under Akbar's eye cannot have been easy, especially at the Mughal court, where princes, such as Salim and his younger brothers Murad and Danyal, were exposed to factionalism and treachery. The imperial life as known from miniatures and chronicles—a tapestry populated with beautiful women, talented and amusing courtiers, skilled artists, musicians, craftsmen, and obliging servants—must have been addictive. Caparisoned elephants and horses waited at the gates of superb palaces, tents, and gardens; every dagger, sword, cup, or throne was a delight to see and use. If all this as well as the excitement of warfare, hunting, polo, and extraordinary food began to bore, princes could turn to the life of the spirit, encouraged by sympathetic wise men and ascetics promising paradise. But the princely life sparked jealous rivalries, and at any moment the tapestry might rip. Only constant watchfulness and occasional violence secured survival at a court in which brother was pitted against brother and son against father.

In a world so risky and changeable, works of art provided a delight and sanctuary more lasting and satisfy-
ing than amorous dalliance, wine, or opium. Ateliers for pictures, jewelry, lapidary work, textiles, and arms and armor were kept busy creating not only delights for the emperor but also gifts for family members, favored courtiers, and rival rulers.

As a youth in Fatehpur-Sikri and Lahore, Prince Salim often visited his father's ateliers, especially those of the painters. He looked on as such masters as Basawan and his son Manohar highlighted faces or burnished and tooled passages of gold. He familiarized himself with every stage of the complex technique, from the processing of the paper to the final burnishing. He watched special craftsmen prepare imported paper made from cloth fibers, cutting it to size and burnishing the surface to smoothness with an egg-shaped, polished agate against a flat stone.

The traditional Indian artist, such as those Prince Salim observed, sits on the ground or floor, with his drawing board comfortably propped against his knee. He begins a miniature by brushing the paper with a light, moist priming coat of white pigment, which is then allowed to dry before being turned over and burnished to provide a smooth ground. Laid out near the artist are his tools: two small pots of water (one to moisten pigments, the other to clean brushes), a jar of binding medium (probably glue), brushes he has made of kitten or squirrel hairs tied into bird quills, and twenty or so mussel or clam shells of assorted pigments. Although he might not prepare these colors himself, he has learned the manual labor and chemistry of doing so as an apprentice. Pigments are of many kinds, and some are more fugitive than others. Crushed and carefully sorted minerals such as lapis lazuli are permanent; saffron, made from the stigmas of crocuses grown in Kashmir, is so fugitive that it is rarely used. Gold and silver pigments are made by beating small ingots into leaf between layers of parchment. The metal is mixed with coarse salt and ground into powder with a mortar and pestle; the salt is then washed out, leaving a fine metallic powder. Mixed with water and binding medium, this is applied with a brush in seemingly drab washes, which when gently stroked with a pointed agate flare into magical brightness. For gold of warmer or cooler hue, copper or silver is added. Other pigments are made from such odd substances as animal urine, crushed beetles, and earths. Verdigris (oxidized copper) gives an intense but corrosive green, which tends to eat through paper unless sealed off.[22]

Although Mughal artists drew from life, most paintings were colored in the atelier, where many were begun with the aid of a *charba* (a piece of transparent gazelle skin onto which the outlines of sketches were

17

traced). This tracing was pricked through, and powdered charcoal was rubbed through the holes, leaving a fuzzy outline. This was reinforced with a black or vermilion line, at first faintly but deepening in intensity as the drawing progressed. Mistakes were scumbled over in white and redrawn. The back of the artist's hand—or a convenient scrap of paper—was used to point brushes. Another scrap was put under the hand to steady it while protecting the vulnerable surface of the miniature. For particularly fine detail, magnifying lenses were used. Some artists wore spectacles, as can be seen in portraits of the Akbar period.[23]

As the picture progressed, the artist moved spontaneously from part to part, refining a chin, ear, or hand, applying arabesques to a slipper, or lending fullness to a bolster. Washes of opaque color were gradually added to the underdrawing; as they built up layer upon layer, these were fused to the paper fibers by repeated burnishing. A special brush or feather was used to banish dust.

Although Mughal artists sketched and colored with dashing quickness, miniature paintings required weeks or even months of sustained work. Flesh tones, textiles, and skies were brought to enamel-like perfection. As pictures neared completion, the jewels and pearls were painted with lustrous globs of pigment applied in relief over gold. On occasion actual jewels were set into the surface.[24] For additional glitter, gold was pricked or striated with the rounded point of a steel needle.

After a final burnishing the miniature was turned over to the clerk of the workshop, who recorded it and passed it on to other specialists, such as the craftsmen responsible for marginal rulings and those who assembled miniatures, calligraphies, and borders for binding.

Simple as the technique of opaque watercolor or gouache painting might seem, it is exceedingly difficult to master. Although royal amateurs such as Emperor Akbar and presumably Prince Salim tried their hand at the art—and ʿAbd as-Samad was of aristocratic background—most artists came from craftsmanly stock and were trained by fathers or uncles. Families of artists passed on tools, pigments, tracings, drawings, and pictures from one generation to the next, thus providing continuity of trade secrets and styles.

The distinction between the court ateliers and those of the bazaars was sometimes ambiguous. The emperor's artists occasionally accepted commercial commissions, and especially talented artists of the bazaar were likely to receive an imperial summons. At times—for example, when Emperor Jahangir inherited his father's artists by the hundreds—painters were dropped from

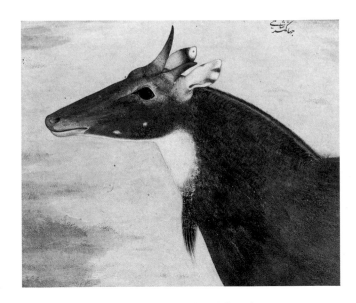

FIG. 3 Detail from Mansur, *Nilgai* (pl. 47)

the imperial lists and compelled to seek employment in the bazaars or at the courts of Rajput princes who had admired the paintings of the imperial court.

As members of the Mughal administrative system, artists and craftsmen received wages comparable to those of soldiers. And like soldiers, they were rewarded for outstanding service. If the emperor responded warmly to a portrait or animal study, he might grant the artist a revenue-producing village or even—if the recipient could afford such grandeur—an elephant. When the imperial or princely patron went on a military campaign, hunted, or visited Kashmir, artists accompanied him as part of the tented entourage to document significant events, people, flora and fauna, and anything else deemed worthy of note. Inasmuch as Mughal artists usually specialized either in portraiture, nature studies, or historical compositions, the patron was less than adequately served unless he brought with him an entire atelier. At times, too, artists were commissioned to paint on walls and to provide designs for carpet and textile weavers, metalworkers, jewelers, and stonecutters.

Because portraiture was a prime concern of Mughal painting, most artists concentrated upon it. Akbar initiated the practice of commissioning likenesses of himself and of his immediate circle.[25] Made by the most admired masters, these provided models for repetition, both by the original portraitist and by other members of the workshop.[26] Although the emperor's artists had access to him and his entourage and could therefore breathe life into copied portraits of them, the most compelling likenesses tend to be by the ablest artists

18

working from life. There is a distinct pecking order to such copies—as well as to those of other Mughal subjects—ranging from nearly contemporary replicas by court painters to versions turned out in the bazaars or at provincial courts. Albeit appealing, the latter lack authority.

Prince Salim also learned the techniques of the illuminators, the usually anonymous artists who provided the Kevorkian Album with two marvelous rosettes (shamsa) (pls. 1 and 5), 'unwan (pls. 2, 3, 6, and 7), and surrounds for calligraphies. Although figural artists also mastered arabesques with which to adorn depictions of costumes and other decorative passages, these especially patient experts, using rulers, calipers, and compasses as well as the more conventional tools of painters, spent their lives creating intricate flowering vines. At times, figural artists assisted them in drawing the flights of golden birds or swooping dragons that adorned especially splendid margins.

As he grew older, Prince Salim turned increasingly from manuscript illustrations to single miniatures for albums. His love of nature inspired him to commission sensitively exacting studies of birds, flowers, and animals, which were painted by two favorite artists, Abu'l-Hasan and Mansur. The ingratiating animal-wisdom of a nilgai, or blue bull, from the emperor's menagerie was understood and recorded by Mansur, who was able to project himself into profound communion with natural life (fig. 3; pl. 47). Understood from within as well as without, the nilgai—with his soft fur, velvety muzzle, and limpid eye—surpasses comparable studies by Dürer, which in comparison seem anthropomorphic and slightly sentimental.

Such pictures were fitted into borders, which in turn—as in the Kevorkian Album—were remarkable works of art in themselves, enriched with arabesques, flowers, flora and fauna, or figures. Although the borders were sometimes by the same artists who painted the pictures, more often they were created by artists who limited themselves to ornamental motifs.[27]

Prince Salim also visited the scribes, who were revered not only for the wondrous forms of their masterful calligraphy but also because they copied the sacred Koran. Reed pens and specially prepared inks ('Ambar-Qalam, for example, wrote in a lustrous brownish black concocted to his own formula) were occasionally supplemented by brushes for filling in outlined writing. At times masters wrote qit'a (calligraphic specimens such as those in the Kevorkian Album) in white or colored pigments. Some were called upon to work on a grander scale in designing inscriptions for architecture or textiles.

One senses Prince Salim's influence on painting by 1588, when the imperial masters illustrated a pocket-size divan (anthology) of verses by the poet Anvari.[28] In this luxurious manuscript—entirely illustrated by major masters—the stormy rhythms of Akbar's early pictures have calmed in keeping with the emperor's more tranquil mood and his son's refined tastes. But Salim's insistence upon astonishing fineness of finish perpetuated an ancient characteristic, for Indian art from its outset in prehistoric times has valued technical brilliance.

Prince Salim was certainly a most extraordinary patron and mentor of the arts, but some of his less admirable deeds must be interpreted in the light of his times and circumstances. Strained relations with his father and fraternal rivalries recalling those that beset Humayun sparked hostility and rebellion. In 1601 he proclaimed himself an independent king at Allahabad, where he established his own court and workshops of painters and craftsmen. A year later, suspecting that Akbar's biographer and friend Abu'l-Fazl had conspired against him, Salim contrived his assassination.

Nevertheless, Salim was restored to Akbar's favor, and when the emperor died in 1605, either from stomach disease or poisoning, Salim succeeded, taking Jahangir (World Seizer) as his regnal name. The empire was now established: it was time to maintain and enjoy it. Akbar had created a vast, well-organized state. Jahangir, and his son Shahjahan, needed only to consolidate it, quash rebellions, and—from force of habit more than necessity—extend the borders.

Jahangir's memoirs, Tuzuk-i Jahangiri, as candid as Babur's, are intimately confessional and touchingly honest, revealing attitudes and deeds ranging from poignant to outrageous. At times extremely tender—on seeing elephants shiver while being bathed, he ordered that the water be heated—he could also be irrationally cruel. But most of all he charms us with his insatiable curiosity, love of life, sentimental whims, wiliness, and generosity.

Mughal India's mood was changing, as is apparent from contemporary writings and from pictures, the styles of which reflected patrons' thoughts and activities. Babur's memoirs (Baburnama) and the illustrations for Akbar's Persian translation of this work invite us into a swiftly paced conqueror's world: bloody military victories and defeats and triumphantly boisterous celebrations, enlivened by noisy camel and elephant combats, wrestling, and drinking bouts. Also engagingly informal and welcoming are the charged scenes of the Akbarnama. But if we entered the increasingly formal world depicted in Jahangir's and Shahjahan's

19

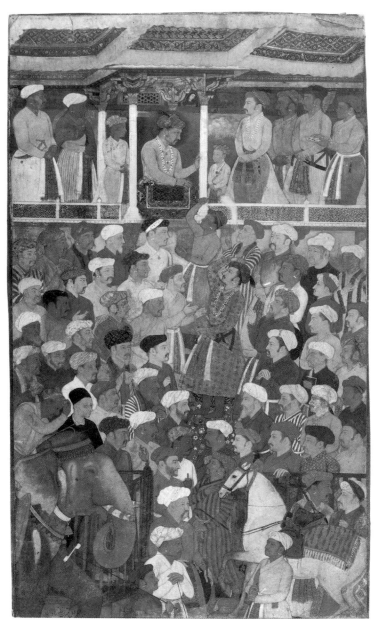

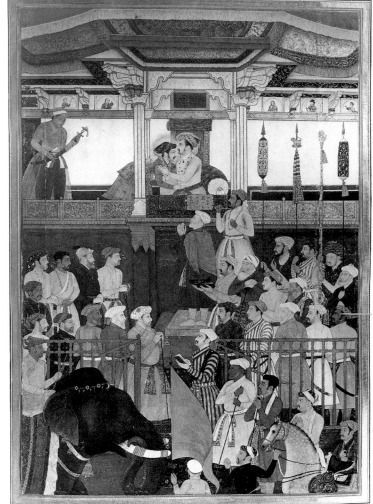

FIG. 4 Attributed to Manohar, *Emperor Jahangir in Darbar.* From a manuscript of the *Tuzuk-i Jahangari,* ca. 1620. Museum of Fine Arts, Boston, Frances Bartlett Donation of 1912 and Picture Fund, 14.654

FIG. 5 Murad, *Jahangir Receiving Shahjahan.* Windsor *Padshahnama,* fol. 193v. Her Majesty Queen Elizabeth II, Royal Library, Windsor Castle

histories of their reigns (figs. 4 and 5), we would feel like uninvited guests at ever more artfully arranged, ever more exclusively imperial, court functions. Life was becoming more codified, religion more orthodox.

The dramas of Jahangir's reign—as reflected in his works of art—are slower in pace and smaller in scale, centered around the hunt, the court, or the harem rather than the battlefield. Shouts give way to muted conversations. Threats to imperial power were now mostly from within—from embittered courtiers, from members of the imperial family, and from the emperor's

introspective mind, as is evident in portraits of him which mirror the effects of stress and strenuous living. One in the Kevorkian Album seems to concentrate upon the jowly flesh of middle age, recorded by Manohar—Jahangir's contemporary—with the same honesty and precision accorded by Mansur to bony vulture legs (fig. 6; pl. 16).

There were many hints at court of the new spirit blended from political stability, psychological uncertainty, and blissful aestheticism. Jahangir's personal weapons are works of art rather than tools for fight-

20

ing. Whereas Akbar's lethal blades and hilts were sturdily joined, Jahangir's more graceful blades were made separately and fastened far less securely into hilts intended for delectation. Symbols of might, his daggers are not mighty.

Mightier by far, in fact, was Nur-Jahan, the daughter of ʿItimaduddaula (pl. 16) and Jahangir's favorite wife, whose hold over the emperor recalls his father's early years under the spell of the harem. But there was no equivocation in Jahangir's love for Nur-Jahan, and her devotion to him was total. An astutely efficient organizer, she also shared his passion for art and architecture, hunting, Kashmiri gardens, wine, and music. While attending to his whims, she furthered the careers of her aspiring relatives, whose fortunes at the Mughal court span three reigns, and elevated them to almost imperial power. Nur-Jahan's father and her brother Asaf Khan attained the highest offices in Jahangir's administration. Her niece Mumtaz-Mahal married Shahjahan, who later built the Taj Mahal in her memory; her nephew Shayesta Khan became Emperor Aurangzeb's most trusted minister. Given her Iranian heritage, it is not surprising that she encouraged art in the Safavid mode, which contributed harmoniously to the jewel-like marble and *pietra dura* tomb she erected at Agra for her father between 1622 and 1628.

Jahangir's view of life combined imperial hauteur with childlike innocence. We are charmed by his unselfconscious joy of possession, whether of works of art, talented artists, musicians, animals for his zoo, or women for his harem. To satisfy his hunger for the beautiful, each of his wine cups, buckles, daggers, and slippers was artistically remarkable as well as efficient. His dark green jade inkpot in the Metropolitan Museum is as rounded and weighty as a grenade; but it is also supremely elegant, carved with a delicate low relief of floral ornament and arabesques, and its low center of gravity makes it untippable.[29]

Jahangir was an impassioned collector whose agents traveled far in search of the curious or beautiful. Works of art in effect "sired" works of art when his artists provided a visual catalogue of everything that interested him, scrupulously painting studies of *blanc de chine* statuettes, Renaissance jewels, German bronzes, European tapestries, and engravings by Dürer, Pencz, and the Flemish Mannerists. Sir Thomas Roe, the ambassador of King James I, described the emperor's excitement on seeing an English portrait miniature (see Chronology, entry for year 1616).

Jahangir's library included superbly illustrated and illuminated Iranian manuscripts, some inherited, others acquired for him by zealous agents. Unlike less

bold collectors, Jahangir felt no qualms about improving his works of art through extensive retouching, as can be seen in the judicious reworking by Abuʾl-Hasan of a miniature in the Kevorkian Album by the Safavid master Aqa-Mirak (pl. 52).[30]

For Jahangir art and life intertwined. All his pictures and objects were shared not only with Nur-Jahan, his family, and his courtiers but also with his artists, for whom these works were sources of motifs. Although the *Tuzuk* contains fewer comments about artists than

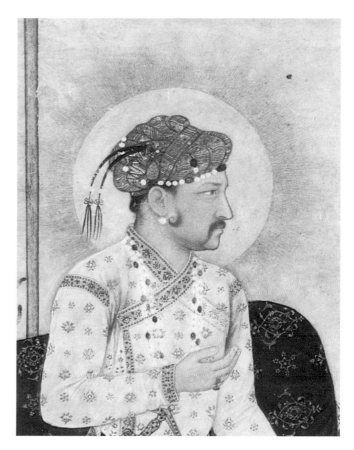

FIG. 6 Portrait of Jahangir; detail from Manohar, *Jahangir and Iʿtimaduddaula* (pl. 16)

one might expect, the emperor's pictures imply long and creative hours spent with artists, showing them works of art and guiding their progress.

The quintessential Great Mughal was not Jahangir but the other great patron of the Kevorkian Album, Shahjahan (King of the World). He is best known in the West for the Taj Mahal, the tomb of his favorite wife, Mumtaz-Mahal, who died while bearing their fourteenth child. Enthusiastically admired in his childhood (as Prince Khurram) by Akbar, in youth and early manhood he became his father's favorite. He led armies with marked success in Rajasthan and in the

21

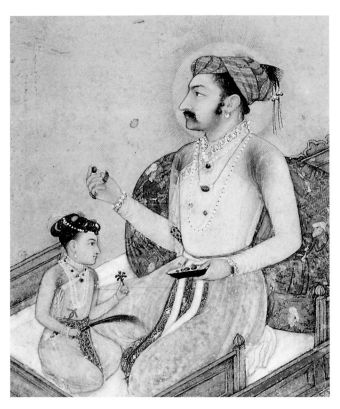

FIG. 7 Detail from Nanha, *Shahjahan and Prince Dara-Shikoh Toy with Jewels* (pl. 55)

solved their bitterness, Shahjahan was enthroned after Jahangir's death in 1627 through the support of Asaf Khan—and a string of murders of convenience.

Shahjahan's portraits are so idealized that in them he hovers unreachably overhead, an elusive, rather touching imperial legend. Whereas Akbar's portraits usually show him in action, or ready for action, and Jahangir's fleshy visage projects him as a palpable man rather than as an emperor, Shahjahan is portrayed as an icon of royalty, static or—in historical pictures—carrying out dignified imperial activities. In one of the Kevorkian portraits he stands above mere earth on a marble platform, weighed down with gems, pearls, and gold, tightly outfitted in rich stuffs and plumes, with dagger and sword, and holding up the ultimate image of empire: a jewel-portrait of himself (pl. 58).[31]

An attempt to grasp Shahjahan's character requires sympathetic effort. Although he commissioned a fully illustrated, very formal history of his reign, the *Padshahnama*, now in the Royal Library at Windsor Castle (see Appendix, figs. 15–18, 20–22, and 26–28), Shahjahan wrote no memoirs, and his jewel-like portraits, exemplified superbly in the Kevorkian Album, almost always show him in profile (pls. 55, 58, 59, and 62).[32] His eyes will not meet those of the viewers. Artists were not encouraged to note the passions that burn from Akbar's portraits or the soulful world-weariness so affecting in likenesses of Jahangir. To understand this evasively royal—or sensitive and shy—being, we should walk through his buildings and tents, admire his jade and rock crystal wine cups, and read of his military successes, of his friends and family, and especially of his tender relationship with his daughter Jahanara Begum. We must also attune ourselves to the stiffly formal, inhibiting, but extremely rewarding world of his pictures.

The Kevorkian portrait of Shahjahan showing a jewel to Prince Dara-Shikoh was painted about 1620, a few years before the embittering rift with his father (fig. 7; pl. 55). In painting this unusually intimate and penetrating likeness for Jahangir, the veteran artist Nanha, who had worked for Akbar, adjusted his manner to the sitter's taste for formality. If the intimacy of pose stems partly from Jahangir's insistence upon psychological revelation, it also documents a genuinely devoted relationship between father and son which lasted until Dara-Shikoh's execution in 1659 at the order of his brother Aurangzeb, who now ruled as ʿAlamgir I. But the jewels and golden throne are equally characteristic of the sitter. Following the rebellion against Jahangir and his enthronement, such baubles were omnipresent, for their intrinsic beauty and as protective barri-

Deccan, and Nur-Jahan promoted his cause by arranging a marriage to her niece. But the familiar, deadly pattern of rivalry and hunger for power soon surfaced. Resentments over matters of protocol were amplified by self-interested courtiers. In 1622, on hearing that his father was seriously ill, Shahjahan is suspected of having eased his path to succession by killing his brother Khusrau, although Jahangir's memoirs record that he "had died of the disease of colic pains, and gone to the mercy of God." But Jahangir's rival Shah ʿAbbas also learned of Jahangir's illness and set off toward India to retake the strategically located fort of Qandahar. By now in better health, Jahangir began to mobilize a countering army, and he ordered Shahjahan to bring his troops from the Deccan. Fearful of weakening his powerful position in the event of his father's death, Shahjahan procrastinated. Nur-Jahan, who virtually controlled the empire, withdrew her support from him in favor of the handsome but ineffectual Prince Shahryar. Open revolt by Shahjahan followed. Imperial armies hounded Shahjahan's forces; after scuttling from the Deccan to Rajasthan, he found refuge at Udaipur with the rana of Mewar. Jahangir's nickname for his once-cherished heir changed from Baba-Khurram to *bedaulat* (Wretch). Although father and son never re-

ers that remind one of his superiority. Shahjahan's deep love for jewels and jewelry is known not only from representations of these works in paintings but also from accounts of the European jewelers who visited his court. Moreover, architecture, costumes, arms and armor, and furniture—everything upon which he doted—took on a crystalline purity of color and form. Under his patronage miniatures glow and sparkle like jewels, as is evident when they are juxtaposed with Akbar's or Jahangir's pictures or with the murky nineteenth-century additions to the Kevorkian Album.

Creation of the Royal Albums

One of the most rewarding sections of a royal Turko-Indo-Iranian library contained albums intended for pleasurable, relaxing contemplation. The earliest examples containing miniatures, drawings, and calligraphies —prototypes of Mughal albums—date from the fifteenth century. Preserved in the library of the Topkapi Saray Museum, Istanbul, they remain in the buildings where they were kept under the Ottoman Empire. One (H. 2153) is especially informative. Assembled for the Aq-Qoyunlu Turkoman Sultan Yaʿqub Beq, it resembles a scrapbook.[33] Like the Mughal albums, it is an omnium-gatherum of portraits of family and friends, stray miniatures and drawings, European prints and copies therefrom, and memorable specimens of fine writing; it is a book to leaf through with friends and family. The borders, however, are plain; each folio is larger than Mughal examples; the *mise-en-page* seems haphazard, not the work of an album specialist. Rich and marvelous as is the grand maelstrom of components—in which demons and dragons cavort beside royal portraits, studies of holy men, or splendid *mashq* (calligraphic exercises)—none appears to have been painted or written specifically for the album.

The earliest artfully composed album is also in Istanbul, the so-called Album of the Seven Masters (Topkapi Saray Museum, H. 2152), which was assembled for the great Timurid patron, Baysonghur Mirza of Herat, for whom the *Shahnama* of 1430 was illustrated. Limited to specimens of calligraphy (*numuna*) by seven major fourteenth-century scribes, it was arranged in a highly sophisticated order, with subtly balanced margins and spacing. Although late fourteenth- and early fifteenth-century Iranian manuscripts were occasionally adorned with rich borders of arabesques, birds, beasts, or even figures, the borders of this album are simple.

The earliest album known to combine miniatures, drawings, and calligraphies in harmoniously planned assemblages was prepared in 1544 by Dust-Muhammad. Also in the Topkapi Saray Museum Library (H. 2154), it was commissioned by Shah Tahmasp's brother, Bahram Mirza.[34] An important forerunner of the Kevorkian Album, it contains a comical miniature and a drawing, both by Shah Tahmasp himself, showing his household servants, as well as work by most other artists and calligraphers of the Safavid court.[35]

The introductory text to the Bahram Mirza album is one of the few art historical essays in Safavid literature. It was written by Dust-Muhammad, whose excellent calligraphy is recognizable in the many subheadings scattered through the now somewhat incomplete volume. Its borders are unadorned, or modestly enlivened by flecks of gold, perhaps because the talents of the great masters of ornamental drawing (Aqa-Mirak, Sultan-Muhammad, and Muzaffar-ʿAli) were available only to the shah himself.

When Dust-Muhammad followed Mir Sayyid-ʿAli and ʿAbd as-Samad to the Mughal court on Humayun's invitation, it is very likely that his talents as album assembler were put to use by the emperor. Given the artist's close associations with the royal Timurid as well as Safavid courts and ateliers and with individual artists, he also might have supplied pictures to the emperor, either by gift or sale. At least one intact folio with enriched borders has survived from one of Humayun's albums, perhaps assembled by Dust-Muhammad. It is half of a double-page composition showing a picnic in the garden of Sultan Husayn Mirza.[36] This folio is in the *Muraqqaʿ-i Gulshan*,[37] now in the Gulistan Library, Teheran, which also contains other material from the earliest Mughal imperial albums. It would have been kept by Humayun in a special room on the uppermost level of his *khana-i tilism* (magic house), where he enjoyed books, gilded pen cases, and beautiful specimens of calligraphy, as well as albums with pictures.[38]

The miniature is set in magnificent original borders heretofore ascribed to artists working for Emperor Jahangir, who admired and was strongly influenced by album pages inherited from Humayun. Drawn in gold by one of Humayun's Iranian artists (perhaps Mir Sayyid-ʿAli, a gifted ornamentalist), its birds and beasts, real and fantastic, swoop and swirl in space suggestive of actual landscape.[39]

If his folios in the *Muraqqaʿ-i Gulshan* underscore Humayun's critical role in the development of Mughal miniature as well as border painting, one must turn to Akbar as the patron responsible for the new artistic synthesis of indigenous as well as imported strains. Whether ornamented with arabesques, birds and ani-

23

mals, or figures, decorated borders were no more traditional to pre-Mughal India than bound books.[40] The borders of Akbar's albums and manuscripts, therefore, are strongly Iranian. The earliest known album borders surround two miniatures—one by Basawan showing a cow nursing her calf; the other by an unidentified master of a doe with her fawn.[41] Both are conventional arabesque designs drawn in gold, and their "Indian-ness" is evident only in the unusual degree of élan.

Inasmuch as Mughal royal albums—more often than manuscripts—were added to over the years (even over several reigns), it is difficult to assign precise dates to them. The *Muraqqa'-i Gulshan* contains folios assembled for Humayun and Akbar, and several of its earlier borders were altered for Jahangir. A companion volume, the so-called Berlin Album, containing material dating from 1590 to 1618, was probably initiated for Akbar and expanded under Jahangir.[42] It too contains pictures gathered by and painted for Humayun, including work by Dust-Muhammad, and its borders—like the later ones in the *Muraqqa'-i Gulshan*—ring changes on the style set by Humayun's Iranians.

Unlike most Iranian borders, however, Mughal ones often emphasize human figures, frequently depicted in lively activities. Although these genre scenes are in keeping with tellingly observed Mughal reportage, they may have been inspired by an atypical Iranian source, such as the inhabited borders of the divan of Sultan Ahmad Jalayir ibn Uways of Baghdad (1382–1410), a marvelous manuscript now in the Freer Gallery of Art.[43] The relationship between these late fourteenth- or early fifteenth-century borders and those of the Berlin Album seems more than coincidental, and the Freer manuscript, or one akin to it, may have once been in Mughal hands. Whatever their source, borders containing sensitively and accurately observed figures, some of them portraits, became a Mughal specialty. Occasionally they overshadow the miniatures or calligraphies they surround, and painters such as Govardhan gave them the same lavish devotion and care accorded miniatures.[44]

Highly characteristic of seventeenth-century Mughal art are the delightful borders containing arrangements of small, silhouetted flowers—sometimes with additional birds, butterflies, and animals—frequently set against the natural tone of the paper. These alternate with energetically and inventively composed arabesques and are seen at their innovative, stately, and occasionally frolicking best in Jahangir's folios—as opposed to Shahjahan's and nineteenth-century additions—for a series of albums. Although none of these albums is complete and all lack their original bindings, many folios from them have survived in the albums now

known as the Kevorkian Album, the Minto Album (largely shared between the Victoria and Albert Museum and the Chester Beatty Library), and the Wantage Album (most folios of which are in the Victoria and Albert Museum).[45]

Jahangir's albums dating from the second half of his reign, as represented by the Kevorkian–Minto–Wantage group, are distinguishable from the earlier miscellanies of portraits, miniatures removed from earlier manuscripts, prints, and calligraphies. Like the Mughal state and Mughal life, they had become more formal, with a stricter policy as to what should be included and excluded. Most of the pictures in them were specifically created for albums: formal portraits of family, court, and distinguished figures from rival states (Safavid Iran, the Deccani sultanates, and even European kingdoms), less formal studies of holy men or other picturesque luminaries, and natural history paintings, illuminations, and carefully chosen calligraphies, all of which were set in unifying, sumptuously illuminated surrounds. In the Kevorkian Album only one miniature—Aqa-Mirak's *Dancing Dervishes* (pl. 52)—is a collected rather than a commissioned picture. Otherwise—excluding the folios added in the nineteenth century—only calligraphic specimens, two double-page frontispieces, and a few richly illuminated folios from a treatise on calligraphy are "strays" from earlier sources. Unified and harmonious in spirit and appearance, the album contains no prints or drawings, in which respect it is fully consistent with its companions in Dublin and London.

Botanical and floral arabesque borders in color and in gold give springtime freshness, a uniquely appealing Mughal contribution to the arts of the book. These lyrically ornamental yet accurate border paintings—to which birds, insects, and animals are sometimes added—exemplify Jahangir's enthusiasm for nature and for art.[46] In the *Tuzuk* he wrote eloquently of the flowers "beyond all calculation" of Kashmir, many of which he described in passages at once poetic and analytical. In 1620 he commissioned Mansur, whom he entitled *Nadir al-'asr* (Wonder of the Age), his foremost specialist in flora and fauna, to paint "more than one hundred" botanical studies.[47] Their transplantation from miniatures to borders around 1620 was a happy and natural step based upon various prototypes. For centuries Iranian artists had scattered less accurately rendered flowers in miniatures as backgrounds to tents, thrones, or horsemen. Jahangir's enthusiasm for European engravings and etchings as well as for flowers may have familiarized him with European botanies and floral pattern books such as Pierre Vallet's *Le Jardin du tres*

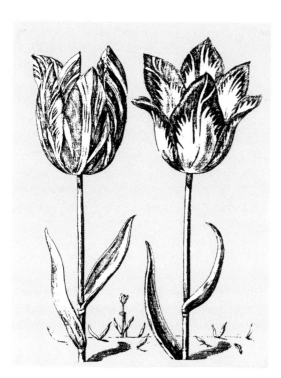

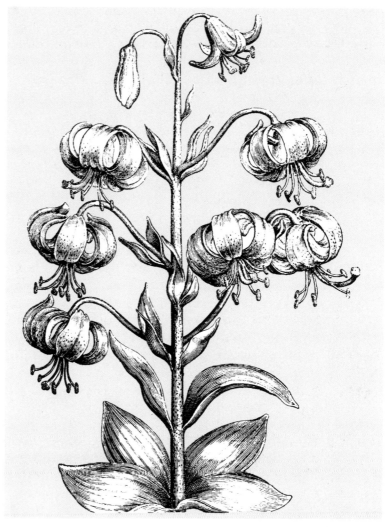

FIG. 8 Tulip. Crispian van de Passe, *Hortus floridus*, 1614–17. Reproduced from Hatton, *Handbook of Plant and Floral Ornament*, p. 522, pl. 47

FIG. 9 Turk's-cap lily. Crispian van de Passe, *Hortus floridus*, 1614–17. Reproduced from Hatton, *Handbook of Plant and Floral Ornament*, p. 525, pl. 50

chrestien Henri Quatre (1608), Johann Theodor de Bry's *Florilegium novum* (1611), and Crispian van de Passe's *Hortus floridus* (1614–17). Whether or not Jahangir saw these publications, which came out in several editions and were widely pirated, it is likely that he knew and admired prints of this kind and showed them to his artists, who had grown up in a flower-conscious tradition (see fig. 2). In these engravings, as well as in European textiles which might also have been known to him,[48] one finds precisely silhouetted flowers strikingly similar in design and arrangement to those the emperor and his artists adapted for borders of albums (figs. 8 and 9).

Iranian patrons, such as Sultan Ahmad Jalayir and Shah Tahmasp, occasionally commissioned major artists to enrich borders. The remarkable genre subjects

in the borders of the Jalayirid divan have been mentioned, and it is also useful to recall the superb drawings in two tones of gold and silver commissioned by Shah Tahmasp for the borders of a now-scattered copy of Saʿdi's *Gulistan* (Garden) and for his sumptuously illustrated manuscript of Nizami's *Khamsa* (Quintet). Many of the lively and inventive fantasies for the former, datable to about 1525–30, can be assigned to the shah's greatest artist, Sultan-Muhammad; while those for the latter (1539–43) are often by Aqa-Mirak, an extraordinary artist who specialized in calligraphically ornamental animals and dragons.[49] Usually, however, Iranian manuscripts, even those for eminent royal patrons, were given borders that are appealing for their simplicity, variations of color, and rightness of proportion. Some were flecked with gold or enlivened with

25

pleasing arabesques painted by excellent craftsmen rather than by major court painters.

Mughal patrons from Humayun onward gave more prominence to borders. In several instances, as in Akbar's manuscript of the *Tarikh-i alfi* (Millennial History) of about 1592–94, borders overflow with illustrative scenes.[50] Moreover, these pictorial borders, like those of the *Muraqqaʿ-i Gulshan* and the Berlin Album, are by important imperial artists. Although only a few by Daulat are signed, many of Jahangir's floral borders are so artistically brilliant that they must be by major masters, sometimes those responsible for the miniatures they surround. As might be expected, their colors are sensitively related to the central image, as well as to the facing page.[51]

When Shahjahan inherited the royal library, including his father's albums, he made no effort to add to the *Muraqqaʿ-i Gulshan* or to the Berlin Album, which had been completed decades before. He shared his father's enthusiasm, however, for albums still in active preparation, especially those with floral and arabesque borders. Inasmuch as no single album of this series of once-bound volumes of uniform size is intact, one can only speculate as to Shahjahan's impact upon them on the basis of single folios, many of which bear his handwriting in the lower margins.

Most latter-day art historians see Shahjahan more as a patron of architecture and the decorative arts than of painting, but the pictures made for him, in many cases by artists trained in his ateliers, indicate his profound enthusiasm for this art. As a young man, he owned a remarkable small album containing a very personal selection of excellent portraits and drawings, some of which may have been given to him by Akbar.[52] Several are outstanding examples of Akbari and early Jahangiri art; and a number of folios bear lengthy autograph specimens by the prince himself.[53] If as a young man he admired the work of such Mughal old masters as Basawan, his commissioned pictures show that his view of painting conformed to the rest of his changing attitudes and moods. The informality of his portrait with Prince Dara-Shikoh by Nanha (pl. 55) might not have pleased him later on, when he preferred to be represented as the almost abstract, depersonalized embodiment of imperial authority.

Shahjahan's floral borders, like his portraits and animal studies, are less individualized than those of Jahangir. He was more concerned with their pattern, arrangement on the page, colors, and grace. His arabesque borders and spiraling stalks and flowers are less rigorously disciplined than Jahangir's and occasionally bring to mind the flamboyance of Rococo fantasies.

26

The Royal Albums in the Nineteenth Century

The fate of Shahjahan's albums is sad. Only one mid-seventeenth-century imperial Mughal album of pictures and calligraphies has survived intact. It was commissioned by Prince Dara-Shikoh in 1633 and presented to his wife Nadira Banu Begum in 1642. It alone retains the original binding, which is of black morocco with large rectangular panels of red morocco stamped with a garden-like design of strapwork and flowers.[54] Like all the others, the Kevorkian and Wantage albums had strayed from the imperial library by the early nineteenth century, when they were supplemented with copies and pastiches of miniatures and calligraphies, probably by one or more dealers who had acquired them from the ever-weakening Mughal court and who wished to increase their value on the art market. Although the imperial library suffered most when Nadir Shah of Persia sacked Delhi in 1739, it continued to be drained of manuscripts and albums as the wealth and power of the emperors diminished. In the early nineteenth century dealers sold such material to Indian and foreign collectors. The Maharaja Sawai Man Singh II Museum, Jaipur, owns an "imperial" album of miniatures and calligraphies acquired in the early nineteenth century from a Delhi dealer. Like many of the Wantage folios—seventeenth-century originals as well as copies—several were "authenticated" by being stamped with Jahangir's seal.[55]

Some of the added miniatures are the work of the best available talent, trained in the imperial workshops. A few can be assigned on stylistic grounds to artists employed by William Fraser, whose life in Delhi, Haryana, and the Hills is brilliantly documented by an extensive series of watercolors by highly gifted Delhi artists.

Fraser (1784–1835) was the younger brother of the talented landscape artist and author James Baillie Fraser (1783–1856) whose artistic judgment must have guided the Fraser painters. Born to a landowning family in Scotland, William reached Bengal in 1799. By 1805 he had moved into the *moffusil* (the provinces) as secretary to the Indianized Britisher, American-born Sir David Ochterloney. "Loony Akhtar" (Crazy Star), as he was known to some, was the British resident at Delhi between 1803 and 1806 and again from 1818 to 1822. His devotion to India was so profound that he took thirteen wives, each outfitted with her own elephant.[56] Although much of William Fraser's career

was spent with Ochterloney, he also served on a mission to Kabul, and he and his brother campaigned in the Punjab Hills between 1814 and 1816 with Sir James Skinner, another colorful patron of painting. In 1819 William Fraser settled in Garhwal, and in 1826 he became a member of the Board of Revenue of the Northwest Provinces. He returned to Delhi in 1830 and in 1835 was assassinated at the order of an erstwhile friend, the nawab of Firozpur, with whom he had clashed over a matter of inheritance.

Fraser's artists would have belonged to a circle of art lovers which included dealers, collectors, and assorted hangers-on—the sort of enthusiasts who to this day in India haunt artists' studios and applaud each master stroke of the brush. Indeed, the Fraser brothers themselves, who mixed freely with Indians, must have relished such activities while commissioning or acquiring

pictures. The connection between the Fraser and Kevorkian albums is further supported by a series of Fraser copies of Kevorkian miniatures,[57] and it is not inconceivable that either William Fraser or his brother owned the Kevorkian Album, which was bought in Scotland by the Rofes.

The work of the Fraser artists varies in quality and technique. Several of the earlier examples from the series were painted in the traditionally Mughal medium of highly burnished opaque watercolor; this soon gave way—perhaps under James Baillie Fraser's guidance—to European gouache with transparent washes. When the artists felt strongly about their subjects and studied the villagers, soldiers, or courtesans from life, the vitality and incisive observation of their work would have pleased Jahangir. However, when they merely copied or made pastiches from earlier pictures—as in Fraser

FIG. 10 *Four Village Headmen and Two Children.* From an album commissioned by William Fraser. Northwest Indian, nineteenth century. Fogg Art Museum, Collection of John Goelet, TL 25632.2

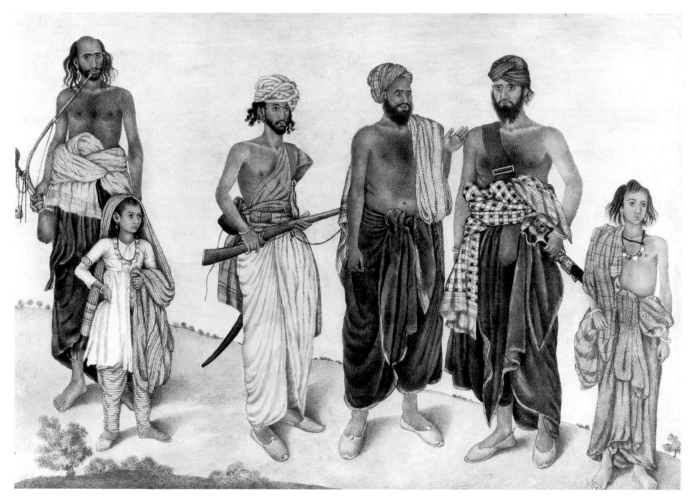

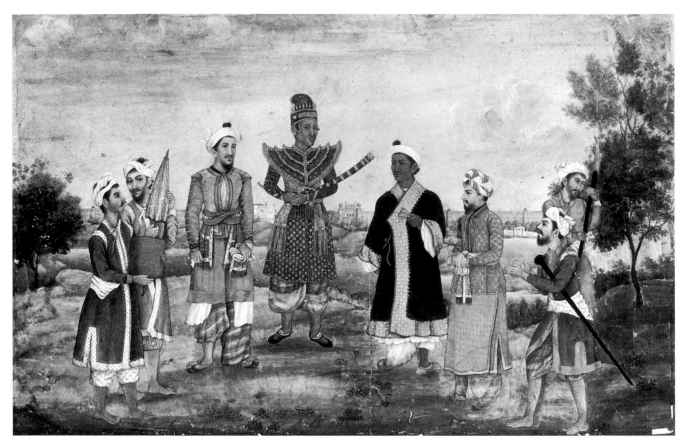

FIG. 11 *Eight Men in Indian Costume.* Indian, Mughal, eighteenth century. The Metropolitan Museum of Art, Gift of Dr. Julius Hoffman, 09.227.1

FIG. 12 Portrait of Shahjahan; detail from Payag, *Shahjahan Riding a Stallion* (pl. 59)

FIG. 13 Portrait of Shahjahan; detail from *Shahjahan Riding a Stallion,* a nineteenth-century copy (pl. 86)

FIG. 14 Detail from *Eight Men in Indian Costume* (fig. 11)

miniatures taken from seventeenth-century originals, several of which are in the Kevorkian Album—the results are coldly uninspired. Figures are as shapeless as sacks, with puffy, prettified faces and hands that resemble gloves.

Four Village Headmen and Two Children Standing on a Hillside (fig. 10), an outstanding folio from the Fraser Album, so effectively summons ghosts from early nineteenth-century India that we seem to hear clanks,

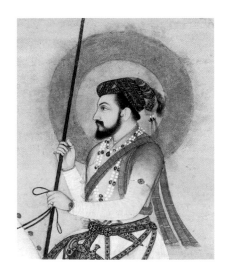
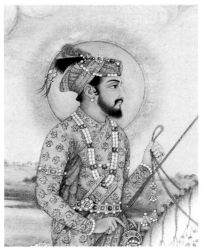
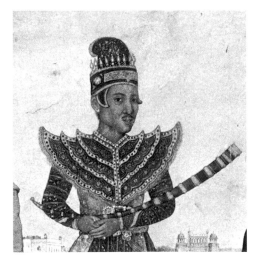

rustling, and the gurgling of a hookah. Encouraged to show every textile, weapon, and twist of hair with illusionistic accuracy, the artist proves that the Mughal tradition remained brilliantly alive well into the nineteenth century.[58]

Although not from the Fraser Album itself, a group portrait in the Metropolitan Museum (fig. 11) is not only characteristic of the series in style but also includes the picturesque figure of a Burmese nobleman—probably the ambassador to Delhi—who also appears in one of the Fraser folios.[59]

In the New York version, the figure was reversed by pouncing, and a Burmese parasol was transformed into a closed umbrella, suggesting a slightly later date. It is helpful to consider this painting from the Delhi artistic circle of the Frasers in relation to two other pictures. On comparing a detail from it to one from Payag's seventeenth-century equestrian portrait of Shahjahan (MMA fol. 21v; fig. 12; pl. 59) and to its later copy in the Kevorkian Album (FGA 39.46a; fig. 13; pl. 86), many differences and similarities become evident. In the copy Payag's incisive portrait has not only been reversed through tracing but has also been coarsened and vitiated. Its draughtsmanship is slack; Shahjahan's elegant profile has been clownishly masked; imaginatively conceived, precisely observed ornament is now formlessly tawdry; the jewel-like palette has turned to mud; and amply rounded forms have been flattened. Harmoni-

ous, understated unity gives way to showy chaos. But if we compare it to a detail of the Fraseresque painting (fig. 14), it is apparent that the more immediate and compelling contemporary subject and the meretricious copy are from the same workshop, perhaps by the same hand. Brushwork, coloring, and treatment of ornament, faces, hands, and textiles are strikingly similar. Moreover, the landscape with architecture recalls the architectural panorama beyond Shahjahan, the only inventive passage in the copy after Payag, and confirms our belief that the occasionally excellent Kevorkian copies and pastiches are by the Delhi workshop whose finest hours were spent in the service of the Frasers.

The borders of the added folios were also intended to resemble Jahangir's and Shahjahan's originals. Despite the time and effort lavished upon them, there is no doubt as to their lateness. The calligraphy is inarticulate, ponderous, and soft, and the chaotic tangle of floral arabesques—with their bumptiously bright leaves and flowers—wriggles with the rhythms of boiling spaghetti.

Nevertheless, one should be grateful to the Delhi merchants and their artists, who preserved the many superb folios from Jahangir's and Shahjahan's albums and who provided them with a "coda" of companions which are pleasurably intriguing at worst and at best evoke the nostalgia and continuing vitality of a great culture at sunset.

1. The calligraphies are by preeminent scribes, and the miniatures represent virtually all the major artists of the imperial court, notable exceptions being ʿAbid, Mirza Ghulam, Muhammad-ʿAli, and Hunhar.

2. See suggestion later in this essay that it might have been acquired by two Indophile Scottish brothers, William and James Baillie Fraser.

3. Hollander, *International Law of Art*, pp. 112–13, 170–71.

4. See Beach, *Imperial Image*, pp. 177–91.

5. Davidson, "Notes."

6. See Falk and Archer, *Indian Miniatures in the India Office Library*; this collection has now been transferred to the British Library.

7. Staude, "Muskine"; Staude, "Contribution à l'étude de Basawan"; Skelton, "The Mughal Artist Farrokh Beg"; Welch, "The Paintings of Basawan."

8. For the catalogue, see Welch, *Art of Mughal India*.

9. For an example of the Central Asian (Uzbek) style Babur is likely to have patronized, see Welch, *India*, no. 86.

10. See Dickson and Welch, *Houghton Shahnameh*, esp. pp. 15–48.

11. Welch, "A Mughal Manuscript," pp. 188–90, pls. 97–104.

12. Dickson and Welch, *Houghton Shahnameh*, fig. 47.

13. See Dickson and Welch, *Houghton Shahnameh*, pp. 118–28.

14. The so-called Bahram Mirza Album, Topkapi Saray Museum Library, H. 2154; see Dickson and Welch, *Houghton Shahnameh*, pp. 15A, 35B, 36A, 40A, and 46A.

15. Welch, *India*, no. 85.

16. Abu'l-Fazl, *Aʾin-i Akbari*, pp. 108–109.

17. Several of these had survived into Akbar's reign, as in the Deccan, in Gujarat, Bengal, and the Punjab; for Sultanate painting, see Welch, *India*, nos. 78–81.

18. Abu'l-Fazl's account of the campaign against "that noble lady" Rani Durgavati of Gondwana (in Central India), at whose head "the hand of destruction flung the dust of annihilation," not only describes Mughal admiration of her courage but also notes that the treasure captured from her in 1564 included "uncoined gold, decorated utensils, pearls, figures, pictures, jewelled and decorated idols, figures of animals made wholly of gold, and other rarities" (Abu'l-Fazl, *Akbarnama*, II, pp. 326–33).

19. For several variously influenced but still characteristic manifestations, see Welch, *India*, nos. 19–24 (South India); 26–29 (Orissa); 31 (Western India); 46 (Bengal); 224–27 (Rajasthan and Uttar Pradesh). See also Chandra, *Tuti-Name of The Cleveland Museum*; Goswamy, Ohri, and Singh, "A 'Chaurapanchasika Style' Manuscript."

20. See Abu'l-Fazl, *Aʾin-i Akbari*, pp. 108–114.

21. Abu'l-Fazl, *Aʾin-i Akbari*, p. 115.

22. For a recent discussion of pigments used in Mughal painting, see Purinton and Newman, "A Technical Analysis of Indian Painting Materials," pp. 107–113. For a comparable technique, as practiced in England, see Murrell, *The Way Howe to Lymne*.

23. Welch, *India*, no. 105.

24. Welch, *India*, no. 154.

25. This was also the practice at the court of Queen Elizabeth I, as is explained by Roy Strong in *Artists of the Tudor Court*, pp. 119–32.

26. Govardhan's posthumous portrait of Akbar (pl. 9) is based on

the Cincinnati portraits of Akbar in old age by Manohar; Welch, *Imperial Mughal Painting*, pl. 15.

27. For borders, and a miniature, by such a specialist with a markedly personal style, see Welch, *India*, nos. 151, 154, and 161; also Welch and Welch, *Arts of the Islamic Book*, nos. 56, 57, 62, 65, 72, 73.

28. Schimmel and Welch, *Anvari's Divan*.

29. Welch, *India*, no. 122.

30. See also Welch, *India*, no. 139.

31. Imperial Mughal portraits framed in gold or silver, intended to be worn as jewels or lockets, were probably inspired by European Mannerist works. Initiated in England at the court of Queen Elizabeth I, they are known from the reign of Jahangir onward and were given to courtiers for purposes of official propaganda. For a portrait of the emperor wearing such a jewel, see Stchoukine, *La Peinture indienne*, pl. 34. Sir Thomas Roe, who probably introduced such portraits to Jahangir, tells of receiving from him "a picture of him selfe set in gould hanging in a wire gould chaine" (Roe, *Embassy*, I, p. 244). Also see a jewel-portrait of Nur-Jahan attributable to Abu'l-Hasan in Welch, "Mughal and Deccani Miniature Paintings," fig. 13.

32. For rare exceptions, portraits in three-quarter view by Manohar showing him at twelve before his image had been standardized, see Godard, "Les Marges du Muraqqa‘ Gulshan," p. 33, fig. 26, and Welch, *Imperial Mughal Painting*, pl. 15.

33. See Dickson and Welch, *Houghton Shahnameh*, especially pp. 20–24. This album has recently been reexamined by Wheeler Thackston, who confirms that most of its calligraphies were written for Sultan Ya‘qub Beg, and that none of them is later than his reign.

34. See Dickson and Welch, *Houghton Shahnameh*, especially pp. 39–41, 118–19.

35. For the miniature, see Welch, *A King's Book of Kings*, fig. 14.

36. Gray and Godard, *Iran: Persian Miniatures—Imperial Library*, pl. XVII.

37. This album also contains most of the major miniatures that have survived from the reign of Humayun, including a large double-page composition attributable to Dust-Muhammad showing a feast at the Safavid court. Its golden arabesque borders are of the Humayun period, with additional birds in full color painted for Jahangir. See Dickson and Welch, *Houghton Shahnameh*, for bibliography and illustrations; and Gray and Godard, *Iran: Persian Miniatures*, pls. XVII–XIX, XXI–XXIV.

38. Ansari, "Palaces and Gardens of the Mughals," pp. 50–72.

39. Humayun's interest in natural history painting—"a beautiful bird flew into [his] tent, the doors of which were immediately closed, and the bird caught; his Majesty then took a pair of scissors and cut some of the feathers off the animal; he then sent for a painter, and had a picture taken of the bird, and afterwards ordered it to be released"—is documented in the memoirs of Humayun's butler; see Jouher, *Private Memoirs*, p. 43.

40. Indigenous books, prior to the Sultanate period, were written on horizontal lengths of palm leaf and were kept between wooden boards. This unsewn format and shape survived the arrival of paper, although in time folios increased in height while lessening in width. Under the influence of the Muslim sultans, borders were occasionally enriched by arabesques. See Losty, *Art of the Book in India*.

41. Welch, *A Flower from Every Meadow*, no. 55 (border not shown); the second miniature is in the collection of the late Edwin Binney, 3rd.

42. Kühnel and Goetz, *Jahangir's Album in Berlin*. Like the *Muraqqa‘-i Gulshan*, it was probably looted from the Mughal library by Nadir Shah in 1739. It was acquired in 1861 by Brugsch Pasha, an Egyptologist who visited Teheran.

43. Martin, *Miniatures of the Period of Timur*; we were pleased to discover that Martin also suggests this.

44. This is also true of the important, later Shahjahan period albums, assembled after ca. 1645 and now scattered, in which portrait-like figures—craftsmen, merchants, soldiers, and household servants—appropriate to the central portrait or miniature either stand

alone or are dispersed in small groups. They were usually painted by the same artist as the miniatures and are arranged against the natural creamy tan of the paper, which is enriched with small flowers drawn in gold. Many are listed in Beach, *Grand Mogul*, pp. 76–77.

45. Marie L. Swietochowski has suggested on the basis of other long-scattered, largely unpublished folios that originally there might have been fifteen or more such albums. Although the Minto Album has not been published completely, many of its folios have been reproduced, as listed in Beach, *Grand Mogul*, p. 74; for the Wantage Album, see Clarke, *Indian Drawings*; for a stray folio, see Welch, *India*, no. 147a, b. Valiant attempts to sort out these albums on the basis of seemingly early folio numbers written within the gold rulings have not as yet been wholly successful.

46. Although flowers had long been frequent motifs in Indian art, Jahangir's enthusiasm inspired floral bas-reliefs, wall paintings, and textiles comparable to the designs on borders.

47. See Welch, *India*, no. 145.

48. See Strong, *Artists of the Tudor Court*, pls. 1 and xx, and no. 206; Strong, *The English Ikon*, particularly nos. 159, 214, 244, and 354.

49. Dickson and Welch, *Houghton Shahnameh*; Welch, *Wonder of the Age*, nos. 45, 46, 49, 50, 52, 53, and 63.

50. This is also the case in many folios of Akbar's *Darabnama* of ca. 1570 (British Library, Ms. Or. 4615).

51. Those signed by Daulat, who specialized in flowers, insects, and birds painted in several tones of gold against deep indigo grounds, raise the question as to whether he is also the artist known from inscribed miniatures. The Kevorkian Album contains an inscribed portrait by him of ‘Inayat Khan (pl. 26). Beach, in *Grand Mogul*, p. 114, is probably correct in seeing them as separate personalities; but border illumination might have been a late specialty of this painter, whose career, and changes of style, can be traced into Akbar's reign.

52. See Welch, *India*, no. 107.

53. Beach, *Grand Mogul*, p. 74, sums up the information on this album, to which he refers as "the Sultan Khurram Album."

54. Falk and Archer, *Indian Miniatures in the India Office Library*, no. 68. The album (I.O.L. Add. Or. 3129) has since been transferred to the British Library.

55. We agree with Rosemary Crill that a Delhi dealer or dealers obtained imperial albums and adulterated them for increased profit. She notes that several folios from the Wantage Album in the Victoria and Albert Museum bear not only impressions of Jahangir's seal but also that of Nadaram Pandit, who, she suggests, "managed to get hold of the imperial seal and one at least of the imperial albums . . . and then concocted a mixture of genuine and fake paintings, the latter presumably commissioned by himself, for sale to the gullible British . . ." (see Crill, "A Lost Mughal Miniature Rediscovered," pp. 330–36).

56. See Archer, *Company Drawings*, pp. 8, 170, 197, 201–203, 209, color pl. D; Welch, *Room for Wonder*, no. 46, pp. 108–109; Gupta, *Delhi Between Two Empires*, pp. 10, 14, 15.

57. Some, indeed, are additional versions of copies in the Kevorkian Album from originals also in the album.

58. Mildred Archer and Toby Falk are now preparing a fully illustrated study of the exciting and important Fraser Album. For the Fraser copies from seventeenth-century originals, see "Oriental Miniatures and Illumination," *Bulletin No. 34*, Maggs Bros. Ltd., nos. 11: *Christ Enthroned*; 12: *Jahangir Standing on a Gold Stool* [MMA fol. 19v; pl. 11]; 13: *Emperor Shah Jahan Standing on a Globe* [FGA 39.49a; pl. 62]; 14: *Portrait of Jadu Rai of the Deccan* [MMA fol. 6r; pl. 74]; 15: *A Duriya Walking in a Landscape with a Lion on a Chain* [MMA fol. 11v; pl. 77]; 16: *An Ascetic with a Grey Bear on a Chain* [MMA fol. 10r; pl. 76] and a copy [MMA fol. 9r; pl. 96]; 17: *Portrait of Mulla Muhammad Bijapuri Standing Holding a Scroll* [MMA fol. 34r; pl. 38]; 18: *Portrait of Qilich Khan* [MMA fol. 30r; pl. 70]; 19: *Portrait of Khan Sipar Khan* [MMA fol. 37v; pl. 67]; and 20: *Portrait of Prince Daniyal* [MMA fol. 32r; pl. 18].

59. See sale catalogue, Sotheby's, London, July 7, 1980, lot 32. I am grateful to Toby Falk for confirming the Burmese identification and for suggesting that he was the ambassador.

The Calligraphy and Poetry
of the Kevorkian Album

ANNEMARIE SCHIMMEL

O NE OF THE FEATURES THAT IM-
mediately strikes the observer who studies the Kevor-
kian Album is that miniatures and calligraphic pages
alternate regularly: the reverse of almost every minia-
ture bears a fine piece of calligraphy, carefully sur-
rounded, like the painting, with delicate borders. Such
is the case in most known Mughal albums. This ar-
rangement shows that calligraphy was as highly ad-
mired and esteemed as was painting. In fact, it was
favored by the Muslims over any other art form. The
calligrapher who was able to write the uncreated word
of God—that is, the Koran—in flawless, beautiful let-
ters was sure he would be admitted to Paradise. Even
someone who could write only the *bismillah*, the in-
troductory formula of each Koranic chapter and, con-
sequently, of each and every human action, in good
lettering was promised that he would receive heavenly
bliss and paradisiacal joy, for the Prophet Muhammad
said: "Whoever writes 'In the name of God the Merci-
ful and Compassionate' in fine lettering, will enter
Paradise."[1]

Styles of Script

The Koran was first written in the old, impressive
angular style known as kufic, which remained in use
for the sacred book as well as for epigraphic purposes
from the seventh to the thirteenth century. During these
centuries the letters developed into highly decorative
forms. At the same time a cursive type of handwriting
was always in use and can be seen scribbled on the
Arabic papyruses of ancient days. When paper became
more readily available to the Muslims in the late eighth
century, the styles of cursive writing—at that time used
mainly for nonsacred texts—were shaped by the exi-

gencies faced by scribes working in imperial and mu-
nicipal chancelleries, by book copyists, and by authors
and teachers. These cursive styles were given mathe-
matical shapes by the vizier Ibn Muqla in Baghdad
(d. 940), who invented an ingenious system of measur-
ing the letters by dots and circles and establishing the
exact relations between them. The alif, the first letter
of the Arabic alphabet, is shaped like a straight verti-
cal line and is always the yardstick for all other letters.
Ibn Muqla's system was refined during the following
centuries and still remains valid. By the end of the
thirteenth century this system had reached its perfec-
tion at the hand of Yaqut al-Musta^csimi (d. 1298), whose
numerous disciples carried the different styles of Ara-
bic cursive writing through Iran, Turkey, the Arab coun-
tries, and finally India, while North Africa and Spain
developed a style of their own.

In Iran and the countries where Persian was used as
the language of literature and administration, the six
classical styles developed by Ibn Muqla and his fol-
lowers were used in Arabic texts. In many Persian writ-
ings, however, a tendency to slanting is visible from
early days. The structure of Persian, with numerous
letter endings that lend themselves to an extension
toward the lower left (such as final *ya^c*, *shin*, and *ta*),
probably encouraged this tendency. Slowly, a "hang-
ing" style developed in the Persianate area. This style
turned into a calligraphically mature hand around 1400
when Mir-^cAli of Tabriz applied the rules of measur-
ing the letters with dots and circles to the hanging
style. With him began the style called nasta^cliq, which
in the following centuries reached perfection.

Nasta^cliq, called by its admirers "the bride among
calligraphic styles," proved an ideal vehicle for poetry.
From the early fifteenth century onward, it was used

to write the great epics of the Persian language, such as Firdausi's *Shahnama* (Book of Kings) and Nizami's *Khamsa*, a quintet of five romantic epics. Both works offered great challenges not only to the calligrapher but also to the miniature painters who illustrated the numerous events recounted in them. Lyrical poetry was also written in nastaʿliq, and here the calligraphers (at least in royal or princely ateliers) were assisted by masters who decorated the borders with golden arabesques, fantastic animals and flowers, or stenciled motifs.

The calligraphers discovered that they could create lovely border motifs by writing poems diagonally around the central pieces. Diagonal writing became fashionable for pages with poetry because it corresponds so exactly to the slanting movement of the letters. Thus, numerous divans—collections of the poetry of a master poet or anthologies of favorite verses— were put together. In the late fifteenth century the *safina*, a small oblong book, bound at the narrow side, was in vogue in eastern Iran; the great masters of calligraphy devoted themselves to writing the verses of their favorite poets in minute nastaʿliq. These small albums were decorated sometimes with line drawings, sometimes with fine ornaments in gold. They could be easily carried in the sleeve or perhaps in the turban.[2] The calligraphers also began to compose single pages of poetry which would then be collected by their patrons and admirers. This latter art was apparently fully developed at the court of Husayn Bayqara, the Timurid ruler of Herat (r. 1456–1506), for we know that in his entourage some excellent imitations of album pages bearing the name of Sultan-ʿAli were fabricated for entertainment.[3]

Some verses were favorites with either the calligraphers or their patrons and customers; each master repeated them in his distinctive style, and thus the same Persian quatrain may appear time and again in different hands. Quatrains, or *rubaʿi*—that pithy, elegant form of poetry which resembles an epigram—were best fitted for a rectangular page and could be gracefully draped over cloud bands, arabesques, and flowers. These pages usually bear the calligrapher's name in the lower left corner, sometimes also at the bottom, or in rare cases at the left side. The calligrapher sometimes mentions the poet's name in the upper right corner or inserts a brief invocation of God, using one of the ninety-nine Divine Names. Such single pages could also contain fragments of a ghazal (a lyrical poem) or, rarely, an Arabic prayer or invocation. On larger album pages the calligrapher might combine several verses, writing in different directions in script of different sizes.

Pages in nastaʿliq for which a very broad pen has been used generally do not look as attractive as those written with a medium or fine pen.

The Timurids had always been eager collectors of calligraphic items and of manuscripts. Some princes were themselves accomplished calligraphers; among them were Ibrahim Mirza in Shiraz and Baysonghur Mirza in Herat, whose library was famous for the number of outstanding masters who worked there. From his court in the first decades of the fifteenth century the calligraphic tradition, and love of beautiful penmanship, continued to the court of Husayn Bayqara, who enjoyed the presence of Sultan-ʿAli Mashhadi (ca. 1435–1519), the most outstanding nastaʿliq calligrapher of the time. Sultan-ʿAli wrote dozens of exquisite copies of the classical Persian epics and lyrics and also penned several copies of his patrons' own poetry— some of his beautiful manuscripts of the Turkish verse of Husayn Bayqara as well as the lyrics and epics of Mir ʿAli-Shir Navaʾi, the king's trusted friend and companion, are still extant. Toward the end of his life he wrote the small Turkish divan of the ruler of Bukhara, ʿUbaydullah Khan, the nephew of the first Uzbek conqueror of Herat, Shaybani Khan (British Museum, Add. 7909).[4] But at that time a new talent had emerged among the calligraphers of Herat—Mir-ʿAli of Herat, the favorite of later generations.

Mir-ʿAli of Herat

Virtually all the calligraphies in the Kevorkian Album, as well as those in the Berlin Album, bear Mir-ʿAli's signature. As he signed his name in many different ways, some scholars tend to ascribe part of the pages with the name of Mir-ʿAli to another master with the same name, who went to India and died there in 1528.[5] This, however, seems difficult to prove. The signatures from the Kevorkian Album and from other known album pages range from the simple Mir-ʿAli or, more frequently, *Al-faqir* [the poor] Mir-ʿAli to elaborate formulas such as "The poor Mir-ʿAli, may God forgive his sins and cover his faults!" Sometimes he calls himself "the sinful slave" ʿAli or the "sinner" Mir-ʿAli, while at other times he proudly signs himself *al-katib as-sultani* (the royal scribe).

Few of his pages were fully provided with diacritical dots, and he never wrote the second stroke on the Persian letter *g* to distinguish it from *k*. Some pages appear to have been rather carelessly jotted down and employ even fewer diacritical marks than usual. One

of these pages (MMA fol. 13r; pl. 48) bears the word *harrarahu* instead of the usual *katabahu*, both meaning "has written." These words are, however, generally used for different levels of accuracy and elegance. In the Turkish calligraphic tradition *harrarahu* was sometimes used for clean copying, but the Kevorkian page with this formula looks rather like a hastily penned *mashq*, a page of practice.[6] One single page (MMA fol. 24v; pl. 57) does not bear a signature but looks like his penmanship.

Mir-ʿAli was born in the late fifteenth century into a good family in Herat, then the center of nastaʿliq calligraphy, Persian poetry, and mystical thought. As a youth, he took the famous court calligrapher Sultan-ʿAli Mashhadi as his model. Young Mir-ʿAli witnessed the death of Mir ʿAli-Shir Navaʾi in 1501. Navaʾi was a Maecenas to the poets and literati who gathered in his famed *majlises* to show their wit and eloquence in verse and literary riddles.[7] Sultan Husayn Bayqara died in 1506, and Herat became a bone of contention between the newly emerging powers in Central Asia. Mir-ʿAli must have met Husayn's young cousin Babur, who would found the Mughal empire in India, for he wrote some poems for him. But Babur did not stay in eastern Iran. Herat was attacked first by the Uzbeks, led by Shaybani Khan, and then fell for some time to the rising Shia kingdom of Iran, under the leadership of Shah Ismaʿil I, the Safavid. In 1507 Mir-ʿAli was probably present when the preposterous Shaybani Khan claimed to surpass Sultan-ʿAli in calligraphy and corrected a painting of the master painter Bihzad in order to impress his Turkish officers.[8] After Shaybani's death at the hands of the Safavids, Herat remained for some time after 1510 under Safavid rule, and the Safavid prince Sam Mirza, who resided there and whose name appears on MMA fol. 4v (pl. 21), wrote an interesting account of the literary climate of the area during the second and third decades of the sixteenth century.

Herat changed hands several times and was conquered by the Uzbeks in 1528/29. The Shaybanid Uzbeks under ʿUbaydullah Khan wanted to make their court at Bukhara a replica of the defunct Timurid court at Herat, and they carried away a number of artists, poets, and craftsmen. Among them was the calligrapher Mir-ʿAli. He worked in the library of ʿUbaydullah's son Abuʾl-Ghazi ʿAbdul-ʿAziz Khan, a prince who was noted as a decent calligrapher in the naskh style and as a poet in Persian and Turkish—very much like most rulers in the eastern Islamic lands. He also had "an exaggerated interest in Sufism."[9] Mir-ʿAli, although a devout Shiite, was apparently on good terms with his patron and the actual ruler, "ʿUbaydullah Khan of heavenly justice and with an ocean-like heart" (Berlin Album, fol. 21v).

Besides the numerous album pages which bear Mir-ʿAli's signature, several major works from the last two decades of his life are known. Among them is a copy of Amir Khusrau's *Matlaʿ al-anwar*, dated A.H. 947/ A.D. 1541 and written for Sultan ʿAbdul-ʿAziz (Khudabakhsh Library, Patna); a *Bustan* of Saʿdi, dated A.H. 949/A.D. 1543, with sixteen miniatures (Calouste Gulbenkian Foundation, Lisbon, L.A. 177); and a copy of Nizami's *Makhzan al-asrar* with three miniatures, written in A.H. 952/A.D. 1545 (Bibliothèque Nationale, Paris, Supp. persan 985). Of special interest is one of the last signed works of Mir-ʿAli, written for ʿAbdul-ʿAziz Khan in Bukhara in A.H. 956/A.D. 1549, which contains three romantic Persian poems: *Sinama* (Thirty Letters), *Dehnama* (Ten Letters), and *Raudat al-muhibbin* (The Garden of the Lovers). This seems to be the same selection as that found in the Chester Beatty Library, an anthology in which the last piece is called *Firaqnama* and is ascribed to Salman-i Savaji. According to the catalogue, this anthology bears "the fabricated signature of Sultan-ʿAli al-Mashhadi al-Katib" and was written for Abu Saʿid the Timurid, Emperor Babur's grandfather.[10] This manuscript, or a copy of it, may have been before Mir-ʿAli when he wrote his anthology, for he sometimes copied works written by his predecessor. The copy of 1549 (Salar Jung Museum, Hyderabad, A. Nm. 1116) has an inscription in the hand of Shahjahan: "In the name of God the Merciful the Compassionate—Oh God! This anthology, comprising the *Sinama* of Mir Husayn, the *Firaqnama* of Salman, and another item, entered the library of this petitioner on the date of 23 Bahman ilahi, corresponding to the eighth of Jumada II, which is the date of my blessed enthronement." Shahjahan must have been very fond of this manuscript, which reached him when he ascended the throne and inherited the precious manuscripts that his father, Jahangir, had collected. The possibility that this anthology was copied from a Sultan-ʿAli manuscript is enhanced by another manuscript in the Salar Jung Museum (A. Nm. 130), that is, Jami's *Tuhfat al-ahrar*, written by Mir-ʿAli in A.H. 939/ A.D. 1533 in Bukhara, "copied from the codex written by Sultan-ʿAli Mashhadi."

Whereas Sultan-ʿAli's fame (at least in our day) rests primarily upon beautiful copies of classical Persian and Turkish epics and lyrics, Mir-ʿAli is best known for his album pages. The majority of them contain Persian verses, usually quatrains, sometimes fragments of lyr-

ical poems, and now and then an apothegm from a Sufi text.[11] One also finds some Arabic verses and prayers, although Arabic does not look as beautiful as Persian in nasta'liq characters. One fine page by Mir-'Ali, dated A.H. 944/A.D. 1537, contains Jami's famous Arabic poem which begins *"Ah min al-'ishq wa halatihi . . . "*(Woe upon love and its states . . .).[12] Later craftsmen sometimes cut out pages written in a large hand by Mir-'Ali and pasted the letters on an album leaf so as to produce the impression of a new page (see MMA fol. 21r [pl. 60] and FGA 54.116b).

Mir-'Ali's calligraphy was so renowned that even in Turkey an eighteenth-century poet could compare the flawlessly beautiful face of his friend to an album page penned by Mir-'Ali and 'Imad al-Husayni,[13] the famed master of Shah 'Abbas's court (assassinated 1615). Pages signed by Mir-'Ali were collectors' items both in Iran and in India: Prince Ibrahim Mirza, the talented scion of the Safavid house (d. 1577), had an enormous collection of pages written by Mir-'Ali, including a set that the calligrapher had prepared for the time when he would have to finance his pilgrimage to Mecca.[14] As Mir-'Ali's death probably occurred in 1556, Ibrahim Mirza was close enough in time to him to purchase many of his works.

Sayyid Ahmad Mashhadi (d. 1578), Mir-'Ali's favorite and most faithful disciple, whose writing "was indistinguishable from the writing of the Mir," left the Shaybanid court after the master's death and returned to his hometown, the sacred city of Mashhad.[15] If it is true that the calligrapher's children went from Bukhara to India after their father's death,[16] the great number of Mir-'Ali's pieces in Indian royal collections could be easily explained.

The Mughal princes were as eager to collect Mir-'Ali's writings as was the Safavid prince Ibrahim: the pages of the Berlin Album as well as of the Kevorkian Album bear ample witness to the Mughals' infatuation with his handwriting. Jahangir describes in his memoirs how his father's trusted friend, Khankhanan 'Abdur-Rahim, gave him a copy of Jami's *Yusuf and Zulaykha* in Mir-'Ali's hand, beautifully bound and worth one thousand gold mohurs.[17] And while Shahjahan's sons Dara-Shikoh and Aurangzeb were instructed in nasta'liq by relatives of Mir-'Imad, the emperor's second and favorite son, Prince Shuja', "imitated some pages by Mir-'Ali."[18]

One question the observer will ask is: Are all the pages that bear Mir-'Ali's signatures really his own? How many pages could a single calligrapher write in the course of his life? It seems that a good number of

them are genuine, but there are some clues as to how their number increased even during the artist's lifetime. Mir-'Ali was apparently a gentle, friendly person; it is said that he was somewhat hard of hearing.[19] Some of his colleagues did not show him due respect, and Qasim Shadishah, a noted calligrapher in Bukhara,[20] attacked him by claiming:

For that reason his writing has no foundation
Because his ear has never *heard* anyone's instruction.

Some of the master's own disciples went even further in their misbehavior. Mir-'Ali was very generous in signing calligraphic pages and sometimes wittingly or unwittingly put his name on pages which his disciples placed before him as though they were his own works. Other students signed his name without his permission. One of them, Mahmud Shihabi Siyavushani, who was highly praised by the master in one of his poems, was mildly rebuked in another:

Whatever he writes, good or bad,
He does it all in the name of this lowly one!

Thereupon Siyavushani replied: "I sign only the bad ones with his name!"—an answer that is rightly called by Mir-'Ali's modern biographer, Mehdi Bayani, "an utmost breach of etiquette."[21] Yet the master, fond of this talented disciple, seems not to have taken any drastic measures against him. In another case, however, he finally became angry. Mir Chalama, one of his best disciples, was given permission to sign with the master's name but impudently replied: "Who are you that I should sign with your name?" This was too much even for the gentle master calligrapher: it is said that he cursed the student who soon after became blind.[22]

Whatever the historical truth of these anecdotes, they definitely point to Mir-'Ali's generosity in allowing others to sign his name, and it will probably prove impossible to sort out the hands of his disciples among the numerous pages that bear his name.

One might try to differentiate the pages according to the type of paper used or the ornaments that were later added in harmony with the outer border of the page onto which the sheet was mounted in the album. A few pages are written on a softly marbleized grayish paper (thus MMA fol. 31r [pl. 72]; Berlin Album, fol. 22a; Collection Prince Sadruddin Aga Khan, no. 73; a page in the Nelson Gallery–Atkins Museum, Kansas City, 48.12/2).[23] Other pages show a barely visible floral design under and around the letters(Berlin Album, fols. 2v and 8v). An examination of the types of paper and

Mir-ʿAli as Poet

Pages which can be ascribed to Mir-ʿAli almost beyond doubt are those which contain riddles, chronograms, and his own verse. He was not only a calligrapher but also a poet—not a great one but no worse than many versifiers whose lines fill the pages of later anthologies. The numerous album pages which begin with the line *li-katibihi* (by its calligrapher) show that Mir-ʿAli knew well how to use traditional imagery, wordplay, and rhetorical devices. In fact, it would have been surprising if he had not adopted the literary style of those whose verses he copied year after year, from morning to evening. Quite a few poems which do not bear his name but which deal with the art of writing or use a specifically calligraphic vocabulary may well be his own compositions. One of Mir-ʿAli's poems was copied frequently by others and was even reproduced in cutout letters in 1537 by ʿAli Sangi Badakhshi, the master-cutter. In these lines the calligrapher laments his miserable state, using images from calligraphy and music, the twin arts that are produced by the reed pen and the reed flute and that reveal the artist's deepest secrets. Lonely and homesick, Mir-ʿAli complains that calligraphy has become a burden for him.

My hand became [curved like] a *waw*, my foot a *dal*, and my
 heart a [crooked] *nun*,
Until the writing of poor me, sick of heart, became so well
 shaped...
From a lifetime of calligraphic exercises my stature became
 bent like a harp,
So that the script of poor me, the dervish, could become so
 perfect [lit., "reach this canon"].
The kings of the world sought me while
In Bukhara my liver is steeped in blood in order to earn my
 living...

He closes his complaint with the line:

Alas! Mastery in penmanship became the chain of the foot
 of this demented one [*majnun*; demented people were usu-
 ally shackled].[24]

Mir-ʿAli, like all his peers, constantly reminded his readers and his students of the difficulties that beset a calligrapher, a profession for which, according to another poem of his, five things are essential: a sensitive temperament, understanding of the art of calligraphy, a good hand, endurance in the face of hardship, and the necessary tools—"if one of these is missing, it cannot be done properly."[25] Incessant practice is required, and the calligrapher should always keep the great masters' models before him. He should write small letters during the day and large letters in the evening when the light becomes dimmer.[26]

Forty years of my life were spent in calligraphy—
The tip of calligraphy's tresses did not come easily into my
 hand.
If one sits leisurely for a moment without practicing,
Calligraphy disappears from one's hand like the color of henna.

On the other hand, Mir-ʿAli, who always acknowledged the mastery of his teacher Sultan-ʿAli, was rightfully proud of his own achievements. It can be assumed that the poem which surrounds a fine page of his (FGA 39.49b; pl. 61) was composed by him as well. Playing with the expression "to put one's finger on something," which means also "to blame," he boasts:

No one puts his finger on my letters save the pen
When I write, for example, [script] from large inscriptions to
 dust script.
The products of my hand and my tongue are today
In the eyes of the excellent [connoisseurs] like most precious
 pearls.
The days sing of my calligraphy and of the art of my poetry—
If the enemy does not accept that, let him...
What is the use of pretending, oh heart? For it [my rank] is
 well known
Both from the fineness of [my] calligraphy and the solidity of
 my verse.
It suffices as testimony for my state that
Everyone buys my verse for a gold coin in the marketplace.

Interestingly, two more fragments with the same rhyme (-*ar*) and meter (*mujtathth*) have come to light in related Mughal album pages: one surrounds MMA fol. 24r (pl. 58); the other is on V&A 24–1925. None of the three pieces has a first rhyming hemistich; they may be separate *qitʿa* (fragments), but they may also form parts of a lengthy *hasb-i hal*, a description of the master's unhappy state in Bukhara in his old age, when his eyesight became weaker and he felt unhappy in spite of the growing admiration for his art in other countries. The poem on the V&A page takes up his familiar complaint of being fettered by his calligraphy:

In the world, I, the unfortunate person, lived in such a way
That nobody saw even a hair's tip of molestation from me.
Despite my virtue and skill, I am for the people of the world,
Due to my frustration and poverty, like the dust on the road.
The fame of my perfection has reached today
From Rum [Anatolia] to China and from India to Tatary.

Sometimes there came to me a message of kindness from
 Rum and Iraq,
Sometimes from India official letters full of generosity.
But my script has become a chain for my foot—
I am fettered, I cannot go to any country.

In the Kevorkian fragment the master uses a word
that was to become popular in the second half of the
sixteenth century and especially in the later Indian
style of poetry—that is, ʿaynak (spectacles or glasses).
Miniatures of the period show painters and calligra-
phers with small eyeglasses. The expression that one's
two eyes "became four" means that one is intensely
waiting or searching for something. Therefore the aging
master complains:

On my eyes there are no spectacles for the sake of writing—
Rather, my eyes have become four from constantly [looking]
 for two pieces of bread.
In the garden I am distressed [lit., "narrow-hearted"]. How
 could it [my heart] open,
Since in the eye of me, the sad one, rose and thorn are the
 same?
I have not drunk the wine of comfort from the goblet of
 turning time.
What is wine? I am taken by the pain of satiety.
Should my eye fall upon a [beloved with] roselike cheek,
My occupation is, like that of the nightingale, bitter
 complaint.
Now, owing to the cruelty of the [revolving] sphere, equal for
 me are
Union with the faithful friend and the company of rivals.
As the morning of old age dawned and the night of youth
 passed,
There is no difference between winter and spring.
What can I do? Owing to the unkindness of the dark blue sky
The day of joy has become black for me like the dark night . . .

The tenor of this rather artless poem is the same as
that of the numerous little love verses which bear the
remark "by its calligrapher" and quite a few more,
which are complaints about faithless friends and life's
hardship and can probably be assigned to Mir-ʿAli.

There are signed verses by Mir-ʿAli on MMA fols. 7v,
19r, and 36r (pls. 27, 12, and 56); MMA fol. 28v (pl. 93)
contains the same verse as MMA fol. 19r (pl. 12). The
calligrapher wrote at least two quatrains in honor of
Babur, the first Great Mughal. He also praised his pa-
tron, ʿUbaydullah Khan, Shaybani Khan's nephew, who
ruled in Bukhara from 1512 to 1539; in this poem he
returned to the Turkish idiom which he had already
used in Herat, where Navaʾi was the great protagonist
of classical Chagatay-Turkish literature.[27]

One of Mir-ʿAli's most famous poems was written
for—and calligraphed in large characters in—the mau-

soleum of Imam ar-Rida in Mashhad. On this occa-
sion the calligrapher composed several chronograms,
one giving the date of A.H. 928/A.D. 1521. Mir-ʿAli was
the master of an art typical of the Persianate world
almost to this day—the art of inventing chronograms
for certain events by using the numerical value of a
word or a sentence in order to produce the date of an
event such as the completion of a building, the birth
of a son, a conquest, or a death (in later times the date
of the completion of a book can often be deduced from
the numerical value of its title). Every Arabic letter
has a numerical value; the sequence of the "numeri-
cal alphabet" (abjad) relies upon the ancient Semitic
sequence of letters and thus differs from that of the
modern Arabic alphabet. In connection with the in-
scriptions in the mausoleum of Imam ar-Rida, a safina
page written by Mir-ʿAli and pasted above the picture
of a turkey (V&A 135–1921) contains a chronogram
for A.H. 939/A.D. 1532, madh-i imam-i hashtumin
(praise of the eighth imam), the original of which he
wrote "in a large hand and also pasted [it] up in the
mausoleum opposite the head [of the tomb]."[28] That
implies that he must have gone to Mashhad, the Shia
sacred place, several times during his stay at the
staunchly Sunni court of the Uzbeks. The first of Mir-
ʿAli's chronograms in the Kevorkian Album (MMA fol.
20r; pl. 54) gives A.H. 936/A.D. 1530 as the date of the
conquest of Astarabad in Gilan by the young prince
ʿAbdul-ʿAziz. Interestingly, the page consists of lines
of poetry which clearly come from another manuscript
and are pasted on the page, giving it a quite original
look. A chronogram which yields the date of A.H.
941/A.D. 1534 for the investiture of Shah Muhammad
as ataliq is given in MMA fol. 33r (pl. 36). The Berlin
Album (fol. 8v) has a chronogram for the investiture of
a vizier in A.H. 937/A.D. 1531, and another (fol. 21v)
that gives the date of the building of a fountain by
Sultan ʿAbdul-ʿAziz as A.H. 950/A.D. 1543, while Huart
quotes the chronogram for the foundation of a mad-
rasah, a theological college, in A.H. 942/A.D. 1535.[29]
Furthermore, FGA 48.20a (pl. 84) gives a chronogram
for A.H. 940/A.D. 1533–34, the date of the construction
of "a marvelous, nice, graceful mosque" by Mirza
Khwajagi.

Thus, Mir-ʿAli the royal scribe appears in the collec-
tions from Mughal days in his threefold capacity as
calligrapher, poet, and author of skillful chronograms
and of some riddles, all on well-balanced, medium-
sized pages.

Calligraphic Fragments in Borders

Some small fragments at the borders of major calligraphic pages and Mughal portraits also bear the signature of Mir-ʿAli and in a number of cases the name of his master, Sultan-ʿAli. The minute pieces of nastaʿliq calligraphy, which surround the majority of the pages in the albums and fragments of albums at our disposal, look at first sight like integral parts of the composition. Some are arranged in one line, others in two (there are rarely more than two); the backgrounds are white, cream, or sometimes bluish or light brown. But it soon becomes evident that these pieces of poetry (and sometimes prose) have no relation to the content of the page, be it picture or calligraphy, and that they are not written on the page but carefully cut out, pasted on the border, and then surrounded with delicate ornaments which integrate them into the picture-cum-border unit. There are lines from ghazals, from epic or didactic poetry, from prose texts; quatrains are found rather frequently. These elements are predominantly in Persian, but now and then Turkish fragments are found. Some pieces appear to be full pages from a *safina*; that is especially the case when the painting shows an animal (black buck, turkey, mountain goat, and the like)

The explanation for the presence of such unconnected pieces can be found in the work of a late sixteenth-century Ottoman calligrapher, ʿAli Efendi. In his book *Manaqib-i hunarvaran* he writes that in the royal Ottoman ateliers artists cut up pages with poetry on them "and place at the border of each page unconnected verses like a commentary, that means, they divide every poetical piece into four and separate each hemistich from its relatives and paste it wherever they want."[30] This is exactly what happened at almost the same time in the ateliers of Jahangir and Shahjahan. The artists who did this may have been inspired by calligraphers who wrote texts in smaller letters around their own larger compositions, thus creating a well-balanced page.

The majority of the album pages at our disposal are decorated in the manner that ʿAli Efendi describes. The artists certainly did their best to incorporate these fragments of exquisite writing fully into the page. But the interesting aspect of these borders is not so much their calligraphic art, even though there are several pieces signed by Sultan-ʿAli or Mir-ʿAli (the name of Shah-Mahmud Nishapuri also appears).

Rather, it is the content of the border pieces which allows us a glimpse into the working of the ateliers in Mughal India shortly after 1600. All the poets whose verses can be identified by signature or by inner criteria are those whose works were highly appreciated in Herat during the late fifteenth century and whose names occur in the biographical dictionaries of Daulatshah, Mir ʿAli-Shir Navaʾi, and Sam Mirza. Poems by artists who were contemporary with Sultan Husayn Bayqara of Herat can also be found on some pages. The craftsmen at the Mughal court, as well as in Istanbul, must have had at their disposal a number of divans and anthologies in *safina* form which may have been slightly damaged but could be used to decorate other pages or to create new pages (thus MMA fols. 16v, 20r, and 21r; pls. 43, 54, and 60). That the border pieces are of late Timurid origin is also borne out by the fact that the calligraphy is in most cases a very fine "dust" nastaʿliq.

We may assume that the nobles who left Herat in the turbulent decades after the Safavid and Uzbek conquests took with them their favorite collections of poetry—luckily available in small, handy volumes which were read and reread until some pages were worn out. The Mughal craftsmen then selected whatever was of use for decorative purposes and pasted the fragments around the borders. These borders would thus reflect the literary taste of the Timurid aristocracy in Herat—and, indeed, that is the result of a closer examination of the fragments, even though all of them cannot yet be identified. Later imitations of Mughal miniatures, such as MMA fols. 25–28 (pls. 87–94), follow the classical models, but the calligraphy is written directly on the page and consists mostly of one continuous poem or of verses that are appropriate for the subject of the painting; none of them contains poetry by a Timurid writer (the great classical favorites, Saʿdi and Nizami, are much better represented). Furthermore, most of these late pages consist of two miniatures pasted together, rather than the traditional combination of a miniature on one side and calligraphy on the other.

Let us survey the content of the border calligraphies. The great epical poems of earlier centuries which were so often decorated by miniatures surround a few pages: thus, Nizami's *Iskandarnama*, the romance about Alexander's search for the Water of Life, is found on MMA fols. 12v, 20r, and 29r (pls. 45, 54, and 26). Two stories seem to belong to Sanaʾi's didactic *mathnavi*, the *Hadiqat al-haqiqa* (The Orchard of Truth)—MMA fol. 10v (pl. 75) and FGA 48.21a (pl. 98); neither is cut out. Poems or fragments by Hafiz, the

favorite of all lovers of Persian poetry, appear in larger calligraphies (thus MMA fol. 16v [pl. 43], which, however, is skillfully cut out from a divan manuscript; Berlin Album, fol. 2v; FGA 39.49a [pl. 62]); the two fragmentary ghazals that surround MMA fol. 17v (pl. 49) belong to his best-known verses.[31] Incidentally, an album page in the Chester Beatty Library (CB 7/13), which shows portraits of Jahangir and an unidentified but clearly Turkish nobleman, is surrounded by the first ghazal of Hafiz's divan without its initial line.

The poet Saʿdi is represented by a few fragments of lyrics and small pieces from the *Bustan* and *Gulistan*, but his lines appear less frequently than one would expect. The only full ghazal by Saʿdi surrounds MMA fol. 9v (pl. 95); however, it is not cut out but written on the border of the page and is, like the calligraphy which it surrounds and the painting on the recto side of the folio, identifiable as a later addition. It was penned at a much later time when the poets preferred by the fifteenth-century Timurids had fallen into oblivion, and anthologies with their works were no longer easily available to the craftsmen; Saʿdi's poetry, however, remains a favorite to our day.

Among the poets, the absolute favorite is Shahi, "the sovereign of the rhyme," as Qadi Ahmad calls him.[32] His name occurs more frequently in the border pieces than that of anyone else, and there may be even more, as yet unidentified lines by him.

Amir Shahi Sabzvari Firuzkuhi, a member of an aristocratic Persian family, was connected with the court of the Timurid prince Baysonghur in Herat and played a leading role not only as a poet but as a kind of all-around courtier. When Baysonghur died in 1434 at the age of thirty-four, Shahi composed a quatrain that was regarded as the best of all the elegies written for the talented prince.[33] Shahi remained the favorite of the Timurids in the decades following his death in 1453. Daulatshah, himself a member of the Timurid literary establishment, places him at the beginning of the seventh generation of great poets and claims that he "combines the ardor of Amir Khusrau, the delicacy of Kamal-i Khojandi, the grace of Hasan Dihlawi, and the clarity of Hafiz"; he adds: "He was a master scribe, and as a painter he was so [outstanding] that this verse would befit him:

If a picture from his pen were brought to China,
How would [the Chinese master painter] Mani look at his
 own art?"[34]

Daulatshah also mentions that Shahi was a fine musician. Jami speaks of him in his *Baharistan*, and

Mir ʿAli-Shir Navaʾi regarded him as the greatest master of lyrical poetry in the fifteenth century, rivaled only by Katibi Turshizi; his melodious verse was so well known all over the Persian-speaking world that even the grim adversary of the early Safavids, the Ottoman sultan Selim I (r. 1513–20), imitated his style in his own Persian poetry.[35]

How much Shahi was loved becomes evident from the astonishing number of manuscripts of his divan, which was copied by all the outstanding masters of nastaʿliq—among whom were Ahmad Abrishimi (copy dated 1511), who was Sultan-ʿAli's disciple; Mir-ʿImad al-Husayni (d. 1615) in Iran; Mahmud-i Nishapuri (d. 1548); Muhammad Muʾmin of Herat; and Sultan-ʿAli Mashhadi himself, who calligraphed the relatively small work several times. All major libraries in the Middle East, India, and Europe own beautifully written copies of his work, and yet, despite this wealth of reliable material, no critical edition of Shahi's poetry is available. There are some cutout pages of his verse in various collections. Shahi's divan sometimes was illustrated: one superb manuscript was prepared in Akbar's day (completed 1595). It is now dispersed, but two pages with miniatures have been analyzed by Stuart Cary Welch,[36] and two more pages are preserved in the collection of Prince Sadruddin Aga Khan.[37] One of the fragments at the border of MMA fol. 2r (pl. 34) contains the ghazal that was chosen for illustration by Akbar's court painters.

Altogether nine fragments around the borders of the Kevorkian Album bear Shahi's name, but more fragments are likely to belong to his divan. These are MMA fols. 1r (two poems), 2v, 2r, 7v, 16v, 18v, and 37r (two poems) (pls. 33, 34, 27, 43, 51, and 68); one verse occurs both on MMA fols. 1r and 37r, which shows that the craftsmen had at least two different collections of his work at their disposal. Another example of his verse is found around the border of a page in a Jahangir album formerly in the Marteau collection, around a calligraphy by Mir-ʿAli.[38]

Another poet who is represented twice in the borders of the Kevorkian Album is Qasimi (Qasim al-anvar), a poet from western Iran (d. 1433) noted for his Sufi inclinations and his close relations with the shrine of Ardabil, the cradle of the Safavid dynasty.[39] Qasimi belonged for some time to the same artistic circle as Shahi; he spent a few years at Baysonghur's court in Herat where he had come from Tabriz via Nishapur but then left the prince's entourage. He died in 1433, and Mir ʿAli-Shir Navaʾi later had a mausoleum built for him in the city of Khargird. "A man of gnostic wis-

dom, accepted by the pious and the good"—that is Daulatshah's description of him.[40] He calls him *Safi al-milla wa'd-din*, thus pointing to his relation with the shrine of Safiuddin of Ardabil. Qasim al-anvar was renowned as a spiritual leader perhaps even more than as a poet. Nevertheless, a considerable number of manuscripts of his poems exist in the libraries of Iran and Europe, and his divan has been edited recently.[41] As in Shahi's case, Qasimi's verse was written by the masters of penmanship; the Berlin Album contains a fragment of one of his poems, signed by Sultan-ʿAli Mashhadi. The two ghazals by him in the Kevorkian Album (MMA fols. 10r and 11v; pls. 76 and 77) belong together, for both of them (*Dervish Leading a Bear* and *Dervish with a Lion*) are thematically similar and seem to have formed a unit in the original album.

There are two fragments of the divan of Asadi Tusi Mashhadi (d. 1464), who worked at the court of the Timurid prince Babur (MMA fol. 35r [pl. 64] and, surprisingly, the non-cutout border of MMA fol. 27r [pl. 88]).[42] The Berlin *Albumblätter* also contains some of his lines, which shows that his work continued to be liked at the Mughal court.[43]

Another fragment is by ʿIsmat Bukhari (MMA fol. 18v [pl. 51]), another early Timurid poet who was highly appreciated in Herat. ʿIsmat, who died between 1425 and 1437, had been a panegyrist of Timur and continued to sing the praises of Sultan Khalil, whose court poet he became. He was considered by later authorities, such as Azad Bilgrami in eighteenth-century India, to be a follower of Amir Khusrau.[44]

Some verses of ʿIsmat's pupil Khayali, who died around 1446, appear on MMA fol. 18v (pl. 51). Somewhat earlier, but certainly much more famous, is Kamal Khojandi (d. 1400), a lyrical poet whose importance is acknowledged by modern critics as well.[45] His name is found on one of the cutout borders (MMA fol. 23v; pl. 15). Auhadi Kirmani (d. 1338), the author of the mystical epic *Jam-i Jam*, is represented once (MMA fol. 3v; pl. 23) in minute calligraphy.[46]

The anthologists who worked at the Timurid court in Herat were particularly fond of the two early poets of Delhi—Amir Khusrau and his friend Amir Hasan Sijzi Dihlawi, both disciples of the Chishti saint of Delhi, Nizamuddin Auliya (d. 1325). Amir Khusrau was tenderly called the Parrot of India (because of his sweet verse and his wisdom—parrots are always models of intelligence and are called "sugar chewing") and God's Turk (because he was the son of a Turkish father and "Turk," in poetical parlance, means the "beautiful, radiant beloved"). He was the most outstanding and

influential master of Persian lyrical poetry in the late thirteenth and early fourteenth centuries.[47] His verses abound in delightful wordplay but are also, at least in part, very singable and are an important element of the Indo-Muslim musical tradition. Thus the little ghazal in the border of MMA fol. 17r (pl. 50)—

My heart became wayward in love—
 may it be even more wayward!

is still sung with great fervor in Indian concerts. Amir Khusrau is also noted as an author of *mathnavi*, epical poems which imitate Nizami's Quintet but also describe the actual life at the courts of Delhi. Illustrated manuscripts of Amir Khusrau's Quintet and other epics are rather common. Fragments of his lyrics are found in the borders of MMA fols. 5r and 8v (pls. 66 and 29). They show that his poetry was included in the standard anthologies in Herat. An elegant album page written by Sultan-ʿAli Mashhadi contains some of his verse (MMA fol. 11r; pl. 78), and MMA fol. 1v (pl. 31) is a fine page containing one of his ghazals.

It is possible that the poem of Amir Khusrau's faithful friend Hasan Sijzi[48] (Berlin Album, fol. 24r) belongs to the same *safina* as MMA fol. 11r (pl. 78) or at least to a closely related manuscript as it is also signed by Sultan-ʿAli. While Hasan's poetry is not easily identifiable in the Kevorkian Album, the Berlin Album contains fragments from his poems (fol. 23v), among which the one from the just-mentioned *safina* is historically interesting. It contains a eulogy for Sultan Abuʾl-Muzaffar ʿAlaʾuddin Khilji of Delhi (r. 1296–1316), whose stern justice made him disliked by many of his subjects, especially Hindus. But in spite of his cruelty he was highly praised for his truly Islamic value system by Nizamuddin Auliya and his disciples. Two of the fragments in the Berlin Album (fols. 23v and 24r) certainly belong together and may be from the same anthology from which the Amir Khusrau fragments in the Kevorkian Album are taken, for it was customary to quote verses of both poets in the same anthology, as numerous collections show. A full page in the Berlin Album (fol. 19r) is devoted to one of Hasan's ghazals.

The Berlin Album gives us a glimpse into the workshop of the calligraphers, showing how they repeated their favorite verses.

Who will bring me news from my absent [friend]?

comes from Sultan-ʿAli's *safina* and is repeated on the

calligraphic pages (fols. 20r and 22r) in different sizes, signed both times by Mir-ʿAli "the royal scribe." Again, the literary taste of the Mughal emperors seems to have agreed with that of their Timurid ancestors and relatives: Hasan Sijzi's divan was calligraphed by Mir ʿAbdallah Mushkin Qalam for Prince Salim (the future Jahangir) in Allahabad in the 1590s and was adorned with fourteen miniatures.[49]

It would be astonishing if the anthologies made for the Timurid court, which form the raw material for Mughal borders, had not contained verses by writers living in the capital—some 150 to 200 poets lived in Husayn Bayqara's Herat. Thus, Jami's name appears on several occasions in the border decorations for he was the undisputed master of poetry in all its forms. His talent extended from highly sophisticated but charming lyrical verse to mystical and nonmystical epic poetry, from biographies of the saints to treatises on logographs and extremely refined philological and philosophical works.[50] Jami's lyrics were used for album pages (Berlin Album, fol. 16r; see also V&A 28–1925) and surround at least three of the Kevorkian pages (MMA fols. 17r, 34v, and 35r and FGA 39.50b; pls. 50, 37, 64, and 19). Likewise, quotations from his most famous epic, *Yusuf and Zulaykha*, the favorite of many generations, are found on three leaves in the Kevorkian Album (MMA fols. IV, 12r, and 29v; pls. 31, 46, and 25). Even on a late page (MMA fol. 28r; pl. 94), where the script is not pasted on, a passage of this epic is recognizable. One fragment from *Subhat al-abrar*, a *mathnavi* by Jami, has come to light (MMA fol. 22r; pl. 10). An entire calligraphic page (MMA fol. 8r; pl. 30) in the hand of Sultan-ʿAli is taken from Jami's *Baharistan* and was probably written during the lifetime of the author, who died in Herat in 1492.

Besides the verse of the undisputed master poet and Sufi of Herat, Maulana Jami, we find at least two signed poems by Asafi (MMA fols. 5v and 5r; pls. 65 and 66).[51] Khwaja Asafi ibn Muqimuddin lived at Husayn Bayqara's court and was, as tradition has it, a disciple of both Jami and his friend Mir ʿAli-Shir Navaʾi, who excelled mainly in Turkish verse. Asafi died after the end of the Timurid era in 1517. His divan was apparently quite popular, for another fragment is preserved in the Chester Beatty Library.[52] Asafi came from a family long connected with the Timurid house, and among his friends was Prince Badiʿuz-zaman, Husayn Bayqara's gifted son. Even Babur mentions him in the description of his visit to Herat in 1506.[53] Daulatshah has nothing but praise for him, calling him "the most elegant

poet." For this reason, his divan was often copied and is found in several libraries. The copies in the Salar Jung Museum, Hyderabad, are of special interest: one of them belonged to the court of Muhammad Qutbshah of Golconda (r. 1612–26); another was part of the library of Wajid ʿAli Shah, the last king of Lucknow (deposed in 1856).[54]

Slightly senior to Asafi was his compatriot Suhayli, who is represented on the right border of MMA fol. 5v (pl. 65).[55] Amir Shaykhum Nizamuddin Ahmad (d. 1501) dedicated to Husayn Bayqara an epic poem, dealing with the often retold romance of Majnun and Layla. He belonged to a Chagatay-Turkish family and was in the service of Sultan Abu Saʿid before becoming the top adviser of Husayn Bayqara in matters of government and finance. Suhayli left one divan in Turkish and one in Persian; in Persian he was a disciple of Adhari whose name appears in one of the borders of the Chester Beatty Jahangir Album.[56] But in the history of literature Suhayli is more important as friend and patron of a prolific religious author in Herat, Husayn Waʿiz Kashifi, who is best known for his rather bombastic Persian renderings of Bidpai's fables (*Kalila wa Dimna*) as *Anvar-i Suhayli* (The Lights of Canopus). This title can also be rendered "The Lights of Suhayli," as the translation was indeed inspired by Suhayli. While Daulatshah praises Suhayli as a pure, elegant, and imaginative poet, Babur was critical of his use of "terrifying words," a remark that is puzzling to the modern reader.[57]

One of the poets represented in the borders (MMA fols. 4r and 35r; pls. 22 and 64) is Badruddin Hilali, who was executed in 1529 by the Uzbek conqueror ʿUbaydullah, allegedly because of his Shia tendencies. Sam Mirza, the Safavid (that is, Shiite) author, however, thought that he was a Sunni. Hilali was one of the poets considered outstanding enough to attend the gatherings of Navaʾi, and like Navaʾi and Suhayli, he was a Turk. His lyrical poetry is praised by the political antagonists Sam Mirza and Babur for its smoothness and its melodious flow; but his fame rests mainly upon his epic *Shah u gada* (The King and the Beggar), which deals with a topic common in postmedieval Persian poetry—the love of a destitute beggar for a handsome prince. Hilali is also credited with two other romances, but only his King and Beggar has attracted the interest of later critics (it was translated into German by Hermann Ethé more than a century ago).[58]

Twice the name Mani seems to appear (MMA fols. 7r and 18v; pls. 28 and 51). Nothing is known about

him, but if one reads the name as *Fani*, it is the pen name that Nava'i adopted for his Persian verse.

It would be surprising if the poetry of Mir 'Ali-Shir Nava'i and that of his king, Sultan Husayn Bayqara, were not represented in the cutout pieces around the Kevorkian Album borders. A considerable number of Turkish fragments, which belong to either one of them or the other, are pasted around the album pages. A whole page of Husayn Bayqara's divan is preserved in the Berlin Album (fol. 5v), surrounded by superb marginal paintings. It seems that all the verses which can be assigned to the sultan, either for internal reasons or because they bear his pen name, Husayni, have been penned by Sultan-'Ali Mashhadi, to whom we owe at least two, and probably even more, complete copies of the divan of his royal patron.[59] A fragment from a *mathnavi* in the *ramal musaddas* meter, dealing with *tauhid* (Divine Unity) (MMA fol. 4r; pl. 22), is probably Sultan Husayn's work, for his cousin Babur blames him for using exclusively this easy meter in his Turkish compositions.

As for Nava'i, we have at least one fragment in the borders that bears his name (MMA fol. 35v, upper border; pl. 63), but there may be more of his products among the Turkish verses in the Kevorkian and the Berlin albums.

In the Berlin Album fols. 1r and 13v have his pen name, but the verses are carelessly pasted on in the wrong sequence. Sultan-'Ali calligraphed an early poetical collection of Nava'i's verse, which was recently published in facsimile.[60]

One has to keep in mind that the Chagatay-Turkish poetry was probably not pasted on for the beauty of its calligraphy alone but because the Mughal emperors were still able to enjoy Turkish poetry: "Notwithstanding that I grew up in Hindustan, I am not ignorant of Turki speech and writing," writes Jahangir in his memoirs.[61]

Among the border decorations one finds some prose pieces and two curious specimens of poetry (MMA fols. 6r and 30v; pls. 74 and 69) which pertain to the art of *mu'amma* (riddles). Thus, the portrait of Khankhanan 'Abdur-Rahim (FGA 39.50a; pl. 20) is surrounded by a prose text about riddles.

Mu'amma

The art of *mu'amma* was very popular in Timurid Herat and at the early Mughal court.[62] One of the first known works about this form is that by Sharafuddin

Yazdi (d. 1454), the *Hilal al-mutarraz*,[63] on which Jami based his own treatise on riddles, the *Hilyat al-hilal*. This work on enigmas was written in A.H. 856/A.D. 1452 "in the hand of Jami" and the copy now in the Chester Beatty Library was acquired by "Shah Jahan . . . on the day of his accession, . . . the eighth day of Jumada II (1037 [1628])."[64] That proves the great interest of the Mughals in this art. Another copy of the same work, which until recently was regarded as the oldest extant manuscript, is in the Salar Jung Museum, Hyderabad (cat. no. 1081, B & M 7), written by the calligrapher Sharaf-i Husayni in A.H. 877/A.D. 1472. At the same time, Husayn ibn Muhammad al-Husayni ash-Shirazi an-Nishapuri composed *Risala-yi mu'amma*, a treatise on riddles and logographs, at the request of Mir 'Ali-Shir Nava'i. It was then submitted for approval to Jami. Mir-Husayni "had no equal in *mu'amma*," says Babur in his memoirs when speaking of his visit to Herat. Mir-Husayni, who died in A.H. 904/A.D. 1498, was apparently a favorite of the Herat intelligentsia.[65] Jami quotes two riddles of his on the name of Mir 'Ali-Shir Nava'i in his *Baharistan*.[66] Two full pages of calligraphy by Mir-'Ali in the Kevorkian Album (MMA fols. 3v and 5v; pls. 23 and 65) contain riddles by this master, one of which deals with the name "Bahman." One riddle in the Berlin Album deals with "Yar 'Ali," and another one about the name "Khalifa" in a Teheran collection, written by Mir-'Ali, is certainly by Husayni. Husayni's versified treatise on riddles was copied several times.[67] One manuscript, copied about 1500, also contains five folios with riddles about the Most Beautiful Names of God. A Turkish commentary by Sururi (d. 1562) about this treatise is known and shows how popular the art of *mu'amma* was even in Ottoman Turkey. The treatise begins with the invocation:

In the name of Him who by joining together [*ta'lif*] and
 composition [*tarkib*]
Has well arranged [*tartib*] the enigma of the world. . . .

But what is a *mu'amma*? It is a riddle that has to do with proper names. It was perhaps first an elegant way to allude to a beloved person's name without revealing it to the uninitiated; for it was considered improper to mention the name of a person close to one's heart lest the rival discover whom one loves. However, this understandable tendency to hide the name of the beloved developed in the course of time into a highly sophisticated art, which became increasingly incomprehensible.

Rückert, the only Western scholar to venture into this field, called the system "spiderweb-like" but apparently enjoyed finding the solutions to such verbal tricks.[68] For during the Timurid period and in the subsequent centuries, the readers' or listeners' interest was no longer concerned with the name itself—that was given at the very beginning of the *mu'amma*—but with the tricky ways by which the author reached his conclusion. This disentangling of the author's technique was the real fun for the audience, and the intellectuals of Herat, Delhi, and Lahore enjoyed such games without end, and it is not surprising that Mir-'Ali the calligrapher, after copying so many riddles, also tried his hand at this art.[69] The Mughals inherited the interest in *mu'amma* from their Timurid cousins, and in A.H. 930/ A.D. 1524, a short treatise on logographs was dedicated by one Jununi to Babur. It is called *Nuskha-i Baburi*, and a copy made five years later is preserved in the Salar Jung Museum.[70] At the same time, a *Risala-yi mu'amma* by Ibn 'Ali an-Nundaki was dedicated to 'Abdul-'Aziz Bahadur Khan, the patron of Mir-'Ali, the royal calligrapher in Bukhara. In India Babur's son Kamran Mirza, himself a good poet in Persian and Turkish, was given a treatise of logographs by one Maulana Shihabi.[71] Kamran, blinded and exiled, died in Mecca in 1556, the year that his nephew Akbar ascended the Mughal throne. But the art of riddles remained alive among the Mughals even in the second half of the sixteenth century.

The interest in this art form continued. Shahjahan acquired a work on *mu'amma*, and one 'Imaduddin ibn Shaykh Abu'l-Makarim al-Badhuli dedicated a treatise on logographs to Shahjahan's son Aurangzeb as late as A.H. 1084/A.D. 1673.[72]

It may be that the Mughal emperors, trained in appreciating the complicated ways that lead to the solution of a name-riddle, may have even enjoyed the little fragments of *mu'amma* around the borders of their album pages. They certainly enjoyed the album pages written by Mir-'Ali, and they were able to read and appreciate the Turkish verses around the borders. Thus, the album pages prepared for the royal Mughal library were important for the rulers not only from the visual viewpoint, or for the beauty of their paintings, or as a kind of "photographic" gallery of persons that were considered worthy of being portrayed. They also contained, along with these paintings and single calligraphic pages, many of the poems with which the Timurid elite of the sixteenth and early seventeenth centuries was fully conversant: pleasure added to pleasure!

The Poet Kalim

We are fortunate to have an account of the impression such a royal album left—if not on an ordinary person who would never have had the occasion to look at it—on one of the greatest poets of Shahjahan's time, Abu Talib Kalim (d. 1645).[73] Gazing at a colorful album, he poses the rhetorical question:

By which spring has this meadow been nurtured?

It seems to him as if "each line of writing [*khatt*] is as heart-ravishing as the province [*khatta*] of Kashmir," and the round loops of the letters seem to be "snares to catch the eye of the beholder." The spectators "become intoxicated by the wine that the round letters hold in their goblets," and finally, in perfect bewilderment, eye and script seem to be indistinguishable. The poet remembers Yaqut (the name means "ruby"), the master calligrapher of the thirteenth century, and claims with a fine pun that "If Yaqut had written one third [*thuluth*, also the name of a calligraphic style] of this writing, the caliph al-Musta'sim would have placed him on his eyes out of admiration." Not only the script, but the whole composition of the book is admirable. "What a splendor did the gold-illumination give to the lovely beloved script—as if dawn had embellished and beautified the evening!" There are also paradisiacal houris painted in this album, so lovely "that the young boys in Paradise become their lowliest slaves." Script and painting are intimately joined in such a way that "the curl of the [long letter] *lam* is coiled together with the hair of the tresses in the picture." Furthermore, picture and writing appear, like form and meaning, inseparable: they have embraced each other, and "if the dignity of beauty would not prevent the lovely painted figures from moving, they would happily strut in the garden of the page." Kalim closes his poem with a blessing for Shahjahan for whose album Time has selected a thousand novel pictures.

A second poem by the same court poet is historically even more interesting because he states in the last verses that "the Lord of paradisiacal abode [Jahangir]" had laid out the sketch of this album, but it could not be finished, and now Shahjahan has watered this garden again.

The painter of the workshop of Creation has drawn another circle on the face of art,
And the calligrapher Fate has brought a colorful manuscript from the springtime of the garden of Paradise for [our] time.

The lovely idols in the album make the spectator forget the face of spring—"one cannot call this an album; the diver Pen has dived deep to bring a hundred [loads] brimful of royal pearls." And after some further musings in this style Kalim goes on to claim that although "the soul of Mani [poetically used as the prototype of painterly art] is [generally] the nightingale in the rose parterre of painting, yet this rose garden has produced a thousand [hazar] such nightingales." That is, it surpasses every other work thousands of times (with a pun on hazar, which means both "nightingale" and "thousand"). "The movement of the brush of this magician-painter makes tremble the hands of all idols, and the binding [of the album] is sewn together by Peace of Mind [pun on jam'iyyat, "collect-

edness" or peace] because it holds such a lovely picture [= beloved] in its arms."

After telling the history of the album, the poet then sends blessings to Shahjahan upon whose threshold the sky, that "old man in a patched frock has scattered the coins of the stars. . . ." The "old man in a patched frock" is the normal designation of a mystical leader, but muraqqa', "patched frock," means also "album."

And thus, although one does not learn much about the actual look of the albums which Kalim was allowed to see, one can at least imagine how they were arranged in a sequence of paintings and calligraphies, and it may well be that at least some of the pictures in our album were among those that so enchanted the Persian poet.

1. For the development of Islamic calligraphy see Kühnel, Islamische Schriftkunst; Safadi, Islamic Calligraphy; Schimmel, Calligraphy and Islamic Culture.

2. For typical examples of such anthologies from Iran in the late fifteenth century, see Arberry et al., Beatty Library: Persian Manuscripts, nos. 159 and 185; for those from the later sixteenth century, see nos. 357 and 358. All of them contain verses by the same poets represented in the borders of the Shahjahan and Jahangir albums.

3. Qati'i, Majma' al-shu'ara, p. 103.

4. The divan was "written according to the order of its composer, may God make his shade spread forever over the heads of the Muslims!" See Schimmel, "Some Notes."

5. See the numerous examples in Indische Albumblätter; see also Soucek, "The Arts of Calligraphy," p. 18.

6. For the types mashaqa, harrara, etc., see Schimmel, Calligraphy and Islamic Culture, chap. 2. An example of a ruba'i in mashq by "the lowliest slave 'Ali—may God cover his faults" from A.H. 923/A.D. 1517 was offered at Christie's, London, April 19, 1979, lot 22.

7. See Barthold, Mir 'Ali Shir, and Subtelny, The Poetic Circle.

8. Qati'i, Majma' al-shu'ara, p. 55.

9. Fakhri, Raudat as-salatin, notes, p. 215, replying upon Nithari, Mudhakkir al-ahbab. For the whole scene see Schimmel, "Some Notes," esp. pp. 162–63.

10. Arberry et al., Beatty Library: Persian Manuscripts, no. 149.

11. Thus there are Sufi sayings of the patron saint of Herat, 'Abdullah-i Ansari, found in Mir-'Ali's hand (e.g., FGA 54.116v).

12. Welch, Art of Mughal India, pl. 27; Beach, Grand Mogul, no. 6r.

13. Habib, Hatt u hattatan, p. 158.

14. Qadi Ahmad, Calligraphers and Painters, pp. 155–64.

15. Qadi Ahmad, Calligraphers and Painters, p. 139, says that Sayyid Ahmad Mashhadi left Bukhara after 'Abdul-'Aziz Khan's death and then went to Shah Tahmasp. See also Qati'i's remark about Mir Kalang and other calligraphers who left Bukhara for India, Majma' al-shu'ara, p. 54.

16. Qati'i, Majma' al-shu'ara, p. 226.

17. Jahangir, Tuzuk, I, p. 168.

18. Bayani, Tadhkira-i khushnivisan, no. 303.

19. See Mustaqimzada, Tuhfet el-hattatin, p. 708; Habib, Hatt u hattatan, p. 210.

20. Qadi Ahmad, Calligraphers and Painters, p. 138. Bayani, Tadhkira-i khushnivisan, no. 1193, mentions a divan of Shahi in the Gulistan Library in Teheran, dated A.H. 955/A.D. 1547. A "selection from Sa'di's Bustan" written by Ibn Shadhishah in Bukhara ca. 1525 (thus in the description) is in the Freer Gallery of Art, no. 44.48.

21. Siyavushani's impertinent answer is not given in Qadi Ahmad, Calligraphers and Painters, p. 132, but it is in Bayani, Tadhkira-i khushnivisan, p. 877, and Habib, Hatt u hattatan, p. 226. A copy of Jami's Subhat al-abrar, written by Siyavushani in Bukhara in A.H. 942/A.D. 1535 and dedicated to Abu'l-Ghazi Khan 'Abdul-'Aziz was sold at Sotheby's, London, April 21, 1980, lot 186.

22. Thus Mustaqimzade, Tuhfet el-hattatin, p. 656, and Habib, Hatt u hattatan, p. 194.

23. For the page in the collection of Prince Sadruddin Aga Khan, see Welch and Welch, Arts of the Islamic Book, no. 73; for the Kansas City page, see Welch, Art of Mughal India, pl. 27, and Beach, Grand Mogul, no. 6r.

24. Mir-'Ali's poem is quoted in Qadi Ahmad, Calligraphers and Painters, pp. 130–31, and Bayani, Tadhkira-i khushnivisan, pp. 494–95. Another example of a little poem by Mir-'Ali was offered at Sotheby's, London, April 21, 1980, lot 23.

25. Quoted in Qadi Ahmad, Calligraphers and Painters, p. 130, and Bayani, Tadhkira-i khushnivisan, p. 503.

26. Quoted in Qadi Ahmad, Calligraphers and Painters, p. 130.

27. Qadi Ahmad, Calligraphers and Painters, p. 129, mentions a Turkish poem for 'Ubaydullah Khan; another poem by him is in Beach, Grand Mogul, no. 10v.

28. Qadi Ahmad, Calligraphers and Painters, p. 128; on p. 127 Qadi Ahmad quotes a poem in the meter mutaqarib in honor of Imam 'Ali al-Husayni:

Peace be on the family of . . . Ta-ha and Yasin [i.e., the Prophet Muhammad],
Peace be on the family of the best of the prophets!

29. Huart, Les Calligraphes, p. 219.

30. 'Ali Efendi, Manaqib-i hunarvaran, pp. 45–56.

31. Hafiz, Divan, ed. Ahmad and Na'ini, pp. 87, 101, and ed. Brockhaus, nos. 115, no. 120.

32. Arnold and Wilkinson, Beatty Library, III, pl. 61 (7/13), and Qadi Ahmad, Calligraphers and Painters, p. 68. A glance at the various catalogues of all major libraries in India, Turkey, and Europe shows the enormous quantity of beautiful manuscripts of Shahi's divan, and ancient copies still appear on the market.

33. Browne, *Literary History of Persia*, III, p. 501.

34. Daulatshah, *Tadhkirat ash-shuʿara*, pp. 480–82.

35. Rypka, *History of Iranian Literature*, p. 284. In her exhibition catalogue *Turkish Art of the Ottoman Period* (Washington, Freer Gallery of Art, 1973), Esin Atil mentions that numerous anthologies were composed under Sulayman the Magnificent, Sultan Selim's son, which contained specimens from Shahi's verse, along with poems by Fani and Kamal-i Khojandi, to mention only the most frequently represented writers.

36. Welch, "Early Mughal Miniature Painting," no. 3, pp. 136–37, and Welch, *Art of Mughal India*, pls. 5A and 5B.

37. Welch and Welch, *Arts of the Islamic Book*, no. 59.

38. Marteau and Vever, *Miniatures persanes*, pl. 168.

39. Browne, *Literary History of Persia*, III, pp. 473–86.

40. Daulatshah, *Tadhkirat ash-shuʿara*, pp. 385–92.

41. One of the oldest manuscripts of Qasim's divan is in the Bibliothèque Nationale, Paris (Supp. persan 1777; A.H. 852/A.D. 1448). See Massé, "Quinze poesies de Qasim al-Anvar."

42. Daulatshah, *Tadhkirat ash-shuʿara*, pp. 515–23. A copy of Asadi Tusi's divan made one year after the poet's death, in A.H. 870/A.D. 1465, is preserved in the Salar Jung Museum, Hyderabad, cat. no. 1552, A.Nm. 402; another, dated A.H. 896/A.D. 1491, in the same collection (cat. no. 1553, A.Nm. 403) was penned by Sultan-Muhammad Nur.

43. *Indische Albumblätter*, pl. 4.

44. Daulatshah, *Tadhkirat ash-shuʿara*, p. 398; Rypka, *History of Iranian Literature*, p. 274. Azad Bilgrami, *Khizana-i ʿamira*, p. 214. Jami, in his *Baharistan*, is quite critical of ʿIsmat.

45. Browne, *Literary History of Persia*, III, pp. 320–30; Rypka, *History of Iranian Literature*, p. 262, for positive evaluations.

46. Browne, *Literary History of Persia*, III, pp. 141–46; Rypka, *History of Iranian Literature*, p. 254.

47. The comprehensive work on Amir Khusrau is Waheed Mirza, *Life and Works of Amir Khosrau*; see also Browne, *Literary History of Persia*, III, pp. 108–111; Rypka, *History of Iranian Literature*, pp. 257ff.; Schimmel, *Islamic Literatures of India*, pp. 16ff. About illustrated manuscripts of his works, see Stchoukine et al., *Illuminierte Islamische Handschriften*, nos. 27, 62; Ettinghausen, "Pre-Mughal Painting in India," p. 192.

48. Browne, *Literary History of Persia*, III, p. 108; Rypka, *History of Iranian Literature*, pp. 717f.

49. Beach, *Grand Mogul*, no. 1.

50. Browne, *Literary History of Persia*, III, pp. 507–548 and passim; Rypka, *History of Iranian Literature*, pp. 286f. Jami's *Yusuf and Zulaykha* has been translated several times into Western languages, beginning with the German version of Vincenz von Rosenzweig-Schwannau in 1824.

51. Daulatshah, *Tadhkirat ash-shuʿara*, pp. 584–86; Rypka, *History of Iranian Literature*, p. 284; Subtelny, *The Poetic Circle*, pp. 122–24.

52. Arnold and Wilkinson, *Beatty Library*, III, pl. 53 (7/1).

53. Babur, *Baburnama*, p. 286.

54. Several sixteenth-century copies are found in European libraries; a few have lately been available in auctions (thus Sotheby's, London, April 26, 1982, lot 89, a copy from the late sixteenth century). The copy in the Salar Jung Museum with the seal of Muhammad Qutbshah of Golconda is cat. no 1661, A.Nm. 246, and the one that was in Wajid ʿAli Shah's library is cat. no. 1667, A.Nm. 250.

55. Daulatshah, *Tadhkirat ash-shuʿara*, p. 378; Browne, *Literary History of Persia*, III, p. 457; Subtelny, *The Poetic Circle*, pp. 117–20.

56. Arnold and Wilkinson, *Beatty Library*, III, 7/11.

57. Babur, *Baburnama*, p. 277.

58. Browne, *Literary History of Persia*, III, p. 489; Rypka, *History of Iranian Literature*, pp. 285f.; Ethé, "Neupersische Literatur," pp. 246, 297; and Ethé, "König und Bettler" (1870).

59. An incomplete, very beautiful copy is in the Metropolitan Museum of Art, 1982.120.1.

60. A facsimile copy of miniatures from Navaʾi's divan in various European collections was published in Moscow in 1964.

61. Jahangir, *Tuzuk*, I, pp. 109–110.

62. For *muʿamma* as part of Timurid culture, see Subtelny, "A Taste for the Intricate," and Shams-i Hoseyni Anwari, *Moʿamma and Loghaz*.

63. Bibliothèque Nationale, Supp. persan 126; British Museum, Or. 3509.

64. Arberry et al., *Beatty Library: Persian Manuscripts*, no. 132.

65. Subtelny, *The Poetic Circle*, pp. 131–32.

66. Jami, *Baharistan*, p. 103.

67. An example is in the Bibliothèque Nationale, see Blochet, *Catalogue*, II, p. 650; another is in the British Museum, Add. 7778. Two rhymed treatises, *Kanz ar-rumuz* and *Zad al-musafirin*, copied in Iran in the early seventeenth century, were sold at Sotheby's, London, April 26, 1982, lot 98.

68. Rückert, *Grammatik, Poetik und Rhetorik*, pp. 320ff.

69. Qadi Ahmad, *Calligraphers and Painters*, p. 129, quotes Mir-ʿAli's *muʿamma* on the name *Mahdi*:

Happy is he who has fallen a prey to love,
And become estranged from himself and his friends,
Who has all at once freed himself from the shackles of reason,
Who in the taverns has become bereft of head and feet.

Majnun (mad), without head and feet, i.e., without first and last letters, becomes *jnu*, numerical value 59, which is equivalent to the numerical value of *Mahdi*.

70. Salar Jung Museum, Hyderabad, cat. no. 1087, B&M 27.

71. Salar Jung Museum, Hyderabad, cat. no. 1097, B&M 30.

72. Badaʾoni, *Muntakhabu-t-tawarikh*, III, pp. 298 (text p. 215), 446 (323; cf. Azad Bilgrami, *Khizana-i ʿamira*, p. 232), 448 (324–25), 496 (362), 500 (366). Salar Jung Museum, Hyderabad, cat. no. 1098, B&M 15, fols. 1v–61v.

44

Decorative Borders
in Mughal Albums

MARIE L. SWIETOCHOWSKI

THE STUDY OF THE DECORATIVE borders in Mughal albums is in its infancy. The only widely accepted conclusion from the evidence at hand is that the album form consisted of two facing pictures alternating with two facing calligraphy pages. Any other conclusions that are drawn here are dependent on the evidence of the Kevorkian Album, with its dedications to Emperor Shahjahan (r. 1628–58) and therefore in the strictest sense may apply only to albums of the Shahjahan period. A wider study of the format schemes of all extant Mughal albums, including pictures, calligraphies, and borders, might prove either immensely rewarding or utterly frustrating.

Decorated borders have a long tradition in the art of the Islamic book, first appearing in Iran in the fifteenth century. The earliest known border paintings are probably the very beautiful pastoral scenes in wash colors and gold in the divan of Sultan Ahmad Jalayir, dated 1404. The sultan's son-in-law, the Timurid prince Iskandar Sultan, and Iskandar's cousin Sultan Ibrahim were both patrons of manuscripts containing some marginal decoration in gold. Borders decorated in gold are found in sixteenth-century Safavid Persian manuscripts and those of their artistic dependents in Bukhara. Given the foundation of the Mughal school with the help of Iranian artists, the close cultural exchanges between Bukhara and Mughal India, and the diplomatic and commercial contracts and missions between Mughal princes and monarchs and the Safavid court, as well as the large numbers of Persians in Mughal service, it is not surprising that the Mughals took up the practice of decorating borders.

Derivative gold-decorated borders appear in a handful of late Akbari manuscripts,[1] with, however, a greater emphasis on the human figure than in Safavid borders, following the Mughal predeliction for natural observation as opposed to the idealism typical of Iranian prototypes.

During Jahangir's reign these borders were brought to perfection through the use of naturalistic trees, landscape elements, animals, and even human figures. In these lyrical compositions, the gold is often heightened with subtle washes or intensified with flashes of brilliant color. Psychologically probing portraits appear in colors that contrast richly with the gold ground; figures and vignettes based on European prints abound,[2] while birds in brilliant plumage skim above the golden foliage.

Jahangir's albums have come down to us in two volumes. The earlier, known as the *Muraqqa'-i Gulshan* or Gulshan Album, is in the Gulistan Palace Library in Teheran and has pages dated between 1599, when Jahangir was still Prince Salim, and 1609 (A. H. 1018) on one of the borders signed by Daulat. The other album is in the Staatsbibliothek Preussischer Kulturbesitz, Berlin, and has pages dated between 1609 and 1618.[3] Milo C. Beach has written that the majority of detached pages are datable to the early seventeenth century and probably had been removed at some time from the Teheran album.[4]

An art historical puzzle that is still unsolved, although suggestions as to the answer have been made and will be discussed below, leads to a series of questions. Assuming that albums were made for Jahangir after 1618, where are they and what do the borders look like? Was there an evolutionary process—as there was from Akbari to Jahangiri borders—from Jahangiri to Shahjahani borders? Is the evidence as to what turn

such an evolution took simply missing? Or did Jahangiri borders continue the rich mix of the Gulshan and Berlin albums more or less without change—and again the evidence is missing—until an abrupt change took place either late in Jahangir's reign or early in Shahjahan's?

This artistic transformation was the introduction of the formal flowering plants that are synonymous with the reign of Shahjahan (1628–57), not only in album borders but also in architectural decoration (as in the carved stone and *pietra dura* work in such buildings as the Taj Mahal and Red Forts in Delhi and Agra), as well as in sashes, robes, metalwork, jade carving, and, in fact, almost every aspect of artistic endeavor.

Robert Skelton has astutely suggested that this significant change in Mughal decoration grew out of a combination of two occurrences. The first was Jahangir's momentous visit to Kashmir in the spring of 1620, during which he was overcome by the dazzling array of flowering plants and herbs which he movingly and lyrically describes in his journal.[5] The second is the influence on Mughal painters of European engraved herbals.[6] (See figs. 8 and 9; p. 25.)

Not only was Jahangir's thrilled delight in Kashmirian flowers made known to us through his own memoirs, but so too was his statement that he had over a hundred flower portraits painted by Mansur, his greatest nature artist. Skelton has pointed out the similarity of approach between Mansur's Western Asiatic tulip, one of only three surviving flower paintings by him[7] and an illustration of a lily in a French garden book of 1608.[8]

The sixteenth century may be considered the century of the blossoming of the wood-engraved European herbal as an art form. Among the giants of sixteenth-century botanists who produced influential masterpieces of herbals illustrated with engraved woodcuts was Otho Brunfels, who had his work *Herbarum vivae eicones*... published by Sholt of Strasbourg in 1530, 1531, and 1536 with the engraving executed by Hans Weiditz. Another was Leonhard Fuchs, whose *De historia stirpium*... was published in Basel in 1542 with another edition in 1545. He is known to have employed a craftsman to draw the plant from nature, another to copy it onto the wood, and an engraver to cut the block. "In the work of Leonhard Fuchs plant drawing, as an art, may be said to have reached its culmination point."[9]

The works of other botanists were frequently illustrated, not with wood engravings made from material gathered by the botanists but after those engravings of great merit that were already in existence, such as the blocks made for Brunfels and particularly Fuchs. For example, over half the illustrations for the first edition of Rembert Dodoens's *Crüydeboeck*, published in Antwerp in 1554, were taken from Fuchs's 1545 edition after which Fuchs's blocks traveled to England and were used for herbals there. Subsequent works of Dodoens were published by the great Antwerp publisher Plantin. Plantin also published the works of the botanists Charles de l'Ecluse and Mathias de l'Obel in the 1570s and 1580s, and having acquired a large collection of woodblocks, he used and reused them.[10] This is not the place to go into the history of botanical wood engravings in Europe, but the circumstance of large numbers of such botanical engravings being published by Plantin in Antwerp is not without significance in our study.

Christopher Plantin was not only a prolific publisher of herbals but of other works as well, such as the Royal Polyglot Bible, printed between 1568 and 1573, with illustrations by, among others, Jan Wiericx and Philip Galle. This was presented to the emperor Akbar by the Jesuits during their first mission to the Mughal court in 1580. This bible was by no means the only work of Plantin's publishing house or of the Antwerp Guild to have entered Mughal collections.[11]

Milo C. Beach has discussed the subject of European works and copies of them by Indian artists in Mughal collections. He remarks that: "[Georg] Pencz and the two Beham brothers were active in Nüremberg, and their styles were formed under the direct influence of Albrecht Dürer, some of whose prints also reached the Mughal court. They in turn influenced the Flemish Jesuit Jan Wiericx (ii); Both of these artists [Pencz and Crispian van de Passe], as well as several others whose work was in the Mughal imperial collections (Jan Wiericx, Hubert Goltzius, Crispin van der Broeck, and the brothers Jan, Aegidius, and Raphael Sadeler, among others) are known to have been active in the Antwerp Guild about 1580, and some worked for Christopher Plantin. Plantin was known to have been in correspondence with the Jesuits, while a Fleming, Everhard Mercurian, was general of the Society from 1573 to 1581. And as Antwerp was then the leading port in Europe, the quantities of Flemish art brought by the Jesuits and traders to India is easily explained."[12]

It is clear that herbals could have found their way to India by the same route as other European books and pictures, and considering Plantin's association with illustrated herbals as well as with the artists cited in the above quotations, it would have been surprising if they had not done so. The European sources of a few

Mughal pictures of plants have indeed been tracked down but the whole subject is a monumental undertaking that has not yet been thoroughly launched.

While the influence of European herbals may well have affected the way Mughal artists approached flower paintings—a single plant against a plain ground—as in Mansur's *Tulip and Iris*,[13] and while the catalyst for the flowering plant in Mughal art may well, as suggested by Skelton, have been Jahangir's Kashmirian spring of 1620, the transferral of a "portrait" of a single flowering plant into a decorative border scheme made up of a series of flowering plants has yet to be explained.

It is probable that influences other than European herbals were also at work at the Mughal court. Robert Skelton speculates that Sir Thomas Roe, the English ambassador, might have brought a herbal with him as a present for Jahangir. Another even more speculative thought is that Jahangir may have received as a gift a fourteenth- or fifteenth-century book of hours or some such related European religious manuscript of the same period, when they were frequently decorated with exquisite floral borders. A manuscript of about 1250 (now in The Morgan Library, M638), a pictorial history of the Old Testament, was presented to the Persian ruler Shah ʿAbbas the Great in 1605, so a similar gift to Jahangir or Shahjahan would not be without precedent. Such a manuscript might have suggested to a Mughal ruler the suitability of flowering plants as a border design for royal albums.

In addition to the printed herbals and prints of religious or classical subjects and perhaps a devotional medieval manuscript or two that made their way to India, an enormous quantity of devotional pictures with decorated borders must have been extensively used by the Jesuits in proselytizing missions. Since the Jesuits were bent on converting both Akbar and Jahangir and were welcome at the Mughal court, these pictures must have been common there. For example, the catalogue raisonné entitled *Les Estampes des Wierix* contains numerous illustrations of engravings with flowering plants in the borders, often with the addition of butterflies and insects.[14] It is of interest to note that the iris and narcissus appear frequently in these borders, with the tulip, poppy, primula, rose, and lily also found.[15]

In Jahangir's radiant descriptions of Kashmir in the spring he mentions that "the red rose, the violet, and the narcissus grow of themselves . . . the gates, the walls, the courts, the roots, are lighted up by the touches of banquet-adoring tulips." Jahangir also mentions a cultivated and a wild lily and writes the oft-quoted lines:

"The flowers that are seen in the territories of Kashmir are beyond all calculation, those that Nadîru-i-ʿasri Ustad Mansur has painted are more than 100."[16] These passages and other related ones elsewhere in his memoirs make it abundantly clear that Jahangir had his artists paint living specimens whether plants, birds, or animals. The flowering plants that appear in the borders of the albums give up no easy answers. The works of the revered Mansur must have impressed other painters of the court atelier and influenced their work. On the other hand, these artists would have found European prints excitingly exotic and tantalizing.

All the same, even though a very good case can be made for the artistic influence on Mughal art of European printed herbals and single sheets of religious prints and perhaps the royal gift of a European religious manuscript, there is still no irrefutable evidence that albums with floral borders were made for Jahangir between 1620 and his death in 1627.

During the period of Shahjahan, on the other hand, there is no trace of the border decorations of the Jahangiri period, although with the Late Shahjahan Album portrait figures reappear among the plants of the borders. Along with the innovative flowering plants, more eclectic scroll and arabesque designs still appear.

During Shahjahan's reign albums—except for the *Padshahnama*, the history of his reign—appear to have been the preferred form in the book arts. One obvious question arises: Since many of the pictures collected in these albums were painted during Jahangir's reign, could the floral borders of at least some of them have been contemporary? If a verifiable affirmation could be given, the attractive supposition would follow that Shahjahan's artists copied these borders for the sake of consistency and harmony in the albums they were assembling, and in this way the new vogue in border designs became set. Such an answer would also tidily take care of the vexing time lag between Jahangir's Kashmirian spring of 1620 and the appearance of floral borders only in the following reign, some time after 1628. A poem by Shahjahan's court poet Kalim on the subject of the emperor's *muraqqaʿ* (albums) could be interpreted as highly suggestive, if not firm, evidence. Kalim tells us, in the flowery mode in literary fashion at the time, that an album planned by Jahangir was completed by Shahjahan (see AMS, pp. 42–43, for a summary and partial translation). One cannot be sure what stage the planning had reached under Jahangir; however, the word "completed" is used by the poet, implying that the Jahangiri material was already in album form and therefore had decorative borders, pre-

sumably the flowering plant borders of early Shahjahan albums. Further references to Kalim in relation to the albums will be made below. Both Robert Skelton[17] and Rosemary Crill[18] have mentioned that the seal of Jahangir found on some leaves of the Wantage Album appears on both genuine seventeenth-century pages and the late copies on the calligraphy sides, with a small seal bearing the name of Nandaram Pandit on the picture side. This worthy, Crill has pointed out, got hold of Jahangir's seal and at least one imperial album and went to work with it. This link, then, with Jahangir and flowering plant borders is unfortunately untrustworthy.

In considering the borders of Shahjahan's albums the most striking feature is, it seems to me, their consistency. This consistency allows them, with a few exceptions, to be divided into two main groups. The earlier group, in which all of the leaves include a numerical notation in the narrow border to the right of the portraits, includes the seventeenth-century leaves of the Minto, Wantage, and Kevorkian albums, in addition to a number of leaves that have appeared in sales catalogues in recent years.[19]

The later group either belongs to or is closely related to the so-called Late Shahjahan Album[20] and generally has the addition of figures in the borders that relate to the central scene with, usually, either flowering plants or floral scrolls on the calligraphy page borders. These leaves do not have margin numbers. Most of the portraits in the Late Shahjahan Album are of people active during the emperor's reign. On the other hand, the portraits of the Kevorkian Album and seemingly those of the Wantage and Minto albums as well—although I have not carefully studied them in this respect—date either from the period of Jahangir or from fairly early in Shahjahan's reign. Apart from imperial portraits, depictions of holy men, and the odd scene, the great majority of the portraits are of people of special interest to Shahjahan, people who were close to him in his campaigns, when as Prince Khurram he carried out imperial military projects, or men who sided with him in his rebellion against his father, or even men who betrayed him during that rebellion, and men who were particularly important to him during the first decade of his reign.

The association of the first group of albums with Shahjahan's career as Prince Khurram and with the first decade of his reign as emperor may provide the clue to the presence of numbers on the album leaves of the whole earlier group and an approximate date for them. When Shahjahan finally ascended the throne in 1628, considering the court intrigues against him mas-

terminded by his stepmother Nur-Jahan and the vicissitudes of his rebellion and the uncertainty of the succession, he must have felt a tremendous surging triumph as well as appreciation of the power and prestige that were finally his. This is the time that he would assess the imperial library and the potential of the painting atelier, and indeed there is evidence that he did so. This would also undoubtedly have been a time to vindicate his own past actions and memorialize his associates as well as those of importance to his success as emperor. A tremendous upsurge in the creation of new imperial albums must have taken place on Shahjahan's accession, with its impetus lasting at least a decade. Evidence for this is provided by the poet Kalim when he writes of "thousands of marvelous pictures" (see below), even when discounting the hyperbole of poetic license. Since the court artists seemingly worked on the assemblage of several albums simultaneously, a numbering system for the album pages may well have been necessary to avoid chaos, especially if extant album leaves were being incorporated into an organized sequence. When album production presumably settled down to a more sedate pace later in Shahjahan's reign, a numbering system would no longer have been necessary.

Finally, while the impetus for album borders decorated with flowering plants may have come from Jahangir, Shahjahan himself was certainly attracted by flowering plants and gardens. After all, his beloved wife Mumtaz-Mahal had died in 1631, only three years after his accession, and of major importance in the planning of her tomb, the Taj Majal, was its garden with fruit trees and flowering plants which was its setting. Furthermore, the poet Kalim, mentioned above, compares a Shahjahan *muraqqa°* to a flower garden, a conception that seems to have been formally expressed by the floral borders.[21]

Another poem by Kalim—about, as Annemarie Schimmel has pointed out, a different album from that already mentioned—states that "one would even expect the beautiful figures to walk in the garden of the page, but the 'authority' (or 'firmness') of the painting hinders them."[22] This image transforms a Shahjahan album page into a garden, as much a paradisiacal as an earthly one. "The poem ends with the blessing for Shahjahan, who has selected 'thousands of marvelous pictures'—for him, who is like the sun in glory, surrounded by his starlike army."[23]

The Kevorkian Album

There are thirty-nine seventeenth-century folios (including four illuminated pages) in the Kevorkian Album; of these, thirty-six are in the Metropolitan Museum and three are in the Freer Gallery of Art. Ten of these folios, or five pairs, certainly faced each other in the albums to which they originally belonged (there are also two additional folios that probably faced each other). It seems to have been the practice in the early period of Shahjahan to insert small numbers in the narrow gold band between the outer margin and the inner, if there was one, always at the right side of the leaf (what appear to be earlier numbers occasionally appear in the same gold band beneath the picture) and always on the picture side, never on the calligraphy side, of a folio. Those folios in the Kevorkian Album that were paired would obviously have consecutive numbers in their borders. Each pair of pictures has the same border scheme. However, they all also have the same border schemes on their calligraphy sides. These pages would have faced now-missing calligraphy pages with similar borders. The facing leaves in this album and their borders are listed below, with the Group A pictures listed first and the Group B second. Those folios that have even margin numbers on the recto and uneven margin numbers on the verso side have been designated Group A, while those that have uneven margin numbers on the recto and even margin numbers on the verso have been designated Group B. This is the most basic division within the Kevorkian Album in that the two groups could never have belonged together because if they had, calligraphy pages and portrait pages would face each other in violation of the basic Mughal album format. For example, in Group A, MMA fol. 7r (pl. 28) with margin number 4 faced MMA fol. 8v (pl. 29) with margin number 3, and each has a border design of flowering plants in gold on a pink ground as portrait borders and an all-over floral scrolling design with variations in gold on a blue ground. There are two other album leaves that, while not placed opposite one another according to their numbers, most assuredly belonged to the same album as the pair just mentioned. These are MMA fol. 32 (pls. 17 and 18) with the margin number 52 and MMA fol. 37 (pls. 67 and 68) with the margin number 35; they have border schemes similar to the first two mentioned.

Another set of facing leaves are MMA fol. 1r (pl. 32) with the margin number 58 and MMA fol. 2v (pl. 33) with the margin number 57. The portrait sides of both leaves have a border of flowering plants in colors and gold on a buff ground; the calligraphy borders show flowering plants in gold on a blue ground. Two bird portraits were facing—MMA fol. 15r (pl. 40) with the margin number 44 and MMA fol. 14v (pl. 41) with the margin number 43. These two paintings have a horizontal format, so that when they were placed in the vertical format of the album, each bird "stood" on its tail. On the portrait sides the borders have an all-over design of scrolling floral forms in colors and gold on a buff ground, while the calligraphy sides have borders of flowering plants in color and gold on a buff ground. A third album leaf, a portrait of a nilgai (MMA fol. 13v; pl. 47), is also in a horizontal format and has the same border schemes as do the bird studies on both the portrait and calligraphy side. These three leaves must indeed have been part of the same original album, devoted to bird and animal studies painted in horizontal formats. A slightly problematic pair—MMA fol. 16 (pls. 43 and 44) with the margin number 40 and MMA fol. 12 (pls. 45 and 46) with the margin number 39—also belongs to Group A. They too are bird portraits, but in the more usual vertical format. Both folios have portrait borders of flowering plants in gold on blue and calligraphy borders of an all-over design of a scroll with cartouches, flowers, leaves, and palmettes in pink on gold. The reservation about calling them an indisputable pair is that the recto portrait (pl. 44) has no cutout calligraphy around the picture while the verso portrait (pl. 45) has cutout calligraphy at top and bottom inside the inner border. The blue of the recto picture also is a deeper, truer blue than that of the verso which is a lighter, greener blue. Whether these discrepancies are significant or immaterial cannot be decided at this time.

In Group B MMA fol. 10r (pl. 76) with the margin number 11 and MMA fol. 11v (pl. 77) with the margin number 10 would have faced each other. Both portraits —each of a dervish with an animal—have borders of flowering plants in colors and gold on a buff ground. Their calligraphy pages have borders of the same design.

Another pair is MMA fol. 30r (pl. 70) with the margin number 3 and MMA fol. 31v (pl. 71) with the margin number 2. Like MMA fols. 10 and 11, both portrait and calligraphy borders of these leaves consist of flowering plants in colors and gold on a buff ground. It is not clear, however, whether they belong to the same album as the animal keepers since they have quite distinctive inner borders with cloud-band patterns and do not have the innermost border of cutout poetry of the other pair.

The evidence of these five (or six) pairs suggests that albums of the late Jahangir and early Shahjahan periods had borders with one scheme for the painting or portrait side and another, which might or might not be the same, for the calligraphy side. This pattern appears to have remained constant throughout the album.

Other leaves that seem to have belonged to the same albums, although not facing each other, again fall into Group A or Group B. Three Group A leaves—MMA fol. 3 (pls. 23 and 24) with the margin number 6, MMA fol. 29 (pls. 25 and 26) with the margin number 12, and MMA fol. 6 (pls. 73 and 74) with the margin number 18—have gold flowering plants on a pink ground on the portrait side, which in each case is a recto page, and flowering plants in colors and gold on a buff ground on the calligraphy side. There is a fourth Group A leaf—MMA fol. 33 (pls. 35 and 36) with the margin number 51 and with a portrait on the verso—that has the same border arrangement as the three just mentioned, but it lacks the cutout poetry that forms the innermost border of the others. A question arises: How strict was the border formula within one album? If cutout calligraphy formed the innermost border of three folios of a given album, would this form of embellishment have prevailed throughout? In the absence of corroborative evidence the question remains open. It must be concluded that this fourth leaf may or may not have formed part of the same album as the other three. The sequence of margin numbers of the three recto pages—6, 12, and 18—gives rise to further speculation. What if, after all, border designs did change within an album in certain regular repeats, for example, according to these three numbers, in multiples of six? Could these three folios then be fitted in with others from Group A? First, let us designate MMA fols. 7, 8, 32, and 37 (pls. 27–30, 17, 18, 67, and 68), with like border schemes, Album 1; MMA fols. 1 and 2 (pls. 31–34) are similarly designated Album 2. If these two albums had actually been part of Album 3 (the group just discussed), would there be a conflict in border schemes? In this case, there would not because seeming conflicts can be resolved; for example in Album 1 there is a verso portrait with the margin number 35 which would originally have had to face a recto portrait page with similar borders which would have been numbered 36. Album 3 in multiples of 6 would also have to have a recto portrait with the margin number 36, but since Albums 1 and 3 both have a design of gold flowering plants on a pink ground on the portrait side, the conflict is resolved. There are only two paintings in Album 2, and they do not conflict with Album 1 or 3 in border designs or numbers. Therefore it is possible, as the above

50

speculations demonstrate, that albums had a changing border scheme in regular repeats and that Albums 1, 2, and 3 actually belonged together. However it must be repeated that what is apparent in the Kevorkian Album suggests that the portrait border and the calligraphy border remained constant throughout an album. What is more, except for Albums 1, 2, and 3 as demonstrated, the attempt to establish a repeated sequence with other numbered pages and border patterns in the Kevorkian Album leads to innumerable conflicts which furnish proof that not only are the paintings of Group A and Group B incompatible, but so are many of the paintings within each group (see chart at the end of this essay).

Without even having to struggle with a repeat system, it is obvious, for example, that the recto portrait with the margin number 6 (MMA fol. 3r; pl. 24) of Album 3 could not have faced the verso portrait with the margin number 5 (MMA fol. 4v; pl. 21) because the former has a border of gold flowers on a pink ground and the latter a border of gold flowers on a blue ground. (There is, however, a possibility, for which there is to date absolutely no evidence, that gold flowering plants on a colored ground, regardless of whether it was blue or pink, could have been considered compatible.) The same problem applies to margin number 7 (MMA 36v; pl. 55) when paired with either of the two pages with margin number 8 (MMA fol. 24r and FGA 39.50a; pls. 58 and 20), which have respectively borders of flowering plants in colors and gold (with birds) on a buff ground, gold flowering plants on a buff ground, and gold flowering plants on a blue ground. In addition, of course, the two pages with the same border numbers would have had to belong to different albums at one time. The leaves with margin numbers 17 and 18 (MMA fols. 20v and 6r; pls. 53 and 74) could not have faced each other because the former has a border of gold flowering plants on a blue ground and the latter gold flowering plants on a pink ground on the presumption that these different colors could not be considered allowable pairs. The folio with the margin number 25 (MMA fol. 13v; pl. 47), a verso page with an animal portrait, could not have faced the recto page with the margin number 26 (MMA fol. 17r; pl. 50) even though that is also an animal portrait. The former has a border of an all-over scrolling floral and leaf design in colors and gold on a buff ground and has a horizontal format, while the latter has flowering plants and gold on a buff ground in a vertical format. The leaf with verso margin number 35 belonging to Album 1 (MMA fol. 37v; pl. 67) has a border of flowering plants in gold on a pink ground, while that with recto margin number

36 (MMA fol. 5r; pl. 66) has flowering plants in gold on a blue ground. The leaf with the margin number 51 (MMA fol. 33v; pl. 35) could theoretically have faced that with margin number 52 (MMA fol. 32r; pl. 18), but the latter, part of Album 1, has cutout poetry around the portrait and a verso page of an all-over abstract floral scroll design in gold on blue, while the former has no cutout poetry and a recto page of flowering plants in colors and gold on a buff ground.

In the smaller Group B there are also incompatible borders with consecutive numbers. The verso picture of princely lovers with margin number 44 (MMA fol. 35v; pl. 63) has a border of flowering plants in pink on a gold ground, while its recto calligraphy page has flowering plants in colors and gold on a buff ground. A single figure portrait in Deccani dress on a recto page (MMA fol. 34r; pl. 38) has the margin number 45 and a border of flowering plants in colors and gold on a buff ground. Its calligraphy page has a gold-on-pink flowering plant border. These two leaves obviously belonged to separate albums. Two other folios with consecutive margin numbers present a less clear-cut case. Both of them are portraits of Jahangir, one with his minister Iʿtimaduddaula (MMA fol. 23r; pl. 16) and the other with his father Akbar (MMA fol. 19v; pl. 11); the recto page bearing the margin number 37 and the verso 36. The borders of both portraits have flowering plants in colors and gold on a buff ground, but that of the emperor and his minister has cutout poetry at the bottom and top of the picture and a cartouche arrangement for the palmette, flower-head, and leaf-scroll pattern of the inner border. Its calligraphy page has a border in gold on a blue ground with an all-over pattern of scrolling palmettes, flower heads, and leaves with birds scattered about and a sinuous riband giving accent to the pattern, a design copying most faithfully the border of another calligraphy page in the Kevorkian Album signed by Daulat (MMA fol. 7v; pl. 27). While very fine it lacks the perfection of drawing and brushwork of that master of borders. The portrait of Jahangir and Akbar has no cutout poetry and a continuous flower-head and palmette-scroll inner border in gold on a pink ground. The calligraphy side has a border of flowering plants in gold on a pink ground. The scale of the two pictures is quite different; the figures of Jahangir with Akbar are considerably larger than those of Jahangir and Iʿtimaduddaula, so that visually the two paintings would not have been a particularly appealing pair. It is not clear whether this was of importance or whether the similarity of subject matter overrode aesthetic considerations. The different borders on the calligraphy pages could mean either that they belonged to differ-

ent albums or that the border scheme changed with a system of alternating patterns. To add a further complication, MMA fol. 34r (pl. 38), the portrait of Mulla Muhammad of Bijapur, has the same border arrangement on its portrait and on its calligraphy side as the portrait of Jahangir with Akbar (MMA fol. 19v; pl. 11); neither has cutout poetry, so that there is a good possibility that they both came from the same album, with MMA fol. 23 (pls. 15 and 16) perhaps also included and equally perhaps not, its two clues of margin number and border patterns canceling each other out.

Having discussed the conflicts arising from disparate borders and consecutive numbers, we must now return to those folios that have widely different border numbers but similar border schemes and to those that seem unrelated to any other leaf in the Kevorkian Album. In Group A, MMA fol. 5 (pls. 65 and 66) with the recto margin number 36 and MMA fol. 4 (pls. 21 and 22) with the verso margin number 5 have a border arrangement of flowering plants in gold on a blue ground on the portrait side and on a pink ground on the calligraphy side. The color of the blue borders is different, with that of MMA fol. 4 being lighter in shade, but as they would have been widely separated in the album, this discrepancy would not pose an aesthetic problem. The portrait of the Khankhanan (FGA 39.50a; pl. 20) with the margin number 8 and the painting of the dancing dervishes (MMA fol. 18r; pl. 52) with the margin number 46 not only have similar border arrangements with gold flowering plants on a blue ground on their recto portrait sides but also have fairly unusual buff ground calligraphy-side borders with all-over scrolling patterns in various colors and gold; these borders are quite clearly by the same artist. Their margin numbers show that they were widely separated in the album so that the disparity of subject matter may have no significance. More problematic is *A Youth Fallen from a Tree* (MMA fol. 20v; pl. 53); this painting and that of the dancing dervishes are the only two "scenes" as opposed to portrait studies in the Kevorkian Album. This leaf, which has the margin number 17, has a border of gold flowering plants on a blue ground on its verso, but on the calligraphy side an all-over pattern of grapevines in gold on a pink ground. This is one of the few signed borders in the Kevorkian Album, with the name of Fath Muhammad given in tiny letters in the gold margin below the inner border. Fath Muhammad's name is not otherwise known to me. The picture side of this folio has no inner border, only cutout poetry. The dervish picture has cutout calligraphy above and below and the usual palmette, flower-head, and leaf-scroll border in gold on pink. Again we are faced with

the question of whether the picture of the fallen youth belonged to a separate album from the pictures of the Khankhanan and of the dervishes with identical border schemes or whether it belonged with them in an album with a repeating system of borders. If they came from the same album, the two "scene" paintings would have been widely distant from each other, and one can only speculate that a similar scene painting was placed opposite each of them in their original album or albums. The picture of the fallen youth by the Jahangiri painter Aqa-Riza has an early nineteenth-century copy with an inscription attributing it falsely to Farrukh Beg in the album of the Wantage Bequest in the Victoria and Albert Museum.[24] This copy also has a border of flowers in gold on a blue ground, but on its "calligraphy" side is a picture, also early nineteenth century, of an Indian red-wattled lapwing, falsely attributed to Mansur. In Group A there remain three leaves whose border schemes do not relate either to each other or to any others in the group. They are all pictures of Shahjahan: MMA fol. 24r (pl. 58) with the margin number 8, MMA fol. 36v (pl. 55) with the margin number 7, and MMA fol. 21v (pl. 59) with the margin number 11. Group B has already been covered in the previous discussion.

To summarize the foregoing remarks, from the evidence of margin numbers and border schemes a certain amount can be discovered about how the Kevorkian Album was put together and, within a certain range, the number of Mughal albums drawn from to complete it. The first basic division is between Group A and Group B leaves. Within Group A, which contains twenty-four Mughal leaves, as many as fourteen or as few as nine albums could have been drawn from. In Group B, which contains eleven Mughal leaves, as many as ten or as few as eight, or possibly even seven, albums could have been drawn from. Eleven early nineteenth-century leaves were added to the album, six of which are in the Freer Gallery with five in the Metropolitan Museum.

The following is a summary of the albums from which the Kevorkian album was drawn:

GROUP A FOLIOS: verso portraits have odd margin numbers; recto portraits have even margin numbers.

ALBUM 1:

recto margin number 4 (MMA fol. 7; pls. 27 and 28)
verso margin number 3 (MMA fol. 8; pls. 29 and 30)
recto margin number 52 (MMA fol. 32; pls. 17 and 18)
verso margin number 35 (MMA fol. 37; pls. 67 and 68)
 The first two would have faced each other.

ALBUM 2:

recto margin number 58 (MMA fol. 1; pls. 31 and 32)
verso margin number 57 (MMA fol. 2; pls. 33 and 34)
 These two would have faced each other.

ALBUM 3:

recto margin number 6 (MMA fol. 3; pls. 23 and 24)
recto margin number 12 (MMA fol. 29; pls. 25 and 26)
recto margin number 18 (MMA fol. 6; pls. 73 and 74)
verso margin number 51 (MMA fol. 33; pls. 35 and 36)
 The last has no poetry around portrait and so may not belong to Album 3.

ALBUM 3 OR
ODD LEAVES:

verso margin number 5 (MMA fol. 4; pls. 21 and 22)
recto margin number 36 (MMA fol. 5; pls. 65 and 66)
 The different shade of blue seen in the borders of these folios may not be significant so long as the facing page matched.

GROUP B FOLIOS: verso portraits have even margin numbers; recto portraits have odd margin numbers.

ALBUM 1:

recto margin number 11 (MMA fol. 10; pls. 75 and 76)
verso margin number 10 (MMA fol. 11; pls. 77 and 78)

ALBUM 2:

recto margin number 3 (MMA fol. 30; pls. 69 and 70)
verso margin number 2 (MMA fol. 31; pls. 71 and 72)
 These folios have the same border scheme as Album 1 but have no cutout poetry; they do have distinctive inner borders and subject matter.

ALBUM 3 OR
ODD LEAVES:

recto margin number 45 (MMA fol. 34; pls. 37 and 38)
verso margin number 36 (MMA fol. 19; pls. 11 and 12)
verso margin number 44 (MMA fol. 35; pls. 63 and 64)

ODD LEAVES:

verso margin number 8 (FGA 48.28; pls. 13 and 14)
verso margin number 26 (MMA fol. 22; pls. 9 and 10)
recto margin number 2 (FGA 39.49; pls. 61 and 62)
recto margin number 37 (MMA fol. 23; pls. 15 and 16)

ALBUM 4:

recto margin number 8 (FGA 39.50; pls. 19 and 20)
recto margin number 46 (MMA fol. 18; pls. 51 and 52)
verso margin number 17 (MMA fol. 20; pls. 53 and 54)
 The last may be part of Album 4 but is probably an odd leaf.

ODD LEAVES:

recto margin number 8 (MMA fol. 24; pls. 57 and 58)
verso margin number 7 (MMA fol. 36; pls. 55 and 56)
verso margin number 11 (MMA fol. 21; pls. 59 and 60)
 All are portraits of Shahjahan; MMA fol. 36 is the earliest.

ALBUM 5:

recto margin number 44 (MMA fol. 15; pls. 39 and 40)
verso margin number 43 (MMA fol. 14; pls. 41 and 42)
verso margin number 25 (MMA fol. 13; pls. 47 and 48)

ODD LEAF:

recto margin number 26 (MMA fol. 17; pls. 49 and 50)

ALBUM 6?:

recto margin number 40 (MMA fol. 16; pls. 43 and 44)
verso margin number 39 (MMA fol. 12; pls. 45 and 46)
 These may be odd leaves. The border of MMA fol. 12 is a lighter, greener blue than that of MMA fol. 16.

Of the fifteen different combinations of design and color found in the Kevorkian borders, six appear only once. When the list is separated into Groups A and B, it is found that Group A contains ten different border schemes and Group B seven, indicating the possibility that as many as seventeen different albums may have provided the folios for the Kevorkian Album.

The variety of border schemes and the folios on which they appear in the Kevorkian Album are as follows:

1. PORTRAIT SIDE
Gold flowering plants on a pink ground
CALLIGRAPHY SIDE
Gold abstract and all-over floral pattern on a blue ground
Group A (four folios): MMA fol. 8, verso margin number 3; MMA fol. 7, recto margin number 4; MMA fol. 37, verso margin number 35; MMA fol. 32, recto margin number 52

2. PORTRAIT SIDE
Gold flowering plants on a pink ground
CALLIGRAPHY SIDE
Flowering plants in colors and gold on a buff ground
Group A (four folios): MMA fol. 3, recto margin number 6; MMA fol. 29, recto margin number 12; MMA fol. 6, recto margin number 18; MMA fol. 33, verso margin number 51
Group B (one folio): MMA fol. 35, verso margin number 44

3. PORTRAIT SIDE
Gold flowering plants on a pink ground
CALLIGRAPHY SIDE
Gold flowering plants on a buff ground
Group B (one folio): MMA fol. 22, verso margin number 26

4. PORTRAIT SIDE
Flowering plants in colors and gold on a buff ground
CALLIGRAPHY SIDE
Gold flowering plants on a blue ground
Group A (two folios): MMA fol. 2, verso margin number 57; MMA fol. 1, recto margin number 58

5. PORTRAIT SIDE
Flowering plants in colors and gold on a buff ground (with birds)
CALLIGRAPHY SIDE
All-over geometric and floral design in gold on a pink ground
Group A (one folio): MMA fol. 36, verso margin number 7

6. PORTRAIT SIDE
Flowering plants in colors and gold on a buff ground
CALLIGRAPHY SIDE
Gold abstract and all-over floral pattern on a blue ground
Group B (one folio): MMA fol. 23, recto margin number 37

7. PORTRAIT SIDE
Flowering plants in colors and gold on a buff ground
CALLIGRAPHY SIDE
Gold flowering plants on a pink ground
Group A (one folio): MMA fol. 17, recto margin number 26
Group B (two folios): MMA fol. 19, verso margin number 36; MMA fol. 34, recto margin number 45

8. PORTRAIT SIDE
Flowering plants in colors and gold on a buff ground
CALLIGRAPHY SIDE
Flowering plants in colors and gold on a buff ground
Group A (one folio): MMA fol. 21, verso margin number 11
Group B (four folios): MMA fol. 11, verso margin number 10; MMA fol. 10, recto margin number 11; MMA fol. 31, verso margin number 2; MMA fol. 30, recto margin number 3

9. PORTRAIT SIDE
Flowering plants in gold on a buff ground
CALLIGRAPHY SIDE
Gold all-over wreathlike scroll and floral design on a buff ground
Group A (one folio): MMA fol. 24, recto margin number 8

10. PORTRAIT SIDE
Gold flowering plants on a blue ground
CALLIGRAPHY SIDE
Gold flowering plants on a pink ground
Group A (two folios): MMA fol. 4, verso margin number 5; MMA fol. 5, recto margin number 36

11. PORTRAIT SIDE
Gold flowering plants on a blue ground
CALLIGRAPHY SIDE
All-over interlace and floral design in colors and gold on a buff ground
Group A (two folios): MMA fol. 18, recto margin number 46; FGA 39.50, recto margin number 8

12. PORTRAIT SIDE
Gold flowering plants on a blue ground
CALLIGRAPHY SIDE
All-over design in gold on a pink ground
Group A (three folios; two with a combination of ribands, cartouches, and floral forms; one with grapevines): MMA fol. 12, verso margin number 39; MMA fol. 16, recto margin number 40; MMA fol. 20, verso margin number 17

53

13. PORTRAIT SIDE
 Gold flowering plants on a blue ground
 CALLIGRAPHY SIDE
 Flowering plants in colors and gold on a buff ground
 Group B (one folio): FGA 48.28, verso margin number 8
14. PORTRAIT SIDE
 All-over floral-scroll design in colors and gold on a buff
 ground
 CALLIGRAPHY SIDE
 Flowering plants in colors and gold on a buff ground
 Group A (three folios): MMA fol. 14, verso margin num-
 ber 43; MMA fol. 15, recto margin number 44; MMA
 fol. 13, verso margin number 25
15. PORTRAIT SIDE
 Gold all-over floral-scroll design on a buff ground
 CALLIGRAPHY SIDE
 Gold all-over floral-scroll design on a buff ground
 Group B (one folio): FGA 39.49, recto margin number 27

When we summarize the border patterns and the frequency of their use, we find that the border of flowering plants in colors and gold on a buff ground appears twenty-six times, twelve on a portrait side and fourteen on a calligraphy side. Flowering plants in gold on a pink ground are the next most popular with a total of fifteen, ten on a portrait side and five on a calligraphy side. Flowering plants in gold on a blue ground are found ten times, eight on a portrait side and two on a calligraphy side. Flowering plants in gold on a buff ground appear twice, once on a portrait side and once on a calligraphy side. Flowering plants appear altogether fifty-three times out of a total of seventy; the remaining seventeen borders consist of all-over floral patterns, usually scrolling and sometimes combined with geometric designs. Of this group of seventeen borders there are five in gold on a blue ground, all on calligraphy sides, four in gold on a pink ground, also all on calligraphy sides, five in colors on a buff ground, three of which are on portrait sides and two on calligraphy sides, and finally three in gold on a buff ground, one of which is on a portrait side with two on calligraphy sides. From the above it can be seen that the overall number of border schemes used is relatively small—a total of eight, four of which might be termed naturalistic and four purely decorative.

In contrast to the restricted number of border arrangements used, the number of artists engaged in creating these borders is relatively large, perhaps fifteen or more. Three artists have signed their names: Daulat, Harif, and Fath Muhammad. Daulat has signed his name twice, both times on the calligraphy side of a folio, and in both cases the borders are in gold on a blue ground, one of them with an all-over pattern and the other with flowering plants (MMA fols. 7v and 2r;

pls. 27 and 34). The latter border, in addition to Daulat's signature in the usual place in the gold band below the outer border, has the name Harif written in gold on a golden leaf in the lower left border; this use of gold on gold makes the signature very easy to overlook. The possible implications of this second signature are discussed in the text for this leaf (pl. 34). The leaf that bears the name Fath Muhammad (MMA fol. 20r; pl. 54) has a unique border pattern—an all-over grapevine pattern in gold on a pink ground. Unlike the others, the border signed by Harif (MMA fol. 15r; pl. 40) is not on the calligraphy side but on the portrait side (on the ground beneath the forktail, next to the inner border). In all cases, whether the borders are signed or unsigned, the same artist appears to have painted both borders of any given folio. Of the three names in the signatures, Daulat's is the only familiar one. Elsewhere in the album, the portrait of 'Inayat Khan has been attributed to him (MMA fol. 29r; pl. 26).

The borders' sequence and arrangement have been discussed at length because there do not seem to be any extant Shahjahan period albums that are in their original numbered sequence. Even the Jahangir Album in Berlin has been rearranged, and the Minto Album in the Chester Beatty Library and the Victoria and Albert Museum Album have duplicate numbers as well as missing numbers. At least in the Kevorkian Album all of the early nineteenth-century paintings have contemporary borders, which, although patterned after the seventeenth-century originals, are readily distinguishable.

The Minto Album

In studying the borders of other Shahjahan period albums, the same questions and problems arise as in the Kevorkian Album.[25] In studying the border design systems and border numbers of the Minto Album, for example (as far as possible in that five leaves in the Victoria and Albert Museum were framed, with only one border visible), a pattern similar to the Kevorkian Album paintings emerges, although all the Minto Album pages are seventeenth century. The Minto Album is divided between the Chester Beatty Library, Dublin, which has nineteen folios and the Victoria and Albert Museum, London, which has twenty-one, so that had the album been as originally arranged, which it is not, twenty folios would be missing since the available evidence strongly suggests that albums once contained sixty folios. Of the forty folios in Dublin and London there are three with the border number 21 (two

in the V&A; one in the CB), two with the border number 22 (CB), two with the border number 48 (one in the V&A; one in the CB), two with the number 55 (V&A), two with the number 56 (V&A), and two with the number 60 (CB). There may well be more duplicate numbers in the still unpublished material.

The folios in the Minto Album, as in the Kevorkian, fall into Groups A and B, the Group A folios having even numbers on recto portraits, and Group B folios uneven numbers. There are at least seventeen Group A folios in the Minto Album (seven in the V&A; ten in the CB). There are at least nineteen Group B folios in the Minto Album (ten in the V&A; nine in the CB). There are four folios in the V&A with their border numbers and patterns concealed by frames: V&A 18–1925, Dara-Shikoh on horseback; V&A 9–1925, Parviz received by Jahangir; V&A 17–1925, Shahjahan; and V&A 27–1925, archer, musician, and dervish. Of these V&A 27–1925 has a recto portrait, and V&A 17–1925 a verso portrait. On V&A 10–1921, 21v, an aged mulla, the border and number are showing, but the recto is hidden.

The Wantage Album in the Victoria and Albert Museum, like the Kevorkian Album, had a number of early nineteenth-century folios inserted among the seventeenth-century ones. While there are no duplicate border numbers in the Wantage Album, the presence of both Groups A and B folios attests that groups of folios were assembled from the original albums for which they were planned. There are thirteen Group A folios and one Group B folio.

The border schemes in the Minto Album are, as far as possible but incompletely, listed below according to the numbering system for the Kevorkian Album.

1. PORTRAIT SIDE
 Gold flowering plants on a pink ground
 CALLIGRAPHY SIDE
 Gold abstract and all-over floral pattern on a blue ground
 Group B (three folios): V&A 20–1925, recto margin number 7; CB 7/5, verso margin number 22; CB 7/15, verso margin number 54
2. PORTRAIT SIDE
 Gold flowering plants on a pink ground
 CALLIGRAPHY SIDE
 Flowering plants in colors and gold on a buff ground
 Group A (two folios): CB 7/1, verso margin number 15; CB 7/17, verso margin number 59
4. PORTRAIT SIDE
 Flowering plants in colors and gold on a buff ground
 CALLIGRAPHY SIDE
 Gold flowering plants on a blue ground
 Group A (one folio): V&A 22–1925, recto margin number 55
 Group B (five folios): V&A 28–1925, verso num-

ber 6; CB 7/2, verso margin number 16; V&A 11–1925, recto margin number 17; CB 7/10, recto margin number 35; V&A 26–1925, verso margin number 56
5. PORTRAIT SIDE
 Flowering plants in colors and gold on a buff ground
 CALLIGRAPHY SIDE
 All-over geometric and floral designs in gold on a pink ground (with birds)
 Group B (one folio): V&A 14–1925, recto margin number 49
6. PORTRAIT SIDE
 Flowering plants in colors and gold on a buff ground
 CALLIGRAPHY SIDE
 Gold abstract floral pattern on a blue ground
 Group A (one folio): CB 7/18, recto margin number 60
7. PORTRAIT SIDE
 Flowering plants in colors and gold on a buff ground
 CALLIGRAPHY SIDE
 Gold flowering plants on a pink ground
 Group A (one folio): V&A 21–1925, recto margin number 56
 Group B (one folio): V&A 25–1925, verso margin number 34
8. PORTRAIT SIDE
 Flowering plants in colors and gold on a buff ground
 CALLIGRAPHY SIDE
 Flowering plants in colors and gold on a buff ground
 Group A (five folios): CB 7/12, verso margin number 47; CB 7/13, recto margin number 48; CB 7/14, recto margin number 54; V&A 19–1925, verso margin number 57; CB 7/16, recto margin number 58
 Group B (five folios): CB 7/8, verso margin number 32; CB 7/7, recto margin number 31; V&A 13–1925, verso margin number 38, V&A 12 1925, recto margin number 39; V&A 16–1925, recto margin number 55
9. PORTRAIT SIDE
 Gold flowers on a buff ground
 CALLIGRAPHY SIDE
 Gold arabesques on a buff ground
 Group B (one folio): CB 7/3, verso margin number 20
12. PORTRAIT SIDE
 Gold flowering plants on a blue ground
 CALLIGRAPHY SIDE
 Gold floral arabesques on a pink ground
 Group A (one folio): CB 7/6, recto margin number 22
 Group B (one folio): CB 7/9, recto margin number 33
13. PORTRAIT SIDE
 Gold flowering plants on a blue ground
 CALLIGRAPHY SIDE
 Flowering plants in colors and gold on a buff ground
 Group A (two folios): V&A 24–1925, verso margin number 21; CB 7/11, recto margin number 42
14. PORTRAIT SIDE
 All-over floral scroll design in colors and gold on a buff ground
 CALLIGRAPHY SIDE
 Flowering plants in colors and gold on a buff ground
 Group A (one folio): V&A 23–1925, recto margin number 16
16. PORTRAIT SIDE
 Gold flowering plants on a buff ground
 CALLIGRAPHY SIDE

Gold flowering plants on a blue ground
Group B (one folio): V&A 15–1925, verso margin number 48
17. PORTRAIT SIDE
Gold flowering plants on a pink ground
CALLIGRAPHY SIDE
Gold abstract design on a pink ground
Group B (one folio): CB 7/4, recto margin number 21

Supplementary note:
PORTRAIT SIDE: gold floral scroll on buff or faded pink ground
CALLIGRAPHY SIDE: no calligraphy; no border but all-over page design of split leaves and palmettes, etc.; scrolling in gold with touches of black on pink buff (once pink?) ground
V&A 8–1925, verso margin number 1

Beginning numerically in the Minto Album, V&A 8–1925 with the margin number 1 has an all-over decorative arabesque design filling the entire recto page, in gold on a buff ground that appears to have once been pink and is now faded.[26] The verso shows Timur handing the imperial crown to Babur. It has a border of gold on a probably once pink, now buff ground in an all-over floral-scroll pattern.[27] Like this leaf, the two leaves with the margin number 60 in the Minto Album belong to Group A. On its verso one has the same leafy arabesque design in gold with touches of black on a probably faded pink ground. On the recto is a picture of Akbar handing the crown to Shahjahan with Jahangir looking on (CB 7/19).[28] It has a border of gold plants on a probably once pink ground. This leaf clearly complements the leaf with the margin number 1 and delineates the opening and closing pages of an album.[29] This pair of leaves cannot be assigned a border scheme since there is no calligraphy page and hence no second border. It is possible, however, that in putting together numbered leaves in sequence with compatible borders, the leaf with the margin number 59 fitted with number 60. On the portrait side, the verso, is a prince reading a book by 'Abdul-Karim, a pupil of Mansur's (CB 7/17).[30] The border, belonging to the number 2 scheme, has gold flowering plants on a pink ground and has cutout verses. On the negative side are two considerations: the border of the Akbar miniature may originally have been buff and is not then faded pink; and it may have been inappropriate to juxtapose a formal hieratic symbolic painting with an idealized languid lyric one. The plants in colors and gold on buff on the calligraphy side of the leaf with the margin number 59 could seem to lead into the series of leaves with number 8 borders—leaves with margin numbers 56, 57, and 58—which have that same border scheme on both rectos and versos; however elsewhere (see chart, leaves with margin numbers 15 and 16), we find that borders

56

2 and 8 conflict, and so these leaves could not have belonged with that with margin number 59.

The Minto leaf with the margin number 6 (V&A 28–1925) with the verso portrait of Prince Salim by Bichitr belongs to Group B.[31] Its border scheme has flowering plants in colors and gold on a buff ground on the portrait side and flowering plants in gold on a blue ground on the calligraphy side. There are cutout verses on the sides of the painting. There are four other Group B leaves of the Minto Album with the same number 4 border scheme. The verso leaf with the margin number 16—a miniature by Govardhan depicting a prince drinking with his wife—also has cutout verses only on the sides of the folio (CB 7/2).[32] It is fairly safe to assume that this picture and the verso portrait of Prince Salim with the margin number 6 originally belonged to the same album, perhaps one devoted to portraits of the royal family and those closely tied to them.

The recto portrait with the margin number 17—a dervish in *nim qalam* by Farrukh Beg—has verses totally surrounding the picture (V&A 11–1925).[33] According to number sequence, this would have appeared opposite the prince with his wife (CB 7/2) in an album. Whether this was likely or not depends on how rigid the border scheme was, including the presence or absence of verses and, if present, their layout. Also, how much attention was paid to the compatibility of facing miniatures? Is it likely that a dervish would be placed opposite a domestic princely scene? If the Dara-Shikoh Album in the India Office Library can be used as a comparison, there would seem to be no problem in this respect.[34] In spite of border compatibility and number sequence then, a firm conclusion cannot be reached as to whether the two paintings just discussed belonged to the same or to separate albums.

The next margin number from the Minto Album with the same (number 4) border scheme is 35 (CB 7/10), a recto portrait by Balchand of Shahjahan on a globe with his four sons. There are no surrounding verses. The border of the verso calligraphy page—gold flowering plants on a blue ground—is signed by Daulat ('amal-i Daulat). David James writes: "The outer border [of the calligraphy side] is identical to that of 50 (a) signed by Harif."[35] Tantalizingly the author does not tell us what album leaf or painting bore the exhibition number 50a. It is possibly an error and catalogue no. 51a is meant, in which the author mentions that the border of the painting side is signed by Harif and that of the calligraphy side by Daulat. For more on this subject and the Kevorkian Album connection, see discussion below of the leaf with the margin number 36.

A verso portrait of Asaf Khan by Bichitr (V&A

26–1925), with the margin number 56 and the number 4 border scheme, also has no cutout verses surrounding the portrait.[36] The presentation of this painting and that of Shahjahan just discussed, emphasizing the position and power of the subjects (Asaf Khan, father of Mumtaz-Mahal, for whom the Taj Mahal was built, is shown as protector of the empire with a city in the background and mounted troops in the middle ground), is an affirmation of their having been chosen or commissioned for the same album. If, as suggested, the album consisted of portraits of the imperial family and those connected to them by marital or other ties, the picture of Salim and that of the prince and his wife would certainly have been compatible in subject matter, although the discrepancy in the use of cutout verses inserts a wedge of uncertainty. If the four paintings did belong together from the start, the dervish would seem to be odd man out. In the Wantage and Kevorkian albums the leaves with the number 4 border scheme are all in Group A and therefore cannot have once been part of Group B paintings of the Minto Album.

However, there is one Group A painting in the Minto Album with the number 4 border scheme. The verso portrait by Hashim, with the margin number 55, is of Sultan Muhammad Qutb al-Mulk (ruler of Golconda from 1612 to 1626) (V&A 22–1925).[37] In the Wantage Album there is a verso portrait of Shahjahan by Balchand that has the margin number 1 and so belongs to Group A. It has no cutout verses and also has a number 4 border scheme. The blue-and-gold border on the recto side is exceptionally rich with birds and animals and landscape elements in addition to the flowering plants (V&A 112–1921).[38] These two leaves could well have come from the same album with portraits of the Mughal royal family placed at the beginning and other Indian rulers farther along.

Also in the Wantage Album, with a number 4 border scheme, there is a Group A verso painting of a turkey cock with the margin number 11 (V&A 135–1921).[39] It has verses above and below, mostly diagonally placed. It may have belonged originally to a separate album of natural history subjects, or it may be that such subjects were incorporated into largely portrait albums for the sake of variety. The use of a wide band of diagonal verses in many bird and animal paintings may simply be a device to combine a horizontal format with a vertical page. It may then have belonged to the other Group A leaves with number 4 borders.

The two Group A leaves with number 4 borders from the Kevorkian Album, with the margin numbers 57 and 58—the portrait of Maharaja Bhim Kunwar by Nanha (MMA fol. 2v; pl. 33) and that of Sundar Das,

Raja Bikramajit by Bichitr (MMA fol. 1r; pl. 32)—have cutout verses. As mentioned earlier, the addition of verses may simply be a device to expand the rather small portrait space of these two miniatures. If such was the reason, then these two leaves, which undoubtedly belong together, may also have been part of the album containing the Minto and Wantage leaves with number 4 borders.

If the prevailing convention allowed number 6 border schemes to be grouped with number 4 ones, then the Minto Album Group A recto leaf with the margin number 60 may have been the final leaf of an album, with the verso portrait of Shahjahan by Balchand, with the margin number 1, from the Wantage Album (V&A 112–1921), the initial leaf of the same album. Number 6 borders have the same arrangement of flowering plants in colors and gold on a buff ground on the portrait side, with the same color scheme of gold on blue on the calligraphy side as number 4 borders, but in an all-over pattern rather than flowering plants. The recto leaf with the margin number 60 is a miniature by Farrukh Beg depicting a youth in a garden (CB 7/18).[40]

There is one other Group A leaf with the number 6 border scheme in the Wantage Album. The verso leaf, which has the margin number 19, depicts a black buck being lead by its keeper (V&A 134–1921).[41] There are verses, mainly diagonal, at the top and bottom, seemingly intended to make the square image vertical. It is possible that these six leaves from the Minto, Wantage, and Kevorkian albums, with their number 4 and 6 border schemes, originally belonged to the same album.

The next margin number of the Minto Album is 7, which appears on a recto leaf (V&A 20–1925). This Group B picture, which shows ʿAbdullah Khan Uzbek out hawking, is the work of Nadir az-zaman. The border consists of golden flowers on what appears to be a faded pink ground with no surrounding verses; on the calligraphy side the border has rather regular, fine golden arabesques on a blue ground. This would then be border scheme number 1. A second Group B leaf from the Minto Album has the same border scheme: the verso portrait of Jahangir with an orb by Bichitr with margin number 22 (CB 7/5).[42] The portrait is also without surrounding verses, and the two probably came from the same original album. A third Minto Group B leaf with a number 1 border scheme has the margin number 54 on the verso portrait—the much-discussed picture of Jahangir shooting at the head of Malik ʿAmbar (CB 7/15).[43] There are no surrounding verses. Both the gold flowers on pink of the recto side and the gold floral scrolls on blue of the calligraphy

side closely resemble the borders by Daulat in the Kevorkian Album (MMA fol. 7; pls. 27 and 28), which, while the same number 1 scheme, belong to Group A. (There is an early nineteenth-century copy of the Minto Jahangir in the Kevorkian Album [FGA 48.19b; pl. 81]. No attempt was made in this copy to imitate the original borders in either color or pattern.) In fact, leaves with the number 1 border scheme in both the Wantage and Kevorkian albums belong to Group A.

The next margin number in the Minto Album sequence is 15, which appears on a verso leaf. This Group A leaf shows a painting by Padarath of a mountain sheep (CB 7/1).[44] Above and below is a wide band with verses, some diagonally arranged. The border consists of golden flowers on a pink ground, while the recto calligraphy border has flowering plants in colors and gold on a buff ground. This is a number 2 border scheme. The only other Group A leaf with the number 2 border scheme in the Minto Album is that with margin number 59, a prince reading a book, already mentioned (CB 7/17). In the Wantage Album there is a Group A leaf with number 2 border scheme: a portrait of a Himalayan wild goat by 'Inayat (V&A 138–1921), a recto page with the margin number 52.[45] There are four Group A leaves from the Kevorkian Album with the number 2 border scheme (MMA fol. 3, with the margin number 6 on the recto; MMA fol. 29 with the margin number 12 on the recto; MMA fol. 6, with the margin number 18 on the recto; MMA fol. 33 with the margin number 51 on the verso); all are portraits, and one of them (MMA fol. 29r) is mounted with four portraits.

While it is reasonably certain that the two animal pictures came from the same original album, it is uncertain whether whole albums were devoted to natural history subjects, of which, considering Jahangir's avid interest in the subject, there must have been a considerable amount, or whether they were dispersed for variety's sake throughout albums preponderately containing portraits, in which case all the number 2 borders from the Minto, Wantage, and Kevorkian albums may have once belonged together. In the Dara-Shikoh Album flowers, birds, and portraits are all included, with appropriate subjects facing each other.[46]

The next margin number in the Minto Album is 16, which appears on a recto portrait. This Group A picture depicts a zebra (V&A 23–1925);[47] a creature mentioned, like several other subjects of Jahangiri animal and bird portraits, in that emperor's memoirs. In spite of consecutive numbers, however, the mountain goat and the zebra could not have belonged to the same album as their border schemes clash. The goat with its border of gold plants on a pink ground would not

58

have faced a border of an all-over floral-scroll pattern in colors and gold on buff. What is more the goat stands horizontally on the page while the zebra, with the album held vertically, would stand on its tail. This border scheme, number 14 (with plants in colors and gold on buff on the calligraphy side), as well as the positioning of the animal is unique in the Minto Album. Similar in all respects are the leaves with margin numbers 25, 43, and 44 in the Kevorkian Album (MMA fols. 13, 14, and 15; pls. 47, 48, 41, 42, 39, and 40) with pictures of a nilgai, a hornbill, and a forktail, the nilgai's border being almost identical to the zebra's. It is virtually certain that these four leaves originally belonged together in an album. Was the original album made up entirely of bird and animal pictures in this format where the book must be turned sideways for viewing, or were they interspersed with pictures in the usual vertical format? If the latter, could they have been intermingled with leaves with number 8 border schemes, for example, that have plants in colors and gold on buff on both portrait and calligraphy borders, inasmuch as the color scheme of number 14 and number 8 borders remains consistent and all bird and animal pictures would have the same border schemes? If the assumption is correct that the Kevorkian, Minto, and Wantage albums were all made up from the same pool, then a snag arises, as there is a second Group A leaf with the margin number 16 in the Wantage Album. It has a recto picture of the martyrdom of Saint Cecilia (V&A 139–1921)[48] and a number 8 border scheme. The two Group A recto leaves with the margin number 16 could not, obviously, have belonged to the same album, so perhaps it is wiser after all to leave the number 8 borders in one group and the number 14 borders in another.

We next come to the folio with the margin number 20 on the verso and thus belonging to Group B. This portrait by Govardhan (CB 7/3)[49] shows a mounted prince, allegedly Timur, according to Jahangiri inscriptions. It has no surrounding verses, and the border has gold flowering plants on a buff ground with gold floral arabesques on a gold ground on the recto calligraphy side. This is the only number 9 border in the Minto Album, unless I am mistaken in thinking that the leaves with margin numbers 1 and 60 originally had pink rather than buff grounds. If buff is their true color, then they would fit with this leaf, and indeed the subject matter is very consistent, since the leaf with margin number 1 also shows Timur. One odd thing about the leaf with the margin number 20 is that it looks like half of a double-page composition and perhaps originally came from a history of Timur. Perhaps the other

half was damaged or lost, or perhaps it was mounted on a now-missing recto folio with the margin number 21. While there is no other Group B number 9 border in the Minto Album and none in the Wantage and Kevorkian albums, there is a verso leaf with the margin number 24 which shows Shah ʿAbbas I of Iran receiving the Mughal ambassador Khan ʿAlam in 1616.[50] It very likely belonged to the same album as the Minto leaf with the margin number 20.

Speculating that it was permissible to have both flowering-plant borders and floral-scroll borders in the same album providing their color schemes were the same, a leaf with a number 15 border scheme (gold floral scrolls on buff on both sides of the leaf) might be added to the two number 9 borders as possibly once belonging together. This leaf, with the margin number 27 on the recto portrait side, shows Shahjahan standing on a globe (FGA 39.49a; pl. 62). It is the only number 15 border in all three albums.

Of the three leaves in the Minto Album with the margin number 21, the one from Group B is a recto page with a picture of Jahangir playing holi (CB 7/4).[51] Its border consists of gold flowering plants on a pink ground, with an all-over geometric and floral design on the calligraphy side in gold on pink. This border scheme, number 17, is unique in the Minto, Wantage, and Kevorkian albums, and this precludes any supposition that it could ever have faced the leaf with the margin number 20.

The other two verso leaves with the margin number 21 belong to Group A. The portrait of the aged mulla by Farrukh Beg (V&A 10–1925) has a border of flowering plants in colors and gold on a buff ground in a less naturalistic style than the usual borders, with no surrounding verses; the border of the calligraphy side is hidden by the frame, and so the number of the border scheme cannot now be determined. It cannot, however, have originally belonged with the painting of the dervish (fol. 17r) also by Farrukh Beg, because that picture belongs to Group B.

The third border with the verso margin number 21 contains a portrait of Dhuʾl-Fiqar Khan, Turkman, by Nanha (V&A 24–1925). It has surrounding verses and a border of flowering plants in gold on a blue ground with an inscription reading: "Completion of gilding: Daulat" (AMS). The recto calligraphy page has a border of flowering plants in colors and gold on a buff ground with an inscription stating that it is the work of Daulat. A second leaf in the Minto Album with the same number 13 border scheme is a recto leaf with the margin number 42 which belongs to Group A. This leaf shows a camp scene by Govardhan (CB 7/11).[52] No margin number is visible in the illustration, but it is given in the catalogue as 36;[53] however AMS and MLS have confirmed that the margin number is actually 42. The recto border of gold flowering plants on a blue ground is signed by Harif, while the verso border of flowering plants in colors and gold on a buff ground is signed by Daulat.[54] Here there is the same puzzling connection between Daulat and Harif that was observed in the Kevorkian Album. Since it seems to have been the practice for the same artist to paint both borders of an album leaf, the question again arises: Were Harif and Daulat the same person? The other possibility, already mentioned, is that Harif was a student and close disciple of Daulat, painting in a virtually identical style. It will be remembered that the Kevorkian Album leaf signed by Harif is identical in style to the verso portrait border of which the recto is signed by Daulat (MMA fols. 15 and 2; pls. 39, 40, 33, and 34), with Harif's name hidden in the border itself (MMA fol. 2r; pl. 34). These two leaves in the Minto Album, with margin numbers 21 and 42 (V&A 24–1925 and CB 7/11), almost certainly belonged to the same original album. These are the only leaves in the Minto Album with border scheme number 13.

There is only one leaf in the Kevorkian Album with this number 13 border scheme (FGA 48.28b) but it is a Group B leaf. There is one leaf with this border arrangement in the Wantage Album (V&A 136 1921); a recto page with the margin number 20, it is the well-known picture of the Himalayan cheer pheasant. With so few numbered leaves with this border scheme presently known, it is impossible to say whether the two originally belonged to the same album or not. The pheasant has no surrounding verses. Another Group A leaf with the number 13 border scheme is in an American private collection.[55] The picture of the old sufi by Farrukh Beg is a recto leaf and has the margin number 36. It has verses above and below and the seal of Nadaram Pandit on the recto and Jahangir on the verso like a number of the Wantage Album pages with which it may once have been bound or was slated to have been bound. It is more than likely that at least three of these leaves once belonged together and possibly also the fourth, the pheasant.

If it is permissible to incorporate leaves with number 11 borders and those with number 13 borders— number 11 having the same gold plants on blue on the portrait side and colors and gold on buff on the calligraphy, but in an all-over pattern rather than the flowering plants of number 13—then the Kevorkian portrait of Khankhanan ʿAbdur Rahim, a recto leaf with the margin number 8 (FGA fol. 39.50a; pl. 20), and the

Kevorkian picture of the dancing dervishes, a recto leaf with the margin number 46 (MMA fol. 18r; pl. 52), may also have once belonged to the group of leaves just discussed.

The folio with margin number 22 belonging to Group B (CB 7/5) has already been discussed. The second folio with the margin number 22—a portrait of Shahnawaz Khan by Hashim (CB 7/6)—is a recto page and belongs to Group A.[56] The portrait is surrounded by verses, and its border has gold flowering plants on a blue ground; the calligraphy side has gold floral arabesques with birds on a faded pink ground. The leaf therefore has a number 12 border scheme. It is the only Group A leaf in the Minto Album with this border scheme. However, there are four leaves in the Wantage Album with this border scheme. Two of them, close in appearance, seem to have borders by the same hand. One has a portrait of Mirza Ghazi ibn Mirza Jani of Sind by Manohar on the recto side, with the margin number 18 (V&A 118–1921), and the other has a portrait of Amir Jumla by Shivadas on the verso side, with the margin number 41 (V&A 121–1921).[57] Both have two rows of verses surrounding the portrait, and they undoubtedly belong together. The third leaf, a verso page with the margin number 31, contains a painting of Ray Bharah and Jassa Jam, two landowners from Gujarat (V&A 124–1921). The presence or absence of surrounding verses was not noted.[58] On the calligraphy side the number 10 appears minutely in the lower margin. The fourth Wantage leaf with the number 12 border and the margin number 53 has on the verso a picture of Shah Tahmasp by Shahifa Banu (V&A 117–1921).[59] The magnificent border is filled with birds as well as plants; verses also surround the picture.

The Kevorkian Album has three leaves with number 12 border schemes. One, with the margin number 17 on the verso, shows a youth who has fallen from a tree (MMA fol. 20v; pl. 53). It has surrounding verses. In number sequence this would have faced Amir Mirza ʿAli Beg with its recto margin number of 18. The question of whether this would have been aesthetically permissible or whether another scene rather than a portrait would have faced the Kevorkian leaf will have to await further evidence. The two other Kevorkian leaves with number 12 borders contain the portrait of the pair of vultures, with the verso margin number 39 (MMA fol. 12v; pl. 45), which has verses at top and bottom, and the portrait of a dipper and other birds, with the recto margin number 40 (MMA fol. 16r; pl. 44), which has no verses. Assuming that bird pictures could be mixed with portraits, there is no reason why the leaves with margin numbers 39 through 41 were not in their

original sequence. It is also possible that leaves with number 10 borders could belong to this group. Like leaves with number 12 borders, they have the same gold plants on a blue ground on their portrait sides; on their calligraphy sides, however, they have gold plants on a pink ground rather than an all-over design in gold on pink. There are two Group A leaves with number 10 borders in the Kevorkian Album: the portrait of Sayf Khan Barha, with the verso margin number 5 (MMA fol. 4v; pl. 21), and Khan-Jahan Barha, with the recto margin number 36 (MMA fol. 5r; pl. 66), both with surrounding verses. If all of the leaves with numbers 10 and 12 border schemes belong together, there would then be ten leaves from one album.

There is only one Group B leaf with a number 12 border in the Minto Album and none in the Wantage. There are no Group B number 10 borders in any of the three albums. The Minto leaf has on its recto, which has the margin number 33, a portrait of Muhammad Riza Kashmiri by Bichitr (CB 7/9).[60] The picture is surrounded by verses.

The Minto leaf with the recto margin number 23 is a painting by Govardhan showing Shahjahan and Dara-Shikoh on horseback (V&A 18–1925); it belongs to Group B. There are no surrounding verses. The border consists of flowering plants in colors and gold on a buff ground, but unfortunately the border on the calligraphy side has not been described and the painting is framed so at this time a border scheme number cannot be assigned. The information on the painting border was given by AMS after seeing a photograph. In an entry for this painting in a 1976 exhibition catalogue, it is remarked: "Before the Minto album was dismantled, facing this page was a similar composition of Timur and attendant, both on horseback.... The painting is now in the Chester Beatty Library (Arnold [1936] III, pl. 55). The original confrontation of the two paintings depicting the 'First and Second Lords of the Happy Conjunction,' i.e., Timur and Shah Jahan, was deliberate."[61]

Presumably the dismantling referred to is that which allowed roughly half of the album to be sold to the Victoria and Albert Museum and half to the Chester Beatty Library. If the two leaves did indeed face each other, then the deliberate juxtapositioning must have been done when the Minto Album was assembled from odd leaves from a number of Mughal albums. The leaf with Timur's alleged portrait bears the margin number 20 and therefore could not originally have been opposite the leaf with the margin number 23. What is more, the borders around the portraits do not match, that with margin number 20 having flowering plants in gold on a buff ground and that with margin number

23 having flowering plants in colors and gold on a buff ground. The cardinal rule for facing pages has proved to be that they must have similar borders.

The Minto picture of Parviz received in audience by Jahangir (V&A 9–1925) is framed with no border showing.[62] Since Jahangir is facing left, it is probably a verso leaf and therefore belongs to Group B. According to AMS's notes, the margin number is 30, there are no surrounding verses, and the border consists of flowering plants in colors and gold on a buff ground. Since the picture does have surrounding verses,[63] perhaps this is not really the leaf described by AMS. In any case, since the border of the calligraphy side has not been described, the leaf cannot at this time be assigned a border scheme number and cannot be placed in either Group A or Group B.

The Minto recto leaf with the border number 31 shows a young prince in a garden with sages, by Bichitr (CB 7/7).[64] It belongs to Group B. Its border is decorated with flowering plants in colors and gold on a buff ground, and there are no surrounding verses. The border of the calligraphy side also has flowering plants in colors and gold on a buff ground. Thus the border scheme is number 8. It is signed Muhammad Khan Musavvir within the calligraphy area.[65] Muhammad Khan is known from a signed painting (fol. 21v) in the Dara-Shikoh Album in the India Office Library which is dated A.H. 1033–34.[66] Other miniatures in this album attributed to this artist on the basis of style are fols. 15v, 22v, 23v, 50r, and 65v. Some of these show the distinct influence of European herbals. If the leaf with the picture of Jahangir receiving Parviz (margin number 30) also has a number 8 border, which is probable, the Minto portrait could have been opposite it in their original album, since they are certainly compatible subjects.

The painting of Sultan Parviz in a garden with friends (CB 7/8) is a verso leaf with the border number 32.[67] It has no surrounding poetry, and the border, like the previous leaf and possibly two or three leaves, has a number 8 border scheme. The calligraphy sides of the leaves with the margin numbers 31 and 32 would have faced each other in their original album.

Other leaves with the same number 8 border scheme are in the Victoria and Albert section of the Minto Album. The painting by Balchand of Shahjahan's three younger sons (V&A 13–1925) is a verso page with the margin number 38. Manohar's portrait of Shahjahan on horseback (V&A 12–1925) is a recto page with the margin number 39. Neither of them has surrounding verses. It seems a virtual certainty that these two leaves faced each other in their original album; this album

may also have included the leaves with margin numbers 31 and 32 and, if their borders also conform to the number 8 scheme, the leaves with margin numbers 23 and 30. All five are royal Mughal portraits. At least four and probably all belong to Group B.

Another Group B leaf in the Minto Album with the number 8 border scheme has a recto portrait, with the margin number 55, of ʿAbdullah Khan Feroz Jang with the head of Khan-Jahan Lodi (V&A 16–1925). It has cut-out verses. It may (or may not) have belonged to the same album as the royal portraits but in any case to a different section of it, and the surrounding verses may well have been inserted to add to the size. The picture itself was also enlarged at some time as is evidenced by a change of shade in the green background. The Kevorkian Album has a copy of this painting dating to the early nineteenth century (MMA fol. 25r; pl. 90); no attempt has been made to emulate the borders of the earlier painting in the copy.

Only one Group B picture in the Wantage Album has a number 8 border scheme. It has the margin number 46 on the verso and is a painting by Manohar of Jahangir receiving his foster brother Qutbuddin in 1605 (V&A 111-1921).[68] It has cutout verses around the painting. This page must surely have belonged to the same original album as the Minto Album royal portraits with the same border arrangements. If the painting with margin number 23 (Shahjahan and Dara-Shikoh on horseback) can be confirmed as belonging to this album, then royal portraits can be presumed to have filled the album from at least folio 23 to folio 48, and a search for the missing folios might well be rewarding.

There are four Group B leaves in the Kevorkian Album that also have the number 8 border scheme. Two of them are portraits of courtiers—MMA fol. 30r (pl. 70) with the margin number 2 and MMA fol. 31v (pl. 71) with the margin number 3—and have no surrounding verses (see above for a discussion of these leaves). Theoretically they could have belonged to the same album as the group in the Minto Album. On the other hand, they have very distinctive inner borders which set them apart somewhat. Also, it cannot be determined at this time if the Minto leaves came from an album totally devoted to the royal family and those with close marital or other ties to it. The other two Kevorkian leaves with the number 8 border scheme show a dervish with a lion and a dervish with a bear (MMA fol. 11v [pl. 77] with the margin number 10 and MMA fol. 10r [pl. 76] with the margin number 11). Both have cutout verses. At this stage there is not enough evidence for a definitive solution to the question of whether or not all of these leaves originally belonged

in one album or were separated as to subject matter or the presence or absence of verses.

The Minto Album also has five Group A leaves with the number 8 border scheme. A bust portrait of Jahangir in a window and below him a bust of Christ in a window has the margin number 47 and is a verso page (CB 7/12).[69] In its original album it would have faced the bust portrait of Jahangir by Hashim with the bust portrait of an Ottoman below him (CB 7/13), since this recto leaf has the margin number 48.[70] Both leaves have cutout poetry. The verso portrait of Dara-Shikoh holding a tray of jewels by Chitarman has the margin number 57 in the margin and a number 8 border scheme (V&A 13–1925).[71] It originally would have faced the recto leaf with margin number 58 with a painting by Bichitr of the emperor Shahjahan in majesty (CB 7/16).[72] Neither of these paintings has cutout verses. A fifth leaf in the Minto Album with the number 8 border scheme has the portrait of a Sufi holding an orb by Bichitr on its recto side and bears the margin number 54 (CB 7/14).[73] The leaf has no cutout verses. Until we know for certain whether cutout verses were used simply to enlarge the space around a painting to make the border of agreeable proportions or whether they had some other significance, we cannot verify that these five leaves had been in the same original album.

In the Wantage Album there are two Group A leaves with the number 8 border scheme. One is a portrait of Asaf Khan by Balchand (V&A 120–1921), a verso leaf with the margin number 45.[74] There are cutout verses around the portrait. It is entirely appropriate that this leaf and the Group A Minto leaves with the number 8 borders once belonged together (leaving aside the verses-or-no-verses question) as Asaf Khan was the brother of Nur-Jahan and father of Mumtaz-Mahal.

The second Wantage Group A leaf with the number 8 borders shows the martyrdom of Saint Cecilia on the recto with the margin number 16, mentioned earlier (V&A 139–1921). Here it seems clear that verses surrounding the painting fulfill the function of giving the picture space a more vertical format and bringing it to the suitable album size. The verso equestrian portrait of Shahjahan with the margin number 11 (MMA fol. 21v; pl. 59) is the only Group A miniature in the Kevorkian Album with the number 8 border scheme. It has no cutout verses, and indeed there would be no room for them. These last two leaves seem to speak for the theory that the presence of cutout verses was due to the aesthetic requirements of each individual leaf and of the miniature's size in relation to its border.

To continue our numerical progression of Minto Album margin numbers, we come to a Group B leaf

with the margin number 34 on the verso. It is a portrait of Muhammad 'Ali-Beg, the Persian ambassador (V&A 25–1925).[75] The border consists of plants in colors and gold on a buff ground. This is the original seventeenth-century Mughal painting from which the early nineteenth-century one in the Kevorkian Album (MMA fol. 27v; pl. 87) was copied. It has no surrounding poetry (unlike the later copy, which, however, has retained a border of flowering plants in colors and gold on a buff ground) and a border on the calligraphy side of flowering plants in gold on a pink ground which designates it a number 7 border scheme. (The nineteenth-century copy has a bird on the recto where the calligraphy should have been and a border of gold flowers on a blue ground.) This is the only number 7 border scheme in the Minto Album in Group A or B, and there are none in the Wantage Album. In the Kevorkian Album there are two leaves with number 7 border schemes. The verso portrait of Jahangir and his father Akbar, with the margin number 36 (MMA fol. 19v; pl. 11) has no surrounding verses. The second leaf, with the margin number 45 on the recto, shows Mulla Muhammad Khan Wali of Bijapur (MMA fol. 34r; pl. 38) and also has no surrounding verses. There is no reason why these three leaves could not have originally belonged together.

There is a Group B leaf in the Minto Album with a number 5 border scheme, that is, like number 7 with plants in colors and gold on a buff ground on the portrait side, but, instead of plants in gold on a pink ground on the calligraphy side, an all-over abstract pattern in gold on a pink ground. If this was a permissible grouping in an original album, it is possible that this leaf, a recto portrait of Prince Khurram with the margin number 49, also belonged with this group (V&A 14–1925).[76] It does, however, have cutout verses along the sides, and until this vexing question of verses has been settled, caution is required.

The Kevorkian Album also has one leaf with a number 5 border scheme, but it belongs to Group A. On the verso, with the margin number 7, is the charming portrait of Shahjahan with his young son (MMA fol. 36v; pl. 55). It is the only Group A leaf with a number 5 border scheme in all three albums. There are no leaves in the Wantage Album with either number 7 or number 5 border schemes.

A verso portrait of Shah Shuja' by Balchand (V&A 15–1925) bears the margin number 48 and therefore belongs to Group B. It has a border of golden flowers on a buff ground, with golden flowers on a blue ground on the calligraphy side; verses surround the portrait. This border scheme is number 16, and this leaf is the

only leaf in the Minto, Wantage, and Kevorkian albums with this border scheme. The borders of this leaf are a puzzle, as the very pale whitish-buff of the portrait border and the pale gray-blue of the calligraphy border more closely resemble some of the early nineteenth-century Wantage Album borders than the seventeenth-century ones in the albums.

The second Minto leaf with the margin number 48 (CB 7/13) belongs to Group A and has already been discussed under border scheme 8.

Other album leaves with margin numbers up to 60 have already been discussed. As mentioned earlier, the Minto portrait by Bichitr of an archer, a musician, and a dervish (v&A 27–1925) is framed and has no surrounding verses, but beyond that nothing is recorded, neither its border number nor the border descriptions.[77] The nineteenth-century copy in the Kevorkian Album (FGA 48.21a; pl. 98) is a recto page, so perhaps the original is also a recto.[78] The copy has a border of an all-over floral scroll in colors and gold on buff on the portrait side and flowering plants in colors and gold on buff on the verso which has the picture of a bird instead of calligraphy. However, we have already seen that the nineteenth-century artist often ignored the original seventeenth-century border scheme for his own invention, and in any case, this border scheme, number 14 in the seventeenth-century paintings that we know, was confined to animal and bird portraits in a horizontal format, of which there are three in the Kevorkian Album and one in the Minto.

Another Minto Album leaf (v&A 17–1925) also by Bichitr and also framed, a portrait of Shahjahan in his fortieth year, also yields up no clues as to margin number or border designs from the publications.[79]

The Wantage Album

Most of the Wantage Album leaves have been discussed in the Minto Album section, and so will only be briefly summarized here, with the appropriate reference to the Minto section text cited. Of the thirty-six paintings in the Wantage Album thirty are listed in the 1922 catalogue by C. Stanley Clarke.[80] Thirteen can be assigned a seventeenth-century date[81] and seventeen an early nineteenth-century date.[82] All of the seventeenth-century leaves have margin numbers; there are none on the nineteenth-century leaves. (There is one seventeenth-century leaf not found in the catalogue [v&A 124–1921, 31v] which contains the portraits of Ray Bharah and Jassa Jam, two landowners of Gujarat, by Bishan Das. Five of the early nineteenth-century

leaves are not published [v&A 110–1921, 114–1921, 124–1921, 130–1921, and 13–1921, the last not seen by MLS].)

The fourteen numbered folios of the Wantage Album share eight border schemes, an indication that this was not one organic album to which later additions had been added. Thirteen belong to Group A and one to Group B.

Like the discussion of the Minto Album, the following summary of the Wantage Album leaves treats their borders in margin number sequence.

The border schemes of the Wantage Album are, as far as possible but incompletely, listed below according to the numbering system of the Kevorkian Album.

1. PORTRAIT SIDE
 Gold flowering plants on a pink ground
 CALLIGRAPHY SIDE
 Gold abstract all-over floral pattern on a blue ground
 Group A (one folio): v&A 137–1921, recto margin number 40

2. PORTRAIT SIDE
 Gold flowering plants on a pink ground
 CALLIGRAPHY SIDE
 Flowering plants in colors and gold on a buff ground
 Group A (one folio): v&A 138–1921, recto margin number 52

4. PORTRAIT SIDE
 Flowering plants in colors and gold on a buff ground
 CALLIGRAPHY SIDE
 Gold flowering plants on a blue ground
 Group A (two folios): v&A 112–1921, verso margin number 1; v&A 135–1921, verso margin number 11

6. PORTRAIT SIDE
 Flowering plants in colors and gold on a buff ground
 CALLIGRAPHY SIDE
 Gold floral abstract pattern on a blue ground
 Group A (one folio): v&A 134–1921, verso margin number 19

8. PORTRAIT SIDE
 Flowering plants in colors and gold on a buff ground
 CALLIGRAPHY SIDE
 Flowering plants in colors and gold on a buff ground
 Group A (two folios): v&A 139–1921, recto margin number 16; v&A 120–1921, verso margin number 45
 Group B (one folio): v&A 111–1921, verso margin number 46

12. PORTRAIT SIDE
 Gold flowering plants on a blue ground
 CALLIGRAPHY SIDE
 Gold floral scroll on a pink ground
 Group A (four folios): v&A 118–1921, recto margin number 18; v&A 124–1921, verso margin number 31; v&A 121–1921, verso margin number 41; v&A 117–1921, verso margin number 53

13. PORTRAIT SIDE
 Gold flowering plants on a blue ground
 CALLIGRAPHY SIDE

Flowering plants in colors and gold on a buff ground
Group A (one folio): V&A 136–1921, recto margin
number 20

17. PORTRAIT SIDE
Gold flowering plants on a (faded) pink ground
CALLIGRAPHY SIDE
Abstract all-over floral design in gold on a (faded) pink
ground
Group A (one folio): V&A 123–1921, verso margin
number 23

The verso portrait of Shahjahan with the margin number 1 (V&A 112–1921) belongs to Group A and has a number 4 border scheme, that is, flowering plants in colors and gold on a buff ground on the portrait side, and flowering plants in gold on blue on the calligraphy side.[83] The first picture in an album appears traditionally to have been a royal portrait. The exceptionally beautiful border on the calligraphy side of this leaf—with animals, birds, and landscape elements in addition to plants—has already been mentioned. The other Wantage leaf with the number 4 border scheme contains the famous verso picture of a turkey cock with the margin number 11 (V&A 135–1921).[84] A discussion of these pictures in connection with Group A Minto and Kevorkian leaves with number 4 borders and also number 6 borders can be found in "Minto," above.

The Wantage Album leaf with a number 6 border, which has flowering plants in colors and gold on a buff ground on the portrait side and an abstract floral scroll in gold on a blue ground on the calligraphy, has the picture of a black buck being led by a keeper, which has the margin number 19 on the verso.[85] It is included in the above-cited "Minto" discussion. On the calligraphy side border there are small birds among the scrolling leaves very similar to those on the calligraphy side border of the leaf with the recto margin number 60 in the Minto Album (CB 7/18).[86] These birds suggest the same very fine hand, perhaps that of Daulat, since there is a resemblance here to his signed border on a Kevorkian Album page (MMA fol. 7v; pl. 27). Clarke suggests that the border on the calligraphy side of the Shahjahan portrait is by Daulat, but more because of its artistic perfection, one suspects, than by stylistic comparisons with signed works.

The next numbered leaf in the Wantage Album has the recto margin number 16 and belongs to Group A. This painting by Nini depicts the martyrdom of Saint Cecilia (V&A 139–1921) and has a number 8 border scheme, that is, flowering plants in colors and gold on a buff ground on both portrait and calligraphy sides.[87] The other Group A Wantage leaf with the number 8 border is a verso portrait of Asaf Khan by Balchand

with the margin number 45 (V&A 120–1921).[88] For a discussion of these two leaves in conjunction with other number 8 border schemes of Group A, see "Minto," above.

The only Group B leaf in the Wantage Album with the number 8 border scheme has a verso portrait of Jahangir receiving his foster brother Qutbuddin with the margin number 46 (V&A 111–1921).[89] For a discussion of other Group B leaves with number 8 borders, see "Minto," above, where suggestions are made of the leaves from the three albums that may once have belonged together.

A Wantage leaf, belonging to Group A with the recto margin number 18, contains a portrait of Amir Mirza ʿAli Beg by Manohar (V&A 118–1921)[90] and has a number 12 border scheme, that is, it has a border of gold flowering plants on a blue ground on the portrait side and a gold floral scroll on a pink ground on the calligraphy side. Another Wantage leaf with 12A borders with the margin number 41 on the verso has a portrait of Mir Jumla by Shiva Das (V&A 121–1921).[91] Both portraits have surrounding verses. A third Wantage leaf, with a 12A border with the margin number 31 on the verso, contains a painting of two landowners from Gujarat (V&A 124–1921),[92] while a fourth Wantage leaf in this group has the margin number 53 on the verso margin and contains a portrait of Shah Tahmasp in meditation by Shahifa Banu (V&A 117–1921).[93] In addition to flowering plants the border around Tahmasp has a wonderful medley of flying and sitting birds. The relationship of this leaf to those in the Minto and Kevorkian albums is discussed in "Minto," above.

The next numbered leaf with a different border scheme in the Wantage Album, a Group A leaf, has the margin number 20 on the recto which contains the well-known picture by Mansur of the Himalayan cheer pheasant (V&A 136–1921).[94] It is the only number 13 border in the Wantage Album. There are two Group A leaves with this border in the Minto Album; the Kevorkian Album contains one Group B, but no Group A, leaf with this border. There is also a leaf with this border in a private collection. That, as already mentioned, might once have been bound with or in proximity with the Wantage Album. This group is considered in "Minto," above.

The Wantage leaf with the margin number 23 on the verso shows a portrait of Murtaza Khan by Manohar (V&A 123–1921)[95] and has a border number 17 with flowering plants in gold on a (faded) pink ground on the portrait side and floral arabesques in gold on the calligraphy side. Both borders of the leaf are signed by Daulat. This is the only Group A leaf with a number

17 border in all three albums, there being one Group B leaf with a number 17 border in the Minto Album (Jahangir Playing Holi, CB 7/4).[96] Since it is difficult in some cases to be sure that a border background was once pink and has faded rather than its having been buff from the start, there is the possibility that this leaf's borders are not faded pink but buff, in which case the border scheme would be number 9. There is only one Group A leaf with a number 9 border; on the recto side this Kevorkian leaf has a portrait of Shahjahan by Chitarman with the margin number 8 (MMA fol. 24r; pl. 58).

Of the two seventeenth-century leaves of the Wantage Album still to be mentioned, one has a picture of a Himalayan blue-throated barbet (V&A 137–1921) on the recto page with the margin number 40 and so belongs to Group A.[97] Verses surround the painting. The leaf has a number 1 border scheme—that is, the border on the portrait side has gold flowering plants on a pink ground, while that on the calligraphy side has gold arabesques on a blue ground. This is the only number 1 border scheme in the Wantage Album, and there are no Group A number 1 borders in the Minto Album. There are, however, four Kevorkian Album leaves with number 1 borders, all portraits of royalty or courtiers (MMA fols. 7r, 8v, 32r, and 37v; pls. 28, 29, 18, and 67) and all belonging to Group A. Their margin numbers are 4, 3, 52, and 35, and all have cutout verses. It is certainly possible and even probable that bird, animal, or flower pictures were inserted into albums that were primarily mounted with human portraits to add visual richness as well as variety.

The other and last of the seventeenth-century leaves in the Wantage Album is the portrait of a Himalayan wild goat by ʿInayat (V&A 138–1921).[98] It is a Group A leaf with the margin number 52 on the recto, and it has a number 2 border scheme—that is, gold flowering plants on a pink ground on the portrait side and flowering plants in colors and gold on a buff ground on the calligraphy side. There are no surrounding verses. This leaf has been incorporated into the discussion of number 2 border schemes in "Minto," above.

Miscellaneous Album Leaves

Miscellaneous album leaves have appeared from time to time in auction catalogues. A few of them appear to have margin numbers on the portrait sides, are of a size compatible with our group of three albums, and have borders schematically and stylistically related to them. These have been discussed in the "Minto" sec-

tion, so they will just be mentioned here. Shown in color with its border in the Sotheby's sale catalogue of October 17, 1983, was the picture of Shah ʿAbbas receiving the Mughal ambassador Khan ʿAlam in 1618, by Bishan Das (lot 64). This leaf has the margin number 24 on the verso and so belongs to Group B; it has a number 9 border. For more on this subject see "Minto," above. A second leaf in the same sale, lot 65, a portrait of a Mughal prince, has the margin number 25 on the recto and also belongs to Group B. (There is in addition a small number 6 in the bottom margin.) In spite of the number sequence, this portrait could not have been opposite the Shah ʿAbbas painting because of the disparity in the borders. This leaf has a border on the portrait side of flowering plants in colors and gold on a buff ground as opposed to flowers in gold on a buff ground on the border of the lot 64 painting. The text for this lot 65 portrait states that it is signed by Daulat at the bottom, but if so, this is not discernible in the illustration. Perhaps the calligraphy side border is meant, which is described as "gilt-decorated floral borders." It is not clear what this means. If the border has gold plants on buff, then this border scheme would be unique in all our three albums, or if it means, which seems more likely, that it consists of flowering plants in colors and gold on a buff ground, then it would be a number 8 border. For a discussion of Group B leaves with number 8 border schemes, see "Minto," above.

Two other Shahjahan period album pages were auctioned at Sotheby's on April 16, 1984 (lots 87, illustrated in color in the catalogue, and 88, illustrated in black and white). Lot 87 was a picture attributed to Manohar, of the biblical king David playing a harp. It is a recto page with what appears to be a number 9 in the margin. It has a border of flowering plants in colors and gold on a buff ground, and no surrounding verses. The description of lot 87 reads "mounted on an album page with gilt-decorated floral borders." This statement seems to imply that the borders of portrait and calligraphy sides are similar. The "gilt-decorated floral borders" mentioned in the October 17, 1983, catalogue for lot 65 then mean flowering plants in colors and gold on a buff ground, in which case this leaf with the border by Daulat would fit in with other number 8 borders of Group B, discussed in "Minto," above.

The album leaf with David on the verso, however, is a Group A leaf with a number 8 border scheme. Lot 88 shows a recto leaf with a portrait by Murad of Christ enthroned in glory. It appears to have the number 10 written in the margin. The border appears also to be flowering plants in colors and gold on a buff ground, although the tonal contrasts in the black-and-white

photograph are not so strong as to assure this. Neither picture has surrounding verses. It may be presumed that they were placed opposite each other in their original album and that lot 88 had a similar border of flowering plants in colors and gold on a buff ground on the verso as well as on the recto. The verso calligraphy page is illustrated in color but without the borders. In the upper right corner of the calligraphy section appears the vignette of a cheetah leaping on the back of a black buck, similar to a figure on the calligraphy side (MMA fol. 15v; pl. 39) of the Kevorkian leaf that has a recto portrait of a spotted forktail. The Kevorkian border was signed by Harif, while the small scene in the Sotheby's catalogue, however close, seems to be by a different hand. As mentioned in the catalogue (p. 35): "A later version, as in the case of the preceding lot [lot 87, David] also executed at Delhi, c. 1800 and [also] from the collection of William Fraser, was sold in these rooms, 14th October, 1980, lot 208." In that catalogue, lot 207, the David picture, was not illustrated. The bibliography for lot 87 of the April 16, 1984, sale listing other leaves belonging to the same album seems to refer to leaves belonging to the so-called Late Shahjahan Album.[99] The Late Shahjahan Album pages do not have numbers in their borders, as these do. Also there do not appear to have been a substantial number of copies (if any) of the Late Shahjahan Album pages at the beginning of the nineteenth century as there were of the earlier group of Shahjahan albums. In fact, the early nineteenth-century copies of these two leaves were sold at the 1980 Sotheby's sale along with a number of copies of portraits in the Kevorkian Album and one in the Minto Album. The Sotheby's catalogue (p. 75) states that "these miniatures were executed at Delhi, ca. 1800 after seventeenth century miniatures in royal Mughal albums. They were all mounted in an early nineteenth century album..."

Why were copies of seventeenth-century album leaves made in the early nineteenth century? Was it simply to "water the milk" and so increase the sale profits? Since some of the copies sold at Sotheby's came from William Fraser's collection, did he by chance have a role in encouraging the creation and perhaps the dissemination of the nineteenth-century copies, or were his artists, who had been trained in the imperial Mughal ateliers, unable to resist bringing him copies they had made, perhaps on imperial orders? In this case, it can be imagined that the Mughals themselves, financially straitened under British control, were not above selling off their forebears' album leaves, while wishing for the sake of remembrance to keep copies for themselves. Perhaps, on the other hand, the chief librarian sold off

66

the seventeenth-century leaves and had copies made to avoid detection, at least for a time, and later, when the ruse was discovered, the copies in turn were sold, some to Fraser and some mixed with the disassembled leaves of seventeenth-century albums. Perhaps the nineteenth-century artists were so proud of their achievement that they were convinced that a copy bound into the same album as a seventeenth-century original would be taken as a contemporary seventeenth-century copy, since they were aware that the practice of making copies of one's own paintings existed in the heyday of the Mughal empire. Perhaps one day evidence will come to light and another tantalizing art historical mystery will be solved.

The following copies were included in the 1980 Sotheby's sale: lot 183, Qilich Khan (copy of MMA fol. 30r; pl. 70); 187, Mulla Muhammad of Bijapur (copy of MMA fol. 34r; pl. 38); 189, Prince Danyal (copy of MMA fol. 32r; pl. 18); 190, Ibrahim 'Adilshah (copy of MMA fol. 33v; pl. 35); 191, Mahabat Khan (copy of MMA fol. 3r; pl. 24); 192, Khan Sipar Khan (actually Jansipar Khan; copy of MMA fol. 37v; pl. 67); 193, allegorical portrait of the emperor Jahangir holding a globe (copy of FGA 48.28b; pl. 13); 194, allegorical portrait of Shahjahan standing on a globe (copy of Minto Album leaf, CB 7/16);[100] 195, Jadun Ray Deccani (copy of MMA fol. 6r; pl. 74); 196, Rup Man Singh (Rup Singh Sar, copy of MMA fol. 8v; pl. 29); 201, a dervish leading a lion (copy of MMA fol. 11v; pl. 77); 202, a dervish leading a bear (copy of MMA fol. 10r; pl. 76); 205, Raja Suraj Singh Rathor (copy of MMA fol. 7r; pl. 28); and lots 207 and 208 (the biblical king David and Christ, discussed above). Since the nineteenth-century copies were bound together and since the seventeenth-century paintings of David and Christ have margin numbers and sizes and border schemes similar to those of the Kevorkian, Minto, and Wantage albums, there is no reason to doubt that they all originally came from the same general sources.

Yet another album leaf was sold at Sotheby's on October 15, 1984, lot 86, and is now in a private collection. On the recto is a picture of an old Sufi by Farrukh Beg that is dated A.H. 1024 (A.D. 1615).[101] This Group A leaf with the margin number 36 has the number 13 border scheme—that is, gold flowering plants on a blue ground on the portrait side and flowering plants in colors and gold on a buff ground on the calligraphy side. This leaf also appears to fit stylistically with those that made up the Kevorkian, Minto, and Wantage albums and adds to our corpus of this material. See "Minto," above, for more on this leaf.

In mentioning miscellaneous numbered album leaves

that turn up with borders of a style and size similar to those of the three main albums discussed here, the impression ought not to be conveyed that all numbered album leaves from the Shahjahan period must perforce belong to our trilogy. For example, in the Victoria and Albert Museum there is an album leaf with a portrait of Shahjahan with an inscription stating it to be by ʿAbid. It has the margin number 2 in the usual position and a very thin number 19 in the lower margin. The borders of both sides are decorated with flowering plants in gold on a blue ground. This border scheme is not found in the Kevorkian, Minto, or Wantage albums. This alone, however, would not disqualify it since there are border schemes within those three that appear only once. However, the dimensions of this leaf are almost an inch smaller all around than our group, measuring $14\frac{1}{2} \times 9\frac{1}{16}$ in. (36.9×23 cm.). Stuart Cary Welch has mentioned that other leaves of this slightly smaller size album exist. This matter must be pursued at some future date. In the meantime it is hoped that more leaves of relevance to the whole problem of Shahjahan albums will be brought to light or to the attention of this author so that at least some of the missing pieces of the puzzle can be fitted in place.

Summary

In summary, it is evident from an investigation of the Kevorkian, Minto, and Wantage albums that not one of them, leaving aside the nineteenth-century additions to the Kevorkian and Wantage albums, is a royal Mughal album in its virgin state. What is more, each of the three has leaves that originally belonged together with leaves from the other two albums. The same pool of royal Mughal album leaves seems to have been available to the compilers of the three albums. Though the compilers must have had access to the same material they seem to have carried out their work either separately or with somewhat different goals in mind since the Minto has no nineteenth-century leaves inserted, and the Kevorkian far less in proportion to the seventeenth-century ones than does the Wantage. Presumably the compiling was done at the same time the additional leaves were painted and inserted, that is, in the early nineteenth century. It can be surmised that at the time the pool of album leaves became available to the copiers and compilers they had already been removed from their original royal albums, otherwise the mounters would never have broken the golden rule of having a picture on one side of a leaf and a calligraphy on the other. The compilers would also have known and followed the earlier traditions of border schemes,

whatever they were, and we would be fortunate enough to know them. While occasionally leaves that would have originally been opposite each other remain together, they were probably put that way for visual reasons since the compilers seem to have been oblivious to the system of margin numbers.

As already mentioned, a striking feature of the Kevorkian, Minto, and Wantage albums and of the few stray album leaves is the cohesive style of their borders which seem to have been painted by the same group of artists during roughly the same time span—a time earlier than the so-called Late Shahjahan Album and the Dara-Shikoh Album and later than the Prince Khurram Album and the Jahangir albums. It is unfortunate that the very problem of exactly how leaves were arranged in an album and with what borders cannot be solved at this point. Let us hope that more material will become available and more lacunae filled until a clear picture of the early imperial albums of Shahjahan emerges.

As CAN BE SEEN from the Group A chart and the Group B chart the following border schemes conflict if the leaves are laid out following their margin numbers. Considering the evidence of the leaves that were once opposite each other in which margin numbers make sense and borders are similar, it must be concluded that where the conflicting border schemes listed below occur, different original royal Mughal albums were drawn from.

GROUP A	GROUP B
1 and 10	1 and 4
1 and 12	1 and 6
2 and 4	1 and 8
2 and 5	1 and 13
2 and 6	2 and 7
2 and 8	3 and 8
2 and 12	3 and 15
4 and 8	4 and 7
5 and 9	4 and 8
6 and 12	5 and 16
6 and 13	6 and 8
7 and 14	7 and 8
8 and 9	7 and 12
8 and 11	8 and 9
8 and 12	8 and 12
12 and 13	
12 and 14	

A final list as to borders and leaves that may have originally been made for the same albums follows:

GROUP A

Margin number; accession number; album (Kevorkian, Minto, or Wantage)

BORDER		
	1v	V&A 8–1925; M
	60r	CB 7/19; M
1	3v	MMA fol. 8; K
	4r	MMA fol. 7; K
	35v	MMA fol. 37; K
	52r	MMA fol. 32; K
?	40r	V&A 137–1921; W
2	6r	MMA fol. 3; K
	12r	MMA fol. 29; K
	18r	MMA fol. 6; K
?	51v	MMA fol. 33; K
	15v	CB 7/1; M
	52r	V&A, 138–1921; W
?	59v	CB 7/17; M
4	57v	MMA fol. 2; K
	58r	MMA fol. 1; K
?	11v	V&A 135–1921; W
5	7v	MMA fol. 36; K
	56r	V&A 21–1925; M
6	55v	V&A 22–1925; M
	1v	V&A 112–1921; W
	60r	CB 7/18; M
?	19v	V&A 134–1921; W
7	26v	MMA fol. 17; K
8	47v	CB 7/12; M
	48r	CB 7/13; M
	57v	V&A 19–1925; M
	58r	CB 7/16; M
?	54r	CB 7/14; M
	45v	V&A 129–1921; W
	16r	V&A 139–1921; W
	11v	MMA fol. 21; K
9	8r	MMA fol. 24; K
10	5v	MMA fol. 4; K
	36r	MMA fol. 5; K
11	8r	FGA 39.50; K
	46r	MMA fol. 18; K
12	18r	V&A 118–1921; W
	41v	V&A 121–1921; W
	22r	CB 7/16; M
	31v	V&A 124–1921; W
	53v	V&A 117–1921; W
?	17v	MMA fol. 20; K
	39v	MMA fol. 12; K
	40v	MMA fol. 16; K
13	21v	V&A 24–1925; M
	42r	CB 7/11; M
	36r	Sotheby's, October 15, 1984, lot 36
?	20r	V&A 136–1921, W
14	16r	V&A 23–1925; M
	25v	MMA fol. 3; K
	43v	MMA fol. 14; K
	44r	MMA fol. 15; K
17	23v	V&A 123–1921; W

At least nine albums were used for the Group A paintings from the Kevorkian, Minto, and Wantage albums
K = at least six albums were used
M = at least seven albums were used
W = at least seven albums were used

GROUP B

Margin number; accession number; album (Kevorkian, Minto, or Wantage)

BORDER		
1	7r	V&A 20–1925; M
	22v	CB 7/5; M
	54v	CB 7/15; M
2	44v	MMA fol. 34; K
3	26v	MMA fol. 22; K
4	6v	V&A 28–1925; M
	16v	CB 7/2; M
?	17r	V&A 11–1925; M
	35r	CB 7/10; M
	56v	V&A 26–1925; M
5	49r	V&A 14–1925; M
6	37r	MMA fol. 23; K
7	34v	V&A 25–1925; M
	36v	MMA fol. 19; K
	45r	MMA fol. 34; K

8	31r	CB 7/7; M
	32v	CB 7/8; M
	38v	V&A 13–1925; M
	39r	V&A 12–1925; M
	46v	V&A 111–1921; W
?	55r	V&A 16–1925; M
?	23r	V&A 18–1925; M (framed so border number is conjectural)
?	30v	V&A 9–1925; M (framed so border number is conjectural)
	10v	MMA fol. 11; K
	11r	MMA fol. 10; K
	2v	MMA fol. 31; K
	3r	MMA fol. 30; K

9	20v	CB 7/3; M
12	33r	CB 7/9; M
13	8v	FGA 42.28; K
15	27r	FGA 39.49; K
16	48v	V&A 15–1925; M

At least ten albums were used for the Group B paintings from the Kevorkian, Minto, and Wantage albums:

K = at least seven albums were used

M = at least seven albums were used

W = at least one album was used

1. Beach, *Grand Mogul*, p. 46 and fn. 4.
2. Beach, "The Gulshan Album."
3. Beach, *Grand Mogul*, p. 43.
4. Beach, *Grand Mogul*, p. 46.
5. Jahangir, *Tuzuk-i Jahangiri*, II, pp. 143–44.
6. Skelton, "A Decorative Motif in Mughal Art," pp. 147–52, pls. LXXXV–XCI.
7. Welch, *India*, no. 145, color.
8. Welch, *India*, p. 151.
9. Arber, *Herbals*, p. 174, quote, and p. 180, vis-à-vis Fuchs craftsmen; see also Hatton, *Plant and Floral Ornament*, pp. 1–18 and 49–57 for a discussion of sixteenth-century herbals.
10. Arber, *Herbals*, pp. 72, 190–91.
11. Beach, "The Gulshan Album," no. 332, p. 63, and fn. 2.
12. Beach, "The Gulshan Album," p. 91, fn.
13. Godard, "Un Album de portraits des princes timurides de l'Inde," pp. 273–327, fig. 113.
14. Mauquoy-Hendrickx, *Les Estampes des Wierix*, catalogue raisonné partie, pls. 16, 17, 41, 43, 65, 66, 72, 92, 94, and 99; deuxième partie, pls. 155, 157, and 163; and troisième partie (premier fascicule), pls. 301 and 302.
15. Mauquoy-Hendrickx, *Les Estampes des Wierix*, catalogue raisonné partie, pls. 16 and 130 with both iris and narcissus; pls. 17 and 139 with narcissus; pl. 140 with iris, tulip, and poppy; pl. 41 with iris and narcissus, etc.
16. Jahangir, *Tuzuk-i Jahangiri*, II, pp. 143–44.
17. Skelton, "A Decorative Motif in Mughal Art," p. 150 and fn. 19.
18. Crill, "A Lost Miniature Rediscovered," p. 336.
19. See, for example, Sotheby's, London, 1983, lot 64, Shah ʿAbbas Receiving the Mughal Ambassador, Khan ʿAlam in 1618 by Bishan Das with margin number 24, and lot 65, Portrait of a Mughal Prince, attributed to Bichitr with margin number 25; April 16, 1984, lot 87, Portrait of the Prophet David Playing a Harp, attributed to Manohar, with the margin number 9; and lot 88, Portrait of Christ in Glory Holding an Orb, attributed to Murad, with the margin number 10 (lots 87 and 88 presumably having been facing pages in an album); and October 15, 1984, lot 36, An Old Sufi by Farrukh Beg, with the margin number 36. These will be discussed in the appropriate places below.
20. Beach, *Grand Mogul*, pp. 76–77.
21. I am grateful to Ebba Koch for drawing my attention to this aspect of Kalim's poetry; see also AMS, pp. 42–43).
22. See AMS, p. 42.
23. See AMS, p. 43.
24. Clarke, *Indian Drawings*, no. 5, pl. 4.
25. For a list of the major albums of the Shahjahan period, see Beach, *Grand Mogul*, pp. 24–77.
26. *Indian Heritage*, no. 52, without border.
27. Welch, *Indian Drawings and Painted Sketches*, no. 17v, with border.
28. Arnold and Wilkinson, *Beatty Library*, III, pl. 65, color, without border.
29. *Indian Heritage*, no. 53, not ill., mentions that the Beatty Library leaf is a companion piece to the Victoria and Albert Museum leaf, but it does not mention that one, namely Timur handing the crown to Babur, must have opened the album, and the other, Akbar handing the crown to Shahjahan, must have closed it.
30. Not illustrated in Arnold and Wilkinson, *Beatty Library*.
31. Hambly, *Cities of Mughul India*, no. 47, p. 72, without outer borders.
32. Arnold and Wilkinson, *Beatty Library*, III, pl. 54, without outer borders.
33. Skelton, "The Mughal Artist Farrokh Beg," fig. 10.
34. Falk and Archer, *Indian Miniatures*, no. 68, fols. 25v and 26, 43v and 44, 47v and 48, and so on.
35. James, *Islamic Masterpieces*, no. 51c, detail.
36. Stchoukine, *La Peinture indienne*, pl. XXXVIII, bw, without border. Incidentally, there is an early nineteenth-century copy of this picture in the Metropolitan Museum (MMA 13.228.52). It has a contemporary border of flowering plants in gold on a buff ground with a gold-on-blue flower-head and leaf scroll on the inner border; no attempt was made to copy the original border scheme.
37. Stchoukine, *La Peinture indienne*, pl. XXX, without border; Pinder-Wilson, *Paintings from the Muslim Courts of India*, no. 131, with border.
38. See Clarke, *Indian Drawings*, pl. 23, where he attributes the border to Daulat the Elder.
39. Clarke, *Indian Drawings*, pl. 15, with inner border only; Hambly, *Cities of Mughul India*, p. 95, color, with inner border only; Gascoigne, *Great Moghuls*, p. 132, without borders.
40. Arnold and Wilkinson, *Beatty Library*, III, pl. 64, bw, with surrounding verses but no borders.
41. Clarke, *Indian Drawings*, pl. 8, bw, with borders.

42. Arnold and Wilkinson, *Beatty Library*, III, pl. 57.

43. Arnold and Wilkinson, *Beatty Library*, III, pl. 62, bw, without border.

44. Arnold and Wilkinson, *Beatty Library*, III, pl. 53, color, without borders.

45. Clarke, *Indian Drawings*, pl. 13, bw, with border.

46. Falk and Archer, *Indian Miniatures*, pp. 179–400. There has clearly been some rearranging even here.

47. See, for example, Welch, *Imperial Mughal Painting*, pl. 27, color, with border.

48. Clarke, *Indian Drawings*, pl. 21, bw, with border whose colors are described but which has not been seen by the author.

49. Arnold and Wilkinson, *Beatty Library*, III, pl. 55, bw, without outer border.

50. It was sold at Sotheby's, London, October 17, 1983, lot 64, and was published in Crill, "A Lost Mughal Miniature Rediscovered."

51. Arnold and Wilkinson, *Beatty Library*, III, pl. 56, bw, without outer border.

52. Arnold and Wilkinson, *Beatty Library*, III, color frontis., with border.

53. Arnold and Wilkinson, *Beatty Library*, I, p. 27.

54. James, *Islamic Masterpieces*, no. 51b.

55. Sold at Sotheby's, London, October 15, 1984, lot 36.

56. Arnold and Wilkinson, *Beatty Library*, I, pp. 28–29, not ill.

57. Clarke, *Indian Drawings*, pl. 11, the two lower portraits.

58. This leaf was neither mentioned nor illustrated in Clarke, *Indian Drawings*.

59. Clarke, *Indian Drawings*, pl. 18, bw, with border.

60. Arnold and Wilkinson, *Beatty Library*, III, pl. 60, bw, with border.

61. Pinder-Wilson, *Paintings from the Muslim Courts of India*, no. 139, bw, without border.

62. See Pinder-Wilson, *Paintings from the Muslim Courts of India*, no. 111, without border.

63. See Stchoukine, *La Peinture indienne*, pl. XXVIII, shown with two rows of surrounding poetry but no borders.

64. Arnold and Wilkinson, *Beatty Library*, III, pl. 58, color, without border.

65. This was kindly pointed out to me by David James.

66. Falk and Archer, *Indian Miniatures in the India Office Library*, no. 68, fol. 21v, p. 385.

67. Arnold and Wilkinson, *Beatty Library*, III, pl. 59, bw, with border.

68. Clarke, *Indian Drawings*, pl. 7, bw, with border.

69. Gascoigne, *Great Moghuls*, p. 114, color, with border.

70. Arnold and Wilkinson, *Beatty Library*, III, pl. 61, bw, without outer border.

71. *Indian Heritage*, no. 67, bw, without borders.

72. Arnold and Wilkinson, *Beatty Library*, III, pl. 63, bw, without border.

73. Arnold and Wilkinson, *Beatty Library*, I, color frontis., with inner border only.

74. Clarke, *Indian Drawings*, pl. 11, upper right, without borders, and with subject not identified; Pinder-Wilson, *Paintings from the Muslim Courts of India*, no. 128, without border, subject called Asaf Khan.

75. See Pinder-Wilson, *Paintings from the Muslim Courts of India*, p. 130, bw, p. 75, with border.

76. Gascoigne, *Great Moghuls*, p. 156, color, without border.

77. See Stchoukine, *La Peinture indienne*, pl. XLIV, without outer border.

78. See Beach, *Imperial Image*, p. 191, fig. 38.

79. See Hambly, *Cities of Mughul India*, fig. 61, cropped color ill.; Pinder-Wilson, *Paintings from the Muslim Courts of India*, no. 36, not ill.; Welch, *Art of Mughal India*, pl. 43, bw, without borders.

80. Clarke, *Indian Drawings*, p. 1.

81. Clarke, *Indian Drawings*, nos. 9–15, 19, 22–24, 27, and 30.

82. Clarke, *Indian Drawings*, nos. 1–8, 16–18, 20, 21, 25, 26, 28, and 29.

83. Clarke, *Indian Drawings*, pl. 9, bw, with border; pl. 13, calligraphy page with border.

84. See Clarke, *Indian Drawings*, pl. 15, without outer border.

85. Clarke, *Indian Drawings*, pl. 8, bw, with border.

86. Arnold and Wilkinson, *Beatty Library*, III, pl. 64.

87. Clarke, *Indian Drawings*, pl. 21, bw, with border.

88. Clarke, *Indian Drawings*, pl. 11, no. 11.

89. Clarke, *Indian Drawings*, pl. 7, bw, with border.

90. Clarke, *Indian Drawings*, pl. 11, lower left, bw, without borders.

91. Clarke, *Indian Drawings*, pl. 11, lower right, bw, without borders.

92. Not illustrated in Clarke, *Indian Drawings*.

93. Clarke, *Indian Drawings*, pl. 18, bw, with borders.

94. Clarke, *Indian Drawings*, pl. 16, bw, with borders.

95. Clarke, *Indian Drawings*, pl. 11, upper left, bw, without borders.

96. Arnold and Wilkinson, *Beatty Library*, III, pl. 56.

97. Clarke, *Indian Drawings*, pl. 15, no. 22, bw, without borders; Gascoigne, *Great Moghuls*, p. 62, color, with part of border.

98. Clarke, *Indian Drawings*, pl. 13, bw, with border.

99. The catalogue entry for lot 87 in the Sotheby's sale of April 16, 1984, gives the following references to leaves from a related album: Martin, *Miniature Painting and Painters*, pls. 211–15; Binney, *Collection*, no. 62; Colnaghi, *Persian and Mughal Art*, no. 96 i–iv; and sales at Sotheby's—April 7, 1975 (lots 15, 16), April 12, 1976 (lots 8, 9), May 2, 1977 (lots 27–29), April 3, 1978 (lot 99), and April 23, 1979 (lot 126).

On the Late Shahjahan Album, see Beach, *Grand Mogul*, pp. 76–77.

100. Arnold and Wilkinson, *Beatty Library*, III, pl. 63.

101. Welch, *India*, no. 147.

Charts of the Border Schemes of Leaves Discussed in This Essay

The charts are based on the hypothesis of a sixty-leaf album. They are divided into Group A and Group B folios (Group A recto portraits have even margin numbers, while the verso portraits have uneven margin numbers; Group B recto portraits have uneven margin numbers, while the verso portraits have even margin numbers). Each chart begins in the upper right corner and reads from right to left on each row, concluding in the lower left corner. Each box in the charts represents a recto or verso leaf (see diagram below). The margin number is shown in the upper left corner. The border scheme is noted in the upper center. The collection is indicated in the upper center (*K* = Kevorkian, *M* = Minto, *W* = Wantage, *S* = Sotheby's, *Anon.* = anonymous collector). The border colors are given in the middle of the box; all borders have a flowering-plant design except where "all-over" (all-over continuous design) is indicated. When there are two folios with the same margin number, one appears above the other. The dividing lines between the boxes are explained below.

1v M gold on buff or pink (all-over) P	1r M gold arabs. on buff or pink
1v W 4 colors on buff P	1r W 4 gold on blue C

3v K 1 gold on pink P	3r K 1 gold on blue (all-over) C	2v	2r

6v K 2 colors on buff C	6r K 2 gold on pink P	5v K 10 gold on blue P	5r K 10 gold on pink C	4v K 1 gold on blue (all-over) C	4r K 1 gold on pink P

9v S 8 colors on buff P	9r S 8 colors on buff C	8v K 11 colors on buff (all-over) C	8r K 11 gold on blue P	7v K 5 colors on buff (birds) P	7r K 5 gold on pink (all-over) C
		8v K 9 gold on buff (all-over) C	8r K 9 gold on buff P		

12v K 2 colors on buff C	12r K 2 gold on pink P	11v K 8 colors on buff P	11r K 8 colors on buff C	10v S 8 colors on buff C	10r S 8 colors on buff P
		11v W 4 colors on buff (turkey) P	11r W 4 gold on blue C		

15v M 2 gold on pink (sheep) P	15r M 2 colors on buff C	14v	14r	13v	13r

18v **W** 12	18r **W** 12			16v **M** 14	16r **M** 14
gold on pink (all-over, abs.)	gold on blue	17v **K** 12	17r **K** 12	colors on buff	colors on buff (all-over)
C	P	gold on blue	gold on pink (all-over)	C	P
18v **K** 2	18r **K** 2			16v **W** 8	16r **W** 8
colors on buff	gold on pink	P	C	colors on buff	colors on buff
C	P			C	P

21v **M** 13	21r **M** 13			19v **W** 6	19r **W** 6
gold on blue	colors on buff	20v **W** 13	20r **W** 13	colors on buff (buck & keeper)	gold on blue (all-over)
P	C	colors on buff	gold on blue (bird)	P	C
21v **M**	21r **M**	C	P		
colors on buff	?				
P	C				

24v	24r	23v **W** *17 or 9*	23r **W** *17 or 9*	22v **M** 12	22r **M** 12
		gold on pink (or buff)	gold on pink (or buff) (all-over)	gold on pink (all-over)	gold on blue
		P	C	C	P

27v	27r	26v **K** 7	26r **K** 7	25v **K** 14	25r **K** 14
		gold on pink	colors on buff (animal)	colors on buff (abs.) (animal)	colors on buff
		C	P	P	C

30v	30r	29v	29r	28v	28r

33v	33r	32v	32r	31v **W** *12* gold on blue — P	31r **W** *12* gold on pink (all-over) — C

| 36v **K** *10* gold on pink — C | 36r **K** *10* gold on blue — P | | | | |
| 36v **Anon.** *13* gold on buff — C | 36r **Anon.** *13* gold on blue — P | 35v **K** *1* gold on pink — P | 35r **K** *1* gold on blue (abstract) — C | 34v | 34r |

39v **K** *12* gold on blue (bird) — P	39r **K** *12* gold on pink (all-over) — C	38v	38r	37v	37r

| 42v **M** *13* colors on buff — C | 42r **M** *13* gold on blue (scene) — P | 41v **W** *12* gold on blue — P | 41r **W** *12* gold on pink (all-over) — C | 40v **K** *12* gold on pink (all-over) — C | 40r **K** *12* gold on blue (bird) — P |
| | | | | 40v **W** *1* gold on blue (all-over) — C | 40r **W** *1* gold on pink (bird) — P |

45v **W** *8* colors on buff — P	45r **W** *8* colors on buff — C	44v **K** *14* colors on buff — C	44r **K** *14* colors on buff (all-over) (bird) — P	43v **K** *14* colors on buff (all-over) (bird) — P	43r **K** *14* colors on buff — C

48v **M** 8	48r **M** 8	47v **M** 8	47r **M** 8	46v **K** 11	46r **K** 11
colors on buff	colors on buff	colors on buff	colors on buff	colors on buff (all-over)	gold on blue (scene)
C	P	P	C	C	P

51v **K** 2	51r **K** 2	50v	50r	49v	49r
gold on pink	colors on buff				
P	C				

52v **W** 2	52r **W** 2
colors on buff	gold on pink (goat)
C	P

52v **K** 1	52r **K** 1
gold on blue (all-over)	gold on pink
C	P

54v **M** 8	54r **M** 8	53v **W** 12	53r **W** 12
colors on buff	colors on buff	gold on blue	gold on pink (all-over)
C	P	P	C

57v **M** 8	57r **M** 8
colors on buff	colors on buff
P	C

57v **K** 4	57r **K** 4
colors on buff	gold on blue
P	C

56v **M** 8	56r **M** 8	55v **M** 4	55r **M** 4
colors on buff	colors on buff	colors on buff	gold on blue
C	P	P	C

60v **M**	60r **M**
all-over scroll gold on buff?/pink?	gold on buff?/pink?
C	P

60v **M** 6	60r **M** 6
gold on blue (all-over)	colors on buff
C	P

59v **M** 2	59r **M** 2
gold on pink	colors on buff
P	C

58v **M** 8	58r **M** 8
colors on buff?	colors on buff?
C	P

58v **K** 4	58r **K** 4
gold on blue	colors on buff
C	P

3v **K** 8	3r **K** 8	2v **K** 8	2r **K** 8	1v	1r
colors on buff	colors on buff	colors on buff	colors on buff		
C	P	P	C		

6v **M** 4	6r **M** 4	5v	5r	4v	4r
colors on buff	gold on blue				
P	C				

9v	9r	8v **K** 13	8r **K** 13	7v **M** 1	7r **M** 1
		gold on blue	colors on buff	gold on blue (all-over)	gold on pink (faded)
		P	C	C	P

12v	12r	11v **K** 8	11r **K** 8	10v **K** 8	10r **K** 8
		colors on buff	colors on buff	colors on buff	colors on buff
		C	P	P	C

15v	15r	14v	14r	13v	13r

18v	18r	17v **M** 4	17r **M** 4	16v **M** 4	16r **M** 4
		gold on blue	colors on buff	colors on buff	gold on blue
		C	P	P	C

21v **M** 17	21r **M** 17	20v **M** 9	20r **M** 9	19v	19r
gold on pink (abstract)	gold on pink	gold on buff	gold on buff (all-over)		
C	P	P	C		

24v **S** 9	24r **S** 9	23v	23r	22v **M** *1*	22r **M** *1*
gold on buff	gold on buff (all-over)			gold on pink	gold on blue (all-over)
P	C			P	C

27v **K** *15*	27r **K** *15*	26v **K** *3*	26r **K** *3*	25v **S** 8	25r **S** 8
gold on buff (all-over)	gold on buff (all-over)	gold on pink (mauve)	gold on buff	colors on buff	colors on buff
C	P	P	C	C	P

30v	30r	29v	29r	28v	28r

33v **M** *12*	33r **M** *12*	32v **M** 8	32r **M** 8	31v **M** 8	31r **M** 8
gold on pink (all-over)	gold on blue	colors on buff	colors on buff	colors on buff	colors on buff
C	P	P	C	C	P

36v **K** 7	36r **K** 7	35v **M** *4*	35r **M** *4*	34v **M** 7	34r **M** 7
colors on buff	gold on pink	gold on blue	colors on buff	colors on buff	gold on pink
P	C	C	P	P	C

39v **M** 8	39r **M** 8	38v **M** 8	38r **M** 8	37v **K** 6	37r **K** 6
colors on buff	colors on buff	colors on buff	colors on buff	gold on blue (all-over)	colors on buff
C	P	P	C	C	P

42v	42r	41v	41r	40v	40r

45v **K** 7	45r **K** 7	44v **K** 2	44r **K** 2	43v	43r
gold on pink	colors on buff	gold on pink	colors on buff		
C	P	P	C		

48v **M** 16	48r **M** 16	47v	47r	46v **W** 8	46r **W** 8
gold on buff (looks later)	gold on blue			colors on buff	colors on buff
P	C			P	C

51v	51r	50v	50r	49v **M** 5	49r **M** 5
				gold on pink (all-over)	colors on buff
				C	P

54v **M** 1	54r **M** 1	53v	53r	52v	52r
gold on pink	gold on blue (all-over)				
P	C				

57v	57r	56v **M** 4	56r **M** 4	55v **M** 8	55r **M** 8
		colors on buff	gold on blue	colors on buff	colors on buff
		P	C	C	P

60v	60r	59v	59r	58v	58r

The Kevorkian Album

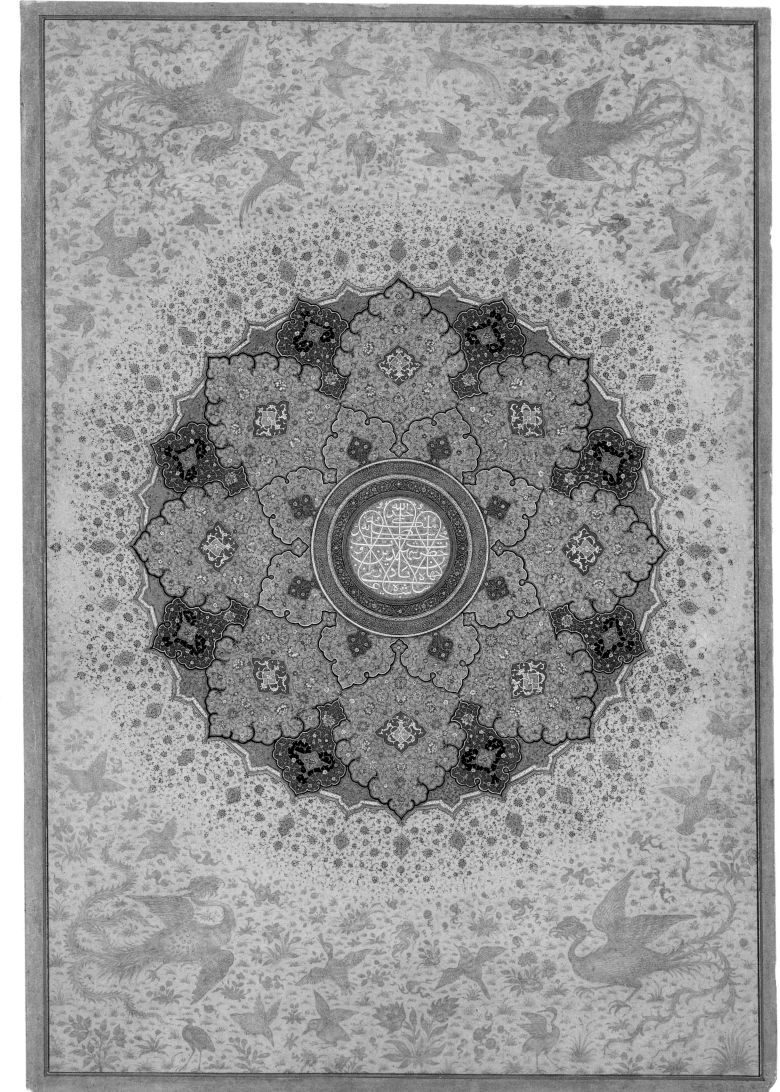

1

1. Rosette (*Shamsa*) Bearing the Name and Titles of Emperor Shahjahan

ca. 1645

INSCRIBED: "His Majesty, Shihabuddin Muhammad Shahjahan, the King, Warrior of the Faith, may God perpetuate his kingdom and sovereignty!"

MMA 55.121.10.39r

METICULOUSLY designed and painted arabesques, often enriched by fantastic flowers, birds, and animals, were painted by specially trained masters of ornament who may also have provided designs for architectural details. Working in bright colors and several tones of gold—some mixed with copper, others with silver—these remarkable artists produced hypnotic, eyecatching fanfares to imperial albums and manuscripts.

The author has written about this *shamsa* (little sun): "Although many Iranian prototypes for this rosette could be cited, they differ strikingly in spirit. Shah Jahan's illuminator envisioned the sunburst not flat, as in Iranian prototypes, but with characteristically Mughal three-dimensionality; and his coloring is tropically warm as opposed to the cool blues and golds of the Iranian mode, which seem in comparison classically restrained. Shah Jahan's *shamsa* is romantic, even passionate, radiating sunlight and expressive of the emotional undercurrents at his court and in his temperament."[1]

The Kevorkian Album contains a second, very similar rosette, bearing the titles of Emperor Aurangzeb (MMA fol. 40r; pl. 5).

SCW

1. Welch, *India,* cat. no. 155.

2. *'Unwan* (LEFT SIDE)

ca. 1630–40

MMA 55.121.10.38r

A MANUSCRIPT often opened with an *'unwan*, a sumptuous double-page composition framing columns of text. Descended in shape from the Roman *tabula ansata*, the *'unwan* was illuminated with richly varied floral arabesques. No two such compositions are quite alike, and one can be sure that the spirits of their patient artists soared while devising myriads of flowering garlands in these formal gardens of the soul.

Mughal illuminations, like Mughal miniatures, descended from earlier, usually Iranian prototypes. Like the pictures, they differ from Iranian prototypes in suggesting three-dimensional forms. The seemingly flat circles of Timurid or Safavid tradition become swelling globes in Mughal India, where cool bluish and golden palettes took on sunny warmth.

The sparkling arabesque "surrounds" known from richly illuminated Mughal manuscripts and albums were often added to earlier, sparer texts to satisfy imperial taste. Their floral arabesques were carried out by the same specialists in the arts of the book who painted *shamsa*. Occasionally, triangular compositions of real or imaginary birds and animals were fitted into corners, either by miniature painters or specialists in decoration.

As reminders of water, fertility, and tranquil gardens, flowers were admired passionately in Iran and India. Miniature painters and designers of tiles, textiles, and architectural ornament strewed them about in cheerying abundance. During the reigns of emperors Jahangir and Shahjahan floramania became epidemic; artists of the book plucked blossoms from all available sources, from Iranian and Chinese paintings, textiles, and metalwork as well as from European botanical engravings. If some flowers were interpreted with studious naturalism, others pranced and tripped according to the artist's interior vision.

SCW

THIS FOLIO and MMA fols. 39v and 38v (pls. 3 and 4) contain the same opening paragraphs from a treatise on calligraphy by Mir-'Ali as do MMA fols. 41v, 41r, and 40v (pls. 6–8). The translation of this passage is given in the text for pl. 7.

AS

3. *'Unwan* (RIGHT SIDE)

ca. 1630–40

MMA 55.121.10.39v

THIS FOLIO and MMA fols. 38r and 38v (pls. 2 and 4) contain the same opening paragraphs from a treatise on calligraphy by Mir-ʿAli as do MMA fols. 41v, 41r, and 40v (pls. 6–8). The translation of this passage is given in the text for pl. 7.

<div align="right">A S</div>

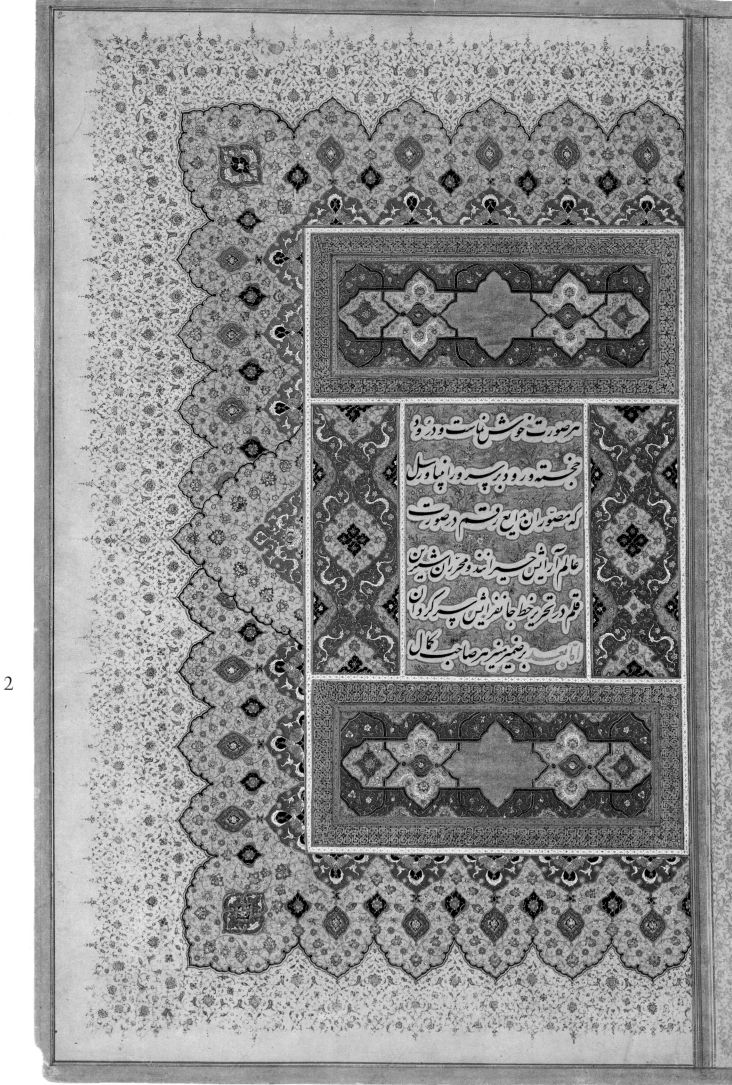

هر صورتِ خوش نماست و دودِ

پختهٔ درود و پسرود اپاورد

که صورتِ آن یک زمان در صورت

عالمِ آرایشِ چیه دانندِ محران شربن

قلم در تحریرِ خطِ جانفزایش پرورِ گردان

آقا به رهبینِ عزیزِ صاحب کمال

3

4. Calligraphy

ca. 1540

MMA 55.121.10.38v

THIS FOLIO and MMA fols. 38r and 39v (pls. 2 and 3) contain the same opening paragraphs from a treatise on calligraphy by Mir-ʿAli as do MMA fols. 41v, 41r, and 40v (pls. 6–8). The translation of this passage is given in the text for pl. 7.

AS

وخاطر فیض پذیر بر جسته مال است که از معدن ذرات تقدیر و صنایع بی شبهه و نظائر لوح و قلم و منقد...

که بورگ بنجانه افلاک اهل مجالس تصویر یان تحت خاک است چنانچه سفته در کمین از رار... در باجین و صحیفه از زمین جه...

و پس این بر نیست و مقصود ازین اثر یک طبع سلیم و دین مستقیم از هر یک بی بضاعت و مقصد حق...

اما حقیقت معرفت از کلام	مرور ق فرصت معروف کار	برگ درختان سبزه در نظر هوشیار

نظام آتی و حد شیخ مصطفوی مثنوی سنها می گردد و آن یا در سلک تحریر و فت تصویر در نا...

بمهارت از آن مستفید نمی توان شد پس این خطی که یک از امور ضروری باشد چنانچه این آیت...

از امور فضیلت کتابت کتابت گنایتی است رب کمال شرف...

آیتی است و حدیث صحیح شرعی نبوی حیث قال صلی الله علیه و سلم واقع است ذکر کت...

خط چنان که رقم راست	بهره کاغذ از ان بری است	خط که از شاید چین تهی است
رزق جمله که کلید	در کف نغمه خط خوب	کہ یا بیا بی دار و خوانده

باعث بر مهمت این مقدمات آنکه نفری بی بضاعت و حقیر استطاعت العبد الخائف...

علی حسینی الکاتب بجدست اهل دل پیر سید وارث از ایشان چشمه سعید و ابن مضوان...

دیگران یک نسخه بند نخه پیام کرد	فیض روح القدس از باند دریا	حسب حال خودمی دیدطم

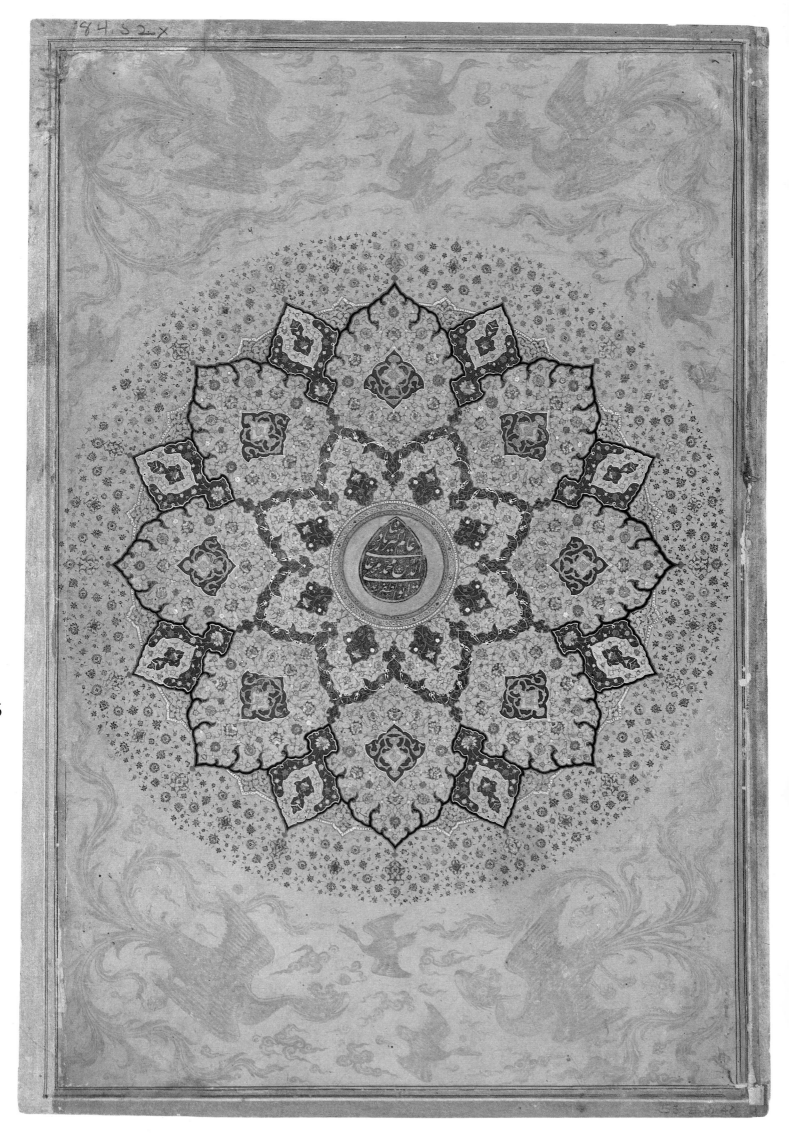

5

5. Rosette (*Shamsa*) Bearing the Name and Titles of Emperor Aurangzeb

ca. 1658

INSCRIBED: Ab'uz-Zafar Muhyi'ddin 'Alamgir
Padshah, *sana* 1 [= year 1 (of his reign) = 1658]

MMA 55.121.10.40r

THIS SHAMSA, the second in the Kevorkian Album,
is very similar to that bearing the name and titles of
Emperor Shahjahan (MMA fol. 39r; pl. 1). It is discussed
in the text for pl. 1.

<div align="right">SCW</div>

THE WRITING is not, as in pl. 1, *tughra* style but is
rather a fine nasta'liq.

<div align="right">AS</div>

6. *'Unwan* (LEFT SIDE)

ca. 1630–40

MMA 55.121.10.41r

THIS FOLIO and MMA fol. 40v form an *'unwan*, a composition discussed in the text for pl. 2.

The translation of this passage is given in the text for pl. 7.

AS

7. *'Unwan* (RIGHT SIDE)

ca. 1630–40

MMA 55.121.10.40v

THIS FOLIO and MMA fols. 41r and 41v (pls. 6 and 8) are the first three pages of a treatise by Mir-ʿAli on calligraphy. Quotations from the Koran and the Prophetic traditions are written in gold. This text uses the traditional imagery known from the works of Mir-ʿAli's master, Sultan-ʿAli, and of Majnun of Herat, as well as of the later Qadi Ahmad. God is presented as the great master painter and calligrapher; the Koran and Prophetic traditions are quoted to prove that beautiful handwriting is not only important for religious life as it opens the gates of paradise but is also useful in that it enables the calligrapher to earn his livelihood. At the beginning of the actual treatise Mir-ʿAli alludes to "virtuous people" who, by their kindness, revived him just as Jesus quickened the dead. Unfortunately, the text ends here, and we do not know whether Mir-ʿAli later referred to his first master or, more likely, to a patron who employed him and gave him superior status. The style of the treatise is complex, with numerous internal rhymes and puns, as was customary.

The text begins on this folio:

Boundless praise and countless lauds to the Creator! The painted album of the sky is one fragment from the works of his bounty and excellence, and the well-cut illuminated sun is one paper-scrap[1] from the lights of His beauty and elegance. [Praise to Him who is] the artist, the pen of whose creative art is the writer of the script [or "down"][2] of the heart-ravishing beauties; the inventor, the line of whose invention is the painter

[The text continues on MMA fol. 41r (pl. 6):]

of every lovely-looking form. And happily arriving prayer for the leader of the prophets and messengers—confused are the rarity-drawing painters about his world-embellishing form, and dizzy the sweet-penned writers when writing about his soul-enhancing script [or "down"].
Further: For the lucid mind of any perfect human being

[The text concludes on MMA fol. 41v (pl. 8):]

and for the favor-receiving mind of those with auspicious return it is not concealed that the goal of the Writer of Fate and the Artist without Equal and Mate from Tablet and Pen and the well-written destinies which are in the library of the sphere is [to prepare] the sessions of painting of the board of dust here—just as the colorful anthology of fragrant herbs and flowers and the elegant page of gardens and arbor-bowers are signs of this. Intended by these signs is to lead [people

with] sound nature and straight intellectual power from each of them toward the original artist and the real goal.

Poem:
Before the wise the green leaves of the trees
Are each a page from the book of the Creator's wisdom!

But real knowledge benefits from the inimitable speech of the Divine Order and the sound traditions of [the Prophet Muhammad] Mustafa, and that [i.e., the book of Nature] does not come into the string of writing or the chain of painting so that one can easily benefit from it.

Now, script is one of the necessary things, as the Koranic verse *"Nun, and by the pen!"* [Sura 68/1] is a metaphor pointing to the abundant excellence of writing. "He taught by the pen, taught man what he did not know" [Sura 96/3] is a verse about the perfect honor of script. And there is the sound Prophetic tradition where he—may God bless him and give him peace!—says: "He who writes beautifully *bismillah* ['in the name of God the Merciful, the Compassionate'] will enter Paradise without reckoning." Now, if someone exerts himself to [produce] beautiful calligraphy, then it is not because of official formalities or public display of art; rather it is out of hope for [the promise in] this Prophetic tradition. And the word of happy conclusion, "You are obliged to [practice] fine writing for it is a key for one's daily bread," likewise supports this idea.

Mathnavi:
When a script is devoid of the admixture of beauty,
The paper becomes black-faced [i.e., disgraced].
The script should run from the pen in such a way
That its reader becomes restful thanks to it.
In the nimble hand a nicely written script—
The pen is an elegant key to one's daily bread.

The cause for arranging these prefaces is that this poor one without merchandise, this lowly one without power and size, the [God] fearing sinner ʿAli al-Husayni al-Katib, came into the service of virtuous people and plucked an ear from their harvest. He saw this expression as a description of his own state:

When the bounty of the Holy Spirit kindly provides help,
Then others can do what Jesus has done.

<div align="right">A S</div>

1. This is an example of the characteristically subtle wordplay: sun = light = bright = paper white.
2. The Arabic word *khatt* means both the "black line of script" and the "black line of the first sign of down on the upper lip and cheek."

هر صورت خوش نمایت و درود

نخجسته و رو د بر پرور انپاو رسل

کهمصوران مطلع رقم در صورت

عالم آرایس حیراند و محران نشین

قلم در تحریر خط جانفرایس سپر کردان

بر ضمیر منیر مهر صاحب کمال

8. Calligraphy

ca. 1630–40

MMA 55.121.10.41v

THE TRANSLATION of this passage is given in the text for pl. 7.

<div align="right">A S</div>

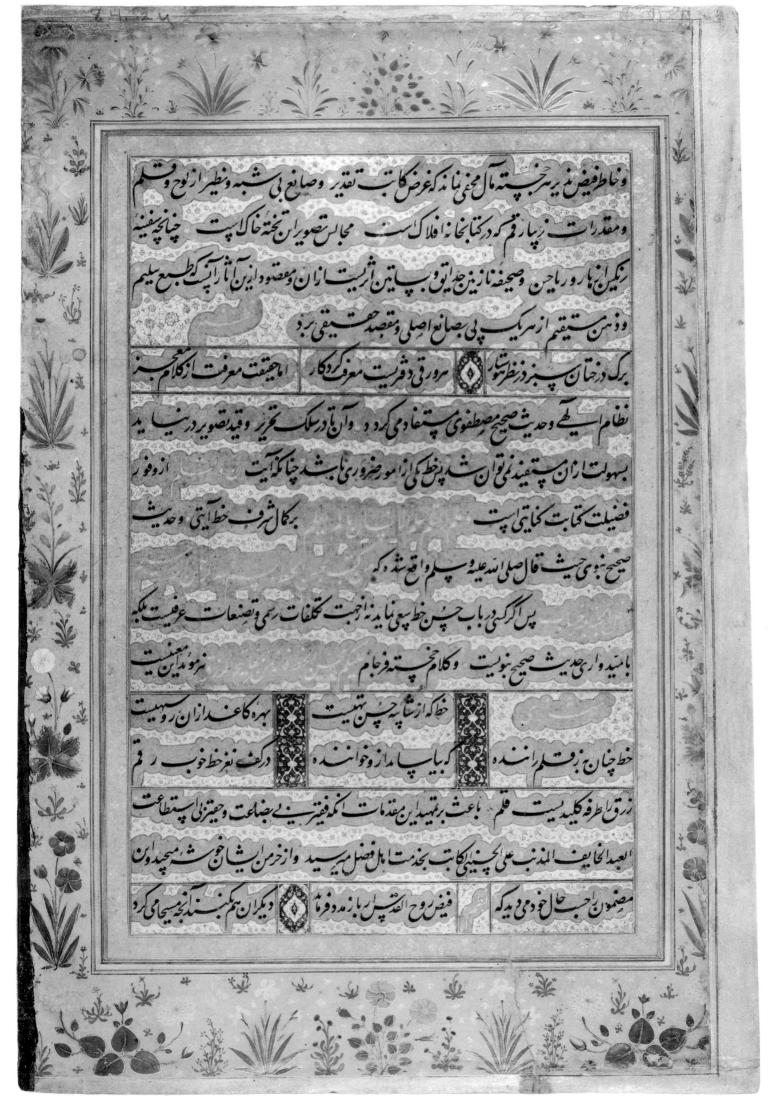

وخاطر فیض پذیر به خجسته آل محفی ناماند که عرض کتاب تقدیر و صنایع بی شبه و نظیر از لوح و قلم

و مقدرات زیبار قلم که در کتابخانه افلاک است مجالس تصویریان تخته خاک است چنانچه سفینه

زنگیل از بهار و ریاحین و صحیفه نازنین جدایی و پیاتین اثریست از ان مقصود از این آثار آنک طبع سلیم

و ذهن ستقیم از هر یک پی بصانع اصلی و مقصد حقیقی برد

| برگ درختان سبز در نظر هشیار | | اما حقیقت معرفت از کلام جنبه |
| سروری دقتریت معروف کردگار | | |

نظام است آنکه حدیث صحیح مصطفوی استفاده می کرد و آن یا در سلک تحریر و قید تصویر در نیاید

بهولت از ان ستقید نمی تواند شد و خط کی از مو ضرور بی ناید چنا که آیت ازوفوز

| فضیلت کتابت کنایتی است | | بکمال شرف خط آیتی وحدیث |

صیح نبوی حیث قال صلی الله علیه وسلم واقع شده که

پس اگر کسی در باب چنین خط سعی نماید نه از جهت تکلفات رسمی و تصنعات ظریفت بلکه

| بامید وارهی حدیث صیح نبویت | | نمونه دین معنیت |
| وکلام خجسته فرجام | | |

| خط که از شا به چین بهیت | | بهره کاغذ ازان رسهیت |
| خط چنان زرقلم رانده | کبیاسپا مدازوخوانده | درکف نغز خط خوب رقم |

زرق را طرفه کلید پست قلم باعث بر تهید این مقدمات آنکه فقیر بی بصالحت و حیلتی استطاعت

العبد النحایف المذنب علی الحسینی کاتب بخدمت مال فضل میرسید واز خرمن ایشان خوشه مسجد وابن

| مضمون را به جان خود می یدک | | فیض روح القدس پل باز مدد فرما |
| دیگران بکم کبسند آنچه مسیحامی کرد | | |

9. Akbar with Lion and Calf

ca. 1630

INSCRIBED: (in Shahjahan's hand) "work [*amal*] of Govardhan"

MMA 55.121.10.22v

GOVARDHAN'S LIKENESS of Akbar (1542–1605) shows the greatest of the Mughal emperors in old age, as he would have been remembered by the two major patrons of this album, his son Jahangir and his grandson Shahjahan. Based upon observation—the artist's imperial career spanned all three reigns—this posthumous likeness is idealized to the point of canonization, reminding us that after his death Akbar was known as ʿArsh-Ashiyani (He Who Nests in the Divine Throne). Serenely smiling, he offers a rosary of jewels to the royal patron for whom he was painted, probably Shahjahan, whose accomplished calligraphy appears in the margin. Above hover a trio of cherubs, tootling, strumming, and bearing an incongruously European crown. In the foreground the power of the *pax Mughalica* is symbolized by a reclining calf, undisturbed by the nearby lion eyeing it with uncharacteristic benevolence. Beyond, a landscape with Indian figures melts into the blue sky. Netherlandish architecture in aerial perspective, adapted from European prints, adds another cosmopolitan note to the composition.

Govardhan, a Hindu whose name is derived from the mountain miraculously elevated by the god Krishna, was one of the six or eight foremost Mughal artists. His psychologically penetrating portraiture and swelling forms suggest that he studied with Basawan, Akbar's greatest master, upon whose painterly brushwork he modeled his own. Darting strokes build up cloud banks in a characteristic palette of subdued grays, whites, tans, and soft blues, accented, as here in Akbar's turban, by areas of chromatic richness. Fond of swirls and sparkle, he enjoyed depicting marbled paper,[1] and he handled gold with extraordinary skill, highlighting, striating, and pricking it. Although his court portraiture is outstanding, Govardhan's most striking characterizations are intimate studies of holy men (see pl. 76), probably painted for Prince Dara-Shikoh, the ill-fated son of Shahjahan, whose religious toleration and mystical tendencies were akin to those of his great-grandfather. When Govardhan painted this insightful portrait of Akbar, he appreciated the affinity between the two notably tolerant imperial mystics and recalled the former with the sympathy he usually accorded to saints.

Govardhan was an artist of extraordinary breadth who also painted many outstanding depictions of the court and its activities. As a young man, he contributed miniatures to the British Library's *Akbarnama* of 1604 (Or. 12988) and to the Chester Beatty *Akbarnama*.[2] We attribute to him one of the few overtly humorous pictures of its period, *Jahangir Playing Holi with the Ladies of His Palace*, describing an incident of such gusto that it has terrorized one of the artist's favorite and oft-depicted animals, a cat whose hair stands on end.[3] Another picture attributable to him is a regal portrait of Shahjahan, on the Peacock Throne.[4] Also attributable to him is the liveliest painting in the Windsor *Padshahnama* (fol. 133r), *Prince Aurangzeb Spearing an Enraged Elephant* (see Appendix, fig. 15), in which the artist reveals that like Bichitr—an exponent of trompe l'œil—he could master European concepts.[5] Although sinuous runs of the brush, a smoky palette, and brilliant characterizations of every personage—from the prince with his retroussé nose (a characteristic of the artist) to the mahouts and footsoldiers—are expected of Govardhan, his handling of recession in space is unique in Mughal painting of the mid-seventeenth century. Inasmuch as the Mughals ordinarily disdained perspective as a jarring violation of the picture plane, it is exciting to see that at least one of Shahjahan's artists effectively suggested distance through vanishing points, line, and color.[6]

Another, probably later, version of the present picture, in black ink heightened with gold, is in the Cleveland Museum of Art.[7]

SCW

THIS VERSO painting has the margin number 26. It contains an inner border with a palmette-and-floral scroll in pink on a gold ground. Its outer border has gold flowering plants on a deep pink ground that bears no resemblance to the usual pink border color. An iris appears in the narrow left margin with a rose above it and, possibly, a rose at the upper right.

MLS

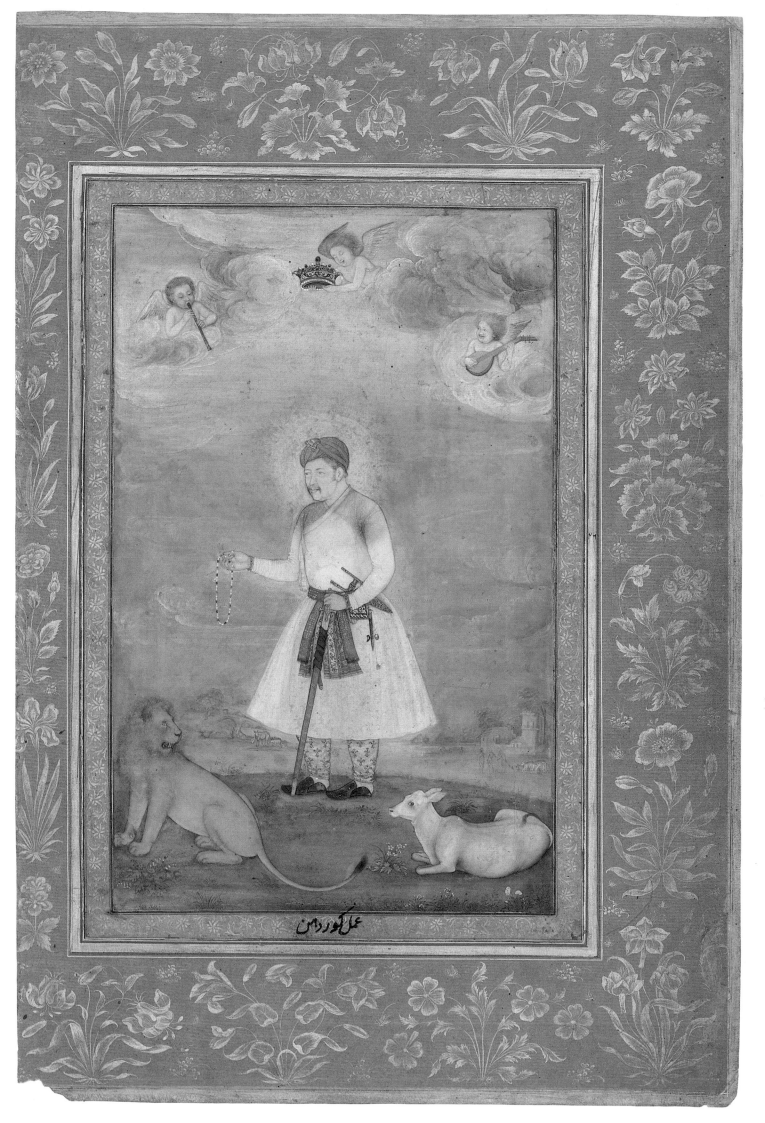

عمل گوردهن

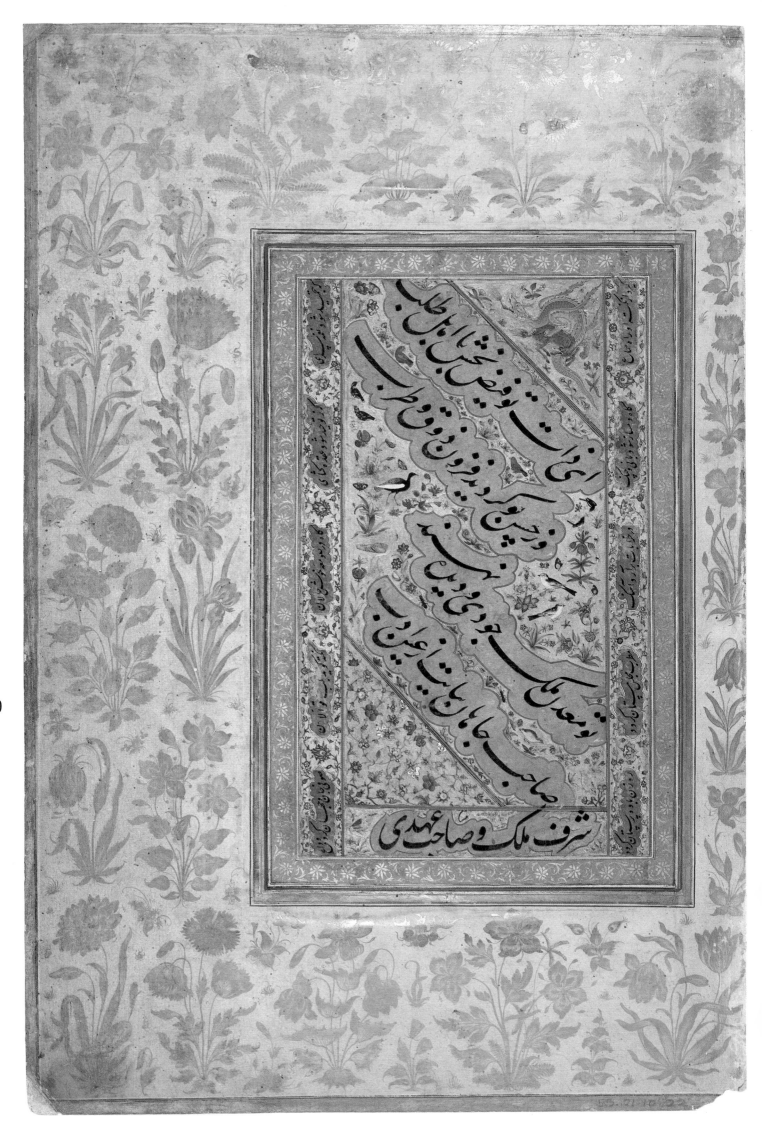

10

1. See Govardhan's *Shaykh Husayn Jami and Attendant*, Marteau and Vever, *Miniatures persanes*, II, pl. CLVI.

2. See Arnold and Wilkinson, *Beatty Library*, II, frontis. and pls. 16 and 31.

3. Arnold and Wilkinson, *Beatty Library*, III, pl. 56. Pl. 59 illustrates a happier feline, listening to Prince Dara-Shikoh.

4. Welch, *India*, no. 154.

5. For a description of the incident, which took place in 1633 on the bank of the Jumna near the palace at Agra occupied by Shahjahan before his accession, see Sarkar, *History of Aurangzib*, I, pp. 9–11.

6. Govardhan's not entirely scientific use of perspective was probably based on studying Northern European engravings, evidence for which is seen in the background of the Kevorkian *Akbar*. Another remarkable historical subject attributable to Govardhan shows Jahangir riding past Akbar's tomb at Sikandra (Chester Beatty Library, Dublin, 34/5; Hambly, *Cities of Mughul India*, jacket cover).

7. See Leach, *Indian Miniature Paintings and Drawings*, p. 92, fig. 26.

10. Calligraphy

ca. 1530–50

MMA 55.121.10.22r

Oh you, whose essence grants seekers bounty rich,
And from whose beauty, joy increases, and delight!
Mine of munificence—the dignitaries put
With proper etiquette their eyes upon your foot!

The last line on the lower border reads:

You are the honor of the kingdom and the lord of the time.

The last two lines in the quatrain contain a pun on the words "eye" and "proper" (ʿayn means "eye," "essence," and "proper").

This poem also appears on v&a 12–1925v, where there is an important addition: under the title "Showing openly what was concealed" Mir-ʿAli begins with two lines of Chagatay poetry about Babur who "by his understanding and perception has finally become world-famous." Then follows the poem, including the last line: "You are the honor of the kingdom . . . " The signature reads: "By its scribe, the lowly, poor, sinful Mir-ʿAli *al-katib as-sultani* in the Abode of Glory, Bukhara."

The verse may have been written during Babur's conquest of India, which probably filled Mir-ʿAli with the hope of seeing Babur one day as ruler in Herat as well. But it must have been many years later, and certainly after Babur's death in 1530, that the "royal scribe," as Mir-ʿAli called himself in the 1530s, dared to reveal his secret loyalty to the founder of the Timurid house.

The page is surrounded by verses in minute *ghubar* (dust script) from *Subhat al-abrar*, one of the seven epics that Mulla Jami (d. 1492), the master of Herat, composed.[1]

AS

THIS RECTO page has an inner border similar to that of the verso and an outer border of gold flowers on a pale buff ground. An iris can be seen in the outer border with a rose beside it. This album leaf resembles no other in the Kevorkian Album and must therefore be the only folio from its original album to have made its way into the Kevorkian Album.

MLS

1. Jami, *Haft Aurang*, p. 466.

99

11. Jahangir and His Father, Akbar

ca. 1630

INSCRIBED: (probably in Shahjahan's hand)
'amal-i Balchand (done by Balchand)

MMA 55.121.10.19v

Born in 1542, Jalaluddin Akbar succeeded his father, Humayun, as the third Mughal emperor in 1556. During his long reign (1556–1605), and especially during his minority under the regency of Bayram Khan (1556–61), the Mughal empire took the shape it was to retain through the end of the seventeenth century.

In his memoirs Jahangir writes of his father with the warmest filial affection even though he, like his own son Shahjahan, rebelled against his father while a prince. Of the emperor's appearance and manner he says: "My father very often conversed with learned men of every sect and religion, especially with the pundits and wise men of India. Even though he was illiterate, because he had associated so much with learned men in discourses, it was impossible to discover from his manner that he was illiterate, and he understood the minutiae of poetry and prose better than can possibly be imagined.

"In stature he was of medium tall build, was wheaten of complexion, and had black eyes and eyebrows. In his countenance refinement preponderated over beauty, and he had the body of a lion, broad in the chest and long of arm. On his left nostril he had an extremely attractive fleshy mole the size of half a pea, and those with expertise in physiognomy held that this mole indicated great prosperity and good fortune. His august voice was loud, and he had an especially nice way of speaking. In his manner and bearing he was not like the people of this world, for in him a divine aura was evident."[1]

Of Akbar's tolerance of religion, a practice followed in large measure by Jahangir, he writes: "There was room in the expanse of my exalted father's peerless realm for practitioners of various sects—unlike other nations in the world, for in Iran there is room for only Shiites and in Turkey, Transoxiana, and Hindustan for only Sunnis. Just as within the vast circle of divine mercy are encompassed all sects and creeds, inasmuch as the Shadow [of God, the king] must be like the [Divine] Essence, in his well-protected realm, the borders of which extend to the great salty ocean, there was room for practitioners of various sects and beliefs, both true and imperfect, and strife and altercation were not allowed. Sunni and Shiite both worshiped in one

mosque, and European and Jew in one church. Universal harmony was his rule, and he conversed with the good and pious of every sect, creed, and religion and attended all according to their condition and understanding."[2]

WMT

Bathed in heavenly light, Akbar (right) stands before his son Jahangir in this double portrait by Balchand. If Jahangir gestures imploringly, and Akbar responds by leaning toward his successor, they do so with good reason. As was so often the case in the Mughal imperial house, father and son were rarely in harmony. Toward the end of Akbar's reign, Jahangir proclaimed himself emperor at Allahabad, where he set up his own court; had not his brothers Murad and Danyal predeceased his father, Jahangir might not have come to the throne. The inscription in the lower margin, written by the picture's patron, Shahjahan, introduces another presence, creating a triad of emperors.

Balchand, a Hindu artist who may have converted to Islam in later life,[3] specialized in imperial subjects, which he painted with humble devotion and tenderness.[4] Although he was allowed within the royal enclosure, even into scenes of imperial intimacy, he sketched from a suitable distance. Akbar's concerned sweetness of expression typifies the gentleness of Balchand's rewardingly restrained but penetrating characterizations, which were executed in immaculately brushed and burnished, crisply edged areas of highly personal color, such as the chocolate brown, faded green, subdued red, black, and violet of Akbar's costume and glove. A painstaking worker with a penchant for arabesques, Balchand lavished these designs on carpets, jewelry, daggers, sashes, gloves, and minute ties of coats.

The mood of Balchand's pictures is solemn and stately. Even as a very young man—as can be seen in his work for the Chester Beatty *Akbarnama*[5]—he portrayed people and animals in arrested motion, as though crystallized. However actively they run or dig, Balchand has consciously posed them as in nineteenth-century

100

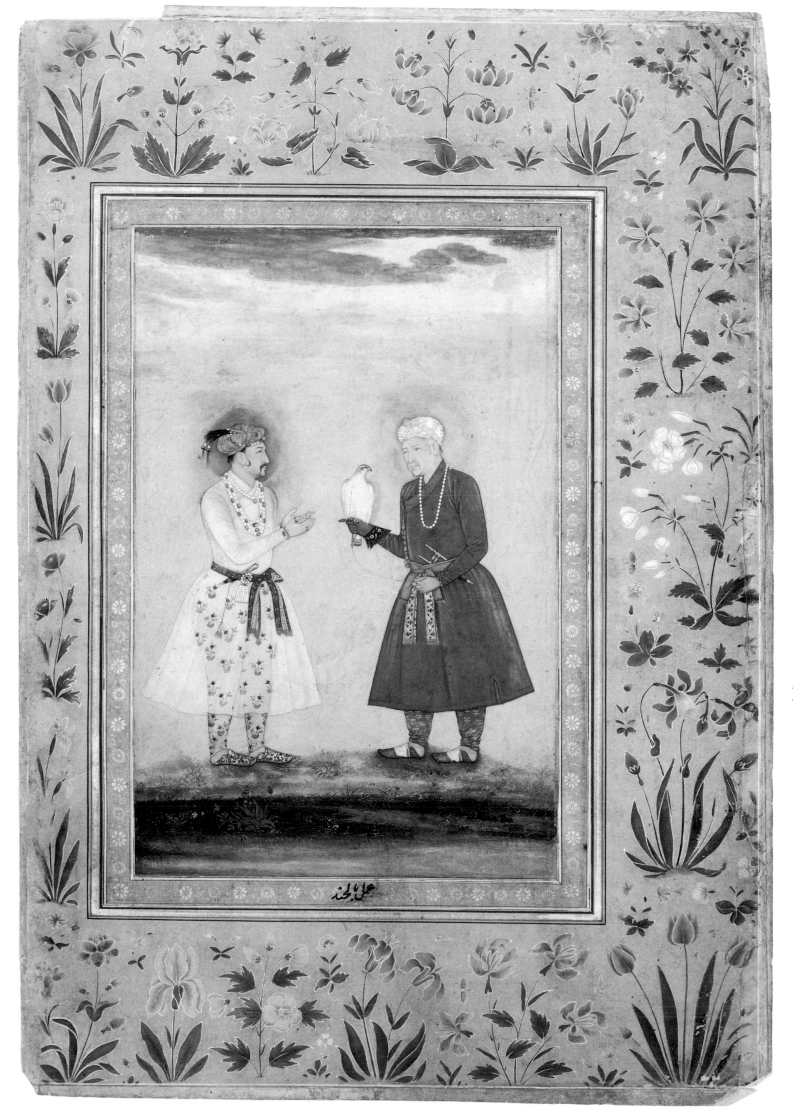

علی بلخی

11

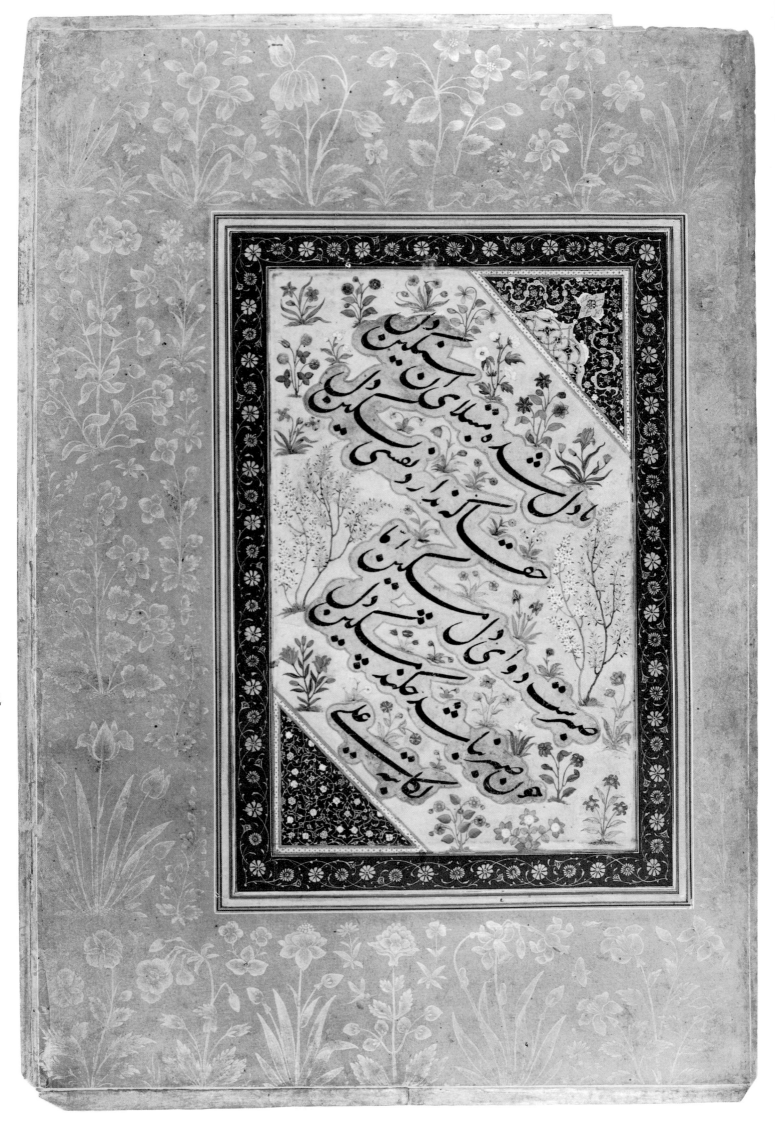

12

photographic tableaux vivants. But he was also a tren- chantly analytic observer, as is apparent from his three miniatures for the Windsor *Padshahnama. Jahangir Receiving Shahjahan Prior to His Departure to Attack Mewar* (fol. 43v; Appendix, fig. 16) recalls Mir Sayyid-ʿAli's record of the Safavid court (Appendix, fig. 15) in its documentation not only of people but also of car- pets, weapons, textiles, glassware, and imperial stan- dards. So knowingly detailed are such objects as the jeweled wand terminating in a carved bird (held over Jahangir by a eunuch) that the artist himself is likely to have designed them. Like his *Shahjahan Attended by His Four Sons* (fol. 72v; Appendix, fig. 17), in which Balchand portrayed himself (arms upraised at left center),[6] this picture reveals the Mughal court with a heightened, almost visionary clarity. Balchand's pro- found—even worshipful—respect for the Mughal fam- ily and his closeness to it are also apparent in his third painting for Shahjahan's history, *Shahjahan Attacks a Lion That Had Thrown Down Anup Singh* (fol. 134r; Appendix, fig. 18). Based upon Abuʾl-Hasan's more im- mediate depiction, it exemplifies the detailed recon- struction of historical incidents admired at the Mughal court.[7]

<div align="right">SCW</div>

Tʜɪs ᴠᴇʀsᴏ ᴘᴀɢᴇ has the margin number 36; it there- fore belongs to Group B. There is no innermost border

of cutout poetry and the inner border is a simple flower- head scroll in gold on a pink ground. The outer border shows the crisply drawn, rather straight-stemmed, and somewhat simplified plants with plenty of air around them, characteristic of this artist, who probably also created the borders for ᴍᴍᴀ fol. 18r and ꜰɢᴀ 39.50b (pls. 52 and 19). Recognizable are a tulip in the lower right corner with perhaps a narcissus-like plant above it and above that a plant whose flowers closely resem- ble the narcissus but whose leaves are not those of the narcissus. In the upper right corner the plant may be a freesia (cult.). In the left border the third plant from the top is a tulip, while below it is a poppy or dian- thus, and below it an iris. The second plant from the left along the bottom is an iris; there is a lily in the center of the bottom.

<div align="right">ᴍʟs</div>

1. Jahangir, *Jahangirnama*, p. 20.
2. Jahangir, *Jahangirnama*, p. 22.
3. See Beach, *Grand Mogul*, p. 95, figs. 5 and 6, for evidence that Balchand tied his jama on the right side, the usual practice of Muslims.
4. See Welch, *Imperial Mughal Painting*, pl. 35, for his touching marriage portrait of Shah Shujaʿ and the daughter of Mir Rustam Safavi, a great courtier who was related to the Safavid royal family.
5. Arnold and Wilkinson, *Beatty Library*, ɪɪ, pl. 24.
6. For enlarged details of this self-portrait and another—from fol. 43v—showing him as a younger man, see Beach, *Grand Mogul*, p. 95.
7. See Welch, *India*, no. 117, a contemporary sketch by Abuʾl-Hasan for the *Jahangirnama* done from firsthand accounts or from observation.

12. Calligraphy

ca. 1540–50

ᴍᴍᴀ 55.121.10.19r

Since this stone-hearted one afflicted my heart,
No moment of rest is there for my heart.
The cure for the poor heart is patience, but oh!
I do not know patience—woe to my poor heart!
By its scribe [*al-katib*], ʿAli

The same quatrain appears on ᴍᴍᴀ fol. 28v (pl. 93) without the phrase "by its scribe."

The general style of the calligraphy seems too hard for Mir-ʿAli, especially the initial letters *m* and *s*, while the style of ᴍᴍᴀ fol. 28v (pl. 93) is more in harmony with his usual style. Yet the signature here suggests that it is his own handwriting.

<div align="right">ᴀs</div>

Tʜᴇ ɪɴɴᴇʀ ʙᴏʀᴅᴇʀ of this recto page is identical to that of the verso except that it is gold on a blue ground. The outer border has gold flowering plants on a pink ground. Since the gold does not stand out distinctly against this soft ground color, plants are very difficult to identify. A tulip appears in the lower left margin, and a stylized iris in the middle right margin; there is a narcissus in the upper left corner and another, proba- bly, in the lower right border. The same artist painted both floral borders of this album leaf.

This album leaf and ᴍᴍᴀ fol. 34r with the margin number 45, a portrait of Mulla Muhammad of Bijapur (pl. 38), have the same border schemes on portrait and calligraphy pages and, since neither has cutout poetry around the portrait, may well have originally been part of the same album.

<div align="right">ᴍʟs</div>

13. Jahangir as the Queller of Rebellion

ca. 1623

INSCRIBED: Abu'l-Hasan

FGA 48.28b

Here one of Jahangir's most painful disappointments has been transformed into a superb miniature by Abu'l-Hasan, a favorite imperial artist.[1] In 1618 Jahangir wrote, "At the present time [Abu'l-Hasan] has no rival or equal. If at this day the masters 'Abdu-l-Hayy and Bihzad were alive, they would have done him justice. His father, Aqa Riza'i of Herat, at the time when I was Prince joined my service. He (Abu'l Hasan) was a *khanazad* of my court. There is, however, no comparison between his work and that of his father (*i.e.*, he is far better than his father). One cannot put them into the same category. My connection was based on my having reared him. From his earliest years up to the present time I have always looked after him, till his art has arrived at this rank. Truly he has become Nadir-i-zaman ("the wonder of the age")."[2]

Abu'l-Hasan was as adept at portraiture, bird and animal studies, still lifes, and landscapes as at architectural scenes seething with figures. In this pictorial fantasy the emperor is portrayed victoriously, on quelling in 1623 the rebellion of his once-favorite son, Prince Shahjahan—henceforth known to him as *be-daulat* (Wretch). His haloed visage expresses omnipotence touched with sorrow and disdain as he surveys the plain below, where the imperial army led by Mahabat Khan (pl. 24) quashes the rebels. In keeping with the meaning of Jahangir's name (World Seizer), he elevates a globe surmounted by the royal seal, which in turn sports a plumed crown, a symbolic creation of utmost artifice, as though it were weightless. To raise him from the mere earth of a flower-tufted hilltop, the emperor stands on a golden taboret worked in relief.

Jahangir's costume is a Mughal masterpiece. Its massive pearls, black and white plumes, harness, weapons, wine-colored leggings, nubbly white shoes, sash, and flaring collars proclaim the wearer's imperial glory. Each sumptuous part—from the black buffalo-skin buckler, adorned with horsemen and footsoldiers drawn in gold, to the orange and gold helmet with blue earflaps—harmonizes so rapturously with the ensemble that one wonders if Abu'l-Hasan did not design as well as paint them. No better garb could be devised for viewing footsoldiers and cavalry, frantic as battling ants.[3]

Abu'l-Hasan's artistic personality was shaped by Jahangir's guidance, by his father's Iranian training, by his study of engravings by Dürer and by Flemish Mannerists, and most of all by his extraordinary sensitivity to the visual world. As a boy of thirteen in 1600, he drew a remarkable Saint John taken from a print by Dürer.[4] But simultaneously he was working in the vigorous Mughal style of Akbar's court, as can be seen in his brilliant *Bullock Cart*, which blends Akbar's powerful idiom and the subtle fineness admired by Jahangir.[5]

Abu'l-Hasan's close involvement with the imperial court provided him with a unique education. Not only did he observe the kaleidoscopic dramas and comedies of Mughal India from the very center, but he also heard the conversations of wits and sages. On the evidence of his illustrations to such Iranian classics as Sa'di's *Bustan* (Garden) and the *Anwar-i Suhayli* (Lights of Canopus) he was also a perceptive reader. His pictures, more than those of any other Mughal artist, reflect the totality of imperial thought and life. Unsurpassed as characterizations, his studies of holy men are as serious and provocative as Govardhan's. But he could also capture an infant's changes of mood from irritation to delight[6] and satirize a petty official's eye-popping outrage.[7]

Abu'l-Hasan was so loyally devoted to Jahangir that his portraits of Shahjahan usually show him as a *be-daulat* rather than as the favorite prince.[8] Although his brother 'Abid painted at least four miniatures for the Windsor *Padshahnama*, signing one of them as the "Brother of Nadir az-zaman of Mashhad," Abu'l-Hasan is not represented in that manuscript. Barely forty years old at the time of Shahjahan's enthronement, he remained Jahangir's artist.

SCW

This verso painting has the margin number 8; it therefore belongs to Group B. It has no cutout poetry around it and no inner border of the usual sort. Its outer border contains flowering plants in gold on a blue ground (neither the plants here nor those on the recto of this leaf are identifiable), with a pair of fancifully rendered birds, which should traditionally be birds of paradise, above the emperor.

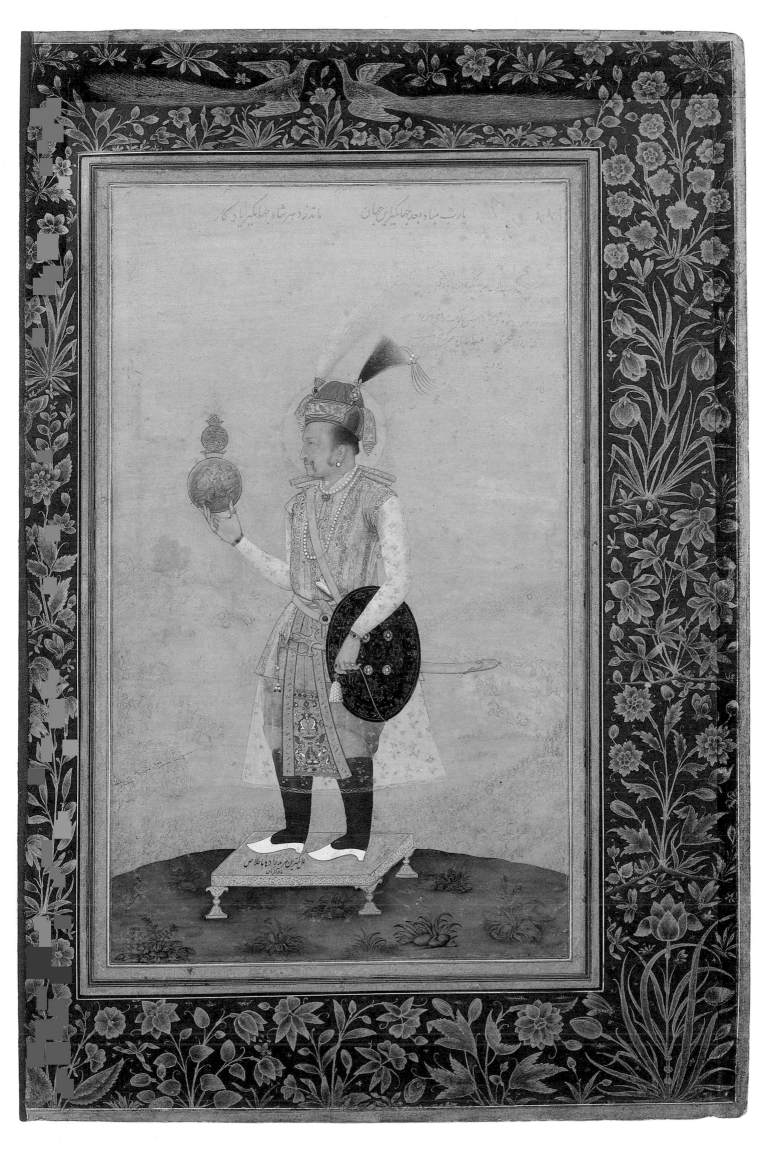

14

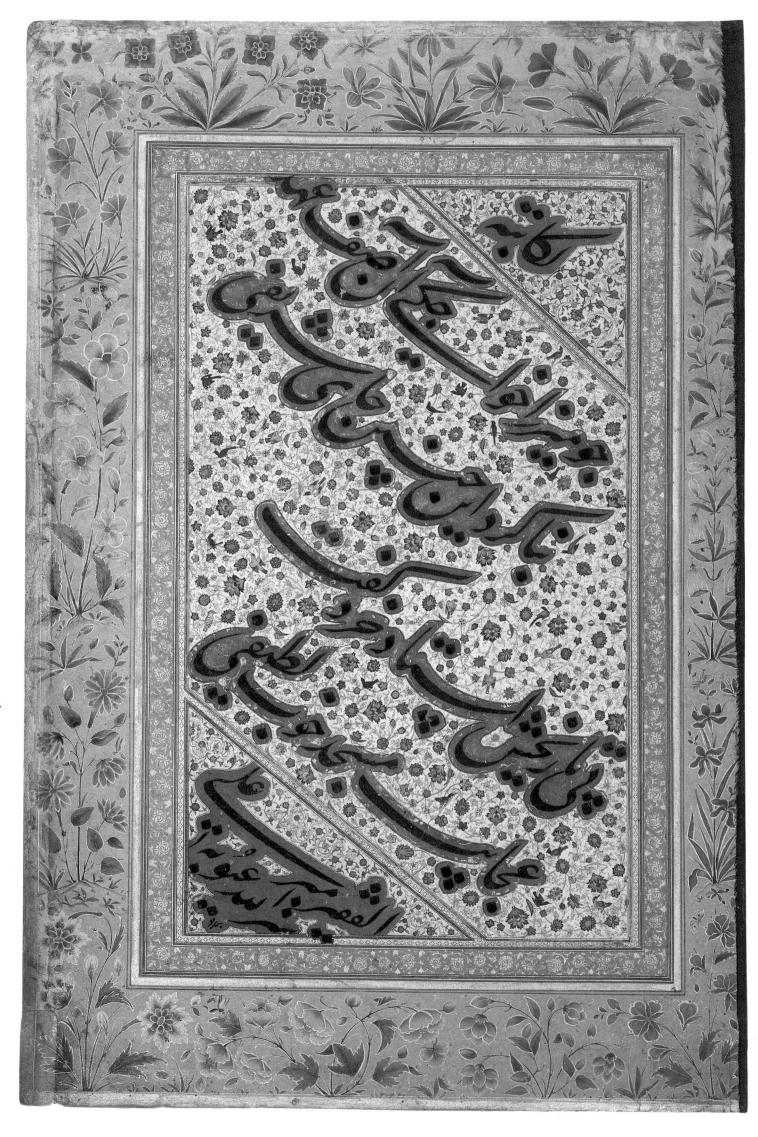

An early nineteenth-century copy of this painting was auctioned at Sotheby's on October 14, 1980, lot 193, illustrated. Unfortunately none of the borders of the group of later copies of seventeenth-century portraits in the Kevorkian Album has been included in the illustrations, so whether or not the border schemes were also copied cannot be confirmed.

<div align="right">MLS</div>

1. It could be claimed that several of Abu'l-Hasan's pictures served to blunt—even exorcize—Jahangir's deeper anxieties by turning them into allegorical paintings. We cite two further examples. Fearful of losing the strategic fortress of Qandahar to the Safavids, Jahangir dreamed that his Iranian rival Shah ʿAbbas appeared in a well of light and made him happy, and he commissioned Abu'l-Hasan to depict the dream in a miniature now in the Freer Gallery (Welch, *Imperial Mughal Painting*, pl.21). Another troubling rivalry, with Malik ʿAmbar of Ahmadnagar, became the subject of Abu'l-Hasan's painted allegory showing Jahangir shooting arrows into the Deccani leader's severed head (see Arnold and Wilkinson, *Beatty Library*, III, pl. 62). A copy of this picture is in the Kevorkian Album (FGA 48.19b; pl. 81) and another is in the collection of Edwin Binney, 3rd (Binney, *Collection*, no. 92).

2. Jahangir, *Tuzuk*, II, p. 20.

3. The Freer Gallery also owns an early nineteenth-century tracing on gazelle skin (*charba*) of this portrait, which is also known from two painted copies, one in the collection of Prince Sadruddin Aga Khan, the other reproduced in Maggs Bros., *Oriental Miniatures*, fig. 12.

4. Gray, "Painting," in *Art of India and Pakistan*, no. 665, pl. 128. The drawing is now in the Reitlinger Collection, Ashmolean Museum, Oxford.

5. See Mehta, *Studies in Indian Painting*, pl. 27; and for a related collaborative miniature, done with his father—*Salim and the Captured Cheetah*—see Welch and Welch, *Arts of the Islamic Book*, no. 60 (see also no. 61 for a related drawing).

6. Beach, *Grand Mogul*, no. 28.

7. Ivanov, Grek, Akimushkin, *Al'bom*, pl. 7.

8. If his *Shahjahan Enthroned* in the Walters Art Gallery (Beach, *Grand Mogul*, no. 29) reveals the emperor as dense and porcine, an oval portrait of the emperor holding the state seal exhibits petulant imperiousness (Welch and Welch, *Arts of the Islamic Book*, no. 71).

14. Calligraphy

Dated A.H. 940/A.D. 1533–34

FGA 48.28a

By its calligrapher

When Mirza Khwajagi, that Asaf of his time,
Built such a noble place,
The intellect invented [the following] chronogram:
"A marvelous, nice, graceful mosque."
 Mir-ʿAli

Asaf was the legendary minister of Solomon and the prototype for civil servants in Islamic poetical language.

The chronogram in the last line expresses the date A.H. 940/A.D. 1533–34.

<div align="right">AS</div>

THE BORDER of this recto page shows flowering plants on a buff ground, and as was the case with the recto page, it has no painted inner border or cutout poetry. This Group B leaf is the only one included in the Kevorkian Album from the album to which it once belonged. The pairs of birds inhabiting the scrolls around the calligraphy have not been identified.

<div align="right">MLS</div>

15. Calligraphy

ca. 1530–45

MMA 55.121.10.23v

Oh you whose absence is an ancient friend
And grief for you an old, consoling friend!
Pain for your sake is our daily guest—
A souvenir from you: scars on our breast.
 The poor [*faqir*] Mir-ʿAli

Both the upper and lower borders contain one line of Chagatay poetry; at the right and left borders are two fragments of Persian ghazals, one signed by Kamal (Khojandi), and a quatrain.

<div align="right">AS</div>

THIS VERSO PAGE has a pattern in gold on a blue ground that is an identical copy of the border, signed by Daulat, of MMA fol. 7v (pl. 27). While the present border is very fine, a close examination of the two reveals that the drawing and brushwork of the signed border are superior. It is interesting to speculate that this prolific border painter worked, perhaps, under the close supervision of Daulat. This would appear to be an odd leaf, not matching in border scheme the other folios of Group B.

<div align="right">MLS</div>

16. Jahangir and Iʿtimaduddaula

ca. 1615

INSCRIBED: (upper right) *Shah Jahangir*; (below) *Manohar banda* (Manohar, slave [of the court]); (on the book) *Allahu akbar. Padishah-i surat u maʿnist az lutf-i ilah. Shah Nuruddin Jahangir ibn Akbar Padshah* (God is the greatest. Nuruddin Jahangir, son of Akbar Shah, is Padishah in form and essence through the grace of God)

MMA 55.121.10.23r

MIRZA GHIYATH BEG was a son of Khwaja Muhammad-Sharif, the chief minister of Tartar-Sultan, the Beglarbegi of Khurasan under the Safavids of Iran. When the family fell on hard times, Mirza Ghiyath Beg set out for India, as many ambitious and talented Iranians had done, to seek his fortune. After the Mirza's resources had been completely exhausted and his wife had given birth to a girl, Mihrunnisa, in Qandahar, a merchant and leader of the caravan in which they were traveling took pity on them; he gave them his protection and introduced Ghiyath Beg to Emperor Akbar at Fatehpur-Sikri. Ghiyath Beg rose in the administrative ranks, and when Jahangir ascended the throne he was awarded the title Iʿtimaduddaula (Reliance of the State).

In 1607 Mihrunnisa's husband Sher-afgan Khan was killed after having mortally wounded Qutbuddin Khan, governor of Bengal, and Mihrunnisa was placed under the care of Jahangir's mother. In 1611 she was married to Jahangir and given the title Nur-Jahan Begum. By virtue of this connection Iʿtimaduddaula became the chief minister of the realm, a position he retained until his death in 1622.

After the death of his father-in-law, Jahangir wrote: "Though he had the burden of responsibility of such a kingdom on his shoulders, and it is not possible for a human being to please everyone when dealing with financial and administrative affairs, yet no one ever went to Iʿtimaduddaula with a petition or business who returned feeling slighted or injured."[1]

Not only a brilliant administrator and royal adviser, Iʿtimaduddaula was an even-tempered, pleasant, and fair man "who did not cherish hatred even against his

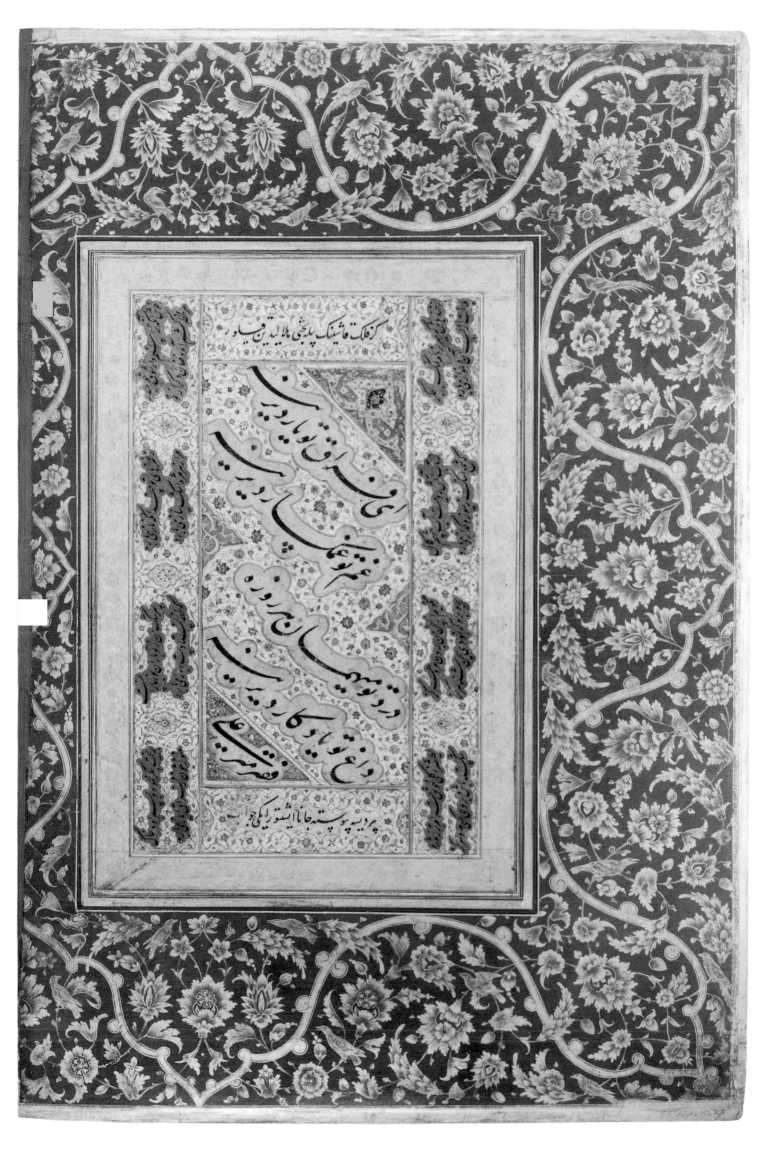

15

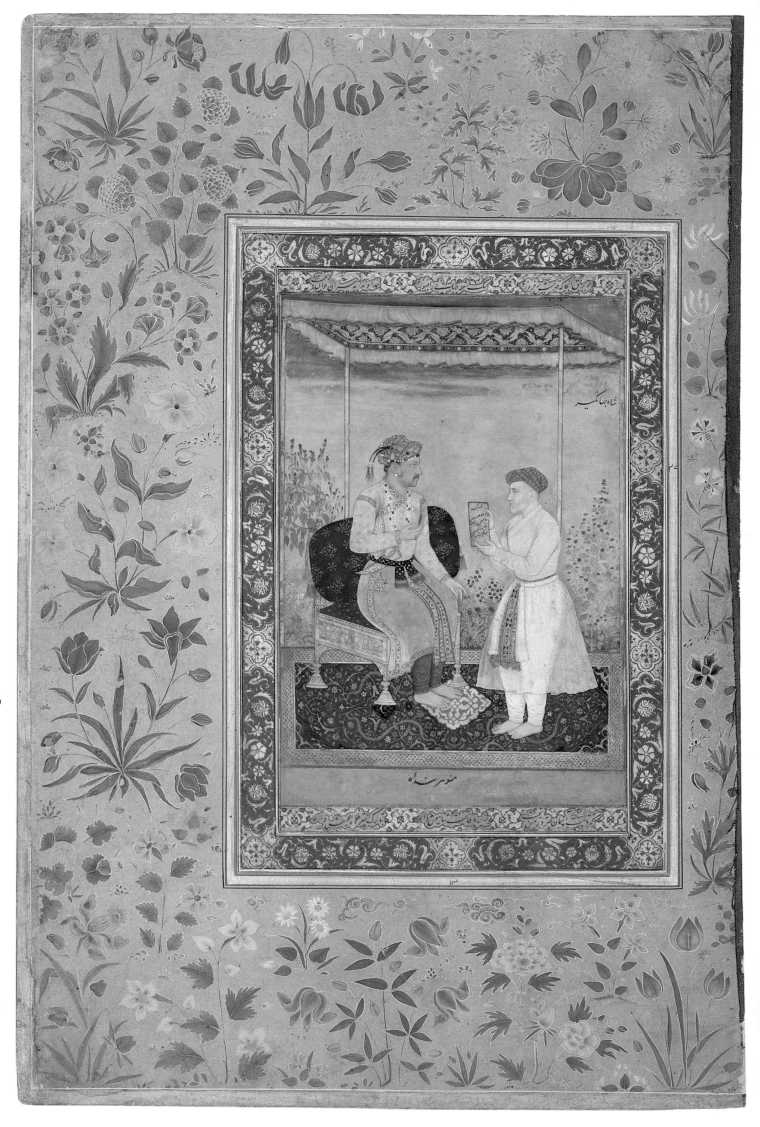

16

enemies."[2] His grief over the death of his wife in his old age caused the emperor to observe that "he maintained the best interests of the state and loyalty to his master, and also kept those in need happy and hopeful. In truth this was his own special style, but from the day his consort went to her eternal reward he lost all interest in himself and from day to day withered away. Although externally he never ceased to manage the affairs of state and administration, inwardly he burned with the fires of loneliness until, after three months and twenty days, he passed away."[3]

WMT

DIGNIFIED AND SERIOUS, the emperor and his father-in-law face one another in respectful silence, as though to demonstrate the increasing formality of the Mughal court. When he commissioned this double portrait, the connoisseurly Jahangir must have been aware of Manohar's unique gift for recording objects. Every sparkling jewel, glint of chased gold, and shimmering textile—from the folkloristic tie-and-dye *patka* to the sumptuous embroideries and brocades—have been rendered in what amounts to a definitive catalogue of these ambulatory imperial treasures—in striking contrast to I'timaduddaula's spartan jewellessness.

Every wrinkle and curl is scrupulously limned, but the isolation of each man reveals the flaw in Manohar's artistic personality. However, if his group portraits offer ranks of specimens sealed in bell jars, his portrayals of individuals can be penetrating. This is particularly apparent in his many uncompromising characterizations of Jahangir, which detail the development of every wrinkle and jowl and provide a clinical dossier of imperial progress from sturdy youthfulness to slightly crapulous middle age.

The son of the renowned painter Basawan, Manohar grew up in the imperial workshops, where his style kept pace with the swiftly changing imperial manner. A superb craftsman, punctilious portraitist and animalier, and inventive designer of textiles, he contributed to most of the major manuscripts and albums from the 1580s into the 1620s. Although this self-effacing painter observed the emperor day-by-day and painted several profound portraits of him, he is not mentioned in Jahangir's *Tuzuk*. Unlike Abu'l-Hasan, he was not blessed with the innovative creative spar-

kle found in Jahangir's foremost painters. In compensation, Manohar stands out as a humble, painterly artist whose arabesques and drapery cavort and ripple with released vitality and express the joy he found in his work.[4]

SCW

THE UPPER and lower levels contain three verses appropriate for the subject; each expresses blessings for "the fortunate ruler" and the "shadow of God" in the *hazaj* meter.

AS

THIS PORTRAIT belongs to Group B. It has the margin number 37 in the right margin; the number 13 is written in the lower margin with a second 13 in the upper border above the left corner of the painting. This would suggest that it was originally intended as the thirteenth folio of an album and later became the thirty-seventh folio of another album. Cutout calligraphy appears at the top and bottom inside the inner border which contains a palmette, flower-head, and arabesque scroll in gold on blue within cartouches. The outer border has colored flowers on a buff ground with a tulip in the lower right corner and possibly a peony next to it. The plant second from the left in the lower border has stylized narcissus flowers with incorrect leaves, appears to have also created the borders for fols. 6v, 17v, 19v, and 29v (pls. 73, 49, 11, and 25).

Another leaf of the Kevorkian Album is a nineteenth-century portrait of I'timaduddaula in a pose very similar to this but in a different costume (FGA 48.20b; pl. 83). That painting also has a gold-on-blue inner border within cartouches and an outer border of colored flowers on a buff ground. Its recto calligraphy page has gold flowers on a blue ground. There is a nervous quality to the drawing not found in seventeenth-century borders.

MLS

1. Jahangir, *Jahangirnama*, p. 386.
2. Shahnawaz Khan, *Maasir*, I, p. 1076.
3. Jahangir, *Jahangirnama*, p. 386.
4. For other penetrating yet stately portraits of Emperor Jahangir attributable to Manohar, see Welch, *India*, nos. 115 and 118. Glenn Lowry's discussion of Manohar, with a list of pictures, is in Beach, *Grand Mogul*, pp. 130–37.

17. Calligraphy

ca. 1500

MMA 55.121.10.32V

By Khwaja Salman [as-Savaji], may God's mercy be upon him.

Coil up in your own tress
 and then ask how I am,
How those are whom the snare
 of your affliction broke:
You want to know how all
 those broken lovers fare—
Then ask me first, for I
 am the most broken one.
 Jotted down [*mashaqahu*] by Sultan-ʿAli Mashhadi

The poem contains puns on the twisted curls which are called "broken" and are compared to snares which capture the hearts of lovers and keep them entangled.

The surrounding poetry consists of two incomplete love poems which were also most probably written by Sultan-ʿAli, for the one on the left contains a ligature typical of his writing.

AS

THIS EXUBERANT and luxuriant treatment of palmettes, leaves, and blossoms on delicately stemmed scrolls in gold on a blue ground is controlled by the finesse and mastery of the drawing. It is very close in brushwork, detail, and overall feeling to the border signed by Daulat (MMA fol. 7v; pl. 27) and in all probability is by the hand of that master. These two folios evidently belonged to the same set as MMA fols. 8 and 37 (pls. 29, 30, 67, and 68).

MLS

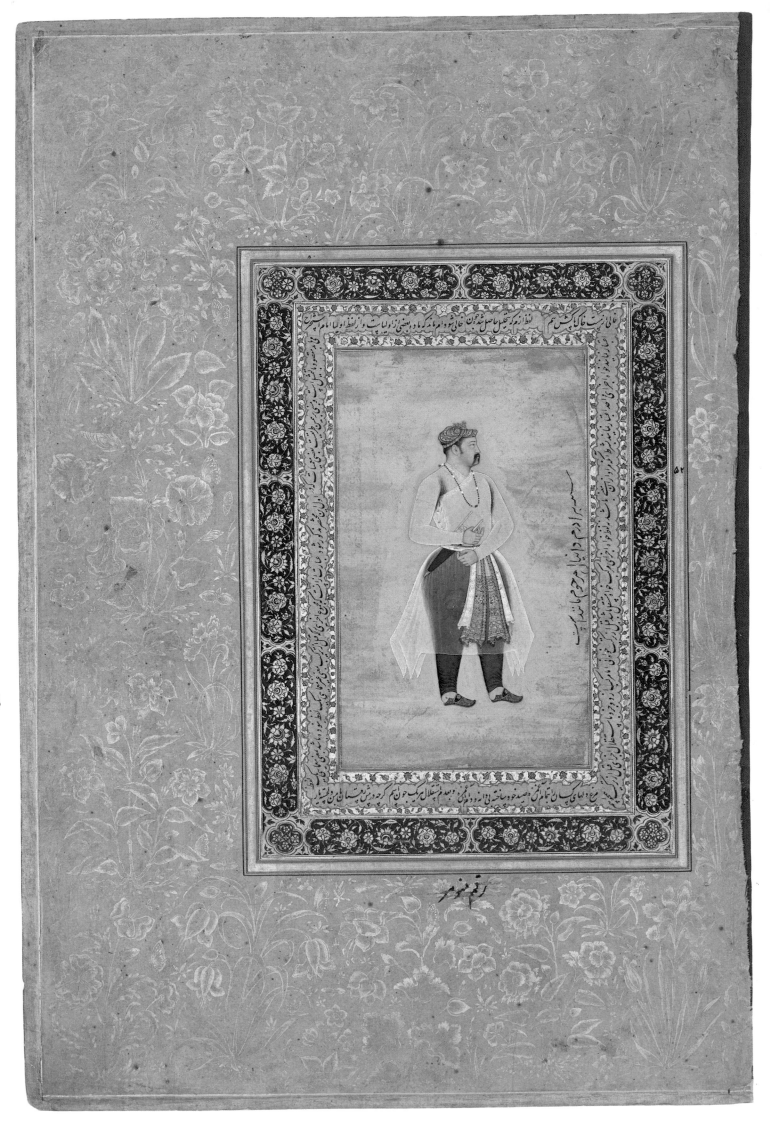

18

18. Prince Danyal

Late sixteenth century

INSCRIBED: (on the picture in Jahangir's hand) *shabih-i baradaram Danyal-i marhum, man-and ast* (a portrait of my late brother Danyal—it is quite like him); (on the border in Jahangir's hand) "drawing [*raqam*] by Manohar"

MMA 55.121.10.32r

THREE YEARS younger than his brother Prince Salim (Jahangir), Prince Danyal was born in 1572, the third son of Akbar. Jahangir writes that, "As his birth took place at Ajmer in the house of one of the attendants of the blessed shrine of the revered Khwaja Mu'inuddin Chishti, whose name was Shaykh Danyal, this child was called Danyal."[1]

After Akbar's conquest of Burhanpur, Prince Danyal was left in charge of that territory, but like his brother Sultan Murad before him, he had already begun to succumb to wine. Several times admonitions were issued by Akbar on the evils of wine and the example of Sultan Murad, who had died at the age of thirty from drinking,[2] but Danyal paid no heed and "however much His Majesty restrained him from such fatal doings, he, inasmuch as he had formed the habit, sacrificed himself to wine"[3] in March 1605. Of his brother's death Jahangir writes in his memoirs: "His death occurred in a peculiar way. He was very fond of guns and of hunting with the gun. He named one of his guns *Yaka-o-janaza* ('the same as the bier'). . . . When his drinking of wine was carried to excess, and the circumstance was reported to my father, firmans of reproach were sent to the Khankhanan. Of course, he forbade it and placed cautious people to look after him properly. When the road to bring wine was completely closed, he began to weep and to importune some of his servants and said: 'Let them bring me wine in any possible way.' He said to Murshid-Quli Khan, a musketeer who was in his immediate service: 'Pour some wine into this *Yaka-o-janaza* and bring it to me.' That wretch, in hope of favor, undertook to do this and poured double-distilled spirit into the gun, which had long been nourished on gunpowder and the scent thereof, and brought it. The rust of the iron was dissolved by the strength of the spirit and mingled with it, and the prince no sooner drank of it than he fell down."[4]

Jahangir also says of his brother's character that he was of "exceedingly agreeable manners and appearance." He was fond of elephants, horses, and hunting and also of Hindi songs, in which language he sometimes composed poetry "which wasn't bad."[5]

WMT

LIKE A natural history specimen mounted for inspection, Prince Danyal—whose features suggest a weaker and coarser Jahangir—is isolated against a pale green ground. Stylistically, this portrait is one of the earliest Mughal miniatures in the Kevorkian Album, conforming in its apple-green ground and in the subject's squat but angular physique and costume[6] to those commissioned by Emperor Akbar for a portrait album "so that, those that have passed away have received new life, and those who are still alive have immortality promised them."[7]

These characterizations were the first examples of deliberately soul-searching naturalism in Islamic or Indian portraiture, intended not only to show outer appearances with the utmost verisimilitude but also to lay bare the sitters' natures. Such psychological studies were so helpful to Akbar and Jahangir in the evaluation of rivals that they encouraged artists to delve ever more deeply into the subtleties of human personality, a factor that influenced the development of Mughal painting.

In keeping with Mughal practice, this portrait was probably painted in the studio after a sketch from life. Danyal's age and the style of the painting date it to the mid-1590s, when the sitter was in his twenties and the artist but a few years older. A powerful drawing of Danyal at a later age (Prince of Wales Museum of Western India, Bombay) can also be assigned to Manohar, who seems to have observed him closely.[8]

SCW

THE SURROUNDING text apparently belongs to the introduction of a treatise on *mu'amma* (riddles). Toward the end the text was put together in the wrong sequence, and the sentence has to be untangled to make sense.

AS

115

THIS RECTO PORTRAIT has the margin number 52 and belongs to Group A. The border contains flowering plants in gold on a pink ground of the same liveliness and delicate brushstrokes as appear in the more abstract design in blue and gold on the verso, suggesting that the same artist—in all likelihood, Daulat—was responsible for both. There is an iris in the lower right corner with another on the inner side of the left margin, with an ipomoea (morning glory) above it and above that a primula. The inner border shows gold flower and leaf scrolls on a blue ground in a pattern of cartouches with the innermost band of cutout poetry having its own narrow guard bands containing a floral scroll. These very narrow guard bands are unusual. Once the dominant outer border format was established, the artist apparently had a certain amount of choice for the rest. Unfortunately there is no way of knowing if the facing portrait, which would have been numbered 51, was also of a member of the royal family.

An early nineteenth-century copy of this portrait was auctioned at Sotheby's on October 14, 1980, lot 189 (not illustrated but description follows original).

<div align="right">MLS</div>

1. Jahangir, *Jahangirnama*, p.20. See also Abu'l-Fazl, *Akbarnama*, II, p. 543.
2. Abu'l-Fazl, *Akbarnama*, III, pp. 1221, 1228.
3. Abu'l-Fazl, *Akbarnama*, III, p. 1254.
4. Jahangir, *Jahangirnama*, p. 21.
5. Jahangir, *Jahangirnama*, p. 21.
6. Danyal wears a transparent cotton four-pointed (*chakdar*) jama which went out of fashion at the imperial court toward the end of the sixteenth century.
7. Abu'l-Fazl, *A'in-i Akbari*, pp. 108–109.
8. Brown, *Indian Painting*, pl. XXI.

19. Calligraphy

ca. 1530–50

FGA 39.50b

THIS PAGE in large calligraphy is signed by Mir-ʿAli. It contains an observation by Hakim Sanaʾi, the mystical poet of Ghazna, concerning a verse of the Koran (Sura 50/16):

The noble Hakim [wise man, philosopher] says concerning [something by] God [lit. "the Divine Truth"]—most high and majestic is He—"And We are closer to him than his jugular vein"; what a pity that you have thrown yourself so far away!

<div align="center">The poor [*faqir*], lowly Mir-ʿAli</div>

To paraphrase, as God has stated that He is closer to man than his jugular vein, it is the greatest loss for man to keep himself from God by sinning and not realizing the closeness of the Lord.

The Persian verses surrounding the calligraphy are by the master poet of Herat, Mulla ʿAbdur-Rahman Jami.

> Oh you with tranquil heart:
> the state of suffering hearts—
> how can you know it?
> How lovers drink their blood
> and eat their hearts from grief—
> how can you know it?

> You, whose protected foot
> was never pricked by thorns,
> The grief of those whose breast
> is wounded, torn apart—
> how can you know it?
> Undisturbed and asleep
> in privacy till morn:
> The sleeplessness of those
> whose eyes are wide awake—
> how can you know it?
> Oh doves that circle high
> above the cypress trees:
> The heartache of those birds
> imprisoned in the cage—
> how can you know it?
> Jami, you and your cup of wine,
> you're high and swoon—
> Tell me, the way and walk
> of sober prudent men—
> how can you know it?

In the last verse there is a pun on *jam* (cup) and the name of the poet, Jami.

The lower lines of the border contain the following *rubaʿi*:

116

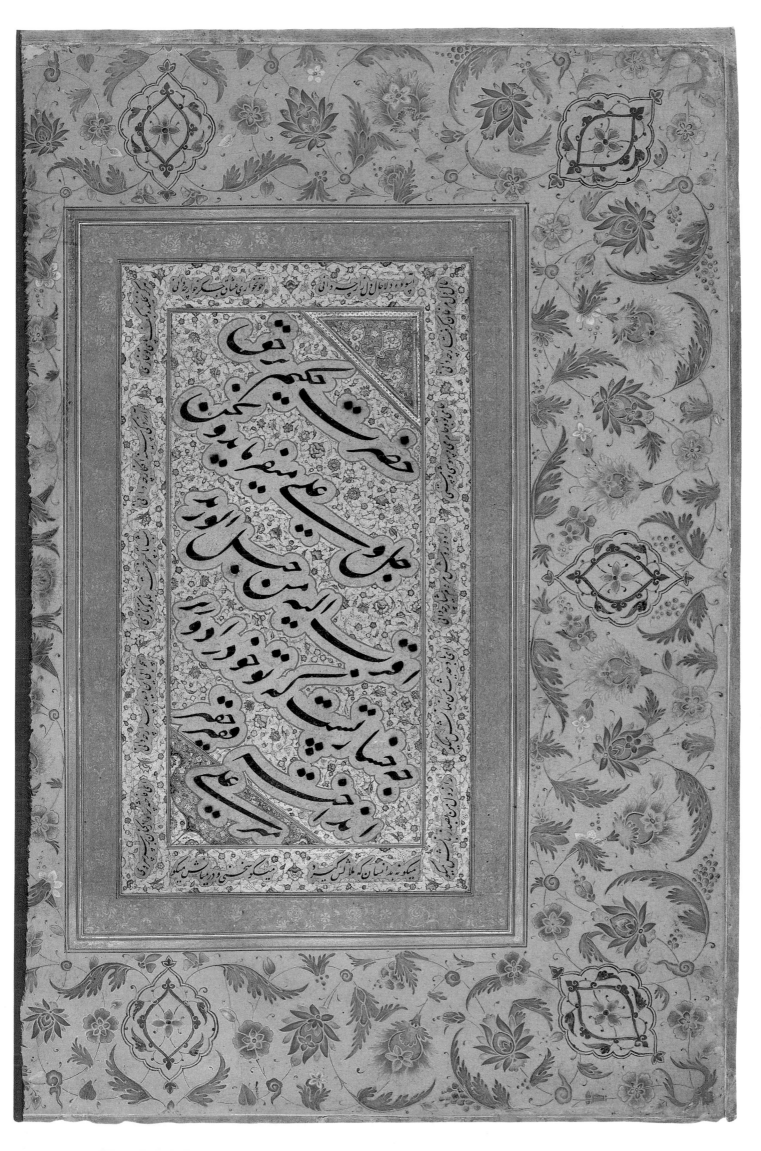

19

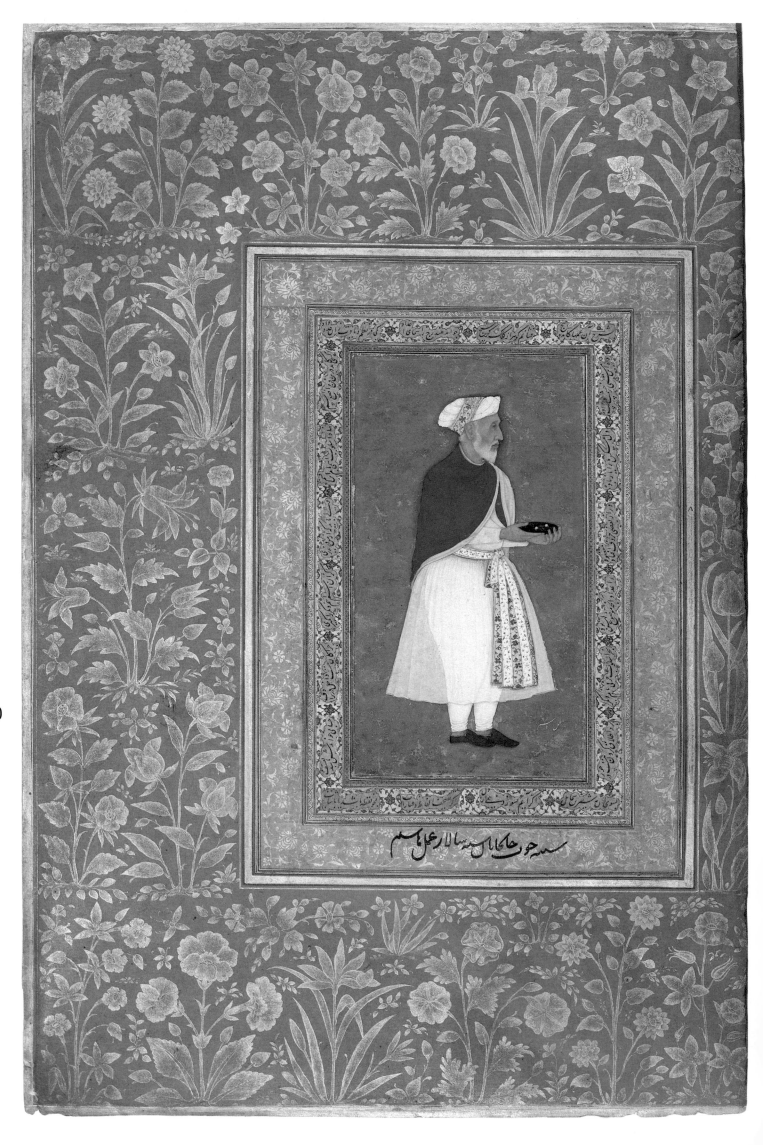

20

Oh Zephir, tell me secretly my story!
Tell with a hundred tongues what's in my heart!
Don't tell it so that boredom overcomes him—
Say now and then a word, just now and then.

<div align="right">AS</div>

T HIS VERSO PAGE has an extremely finely painted border with the pattern of a scroll bearing leaves, palmettes, and flower heads in delicate colors on a buff ground, with five superimposed oval cartouches. This border is very close in drawing, coloring, and decorative scheme to that on MMA fol. 18v (pl. 51); this similarity indicates that one artist was responsible for both leaves.

This leaf could not have belonged to the Group A album designated 3 because the numbering sequence of that album demands plants in color on a buff ground as the calligraphy border. If, of course, albums 1, 2, and 3 of Group A originally belonged together, this leaf could not have belonged to any of the three.

<div align="right">MLS</div>

20. Khankhanan ʿAbdur-Rahim

ca. 1625

INSCRIBED: (on the border in Shahjahan's hand) "a good likeness of Khankhanan the commander [sipahsalar], work [ʿamal] of Hashim"; (on the picture, probably in the artist's hand) "work of Hashim"

FGA 39.50a

ᶜABDUR-RAHIM (1556 1627) was the son of Bayram Khan, to whom Humayun owed the restoration of his Indian kingdom. Bayram Khan had served young Akbar for four years until he was ousted and, after a short reconciliation with the emperor, went to perform the pilgrimage to Mecca, and was assassinated on the way (January 1561). Akbar brought up the son of his old friend, and the boy, who had inherited his father's poetic and military skills, grew up to become one of the most successful officers in Akbar's army. Akbar took him to Gujarat and made him governor there; a decade later—in 1584—he reconquered the rebellious province for the Mughals. Until then called Mirza Khan and farzand (son [of the emperor]), he now inherited his father's title Khankhanan under which he became famous. For some years he was the tutor of Prince Salim (Jahangir), and in 1590–91 he went out to conquer Sind for Akbar. After his return he was soon put in charge of the Deccani war, and he stayed, with interruptions, in Sironj and then in Burhanpur, which he adorned with numerous buildings. His sons grew into excellent soldiers and were very much loved by Jahangir, to whose court the Khankhanan came several times although the relations between the two were not always cordial. The Khankhanan's daughter was married to Akbar's son Danyal, who died in 1605; his eldest son's daughter married Prince Khurram (Shahjahan). Understandably, the Khankhanan sided with Shahjahan when he rebelled against his father, but through obscure machinations he seemed to try to go over to Prince Parviz and Mahabat Khan. Kept under surveillance by Shahjahan, he was again sent as an envoy to Mahabat Khan and, due to some inexplicable events, changed sides and stayed with Parviz. His last surviving son, Darab, who had been Shahjahan's governor in Bengal, was captured and decapitated by Mahabat Khan, and his head, wrapped up as a melon, was sent to the Khankhanan.

It was after these events that Hashim painted the old generalissimo, who was in the end forgiven by his former student Jahangir and reinstalled in full honor in late October 1625. He could not do much, but he was in charge of fighting the rebellious Mahabat Khan. He died in Delhi in early 1627 and was buried in the beautiful mausoleum which he had erected between Humayun's tomb and the shrine of Nizamuddin Auliya when his beloved wife (the sister of Akbar's foster-brother Mirza ʿAziz Koka) had died in 1599.

<div align="right">119</div>

The Khankhanan is remembered not so much for his military skills but for his activities as the greatest patron of poetry and the arts in his time and perhaps in Islamic history. From his early youth he not only composed fine short verses in Persian, Hindi, and Turki but also patronized poets and kept a library where in later days some ninety people were employed. The great poets of the Indian style of Persian such as ʿUrfi (d. 1591) and the Khankhanan's favorite Naziri (d. 1612) wrote eulogies for him. His biography, *Maʿathir-i rahimi*, contains the names of more than a hundred Persian poets who composed hymns in his praise. Painters and calligraphers were active in his library, and he was an avid collector of books in the handwriting of the authors themselves. His superb command of both Persian and Turkish is proven by his Persian translation of Babur's Turki memoirs, which he presented to Akbar in November 1589. His knowledge of Arabic was very good, and it is claimed that he learned some Portuguese to talk to the merchants in the port of Surat and elsewhere.

The Khankhanan's magnanimity was boundless, and he loved to shower gifts on everyone, including stray visitors and poor travelers, so that even today his name represents the greatest generosity among both Muslims and Hindus in the Subcontinent. Although later sources, probably under the influence of some inimical factions at Jahangir's and Shahjahan's courts, claimed that he was treacherous, this view does not agree with the general picture of his generosity or with the fact that he had very strong inclinations toward mysticism, not only being a close friend of the leading Sufis of his time but also apparently being interested in the Hindi *bhakti* movement, as his own verse proves.

This miniature—the last in a long line of portraits, the first of which shows him as a four-year-old presented to Akbar—reflects little of his previous greatness and rank. Only the two pearls and the ruby which he seems to offer (probably to Jahangir when he was reinstalled in office) remind the spectator that the Khankhanan sighed, toward the end of his life, that life was not worth living unless one could give generously.

<div align="right">A S</div>

THIS IS the most penetrating and poignant portrait of the Khankhanan, who for many years represented the empire in the Deccan. It was painted about 1625 and inscribed by Hashim, an artist from that region who became the resident Deccani specialist of the imperial studios. To sweeten a soured relationship, the weary and troubled old gentleman humbly offers the emperor a tray of jewels. Hashim's highly distilled char-

acterization could only have been painted after long association with the Khankhanan. Indeed, one senses the artist's gratitude toward this failing but extraordinary man. He had probably been Hashim's first Mughal patron, at Burhanpur in the Deccan, and he may have introduced the artist to Prince Khurram (Shahjahan) who in turn brought him to the attention of Emperor Jahangir.

Hashim's career was long, brilliant, and varied, progressing from Bijapur, or perhaps Ahmadnagar, to Burhanpur, thence to Mughal Hindustan, and on occasion back to the Deccan. His deliberate, powerful, but floriate line and probity of characterization rank him as an Indian Ingres. The earliest of his identifiable works is one of the most strikingly forceful portraits in Indian art. It depicts Malik ʿAmbar, the mighty statesman and general of Ahmadnagar (Appendix, fig. 19), who was born in Ethiopia in about 1546, sold as a slave, and ultimately reached Ahmadnagar. Intelligence, ambition, and toughness brought him the chief ministership under the Nizamshahi sultan. By 1600 he was the most powerful figure not only in Ahmadnagar but throughout the Deccan and hence was the chief rival to the Mughals in all of India.[1] Hashim decocted the rugged Abyssinian's essence to the point of acrid harshness, envisioning him in a starkly simplified, austerely dignified style. Still a dynamic soldier-statesman in his late sixties, he was probably painted by the young artist—for the Khankhanan?—in 1617. At this bleak moment the great *habashi* (black man) had been defeated by the Mughals and was compelled to bow before Prince Khurram (Shahjahan), who had joined the Khankhanan at Burhanpur. The occasional allies Sultan Ibrahim ʿAdilshah of Bijapur (pl. 35) and Malik ʿAmbar of Ahmadnagar agreed to surrender Ahmadnagar and other forts to the Mughals, to whom they also gave gifts worth a million and a half rupees. Accompanying these, we suspect, was this portrait— and Hashim himself, an admired artist to provide Jahangir with exacting portrayals of Deccani friends and enemies.

All the seeds of Hashim's artistic personality are evident in the Boston portrait—the lightning-flash silhouette, with its craggy features, the plump trunk, arms, and legs, and the strikingly original palette of pink, red, orange, very dark blue-brown, whites, and gold. Like Hashim's later miniatures—including the Kevorkian Khankhanan—it was painted with nautical precision, in sweeping rhythms taut as sails trimmed for a spanking breeze. A lover of diaphanous muslins, Hashim painted *kurtas* (shirts) and pajamas with controlled, gracefully shipshape contour lines, collars and

120

soles of slippers double- or triple-edged in stitching seaworthy as rigging. Folds and wrinkles hug the skin, flow around arms or down chests, eddying in ripples at armpits, gathering tautly over bulky stomachs, and ending at shirt hems in graceful waves. Forms are nobly vigorous and rounded, emphasized by light pigment just within the outlines. Feet and hands are large and sturdy, as are the sitters' attributes: *talwars* (swords) and *katars* (daggers), immaculately drawn, enriched in brilliantly burnished gold, often incised with glittering striations and blazing with painted jewels. Pearl or gold tassels arc from gold chains, attached to *patkas* (sashes) or to the characteristic harnesses of Ahmadnagar, from which tubular containers for firmans (state documents) frequently hang. In his portraits of Deccani personages, textiles are often adorned with geometricized floral arabesques known from surviving but later Aurangabadi examples. Hashim painted strong yet gentle hands with rounded fingertips, perhaps based upon his own. His treatment of eyes varied from the fish-shaped formula of his Deccani work to the calligraphically tempered naturalism of his Mughal period. Ears are accurately observed but conform to Hashim's pleasingly abstracted convolutions of form.[2]

Hashim never entirely shed the lyrical Deccani style of his youth.[3] His later flowering under the Mughals, as represented in the present portrait, retains the luxuriant flourishes of Ahmadnagar and Bijapur. Hashim, however, blended his Deccani ways with the understated norm of imperial naturalism. Under the Mughal aegis his characterizations gained in nuance and his line was honed to scarcely visible sharpness.[4]

At the imperial court Hashim sometimes ventured beyond painting intensely characterized silhouetted single figures to the more challenging double portraits and ultimately to highly complex group compositions. His masterly depiction of human interaction is apparent in two sketches, an animated and humorous study in East Berlin of two musicians from Delhi[5] and a moving sketch in ink and gold in the Bristol City Art Gallery of Dara-Shikoh's ill-fated son Sulayman-Shikoh absorbed by the words of his bearded tutor.[6] Two miniatures in the Windsor *Padshahnama*, are recognizable as Hashim's ambitious initial attempts to paint many figures and animals in landscape settings (*Shahjahan Hunting near Palam*, fol. 164r; and *Shahjahan Shooting Lions with Shah Shuja* and *Dara-Shikoh near Palam*, fol. 219v; Appendix, figs. 20 and 21).[7] His culminating works in this imperial mode, also attributable to him on stylistic grounds, were painted for Emperor Aurangzeb soon after his accession.[8]

SCW

THE PORTRAIT is surrounded by fragments of a text concerning *mu'amma*, riddles on names.

AS

THIS RECTO PORTRAIT has the margin number 8 and belongs to Group A. Its extremely fine border of gold flowers on blue is very close in composition to the border surrounding the dancing dervishes (MMA fol. 8v; pl. 52) and has the same idiosyncratic little leaves spreading from the bottom of the plants. It also has little insects, cloud bands, and tiny plant and grass sprays. The plants in this border appear to include a tulip on the right side, an iris in the upper border, and stylized irises in the left and lower borders. The two folios are almost certainly by the same hand.

MLS

1. See Coomaraswamy, *Catalogue of the Indian Collections in the MFA, Boston*, XI, pl. XXXVIII, no. 13.3103. For an account of Malik 'Ambar, see *History of Medieval Deccan*, I, pp.261–69.
2. For an excellent example of Hashim's forceful but elegant portraiture, see his *Abyssinian from Ahmadnagar*, probably Malik 'Ambar's son Fath Khan, who yielded Daulatabad Fort to the Mughals in 1633 (Welch, *Imperial Mughal Painting*, pl. 34).
3. See Zebrowski, *Deccani Painting*, chaps. 3–6; and Welch, *India*, pp. 284–328.
4. See Beach, *Grand Mogul*, no. 45, detail p. 129, where this is clearly apparent in the razor-thin line between Shahjahan's forehead and turban.
5. Ettinghausen and Schroeder, *Iranian and Islamic Art*, no. O 598.
6. Welch, *Indian Drawings and Painted Sketches*, no. 20.
7. Hashim probably began to paint crowded historical subjects with the assistance of Hunhar, whose *Battle of Shah Bargan* for the *Padshahnama* was recently acquired by the Metropolitan Museum (see *Recent Acquisitions: A Selection 1986–1987*, New York, 1987). Although far less sensitive and masterful than Hashim in characterization and brushwork, Hunhar seems to have instructed the older man in the disposition of figures and animals in space in return for guidance in portraiture and arabesques.
8. See Welch, *Art of Mughal India*, nos. 58, 59, and 60 and fig. 6; Welch, *India*, no. 176. Another large hunting scene (Arnold and Wilkinson, *Beatty Library*, III, pl. 91) can be assigned to Hunhar working under the supervision of Hashim.
The following miniatures and drawings are essential to the understanding of Hashim's personality and artistic development:
1. *Portrait of an Abyssinian* (probably Malik 'Ambar), attributable to Hashim, Ahmadnagar, early seventeenth century; Museum of Fine Arts, Boston, no. 17.3103 (Coomaraswamy, *Catalogue of the Indian Collections in the MFA, Boston*, VI, pl. XXXVIII).
2. *Mulla Muhammad Khan*, MMA fol. 34r (pl. 38).
3. *Sultan Ibrahim 'Adilshah II*, MMA fol. 33v (pl. 35).
4. *An Abyssinian from Ahmadnagar*, probably Fath Khan of Ahmadnagar, signed "Work ['amal] of Hashim," ca. 1633 (Welch, *Imperial Mughal Painting*, pl. 34; Beach, *Grand Mogul*, no. 44).
5. *Jewel-Portrait of Shahjahan*, signed; Cleveland Museum of Art.
6. *Shahjahan in Old Age*, signed "Work ['amal] of Hashim," mid-seventeenth century (Welch, "Mughal and Deccani Miniature Paintings," no. 18, fig. 18).
7. *Prince Sulayman-Shikoh and His Tutor*, inscribed "Work ['amal] of Hashim," ca. 1645; Bristol City Art Gallery (Welch, *Indian Drawings and Painted Sketches*, no. 20).
For an early nineteenth-century traced drawing splotched with color to guide the copyist, also ascribed to Hashim, see *Loan Exhibition of Antiquities*, no. C.104, pl. XLb.

21. Sayf Khan Barha

ca. 1610–15

INSCRIBED: (in Shahjahan's hand) *shabih-i Sayyid Sayfkhan Barha, 'amal-i Nanha* (a portrait of Sayyid Sayf Khan Barha, done by Nanha)

MMA 55.121.10.4v

SAYYID 'ALI-ASGHAR, son of Sayyid Mahmud Khan Barha of the Barha Sayyids, who played a prominent role in the Mughal aristocracy, was a favorite of Jahangir from his days as a prince. In 1606 Jahangir wrote in his memoirs: "I have bestowed on 'Ali-Asghar Barha, who has not a rival in bravery and zeal, ... the title of Sayf Khan and thus distinguished him among his equals and peers. He seems to be a very brave youth and was always one of those few confidants who went with me on hunts and other places. He has never in his life drunk anything intoxicating. Inasmuch as he has maintained this practice during his youth, he will soon attain high dignities."[1]

In the first year of Jahangir's reign, Sayf Khan distinguished himself in a battle against Prince Khusrau near Lahore. His rank was increased over the years, and he was deputed with Prince Khurram (Shahjahan) in the campaign against Rana Amar Singh of Mewar in the eighth year of Jahangir's reign. In the tenth year he was attached to Prince Parviz in the Deccan campaign. He died in 1616 (eleventh year of Jahangir's reign) of cholera.

WMT

LIKE SHAHJAHAN, Nanha admired Sayf Khan Barha's rugged strength and integrity, characteristics evident from his solid stance and straight-forward expression. Nanha was an artist of deep conviction who more than any other Mughal painter appeals to our sense of touch. By exaggerating the fullness of chests, upper arms, or thighs and compacting or attenuating proportions, he sacrificed accuracy to increase empathy. We feel the pressure of Sayf Khan's firm grip on his sword; indeed, so fully does Nanha's picture awaken our senses that we prick our ears for Sayf Khan's voice.

Although Nanha's pictures followed the changes of Mughal style from the 1580s into the first decade of Shahjahan's reign, his work is also identifiable by his treatment of such details as hands and faces and by his knack for entering the spirits of his subjects.[2]

SCW

THE MINIATURE is surrounded by a mystical *mathnavi* in Chagatay Turkish. The lower lines carry the name Sam (i.e., Sam Mirza, the art-loving Safavid prince who was for some years in charge of the city of Herat). There is an isolated verse at the end.

AS

THIS VERSO PORTRAIT bears the margin number 5 and belongs to Group A. The plants, gold on a blue ground, are separated by tiny plants and grass tufts. A single insect appears in the lower margin. The added dimension of color would help here in the identification of hands. It certainly displays a very different painting style from the dense, almost wild treatment of MMA fol. 5r (pl. 66).

A tulip appears in the left margin and as a small plant at the top center. There is a narcissus in the upper left corner. Poppy types appear in the two plants in the top middle, in the upper right corner, and perhaps second in from the lower right corner, although the flowers are not quite right. The plant in the lower right corner can be identified as a cyclamen type by its flowers although the leaves are wrong. The second plant from the left in the lower margin may possibly be identified as *Lilium fritillaria*.

The birds in the branches around the cutout calligraphy surrounding the portrait have been identified as follows: rose-ringed parakeet(?); *Psittacule krameri*(?), in the middle of the right side; magpie robin (*Copsychus saularis*), at the bottom at the left; Brahminy myna (*Sturnus pagodarum*), second from the top, left margin.

MLS

1. Jahangir, *Jahangirnama*, p. 19. See also Shahnawaz Khan, *Maasir*, II, pp. 692ff.
2. For an extensive survey of Nanha's work, see Beach, *Grand Mogul*, pp. 147–50.

122

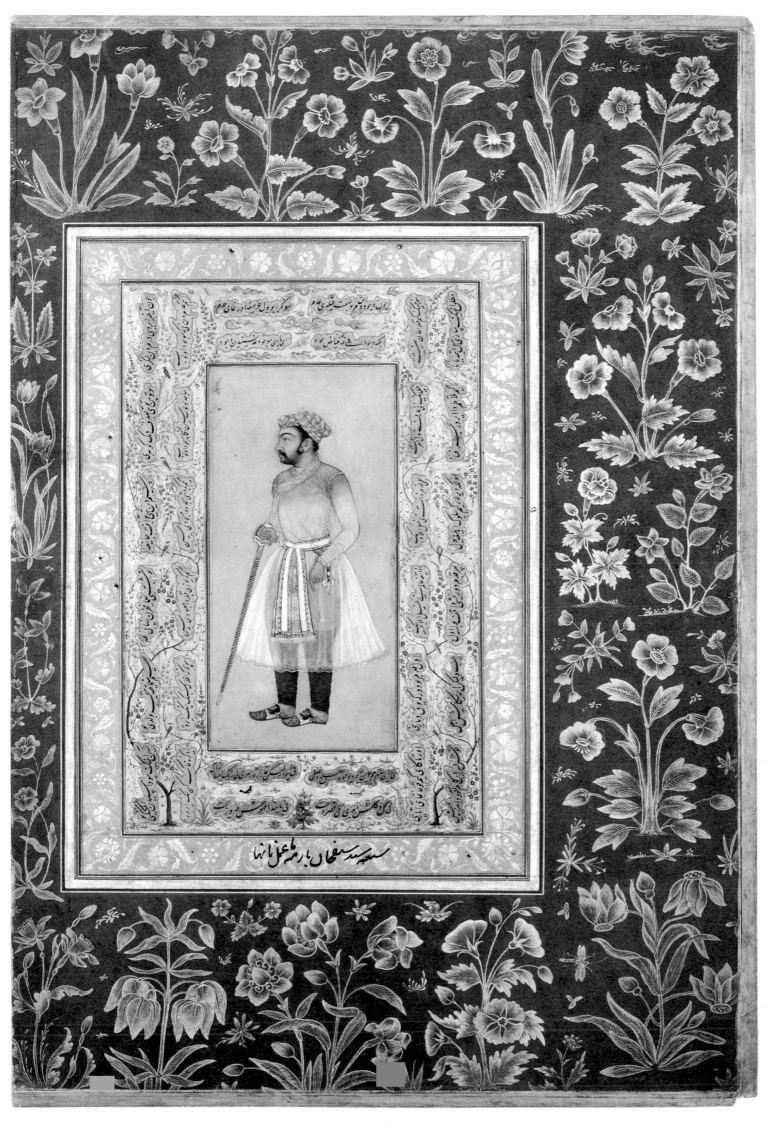

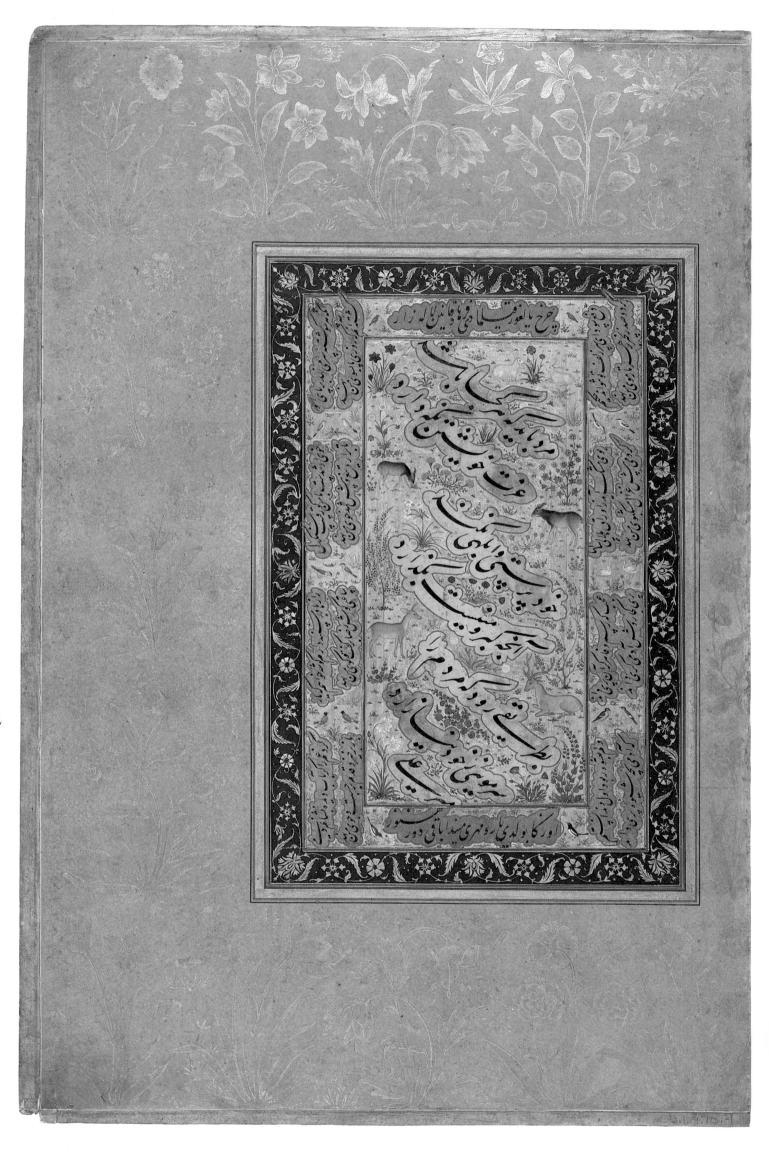

22

22. Calligraphy

ca. 1535–45

MMA 55.121.10.4r

A true man should, where'er he be,
Preserve his honor well;
Show no conceit or foolishness
Or selfish pride in life
And act so that nobody's hair
Is touched or hurt by him.
 Mir-ʿAli

The same poem is found in CB 7/37v.

The page is surrounded by a ghazal by Hilali and a quatrain; above and below is one line of Chagatay Turkish poetry in a very elegant hand, which may well be that of Sultan-ʿAli Mashhadi.

AS

THE BORDER of gold plants on a pink ground has very much the same arrangement of plants as the verso, but they are not identifiable. The birds surrounding the cutout verses bordering the main calligraphy panel have been identified as follows: great gray shrike (?) (*Lanius excubitor* [?]), right side at top; egret (*Egretta* species?), middle of right side; common myna (?) (*Acridotheria tristis* [?]) pair, lower right side; magpie robin (*Copsychus saularis*) pair, bottom, female at left, male at right; red-vented bulbul (*Pycnonotus cafer*) pair, lower left side; Brahminy starling (*Sturnus pagodarum*) pair, middle of left side; white-throated Munia (*Lonchura malabarica*) pair, upper left side. The animals surrounding the central calligraphy verses are, from bottom to top, a pair of sambars (*Cervus*); perhaps a pair of nilgai (*Boselaphus tragocamelus*), and a pair of goats (*Capra*).

The stylistic differences between these borders and those of MMA fol. 5 (pls. 65 and 66) do not militate against their belonging to the same original album since their numbers indicate that they would have been widely separated. This folio, however, could not have belonged to the album called number 3 here, because it would have to have had a gold-on-pink color scheme on the portrait side. If, as is possible, the albums designated 1 and 3 were actually one album, these two leaves must have belonged to a different album. For convenience these two leaves will be called Album 4.

MLS

125

23. Calligraphy

ca. 1530–40

MMA 55.121.10.3v

Maulana Mir-Husayni says
[a riddle] about the name *Bahman.*

O grief, that the good news of union was finally delayed,
And that the heart, a house full of grief, was finally upset.
Tell the messenger of death that my heart has finally enough
Of life without the cheek of that moon of fourteen.
 Written by the poor sinful slave ʿAli the scribe [*al-katib*]

The "moon of fourteen [days]," i.e., the full moon, is the ideal beautiful young beloved, preferably fourteen years old. However, the meaning of the riddle remains incomprehensible to the uninitiated.

The calligraphy is surrounded by verses by Auhadi Kirmani, written in minute script.

A S

THE UNUSUALLY large plants on this verso page are similar to those on the recto. There is, however, much more space around them, although they are surrounded by tiny plants. As bold as that of the recto, the border here is restrained and tranquil. The plants along the top may be identified as *Codonopsis,* left corner; narcissus, center; poppy, next right, and *Lilium,* right corner. A chrysanthemum type is in the middle right border, with a primula in the lower right corner and a poppy next to it. Third from the bottom in the inner border is a *Melanopsis,* with an iris above it.

M L S

126

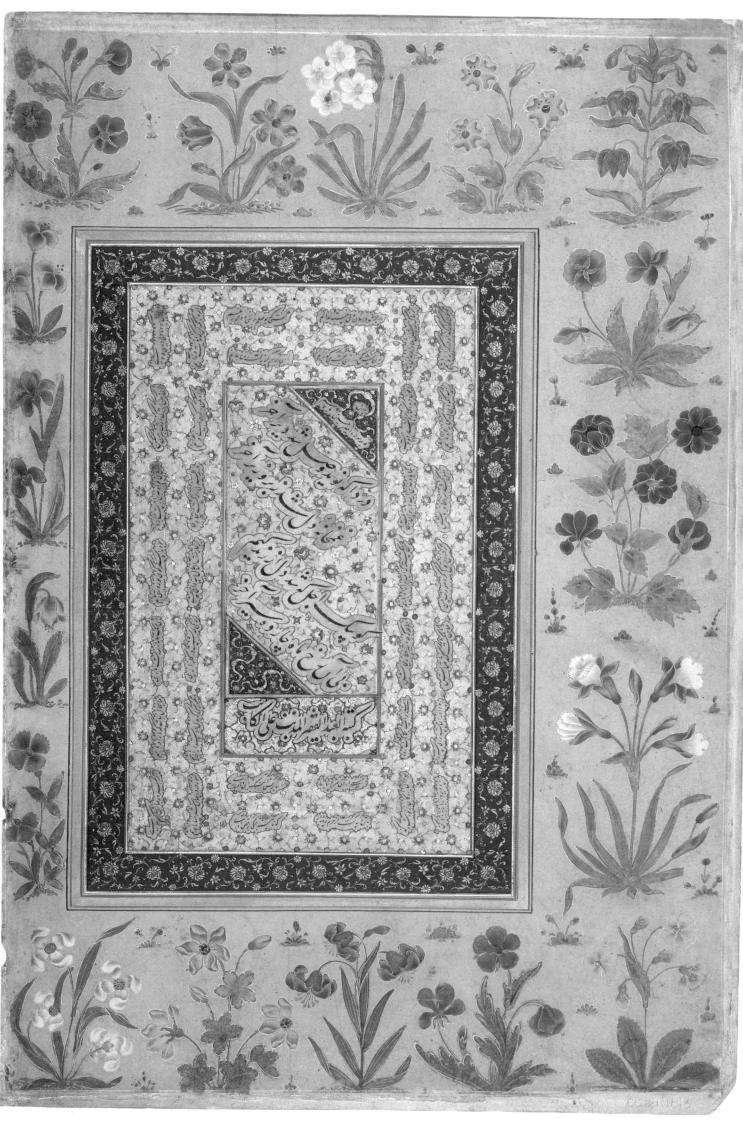

23

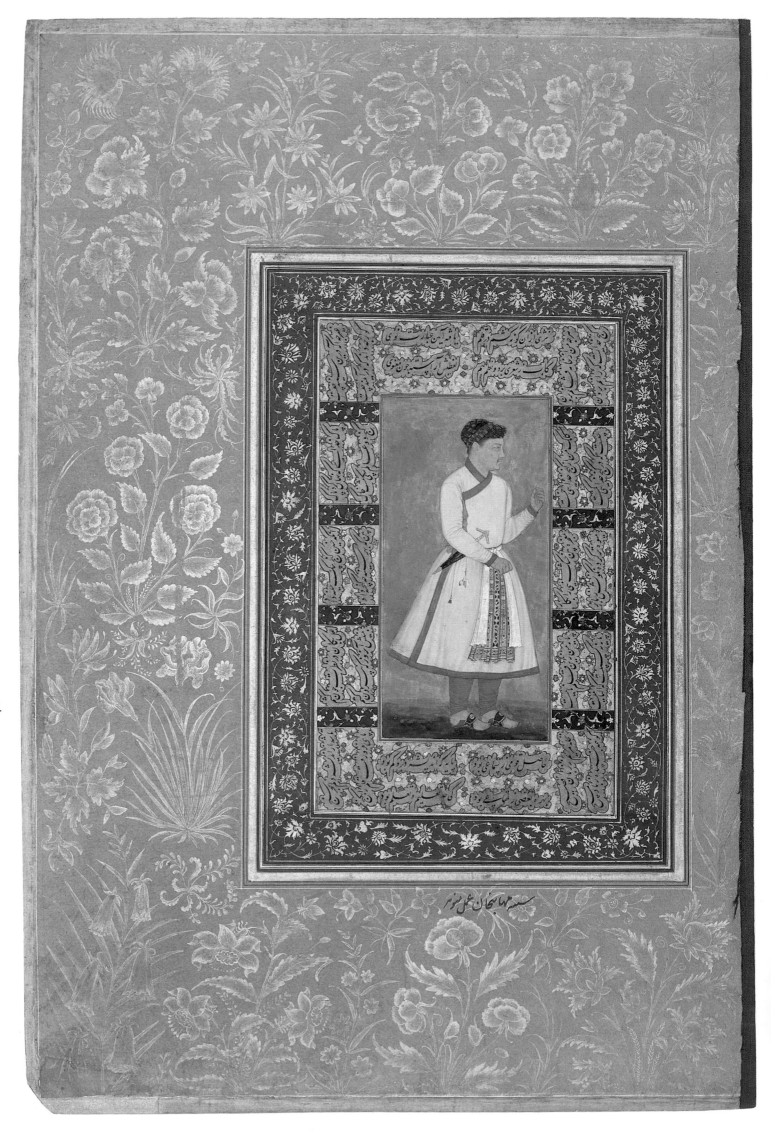

24

24. Zamana Beg, Mahabat Khan

ca. 1610

INSCRIBED: (on the border in Shahjahan's hand)
shabih-i Mahabatkhan, ʿamal-i Manohar (a
portrait of Mahabat Khan, done by Manohar)

MMA 55.121.10.3r

ZAMANA BEG was the son of Ghayur Beg, a noble-man of Shiraz who left Iran and settled near Kabul. As a young man Zamana Beg entered the service of Prince Salim (Jahangir) as a footsoldier and was soon granted a rank in recognition of outstanding service. His first act of real distinction, however, for which he received the rank of 500 and the title Mahabat Khan, was the murder of Ujjainiya, the raja of Bhojpur, who had annoyed the prince with his overbearing manner.[1]

After Jahangir's accession to the throne in 1605, Mahabat Khan was raised to the rank of 1500, then 2000/1300, and then 3000/2500 in 1606 and to the splendid rank of 4000/3500 in 1612.[2] In 1611, however, Jahangir had married the redoubtable Nur-Jahan Begum, and there began the period of the ascendancy of Nur-Jahan, her father Iʿtimaduddaula, her brother Abuʾl-Hasan Asaf Khan, and her favorite, Prince Khurram (Shahjahan), who effectively closed all avenues of approach to the emperor and advancement against their enemies, chief of whom was Mahabat Khan. Although the combined forces of Nur-Jahan's clique were unable to depose Mahabat Khan from his exalted military position, they managed to block his advancement and keep him away on unimportant campaigns until 1622, when Iʿtimaduddaula died and Nur-Jahan had become disenchanted with Shahjahan and needed the general to deal with Shahjahan's rebellion against Jahangir.

In March 1626 Mahabat Khan, having once again fallen into implacable enmity with Nur-Jahan over the question of influence over the emperor and the question of succession, resolved to take matters into his own hands. While Jahangir was camped on the banks of the Jhelum en route to Kabul, Mahabat Khan captured the emperor. Before this attempted coup was fully resolved, Jahangir died in October 1627, and Mahabat Khan ingratiated himself with Shahjahan, who confirmed him as Khankhanan and supreme military commander.[3]

During Shahjahan's reign Mahabat Khan was twice governor of the Deccan, governed Delhi, and commanded the conquest of Daulatabad. He died in 1634

with the rank of 7000/7000, the highest-ranking person not of royal blood at Shahjahan's court.[4]

WMT

IN MUGHAL INDIA it was often helpful to be served by such men as Zamana Beg, Mahabat Khan. His orange pajamas, canary yellow jama edged in purplish red with blue ties, and bright green slippers bear the same stamp of aggressiveness that made him useful—if unpredictable and occasionally dangerous—to his imperial masters. His profile with its broken nose and sly mouth bespeaks fierceness; if his left hand is fit to hold a pink, his right is poised to grab a dagger. Lingering less pleasurably than usual on arabesques, curls of hair, and the delicate indentations of an ear, Manohar stabbed Mahabat Khan onto the paper as the embodiment of a side of Mughal life one would as soon overlook.

For another portrait of Mahabat Khan attributable to Manohar, see the impressive darbar of Jahangir in the album of the Institute of the Peoples of Asia, Leningrad.[5]

SCW

THE PORTRAIT is surrounded by a Persian *mathnavi* about the relation of word and meaning.

AS

THE NUMBER 6 is faintly discernible in the margin, making this a Group A leaf. The portrait side has a border of gold flowering plants on a pink ground, and the calligraphy side has flowering plants in color on a buff ground. Three other leaves in the Kevorkian Album have the same border arrangement. Of these two must have belonged to the same album (MMA fols. 29 and 6; pls. 25, 26, 73, and 74) and the third probably to a different one (MMA fol. 33; pls. 35 and 36). The gold flowers against the pink ground are unusually large and bold with a wonderful variety of leaf forms. It seems

that when painting in gold the artist felt free to cover most of the ground in a riot of flowers which give off a shimmering effect when the light catches them. An iris can be identified in the left border in the second tier from the bottom, with tentative identifications of a lily in the lower left corner and a poppy next to it. Both the gold-on-blue inner border and the innermost border with its two rows of cutout verses are wider than usual, probably in response to the small background area surrounding the portrait.

There is a very similar portrait of Mahabat Khan in the Jahangir Album in the Staatsbibliothek Preussischer Külturbesitz, Berlin.[6] An early nineteenth-century copy of a portrait of Mahabat Khan was sold at Sotheby's on October 14, 1980, lot 191. It is not illustrated, but from the description it seems to be a copy of the present portrait.

MLS

1. Shahnawaz Khan, *Maasir*, I, p. 10.
2. Jahangir, *Jahangirnama*, p. 14, and *Tuzuk*, I, pp. 77, 146, 217. For a discussion of these ranks and titles, see M. Athar Ali, *Apparatus of Empire*, 1985.
3. Muhammad-Salih Kanbo, '*Amal-i salih*, I, p. 266.
4. For other portraits of Mahabat Khan, see Beach, *Grand Mogul*, pp. 62 (a leaf of a *Jahangirnama* manuscript, ca. 1620, from the Museum of Fine Arts, Boston, no. 14.654, showing Mahabat Khan, who is identified on his turban band, directly beneath the emperor), 70, and 84 (Shahjahan in darbar with Mahabat Khan and a sheikh, in the Vever Collection).
5. Ivanov, Grek, Akimushkin, *Al'bom*, no. 32.
6. Kühnel and Goetz, *Jahangir's Album in Berlin*, fol. 22b, pl. 35.

25. Calligraphy

ca. 1541

MMA 55.121.10.29V

An old man was beating a boy with his stick.
The boy said: "Don't beat me—for what is my fault?
I could tell you other men's cruelty, but
If yourself are cruel, to whom could I cry?"
Addressing the lord, you may cry and complain;
You shouldn't cry, feeling the hand of the lord!
 Written by the poor, lowly 'Ali the scribe [*al-katib*],
 may God forgive his sins and cover his faults,
 the last day of the blessed Ramadan 938
 [A.D. 1541]

The poem is from Sa'di's *Bustan*, the chapter on contentment. It is surrounded in the upper lines by two verses from Jami's *Yusuf and Zulaykha*, close to the text which surrounds MMA fol. 12r (pl. 46); at the sides there are *mathnavi* and ghazal fragments.

AS

IN THIS BORDER thin straight stems are in evidence, as they are on the recto. There is also a penchant for a color contrast between a flower's center and surrounding petals. The artist invariably includes a realistic tulip, often placed at an edge or corner as here at the lower left. He often includes a leaf with deeply indented outline and curled up like a cup as in the lower border. An iris appears in the left margin near the center with a narcissus two plants above it, and a plant perhaps intended for a zinnia or dahlia in the lower border, one in from the right corner. The little plant third in from the corner may be a tulip of the *Tagetes* species.

The border artist, one of the album's most prolific, appears to have also created the borders for fols. 6v, 17v, 19v, and 23r (pls. 73, 49, 11, and 16).

MLS

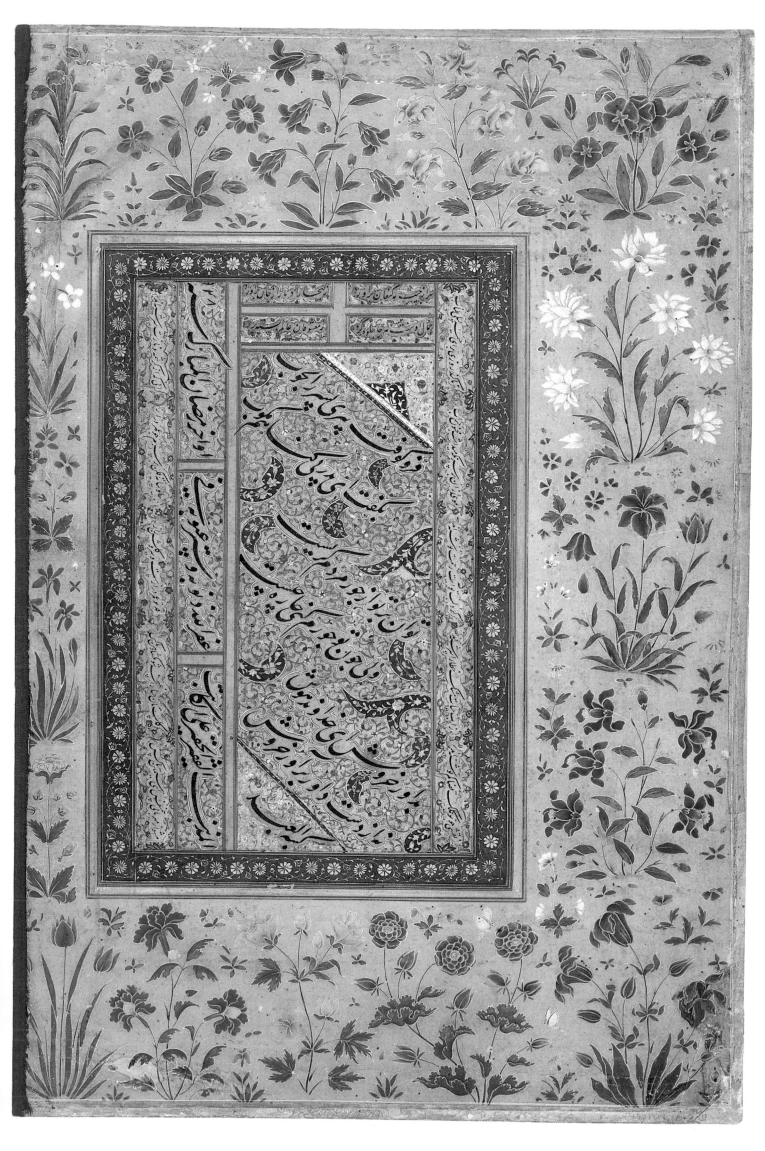

25

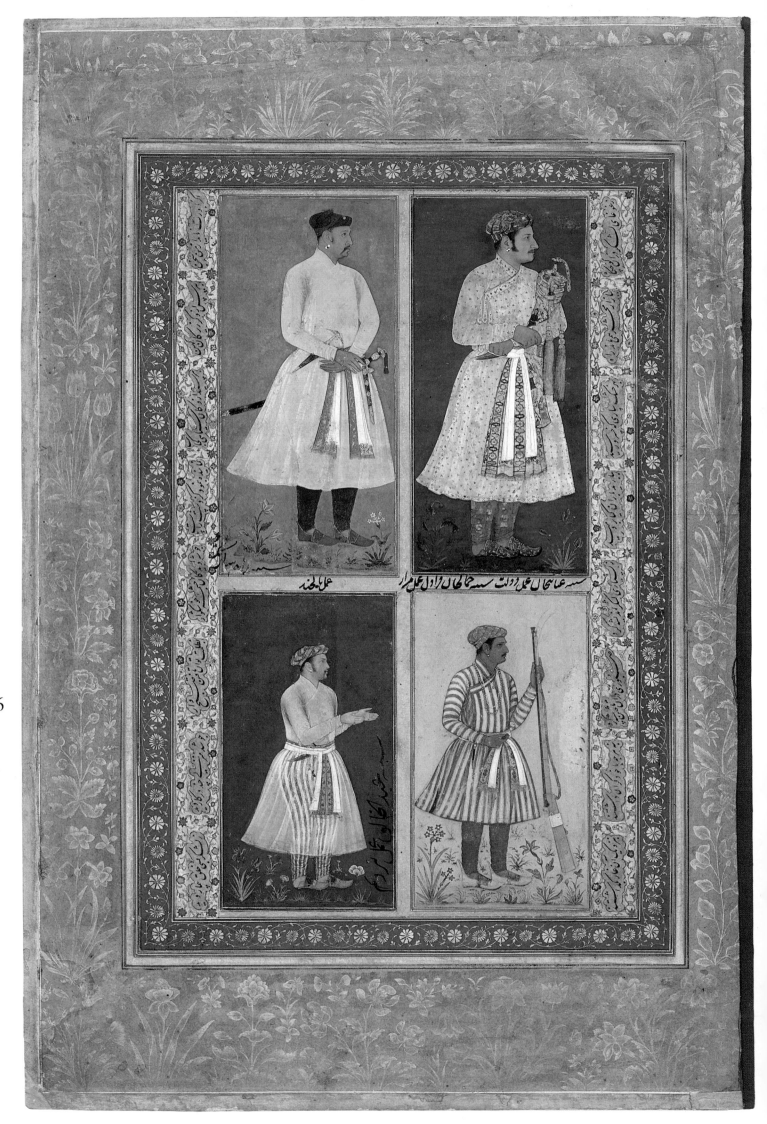

26

26. Four Portraits

Upper left: (in Jahangir's hand) Raja (name illegible); (in Shahjahan's hand) "work of Balchand"

Upper right: ʿInayat Khan, ascribed to Daulat

Lower left: ʿAbdul Khaliq, work of [?] (perhaps by Balchand)

Lower right: (in Jahangir's hand) "work of Jamal Khan Qarawul, Murad" (original inscription on the right in Shahjahan's hand has been effaced)

ca. 1610–15

MMA 55.121.10.29r

ʿINAYAT KHAN was one of Jahangir's favorite courtiers, and the drawing of the dying ʿInayat Khan has been reproduced many times.[1] Here we have a portrait of a younger, healthy ʿInayat Khan. His sad end is described thus by the emperor: "On this day (28 Mihr A.H. 1027 [A.D. 1618]) came the news of the death of ʿInayat Khan. He was one of our closest servants. Even though he ate opium, he would also take a cup whenever the opportunity presented itself. Little by little he became addicted to wine and, since he was of a weak constitution, it sapped him of his strength and vigor. He became afflicted with dysentery and, in this weakened state, was overcome two or three times by cataleptic fits. By our command Hakim Rukna undertook to treat him, but all his strategems were in vain. In addition, he had an amazing appetite and, despite the fact that the Hakim insisted that he not eat more than once a day, he could not control himself and would rage like a madman until finally he got dropsy and became exceedingly emaciated. A few days prior to this he requested that he be allowed to proceed to Agra. I ordered him brought into my presence before his departure, and he was carried in on a palanquin. He seemed so weak and thin that it was amazing, 'skin stretched over bones,' as the saying goes, but even his bones had begun to disintegrate. Although [our] artists exaggerate greatly when drawing emaciated people, nothing resembling him has ever been seen in this world, ... and so I ordered the artists to draw a likeness of him. In short, finding his condition so altered, I told him that at such a time he should not draw a single breath without recollecting the Deity and that he should not despair of His generosity."[2]

Of ʿAbdul-Khaliq there is a mention in Muhammad-Hadi's appendix to the *Jahangirnama* for the twenty-first regnal year (A.D. 1626): "At this time ʿAbdul-Khaliq, nephew of Khwaja Shamsuddin Muhammad of Khwaf, who was one of Asaf Khan's employees and companions, was dispatched with the sword of arrogance to the desert of nonexistence along with Muhammad-Taqi, Shahjahan's *bakhshi*, as the two of them had been taken prisoner during the siege of Burhanpur."[3]

WMT

LESSER courtiers also found their places in imperial albums. Sometimes, as here, their likenesses are particularly lively, perhaps because painters found them easily approachable. Flowers in the foreground of these portraits—which evolved from earlier ones with plain green grounds (see pl. 22)—establish the figures convincingly in space. But to flower-loving Jahangir they may also have invited transplantation into borders, a uniquely Mughal innovation that enriches many folios of the Kevorkian Album.

On the upper left is Balchand's portrait, which is perhaps of Raja Sarang Rao, who according to the *Tuzuk* was promoted in the fifteenth year of the reign of Jahangir, received another promotion following Shahjahan's rebellion, and was later sent to Prince Parviz in 1623–24 with a gracious firman.[4] This work shows the nuances of characterization and fineness of technique brought to small full-length portraits under Jahangir's direction. Subtle harmonies of color, such imaginative touches as reddish-brown pajamas filtered to pink through the muslin jama, elaborately inventive arabesques, and the elegant buoyancy of pose are characteristic of Balchand. (See also pls. 11 and 67.)

ʿInayat Khan might have been forgotten had not Govardhan recorded him just before his tragic death (see above) in two portraits—one drawn, the other

133

painted. Among the best known of all Mughal pictures, they are also the most harrowing, especially when compared to this likeness of the elegant but minor official in good health in which one recognizes the same facial angle, aristocratic nose, and tortoise-like mouth.

The present portrait is ascribed to Daulat, an artist whose career opened in the later sixteenth century under the influence of Basawan. For Jahangir, he painted perceptive studies of personality that invite comparison to those by Govardhan, another of Basawan's followers, whose characterizations surpass Daulat's in seriousness and technique. Perhaps because of this challenge, Daulat's rather thinly pigmented, agreeably colored portraits became more conventional. Although the present miniature is the only one by Daulat in the Kevorkian Album, the album also contains several splendid borders in gold over indigo signed with the same name, which might represent another aspect of his accomplishment. A capable if unexciting figural artist, Daulat contributed at least one miniature to the Windsor *Padshahnama*, the *Reduction of Qandahar*, (fol. 203v).[5]

On the lower left is an unascribed portrait of ʿAbdul Khaliq. This ill-fated nobleman is shown with his hands held up as though to receive an imperial command. Hands and textiles are painted with finesse in colors that justify an attribution to Balchand.

On the lower right is a portrait of Jamal Khan Qarawul. This lesser nobleman holds a matchlock and has the intent gaze and firmness of a huntsman. Murad, who recorded him with exacting precision—and with the artist's usual pipestem legs—was a greatly accomplished member of the imperial ateliers, whose extraordinarily detailed scenes for the Windsor *Padshahnama* provide lively and informative views of Shahjahan's life and surroundings. One of these (*Jahangir Receiving Shahjahan* [fol. 193v]) is inscribed as the work of Murad, "pupil of Nadir az-zaman [Abuʾl-Hasan]." The influence of Abuʾl-Hasan (pl. 13) is evident in Murad's technique, mastery of crowd scenes, and comprehensive observation of objects as well as people. So inventive and knowing are his depictions of architecture that he must also have designed architectural ornament.[6]

SCW

At each side there is a line of Persian poetry, describing a mighty battle. Since these lines are from a *mathnavi* in the *mutaqarib* meter, they may be from Nizami's *Iskandarnama*.

AS

This recto leaf has the number 12 in the margin and presumably was originally part of the same album as MMA fol. 3 (pls. 21 and 22), a Group A album. Mounting four portraits on one folio was not unusual in Mughal albums. It would be of interest to know if the page that would have faced it, an 11 verso, also had four portraits mounted together. The portrait of ʿInayat Khan in the upper right corner is, according to the inscription, by Daulat. Is this the same artist as Daulat the border-painter? In all probability, it is. The drawing and brushwork are extremely fine and the sensitivity of the face is revealing. The consistent practice of Daulat of using humble epithets before his name, whether in painting or border figures or floral borders, suggests a single artist.[7] Also the signatures are written in what appears to be the same hand and always in tiny letters.

The borders of this folio are not by Daulat but are in a different style with flowers with rather straight, thin stems. The artist had not much scope on this border because of its reduced size, but his style emerges more distinctly on the verso (pl. 25). An iris can be seen in the center of the inner border with perhaps a chrysanthemum third from the bottom in the left border, with a tulip third from the top. A narcissus can be identified in the right corner of the upper left painting, an iris in the right corner of the upper right painting, an iris in the left corner of the lower left painting, and perhaps a narcissus in the left corner of the lower left painting.

MLS

1. See, e.g., Beach, *Grand Mogul*, no. 60; Welch, *Indian Drawings and Painted Sketches*, no. 16; the finished painting is in the Bodleian Library, Oxford.

2. Jahangir, *Jahangirnama*, p. 280f.

3. Jahangir, *Jahangirnama*, p. 491.

4. Jahangir, *Tuzuk*, II, pp. 182, 250, and 281.

5. For both portraits of the dying ʿInayat Khan, see Welch, *India*, no. 149a, b; for a dramatic scene by Basawan, see Welch, *India*, no. 110. For an early work by the youthful and aspiring Daulat influenced by Basawan, from a copy of Jami's *Nafahat al Uns*, dated 1602–1603, in the British Library (Or. 1362), see Wellesz, *Akbar's Religious Thought*, pl. 35 (erroneously ascribed to Basawan and Daswanth); and for one of his Govardhanesque scenes of devotees, see Welch and Beach, *Gods, Thrones, and Peacocks*, no. 8.

6. Other miniatures ascribed to this prolific painter in the Windsor Castle *Padshahnama* are fols. 49r, 143r, 146v, and 216v; others can be added on grounds of style: fols. 116r, 123v, and 124r. For other pictures by him, see *Portrait of a Royal Servant*, in Colnaghi, *Persian and Mughal Art*, no. 113; *An Antelope*, formerly collection of the comtesse de Béarn, in Marteau and Vever, *Miniatures persanes*, II, pl. CLXIV; and *A Warrior Frightened by Tribesmen*, from a manuscript of Saʿdi's *Gulistan*, private collection (formerly marquess of Bute), in Welch, *India*, no. 158f.

7. See Beach, *Grand Mogul*, pp. 113–14, under Daulat.

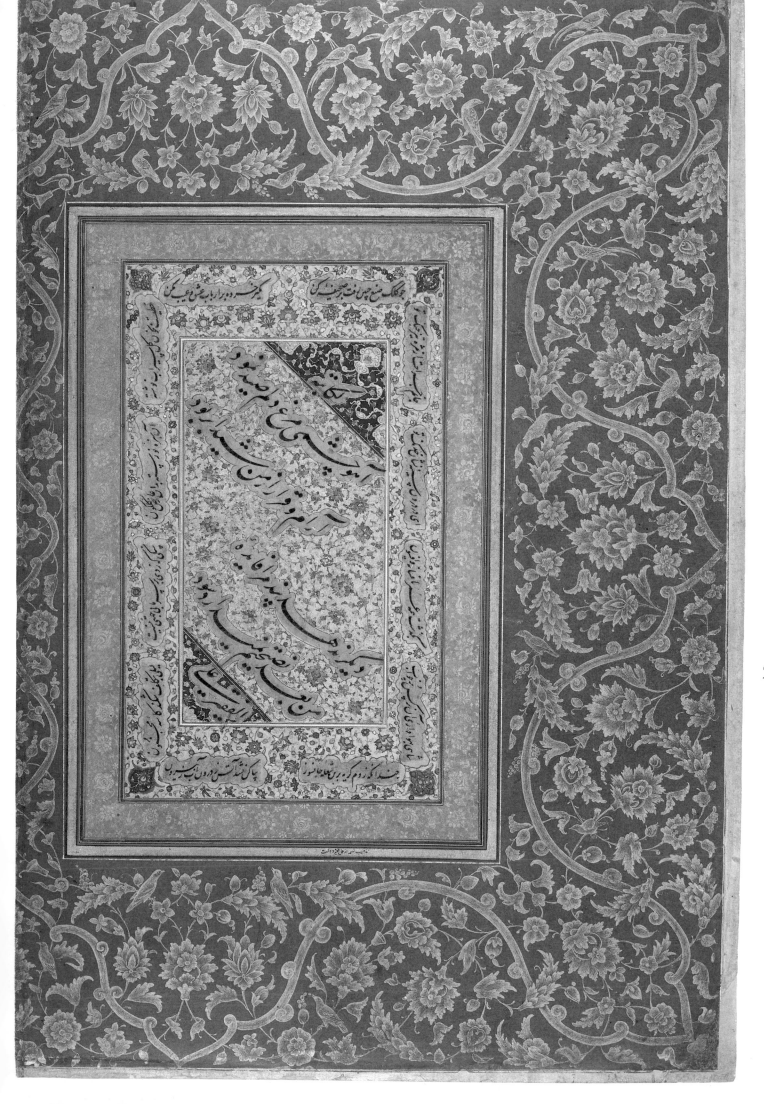

27. Calligraphy

ca. 1540

MMA 55.121.10.7v

By its scribe [i.e., Mir-ʿAli]

> One with the eyes of gazelles
> hunted the bird of my heart,
> Robbed me of steadfastness,
> robbed me, poor lover, of rest.
> Counsel and good advice
> is no longer of use—
> There is no use anymore,
> friends, in counseling me!
> The poor [al-faqir] ʿAli

The verses surrounding this page are by Shahi and apparently belong to the same manuscript as those pasted on MMA 55.121.10.2v (pl. 33). Since in both cases the illumination is done by Daulat, the two pages seem to have been prepared in the imperial atelier at the same time.

AS

Of ALL THE decorated borders collected in this album, only four are signed, and of these two are signed by Daulat as gilder and illuminator in tiny letters in the gold guard band between the inner and outer borders, as here. The design shows gracefully scrolling palmettes, leaves, flower heads, and buds on delicate stems with birds perched at intervals on them and with a ribbon band looping and arching above them. The rhythms of the design suggest lilting cadences, belying the incredible control of the brushstrokes. A comparison between this border and another in the album (MMA fol. 23v; pl. 15) reveals the superior mastery of this hand. The painting of borders in gold on blue would appear to be Daulat's specialty at this time, although the gold plants on a pink ground bordering the portrait on the recto side of the folio were in all probability also by his hand.

Among the most memorable paintings of the artist Daulat are the border paintings of the *Muraqqaʿ-i Gulshan* in Teheran, a part of the same album made for Jahangir which is in the Staatsbibliothek Preussischer Külturbesitz, Berlin. Here, among other subjects, are penetrating portraits of some of Jahangir's leading artists (Abuʾl-Hasan; Manohar; Bishan Das, "the nephew of Nanha"; and Daulat himself). Daulat delighted in humble epithets in his signatures, sometimes using his name, Daulat, in its meaning as "empire." Not only was he a superb portrait painter, as can be judged by his picture of ʿInayat Khan (pl. 26, upper right), but he also painted larger compositions.[1] While it cannot be proven that the Daulat of the borders is the same painter whose signature appears on portraits and other paintings, the quality of sure and supple brushstrokes and similarities in the manner of signatures as well as writing strongly suggest one artist, an artist who in the latter part of his career seems to have turned exclusively to border paintings.

MLS

1. See Beach, *Grand Mogul*, pp. 113–16, for a list of some of Daulat's major works.

28. Raja Suraj Singh Rathor

Late sixteenth century

INSCRIBED: (in Shahjahan's hand?) *shabih-i . . . Raja Surajsingh Rathor, kar-i Bishandas* (a portrait of . . . Raja Suraj Singh Rathor, done by Bishan Das)

MMA 55.121.10.7r

SURAJ SINGH RATHOR was the son of Udai Singh of Marwar in the province of Ajmer, who had joined the Mughal imperium under Akbar and had given in marriage to Prince Sultan-Salim (Jahangir) his daughter Manmati, who became the mother of Prince Khurram (Shahjahan). By virtue of this royal connection, Raja Suraj Singh, the maternal uncle of the prince, was given suitable ranks and a fief in Jodhpur after his father's death.

In 1608 Jahangir records a visit to court by Raja Suraj Singh, when he brought a Hindi poet, Shyam Singh, to recite some of his poetry in praise of the emperor. "Few Hindi verses of such freshness of purport have ever reached my ear," comments Jahangir, who was a great connoisseur of Persian poetry but not much taken with Hindi works.[1]

In 1615 Jahangir was highly pleased by the presentation of an elephant named Ranrawat from Suraj Singh. "It was such a rare elephant that I put it into my private stud," writes the emperor. A few days later Suraj Singh gave Jahangir another elephant, but this time he notes that the second could not be compared to the first, "which is one of the wonders of the age and is worth 20,000 rupees."[2]

Suraj Singh was sent to Gujarat with Prince Murad and later with Prince Danyal when he was posted to the Deccan in the latter years of Akbar's reign. Under Jahangir he served with Shahjahan in the expedition against the rana of Mewar and in the Deccan campaign. He died in the Deccan in 1619, and Jahangir records his death as follows: "On Saturday news came of the death of Raja Suraj Singh, who had died a natural death in the Deccan. He was the descendant of Maldeo, who was one of the principal landholders of Hindustan and had a holding that vied with that of the rana of Mewar, whom he had even overcome in one battle. . . . Raja Suraj Singh, through the good fortune of being brought up by the late king and also by this supplicant at the Divine Court, reached high rank and great dignities. His territory surpassed that of his father or grandfather. His son is called Gaj Singh, and during his father's lifetime he turned over all his financial and administrative affairs to him. As I knew him to be capable and worthy of favor, I promoted him to the rank of 3000/2000 with a standard and the title of raja and his younger brother to that of 500/250 and gave him a fief in his native country."[3]

WMT

RAJA SURAJ SINGH stands before the emperor, his hands obediently crossed, paying homage and awaiting orders. As in most portraits painted for Akbar (but see Prince Danyal, pl. 18), little space was lavished round the figure; when this one was remounted, it was set into a larger expanse of green.

This is an early work by Bishan Das, whose apprenticeship and early career were spent in Akbar's ateliers. His talent as a portraitist was encouraged by Jahangir, who described him in the *Tuzuk* in connection with the Mughal embassy to Iran in 1613: "At the time when I sent Khan ʿAlam to Persia [as ambassador], I had sent with him a painter of the name of Bishan Das, who was unequalled in his age for taking likenesses, to take the portraits of the shah and the chief men of his state, and bring them. He had drawn the likenesses of most of them, and especially had taken that of my brother the shah exceedingly well, so that when I showed it to any of his servants, they said it was exceedingly well drawn." On the embassy's return in 1620, Jahangir wrote that "Bishan Das, the painter, was rewarded with the gift of an elephant."[4]

Another version of this portrait in the Berlin Album is inscribed in Jahangir's firm hand with the artist's name and the fact that Suraj Singh was the *tugay* (maternal uncle) of Prince Khurram (Shahjahan). The date—1608—refers not to the year of the painting but to that of the writing.[5] Both portraits are in the style of

Akbar's reign and must have been painted in the 1590s. They represent the artist's work before Jahangir's patronage had further aroused his talents for psychological acuity and exquisite technical fineness.[6]

Bishan Das excelled not only in portraiture but in panoramic historical miniatures which he painted under three reigns with unfailing masterfulness.[7] Although Jahangir did not honor Bishan Das as one of his "wonders," he so admired the artist that he called upon him to rework displeasing passages in major earlier Iranian pictures.[8]

<div align="right">SCW</div>

Most of the verses surrounding the portrait are a lyrical poem on the appearance of the crescent moon of the Feast of Fastbreaking at the end of the month of Ramadan. The poet, whose pen name appears to be Mani, rejoices that he can drink wine again.

This poem is followed by Persian verses that end:

I am the one who drinks the dregs from the earthen vessel of
 the dogs at your door—
I do not drink the Water of Life from a golden goblet!

The poet thus states that the lowliest thing belonging to his beloved is more precious to him than even the mysterious water that bestows immortality on the seeker.

Another verse from the same poem appears at the border of V&A 123A–1921, where the poet claims:

If you gave me poison, I would eat it from your hand like
 honey,
But from the hands of others I do not eat sugar.

<div align="right">AS</div>

This recto portrait page has the margin number 4 and so belongs to Group A. In what has been designated Album 1, it would have been found opposite the portrait of Rup Singh (MMA fol. 8v; pl. 29), a verso portrait page with the margin number 3. As mentioned earlier, two other leaves also belonged to this album: the leaf with the portrait of Prince Danyal (MMA fol. 32r; pl. 18) with the margin number 52 and the leaf with the portrait of Jahangir Beg, Jansipar Khan (MMA fol. 37v; pl. 67) with the margin number 35. All the portrait sides have flowering plants in gold on a pink ground with inner borders of cutout poetry surrounded by a band of palmette and floral scrolls in gold on a blue or pink, as in this leaf, ground. All have abstract floral scroll patterns in gold on a blue ground on the calligraphy side.

Here, an iris is identifiable in the middle of the inner border and slightly below the middle in the inner side of the outer border.

<div align="right">MLS</div>

1. Jahangir, *Jahangirnama*, p. 80. A line of poetry ascribed to "Mirza Raja, Shahjahan's maternal uncle" is recorded in Mirza Muhammad-Tahir Nasrabadi, *Tadhkira-i Nasrabadi*, p. 55.

2. Jahangir, *Tuzuk*, I, p. 289.

3. Jahangir, *Jahangirnama*, p. 313f. See also Shahnawaz Khan, *Maasir*, II, pp. 914ff.

4. The artist may have returned from Iran before the embassy, however, for one of his liveliest and finest portraits, showing Ray Bharah and Jassa Jam, is likely to have been painted in 1618 (see Welch, *Art of Mughal India*, no. 34).

5. See Kühnel and Goetz, *Jahangir's Album in Berlin*, pl. 35.

6. An early nineteenth-century copy of this portrait was auctioned at Sotheby's on October 14, 1980, lot 205. It is not illustrated, but the description follows the original. [MLS]

7. The author agrees with Milo C. Beach in the attribution of this picture, which brings to mind the artist's equally marvelous description of incidents following the birth of Jahangir. See Beach, *Grand Mogul*, p. 110, and Welch, *India*, no. 114.

8. See Welch, *India*, no. 139.

29. Rup Singh

ca. 1615–20

INSCRIBED: (probably in Jahangir's hand) *sha-bih-i Rup Singh pisar-i Ray Chanda, 'amal-i Govardhan* (a portrait of Rup Singh, son of Ray Chanda, done by Govardhan)

MMA 55.121.10.8v

APPARENTLY this is Rup Singh, the son of Ram Chand (not Ray Chanda as Jahangir[?] has inscribed) and grandson of Jagannath Kachhwaha.[1] He is mentioned but once in the chronicles of Shahjahan's reign, and that in the course of the long list of persons who were sent to chastise Jujhar Singh and Bikramajit.[2]

WMT

ALTHOUGH painted by Govardhan whose studies of ascetics are among the most profound Mughal characterizations, this picture exemplifies imperial portraiture in all its coolly documentary excellence. Colors please, and arabesques, flowers, sword, harness, turban, and jewels—the stock-in-trade of Mughal elegance —are flawlessly rendered. But we suspect that the emperor was not much concerned about Rup Singh, and Govardhan shared his lack of enthusiasm. His usually limpid and vital brushwork is evident only in the sinuous outline of the pajamas, perhaps owing to his self-disciplined adjustment to the court mode of the later 1610s. We sense the strong influence of Abu'l-Hasan's technical perfection, which Govardhan emulated successfully but reluctantly. (For more penetrating portraits by Govardhan, see pls. 9, 63, and 76.)

SCW

THE MINIATURE is surrounded by a fragment from a Persian *mathnavi* which belongs to Amir Khusrau's *Khamsa* (Quintet).

The star of my kingship [*khusrawi*] rose
And made Nizami's tomb tremble.

These lines show that the author, who took Nizami's Quintet as his model, considers his own poetry to be much superior to that of his predecessor.

AS

THIS VERSO PORTRAIT has the margin number 3. The border is filled with gold flowers on a pink ground and would have faced the portrait of Raja Suraj Singh Rathor (MMA fol. 7r; pl. 28), which has the margin number 4. It is interesting to note that the practice was to write the margin number on the portrait side, whether it is on the recto or verso of the folio. Of all border schemes, gold flowering plants on a pink ground are the hardest to read as it is difficult to separate the gold from the ground of almost equal value. The original pink may have provided more contrast, since the color may have faded. Closer inspection reveals delicate insects and butterflies among the graceful plants with cloud bands at the top of both upper and lower border. The inner border here is gold on blue, while on the portrait opposite (pl. 28) it is gold on pink. The innermost border of each has cutout verses. It was apparently of no concern to the border artist, in this case most likely Daulat, that the portraits were strongly contrasting in background color, in the addition of details such as landscape plants or lack of them, in costume, and to a lesser extent in figure scale.

An early nineteenth-century copy of this portrait was auctioned at Sotheby's on October 14, 1980, lot 196 (illustrated, p. 77). The nineteenth-century copyist has not attempted to reproduce the gold flowering plants on a pink ground of the seventeenth-century border and has added instead a border of flowering plants in colors and gold (or so it appears from the black-and-white photograph) on a buff ground. The soft, indistinct style of drawing is identical to that of the border of the copyist of Ibrahim 'Adilshah II and must surely be by the same artist, who perhaps also painted both portraits.

MLS

1. According to Shahnawaz Khan, *Maasir*, I, p. 725.
2. Muhammad-Salih Kanbo, *'Amal-i salih*, II, p. 104.

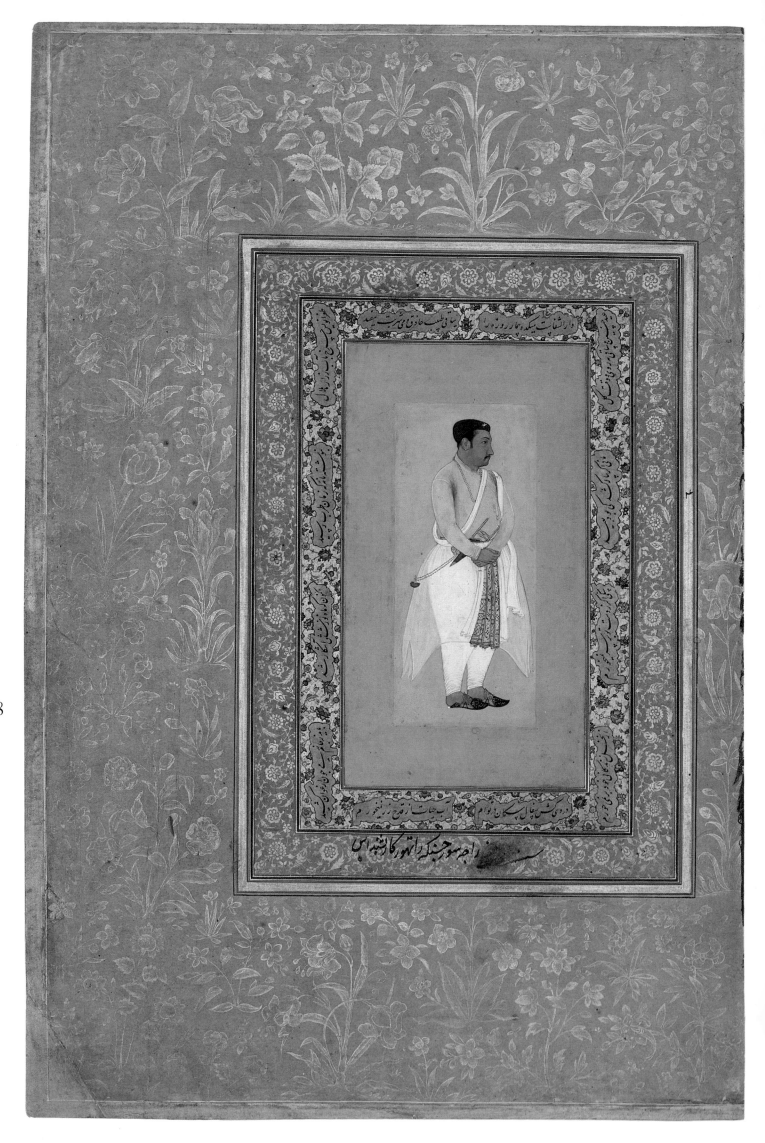

28

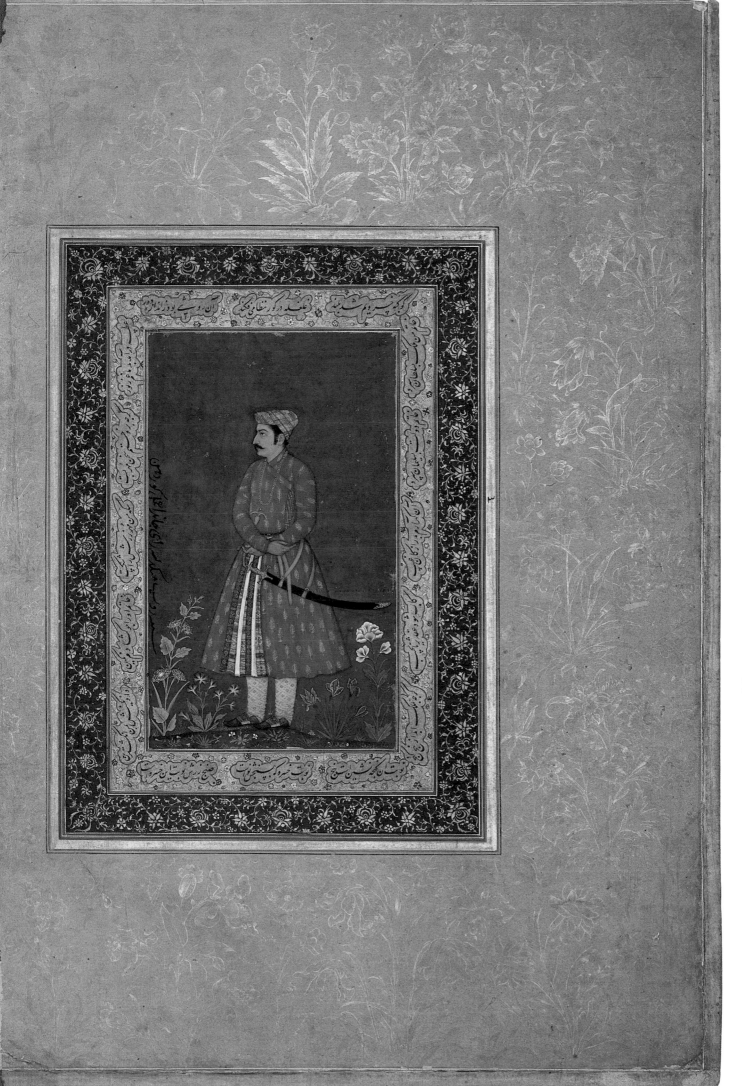

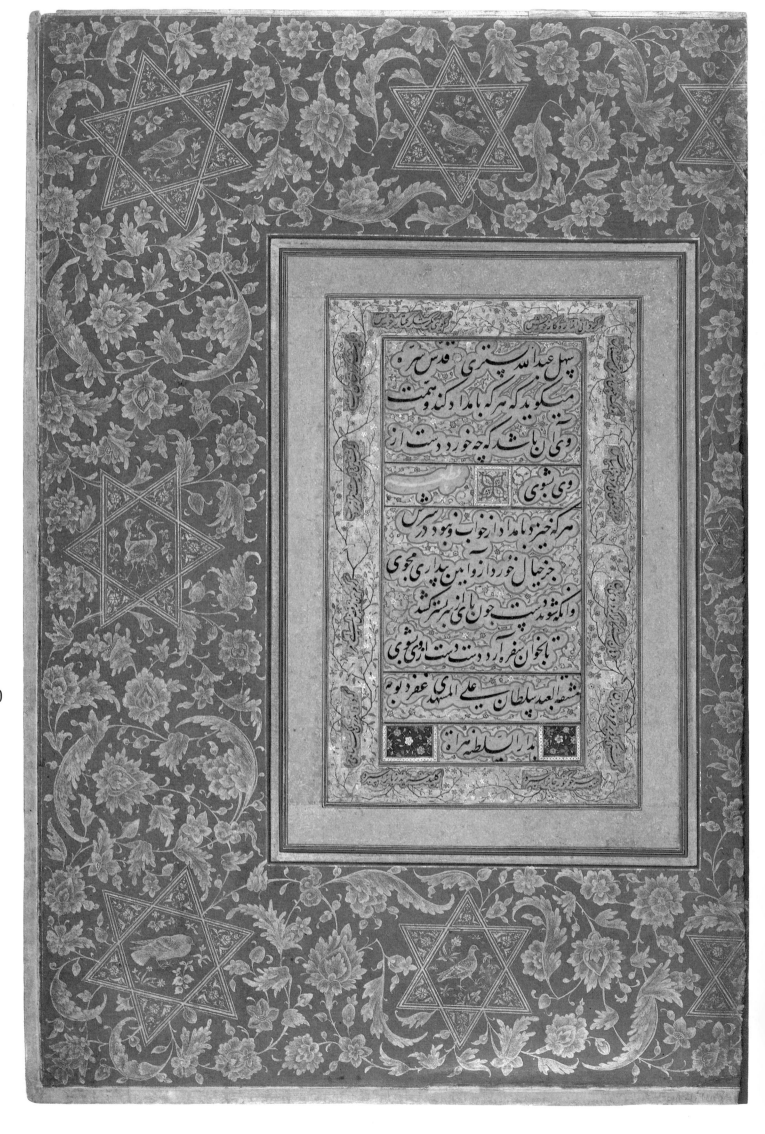

30

30. Calligraphy

ca. 1500

MMA 55.121.10.8r

[A page from Jami's *Baharistan* (Garden of Spring)]

Sahl ibn 'Abdallah at-Tustari—may God bless his soul!—says:
"Anyone who sets his mind in the morning on [the question]
of what he should eat—leave him alone!
Anyone who gets up in the morning with his head full of
nothing but the idea of eating—don't expect the rites of
wakefulness from him!
And he who washes his hand when taking out his foot from
his bed [in order]
To bring his hand to the meal—wash your hands of him."
 Jotted down (*mashaqahu*) by the slave, Sultan-'Ali
 Mashhadi, may his sins be forgiven, in the
 royal capital of Herat

Sahl at-Tustari was a noted mystical leader of the
ninth century in Iraq. His main contribution to Sufi
thought was the development of the doctrine of the
Light of Muhammad. This concept—that the Prophet
Muhammad is the first manifestation of the Divine
Light, sent as an illumination to the dark world—has
colored Muslim mystical thought and poetry for
centuries.

Sahl's little saying, elaborated by Jami into a Persian
verse, is in tune with the ascetic mood of early Sufism:
when one thinks of food when getting up, one
will not be able to lead a truly spiritual life.[1]

The calligraphy is surrounded by fragments of a
mathnavi in the *mutaqarib* meter, possibly from Sa'di's
Bustan (chapter 1, section 13).

<div align="right">AS</div>

THE BORDER of gold scrolling leaves, blossoms, and
palmettes is interspersed with five complete stars and
two half ones at the inner margin formed of two inter-
secting equilateral triangles, one of the oldest, sim-
plest, and continuously popular geometric designs in
Islamic art. The interior hexagons contain a bird or, in
the case of the center one in the outer margin, a pair of
birds surrounded by foliage, which also fills the points
of the star. Because they are in gold rather than natu-
ral colors, the birds are not identifiable. The flowing
rhythms, mastery of line, and unusually fine brush-
strokes, similar to MMA fol. 7v (pl. 27), allow this un-
signed border to be attributed to Daulat. There seems
no reason to suggest a different artist for the verso.
The verso of fol. 2 in the original marginal numbering
system would have had a comparable gold-on-blue ab-
stract pattern border.

<div align="right">MLS</div>

1. About Sahl at-Tustari, see Böwering, *Qur'anic Hermeneutics.*

31. Calligraphy

ca. 1540

MMA 55.121.10.IV

By Amir Khusrau, God's mercy be upon him!

When with a thousand blandishments
 this idol here appears,
From people everywhere a sigh
 that melts the soul appears.
When I think of his stature slim,
 my eyes shed ruby tears!
Where they fall on the ground, a plant
 of many charms appears.
His [graceful] twiglike stature took a root
 so deeply in my heart—
That though one tears it out and out,
 it always reappears!
Don't be surprised when from the rain
 of tears and seed of love,
From Mahmud's dust, like greenery
 a new Ayaz appears!
 Written by the poor [al-faqir] 'Ali,
 may God cover his faults

In Persian poetry tears always resemble rubies or carnelians because they are red from the blood of the despairing lover. The beloved is often compared to a slim tree or a gracefully moving twig or branch, and Amir Khusrau (1256–1325) elaborates this concept in his usual, somewhat mannerist style.

In the last verse of this ghazal Amir Khusrau alludes to the great warrior-king Mahmud of Ghazna (r. 999–1030), the conqueror of northwestern India, who was in love with Ayaz, a Turkish officer who faithfully served him. The figure of the king becoming "a slave of his slave" is a standard one in lyric poetry in the eastern Islamic world and was elaborated in epics during the fifteenth and early sixteenth centuries.

The surrounding lines are five verses from Jami's epic *Yusuf and Zulaykha*.

AS

THE GOLD PLANTS on the blue ground are more densely arranged than on the recto page (pl. 32), and small birds, a butterfly, and cloud bands as well as the odd tuft of grass have been added. Still, the presence of leaves "moving in water" confirms that one artist was responsible for both the recto and verso borders of this folio. The middle of the upper border shows a *Camponela*, while the flower in the middle of the wider border of the right edge may represent a dahlia.

MLS

144

31

32. Sundar Das, Raja Bikramajit

ca. 1620

INSCRIBED: (on portrait in Jahangir's hand) Raja
Bikramajit; (on border in Shahjahan's hand)
"portrait of Raja Bikramajit done by Bichitr"

MMA 55.121.10.11

SUNDAR DAS of the Bandhu region in Allahabad,
"whose ancestors were considerable landholders in
India,"[1] began his career with the Mughals as a scribe
and later majordomo in the service of Prince Khurram
(Shahjahan). In 1617 he was awarded the title Raja
Bikramajit, "which among Hindus is the highest,"[2] and
put in charge of the administration of Gujarat when it
was enfeoffed to Shahjahan. He led the Mughal army
in the campaign against the Jam and Bihara in the Ran
of Kutch and was instrumental in Shahjahan's capture
of Kangra Fort in 1620. During Shahjahan's Deccan
campaign against Malik 'Ambar in 1621 the success
of Mughal strategy was due to Raja Bikramajit's mili-
tary genius, although he was not nominally in charge
of the campaign.

In Shahjahan's rebellion against Jahangir in 1623–24,
Raja Bikramajit sided with the prince and accompa-
nied him with his Rajput forces until he was slain at
the Battle of Bilochpur. Jahangir, who considered Raja
Bikramajit to be Shahjahan's principal "guide to the
desert of error,"[3] records his undisguised glee over the
death of Sundar Das: "The next day they brought
Sundar's head into my presence, and it appeared that
when the musketball hit him and discharged his soul
to the wardens of Hell, his body was taken for crema-
tion to a village that was in that vicinity. Just as they
were about to light the fire, a detachment appeared
from afar, and fearing that they might be taken cap-
tive, they fled in every direction. The headman of that
place cut off his head and took it to Khan A'zam, who
was staying in his fief. The latter brought it to court.
His gloomy countenance appeared just as it always had
and had not yet changed at all. His ears had been cut
off for the sake of the earrings he had, but it was not
known by whom he had been shot. By losing him the

Wretch [Shahjahan] lost courage, as though his luck,
ambition and reason were all [bound up with] that
Hindu dog."[4]

WMT

SO CONVINCINGLY alive is Bichitr's sharp-eyed, aqui-
line-nosed, finely mustached, smiling Sundar Das that
it is particularly disturbing to read Jahangir's account
—quoted above—of receiving the detested Brahmin
Raja's severed head. Inasmuch as the miniature must
have been painted between 1617, when the still-admired
sitter received his title, and 1623, when he was slain,
it belongs to the earliest documented stage in the great
Hindu artist's development. He was already a major
master, as adroit as Abu'l-Hasan to whom he may have
been apprenticed and whose technical brilliance as well
as sensitivity to the world of appearances he shared.
During Bichitr's apprentice phase, Abu'l-Hasan prob-
ably relied upon him to carry out minor passages in
his own miniatures. But Bichitr's highly polished vari-
ant of Abu'l-Hasan's style is unique and personal. One
of the most logical and observant of Mughal artists,
he creates forms that are architectonic and crystalline.[5]
In his work each outline, wrinkle, and fold, each eye-
lash and fingernail, are in perfect focus, with no scum-
bled or *sfumato* passages. Further clues to his style are
seen in his tendency to exaggerate buttocks and in such
European elements as his delight in shadows, in trompe
l'œil reflections on glass, and in glittering highlights
on jewels.

Beneath Bichitr's classic restraint, which has led
some critics to disparage his work as chilly and hard,
one senses intense, occasionally humorous responses
to people and situations, as in Sundar Das's look of sly
optimism while eliciting the emperor's favor by offering

a shiny blue bauble. Like many aspiring Mughal courtiers, Sundar Das paved the road of his career with well-timed gifts. And when he gave a ruby of unrivaled color and water to Prince Parviz who passed it on to his father, Jahangir increased Sundar Das's rank and entitled him Raja Bikramajit.[6]

Bichitr painted one of the most impressive pictures in the Windsor *Padshahnama: Dara-Shikoh, Shah Shuja', Aurangzeb, and Asaf Khan Received at Court* (fol. 50v; Appendix, fig. 22)—with its ranks of marvelous portraits, stunning textiles and architectural detail, and delightful wall paintings of bright flowers against dead white—is unequaled in its display of the restrained grandeur of Shahjahan's court.

Bichitr's eager acceptance of challenges is also apparent in *Musician, Archer, and Dhobi* (V&A 27–1925), a miniature of which there is a late copy in the Kevorkian Album (pl. 98). A virtual homage to Govardhan, it may have been commissioned by Shahjahan (or more likely by Prince Dara Shikoh) as a contest between two great masters. The figure of the archer is "quoted" in reverse from one of Govardhan's pictures with scrupulous attention paid to such mannerisms as excessively thin fingers. Govardhan's appealingly low-keyed palette and his sensitivity to otherworldly personality, however, have been replaced by Bichitr's cerebral firmness. Flowingly relaxed facial expressions are now crisply formal, and rustic cloth worn to dusty but comfortable softness has been brightened and starched by Bichitr as though to pass muster at court.[7]

SCW

The PORTRAIT is surrounded by fragments of two ghazals by Shahi, which correspond to the fragments on pl. 33.

AS

This RECTO PORTRAIT has the margin number 58. The border scheme of this and its facing folio is flowering plants in colors on a buff ground for the portraits and flowering plants in gold on a blue ground for the calligraphy. The painter of this folio drew tall plants with very thin stems varying in color from pale green to dark brown-green to red. The plants were delicately outlined in gold, and when gold was used for leaf veins, it was done with such subtlety as to seem a mere suggestion. The leaves also share in a variety of green shades, while the flower colors lean to purples and mauves. Occasionally his leaves have the agitated look of underwater weeds being pulled by a current. In spite of this, the border has an overall restrained elegance that is very striking. For all their impression of naturalism, the plants in the border do not on the whole lend themselves to identification with the exception of an iris in the lower right corner, possibly a snowdrop at the left edge of the outer margin second row from the bottom, with a Hypoxis above it on the right. Within the portrait area the poppy before the feet and the iris behind are very clear and accurate.

MLS

1. Jahangir, *Tuzuk*, I, p. 325, and Shahnawaz Khan, *Maasir*, I, p. 412.
2. Jahangir, *Tuzuk*, I, p. 402.
3. Jahangir, *Tuzuk*, II, p. 253.
4. Jahangir, *Jahangirnama*, p. 408.
5. The backgrounds of his pictures often contain boxlike clusters of buildings—unrepresented here—which bring to mind the geometry of Cézanne: see the buildings behind his portrait of Asaf Khan in the Victoria & Albert Museum (Stchoukine, *La Peinture indienne,* pl. XXXVIII); these qualities are also clearly defined in *Dara-Shikoh on a Pink Elephant* (Beach, *Grand Mogul*, no. 33).
6. Shahnawaz Khan, *Maasir*, pp. 412–19.
7. *A Rustic Concert*, Chester Beatty Library, Dublin, 7/11; see Welch, *India*, no. 159.

33. Maharaja Bhim Kunwar

ca. 1615

INSCRIBED: (on portrait in Jahangir's hand)
*'amal-i Nanha, shabih-i Bhim Kunwar wa-
lad-i Rana Amar Singh ke khitab-i mahara-
jagi yafta bud* (by Nanha, a portrait of Bhim
Kunwar, son of Rana Amar Singh, who re-
ceived the title of maharaja); (below in Shah-
jahan's hand) *bihtarin nawkaran-i ma dar
ayyam-i shahzadagi Maharaja Bhim o Raja
Bikramajit budand o har do bi-kar-i ma ama-
dand* (our best servants during the days of our
princehood were Maharaja Bhim and Raja
Bikramajit, and they both took our part)

MMA 55.121.10.2V

T HE LAST STRONGHOLD of Rajput independence
against the Mughal imperium was at Mewar, and Rana
Pratap's heroic but unequal struggle against Akbar's
attempts to annex Mewar is one of the subjects of
Rajput bardic literature. In 1597 Rana Pratap was suc-
ceeded by his son Rana Amar Singh, who was unable
to withstand the concerted efforts of the Mughals under
the command of Prince Khurram (Shahjahan) and was
finally forced to capitulate in 1614. The rana was so
humiliated by his defeat that he abdicated in favor of
his eldest son Karan, while the younger son Bhim joined
the Mughals. In 1619 Jahangir writes: "On this day
came the news of the death of Rana Amar Singh, who
died a natural death at Udaipur. Jagat Singh, his grand-
son, and Bhim, his son, who were in attendance on
me, were presented with robes of honor, and an order
was given that Raja Kishan Das should proceed with a
gracious firman conferring the title of rana, a robe of
honor, a horse, and a private elephant for Kumar Karan."[1]

Bhim Kunwar, who was given the title of raja by
Jahangir and later elevated to maharaja, was a firm and
loyal supporter of Shahjahan. During the prince's
rebellion of 1623–24 against Jahangir, it was the
impetuous Rajput Raja Bhim who prevailed against the
better advice of Shahjahan's other military commanders
and persuaded the prince to engage the imperial forces
under Prince Parviz. Although Raja Bhim and his
Rajputs fought fiercely at the Battle of the Tons, the
Rajput prince lost his life in this battle, which is de-
scribed as follows by Shahjahan's court historian: "With
the violence of the wind and a leonine attack with
manly spear thrusts, they brought down the elephant,
which in its fury and madness had no equal; and Raja

Bhim rushed toward Sultan-Parviz. At this time an im-
mense pitched battle took place. As the other com-
manders no longer had the advantage of assisting him,
he turned his face toward his Dispenser of Grace and,
with twenty-seven lance- and sword-wounds, fell."[2]

WMT

A IR AND LIGHT permeate this monumental little
portrait of a brave Rajput, whose transparent muslin
jama billows in the wind. As though to symbolize the
role of a Rajput in Mughal service, he is sumptuously
adorned and yet tightly confined by his richly adorned
pajama and *patka* (sash). These garments can be in-
terpreted as reminders of the imperial policy of armed
might and bribery that reduced Mewar—the senior
Rajput house—to submission. During the ninth year
of his reign Jahangir described his offerings to Bhim
Singh's elder brother, Karan Singh: "As it was neces-
sary to win the heart of Karan, who was of a wild na-
ture and had never seen assemblies and had lived among
the hills, I every day showed him some fresh favour, so
that on the second day of his attendance a jewelled
dagger, and on the next day a special Iraqi horse with
jewelled saddle, were given to him. On the next day
when he went to the darbar in the female apartments,
there were given to him on the part of Nur-Jahan Begum
a rich dress of honour, a jewelled sword, a horse and
saddle, and an elephant. After this I presented him with
a rosary of pearls of great value. On the next day a
special elephant with trappings (*talayir*) were given.
As it was in my mind to give him something of every
kind, I presented him with three hawks and three fal-

cons, a special sword, a coat of mail, a special cuirass, and two rings, one with a ruby and one with an emerald. At the end of the month I ordered that all sorts of cloth stuffs, with carpets and cushions (named *takiya*) and all kinds of perfumes, with vessels of gold, two Gujarati carts, and cloths should be placed in a hundred trays. The Ahadis carried them in their arms and on their shoulders to the public audience hall, where they were bestowed on him."[3]

Nanha's characteristically spirited portrait of the young Mewari prince was probably painted in 1615,[4] a date supported by an inscription dating it prior to 1619, when Bhim's son Jagat succeeded him as rana. Since 1615 Bhim had lived at the Mughal court representing his family and was so admired by Jahangir for his military talent that he was given the *jagir* of Merta. Transferred by imperial order to the service of Prince Khurram (Shahjahan), he served him during the years of rebellion and secured for him the province of Bihar by capturing Patna.

SCW

IN THE upper line and on the left side of the border there is a ghazal by Shahi; on the right side there is a ghazal without end verse, which is probably by the same poet. It seems that the poems on the borders of this leaf and of pl. 32 belong to the same manuscript. Since their old border numbers are consecutive, they were probably prepared at the same time in the royal ateliers.

AS

THIS VERSO PORTRAIT has the margin number 57 and thus belongs to Group A. It would have faced MMA fol. 1r (pl. 32) in an album. The flowering plants of the border around the portrait are different from other designs showing colored flowers on a buff ground in that the stems are gold. The flower heads are brushed with gold, and flowers, stems, and leaves have dark outlines. The coloring of the flowers is lyrical, with delicate shading into darker centers. The leaves are all one shade of ocherish green, and the brushwork is of an unsurpassed lightness and sureness. While this is the second folio in the Kevorkian Album whose verso border is signed by Daulat (cf. MMA fol. 7v; pl. 27), the present border appears to be the only one of flowers in colors and gold on a buff ground in the album by this artist—a great pity since it is a masterpiece. In spite of their exquisite delineation only four plants are identifiable—a poppy in the left border (second from the bottom), another poppy on the inner side of the right border (fifth from the bottom), with a *Rununculus* above it, and to the right of that an iris.

MLS

1. Jahangir, *Tuzuk*, II, p. 123.
2. Muhammad-Salih Kanbo, '*Amal-i salih*, I, p. 188.
3. Jahangir, *Tuzuk*, I, p. 277–78.
4. A slightly later version of this portrait was given by John Goelet to the Museum of Fine Arts, Boston. For an early nineteenth-century traced drawing in reverse of Nanha's portrait, see *Loan Exhibition of Antiquities*, no. C.154, pl. LXIIIa. Inasmuch as this drawing is inscribed in the same fashion as the Kevorkian Album picture, referring both to Raja Bikramajit and to Maharaja Bhim Kunwar, it must have been taken from the Metropolitan Museum miniature, probably at the time the Kevorkian Album was being made up from originals and copies. Like several others of the same sort exhibited in 1911, it is dabbed with color notations, and it was lent by L. Bulaki Das of Delhi.

149

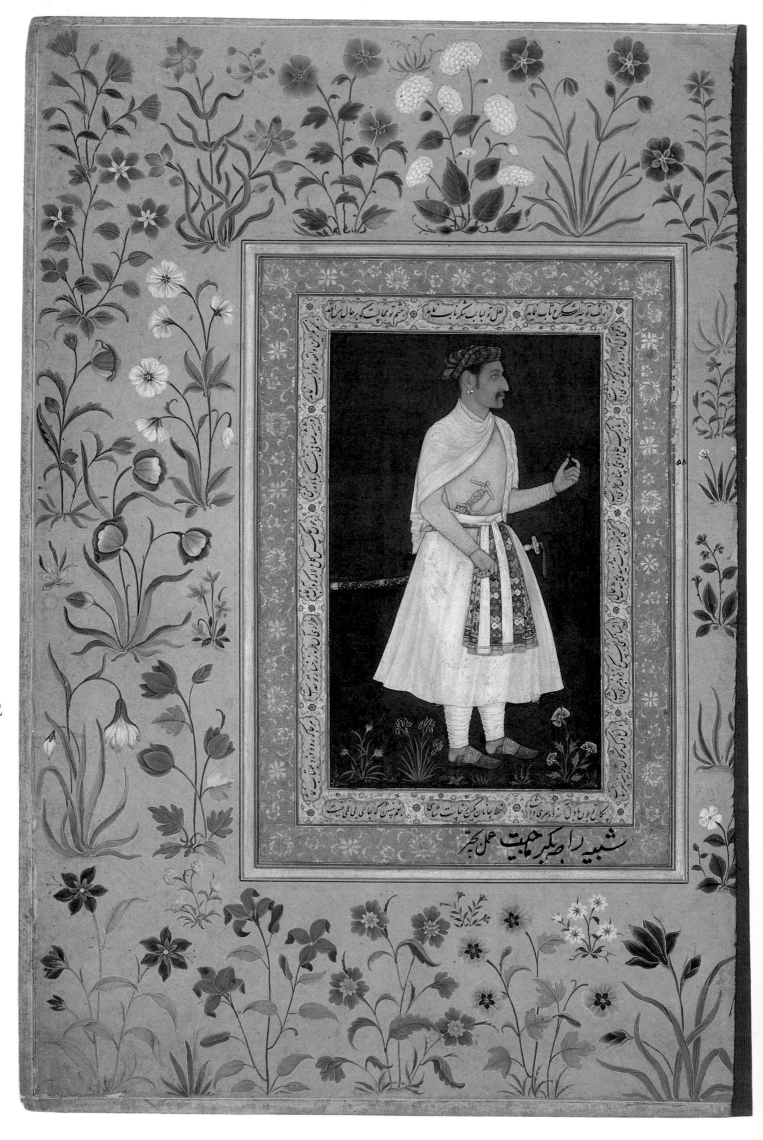

32

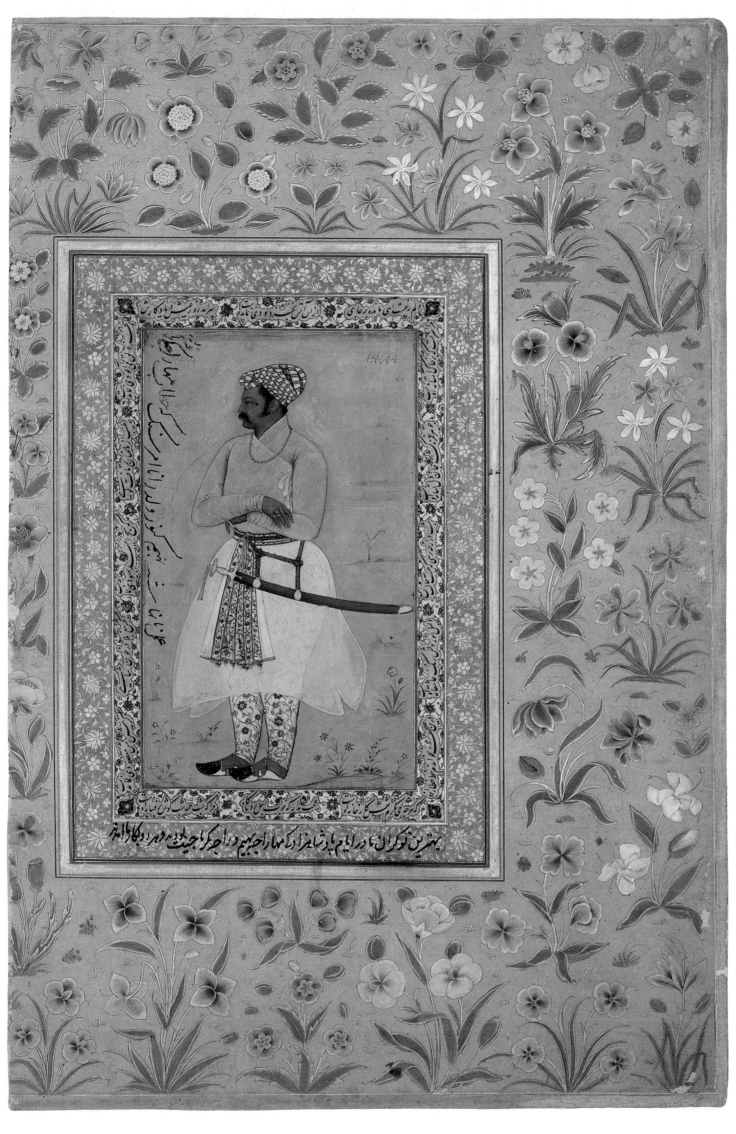

33

34

34. Calligraphy

ca. 1540

MMA 55.121.10.2r

You can well ensnare men's minds by kindness—
He who is not gracious wins no hearts;
Those who helplessly implore him
Do not relish his coquettish ways.
 The poorest of slaves [*afqar al-ʿibad*], ʿAli

The surrounding verses belong to the divan of Shahi; one of them was illustrated in a dispersed manuscript of the divan created during Akbar's time.[1]

AS

In THE GOLD beneath the inner floral border it is stated that the illumination is by the "slave of the threshhold" Daulat. On a leaf of the plant in the middle of the outer border in the second tier from the bottom is written in gold on gold the name Harif. None of the other borders in the album have a name placed within the border design. Was Harif a pupil of Daulat's who had some part in the decoration of the border and slipped his name in where his master might easily not see it? The very beautiful border of the painting of the spotted forktail (MMA fol. 15r; pl. 40) has an inscrip-

tion at the bottom of the painting stating that the gilding was by Harif. If Harif was a pupil of Daulat's, his work is certainly worthy of his master and is stylistically inseparable from it. Perhaps Harif was the real name of the artist who used Daulat as his pen name later in his career.

This border has another unusual feature: many of the flowers do not exhibit brushstrokes but a very fine stippling of the gold, producing a very dense and rich effect. The artist has superb control of his material.

Since this leaf and MMA fol. 1 (pls. 31 and 32) are the only two folios with this particular border arrangement, there is no possibility of confirming or denying whether it was originally part of Album 1 of Group A to which MMA fols. 7, 8, 32, and 37 (pls. 27–30, 17, 18, 67, and 68) belong and which also has a leaf (MMA fol. 7v; pl. 27) signed by Daulat. It is likely that a number of albums were worked on simultaneously in the royal atelier by the same group of artists.

MLS

1. Welch, *Art of Mughal India*, pl. 5B.

35. Ibrahim ʿAdilshah II of Bijapur

ca. 1620

INSCRIBED: (on portrait in Jahangir's hand) *shabih-i khub-i Ibrahim ʿAdilkhan* (a good portrait of Ibrahim ʿAdilkhan); (below, probably in Shahjahan's hand) *ʿamal-i Hashim* (done by Hashim)

MMA 55.121.10.33v

Bijapur WAS the largest and southernmost of the five kingdoms of the Deccan that resulted from the breakup of the Bahmanid empire at the end of the fifteenth century. The sixth sultan of the ʿAdilshah dynasty that ruled Bijapur from 1490 until 1688 was Ibrahim ʿAdilshah II (r. 1580–1626). Nephew of the formidable Princess Chand Bibi of Ahmadnagar and ʿAli ʿAdilshah I of Bijapur, Ibrahim II was "superior to

any of the sultans of the Deccan in both lands and wealth,"[1] and modern writers have viewed him as a "liberal and tolerant monarch who allowed complete freedom of worship to his non-Muhammadan subjects, Hindus as well as Christians."[2] During his reign civil administration was improved and friendly relations were maintained with the Portuguese at Goa, which lay within the borders of Bijapur. The kingdom was

extended down to the borders of Mysore, and the city of Bijapur was adorned with many fine examples of Deccani architecture.

A contemporary Mughal writer, ʿAbdul-Baqi Nihawandi, remarks that the credit for the achievements of ʿAdilshah's reign belonged chiefly to his ministers—"he himself seeks amusement in pleasure and frivolity. He is perfectly acquainted with the science of music and spends most of his time with Indian musicians and singers. He has composed some songs in the Hindi language and has named a number of them *nauras*. His fondness for music is more than can be described."[3]

WMT

"As ʿAdil Khan was constantly asking for a likeness of myself through my son Shah-Jahan, I sent him one with a ruby of great value and a special elephant." So wrote Jahangir in his *Tuzuk* during the thirteenth year of his reign (A.D. 1618), when Sultan Ibrahim was forty-seven years old, approximately the age at which he is shown here. Hashim, whose career has been discussed in connection with his portrait of the Khankhanan (pl. 20), specialized in portraits of Deccani subjects and probably had observed Sultan Ibrahim in Bijapur. Thus, when asked by Jahangir to paint the great connoisseur, musician, and patron in unidealized detail, he did not spare the hook nose, beady eye, and protruding lower lip. Inasmuch as the flowers at the sultan's feet are Deccani in their lyricism but Mughal in their naturalistic scale, this portrait was probably painted soon after the artist's arrival at the Mughal court.

To Jahangir, Sultan Ibrahim was always a rival and often an enemy, hence someone of whom a soul-baring portrait was needed. His domain and wealth had inspired imperial aggression since Akbar's reign. But he also earned Jahangir's reluctant respect as a gifted musician and poet and as a patron of architecture and painting. Inasmuch as the two rulers were pitted against each other in realms of culture as well as on battlefields, Jahangir took equal satisfaction in luring a major artist from the sultan's workshops as in scoring a military coup in the Deccan, where Mughal armies were finally victorious in the late seventeenth century.

Few Mughal artists equaled Hashim in depicting dignified, solidly grounded figures, weighty as the Deccani granite of Daulatabad Fort, moving with infinite authority at elephantine pace yet possessed of paradoxical grace. The impression of forceful dignity is achieved sparingly, with no trace of fussiness, but with reserves of concealed power.[4]

SCW

THE OUTER BORDER of this verso portrait has gold flowers on a pink ground in the exuberant lush style associated with Daulat although the drawing and brushwork are not as fine as that master's. The painter was perhaps a follower or pupil of Daulat. The inner border has a gold flower-head and leaf scroll on a blue ground. There is no innermost border with cutout poetry; this may indicate an album or origin different from that of the three paintings with the same border scheme (i.e., MMA fols. 3r, 29r, and 6r; pls. 24, 26, and 74). Artistic compatibility would suggest that cutout poetry around a portrait would pertain throughout an album, or a lack of it would be equally consistent, unless, of course, the addition of poetic framing borders was dependent on the size of the original painting (unnecessary in large paintings, as here, while filling up the extra space in small paintings). The margin number 51 does not fit in with the multiples of 6 of the other three leaves, which have 6, 12, and 18 as margin numbers. In that scheme 54r and 53v (and not 51v) should have shared the same pattern. Again, according to the margin numbers, this leaf would have faced the recto page with the margin number 52. That is the page with the portrait of Danyal, brother of Jahangir (pl. 18). The small portrait of Danyal and the rather imposing and larger one of Ibrahim ʿAdilshah II would not have looked particularly well opposite each other; however, that does not always seem to have been a consideration.

Of the border flowers, an iris can be identified in the upper left corner. Within the painting a rose appears before the portrait.

An early nineteenth-century copy of this portrait was auctioned at Sotheby's on October 14, 1980, lot 190, (illustrated). The border of this copy appears (from the black-and-white photograph) to consist of flowering plants in colors and gold on a buff ground with rather soft, indecisive drawing. No attempt was made to copy the gold plants on a pink ground of the seventeenth-century border. Gold plants on a pink ground are very rare, if they exist at all, in nineteenth-century borders.

MLS

1. Iskandar Beg, *Tarikh-i ʿAlam-ara-yi ʿAbbasi*, II, p. 1069.
2. Sachchidananda Bhattacharya, *A Dictionary of Indian History*, p. 436.
3. ʿAbdul-Baqi Nihawandi, *Maʾathir-i Rahimi*, II, p. 409.
4. For another version of this portrait, see Heeramaneck, *Masterpieces of Indian Painting*, pl. 236. An early nineteenth-century traced copy, painted in reverse, was exhibited in Delhi in 1911; see *Loan Exhibition of Antiquities*, no. C. 125a, pl. XXXIC.

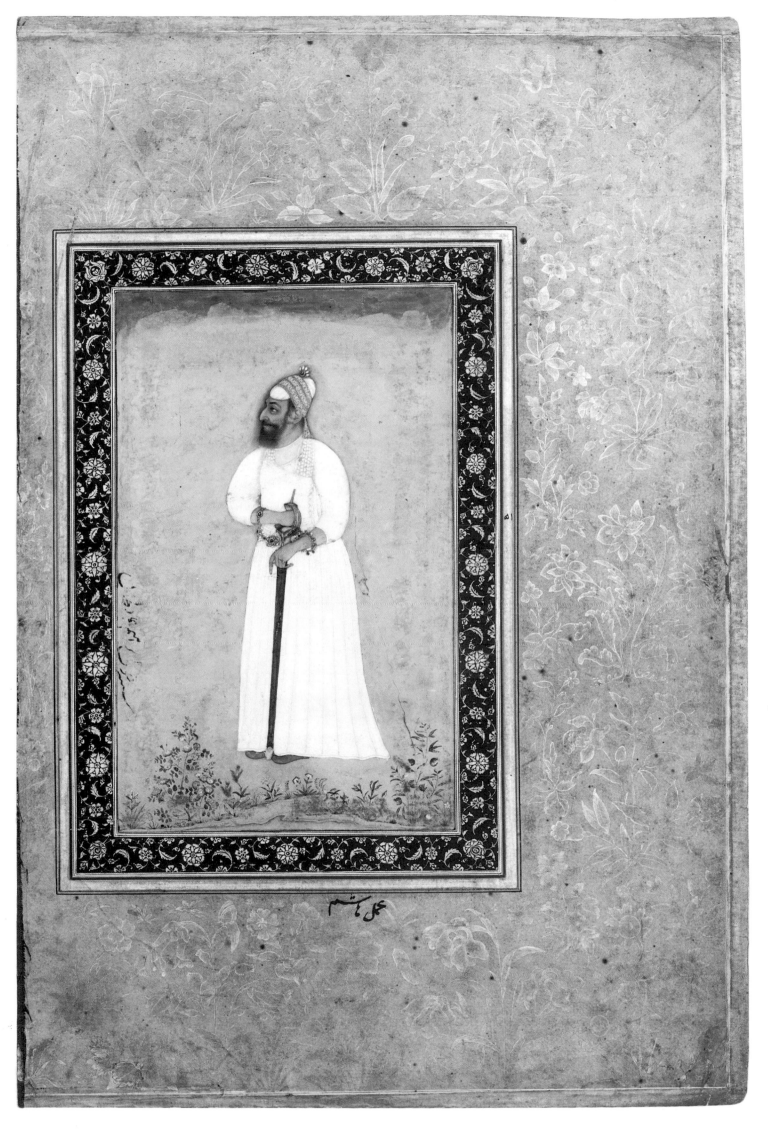

35

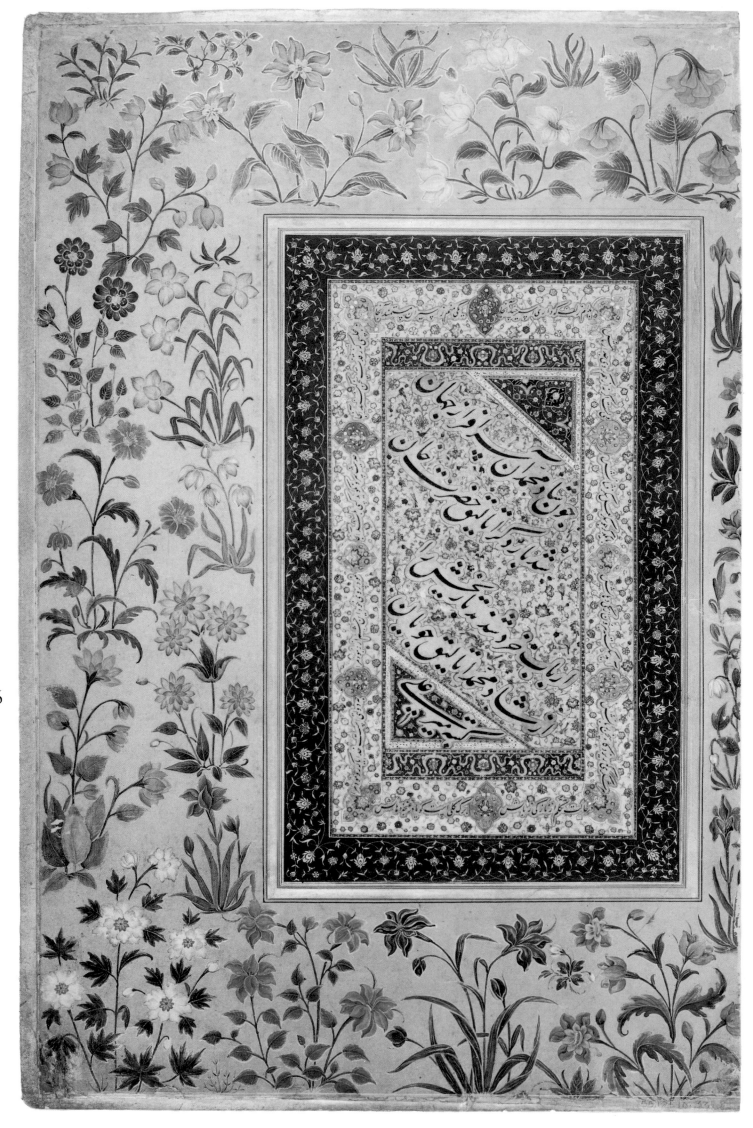

36

36. Calligraphy

1534 or slightly later

MMA 55.121.10.33r

THIS PERSIAN quatrain contains a chronogram for the second investiture of Shad Muhammad as *ataliq* (regent) in A.H. 941/A.D. 1534. The poem was composed and written by Mir-ʿAli in Bukhara.

The page is surrounded by a fragment of a ghazal in the upper line and down the left side, which is followed by the beginning of another ghazal; in the lower line and continuing up the right side is the beginning of a ghazal about the beloved's mouth.

AS

THE LARGE PLANTS are boldly presented, while the gold brushstrokes within the flowers themselves add to the general richness. There is a vitality in the treatment of the plants that masks the slightly heavy-handed drawing. Two irises may be found in the inner border, one plant down from the top and one up from the bottom, with a third one row up on the inner side of the outer border. The plant at the middle of the outer border on the inner side may be a *Galanthus* (snowdrop), while the plant above it is a freesia.

MLS

157

37. Calligraphy

1537–47

MMA 55.121.10.34V

I shan't give up the cypress
 flourishing in my eye:
The gardener knows the cypress
 grows best on riverbanks.
The friend grasped me, quite guiltless,
 and murdered me today—
He never gives a thought to
 what he'll do tomorrow.
 The poor |al-faqir| ʿAli

The poet plays on the commonplace that cypresses usually grow on a canal bank in a garden; as the poet's eye is constantly wet, the slim, cypress-like figure of the beloved survives best there.

The upper and lower parts of the page contain two verses in Chagatay Turkish, the upper one by Navaʾi and the lower one probably by him. The calligraphy seems to be that of Sultan-ʿAli Mashhadi. The cartouches at left and right contain fragments of two ghazals, which may have been written by Jami.

AS

THIS VERSO PAGE has an inner border of gold flower heads and palmettes on a scrolling vine in gold on a blue ground, similar but not identical to that on the recto (pl. 38). The outer border of gold on pink has larger-scale plants in a denser pattern than on the recto. A certain handling of the plants suggests the same artist did both this page and the recto.

An iris, possibly "Japanese" type, may be seen at the upper left, and in the middle of the inner border a *Lacerale tulipa*, perhaps parrot type. At the lower right of the outer border there is also a *Tulipa*, perhaps parrot type (cult.); above it a "peach" type that could be an almond or a hawthorne; above this are an iris and then a plant with cyclamen-type flowers. In the upper corner is a stylized narcissus with a rose next to it.

This folio may have belonged to the same album as MMA fol. 19 (pls. 11 and 12) since the border schemes are the same, and neither has cutout poetry around the portrait. If so, it would be the third album which contributed to Group B.

MLS

158

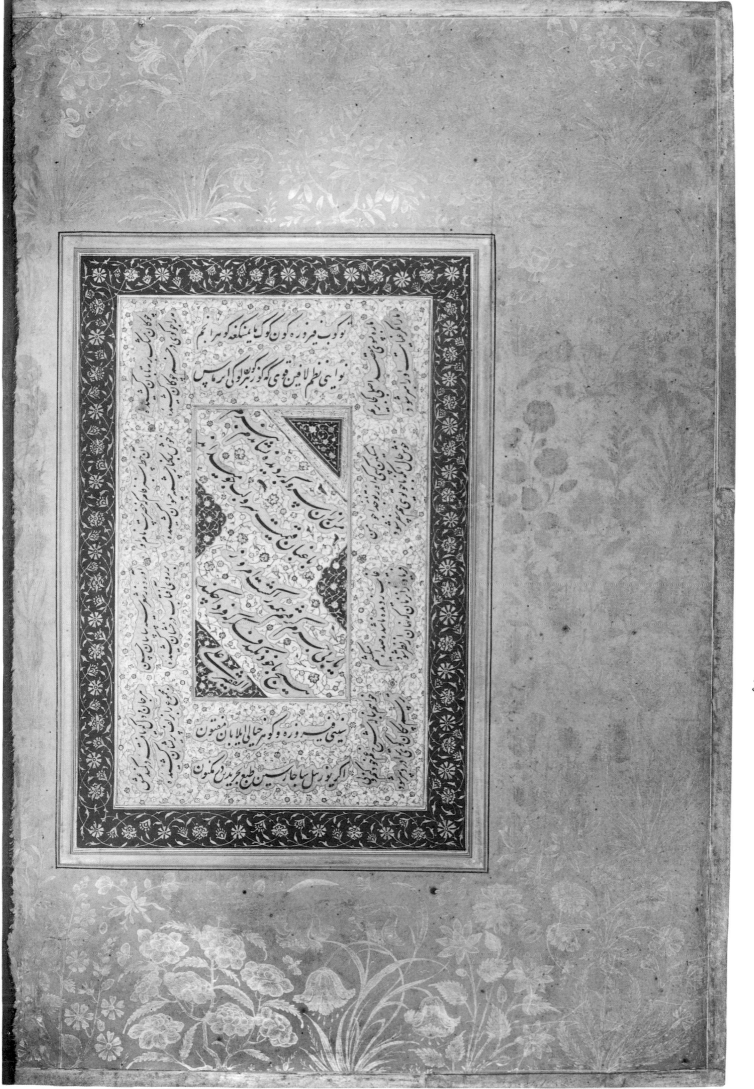

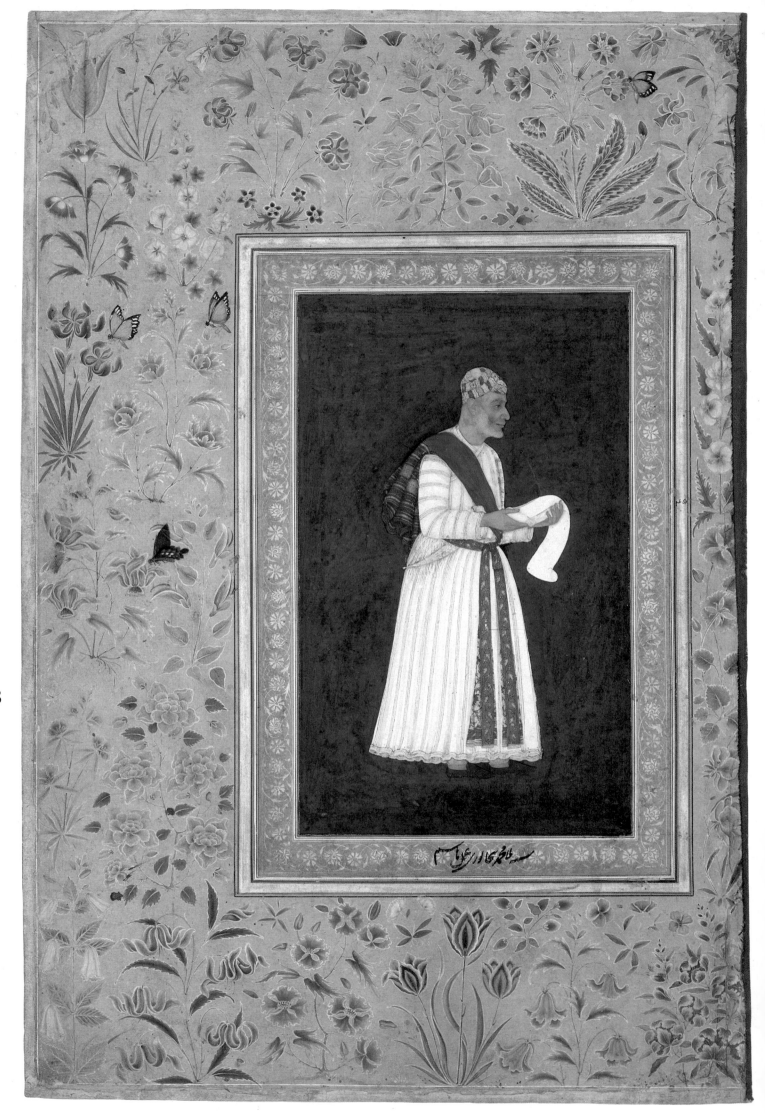

38

38. Mulla Muhammad Khan Wali of Bijapur

ca. 1620

INSCRIBED: (in the border in Jahangir's [?] hand)
"likeness of Mulla Muhammad Bijapuri;
work (ʿamal) of Hashim"

MMA 55.121.10.34r

THIS PORTRAIT probably depicts Mulla Muhammad Khan Wali of Bijapur, summoned in 1621 by Ibrahim ʿAdilshah II to ask the Mughal general Mahabat Khan to send assistance against Malik ʿAmbar. He joined the troops at the head of five thousand cavalrymen and was killed by Malik ʿAmbar in the Battle of Bhatwandi. He was the father-in-law of Mustafa Khan, commander of the Bijapur armies; apparently, like his son-in-law, he worked for better relations between Bijapur and the Mughals. He did not cooperate, however, with Prince Khurram (Shahjahan) when he rebelled in the Deccan.

WMT

LIKE HASHIM'S slightly later and more pungently Mughal characterization of Sultan Ibrahim (pl. 35), this portrait seems to have been painted soon after Hashim's arrival at the Mughal court from the Deccan. Still typical of Deccani (Bijapuri) portraiture are the quaintly congruent feet, lined up like boxcars on a railway track, and certain facial characteristics. Hard as Hashim strove to satisfy the Mughal taste for realism—noting every nuance of texture, color, and shape—he was not yet able to avoid such ingrained Deccani formulas as the fish-shaped eye—still apparent beneath a Mughal one, painted in profile—and the stylized mouth, with its pleasingly abstracted simplifications.[1] Fortunately, Hashim always retained traces of Deccani style—in his measured, rollingly smooth, razor-sharp outlines, which harmonize so effectively with subtle internal modeling that even figures of great bulk seem graceful, and in his rugged profiles, so uncompromising that they seem to have been chiseled from rock.

SCW

THIS RECTO PORTRAIT has the margin number 45 and so belongs to Group B. There is no innermost border of cutout poetry. The inner border is composed of a palmette and flower-head scroll in gold on a pink ground. The outer border is made up of flowering plants with thin stems, rather large flowers, and pronounced gold outlines; a slight indication of root or groundline is faintly visible. Smaller plants fill the interstices, while a very faint groundline runs across part of the bottom of the lower border. The plants that are identifiable include a Rembrandt-type "broken" tulip (cult.) and a lily along the bottom border. Above the lily in the left border is a highly stylized rose, and above that to the left of the butterfly is a cyclamen type but with incorrect leaves. The plant above it is possibly a stylized iris with possibly a stylized dianthus above it; to the right of the dianthus perhaps a geranium. The middle plant of the upper border belongs to the *Liliaceae* and is near to but is not a *Disporum*. A few butterflies are dispersed among the plants, of which a lily and a tulip are to be found in the lower border. The colors are mainly rather pale and give the impression of having faded.

An early nineteenth-century copy of this portrait was auctioned at Sotheby's on October 14, 1980, lot 187 (illustrated). It is impossible to tell from the black-and-white photograph whether the border of this copy, with its design of flowering plants, is in gold on a buff ground or in colors and gold on a buff ground, since there is so little tonal contrast. The seventeenth-century border of flowering plants in colors and gold on a buff ground is full of contrasts, with a sharp nervous quality to the drawing totally lacking in the flaccid forms of the plants of the later leaf.

MLS

1. For an excellent Bijapuri example, see Welch, *India*, p. 297.

161

39. Calligraphy

ca. 1540

MMA 55.121.10.15v

There is no worth in you and in your seeing—
Otherwise [you would see that] there is nothing else in the universe.
The word of love is rarely bought—
Otherwise the Beloved is very conspicuous.
As long as you have not become intoxicated by [acknowledging] His [God's] unity,
The rank of arriving will not be granted to you.
 The poor sinner Mir-ʿAli

These lines express, in a somewhat convoluted style, the mystical concept of the Unity of Being: there is nothing existent but God, and He alone is visible, even though people may not reach the highest degree of love and annihilation in His unity.

The page is surrounded by an encomium for a Timurid prince—apparently a son of Timur, perhaps Shah-Rukh—whose "ascendant is higher than Timur's."

 AS

THE GOLD-ON-BLUE inner border of this verso calligraphy page is almost identical to that of the recto (pl. 40). Panels of cutout poetry along the sides form a partial innermost border. The outer border contains flowering plants on a buff ground. An iris is identifiable in the upper left corner, a poppy in the lower left corner, and a narcissus four plants from the right in the lower border. A *Narcissus bulbocodium* is the small plant third from the right in the upper border. There is no reason to suppose that Harif was not responsible for this border as well as for that of the recto.

The birds painted around the calligraphy panels may be identified as follows: river chat (*Chaimarvornis leucocephalus*), at right above the first line of calligraphy; common rosefinch (?) (*Carpodacus erythrinai* [?]), above the second line of calligraphy; chukor (*Alectoris chukor*), above the third and fourth lines of calligraphy from the bottom along the central vertical axis; white wagtail (?) (*Notocilla alba* [?]), at right above the fourth line of calligraphy from the bottom and at right of the third line from bottom; egret (*Egretta*), bottom right corner. In the upper right corner a black buck (*Antilopa cerricapra*) is being attacked by a cheetah (*Acimonyx jubata*).

 MLS

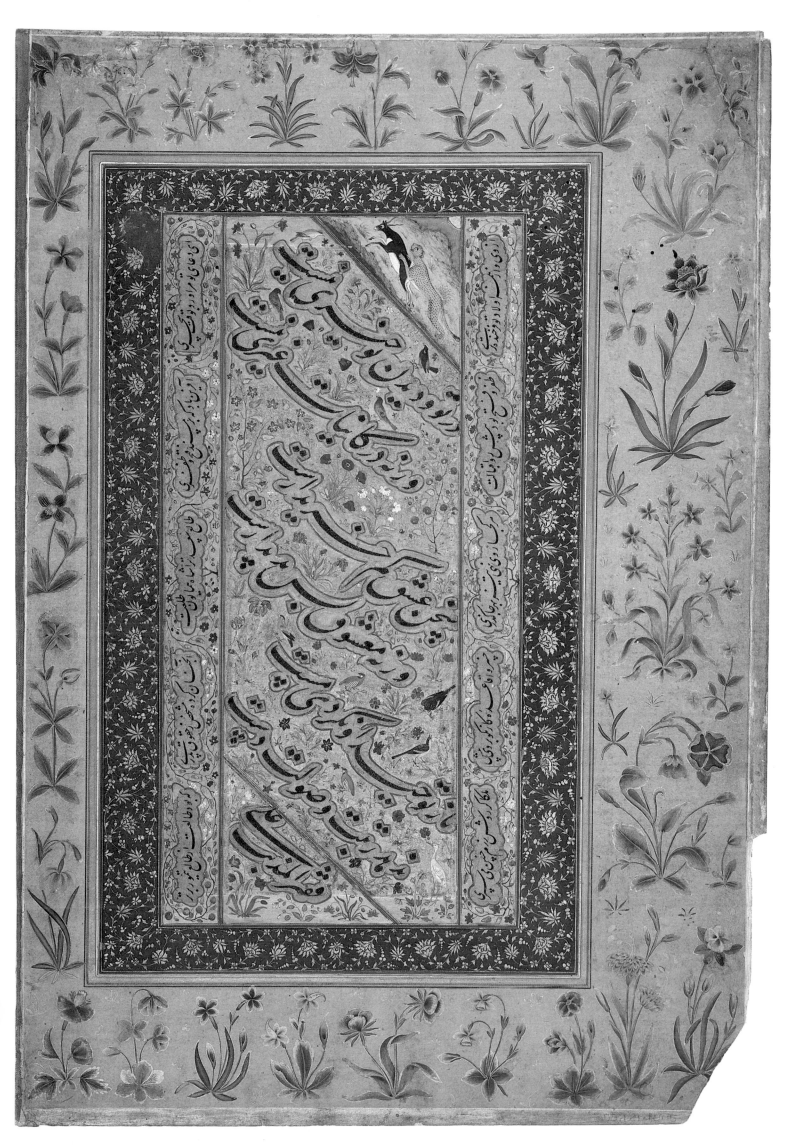

40. Spotted Forktail

ca. 1610–15

INSCRIBED (in fine nastaʿliq): (in sky) *aʿla* [most high]; (on right rock) "equal to the natural size"; (on left rock) "a unique [lit., 'nonrepeated'] beast which the servants hunted in Jangespur and whose likeness they [i.e., His Majesty] ordered [to be drawn] by the servant of the palace Nadir az-zaman [i.e., Abuʾl-Hasan]"; (to left of rock in minute gold script) "work of gold-spreading the painting of Harif." (These last words were rewritten when the cloth was repaired or when the picture was mounted.)

MMA 55.121.10.15r

THE SPOTTED FORKTAIL is a bird of the Himalayas, living by running streams in, preferably, thickly forested ravines, at elevations from three thousand to twelve thousand feet. Its strikingly patterned black-and-white plumage affords it perfect camouflage, blending with the gleam of the flowing water and the deep shadows of rocks as it moves along in search of insects and larvae in the water or stream bed.[1] In what circumstances, one wonders, did the servants of Jahangir find this elusive and beautiful bird? Did Jahangir see it alive or dead? Did Abuʾl-Hasan see it alive or dead and was he also in Jangespur? Where is Jangespur, which is not mentioned in Jahangir's memoirs and does not appear in atlases, historical or contemporary? It can be surmised that Abuʾl-Hasan did not see the spotted forktail in its natural habitat and was unaware of it, or he presumably would have painted it in or beside a mountain stream. Jahangir must indeed have been moved by the beauty of the bird, whatever the circumstances of his seeing it, in that he deemed its portrait worthy of the brush of one of his most esteemed artists.

In his memoirs Jahangir has this to say about Abuʾl-Hasan, to whom he had just given the title Nadir az-zaman (Wonder of the Age): "At the present time he has no rival or equal. If at this day the masters Abduʾl-Hayy and Bihzad were alive, they would have done him justice. His father, Aqa Rizaʾi, of Herat, at the time when I was Prince, joined my service. He (Abuʾl Hasan) was a *khanazad* of my Court. There is, however, no comparison between his work and that of his father (i.e., he is far better than his father). One cannot put them into the same category. My connection was based on my having reared him. From his earliest years up to the present time I have always looked after him, till

his art has arrived at this rank. Truly he has become Nadira-i-zaman ("the wonder of the age"). Also, Ustad Mansur has become such a master in painting that he has the title of Nadiru-l-Asr, and in the art of drawing is unique in his generation. In the time of my father's reign and my own these two have had no third."[2]

MLS

ABUʾL-HASAN drew with the most powerfully sure and articulate line in Mughal art; and whether painting man or beast, he tinctured telling gestures with humor. This spotted forktail (*Enicurus maculatus*), outfitted in starkly elegant blacks and whites, is as dignified as any emperor. Its white-outlined oval eye, precise as a crescent moon, peers alertly from the brow's airy, ping-pong ball roundness. Even in isolation, Abuʾl-Hasan's figures and animals—unlike Manohar's—imply involvement with others. Frail but flexibly springy, the forktail sparkles with the might and comedy of life. Under the palpable feathers, skeletal "architecture" is apparent in the perfectly aligned, arrow-straight legs. Strong as steel girders, they end in claws sharp as fish hooks and are grounded on massive rock. In comparison, everything else in the picture is in flux. Distant birds swoop or hover in a gold-streaked sky against cloud banks; thin, feathery grasses shimmer in gusts of wind that whip water into froth.

This is one of Abuʾl-Hasan's few natural history pictures, and the only one with a contemporaneous inscription.[3]

SCW

THIS MAGNIFICENT painting has an equally magnificent border, consisting of supremely fine and delicate floral scrolls with much gold brushed into the varicolored petals. At the bottom of the picture an inscription in tiny letters states that the gilding was by Harif. His name is not familiar as a painter of scenes or portraits, and it does not appear on any other published borders (this field is, however, in its infancy). For a discussion of Harif and his possible relationship to Daulat, see MMA fol. 2r (pl. 34).

The margin bears the number 44. In a vertically oriented album the bird's tail would be at the bottom. There is a palmette, floral-spray, and leaf-scroll inner border in gold on pink; there is no innermost border of cutout poetry. The forktail would have faced the hornbill (pl. 41) in its original album.

There is a nineteenth-century copy of this painting in the Kevorkian Album (FGA 39.46b; pl. 85) which has

164

the same floral-scroll border scheme, but which in respect to both bird and border cannot be compared to the original. When albums were reassembled in the early nineteenth century and the copies added at that time, they must have been done in considerable haste and carelessness because, of course, a copy must have been intended for a different album from the original. It is also possible that the nineteenth-century copy was indeed assembled into a different album from the original or was at least slotted for such a step and that at some later date the albums were taken apart again and reassembled at a time when the purpose of the nineteenth-century copies was unknown to the later assemblers.

MLS

1. Whistler and Kinnear, *Popular Handbook of Indian Birds*, pp. 95–97, fig. 15.
2. Jahangir, *Tuzuk-i-Jahangiri*, 11, p. 20.
3. Robert Skelton has ascribed two others to him on stylistic grounds; see Welch and Beach, *Gods, Thrones, and Peacocks*, no. 10, and Welch, *A Flower from Every Meadow*, no. 61. Abu'l-Hasan is also likely to have worked with Mansur on the famed *Squirrels in a Plane Tree*; see Welch, *India*, no. 141.

41. Great Hornbill

ca. 1615–20

INSCRIBED: (on border in Jahangir's hand) "work [*kar*] of Master [*ustad*] Mansur"

MMA 55.121.10.14v

THE APPEARANCE of this great hornbill (*Buceros bicornis*), measuring about fifty-two inches long, with black-and-white plumage and yellow casque and bill, is striking enough to have attracted the attention of Jahangir. Perhaps, on the other hand, it was the sound of the bird that was at first riveting, as in flight the wind whistling through its feathers makes a droning noise that can be heard a mile away. When congregating in groups in the larger trees of the forest, it also emits a noisy barrage of bizarre sounds. If Jahangir watched the hornbill feeding, he must have been amused at the way it tossed fruit or other food into the air with the tip of its bill, catching it in the throat and swallowing it.[1]

While the bird is exquisitely painted, its position at the edge of the rock is somewhat awkward and its feet less suited to this perch than to the large branches of the trees of its forest habitat. Perhaps Mansur (if the ascription is correct) had never seen a hornbill in the wild, since its habitat is confined to the area from the Western Ghats to Cape Comarin and the lower Himalayan ranges up to five thousand feet from Kumaon eastward. On the other hand, habitat in natural history painting is a relatively recent concept, and background in seventeenth-century Mughal portraits generally provided a simply neutral if harmonious setting.

Another version of this painting of the hornbill exists, apparently not quite as fine; but whether or not it is a nineteenth-century copy the published account does not say.[2]

MLS

THE RICHLY detailed blacks, whites, and yellows of Mansur's stately hornbill are as rewarding to close inspection as those of a living bird. As in his other natural history studies, Mansur concentrates upon the hornbill directly and objectively. We sense wear on the light but hard beak and feel the coolness of the damp, leathery feet. As usual, Mansur reserved calligraphic flourishes and playfully rhythmic, ornamental runs of the brush for the stones and grasses of the setting. The miniature was enlarged at both sides, probably by Mansur; the original part has, however, darkened in contrast to his carefully matched additions.

SCW

THE PAINTING of the hornbill is as splendid as that of the forktail (MMA fol. 15v; pl. 40) and would have faced it in the album to which they originally belonged. It is a verso page with the margin number 43, and thus both are Group A leaves. The border scheme is compatible with the other, although not quite as fine, with a floral and leaf scroll in colors on a buff ground.

MLS

1. See Whistler and Kinnear, *Popular Handbook of Indian Birds*, pp. 304–305, for a description of the appearance, habits, and distribution of the great hornbill.
2. *Art of India and Pakistan*; Basil Gray, "Painting," p. 159, no. 718. The author says that the one illustrated is somewhat superior to the one he is discussing, which at that time belonged to Geoffrey C. N. Sturt, Painswick, Gloucestershire, but he does not illustrate it.

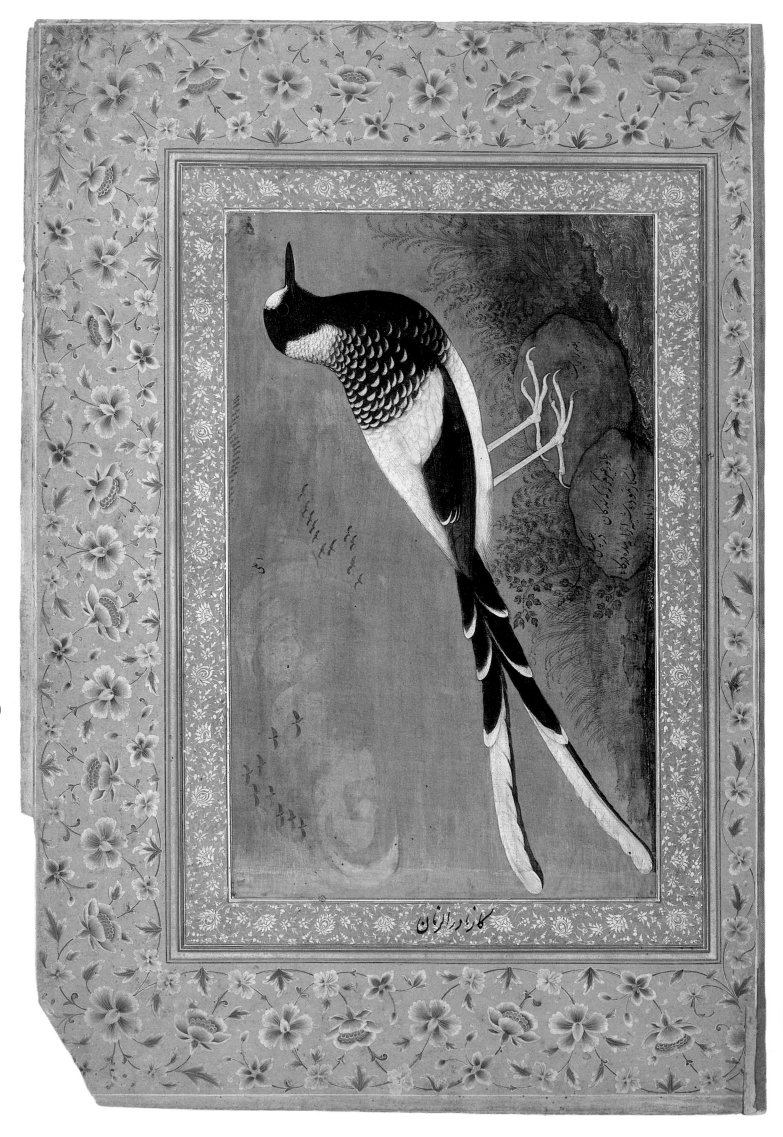

40

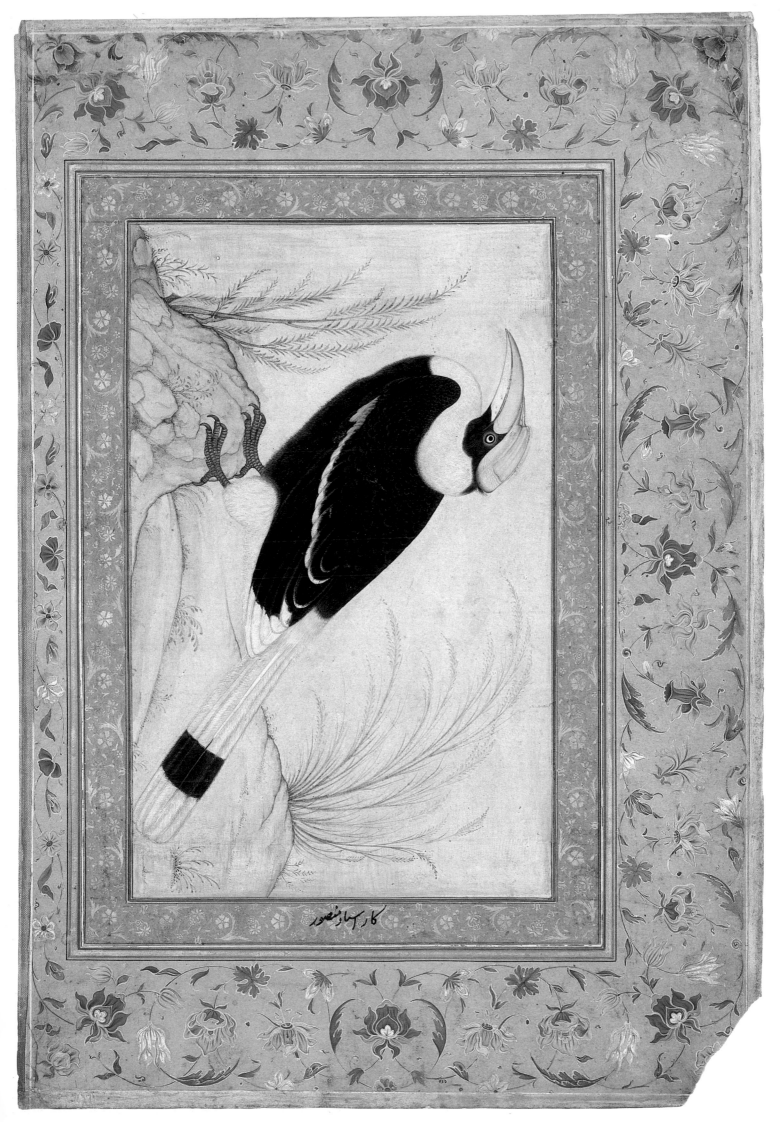

41

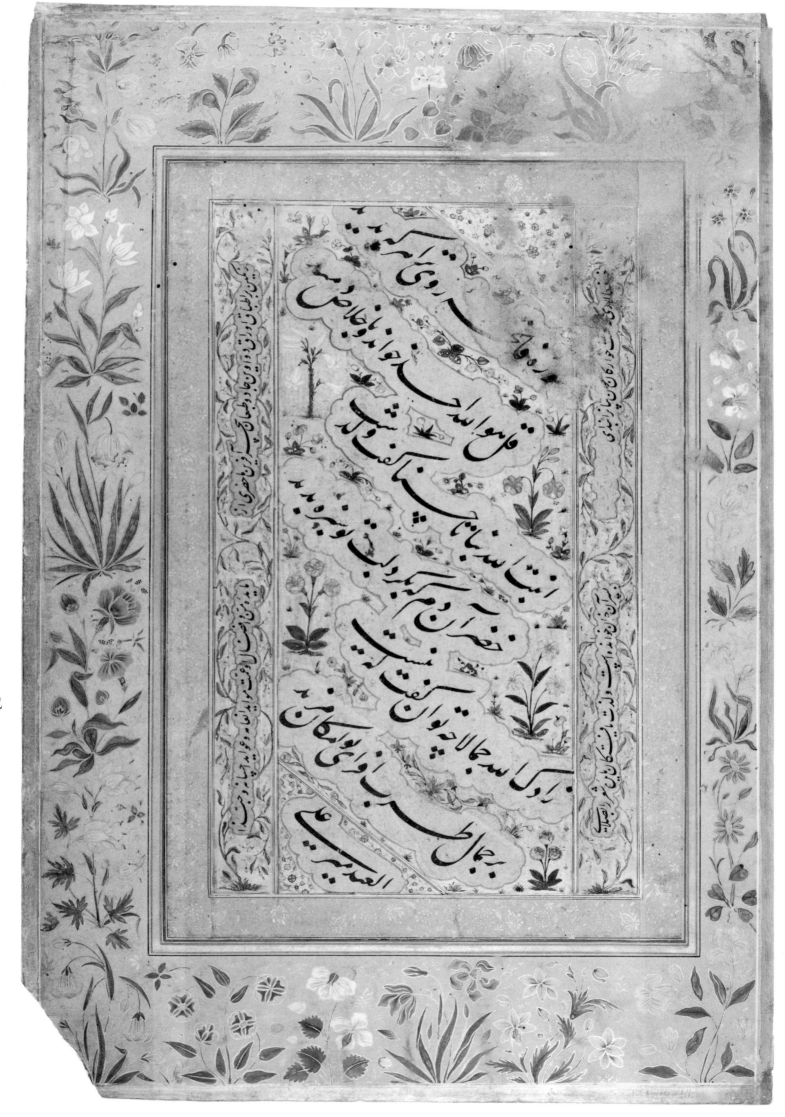

42

42. Calligraphy

ca. 1540

MMA 55.121.10.141

Whosoever sees the *surat-i fatiha* of your face,
Recites, "Say, God is one!" and blows with sincerity.
Khidr said, "God made a fine plant sprout," and passed by
The moment he saw the greenery around your lip.
"May God increase your beauty!"—how can one say that?
For there is no possibility of increase in your beauty that
 makes joy increase!

The author says metaphorically that the face of his beloved is as divine as the *surat-i fatiha* (the first chapter of the Koran) and as beautiful (the first pages of the holy book were usually richly illuminated). Looking at the beloved's face, the lover exclaims, "Say, God is one...," which is the beginning of Sura 112, called *surat al-ikhlas*, the "sura of sincerity," or complete devotion (hence the pun on "sincerity" at the end of the hemistich). To recite this Koranic chapter and then to blow on one's hands and pass them over one's own or someone else's body is still done to avert the evil eye. With such breathtaking beauty one has to fear that the beloved may be hurt by the evil eye or by envious people. Khidr, the mysterious prophet-saint who had drunk from the Water of Life, is immortal: in poetic parlance he is often connected with the beloved's lip which grants the lover immortality by a single kiss (= water of life). The "greenery" is the newly sprouting down around the mouth and on the cheeks of the young beloved; it is compared in a Koranic expression (Sura 3/37) to a delicate plant, and the word "green" leads back to Khidr, whose name is derived from the Arabic root for "green."

This clever verse was apparently very much liked in Timurid days, and it appears on another fine calligraphed page by Sultan-Muhammad Nur (MMA 1982.120.4). Furthermore, the same poem, written by Mir-ʿAli, is also found in V&A 20–1925 on the reverse of a portrait of ʿAbdullah Uzbek. This version contains an additional line:

Those who are slain by grief for you are both poor and rich.
Those who are thirsty for your lip are both miserable and
 happy.

The additional line in the V&A poem takes its wording from a Prophetic tradition about predestination, i.e., "The miserable is miserable in his mother's womb, the lucky one is lucky in his mother's womb." Human destiny is preordained before birth. The lover—thus the poet—experiences both hell and heaven in longing for the beloved's lip.

The surrounding prose text seems to belong to a treatise on rhetoric.

AS

THE CALLIGRAPHY page has, as does MMA fol. 15v (pl. 39), side panels of cutout poetry in the innermost border and a gold-on-pink flower-head, leaf, and palmette scroll on the inner border. The outer border has colored plants on a buff ground. These are not identifiable.

MLS

43. Calligraphy

ca. 1535–45

MMA 55.121.10.16v

THIS PAGE contains two and a half verses from one of the most famous ghazals by Hafiz:

Come, for the castle of hope has a very weak foundation!
Bring wine, for life is built on wind.
I am the servant of the lofty ambition of him who, under the blue sky,
Is free from anything that takes the color of attachment.
How do I tell you that yesterday in the wine house, completely drunk...

The pun in the second line is on *bada* (wine) and *bad* (wind). The second verse expresses the necessity of complete detachment from the world.

The page, which at first sight looks like an original album page, consists of five lines that have been cut out and pasted on the paper. Parts of the same famous poem by Hafiz are found in five slanting lines in V&A 137–1921, and the poem's end, again in five lines, is preserved in CB 7/5v.

A ghazal by Shahi appears in the small cartouches.

AS

ON THIS VERSO calligraphy page the design of the main border is a wide interlacing riband scroll outlined in gold with gold palmettes, flowers, and leaves both on it and in the interstices, with superimposed oval cartouches with pink floral forms and cloud bands on a gold ground. The same basic border design is also found on MMA fol. 18v (pl. 51), the recto side of which has gold plants on blue. On fol. 18v, however, colors on a buff ground are used, and the drawing is very different. Here the riband scroll is broader, with a thin and then thicker double outline and lush palmettes that are not found on fol. 18v. The only leaf with gold-on-blue plants on the picture side and what might be called an all-over design in gold on pink on the calligraphy side is MMA fol. 20 (pls. 53 and 54). It is certainly possible that fols. 16 and 20 originally belonged to the same album, with the dancing dervishes (MMA fol. 18r; pl. 52) and the portrait of the Khankhanan (FGA 39.50a; pl. 20) belonging together in a separate album.

MLS

170

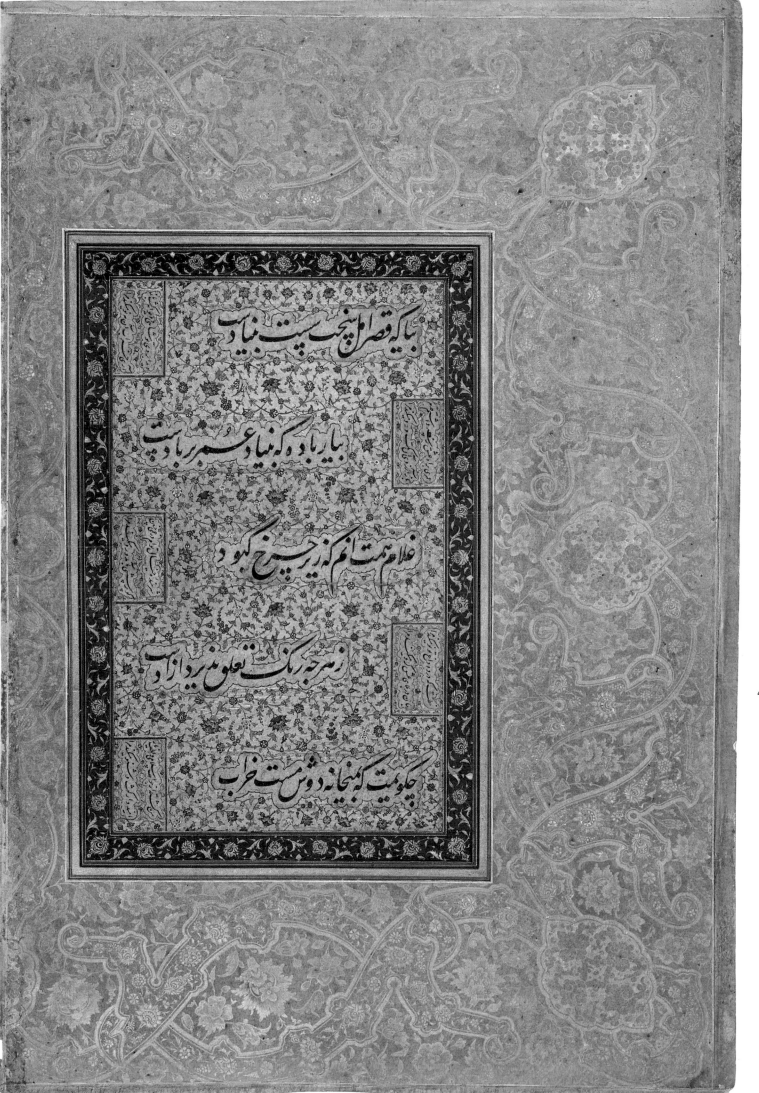

44. Diving Dipper and Other Birds

ca. 1610–15

INSCRIBED (in fine nasta'liq): (on upper rock) Jahangirshahi; (on rock on riverbank) "work ['amal] of the servant of the palace Nadir al-'asr Mansur the painter"

MMA 55.121.10.16r

JAHANGIR'S penchant for flora and fauna was perfectly served by Mansur in this composition of four birds by a stream, beyond which loom peaks reminiscent of the lunar mountainscape observable from Kashmir to Ladakh. Two of the birds fish—one diving in the manner of the *saj* described below by the emperor; the other vigorously attacking a fleeing minnow.

Few artists were singled out for praise in Jahangir's memoirs, but the one most often cited was Mansur. The first of four passages devoted to him in the *Tuzuk* follows the single one about Abu'l-Hasan: "Also, Ustad [Master] Mansur has become such a master in painting that he has the title of Nadiru-l-'asr [Wonder of the Age], and in the art of drawing is unique in his generation. In the time of my father's reign and my own these two have had no third."[1] In 1619 Mansur is mentioned again: "The King of Persia [Shah 'Abbas] had sent with Pari Beg Mir Shikar (chief huntsman) one falcon (*shungar*) of good colour. [It] got mauled by a cat due to the carelessness of the Mir Shikar. Though it was brought to court, it did not live more than a week. What can I write of the beauty and colour of this falcon? There were many beautiful black markings on each wing, and back, and sides. As it was something out of the common, I ordered Ustad Mansur, who has the title of Nadir al-'asr (Wonder of the Age) to paint and preserve its likeness."[2]

Jahangir's next reference to the artist follows an enthusiastic account of Kashmir: "This year [A.D. 1620], in the little garden of the palace and on the roof of the chief mosque, the tulips blossomed luxuriantly. There are many blue jessamines in the gardens, and the white jessamines that the people of India call *chambili* are sweet-scented.... I saw several sorts of red roses: one is specially sweet-scented.... The flowers that are seen in the territories of Kashmir are beyond all calculation. Those that Nadir al-'asr Ustad Mansur has painted are more than 100."[3]

In 1620, while in Kashmir, Jahangir wrote: "I rode to see Sukh Nag. It is a beautiful summer residence (*ilaq*).

This waterfall is in the midst of a valley, and flows down from a lofty place. The entertainment of Thursday was arranged for in that flower-land, and I was delighted at drinking my usual cups on the edge of the water. In this stream I saw a bird like a *saj*. [I]t dives and remains for a long time underneath, and then comes up from a different place. I ordered them to catch and bring two or three of these birds, that I might ascertain whether they were waterfowl and were webfooted, or had open feet like land birds. They caught two.... One died immediately, and the other lived for a day. Its feet were not webbed like a duck's. I ordered Nadiru'l-'asr Ustad Mansur to draw its likeness."[4]

Mansur's career and style are further discussed in the texts for pls. 41, 45, and 47.

SCW

THIS RECTO PAINTING has the margin number 40 and belongs to Group A. It shows birds by a stream and a dipper (*Cinclus*) in the water. It has no cutout poetry but has the usual palmette, flower-head, and leaf-scroll border in gold on a pink ground. The outer border of gold flowers on a blue ground is one of the finest in the album. An iris can be identified in the lower left corner and perhaps a double tulip in the center of the outer border. The plant in the lower left corner may be identified as *Lilium* and the one seen from the top in the inner border perhaps as *Ipomoea*. The plants are large in scale and bold in design yet exquisitely painted with subtle shading and very fine brushstrokes. Little plants and grass tufts are scattered throughout, and flying insects and butterflies abound. Windblown clouds sail across the top of the page. There is something particularly joyful about this border. The painter must have been closely associated with Daulat, but the hand does not seem to be that master's.

MLS

1. Jahangir, *Tuzuk*, II, p. 20.
2. Jahangir, *Tuzuk*, II, pp. 107–108.
3. Jahangir, *Tuzuk*, II, p. 145.
4. Jahangir, *Tuzuk*, II, p. 157.

45. Red-Headed Vulture and Long-Billed Vulture

ca. 1615–20

INSCRIBED (in fine nasta'liq): (on upper rock)
Jahangirshahi; (on lower rock) "work ['amal]
of the servant of the palace Mansur Nadir
al-'asr"

MMA 55.121.10.12v

In a fire-and-brimstone palette of blacks, grays, and turkey-wattle red, Mansur arranged two incongruously elegant scavengers (a red-headed vulture [*Aegypius calvus*] and a long-billed vulture [*Gyps indiens*]) for the fullest aesthetic and dramatic effect. While contemplating and sketching, he noted beauty in their ugliness and understood their wise patience. Hungry-eyed, they stare like cats at goldfish, spellbound by something—perhaps enticing carrion—arranged by the artist. A few streaks of white-and-tan rocks for perching, sprigs of foliage, and spare brushstrokes of *nim qalam* (washes of earth pigments, now slightly darkened by oxidization) provide a convincingly natural stage for the macabre pair.

Although the birds have been transfixed with photographic accuracy, the calligraphic, double-edged contour lines of the rocks and brushed flourishes of foliage display Mansur's accomplishment in the Iranian mode, the mastering of which also sharpened his eye for abstract patterns of feathers and enabled him to silhouette these birds with the sinuous precision of nasta'liq script.[1]

Mansur's career and style are further discussed in the texts for pls. 41, 44, and 47.

SCW

The miniature is surrounded by verses from a *mathnavi* in the *mutaqarib* meter; they belong to Nizami's *Sharafnama-i Iskandari*, the first part of his *Iskandarnama*. There are two related fragments of this epic: one in the lower line in pl. 54 and one on pl. 26.

AS

This verso page has the margin number 39 and so belongs to Group A. It has cutout verses above and below only, an arrangement also found in the painting of the dancing dervishes (MMA fol. 18r; pl. 52). The inner border is formed of a palmette-and-leaf scroll. The outer border contains finely drawn flowering plants in gold on a blue ground. Smaller plants, grass tufts, and butterflies appear around the plants, most of which show a base of grass-covered groundlines or a variety of little leaf forms. The stems —which are outlined in gold on either side with a slightly darker center and thus appear hollow—have many tendrils. There is a certain space around the plants which are carefully placed and drawn with great control. An iris appears at the lower left with a narcissus above it, a small narcissus at the bottom of the lower border, a chrysanthemum-like plant at the lower right corner, and a poppy-like plant above it.

There is a nineteenth-century copy of the red-headed vulture in the Kevorkian Album (MMA fol. 25v; pl. 89). That it is an early nineteenth-century copy cannot be doubted when compared to this seventeenth-century painting. There is also a fine Mughal painting of what appears to be a long-billed vulture in the Chester Beatty collection, Dublin, which faces to the right instead of the left.[2] In the Kevorkian Album, there is also an early nineteenth-century copy of what appears to be a long-billed vulture facing right (FGA 49.19a; pl. 82). It is very close to the long-billed vulture in this painting and to the one in the Chester Beatty Library, but since several are known one cannot be sure which was the model for the later copyist.

The border schemes of this folio, flowering plants in gold on a blue ground on the portrait side and an abstract scroll, cartouche, palmette, and leaf design on the calligraphy side, prevail also on the folio of the dipper-like bird which has the margin number 40 (MMA fol. 16r; pl. 44) and would presumably have faced this page in their original album.

MLS

1. For early portraits by Mansur, in which his calligraphic draughtsmanship is apparent in the thickening and thinning outlines of flowers, see Welch, *Art of Mughal India*, no. 18, and Tandan, *Indian Miniature Painting*, fig. 15.
2. Arnold and Wilkinson, *Beatty Library*, III, pl. 80.

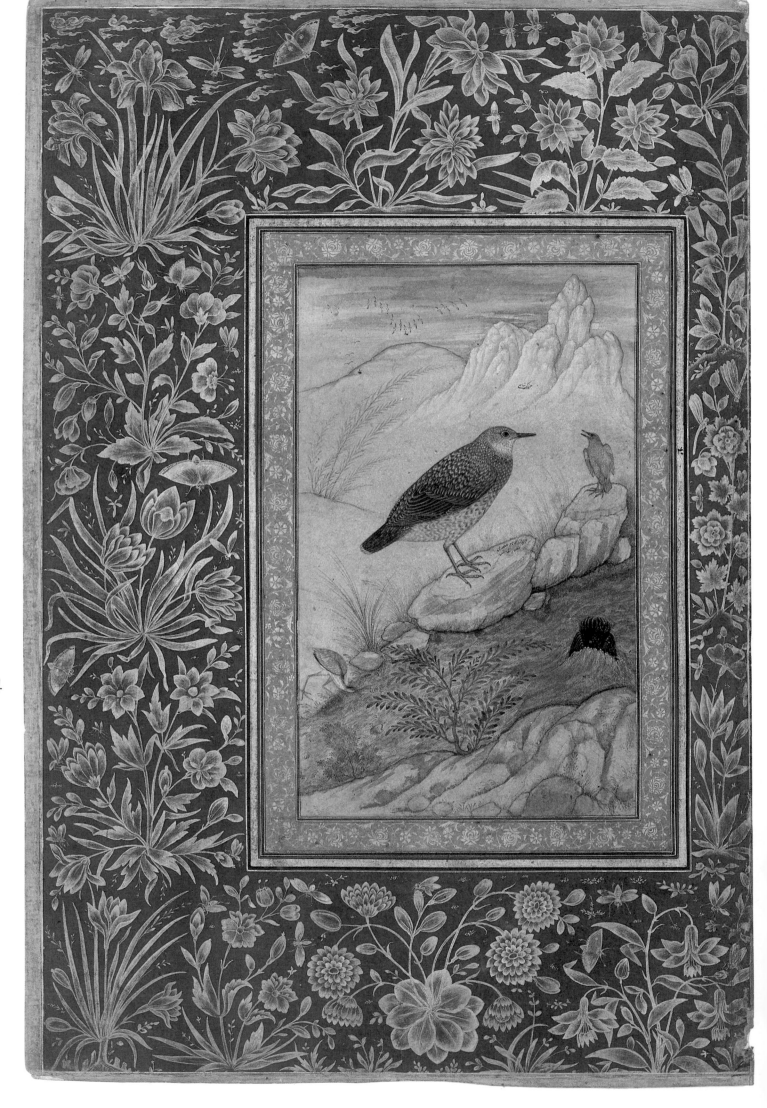

44

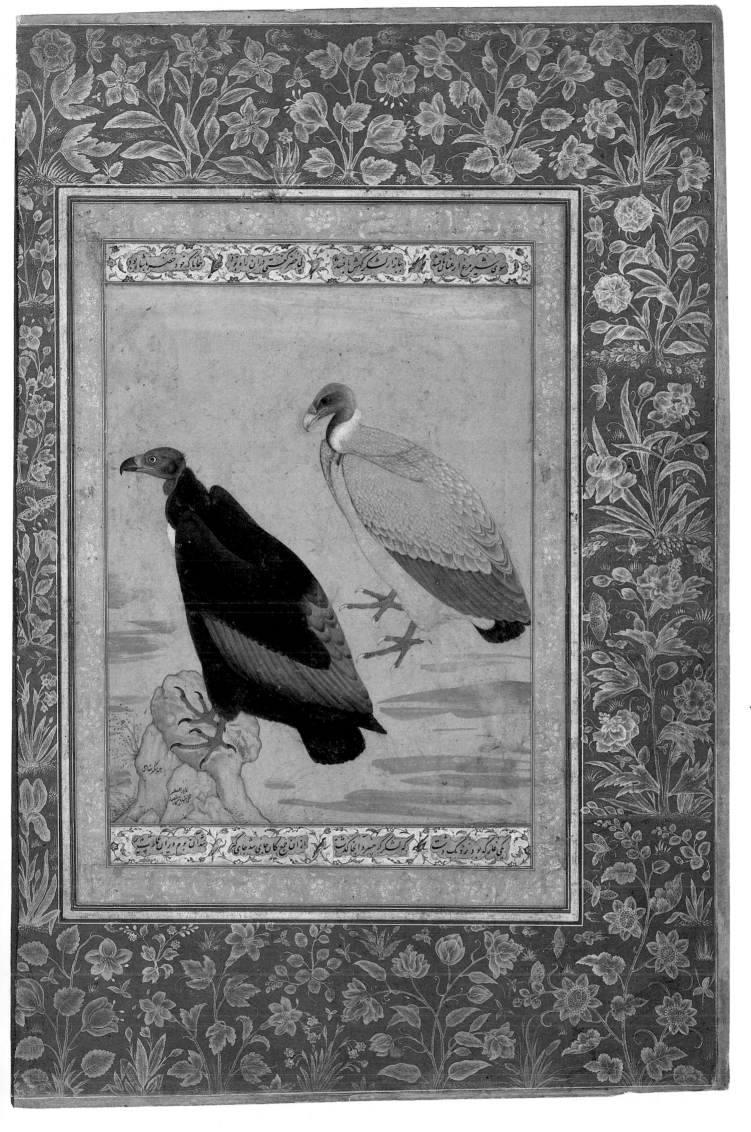

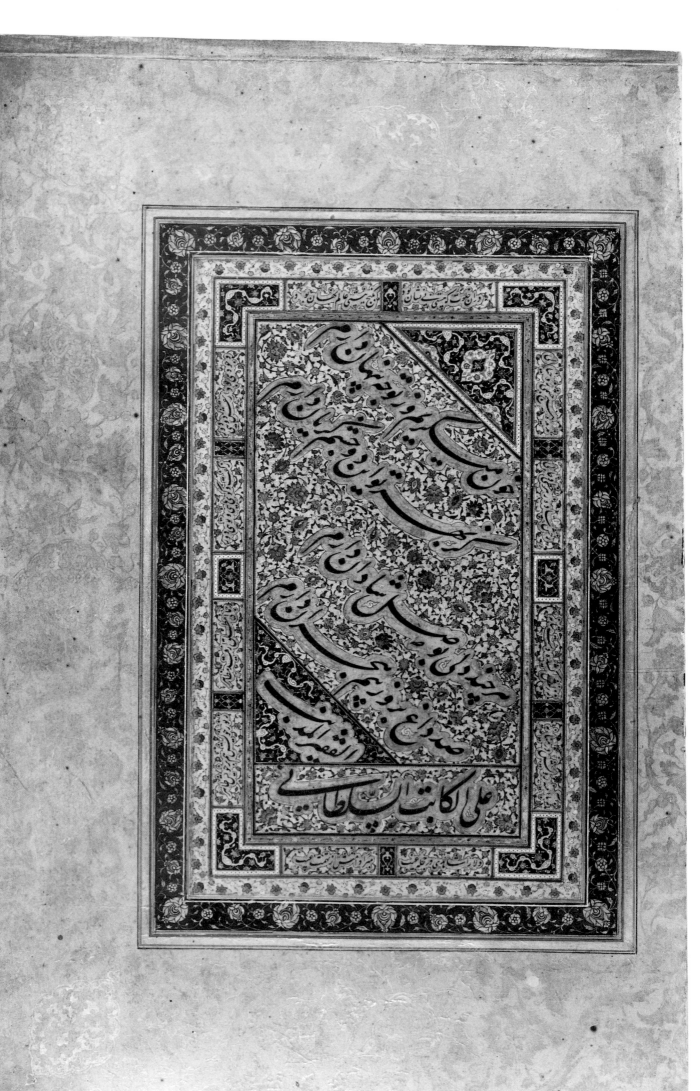

46

46. Calligraphy

ca. 1535–45

MMA 55.121.10.12r

I'm weeping blood and do not tell you, dear,
That my two eyes are shedding tears for you.
Though union fills my heart with joy, I have
A hundred scars from fear that you may leave.
> The poor, the sinner, 'Ali the royal scribe
> [*al-katib as-sultani*]

The page is surrounded by the beginning of the ac-
tual story in Jami's famous epic *Yusuf and Zulaykha*,[1]
which follows the introductory religious poems. An-
other fragment of the same cut-up manuscript is on
MMA fol. 29v (pl. 25).

AS

THE BORDER of this recto leaf contains a long, un-
dulating leaf scroll surrounded by leaves and palmettes
with superimposed cartouches in gold on a pink ground.
The inner border is similar to that of the verso but in
gold on blue.

MLS

1. Jami, *Haft Aurang*, pp. 591–92.

47. Nilgai

ca. 1620

INSCRIBED (in fine nasta'liq): (at top of picture in the artist's [?] hand) Jahangirshahi; (in front of legs in the artist's [?] hand) "work ['amal] of the servant of the palace Nadir al-'asr [Mansur]"

MMA 55.121.10.13V

JAHANGIR'S interest in natural history was surpassed only by his passion for hunting. The large and noble nilgai (*Boselaphus tragocamelus*), or blue bull, was a favorite prey. An act revealing the least admirable side of Jahangir's character is recorded in his memoirs. His shot at a nilgai on a hunting expedition was spoiled by the sudden appearance of a groom and two bearers. Enraged, he ordered the groom killed on the spot and the bearers hamstrung and paraded through the camp on asses.[1] Fortunately these acts of extreme cruelty seem to have been rare, and a more characteristic and humane side of Jahangir's character emerges in another nilgai hunting anecdote from his memoirs: "The story of this nilgaw was written because it is not devoid of strangeness. In the two past years, during which I had come to this same place to wander about and hunt, I had shot at him each time with a gun. As the wounds were not in a fatal place, he had not fallen, but gone off. This time again I saw that nilgaw in the hunting-ground (*shikargah*), and the watchman recognized that in the two previous years he had gone away wounded. In short, I fired at him again three times on that day. It was in vain. I pursued him rapidly on foot for three kos, but however much I exerted myself I could not catch him. At last I made a vow that if this nilgaw fell I would have his flesh cooked, and for the soul of Khwaja Mu'inu-d-din would give it to eat to poor people. I also vowed a muhr and one rupee to my revered father. Soon after this the nilgaw became worn out with moving, and I ran to his head and ordered them to make it lawful [cut its throat in the name of Allah] on the spot, and having brought it to the camp I fulfilled my vow as I had proposed. They cooked the nilgaw, and expending the muhr and rupee on sweets, I assembled poor and hungry people and divided them among them in my own presence. Two or three days afterwards I saw another nilgaw. However much I exerted myself and wished he would stand still in one place, so that I might fire at him, I could get no chance.

With my gun on my shoulder I followed him till near evening until it was sunset, and despaired of killing him. Suddenly it came across my tongue, 'Khwaja, this nilgaw also is vowed to you.' My speaking and his sitting down were at one and the same moment. I fired at and hit him, and ordered him, like the first nilgaw, to be cooked and given to the poor to eat."[2]

MLS

LIKE THAT OF Abu'l-Hasan, Mansur's career can be traced to Akbar's reign. His talent for natural history subjects was encouraged, and his illustrations to such manuscripts as the earliest *Baburnama* and *Akbarnama* manuscripts include many studies from life of birds and animals.[3] A draughtsmanly artist, Mansur concentrated upon motion with brushstrokes that are never ruler-straight or even regular. His album paintings often developed over sketches done in the field. Possessed of an easy grace that enabled him to enter nature's inner worlds, he painted spirit as well as form with a stalker's awareness of animals' movement, of their habits and habitats. Each evanescent bird, animal, flower, or tree seems to have held still barely long enough for Mansur to note essences of proportion and balance. Detailed articulations of each feather or petal were attended to later in the studio, in painstakingly brushed washes and body color. Observant as a Fabre or Thoreau, he reveled in the quick, intuitive intelligence of his subjects and noted their interrelationships without the cloying sentimentality of so much natural history painting.

This unusually graceful nilgai probably roamed in Jahangir's zoological garden. As painted by Mansur, its sensitively observed fur, cartilaginous ears, velvety muzzle, and smooth horns invite stroking. So precise was the artist's observation—down to peculiarities of marking and a horn broken off at the tip—that one can imagine the animal from every angle. But scien-

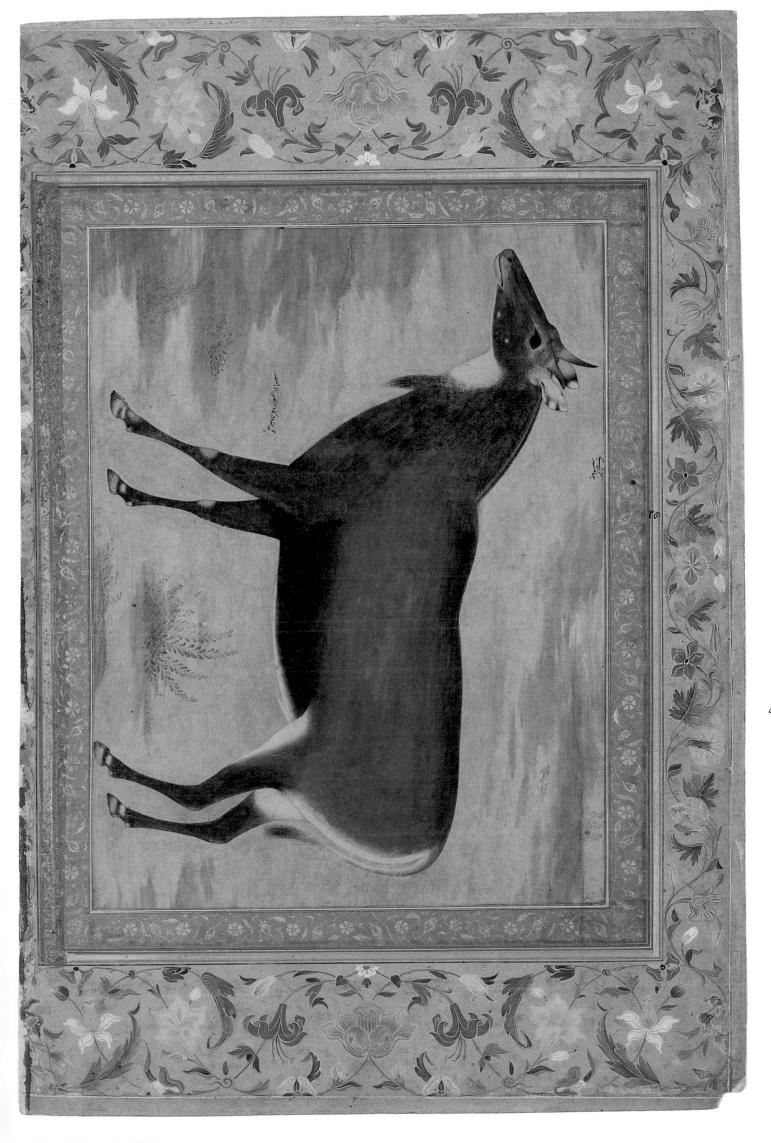

47

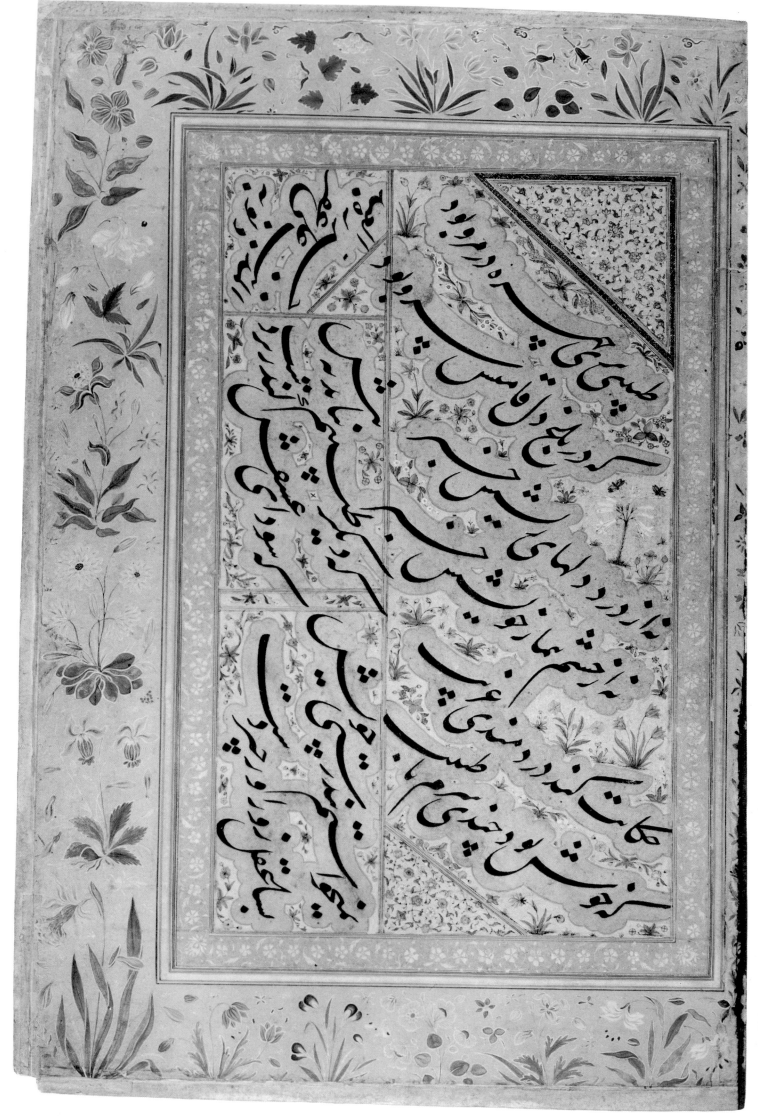

48

tific accuracy was not Mansur's sole concern: artful silhouetting against a dusty pink ground enhances the blueness of the fur, amplifies the animal's noble presence, and lends lyricism to a memorable image.[4]

Mansur's style and career are further discussed in the texts for pls. 41, 44, and 45.

SCW

THIS VERSO page has the margin number 25. It is similar in horizontal format, with the head at the top when the folio is held vertically, to the pictures of the hornbill and forktail (MMA fols. 14v and 15r with margin numbers 43 and 44; pls. 41 and 40); it is thus likely that this painting belongs to an earlier portion of the same album, probably devoted to animal and bird pictures. In all three the portrait borders have a floral-scroll pattern, with flowering plants on the cal-ligraphy side. Each design is different, however. The plants and leaves here have a strong painterly quality with an impression of lively naturalism in the plants (even if only a lily, a narcissus, and perhaps a morning glory are tentatively recognizable) and an exuberant earthy rhythm to the scroll.

MLS

1. Jahangir, *Tuzuk*, I, p. 164.
2. Jahangir, *Tuzuk*, I, pp. 189–90.
3. Beach, *Grand Mogul*, pp. 140–43, has listed most of Mansur's works, but also see Das, *Mughal Painting During Jahangir's Time*.
4. It has been pointed out by MLS that a painting of a zebra in the Victoria and Albert Museum (Welch, *Imperial Mughal Painting*, pl. 27) has such a similar border to that of the nilgai that it must have been painted by the same artist and that the zebra and the nilgai were probably once part of the same album. For another portrait of a nilgai, unsigned but attributed to Mansur, lent by the executors of the late P. C. Maruk, see Ashton, *Art of India and Pakistan*, pl. 139.

48. Calligraphy

ca. 1540

MMA 55.121.10.13r

There was in Merv a beautiful physician,
A cypress in the garden of the heart:
He did not know how many hearts he wounded,
He did not know how dangerous his eyes.
A poor afflicted one said, "Lovely is it
To be with this physician for some time,
I do not want my health to be restored,
For then the doctor would not come again!"
How many intellects, strong, full of vigor,
Have been subdued by passioned love for him!
 Written by [*harrarahu*] the sinful slave
 'Ali, may God forgive his sins!

This is a short Persian *mathnavi* in the *mutaqarib* meter. The theme of lovesickness is common in Persian and related poetry, and the beloved is often described as a physician without whom one cannot live and for whose sake one wants to be ill.

The calligraphic style is unusually soft for Mir-ʿAli; perhaps the word *harrarahu* is used instead of the usual *katabahu* to mean "written as an exercise," for it certainly does not have the normal meaning of "clean copied."

AS

THE LIMITED space of the border surrounding the calligraphy gives less opportunity for virtuosity than the scrolling design on the verso border (pl. 47) although the use of a grapevine-like leaf in both borders suggests the same hand. Not one of the plants here is easily identifiable. Of particular delight to the eye are the little plants so charmingly fitted in the irregular spaces formed by the "clouds" surrounding the calligraphy.

MLS

181

49. Calligraphy

ca. 1530–50

MMA 55.121.10.17v

THE CENTRAL text, taken from a religious *mathnavi* in the *mutaqarib* meter, perhaps Sa'di's *Bustan*, begins:

To the wise man who solves difficulties [it is evident]:
You are a guest, the world is a guesthouse . . .

and ends:

Even though a person is famous by a hundred names,
The "seeker of good" is better than all of them.

The poem is surrounded by the end of a ghazal by Hafiz[1] and the beginning of another ghazal by him;[2] the calligraphy may well be that of Sultan-'Ali Mashhadi.

AS

THE CALLIGRAPHY is surrounded by both cutout poetry and an inner border of gold palmette scrolls on a blue ground. The birds in the branches between the cutout poetry have not been identified. The outer border contains plants in gold on a pink ground. This is the only folio in Group A with the border scheme of flowering plants in colors on a buff ground on the portrait side and gold plants on a pink ground on the calligraphy side. It would seem that this is the only leaf inserted here from the album to which it originally belonged.

This border may be assigned to one of the more prolific border artists, who also appears to have painted the borders of MMA fols. 6v, 19v, 23r, and 29v (pls. 73, 11, 16, and 25).

MLS

1. Hafiz, *Divan*, ed. Brockhaus, no. 115; ed. Ahmad-Na'ini, no. 97.
2. Hafiz, *Divan*, ed. Brockhaus, no. 120; ed. Ahmad-Na'ini, no. 101.

182

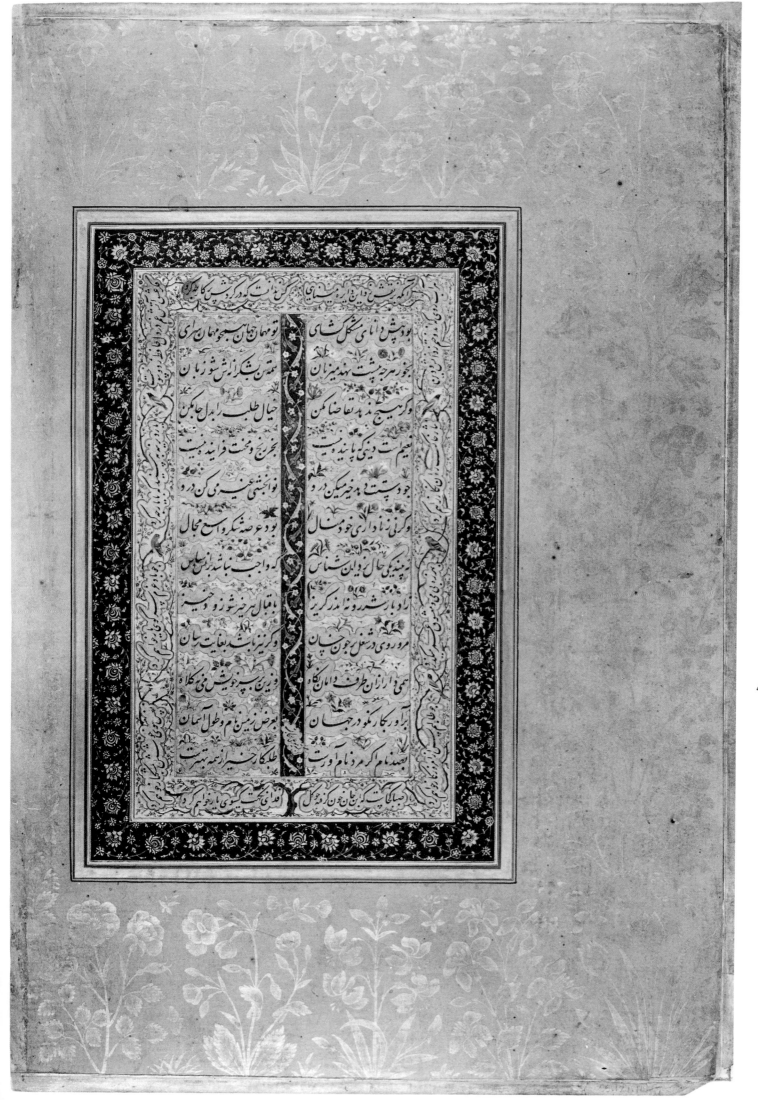

49

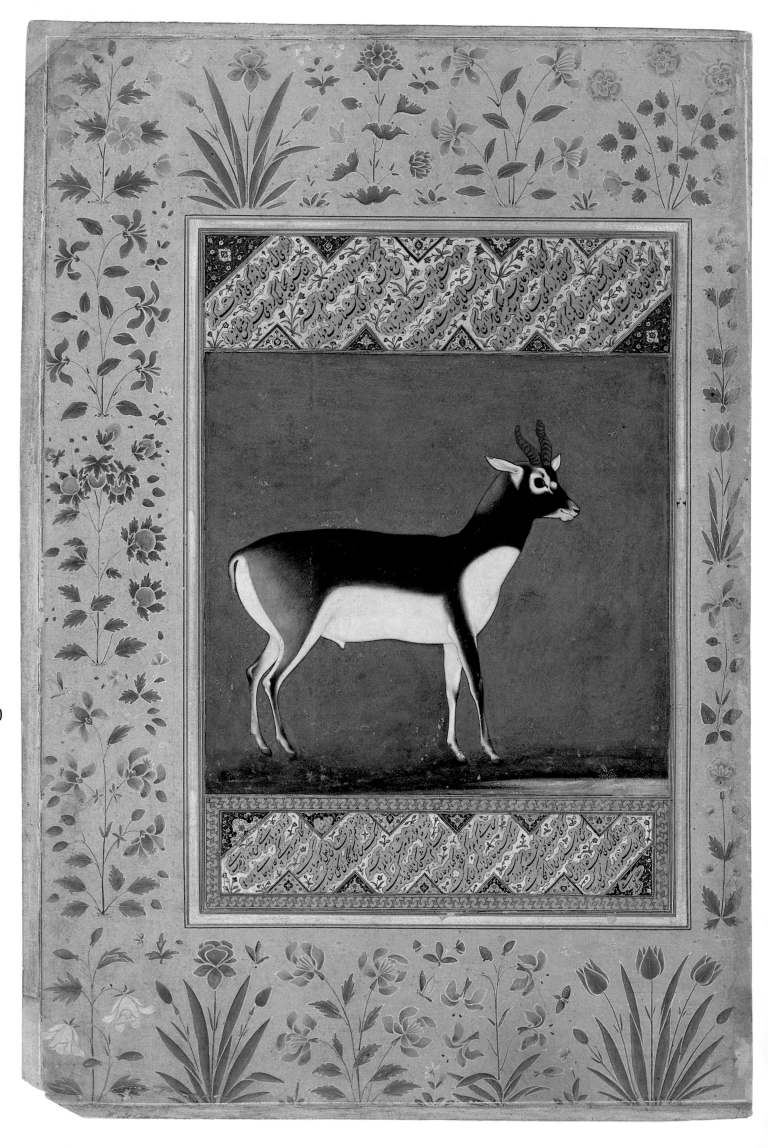

50

50. Black Buck

ca. 1615–20

Uninscribed but probably by Manohar

MMA 55.121.10.17r

Tautly modeled and glowingly sleek, with deftly modulated white, black, and tan coat, this black buck stands apart from Mansur's and Abu'l-Hasan's animal studies as a calculated "work of art" rather than a knowing portrayal of a specific creature. The buck's stylized mask with its crisply rounded eye and firmly set mouth brings to mind the patterned abstraction of Achaemenid relief sculpture. Despite this glyptic precision, forms are not sharply observed. Beneath the fur, the skull and jaw seem vague and soft, and the nostrils are ill-defined. Horns spring illogically from nowhere into amorphous, textureless stubs.

A more finished but strikingly similar miniature in the Victoria and Albert Museum showing a groom leading a black buck was probably painted by the same hand. Convincingly inscribed as the work of Manohar, it is also identical in the handling of tufts of grass.[1] Two further studies of bucks attributable to Manohar are in the *Muraqqa-ʿi Gulshan* in the Gulistan Library, Teheran.[2]

SCW

The upper part is a page from a *safina* with the end of a poem by Amir Khusrau and the beginning of one of his most famous poems:[3]

My heart became wayward in love—may it be even more wayward!
My body became helpless from weakness [lit., "having no heart"]—may it be even more helpless!

The lower part is a page from another *safina* with the last line of a ghazal by Jami and a complete ghazal by the same poet,[4] calligraphed by Sultan-ʿAli Mashhadi, probably during the author's lifetime.

AS

The recto portrait has the margin number 26. Cutout verses are set diagonally above and below with a narrow chain-link border around the lower ones; the usual floral-scroll inner border is omitted. The outer border has flowering plants in colors on a buff ground. A tulip is placed in the lower right corner and in the right margin, with perhaps a peach in the left margin and possibly a rose in the upper right corner.

One of the animals Jahangir most liked hunting was the black buck. He kept decoy bucks to lure wild ones and tells a story of an enraged wild one attacking his decoy among a crowd of onlookers.[5] Elsewhere the emperor mentions hunting antelope with cheetahs.[6] In Jahangirpur, one of the emperor's fixed hunting places, he had ordered a stone sculpture in the form of an antelope as a gravestone for his favorite decoy black buck "which was without equal in fights with tame antelopes and in hunting wild ones." Jahangir ordered that, because of the rare quality of that beast, no one should hunt the deer in the area or eat its flesh.[7]

MLS

1. See Clarke, *Indian Drawings*, pl. 8.
2. See also the painting of a buck, believed to be by Manohar, in the British Museum, published in Havell, *Indian Sculpture and Painting*, pl. 62.
3. Amir Khusrau, *Divan*, ed. Darvish, nos. 59 and 75.
4. Jami, *Divan*, ed. Riza, nos. 16 and 209.
5. Jahangir, *Tuzuk*, II, p. 43.
6. Jahangir, *Tuzuk*, II, p. 109.
7. Jahangir, *Tuzuk*, I, p. 91.

51. Calligraphy

ca. 1530–50

MMA 55.121.10.18v

Oh friends who are close to the Friend—
Why don't you offer thanks for that?
Don't kill poor me like a stranger here,
As much as you are from this land.
Should he kill me, I'd gladly be
His sacrifice—do not scold him!
You people that live without pain—
Alas—what kind of work do you?
 The poor [al-faqir] ʿAli

These verses are surrounded by a fragment of ʿIsmat Bukhari's poetry (above); a ghazal by Shahi (right border), part of which also occurs on MMA fol. 1r (pl. 32); a quatrain (bottom), which can be identified as being by Khayali;[1] and a ghazal (left border) by Mani(?).

 AS

THE BORDER of this verso page has a very finely executed pattern of a wide scrolling band which in places curls around itself and in others is marked by a superimposed quatrefoil. The background is buff, and the buff scrolling bands are outlined in gold and red and bear a delicate floral stem. Leaves, flower heads, and a palmette fill the quatrefoils. Beneath is a delicate floral scroll with pink blossoms with blue centers and green leaves, all edged with gold.

The artist of this folio painted the borders of FGA 39.50 (pls. 19 and 20). It contains a portrait of the Khankhanan on the recto with a gold-on-blue border and on the verso an abstract scroll design in colors on a buff ground. The two borders being by the same artist would not necessarily lead to the conclusion that they belonged to the same album were it not for the identical border schemes.

 MLS

1. Jami, *Baharistan*, p. 102.

52. Dancing Dervishes

Safavid miniature, mid-sixteenth century

Uninscribed; attributable to Aqa-Mirak, with extensive retouching, probably by Abuʾl-Hasan, ca. 1610

MMA 55.121.10.18r

THROUGH ecstatic dancing, inspired by music and recitations of religious and nonreligious poetry, Sufis achieve *wajd* (ecstasy; lit., "finding God"). Although whirling dancing was practiced as a means of achieving mystical states from very early times in the Islamic world, it was institutionalized at the end of the thirteenth century by Sultan Walad, son of the great mystical poet Jalaluddin Rumi, who died at Konya (Anatolia) in 1273.

This ceremonial *mevlevi samaʿ* (mystical concert and dance) was usually held on Fridays after congregational prayers; Annemarie Schimmel has described the ritual: "The *samaʿ* is regulated by very strict rules. The sheikh [spiritual guide] stands in the most honored corner of the dancing place, and the dervishes pass by him three times, each time exchanging greetings, until the circling movement starts. This is to be performed on the right foot, with accelerating speed. If a dervish should become too enraptured, another Sufi, who is in charge of the orderly performance, will gently touch his frock in order to curb his movement. The dance of the dervishes is one of the most impressive features of the mystical life in Islam, and the music accompanying it is of exquisite beauty, beginning with

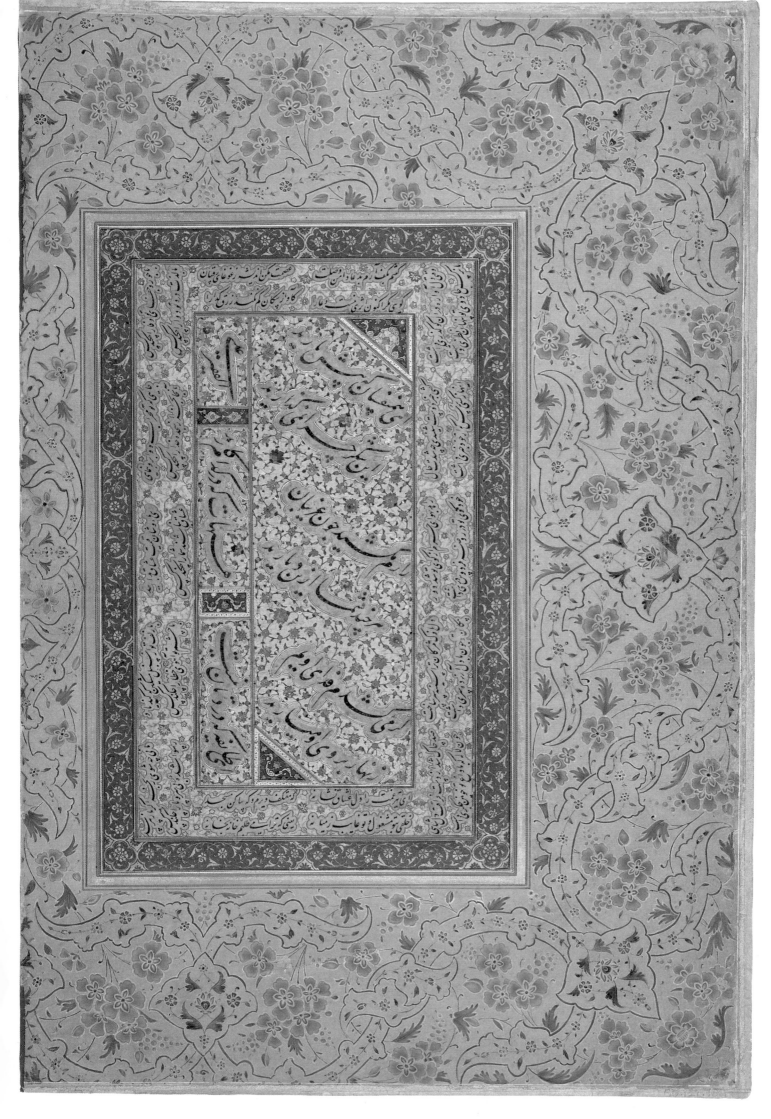

51

52

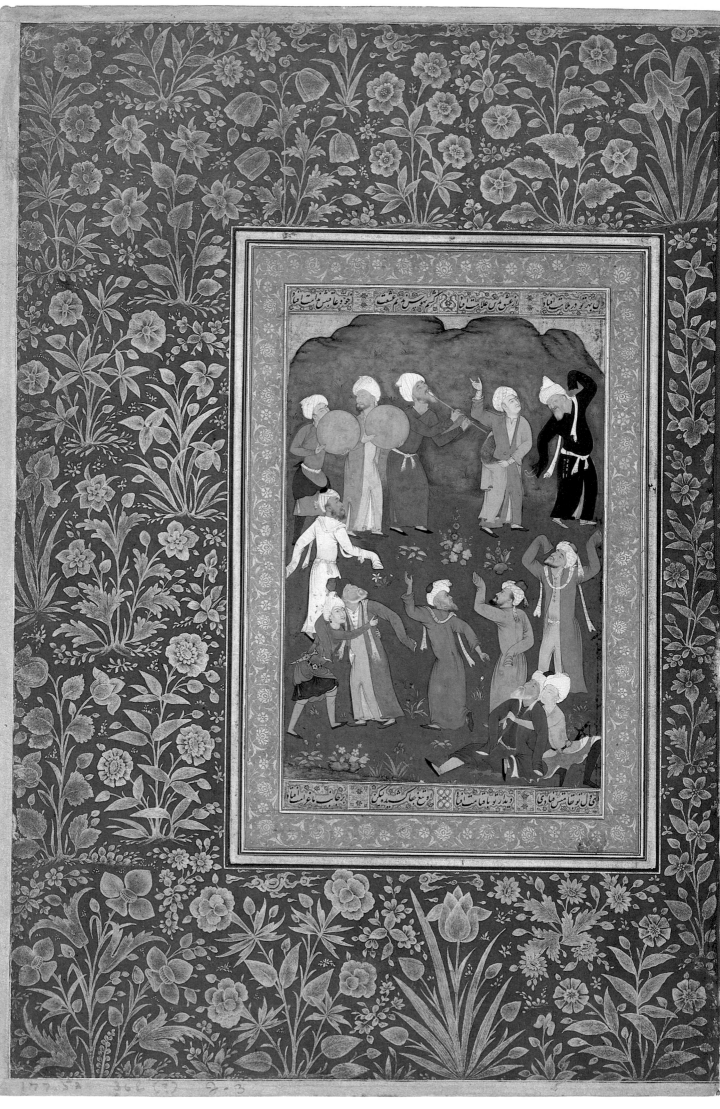

the great hymn in honor of the Prophet (*na‘t-i sharif*, written by Jalaluddin himself) and ending with short, enthusiastic songs, sometimes sung in Turkish."[1]

Jahangir described Sufis dancing during the fifth year of his reign (1610): "On the night of Monday the 8th [Safar], having sent for Shaikh Husain Sirhindi and Shaikh Mustafa, who were celebrated for the adoption of the ways of dervishdom and the state of poverty, a party was held, and by degrees the assembly engaged warmly in *sama‘* and *wajd*. Hilarity and frenzy were not wanting. After the meeting was over, I gave money to each and gave him leave."[2]

Jahangir might have recalled the ecstatic Sufis dancing at court when he inspected this painting, which might also contain portraits of the two sheikhs among the devotees extensively repainted for him. Such retouching reflects the emperor's occasionally less than total enthusiasm for Iranian painting of the Safavid style. However much he admired its harmonies, color, line, and ornament, he so preferred the accuracy of Mughal portraiture that he ordered faces or even entire figures reworked by his own artists.[3] Close inspection of this miniature not only reveals many faces and hands in early seventeenth-century style but also shows that the Safavid turbans—with characteristic long, narrow batons—as well as adjoining areas of landscape and costume have been excised with a scalpel and covered over. Because of such tampering, it is not surprising that this is one of the few unattributed early miniatures in the album.

The Safavid painter of this retouched and cropped scene can be identified on stylistic grounds as Aqa-Mirak, one of Shah Tahmasp's senior artists. Palette, draughtsmanship, composition, idiosyncratically angular gestures, proportions, and costumes, as well as the treatment of landscape, stones, ears, tufts of flowers, and countless other minutiae, support this attribution to an artist who—with Sultan-Muhammad and Mir Musavvir (father of Mir Sayyid-‘Ali)—was one of the three paramount artists at the time of Shah Tahmasp's most energetic patronage. By influencing Mir Sayyid-‘Ali and ‘Abdus Samad he contributed to the formation of the Mughal imperial manner. The former was apprenticed to him as well as to Sultan-Muhammad in Tabriz and painstakingly finished several of his most admired pictures. Conceivably, Mir Sayyid-‘Ali brought this miniature to the Mughal court.

Because this truncated and cosmetically "improved" picture is also one of Aqa-Mirak's less striking works, its artistic and historical significance may have gone unrecognized by Jahangir.[4]

The extensive retouching emphasizes the roundedness of the forms, especially in the faces, and is disturbingly at odds with Aqa-Mirak's more two-dimensional design. It can be dated to the early, most experimental years of Jahangir's patronage and is almost certainly by the very youthful Abu'l-Hasan, whose masterly surgery and retouching expunged most of the evidence. Although Aqa-Mirak's formula for painting turbans is still recognizable (his turbans invariably bulge to the left and are outlined and drawn with unmistakable tidiness), the *kulahs* (felt caps ending in upright batons) have been removed or covered over, along with parts of the cloth wrapped around them. In the treatment of such faces as those of the flute player and the more ecstatic Sufis, the emperor directed his innovative artist to extremes of illusionistic distortion—ranging from the cloyingly sweet to the grotesque—unprecedented within Islamic traditions.

The author's argument attributing the reworking of the dervishes to Abu'l-Hasan was based largely upon the heightened, even extreme naturalism of faces, which brought to mind comparably supercharged visages in Abu'l-Hasan's inscribed *King Dabshalim and the Sage Bidpai*[5] (Appendix, fig. 23). These qualities are also apparent in several miniatures ascribable to Abu'l-Hasan in a copy of Sa‘di's *Bustan* copied at Agra by the scribe ‘Abdur-Rahim al-Harawi in A.H. 1014/A.D. 1605–1606.[6] *The Devotee and the Fox* (fol. 67v; Appendix, fig. 24) and *An Old Man Consults a Doctor* (fol. 176r; Appendix, fig. 25) both exemplify the youthful artist's intensity of spirit, his brilliant coloring and minute finish, and his unprecedentedly extreme naturalism.

A Mughal drawing in the India Office Library includes figures, some of them in reverse, traced or copied from this miniature.[7]

<div align="right">SCW</div>

Tʜɪs ᴘɪᴄᴛᴜʀᴇ of ecstatic dervishes is surrounded by a ghazal in which the poet complains that love has brought him universal blame and that the sight of the beloved's slim stature, *qamat*, reminds him of resurrection, *qiyamat* (when all human beings are called from their graves to face the Last Judgment; a common word for a state of complete confusion and fear).

<div align="right">AS</div>

Tʜɪs ᴘᴀɢᴇ has the margin number 46 and belongs to Group A. The gold-on-blue border has extremely fine drawing and a crispness that makes it tempting to relate it to Fath Muhammad, the artist of the border

<div align="right">189</div>

of MMA fol. 20r (pl. 54). However, the present border lacks the staccato, almost spiky quality of the other and is much more placid and restrained. The composition is extremely dense, with plants, grass tufts, and flower sprays, as well as cloud bands, filling every available space. The little leaf patterns spread out from the base of the plants in a manner that may serve as a signature of this painter, who also appears to have created the borders of MMA fol. 19v and FGA fol. 39.50b (pls. 11 and 19). A small iris can be found in the upper border and a larger one along the left edge; a poppy appears in the lower left corner and a stately tulip in the lower margin.

MLS

1. Schimmel, *Mystical Dimensions of Islam*, p. 325.

2. Jahangir, *Tuzuk*, I, pp. 172–73.

3. For a major Iranian miniature by Shaykh-Zadeh reworked for Jahangir by Bishan Das, see Welch, *India*, no. 139.

4. For the style and work of Aqa-Mirak, see Dickson and Welch, *Houghton Shahnameh*, I, pp. 95–117, figs. 133–64.

5. The manuscript is in the British Library, Add. 18579, and is dated in the colophon A.H. 1019/A.D. 1610–11; two of the thirty-six miniatures are dated six years earlier. For an illustration in color see J. V. S. Wilkinson, *Light of Canopus*, pl. VI. For comparably intensified characterizations, see *A Dervish and a Musician* by Daulat in Welch and Beach, *Gods, Thrones, and Peacocks*, no. 8.

6. For Jahangir's *Bustan*, formerly in the collections of Barons Maurice and Edmond de Rothschild and of John Goelet, see Stchoukine, "Un Bustan de Sa'di"; Welch, *Art of Mughal India*, no. 24; Welch, *Flower from Every Meadow*, no. 62, pp. 103–104.

7. See Falk and Archer, *Indian Miniatures in the India Office Library*, no. 94.

53. A Youth Fallen from a Tree

ca. 1610

INSCRIBED: (over a butterfly on the border above the painting, smudged and barely visible) "drawing [*raqam*] of Aqa-Riza [Jahangiri]"

Enlarged at the top, presumably by Aqa-Riza Jahangiri himself

MMA 55.121.10.20V

Tempted by a bird's nest to climb a tree, a boy fell to his death. His father, consoled by a philosophical Sufi, vents his anguish. Although Aqa-Riza Jahangiri made a strenuous effort to dramatize the tragedy, deep-rooted Iranian ways vitiated his stalwart attempt to express emotion directly. Like us, the emperor was probably troubled by such mannerisms as the ludicrously tiny feet supporting the Sufi's ballooning body. Jahangir's inbred Mughal preference for sensitive naturalism prompted him to give little encouragement to the artist's Iranian harmoniousness. In discussing the artist's son Abu'l-Hasan (pl. 13), we quoted Jahangir's single unenthusiastic reference to Aqa-Riza in the *Tuzuk*: "His father, Aqa Riza'i of Herat, at the time when I was Prince, joined my service. He (Abu'l-Hasan) was *khanazad* of my court. There is, however, no comparison between his work and that of his father (*i.e.*, he is far better than his father)."[1]

Jahangir's inclusion of Aqa-Riza's work in his albums and manuscripts can be explained on several grounds. The worthy Iranian artist mastered many styles, from the calligraphic manner of his great Safavid namesake (the original Aqa-Riza, also known as Riza 'Abbasi) to finely executed imperial portraits with few traces of the Iranian manner. He was also capable, industrious, and so ingratiating that he tried to conform to Mughal taste.[2] Moreover, Jahangir's admiration of the son's genius caused him to look favorably upon the father. Such encouragement would have been approved by the Iranian faction that was gaining power both at court and in his household, led by Jahangir's favorite wife, Nur-Jahan.

SCW

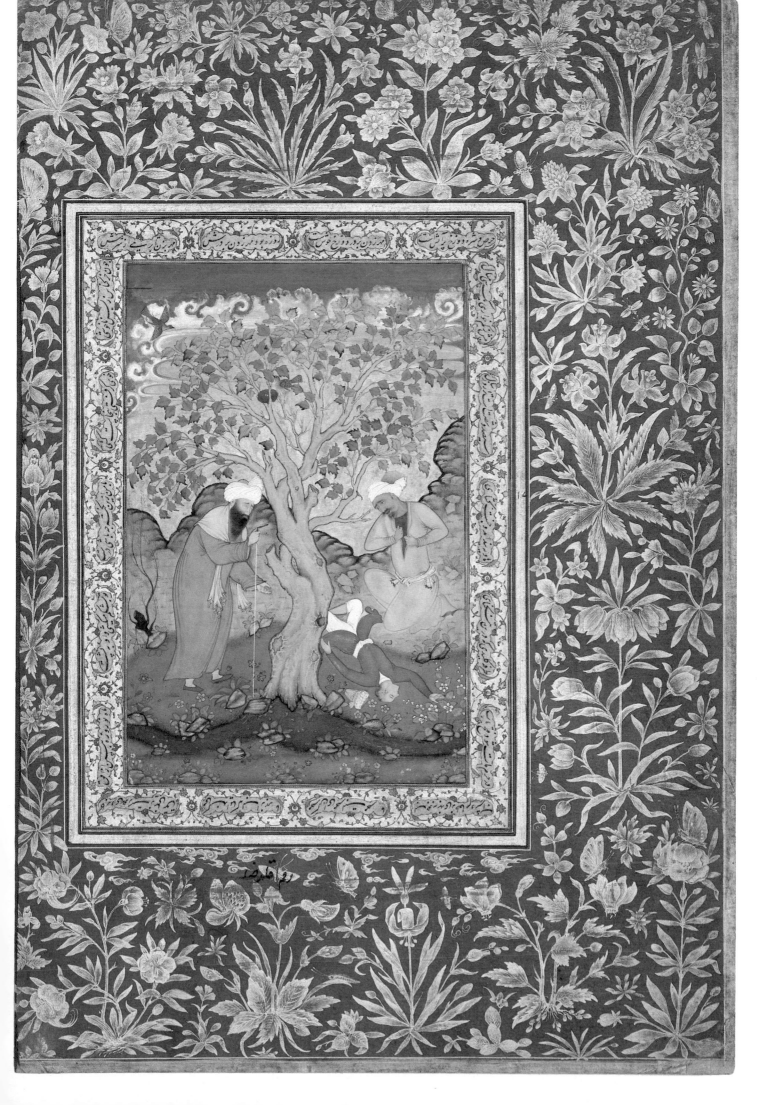

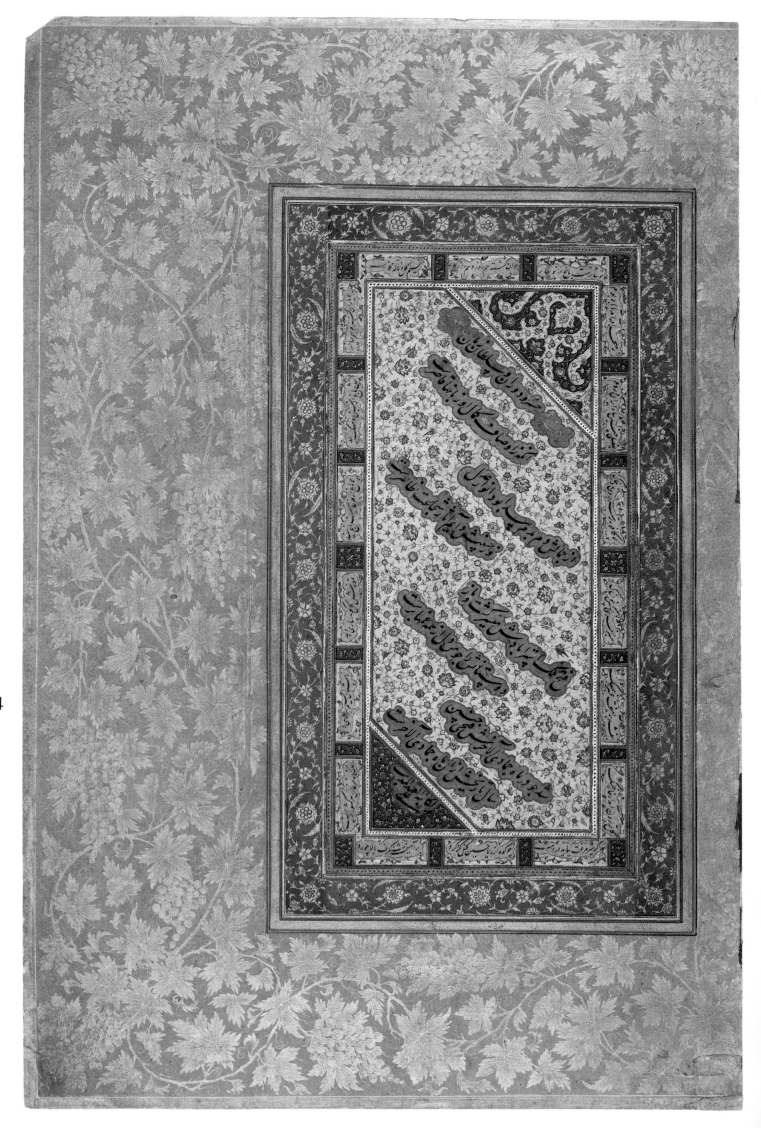

54

THE MINIATURE is surrounded by a lengthy *mathnavi* in the *ramal* meter about the necessity of fasting in the month of Ramadan; it may be part of a longer poem.

<div align="right">AS</div>

THIS PAGE has the margin number 17 and belongs to Group A. The very densely filled border of gold plants on a blue ground is in a very crisp style that almost suggests that the leaves have swordlike edges. Among the plants are butterflies, insects, and cloud bands. In the upper left corner is a poppy, with, possibly, a gentian next to it, while the large spiky plant in the lower right border is a *Frittilaria imperialis* (cult.), with a

cyclamen type second from the right in the bottom row and perhaps a lily in the lower right corner.

<div align="right">MLS</div>

1. Jahangir, *Tuzuk*, II, p. 20.
2. For a generous listing of Aqa-Riza's works, see Beach, *Grand Mogul*, pp. 92–95.
There is a nineteenth-century copy of this painting in the Wantage Album (V&A 136–1921) entitled "An Incident in the Life of Khwaja Jahah (Dost Muhammad) by Farrukh Beg." On the reverse of this leaf is a painting of an Indian red-wattled lapwing. Apparently in the nineteenth century album-leaf copiers or compilers were unaware of the unwavering seventeenth-century album sequence of alternating pairs of pictures and calligraphies. (See Clarke, *Indian Drawings*, no. 5, pl. 4, and no. 21, pl. 14.) [MLS]

54. Calligraphy

After 1530

INSCRIBED (on border): "work [*ʿamal*] of Fath Muhammad"

MMA 55.121.10.20r

THE POETICAL chronogram commemorates the conquest of Astarabad in A.H. 936/A.D. 1530; the date is found from the name of the month, *Jumada al-akhir*. It is signed, "By its scribe, the sinful slave Mir-ʿAli," and is a typical example of Mir-ʿAli's skill as a deviser of chronograms. The lines are cut out from another manuscript and skillfully pasted on the paper to give the impression of an original page.

The poem is surrounded by a minutely written *mathnavi* in the *mutaqarib* meter, apparently from Nizami's *Sharafnama-i Iskandari* (cf. MMA fol. 12v; pl. 45).

<div align="right">AS</div>

THIS RECTO page has an all-over border design of a grapevine (*Vitis*) in gold on a pink ground. The style is as dense and crisp as the border on the verso (pl. 53). This folio and MMA fol. 18r (pl. 52) are the only two scenes—as opposed to portraits, be they of man, beast, or bird—in the Kevorkian Album. It would seem logi-

cal to suggest that these two folios came from the same album. The present folio, however, has the margin number 46 which rules out the possibility of the folios' having once been facing pages. Another difficulty is that the calligraphy-side border here is a pattern of gold on pink and the calligraphy-side border of the dervishes leaf is a scroll-and-floral design in colors and gold on a buff ground. This disparity does not rule out the two leaves' having belonged to the same album, since there may have been varied border arrangements; however, if the calligraphy sides of the two folios had the same border scheme, their having come from the same album would be reasonably certain, while as it is the question remains open.

This folio could not have been part of the album designated here as 3 of Group A because, if it were, it would have a gold-on-pink border on the portrait side. If it belonged to the same album as MMA fol. 18 (pls. 50 and 51) and FGA 39.50 (pls. 19 and 20), then they too could not have belonged with that group.

<div align="right">MLS</div>

55. Shahjahan and Prince Dara-Shikoh Toy with Jewels

ca. 1620

INSCRIBED: (in Jahangir's hand) "work ['amal]
of Nanha"

MMA 55.121.10.36v

INTIMATELY seated upon a small golden throne, father and son enjoy an imperial pleasure: inspecting rubies and emeralds. The five-year-old prince, whose light skin and incipiently aquiline nose identify him as Dara-Shikoh (1615–59), is festooned with pearls, as befits the eldest and favorite son of Shahjahan.[1] Although the turbaned, daggered, and earringed boy resembles a diminutive imperial adult, his eye fixes on a dish of gems with childish covetousness, and his tiny hands playfully wave a peacock chowrie and jeweled turban ornament—perhaps birthday presents from a fond father. Nanha's portrait offers an appealing glimpse into imperial family life and, in its fineness of finish and naturalism, demonstrates his success in keeping abreast of developments in the imperial studios.

In keeping with Shahjahan's supremely royal proclivities, this folio is particularly rich. A splendid bolster is covered in brilliantly colored Safavid figural brocade, and the heavenly park of birds and flowers in the borders is unequaled in lyrical sumptuousness. In the lower border the peacock's spreading tail proclaims its (and Shahjahan's) amorousness.

SCW

THIS VERSO portrait has the margin number 7 and so belongs to Group A. The inner border has the standard flower-head, palmette, and leaf-scroll pattern in gold on a blue ground, here within cartouches. There is no innermost border with cutout poetry. While other borders do contain birds among the foliage, this is the only one in the album in which they play as important a role as the flowers. In the upper border, above the figures, fly two birds that may with caution be identified as birds of paradise (*Paradisia* species?), symbols of royalty. The pair of birds flying in the upper right are a species of pigeon, while the partridges below them are chukors (*Alectoris chukar*) and the pair below them are demoiselle cranes (*Anthropoides virgo*). The group at the bottom center are Indian peafowl (*Pavo cristatus*). The identifiable plants are all clustered in the upper right with a narcissus in the corner; there is a rose beneath it with a poppy on its left and a crocus left of that. What may possibly be a peach is situated above the bird of paradise to the left.

MLS

1. The identification of Prince Dara-Shikoh is supported by numerous portraits of Shahjahan's sons, particularly Bichitr's *Shahjahan Receiving His Sons at Court*, fol. 50v, in the Windsor *Padshahnama* (reproduced in Gascoigne, *Great Moghuls*, p. 145).

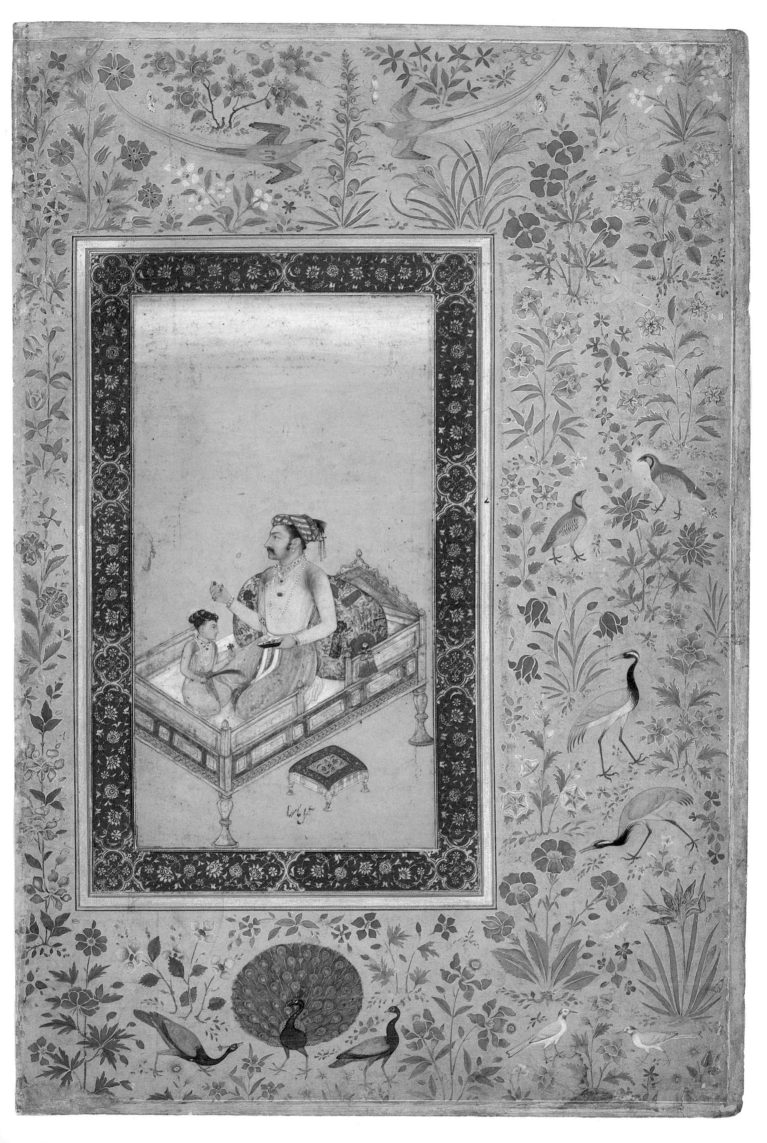

56

56. Calligraphy

ca. 1530–50

MMA 55.121.10.36r

By its scribe

Your black eye murdered poor lamenting me—what can I
 do?
It carried off my heart's tranquillity—what can I do?
I have no patience now without you, say—what can I do?
In short, the whole affair slipped from my hand—what can
 I do?
 The sinful slave ʿAli

The piece is surrounded by fragments of two gha-
zals and by a *rubaʿi*.

AS

THE BORDER design of this calligraphy page has an
innermost border of cutout verses with an inner bor-
der of the same basic pattern as on the verso but with-
out cartouches. The outer border, in gold on a pink
ground, has an all-over geometric pattern of quatrefoils
and rosettes with floral and leaf sprays within and
around them. The verso bears the margin number
7, while here, in the gold band beneath the inner bor-
der, is the margin number 21; this indicates that the
leaf must have been part of two different albums
before entering the Kevorkian Album. Its border
scheme has no relationship with that of any other folio
in the album.

MLS

57. Calligraphy

ca. 1530–50

MMA 55.121.10.24v

Last night the torrent of my tears
 destroyed the roads of sleep;
I drew a picture on the flood,
 remembering your black down.
The face of my beloved thus
 appeared before my eyes—
I gave some kisses from afar
 upon the moonbeam's cheek.
The vision of his eyebrows here,
 and I—my cloak all burnt—
Thought of the prayer niche and took
 my glass and drank my wine.

The poet describes his state in images that are commonplace in Persian poetry. He weeps so much that sleep cannot find a way to him. He then draws (lit., "writes") something on the water to conjure up the down that grows about his young beloved's lip; this image plays on the word *khatt,* which means both "black down" (the soft facial hair of an adolescent boy) and "script." By inscribing the flood of tears with such a picture, he sees the friend's face like moonlight and, as it is only a mirage, sends some kisses from a distance. The friend's eyebrows, beautifully arched, look like a prayer niche, and he turns to them as though he were praying.

The page is surrounded by three Chagatay-Turkish verses which form the beginning of a ghazal about the "fire of love" and which may have been calligraphed by Sultan-ʿAli.

AS

THE BORDER of this verso page is, like its recto, painted in gold on a pale buff ground. It is decorated with a wreathlike undulating scroll of overlapping leaves over a scroll of flowers, leaves, and palmettes on delicate stems. The nineteenth-century artist of the border of MMA fol. 28v (pl. 93) copied this design with minor variations. A comparison of the two reveals that the easy mastery found in the seventeenth-century border is entirely lacking in the later one.

MLS

58. Shahjahan Nimbed in Glory

Dated 1627–28

INSCRIBED: (on platform, perhaps in Shahjahan's hand) "work [ʿamal] of Chitarman, the divine [ilahi] year one" (i.e., the first regnal year, A.D. 1627–28)

MMA 55.121.10.24r

SMILING genially, as though making a presentation to a revered personage, Shahjahan raises a gem-studded pendant suspended from a golden cord. It is the ultimate benefaction, a jewel-portrait of himself. This theatrical vision of Shahjahan's worldly and otherworldly glory so borders on excess—it is the most flamboyant portrait of Shahjahan—that some critics have questioned its authenticity.[1] Through the parted clouds radiant light falls upon the glowing splendor of Shahjahan, the pink of whose coat is echoed in the hue of one of the many rings of his nimbus. Cherubs of European inspiration dive from heaven bearing offerings of spiritual flames and ropes of jewels to magnify the divine burden of imperial treasure.[2] One of his attributes—a broad band composed of strands of pearls, rubies, and emeralds—is a *sahra,* the veil usually worn by Muslim bridegrooms. Its apt presence here, however, has been interpreted by Dr. ʿAli Asani as a knowing allusion by Hindu Chitarman to the God Vishnu, one of whose titles, "King of the World," is identical in meaning to the title "Shahjahan." For Chitarman the *sahra* probably represented an important attribute of Vishnu, who has always been considered the husband of the Earth.[3]

198

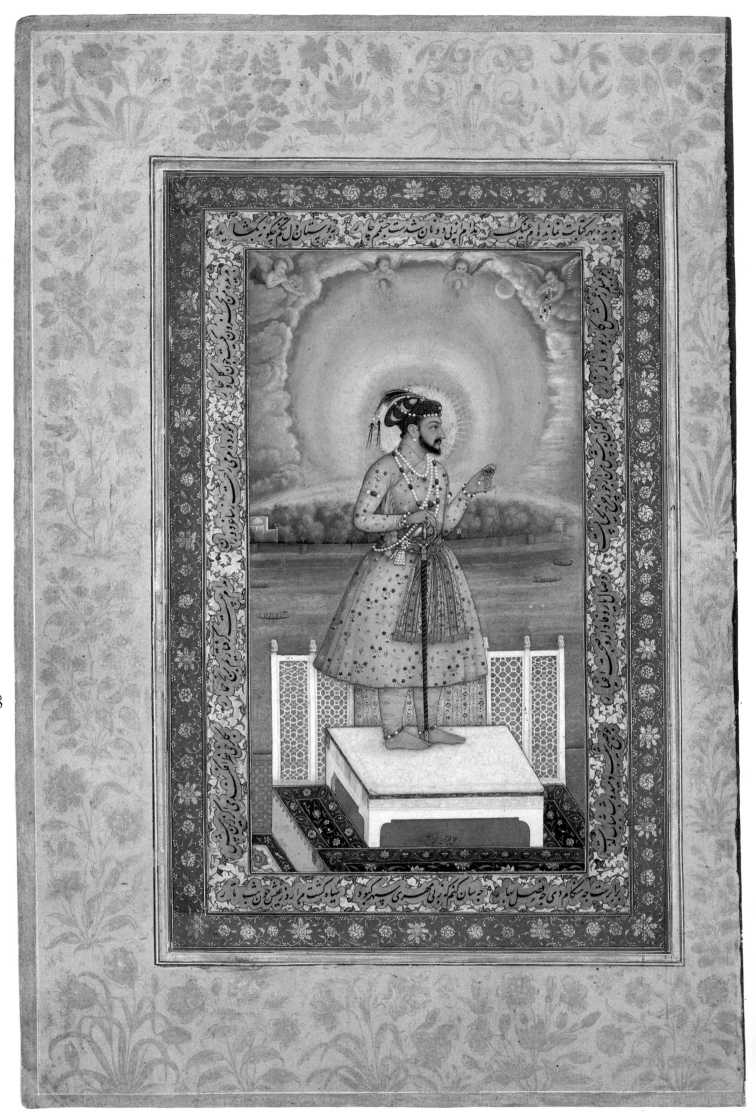

58

Works by most of the state craftsmen and designers of the Mughal imperium are represented here: jewelers, carpet and textile weavers, architects, feather workers, armorers, marble workers, shipwrights, and artists. The emperor stands on a carpeted marble platform before a pierced marble railing with elephant-shaped finials, over which is draped a magnificent golden brocade. Royal barges graceful as dragonflies cross the Jumna River, perhaps bringing an honored guest; beyond stretches a densely wooded garden with pavilions.

This is Chitarman's masterpiece and his earliest dated picture, painted during his "classical" phase, soon after Shahjahan's accession, before his painted faces smoldered into dark-eyed sootiness. Although his later phase carried the style of Govardhan to extremes of seventeenth-century imperial romanticism, the taut draughtsmanship, pure and brilliant color, and technical refinement seen here proclaim his disciplined training in the imperial ateliers under Abu'l-Hasan. Several of Chitarman's inscribed pictures portray Prince Dara-Shikoh, and it is likely that the artist served him under the supervision of Govardhan, to whom paintings by Chitarman have occasionally been attributed.[4]

Two portraits of Chitarman's presumed patron are almost as theatrical in their heavenly illumination as the present work, reflecting Dara-Shikoh's mystical religiosity and influences from European metaphysical iconography.[5]

Chitarman's royal and courtly characterizations, which became more mannered over the years, are agreeable but exceedingly formal. Figures stand at ramrod attention, frequently with overlong arms and with pleasant but lifeless countenances. As if in reaction to the spider-thin fingers characteristic of Govardhan, Chitarman often lapsed into painting sausage-plump ones tapering elegantly at the tips. This formula as well as idiosyncratic proportions and gestures and prancing horses enables one not only to attribute to him a stray folio from the Windsor *Padshahnama* but also to identify him as the artist of several genre pictures inspired by Govardhan's studies of holy men.[6]

SCW

THIS PORTRAIT is surrounded by a *qit'a*, in which the poet complains of the vicissitudes of fate. It begins with the verse:

On my eyes there are no spectacles for the sake of writing,
My eyes became four for the sake of two pieces of bread.

It seems certain that these melancholy verses are by Mir-'Ali (for a more extended translation, see p. 36).

"To become four-eyed" is an idiom that means "to have the greatest longing." The poem, in which the writer complains that he can no longer distinguish rose and thorn, spring and autumn, is one of the first instances of the use of the word *'aynak* (spectacles) in Persian poetry. The word became very popular in the poetry of the late sixteenth century, and miniatures from that time show artists wearing small spectacles.

AS

THIS RECTO page has the margin number 8 and so belongs to Group A. Its border system, however, is not related to that of any other folio in the Kevorkian Album. In the first place, the figure of the emperor and his environment take up considerably more space than the usual portrait, and when the portrait is surrounded by cutout verses in the innermost border and scrolling gold palmette and floral forms on the inner border, there is little room left on the outer border. This outer border is decorated with flowering plants in gold in a somewhat sketchy but assured style on a pale buff ground.

MLS

1. Beach, *Grand Mogul*, p. 113.

2. Likely sources for the cherubs are such prints as *The Crowning of the Virgin* by Johannes Sadeler I after J. Stradanus, for which see Schetter, *Hollstein's Dutch and Flemish Etchings*, no. 308.

3. Terrestrial divinities are frequent partners of Vishnu's avatars; see Gonda, *Aspects of Early Vishnuism*, pp. 27ff. In the Vishnu Purana, the Earth (Prithvi) is referred to as Madhavi (the bride of Madhava, i.e., Vishnu) (Wilson, *Vishnu Purana*, p. 27). I am grateful to Dr. 'Ali Asani for this information. For a miniature of Shahjahan bestowing a Muslim bridegroom's veil (*sahra*) upon Prince Dara-Shikoh, see the Windsor *Padshahnama*, fol. 123v.

4. For Govardhanesque pictures ascribable to Chitarman, see *A Sufi Visiting Sivaite Ascetics*, ca. 1635 (Brown, *Indian Painting*, pl. LII; also Beach, *Grand Mogul*, p. 165); *A Dervish, a Musician, and a Soldier* (Arnold and Wilkinson, *Beatty Library*, III, pl. 69); and *A Drinking Party*, ca. 1660 (Arnold and Wilkinson, *Beatty Library*, III, pl. 84). Other pictures attributable to him are in the Dara-Shikoh Album, now in the British Library (ms. I.O.L., Add. Or. 3129), for which see Falk and Archer, *Indian Miniatures in the India Office Library*, no. 68, fols. 4, 8, 17–19, 31–33, 35, 36, 52, 54, 60, and 72, most of which have been assigned by Falk and Archer to "Painter B."

5. For an inscribed portrait in the Morgan Library, New York, showing Dara-Shikoh within an oval aura, see Beach, *Grand Mogul*, pp. 112–13; an equestrian portrait of Dara-Shikoh rightly attributed by Beach is in the Keir Collection (Robinson et al., *Islamic Painting*, v.71); for a jewel-portrait of Dara-Shikoh by Chitarman, see Falk and Archer, *Indian Miniatures in the India Office Library*, no. 71.

6. For the artist's characteristic treatment of fingers and proportions, see the Morgan Library portrait of Dara-Shikoh referred to in n. 5 above.

For Chitarman's *Padshahnama* miniature in the Art Institute of Chicago (no. 1975.555), see Beach, *Grand Mogul*, p. 83. For an early nineteenth-century traced drawing touched with color of this miniature, also ascribed to Chitarman, see *Loan Exhibition of Antiquities*, no. C.132, pl. XLIIb.

59. Shahjahan Riding a Stallion

ca. 1627

INSCRIBED: (on inner border in Shahjahan's hand) "work [ʿamal] of Payag"

MMA 55.121.10.21V

PEERLESS Shahjahan was always shown in profile to avoid the demeaning effrontery of being seen head-on by viewers. In his supremely imperial portraits, every jewel, sash end, and whisker are as perfect as his smile. Payag's equestrian image conforms to this rubric—even the horse is idealized.[1] The single dissonant note is struck in the horizon line, which has a jarring, ragged unevenness. Although Shahjahan demonstrated military and political astuteness as a prince and was eased onto the throne by hard-fisted, even murderous tactics, as emperor he deliberately insulated himself against day-to-day realities. Thus the emperor's character meshed with the empire's ethos in a thirty-year reign that saw not only a peak of imperial wealth and power but also the early symptoms of decline. Secular as well as religious orthodoxy was on the rise, and court etiquette reached new levels of complexity and strictness. Portraiture reflected these changes. If Akbar and Jahangir spurred artists to ever-deeper revelations of personality, Shahjahan urged them to keep a safe distance and to avoid all signs of changeable moods, of aging and anxiety, or of less than courtly deportment. Using the equivalents of soft-focus lenses and all-concealing cosmetics and spotlights, artists reshaped reality to create an immaculate, unapproachable symbol of empire personified. Shahjahan's likenesses deny the passage of time; his beard was eventually shown as gray, but otherwise it is impossible to date his portraits by wrinkles or pouches. Artists reserved accuracy of observation—on a sliding scale—for lesser beings, such as younger members of the royal family, courtiers, common soldiers, or craftsmen. Only enemies and holy men were exposed to total candor.

In Mughal India artists' lives were usually more tranquil and longer than those of emperors and princes. Payag, like his older brother Balchand, was trained in Akbar's ateliers, after which he adjusted his style to each successive idiom. For him, creative partnership ran smoothest not under Akbar or Jahangir but under Shahjahan, for whom he provided several remarkable historical illustrations as well as single miniatures and at least one drawing. His pictures can be divided into two types, both of which he painted with evident pleasure: formal "state" pictures, such as the present one, and more personal ones, in which he dared express deeper feelings. In the former the Mughal court is on public display, fully primped; in the latter, his most remarkable and original achievements, Sturm und Drang prevail. Moodily dark, these compositions—the greatest of which were made for the Windsor *Padshahnama*—offer Grand Guignol scenes of bleeding soldiers, moldering corpses and skeletons, pensive ascetics, and toothy old veterans. To accentuate somberness, they are placed in awesome mountainscapes or in picturesque hamlets, frequently lit by shadowy moonlight, flickering lamps, or the flash of exploding rockets. Payag's battle and genre subjects must have evoked ambiguous responses from Shahjahan. Cracking through courtly insulation, they describe lost battles as well as victories and lay bare private fears. It is to his credit that Shahjahan not only admired their artistic quality but also included such pictures in the official history of his reign.[2]

For an early nineteenth-century copy of this portrait, see FGA 39.46a (pl. 86). An early nineteenth-century traced drawing, in reverse, with splotched color notations, also inscribed to Payag, may be the "link" between the present original and the copy.[3]

SCW

THIS VERSO portrait has the margin number 11 and belongs to Group A. The page has no cutout poetry in the innermost border but has the typical gold-on-pink inner border of flower heads and palmette scrolls. The colored plants on the buff ground of the outer border are perforce of small scale, the only identifiable one being a possible cyclamen in the upper left corner. Within the picture the pair of birds flying on the left are pigeons (*Columba* species?), while those on the right are hoopoes (*Upopa epops*).

MLS

1. Govardhan's more spirited study of the stallion, seen from the other side, appears in a miniature for the Windsor *Padshahnama*, fol. 133r, showing fourteen-year-old Prince Aurangzeb spearing an outraged elephant as his father looks on.
2. Payag's inscribed works for the *Padshahnama* are fols. 91v, 101v, and 213v; uninscribed ones attributable to him are fols. 48v, 51r, 115v, 175v, and 194r, as well as *The Siege of Qandahar* (Welch, *India*, no. 162b).
3. See *Loan Exhibition of Antiquities*, no C.136, pl. XLVb.

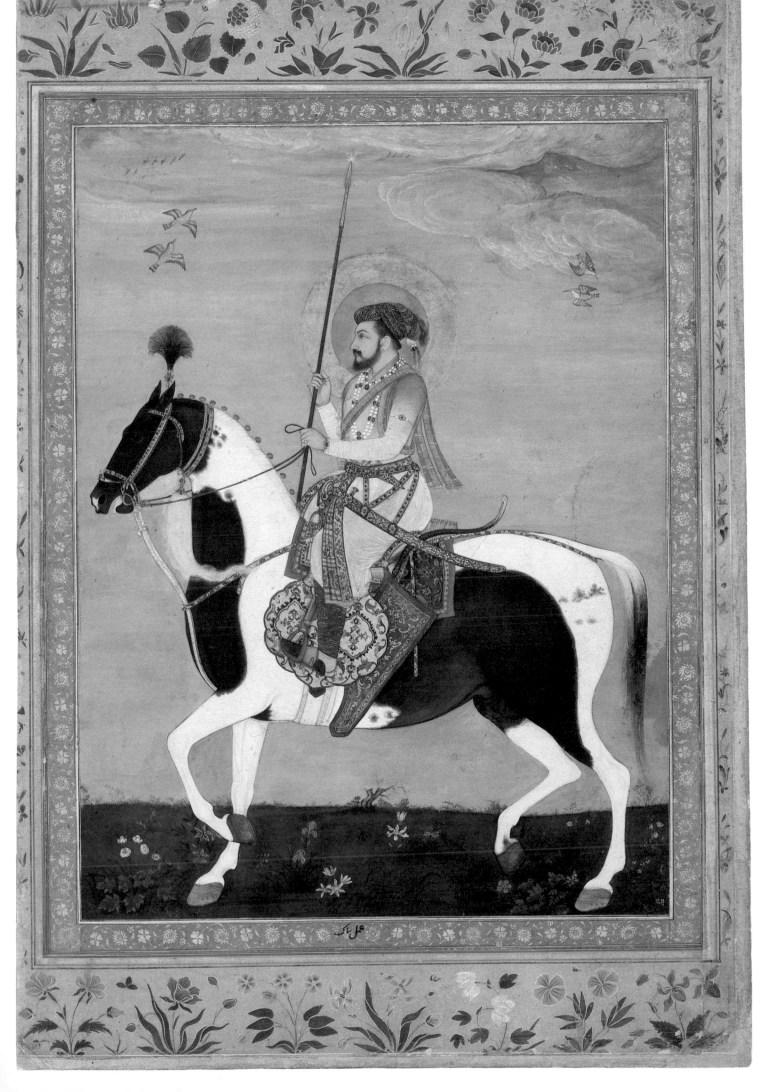

59

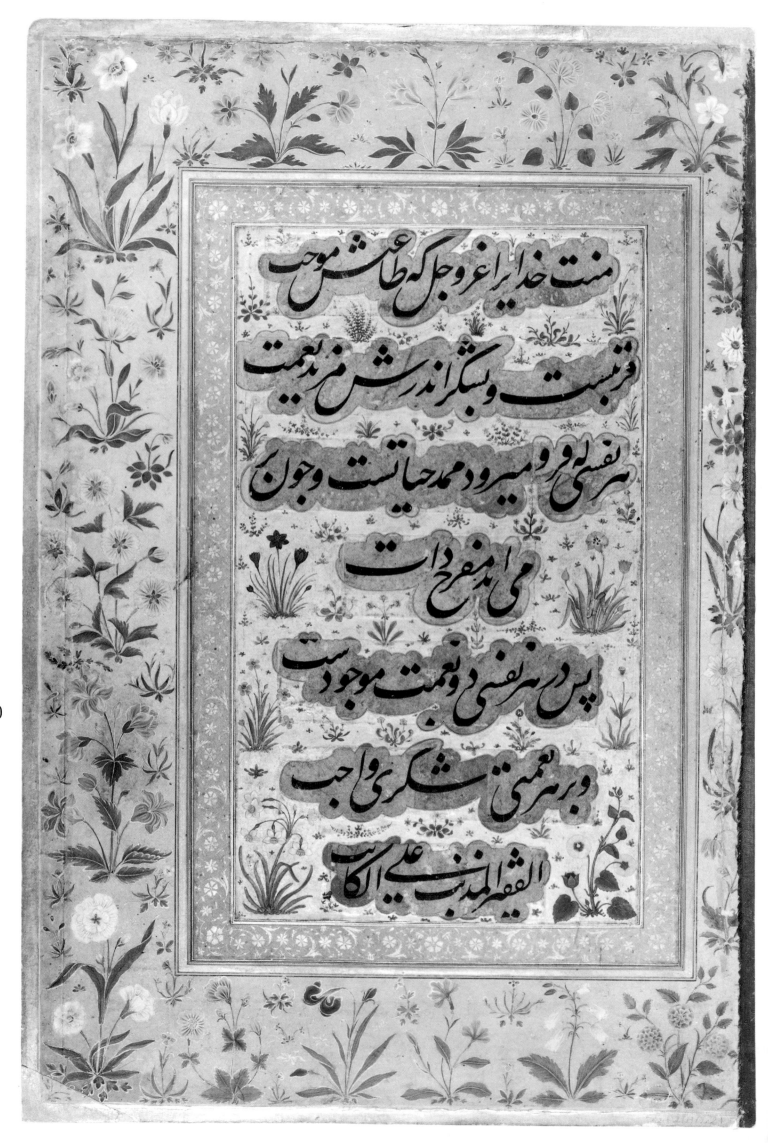

منت خدای را عز و جل که طاعتش موجب

قربت است و بشکر اندرش مزید نعمت

هر نفسی که فرو میرود ممد حیاتست و چون

می اید مفرح ذات

پس در هر نفسی دو نعمت موجودست

و بر هر نعمتی شکری واجب

الفقیر المذنب علی الکاتب

60. Calligraphy

ca. 1530–50

MMA 55.121.10.21r

Thanks be to God Most High and Glorious that obedience to Him leads to proximity and that by thanking Him there is increase in bounty. And every breath that goes down is an extension of life, and when it comes up it is an exhilaration for the essence. That means that in every breath there are two graces inherent, and for every grace, gratitude is necessary.

The poor sinner 'Ali the scribe [al-katib]

This prose passage was cut out from another page and pasted together to form a new calligraphic page. Missing dots were added when the background was painted.

The text expresses a traditional Sufi belief: grace requires thanks, and gratitude in turn produces new bounty. The idea that breathing has a twofold grace was known to the early mystics of Islam, but it may be that this piece belongs to a Naqshbandi treatise, perhaps to a writing by Jami or his followers, for the Naqshbandi order laid special emphasis on breathing during the recollection of God.

AS

L IKE ITS verso, this recto page has a border of plants in various colors on a buff ground. A narcissus can be found in the upper left corner and an iris left of center in the lower border. Surrounding the calligraphy is a tulip at right center with a narcissus below it and another in the lower left corner. In the lower right corner is an ipomoea. At the left center the plant is perhaps a crocus with a poppy above it.

This painting probably came from an album of royal portraits not related to others in the Kevorkian Album. In any case it could not have belonged to Album 3 of Group A, as the border pattern conflicts. It is the only folio in Group A that uses colored plants on a buff ground as the scheme for both borders.

MLS

205

61. Calligraphy

ca. 1530–50

FGA 39.49b

A quatrain by Hafiz, calligraphed by Mir-ʿAli:

A torrent surrounded the ruins of life
And began to fill up the goblet of life.
Be careful! The porter—that's Time—swiftly takes
The furniture out of the house of this life!

The same quatrain occurs on another page from a Shahjahan album (Los Angeles County Museum), written by "the sinful, poor Mir-ʿAli." It is surrounded by a cutout poem that can be ascribed to the calligrapher himself, in which he boasts of his achievements in both calligraphy and poetry (for a translation, see p. 35).

AS

THE VERSO border is similar in design and coloring to the recto (pl. 62), although not identical. This folio also does not compare in border scheme with any other in Group B.

MLS

62. Shahjahan, Master of the Globe

Dated 1629

INSCRIBED: (at bottom, in good nastaʿliq) "work of Hashim. On the second of Jumada 11, day Monday, year 1028 [January 27, 1629] the portrait was executed"; (on parasol) Shahjahan's genealogy, which is traced to Timur; (on the scroll held by the people on the globe)—

Oh God, keep this king, the friend of the dervishes,
Under whose shadow people's peaceful existence [is maintained].
[Keep him] for a long time established over the people;
Keep his heart alive by the succor of obedience [to You]. [AS]

FGA 39.49a

SHAHJAHAN'S leading artists all painted state portraits, often incorporating complex programs of imperial symbolism. In this miniature, commissioned soon after the emperor's accession, Hashim bestowed a multiplicity of honorifics, both temporal and spiritual, upon his patron.[1] Taking the imperial name literally, he placed Shahjahan (King of the World) atop the globe, which he adorned with holy men attesting to the emperor's humility, as well as with the familiar metaphor of Mughal stability and power, a sheep and lion dozing tranquilly together. Above, emerging from auspicious rainclouds, two putti offer a jeweled sword and crown, while a third holds a royal parasol bearing the imperial pedigree. The emperor's rose-violet pajamas are boldly adorned with undulating gold and silver flowers. He holds up an amulet of health-giving carnelian framed in gold.[2] The exquisitely finished profile proclaims the emperor's amiable sensitivity.

206

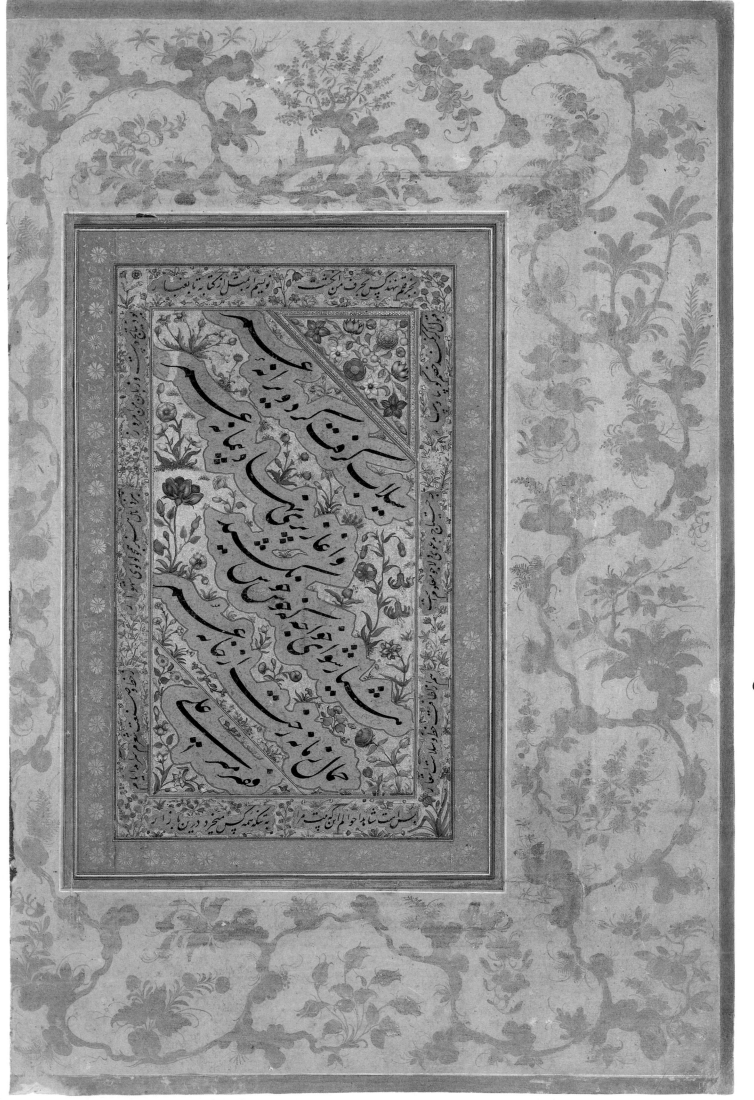

61

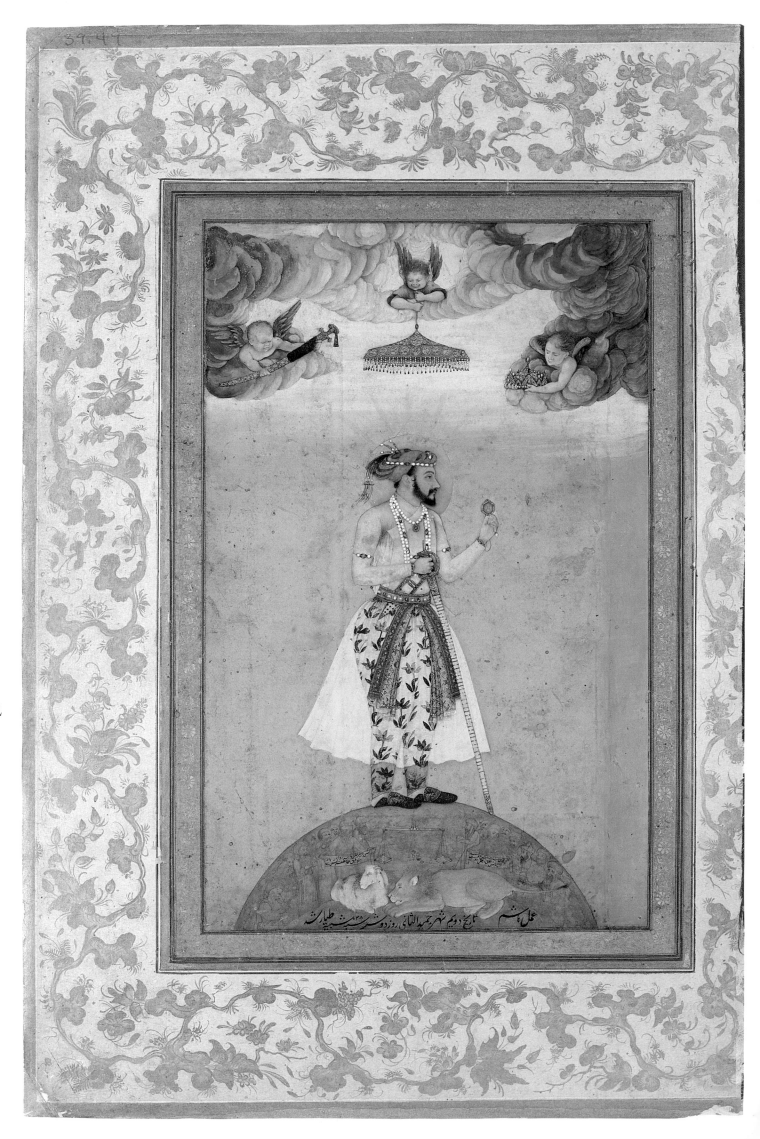

62

It is strikingly similar to Hashim's jewel-portrait in the Cleveland Museum of Art, painted soon after Shahjahan's accession, while also looking ahead to his portrayal of the ruler toward the end of his reign, showing him gray-bearded and slightly pudgy.[3]

Hashim's career at the Mughal court further blossomed after the accession of Shahjahan, for whom we believe he had worked years before in the Deccan (see pl. 20). Although he continued to serve as the atelier's specialist for portraiture of Deccani notables, he also portrayed the emperor, his family, and his courtiers, rivaling the greatest imperially trained masters in sensitivity to personality. No longer limited to the powerfully characterized single figures known from his Deccani and earlier Mughal phase (see pls. 35 and 38), he became expert in more complex compositions, alive with large numbers of figures depicted at court or in the hunting field.[4]

SCW

THIS RECTO page has the margin number 27. It has no decorated inner border or cutout poetry. Its outer border has an abstract scrolling branch with plants, leaves, and fungi in gold on a pale buff ground. Although it is inscribed to Hashim, the pose of Shahjahan is very close to that seen in Chitarman's portrait of the emperor (MMA fol. 24r; pl. 58).

MLS

1. With regard to this picture we differ with Milo C. Beach, who catalogued it as "mid-17th century with later additions" and further commented that Hashim "may well have executed a model for this composition. Here, however, the angels and the effect of the emperor's trousers under the transparent skirt are far below the level of competence associated with the painter's reliable works" (*Imperial Image*, pp. 187–88). After studying the original with great care, we persist in seeing it as a splendid and intact work by Hashim. It has since been examined by the conservators of the Freer Gallery, who found no evidence of retouching.

2. Many Muslims believe that carnelian is therapeutic. A Mughal carnelian dated 1620 is inscribed with a prayer against illnesses of the stomach.

3. Beach, *Grand Mogul*, no. 45, pp. 127, 129. Beach apparently rejects the signed jewel-portrait in the Cleveland Museum of Art (Gift of J. H. Wade; 20.1966) as a work by Hashim and dates it to the mid-seventeenth century. It is misidentified as a portrait of Dara-Shikoh (Beach, *Grand Mogul*, no. 64, p. 167).

4. For Hashim's profound and poignant grasp of personality, see his drawing of the ill-fated Prince Sulayman-Shikoh and his tutor (Welch, *Indian Drawings and Painted Sketches*, no. 20). Pictures for the Windsor *Padshahnama* attributable to him include the double-page frontispiece depicting the gray-bearded Shahjahan facing Sultan Timur (fols. 2v and 3r), *Shahjahan Hunting Deer at Palam* (fol. 164r), and *Shahjahan, Dara-Shikoh, and Shah Shujaʿ Hunting Lions at Bari in the Province of Akbarabad* (fol. 219v). The most ambitious, and successful, court and hunting scenes attributable to him, however, were painted for Emperor Aurangzeb: *Aurangzeb in Darbar* (Welch, *Art of Mughal India*, no. 58), *Aurangzeb with Sultan Aʿzam and Courtiers* (Welch, *Imperial Mughal Painting*, pl. 37), and *Emperor Aurangzeb Shooting Nilgai* (Welch, *India*, no. 176).

For another version of this miniature in the Chester Beatty Library, see Arnold and Wilkinson, *Beatty Library*, III, pl. 86. Although the author knows this picture only from the excellent reproduction in the Beatty catalogue, it is certainly a mid-seventeenth-century replica from the imperial workshop, lacking the fineness and lively buoyancy of Hashim's original. This may explain Milo C. Beach's statement that it is "a later, nineteenth-century copy of this exact composition, including some identical inscriptions" (*Imperial Image*, p. 188).

63. Shah Shuja' with a Beloved

ca. 1632

INSCRIBED: (on border in Shahjahan's hand)
"work ['amal] of Govardhan"

MMA 55.121.10.35V

ALBEIT IDEALIZED, this lightly mustached prince is identifiable as Shah Shuja' (1616–60), who was Jahangir's favorite grandson and who spent most of his life as governor of Bengal. He lived in contented, near-imperial splendor, writing verses, encouraging musicians, and ruling with admirable clemency and justice—until his brother Aurangzeb seized the throne in 1658. In 1659 Shah Shuja' and his large army were defeated by the imperial forces at Khajua, near Allahabad. He was forced to withdraw to Bengal; two years later, hounded into Assam by Aurangzeb's armies, he and his family and a small number of loyal retainers disappeared from history.

Studded with jewels and pearls, luxuriant with transparent, gold-threaded muslins, enriched with flowers, brocaded arabesques, and the agreeable stains of scented unguents, Govardhan's lovers nevertheless seem to have inspired the artist only in fits and starts. If the beloved's sweetly passionate face, inviting gestures, and wind-swept dopatta caught Govardhan's fancy, the coarse-handed, slightly simpering prince—whose appearance had changed in adolescence from beguiling boyishness to prematurely middle-aged heaviness—apparently did not. While her expression is fresh with conviction, his smile is cloying and his eyes are theatrically fixed heavenward rather than on the joys at hand. But it is pre-sumptuous to question passages in a painting made for Shahjahan by his most serious artist. Rather than applying our own standards, we should recall that to this day in Indian theater, dance, and art facial expressions of unquestionable sincerity sometimes seem overdramatized to the uninitiated.[1]

The prince's inamorata is not his wife, the daughter of Mirza Rustam Safavi of the royal house of Iran, whose aristocratic mien is well known from a wedding portrait by Balchand datable to 1633.[2]

SCW

THE INNER BORDER of palmettes, leafy fronds, and flower heads is wider and more elaborate than usual. The outer border contains gold flowering plants on a pink ground. The plant below the center on the outer border's right edge is probably a stylized rose; the buds are correctly rendered, but the leaves are wrong. There is no cutout poetry.

MLS

1. This is especially evident in the artfully contorted visages of singers of ghazals (Persian and Indian love songs), which might seem unsympathetic to foreigners but which occasionally move Indians to tears.
2. Welch, *A Flower from Every Meadow*, no. 65; Welch, *Imperial Mughal Painting*, pl. 35; Beach, *Grand Mogul*, no. 31.

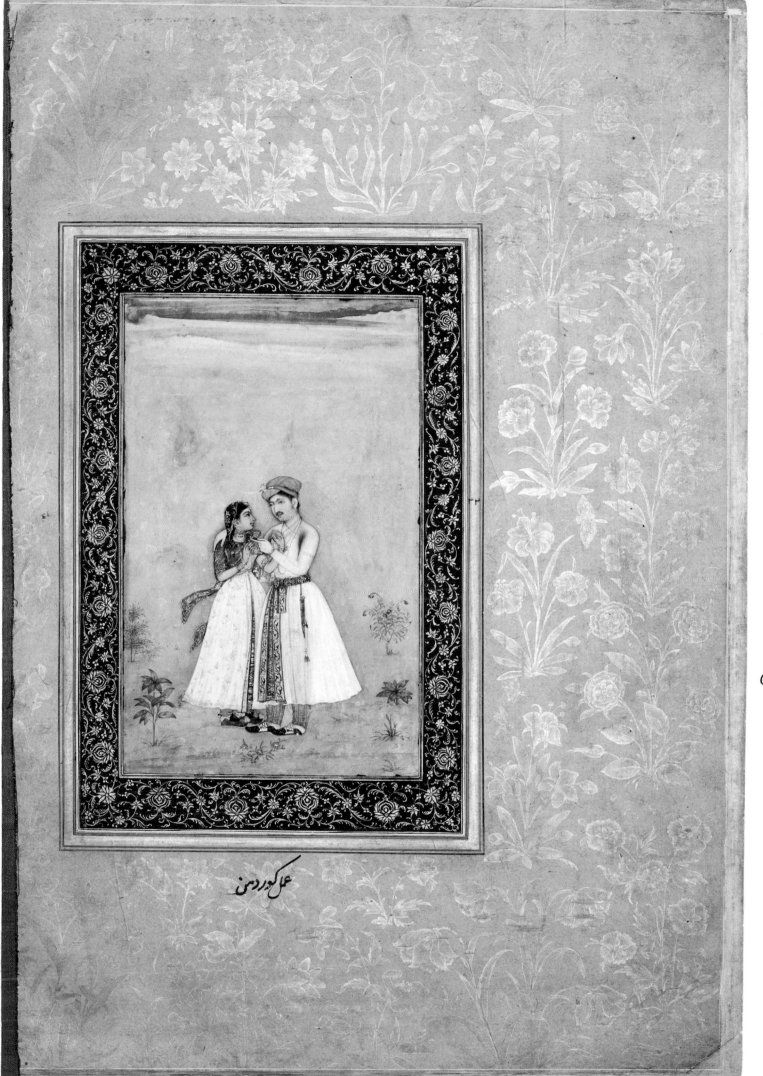

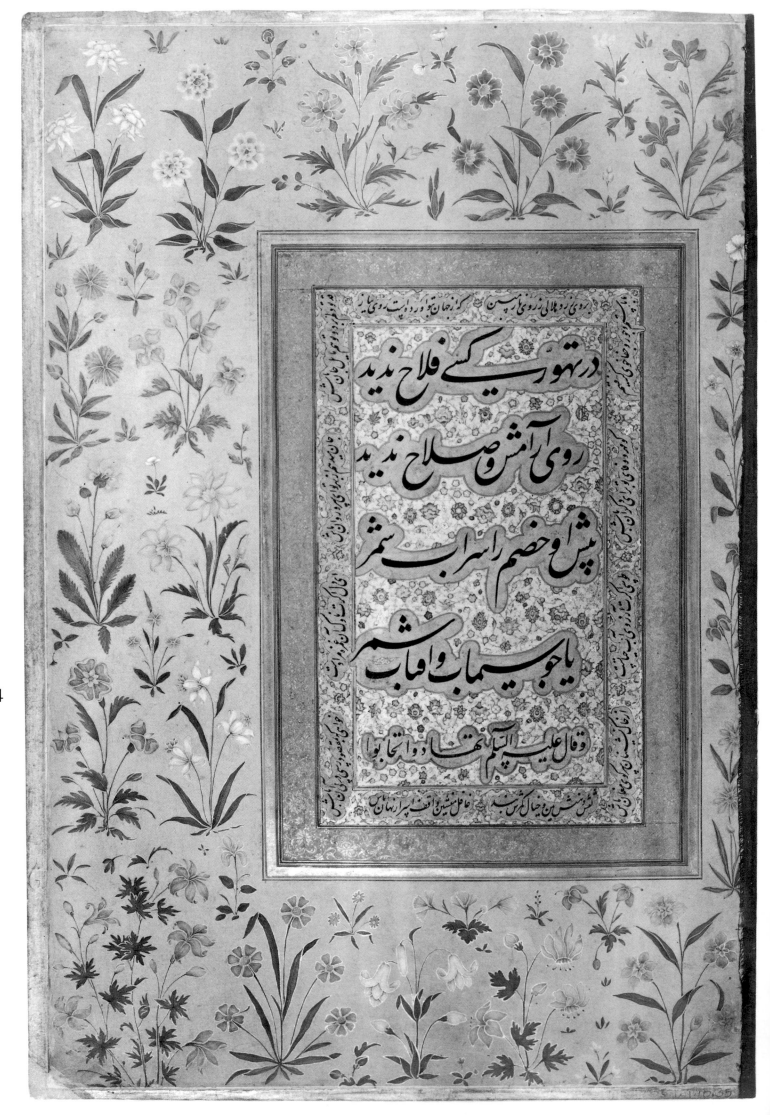

64

64. Calligraphy

ca. 1530–50

MMA 55.121.10.35r

No one careless has ever seen prosperity
Or the face of rest and propriety.
Before it [i.e., patience?] count the enemy like a mirage
Or count him like mercury and the sun [i.e., vanishing and
 unreal].

The poem is followed by the Arabic quotation: "He—peace be upon him—said: 'Make presents to each other and have mutual love.'" This is, according to the wording of the blessing formula, a saying of ʿAli ibn Abi Talib, the first imam of the Shia, whose *Forty Sayings* was transformed into poetry by several poets, including Jami.

The page is surrounded by a poem by Tusi and verses by Hilali.

AS

THIS RECTO page has an inner border of gold on a pink ground and an outer border of flowering plants in colors on a buff ground. The plant in the center of the lower border may be a *Galanthus.* The border scheme of this folio does not correspond to any other in Group B.

MLS

65. Calligraphy

ca. 1530–50

MMA 55.121.10.5V

Hazrat Mir-Husayni—God bless his soul!—says:

The letter that drops from the pen—
It is evident what appears from it.
The letter is what God
Pours on the servant's heart.
 Written by the poor Mir-ʿAli the scribe [al-katib],
 may God cover his faults!

This is a *muʿamma* (riddle), a form of which Amir Husayni was the undisputed master in Timurid Herat. He died in 1498, and the formula used after his name shows that Mir-ʿAli penned this page after his death. I was not able to find a correct solution for the riddle.

The page is surrounded by several fragments of Persian ghazals—left border: a ghazal by Suhayli without its first lines; right border: a ghazal by Asafi; lower border: the *matlaʿ* (introductory verse) of another ghazal. Suhayli and Asafi both belonged to the court of Husayn Bayqara.

 AS

THE GOLD PLANTS on the pink ground in this border are less densely spaced than on the recto border (pl. 66). However, the same plant with leaflike oval flowers appears on verso and recto, indicating that the same painter created both borders. Here insects fly among the plants, while tulips and narcissi appear in the bottom border. The only other leaf with gold plants on a blue ground on the portrait side and gold plants on a pink ground on the calligraphy side is MMA fol. 4 (pls. 21 and 22). That leaf and the present one were probably from the same original album.

 MLS

66. Sayyid Abuʾl-Muzaffar Khan, Khan-Jahan Barha

ca. 1630

INSCRIBED: (in Shahjahan's hand) *shabih-i khub-i Sayyid Khan-Jahan Barha, ʿamal-i Laʿlchand* (a good portrait of Sayyid Khan-Jahan Barha, done by Laʿlchand)

MMA 55.121.10.5r

SAYYID ABUʾL-MUZAFFAR KHAN joined Prince Sultan-Khurram (Shahjahan) in the 1620 Deccan campaign and impressed the prince greatly with his feats of bravery in battle. The Sayyid also joined Shahjahan in his rebellion against Jahangir in 1623–24.

When Shahjahan came to the throne, he gave Sayyid Abuʾl-Muzaffar Khan the rank of 4000/3000, presented him with 100,000 rupees as a gift, and appointed him governor of Gwalior. He took part in the various expeditions against Khan-Jahan Lodi and the campaign against the Nizamshah in the Deccan, for gallantry during which he was raised to the rank of 5000 and given the title Khan-Jahan. He was deputed, along with ʿAbdullah Khan Bahadur and Khan-Dauran, to put an end to the rebellion of Jujhar Singh Bundela. He spent the last few years of his life between his fief in Gwalior

and court. In 1645 he was stricken with paralysis and died after a few months.

Shahnawaz Khan, the author of *Maasir al-umara*, says that, unlike the autocratic and cruel ʿAbdullah Khan, Khan-Jahan Barha "had a great name and was possessed of much character and generosity. He spent his life with honor. To every one of the royal servants who was associated with him he gave villages out of his fief. He was very gentle and considerate."[1]

 WMT

LAʿLCHAND was one of the lesser painters in Shahjahan's academy. His failings become instructively evident when one compares his pictures to those of major masters. He was an industrious if impatient or even hasty craftsman, capable of maintaining the high

214

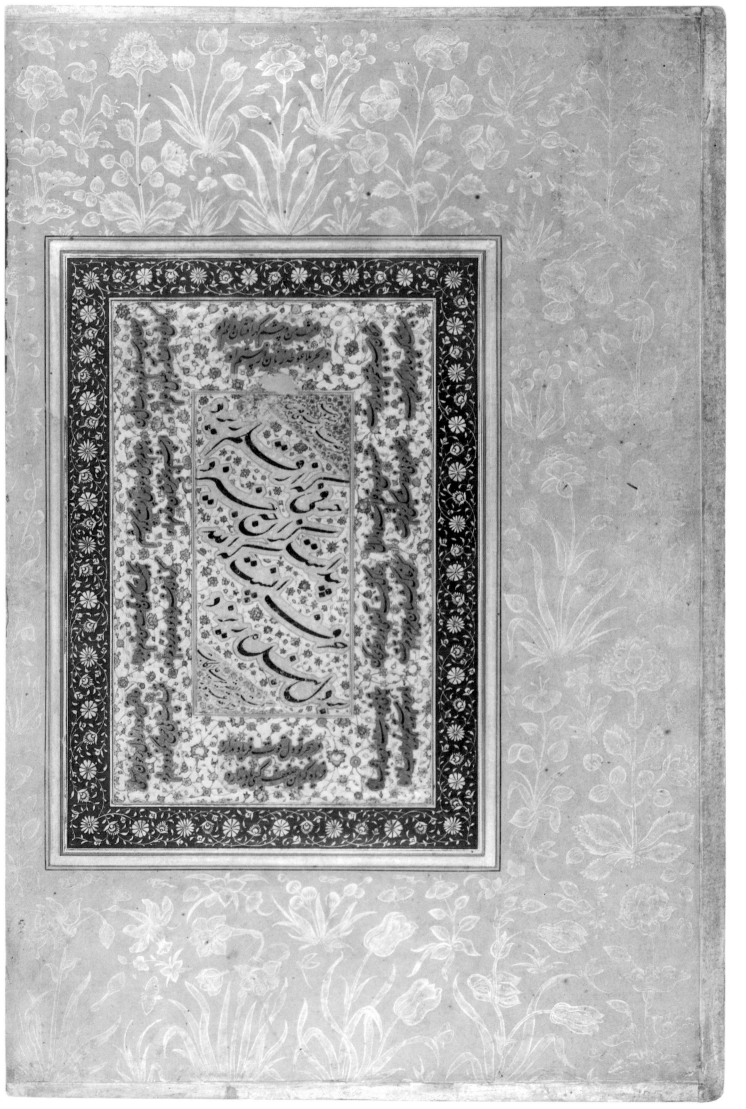

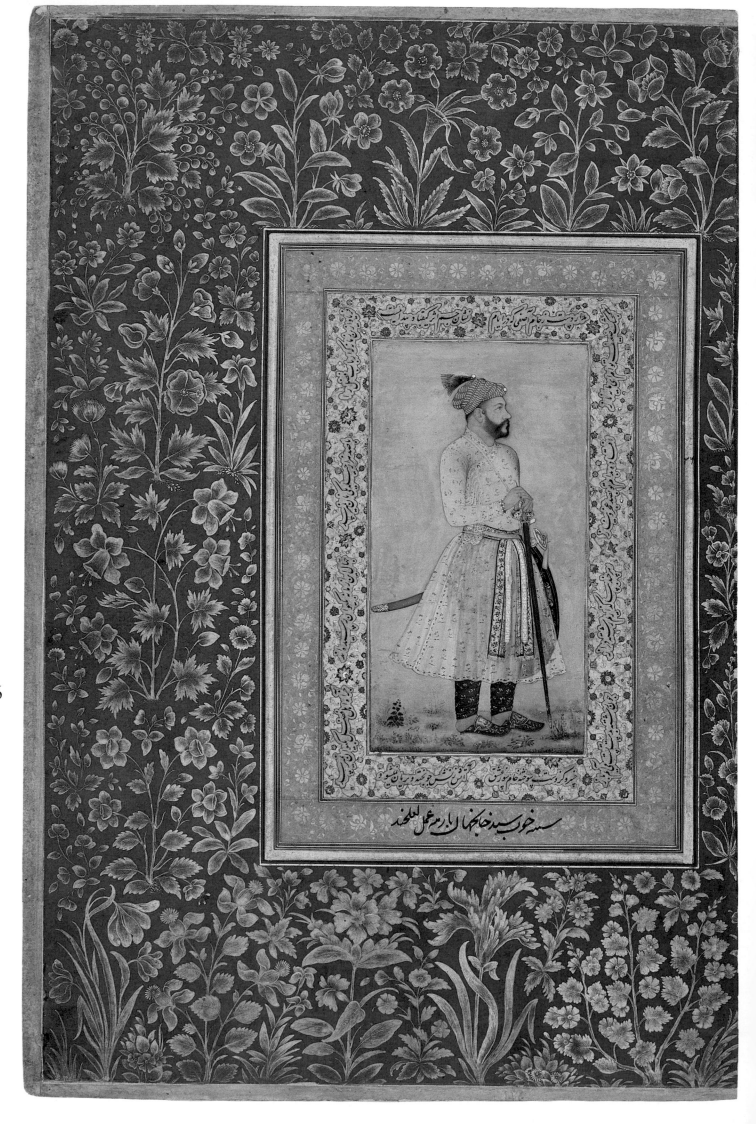

66

standards of the imperial ateliers only in single portraits; his larger figural compositions are accomplished in their parts but suffer from overall disunity and irresolution. This is apparent in an inscribed miniature for the Windsor *Padshahnama* (fol. 46v; Appendix, fig. 26) showing Prince Khurram (Shahjahan) receiving the submission of Maharana Amar Singh of Mewar. This episode took place in 1615 and was painted for the *Tuzuk-i Jahangiri* by Nanha;[2] La'lchand relied upon the earlier miniature, from which he copied the overall composition and the principal figures. Prince Khurram, the rana, and their immediate surroundings—such as the striped bolster—were scrupulously taken from the earlier miniature, but most of the courtiers and attendants farther from the throne were replaced from La'lchand's stock of likenesses. A few eminent courtiers, moreover, appear in La'lchand's version not as they looked to Nanha in 1615 but in up-to-date likenesses.

When seen in groups, La'lchand's dour, uninvolved figures seem awkward, their legs slightly—but disconcertingly— too long or too short and their heads too big or too small. Just as his overall designs lack spatial logic and architectonic cohesiveness, his courtiers, textiles, and elephants alternate between taut roundness of form and inconsistent flatness. However finely executed, arabesques fail to sparkle, are uninventive and flabby. Pigments are applied with whimsical unevenness, some thin, others thick, producing a softly mottled appearance that suffers in comparison to the precise, enameled clarity of greater artists.[3]

A crowded miniature by Bola in the Windsor *Padshahnama* (fol. 70r; Appendix, fig. 27), which shows Shahjahan being weighed against sacks of coins or gems while receiving his sons and courtiers, includes a nearly identical portrait of Khan-Jahan Barha, standing among the higher courtiers, just below the throne platform. Although the present likeness is livelier and more convincing (hence closer to a study from life), the similarities are startling, down to the precise stance and pose of hands and the same jeweled turban ornament and *patka* (sash). At least as early as the Jahangir period, standard likenesses were pooled by court artists for duplication as needed; even the most admired artists, such as Abu'l-Hasan, sketched notable events as they occurred or reconstructed them soon thereafter from the accounts of participants and witnesses.[4] Moreover, inasmuch as the Mughals maintained detailed records —times and places of receptions, lists of visitors, gifts given and received, and noteworthy incidents—information was accessible to painters for the reconstruction of historical assemblies and events.

SCW

THE CALLIGRAPHIC fragments contain in the upper line a ghazal by Asafi, in the lower part the last lines of a ghazal by Amir Khusrau,[5] and in the left part a quatrain which is so amusingly unrelated to the portrait of the successful courtier that it is worth translating:

Woe over this time when the virtuous people
Cannot find a single piece of bread with a thousand tricks!
The stupid have now reached [the highest sphere, that of] Saturn,
But only the sigh of the virtuous reaches Saturn!

Here the poet elliptically observes that the stupid have reached the apogee of success, while the virtuous people, in deep abjection, heave a sigh so strong that it reaches to the highest sphere.

The use of such inappropriate lines shows that the craftsmen in the atelier apparently pasted the cutout verses wherever they found a suitable space.

AS

THIS RECTO portrait has the margin number 36, thus placing it in Group A. The borders around the portrait have very dense gold flowers on a blue ground. Certain idiosyncrasies—the predilection for particularly leafy plants, for serrated leaves, and for long stems, as well as the handling of shading—are characteristic of this painter. Two of the plants, one in the middle of the left margin and the second one row up from the bottom, are poppy types with a dianthus at the left center of the outer margin and an iris at the right of the outer margin slightly above center. The most distinctive plant in the upper left corner may be a *Lunavia*. The wild-looking plant in the right center of the lower border may be intended for a parrot tulip.

This leaf could not have belonged to Album 1. In that album a portrait with the margin number 36 would have to have a gold-on-pink border.

MLS

1. Shahnawaz Khan, *Maasir*, I, p. 795.
2. Nanha's picture is now in the Victoria and Albert Museum (I.S. 185–1984). See Skelton, "Recent Acquisitions," p. 16.
3. Although fol. 46v is La'lchand's only signed illustration in the *Padshahnama*, others can be attributed to him on stylistic grounds: fol. 97v, *Shahjahan Receives Muhammad 'Ali Beg, Ambassador from Shah Safi*; fol. 123r, *Marriage Procession of Prince Dara-Shikoh* (left half); fols. 125v and 126r, *Marriage Procession of Prince Shah Shuja'*; and fol. 217v, *Celebration by Night of the Marriage of Prince Aurangzeb to the Daughter of Shahnawaz Khan*.
4. See Welch, *India*, no. 117, for Abu'l-Hasan's drawing of an episode during a hunt.
5. Amir Khusrau, *Divan*, no. 827.

67. Jahangir Beg, Jansipar Khan

ca. 1627

INSCRIBED: (in Shahjahan's hand) *shabih-i Jansipar Khan, ʿamal-i Balchand* (a portrait of Jansipar Khan, done by Balchand)

MMA 55.121.10.37v

IN THE TWELFTH year of Jahangir's reign (1617) the emperor writes: "On Saturday the thirteenth of Aban, Jahangir Khan Quli Beg Turkman, who has been ennobled by the title Jansipar Khan, came from the Deccan and paid his respects. His father had held the rank of amir under the ruler of Iran but came out of his native land in the time of His Late Majesty [Akbar], was given a rank and dispatched to the Deccan. He [Jahangir Beg] was brought up in that province. Although in his absence he had repeatedly rendered service, since my son Shah Khurram [Shahjahan] had come to court and spoken of his devotion and fidelity [*jansipari*], I ordered that he should come alone to court and wait upon me and then return."[1]

In 1623 the imperial Mughal forces, allied with Mulla Muhammad Lari, the minister of Bijapur (pl. 38), were surprised by the skillful Malik ʿAmbar, minister of Ahmadnagar, and were routed at Bhaturi near Ahmadnagar. Jansipar Khan, who had come from his nearby fief at Bir, escaped to his fortress and made ready for a siege. Shortly before Jahangir's death Khan-Jahan Lodi, the Deccan commandant of the Mughals, was bribed by Malik ʿAmbar's son Hamid Khan and handed over to him the whole country of the Balaghat as far as Ahmadnagar Fort. All Mughal commanders, Jansipar Khan included, were required to withdraw and turn their holdings over to Hamid Khan's agents.

At Shahjahan's accession to the throne Jansipar Khan was appointed governor of Allahabad, "but according to the rule of the revolving heavens—that every good is allied with evil, and every joy is mixed with grief —the wine of success in this instance was followed by the crapulousness of failure, and the limpid waters of joy had at the bottom a sediment of sorrow. The cup was no sooner filled than it was emptied, and the roll not finished without the pages being turned over; in this very year did the cup of his life overflow."[2]

WMT

BALCHAND'S characterization, with its wrinkled brow and eyes, gracefully opened left hand, and old man's stance, conveys the reserved courtliness of this gentleman accustomed to Deccani ways. His off-white, honey-yellow, reddish-brown, deep blue-gray, and gold costume is probably due equally to the artist's subtly inventive palette and the sitter's refined taste. Red and white flowers in the left foreground establish the setting, while seeming to offer courtly salutes. Lacier ones, to the right, reflect Jansipar Khan's gentle demeanor.[3]

SCW

THE PORTRAIT is surrounded by Persian verses from a *mathnavi* in the *hazaj* meter about "word" and "meaning," perhaps from a treatise about riddles.

AS

THIS VERSO portrait has the margin number 35 and belongs to Group A. The border design and coloring are consistent with those of MMA fol. 7r (pl. 28; margin number 4) and MMA fol. 8v (pl. 29; margin number 3), indicating that all three had come from the same album. The gold plants in the border are generally smaller than usual to accommodate the addition of animals and birds. At the bottom a lion and a buffalo face each other on either side of the hillock with a flowering plant growing on it. In the corner there is the somewhat startling back view of a plump reclining buffalo, which is only partially foreshortened as if seen from above as well as behind. Above it is a second recumbent buffalo, with its head facing forward. The horns of both animals almost touch at the top in a circle, making a wonderful repeat. Next comes a small deer with curved horns seen in profile and looking over its shoulder. Just above the deer, in the middle of the border, two birds perched on the plant stems as if they

218

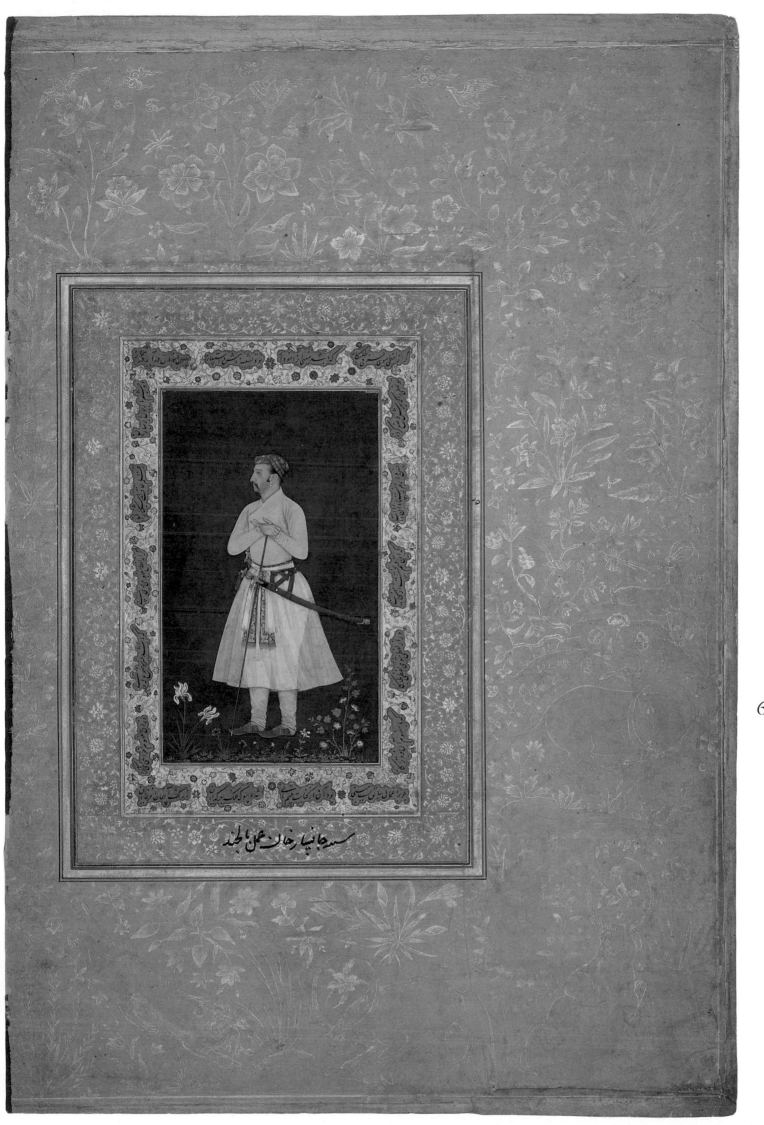

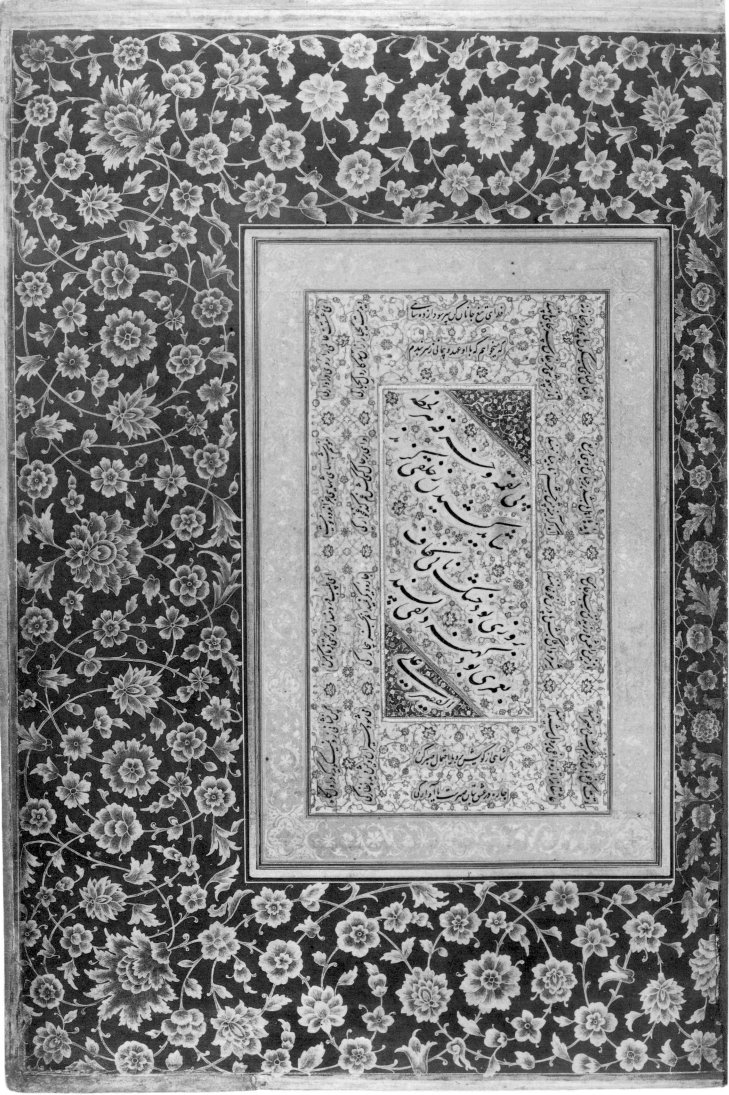

68

were tree branches face each other. A bird resembling a moorhen, as large as the deer, is to be found farther up. There are also three birds flying under the cloud bands at the top of the border. None of the experts has been able to see the plants, birds, or animals clearly enough for identification. The inner border is gold on pink with the identification of the subject and attribution to the artist written in the lower part, and the innermost border contains cutout verses.

The artist also seems to have painted the recto side of the present folio. Neither his drawing nor his brushstrokes appear to be quite as fine as those of Daulat.

Within the picture itself an iris can be identified at the lower left.

MLS

1. Jahangir, *Jahangirnama*, p. 227.
2. Shahnawaz Khan, *Maasir*, I, pp. 752ff.
3. An early nineteenth-century copy of this portrait was auctioned at Sotheby's on October 14, 1980, lot 192 (called Khan Sipar Khan). It is not illustrated, but by the description given, it is very close to the present picture. [MLS]

68. Calligraphy

ca. 1530–50

MMA 55.121.10.37r

One is plagued and injured all the time
For a morsel's sake and for a cloak—
But for one's day dry bread is enough,
For one's life an old coat is all right.
 The poor [*al-faqir*] ʿAli

The same quatrain is found in the Berlin Album, in Cod. Mixt. 313, Vienna, fol. 16a, and in a Mughal copy (FGA 1958.157).[1]

The surrounding lines consist of ghazals by Shahi— the end of one of his poems appears in the upper line, and a full ghazal runs down the left and across the lower level. The poem on the right is incomplete but seems to be by Shahi.

AS

THE ABSTRACT design of flower heads, palmettes, and leaf scrolls in gold on a blue ground is very close to the others that belong to this set, particularly to MMA fol. 32v (pl. 17). However, it has a slightly deeper blue border and appears to have a more lavish use of gold and less finely blended brushstrokes, although it may be that the darker blue ground emphasizes these impressions. In any case, if the borders of this folio are not by Daulat himself, they must certainly be the work of a closely supervised pupil.

MLS

1. Beach, *Grand Mogul*, pl. 11.

69. Calligraphy

ca. 1530–50

MMA 55.121.10.30v

THE LARGER lines in the upper part read:

If the dagger of your love
 cuts my neck, it's fine with me,
For who still thinks of his head
 will not reach the highest place.
Don't be lesser than the pen—
 don't you see the secret is:
Pens become not perfect, friend,
 if you do not cut their heads!
 The poor [al-faqir] Mir-ʿAli

These lines are followed by the latter part of a *qasida* in honor of Imam ʿAli and his family, and by a Persian praise poem for the eighth imam, ʿAli ibn Musa ar-Rida.

The poetry may well be by Mir-ʿAli; the use of the pen, which has to be trimmed in order to write, as a metaphor of man who has to suffer in order to reach his final goal is fitting for a calligrapher. The imagery is, however, found rather frequently in mystical Persian poetry, for to give away one's head is the supreme goal of the martyr of love. (The same poem, penned in larger script by Mir-ʿAli, is also found in the Berlin Album, fol. 12v.) Furthermore, Mir-ʿAli was an ardent Shiite and wrote honorific poems in the eighth imam's mausoleum in Mashhad.

<div align="right">AS</div>

THIS VERSO page has an inner border virtually identical with that of MMA fol. 31r (pl. 72), also in gold on blue. Its outer border is clearly by the same hand. The bottom border, beginning after the small plant in the left corner, shows a lily, a tulip, a dahlia, a lily, and another lily. A chrysanthemum is placed above the right-corner lily with, above it, a *Lilium* with another *Lilium* in the upper right corner and a third to its left. Next left comes a cyclamen-type flower, and second from the left is a *Gesnerinceae* (cult.). The third plant down in the left margin is a dianthus with a narcissus below it. While the artist here has varied the plant sizes, with medium-sized and tiny ones among the larger dominant plants, he does not use grass tufts nor does he include butterflies and insects. The same artist clearly painted both borders of this folio.

<div align="right">MLS</div>

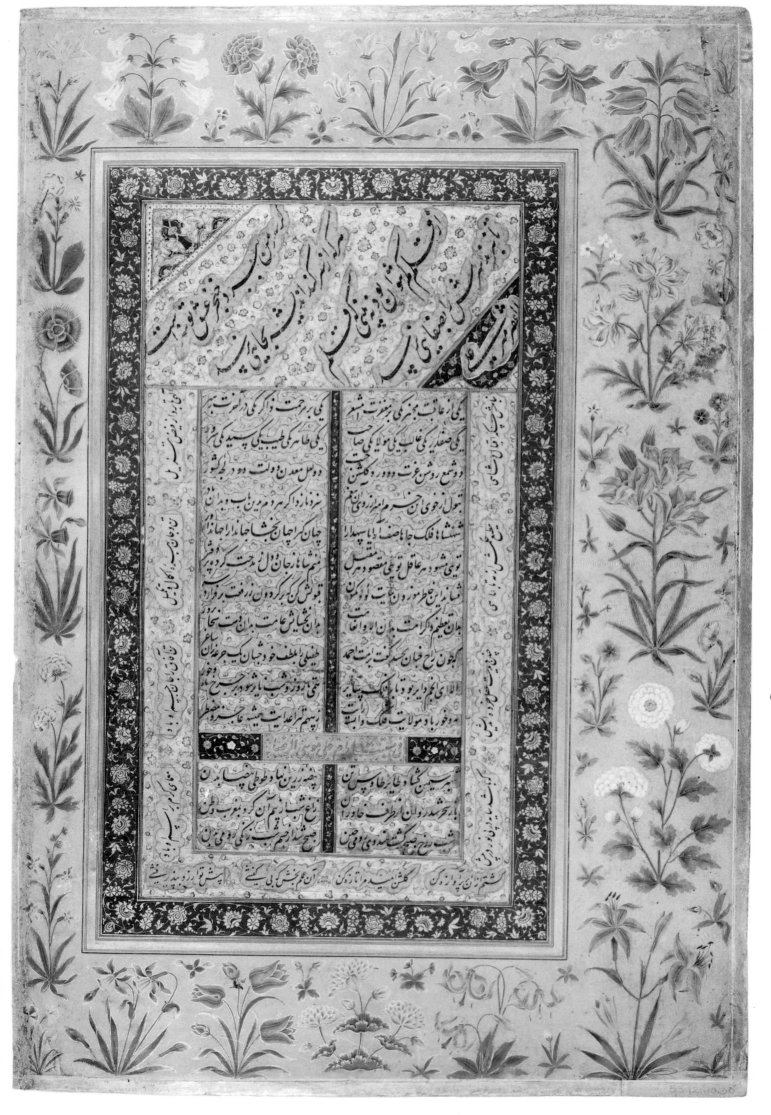

69

70. Qilich Khan Turani

ca. 1640

INSCRIBED: (in Shahjahan's hand) *shabih-i Qilich Khan hakim-i qal ʿa-i Qandahar ʿamal-i Laʿlchand* (a portrait of Qilich Khan, governor of Qandahar Fort, done by Laʿlchand)

MMA 55.121.10.30r

IN HIS YOUTH Qilich Khan was in ʿAbdullah Khan's service and was a loyal follower of the general throughout his career. He held a number of important posts and governorships, including those of Delhi, Allahabad, and Multan under Shahjahan.

Qandahar Fort, a bone of contention between the Mughals and the Safavids of Iran for many years, had been held by the Safavids since 1625, when the Safavids, taking advantage of the internecine strife between Jahangir and Shahjahan, captured the fort. For the first decade of his reign Shahjahan was too preoccupied with other matters to undertake a campaign against Qandahar, but in the eleventh year, 1637, the imperial forces were sent toward the Punjab to take Qandahar. When the Safavid commander of the fort, ʿAli-Mardan Khan, sent to Shah Safi for reinforcements, the Safavid shah was secretly planning to have ʿAli-Mardan Khan killed and install his son Muhammad-ʿAli Beg in his place. ʿAli-Mardan Khan, however, learned of this plot, forestalled the arrival of Siyavush Qullar-aqasi from Mashhad, and sent word to Saʿid Khan in Kabul and Qilich Khan in Multan that he was ready to hand over the fort to the Mughals. When Shahjahan was informed of this stroke of luck, he sent a message to Qilich Khan to "get yourself posthaste with all the forces available in Multan to Qandahar, along with Yusuf-Muhammad Khan (the governor of Bhakkar) and Jannisar Khan (the garrison commander of Sivistan)."[1]

Qilich Khan remained the governor of Qandahar for several years. He was reappointed to Multan, then to the governorship of the Punjab, where he died in 1654.

WMT

LEANING backward to support the weight of his shield, Qilich Khan is the quintessential military man. Laʿlchand—the equivalent of a skillful court photographer—has recorded his outer form from plume and whisker to toe, describing exactly his feathery beard, slightly protuberant belly, and pale skin. The superficiality of the characterization may disappoint, but there are delights in the soldierly still life of archer's rings hanging from the belt and of the inner side of a Mughal shield. The same proud officer can be seen in triumphant action, accepting the keys to a defeated city, and in frustration, at the siege of Qandahar, in stray folios—now in Paris and in the United States—from the *Padshahnama*.[2]

SCW

THIS portrait has the margin number 3 and would have originally faced the portrait of Khan-Dauran (MMA fol. 31v; pl. 71), both leaves belonging to Group B. The two folios have identical cloud-band inner borders in gold on pink and outer borders of colored flowers on a buff ground, and the same artist appears to have painted both. The same hand has written identifications of subject and artist in the lower inner borders of both leaves.

Varieties of lilies appear at the upper left corner, second from right in the upper border, second down in the right border, and in the middle of the lower margin. The second plant from the left in the lower border may also be a lily, while the plant of the right center of the outer border may be either a lily or an iris. Above it is a poppy with another second from the right in the lower border, while the plant in the upper right corner may also be a poppy. Chrysanthemums are found in the lower right corner and in the center of the upper border. A narcissus is found in the lower right margin with a dianthus above it. The large plant second from the left in the upper border is a dahlia.

MLS

1. Muhammad-Salih Kanbo, *ʿAmal-i salih*, II, p. 274.
2. Welch, *India*, nos. 162a and b. It has been noted by MLS that an early nineteenth-century copy of this portrait was auctioned at Sotheby's on October 14, 1980; she has remarked that although it is not illustrated, its description is consistent with this painting.

224

71. Khan-Dauran Bahadur Nusrat-Jang

ca. 1640

INSCRIBED: (in Shahjahan's hand) *shabih-i Khan-Dauran Bahadur Nusrat-Jang, ʿamal-i Murad* (a portrait of Khan-Dauran Bahadur Nusrat-Jang, done by Murad)

MMA 55.121.10.31v

KHAN-DAURAN was born Khwaja Sabir, the son of Khwaja Hisari Naqshbandi. Patronized as a youth by the Khankhanan ʿAbdur-Rahim, he later entered the service of the Nizamshah of Ahmadnagar in the Deccan, where he received the title Shahnawaz Khan.

Returning to Mughal territory he joined Prince Khurram (Shahjahan) and was entitled Nasiri Khan. He remained a loyal supporter of the prince during Shahjahan's rebellion against his father Jahangir until the decisive Battle of Tons in 1624, when Nasiri Khan's father-in-law ʿAbdullah Khan deserted the prince and went over to Malik ʿAmbar, and Nasiri Khan was obliged to follow. After Malik ʿAmbar's death he remained in the Nizamshah's service until the second regnal year of Shahjahan, when he presented himself at court and received the rank of 3000/2000.

Among the many military campaigns in which he participated were the siege and conquest of Qandahar and the conquest of Daulatabad. For distinguished service during the latter campaign, he received the title Khan-Dauran and the rank of 5000/5000.

In Shahjahan's ninth regnal year (1636), Khan-Dauran led the "chastisement" against Jujhar Singh the Bundela and his son Bikramajit, who had rebelled against the emperor; he sent their heads to court, for which he received the title Bahadur. The next year he presented Shahjahan with two hundred elephants he had taken from Bijapur and Golconda. An elephant named Gajmoti, which was taken from the Qutbshah of Golconda, was considered the finest elephant in the Deccan. For this, the title Nusrat-Jang was bestowed upon Khan-Dauran.

By the time of his death in 1645 Khan-Dauran had been promoted to the highest imperial rank held by a person of nonroyal blood, 7000/7000. He died from a knife wound inflicted by a Brahmin servant he had taken from Kashmir and converted to Islam.

WMT

MURAD is best known for his illustrations to the Windsor *Padshahnama*, one of which (fol. 193v) provides the name of his mentor. It is signed "the pupil of Nadir az-zaman, Murad." He is most admired for detailed interior views of Shahjahan's palace. Indeed, the primary subjects of his historical pictures are not people but the richly polychromed walls, screens (*jalis*), and railings decorated with lively arabesques and acanthus motifs based upon European as well as Iranian and Mughal prototypes. (Many of the European motifs were derived from engravings, such as those of Enea Vico, which were published in Rome in the sixteenth century.) These elements and his renderings of carpets and other textiles provide such vivid and complete pictorial sources for the study of the architecture and ornament of the Shahjahan period that it seems likely he worked as a designer as well as an artist. Forms are immaculately hard-edged; colors are dark and glowing, with much crimson, slate green, and burnt orange, applied with jewel-like precision.[1]

Murad's painting in the Windsor *Padshahnama* showing the departure of Prince Muhammad Shah Shujaʿ for the conquest of the Deccan includes a portrait of Khan-Dauran Bahadur Nusrat-Jang (fol. 146v; Appendix, fig. 27) that is nearly identical to the present one. Differences are few: in the manuscript, he wears a sword but no *katar* (dagger), his hands rest upon a long staff, and his jama is less transparent. But the most peculiar feature is the same—his stance, with one cushion-like knee shot forward in a surprisingly unmilitary wobble.[2]

SCW

THIS VERSO portrait has the margin number 2 and belongs to Group B. It would have originally faced MMA fol. 30r (pl. 70), and the borders of both appear to be by the same hand. There is no cutout poetry in the innermost border. The inner border contains gold cloud bands within a cartouche framework and is wider than

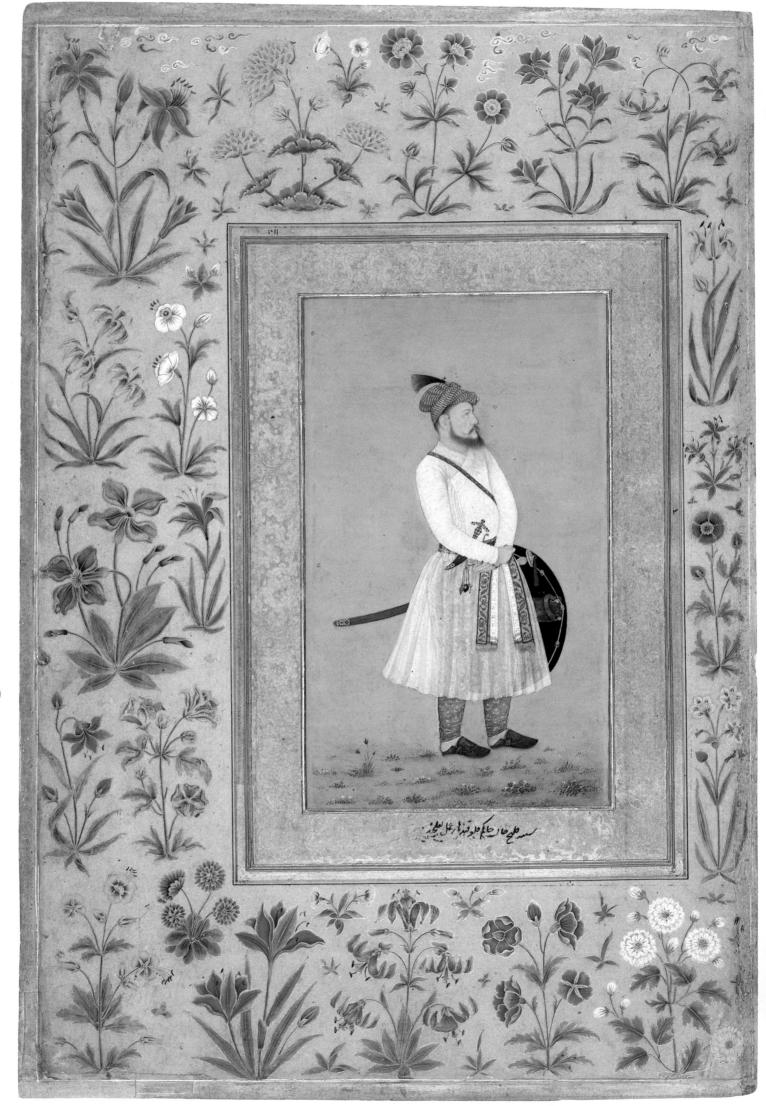

70

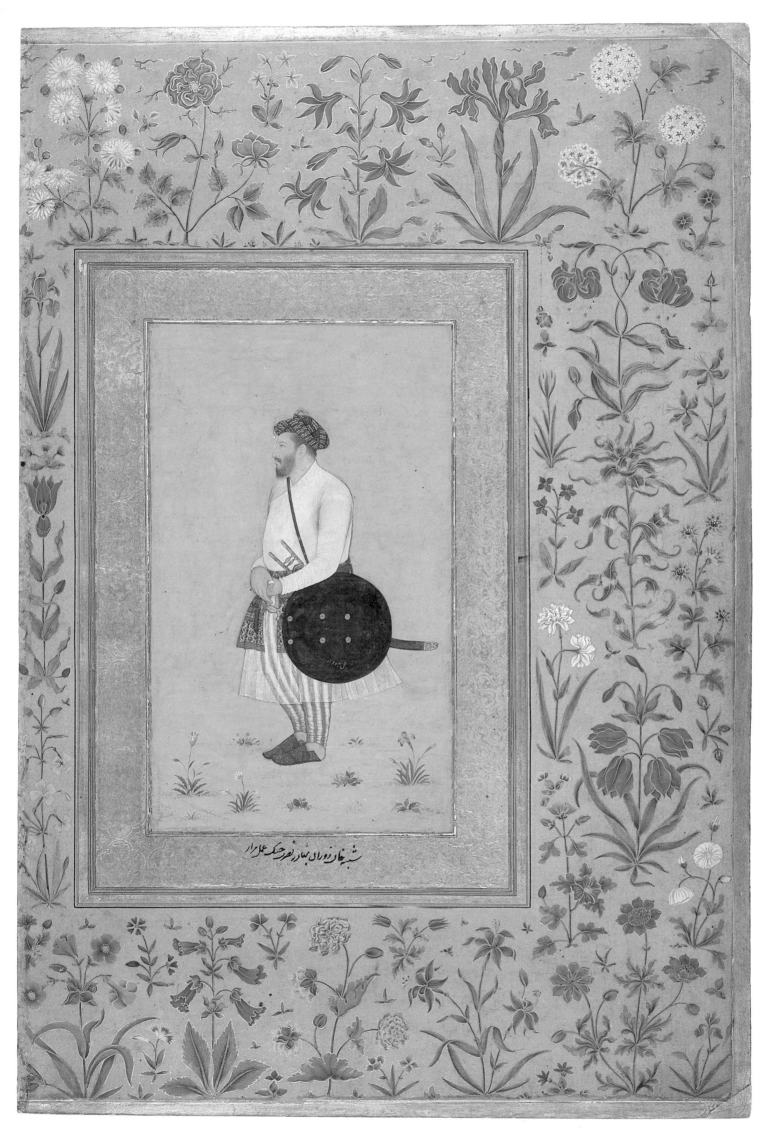

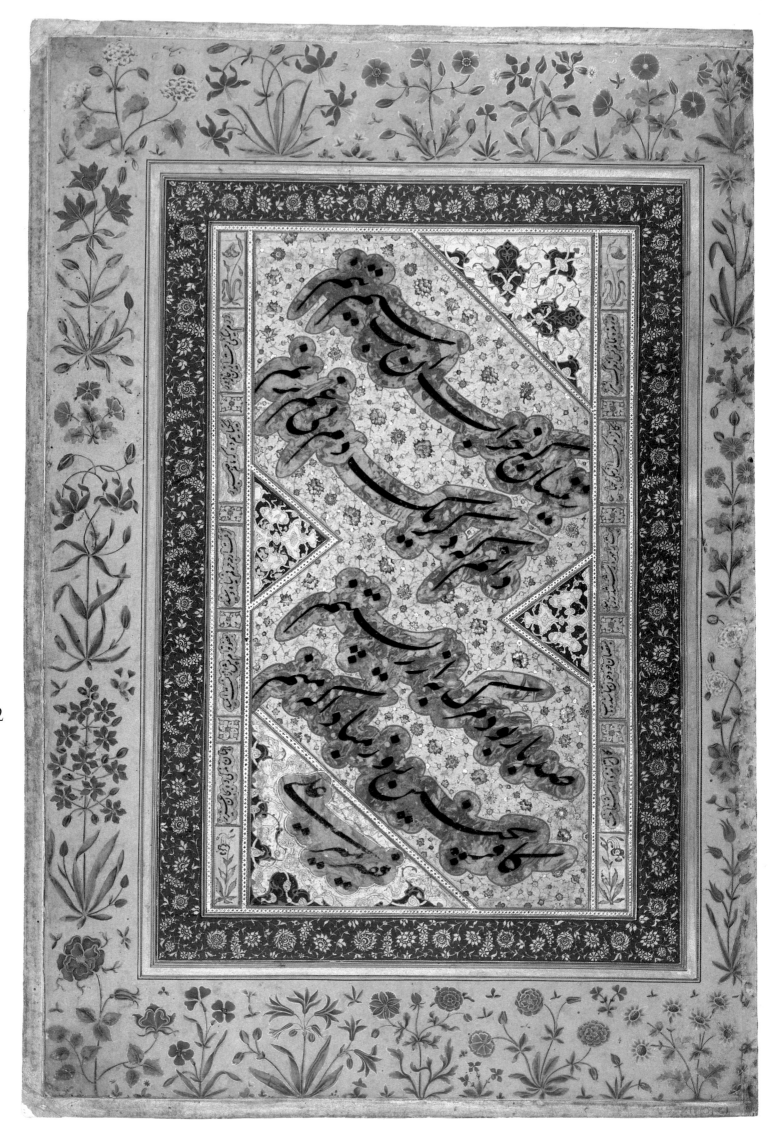

72

usual. The outer border has boldly rendered large plants in colors and gold on a buff ground. From left to right in the upper border the plants can be identified as perhaps chrysanthemum, rose, lily, iris, and *Umbelliferae* (similar to Queen Anne's lace). Below the *Umbelliferae* there is a lily, and farther down at the left possibly a double narcissus, with a stylized lily slightly below and to its right. A small iris occupies the lower right corner. In the narrow inner border there is also an iris with a tulip below it and a *Primula floribunda* below the tulip.

<div align="right">MLS</div>

1. He provided the following illustrations to the Windsor Castle *Padshahnama*: fol. 49r, *The Return of Prince Khurram to his Father After the Reduction of Maharana Amar Singh of Mewar*, signed "Murad Musavvir [the Painter]," based on an earlier drawing (for which see Falk and Archer, *Indian Miniatures in the India Office Library*, no. 56); fol. 143r, *The Siege of Daulatabad by Shah Shuja'*, signed "Murad"; fol. 146v, *The Departure of Shah Shuja' for the Deccan*, signed "Murad"; fol. 193v, *Jahangir Receives Prince Khurram*, signed "Nadir az-zaman's pupil Murad"; and fol. 216v, *Shahjahan Receives Prince Aurangzeb*, signed "Murad." Fol. 115v, *Shahjahan Receives an Embassy of Europeans*, is unsigned but attributable to him. *Shahjahan Honors the Religious Orthodoxy*, a double-page composition attributable to him, was separated from the manuscript and is now in the Freer Gallery (see Welch, *Imperial Mughal Painting*, pls. 31 and 32).

2. For a portrait of the Khan-Dauran as a thick, bent, old curmudgeon with an engagingly wicked gruffness, see Hashim's miniature in the Chester Beatty Library, Dublin (Arnold and Wilkinson, *Beatty Library*, III, pl. 72). Two later versions are in the collection of the India Office Library, a miniature (no. 105 viii) and a drawing (no. 74); see Falk and Archer, *Indian Miniatures in the India Office Library*, nos. 74 and 105 viii. A miniature by Daulat in the Windsor *Padshahnama* shows him receiving prisoners after the reduction of Daulatabad (fol. 203v). An unusually large drawing of his face in profile, probably by Hashim, is in the Red Fort Museum, Old Delhi.

72. Calligraphy

ca. 1530–50

MMA 55.121.10.31r

A silver-bodied idol ruined me—
I know I'll never live now without pain!
A hundred deaths were better than this life!
No infidel may live through such a day!
 The poor [al-faqir] Mir-'Ali

The quatrain is written on marbleized paper. It is surrounded by a poetical prayer in the *mutaqarib* meter, possibly from Sa'di's *Bustan*.

<div align="right">AS</div>

THIS RECTO calligraphy page has the same border scheme as its verso (pl. 71) and was painted by the same hand. The inner border is a variant on the palmette, flower-head, and leaf-scroll border, here gold on blue, with the flower heads superimposed on each other to give a flowering leaf shape to the palmettes. Of the plants in the outer border, in colors and gold on a buff ground, the three large plants in the middle section of the wider left border belong to the lily family, while in the bottom left corner is a stylized rose.

<div align="right">MLS</div>

73. Calligraphy

ca. 1530–50

MMA 55.121.10.6v

If the moon were beautiful like you,
Smaller than a crescent were the sun!
In your time, oh friend, who has the strength
To be patient without you at length?
 The servant Mir-ʿAli the scribe [al-katib], may his
 sins be forgiven

The verses surrounding this artless composition belong to a five-verse ghazal whose author is not mentioned. As it is signed by Mir-ʿAli, it may be one of his own poems.

The signature, "written by the poor ʿAli al-katib," which must have been written in the lower left corner in the original, is pasted in the center, violating the borderline.

AS

THE TALL straight stems and contrasting colors within a single flower as well as the treatment of the tulip, here at the lower left corner, identify the painter of both the recto and verso borders of this folio as the artist who was also responsible for the borders of MMA 17v, 19v, 23r, and 29v (pls. 49, 11, 16, and 25).

Here, a narcissus is found in the top and right borders and an iris and poppy in the left one.

MLS

74. Jadun Ray

ca. 1622

INSCRIBED: (in Shahjahan's hand) *shabih-i Jadun Ray Dakkani, ʿamal-i Hashim* (a portrait of Jadun Ray of the Deccan, done by Hashim)

MMA 55.121.10.6r

A NOBLEMAN of the Jadwan tribe, Jadun Ray originally owed allegiance to the Nizamshah of Ahmadnagar. When Shahjahan waged his campaign in the Deccan on Jahangir's behalf in 1620 to retake the Deccani territories that had been seized by the Maratha bands under Malik ʿAmbar in league with Bijapur and Golconda, Jadun Ray joined Shahjahan and allied himself with the Mughals. Thereafter "he held the choicest [fiefs] in the Deccan, and rendered great assistance to the governors of the country, and always furthered the imperial cause; himself living in great comfort and affluence."[1]

When Shahjahan defied his father and made open rebellion from the Deccan, Jadun Ray was among the chiefs who initially supported Shahjahan; but when the prince's fortunes took a turn for the worse and he was obliged to leave Mughal territory, Jadun Ray and some others accompanied him across the Tapti River into the realm of the king of Golconda "simply because their private holdings lay on the way"[2] and thereafter abandoned the prince and joined the imperial forces against him.

In the third year of Shahjahan's reign, Jadun Ray again proved treacherous to the Mughals and rejoined

230

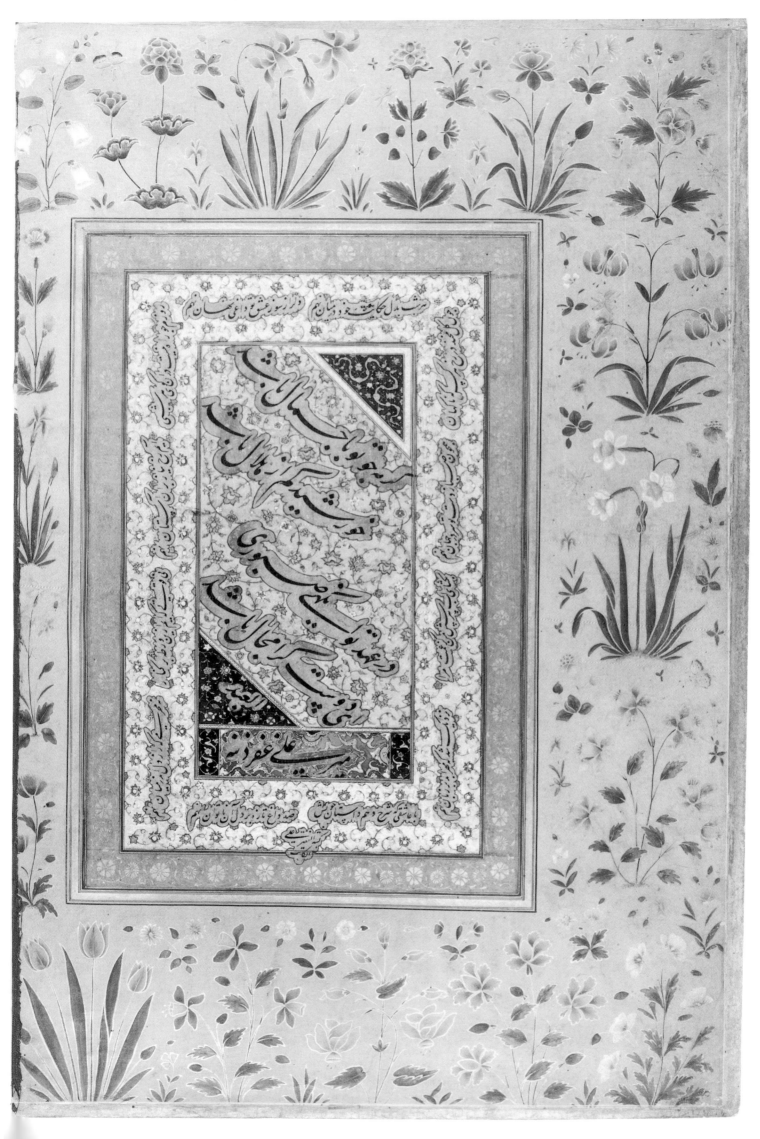

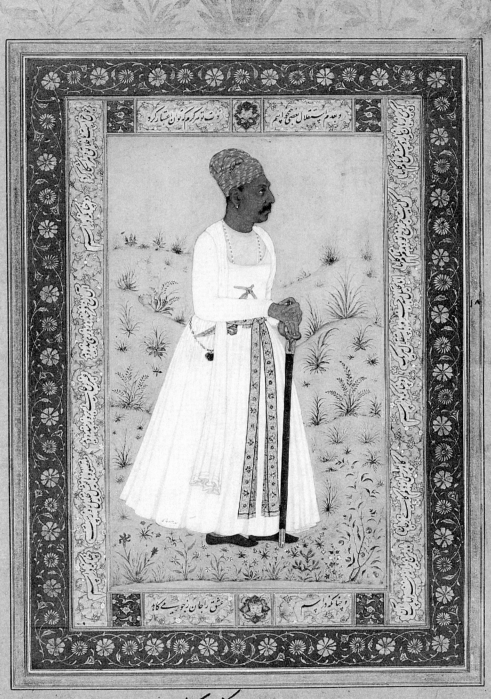

his old suzerain, Nizam ul-mulk, the Nizamshah of Ahmadnagar. His end is described in the *Shahjahan-nama*: "When this ill-fated creature, with his tribe and children, severed themselves from the retinue of good fortune and joined with the Nizam ul-mulk, because faithlessness and treachery had repeatedly been done by him, the usually short-sighted Nizam had a rare display of farsightedness by desiring to have him imprisoned in expiation. He therefore suggested to his confidants that when Jadu[n] came into his presence, he and his people should be seized and arrested. As this plan was approved, he was summoned to court and, having absolutely no knowledge of the affair, appeared in the assembly with his sons. That group then sprang from their ambush and tried to seize them, but they resisted and unsheathed their swords and began to fight. Their attempts were futile and in the end, with the onslaught of the Nizam ul-mulk's men, he and his two sons Ujla and Raghu, along with his grandson and successor Baswant Rao, were killed. When this event, which should have taken place long ago, happened, that low, contemptible one, who could have been condemned to death by any religion, paid for his odious actions."[3]

WMT

Hashim's uncanny gift for biting characterization is nowhere more evident than in the profile of this smilingly treacherous opportunist. Unlike most of Hashim's other portraits of Deccani rulers and courtiers, it was probably painted from life before the artist moved north. Although the pose and outline are in Ahmadnagar style, the exquisitely finished, roundly modeled face indicates his adjustment to Mughal practice, presumably to satisfy Prince Khurram (Shahjahan). Flowers scattered helter-skelter suggest, however, that hard as Hashim tried to please his new patron, he was not yet fully aware of Mughal botanical tastes. As always in his work, even in his pre-Mughal phase, Hashim explored the sinuous hollows of ears with sensitive perception. His treatment of hands is also noteworthy, often showing them, as here, with long, bony fingers, resting against the twiglike finials of typically Deccani sword hilts.[4]

Suspended from a chain at Jadun Ray's belt is a characteristically globular Deccani container (*chunardan*) for lime used in the preparation of *pan*—the sliced areca nut, lime paste, and spices, which are folded triangularly in a betel leaf and chewed by many Indians. Also hanging from his sash is a jeweled gold object, perhaps a fob attached to his dagger.[5]

SCW

The verses that surround the picture appear to be mixed up in certain places. They consist of four-line stanzas, and in every fourth line one reads "and thus in the name" with a space after these words. The enigmatic text is part of a treatise on *muʿamma* (riddles), and no fewer than three more Mughal pictures are surrounded by pieces from the same poem. These are V&A 137–1921 (green bird), V&A 24–1925 (portrait of Dhuʾl-Fiqar), and CB 7/17 (portrait of a prince reading a book). The meaning of the phrase "and thus in the name" becomes clear in V&A 16–1925v, a full page which shows that after these words a proper name was inserted with red or gold ink. In the cut-up pages, however, the name was either deleted or never filled in.

"And thus in the name" is the introduction to the following hemistichs: "And thus in the name of Bahman..." and "And thus in the name of Tahir...." The ensuing verses describe how to build a riddle around these names.

The pages that are surrounded by fragments of this riddle-poem were almost certainly not part of one set of pictures. It has been noted by MLS that their border schemes are incompatible: the present painting, with the margin number 18, has the border scheme number 13, the two V&A paintings, with the margin numbers 20 and 21, have the border scheme number 12; and the Chester Beatty portrait, with the margin number 59, has the border scheme number 2. This would seem to indicate that a number of albums were being worked on concurrently in the same studio.

A spiritual self-portrait of the painter Farrukh Beg as Saint Jerome is likewise surrounded by fragments of this riddle-poem.[6]

AS

This recto portrait has the margin number 18 and must have belonged to the same set as the leaves with the margin numbers 6 and 12 (that is, MMA fols. 3 and 29; pls. 23–26). The question here arises as to whether it is chance that the border numbers of these three folios, all with portraits on the recto side, were originally in an album where this border scheme of gold flowers on pink on the recto page and colored flowers on buff on the verso appeared in multiples of six, or whether it is chance that this particular set of numbered leaves survived from an album with this border scheme throughout. If the former, these pages could conceivably have been part of the albums designated 1 and 2 of Group A. Where it would appear to conflict with Album 1 at portrait pages with margin numbers 36 recto and 35 verso, it actually does not because in both sets the portrait sides have the same gold-on-pink

arrangement. This number sequence also is compatible with the pair of folios designated Album 2 (MMA fols. 1 and 2; pls. 31–34), so theoretically albums 1, 2, and 3 (MMA fols. 3, 29, and 6; pls. 23–26, 73, and 74) could have belonged together, although there is no firm evidence that this was the case.

The pink flowers on a gold ground on this recto page are in the same style as those on the verso. When painting in gold on a blue or pink ground, the artist usually employs a more luxuriant decorative scheme. In this border a tulip appears in the middle of the top and the bottom borders and in the lower part of the inner and outer borders. An iris is identifiable at the left middle

of the outer border. An iris is also seen in the lower left corner of the picture.

MLS

1. Shahnawaz Khan, *Maasir*, I, p. 717.
2. Beni Prasad, *Jahangir*, p. 371.
3. Muhammad-Salih Kanbo, *'Amal-i salih*, I, p. 375.
4. It is interesting to compare this portrait brimming with life to a superbly finished but dry likeness of Muhammad-Quli Ibrahim Qutb Shah of Golconda which was painted from earlier sketches at the Mughal court for Jahangir; see Stchoukine, *La Peinture indienne*, pl. XXX.
5. An early nineteenth-century copy of this portrait was auctioned at Sotheby's on October 14, 1980, lot 195. Although it is not illustrated, its description is consistent with this painting. [MLS]
6. Welch, *India*, no. 147a.

75. Calligraphy

ca. 1530–50

MMA 55.121.10.10v

Gave I my life and died from grief,
 my pain would not decrease,
And from your love my suffering heart
 would still not find release.
And should your love and faithfulness,
 Oh faithless one, decrease—
My love, my ancient faithfulness,
 would never yet decrease
 Poor [*faqir*] 'Ali the scribe [*al-katib*]

The page is surrounded by a fragment from a Persian *mathnavi* in the *khafif* meter that tells a story about a person with a squint. Meter and topic suggest that it is from Sana'i's *Hadiqat al-haqiqa*, the early twelfth-century work that was the first mystical-didactic poem written in Persian.

AS

THE BORDER of this verso page has the same scheme as that of the recto and is certainly by the same hand. The inner border here has palmettes and flower heads in gold with a rather prominent leaf scroll, both here and on the recto, rather sketchily drawn.

MLS

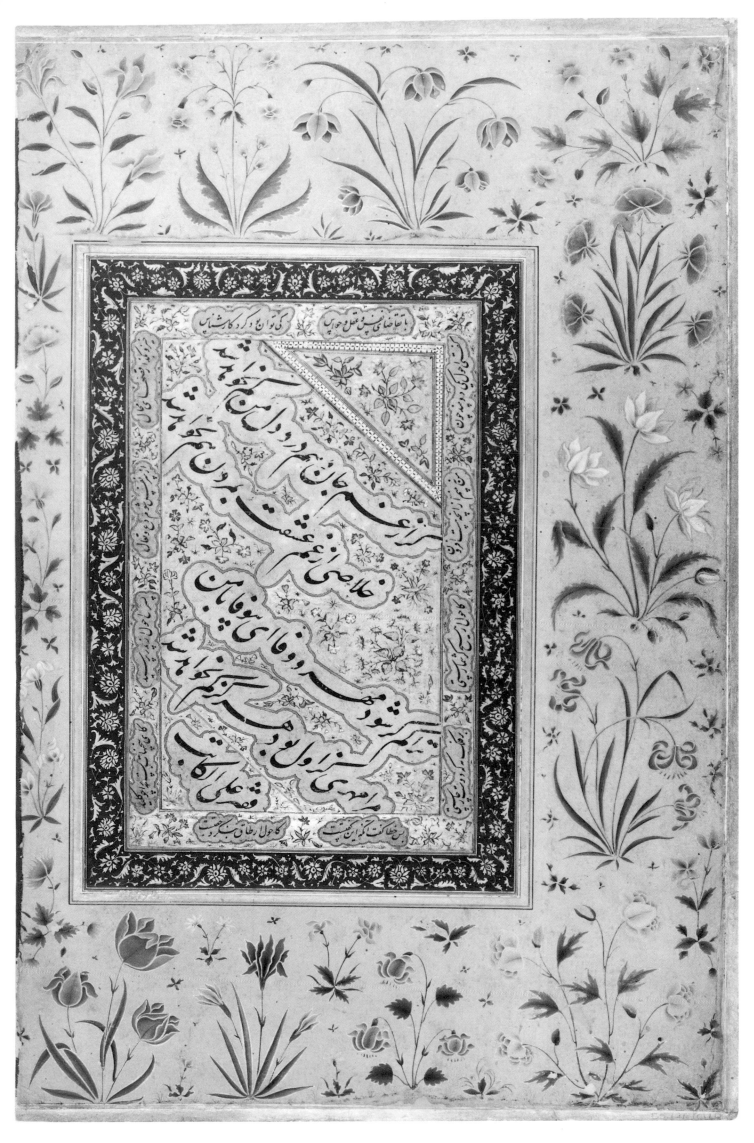

75

76. Dervish Leading a Bear

ca. 1630–40

INSCRIBED: (on border in Shahjahan's hand) "work ['amal] of Govardhan"

MMA 55.121.10.10r

Out of respect as well as curiosity, Babur, the first Mughal emperor, visited ascetics, as did most of the others in his line. Jahangir's admiration of saintly Jadrup, a Hindu hermit known for his extreme austerity, is described in the *Tuzuk*. But of all the Mughals, the most concerned with holy men was Prince Dara-Shikoh, eldest son of Shahjahan; it is probably for him that Govardhan's and Padarath's facing miniatures of dervishes were painted. Sermons in paint, these spiritual foils to courtly portraits must have chilled imperial souls. Govardhan's bony, troubled dervish, striding uphill with his amiable bear, invites comparison to Padarath's more static composition (MMA fol. 11v; pl. 77) in which the detailed landscape stretches out like a photographer's panoramic backdrop, a far cry from Govardhan's darkling landscape. Windswept grass, a yellow, sandy path, agitated green horizon line, and a troubling purple-to-streaked-blue sky establish a mysterious gloom, bereft of eye-trapping detail. Although ritual burns scar both dervishes, only those painted by Govardhan communicate their sting. Unlike the trappings of Padarath's ornamentally deluxe ascetic, the furs and cinctures of Govardhan's dervish bespeak misery. He moves us as effectively as he moves the bear, whose leash is gripped firmly (unlike that in Padarath's picture), and which paces along, mastered by a slender but threatening stick.

This wandering Sufi wears a red earring in his right ear and has iron bangles around his arms and right ankle, as the somewhat unorthodox dervishes known as Qalandars and Haydaris did from the Middle Ages on (these dervishes belonged to not-so-respectable but quite influential branches of Sufism in India and in medieval Turkey). The white pattern on the red skullcap is reminiscent of the *ajrak* designs in Sind (the *ajrak* was a cotton cloth stamped with red, blue, and black motifs and worn as a turban, loincloth, shawl, etc.).

Govardhan not only compels the viewer to concentrate upon the ascetic and his disciplined bear but also urges speculation. The allegory brings to mind one familiar to Sufis in which the higher self (here perhaps symbolized by the dervish) struggles to overcome his baser instincts (the bear). His self-denials—burns, ragged garb, fasting, and wandering—give him strength in his struggle against evil.[1]

Govardhan's studies of holy men[2] are among the supreme examples in Mughal art of a genre favored by Emperor Akbar and by his great-grandson Prince Dara-Shikoh, who devoted much of his life to mystics and mystical thought. Presumably, this picture, the most serious in the Kevorkian Album and one of a scattered group that illustrates the prince's religious interests, was given by him to his father. (For a late version of this miniature, see MMA fol. 9r; pl. 96.)

SCW

The picture is surrounded by a ghazal without its opening lines by Qasimi (Qasim al-anwar); the last line is the beginning of another ghazal by him.

AS

This recto page has the margin number 11 and so belongs to Group B. In addition to the innermost border of cutout verses, it has an inner border of flowerhead, palmette, and leaf-scroll pattern in gold on a pink ground. The outer border contains flowering plants on a buff ground. They have rather thin stems and sparse leaves and are heavily outlined in gold; smaller plants appear between them. Along the bottom margin there is a continuous ground plane on which the plants rest. This feature is relatively unusual. Only a campanula (prob. cult.) located at the left center of the outer margin and an iris in the center of the inner margin can be identified.

MLS

1. For austerities in Sufism, see Schimmel, *Mystical Dimensions of Islam*, indexed under "suffering."
2. For other portrait studies of holy men by Govardhan, see Brown, *Indian Painting*, pls. LXVI and LXVII; Stchoukine, *Les Miniatures indiennes*, pl. XI; Ivanov, Grek, Akimushkina, *Al'bom*, pls. 12 and 13; Welch, *Art of Mughal India*, no. 46; Welch, *A Flower from Every Meadow*, no. 63, pp. 104–106; Welch, *India*, nos. 159 and 160; Beach, *Grand Mogul*, nos. 22, 41, and 43; Nouveau Drouot, Paris, sale cat., June 23, 1982, no. 11; Schimmel, *Islam in India and Pakistan*, pl. XXIVa.

77. Dervish with a Lion

ca. 1630

INSCRIBED: (on border, in Shahjahan's hand) "work [*ʿamal*] of Padarath"

MMA 55.121.10.11V

EQUIPPED WITH satchel, pouch, begging bowl, dagger, knife, and staff, this courtly ascetic roamed the land with a friendly lion, as young and elegant as himself. During the tranquil decades of Jahangir's and Shahjahan's reigns, devotees were favorably received at court where they were often indulged with imperial largesse. This well-bred holy man, sporting rakish headgear foppishly wound in blue cloth and a fur skirt upheld by rugged chains, seems new to the path of devotion. But the dedicatory scars from self-inflicted burns on his upper arm—perhaps resulting from an initiatory ritual—are evidence of his ardent spiritual longing.

Padarath's formative period can be traced from inscribed illustrations to historical manuscripts of the 1590s. The few works he painted for Jahangir indicate changes of style as well as subject, from typically Akbari, active, crowded historical compositions to Jahangir's finely detailed illustrations for fable books and natural history studies. Here, in one of his latest miniatures, he took on the ambitious challenge of genre portraiture. He was not an artist of the first rank, and his historical pictures pall in comparison to those of Basawan or Miskin. His flora, fauna, and ascetics, moreover, are overshadowed by those of Mansur, the brilliant specialist in natural history, and Govardhan's studies of holy men are far more penetrating. The landscape and the lion of the present miniature bring to mind Padarath's inscribed *Long-Haired Mountain Sheep* in Dublin, an appealing if somewhat boneless characterization set against a romantic sunset sky, and a finely finished study of a pheasant, formerly in the Rothschild collection. Both include grass, scrub, and flowers painted in Padarath's unique manner, reminiscent of Arthur Rackham's spidery illustrations to fairy tales.[1]

SCW

THE SURROUNDING verses are, like those on MMA fol. 10r (pl. 76) from Qasimi's *Divan*. One is the end of a ghazal; the other is the beginning of the ghazal whose closing lines are on pl. 76. This indicates that the two pages, whose margin numbers are consecutive, were prepared at the same time, with the craftsmen using the same poetry book.

AS

THIS VERSO leaf has a cutout-poetry innermost border and a flower-head, palmette, and leaf-scroll inner border in gold on a pink ground. The outer border contains flowering plants in colors and gold on a buff ground. The plants are on the whole straight-stemmed with simple leaf forms. There are six along the top and bottom and two side-by-side along the wider outer margin. A number of tiny insects, leaf sprays, grass tufts, and clouds are present. The very pronounced crocus plant at the lower inner side of the right border with what would seem to be its bulb may well have been copied from a European herbal. None of the other plants show realistic roots or bulbs. Among them a narcissus can be identified in the lower left corner, with another in the upper border second from left and a third, this one of the *bulbocadium* type, second from right. A dianthus appears at the right of the outer margin, the second plant from the top. Below it is what looks like a *Galanthus* but with superior ovary. In the lower border the plant second from the left is an *Iridaceae* with a lily two plants to its left.

MLS

1. See Arnold and Wilkinson, *Beatty Library*, III, pl. 53, and Brown, *Indian Painting*, pl. LIV; also Colnaghi, *Persian and Mughal Art*, no. 100, and Beach, *Grand Mogul*, no. 70. The uninscribed pheasant, attributable to Padarath on stylistic grounds, is based upon Mansur's well-known drawing in *nim qalam* of a Himalayan cheer pheasant in the Victoria and Albert Museum, published in Welch, *Indian Drawings and Painted Sketches*, no. 14.

It has been pointed out by MLS that a fine early nineteenth-century copy of this miniature, also ascribed to Padarath, is in the Wantage Album (V&A 133–1921); see Clarke, *Indian Drawings*, no. 18, pl. 12.

A second nineteenth-century copy, with the lion walking as in the Kevorkian Album leaf, has also been noted by MLS; it was sold at Sotheby's, October 14, 1980, lot 201 (border unillustrated).

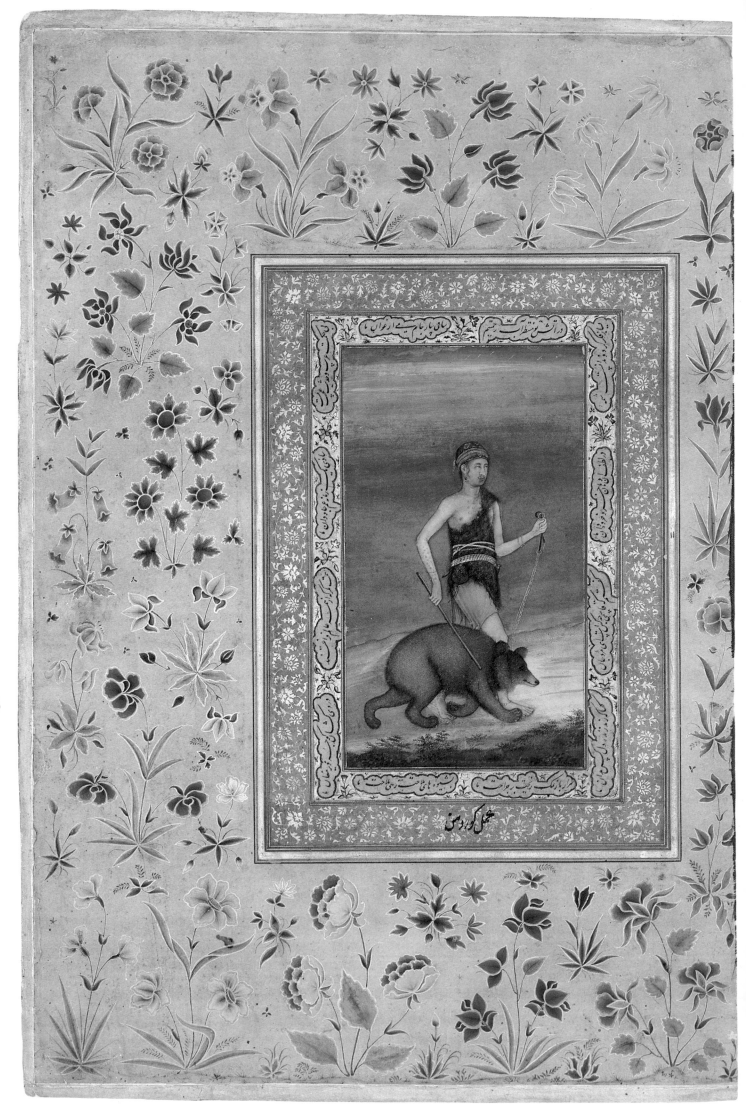

76

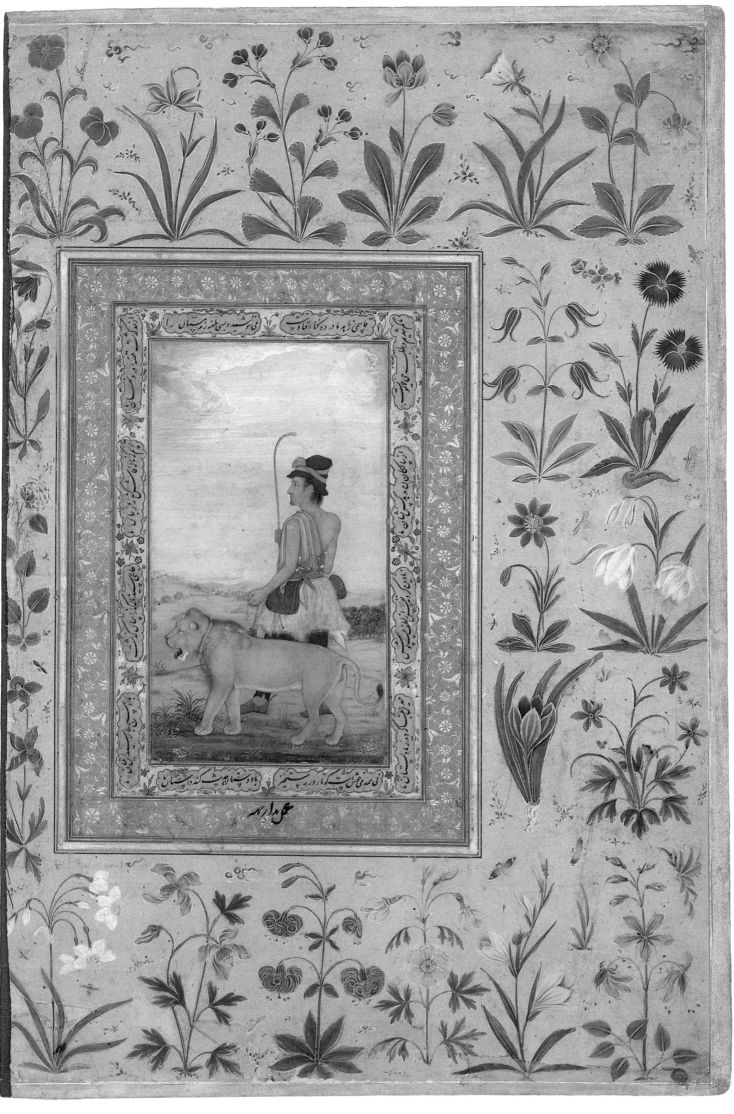

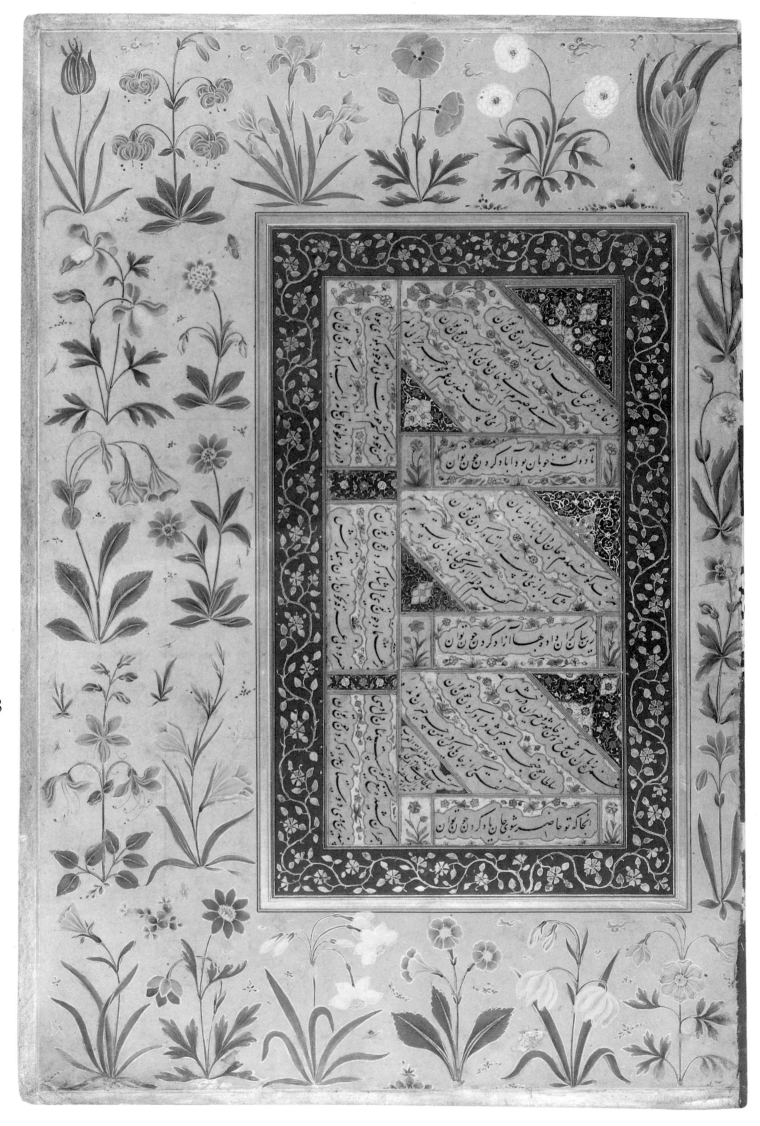

78

78. Calligraphy

ca. 1530–50

MMA 55.121.10.IIr

THE WHOLE page contains one beautifully calligraphed ghazal by Amir Khusrau; the signature in the lower left corner reads, "Written by the poor, lowly, miserable slave Sultan-ʿAli Mashhadi in the capital, Herat."[1]

The poem has the *radif* (recurrent rhyming phrase) "how can one . . . ?" It describes the state of the lover: How can one complain when the dagger of the king's glance wounds one? How can one build a house on the day of storm (that is, how can one be patient while experiencing the cruelty of the beloved)? And so the questions continue.

The poem's last two hemistichs, written in the center of the left side, are in the wrong sequence; it may be that Sultan-ʿAli changed the sequence because he wanted to avoid the repetition of the same rhyme-words in the three lower lines. Similar changes of lines for the sake of aesthetic effect occur several times in the border calligraphies.

<div align="right">AS</div>

THIS RECTO page has the same border scheme as the verso. Its inner border, however, in gold on blue, has a more pronounced pattern than usual with one continuous scrolling stem with flower heads and leaves. There is no doubt that the same artist painted both borders of the folio since the crocus, here in the upper right corner, is identical to its counterpart on the verso. The narcissus third from the left at the bottom is also virtually identical to the one at the lower left of the verso, and the lily second from the left in the upper border has its counterpart in the lower border of the verso. Here, in addition, a tulip is found in the upper left corner, an iris next to the lily, a poppy next to the iris, and a chrysanthemum next to that. In the outer border the plant below the tulip is perhaps a clematis and the plant below that is a primula. The plant to the right below the primula can be identified as an *Iridaceae* and in the lower left corner is a *Narcissus bulbocadium*. In the lower border the third plant from the left is also a narcissus with a primula to the right of it and to the right again possibly a *Galanthus* but with superior ovary, like its counterpart on the verso border.

<div align="right">MLS</div>

1. Amir Khusrau, *Divan*, no. 1623.

79. Emperor Humayun

Early nineteenth century

INSCRIBED (in nasta'liq): "the portrait of Nasi-ruddin His Highness Humayun Padshah, the victorious emperor. A.H. 1019 [A.D. 1610–11]"

FGA 39.48b

NEATLY FINISHED, brightly colored, and glittering with generous zones of gold, this portrait of Emperor Humayun enthroned beneath a symbolic imperial parasol is a nineteenth-century work. Like the other later folios in the Kevorkian Album, it does not bear sustained scrutiny. The emperor's face is as blank as a mask; although he and his attendant are anatomically accurate, their bodies are skeletonless as tailors' dummies. Hands resemble gloves, and gestures are less alive than the red bolster. Indeed, if anything in the painting is vital enough to move, it is the piano-legged tinsel throne, which seems capable of waddling across the carpet. Like the costumes, the portrait is a mire of arabesques painted with more fuss than structure. Were its rhythmless patterns to speak, they would mumble incoherently.

With its fellows this picture also suffers from murkily inferior pigments. Neither artists nor patrons could afford—or could find—the finest lapis lazuli and other pure colors that were available to the imperial studios in their heyday, hues that lent Jahangir's and Shahjahan's folios jewel-like brilliance. Humayun's purple caftan is only stagily royal, and his sword-bearer's coat is a frisky blue unknown in early pictures. Brushwork is skimpy and lacks resonance; the colors are applied with the workmanlike timidity of a copyist, not with the bold authority of earlier masters. But such is too often the nature of copies and later versions of early pictures. Even major seventeenth-century artists made duplicates of unexpected lifelessness; and early nine-

teenth-century Delhi artists could rise to remarkable heights when stimulated by patrons such as the Frasers.

The composition of this portrait is derived from the sixteenth- and seventeenth-century likenesses that perpetuated imperial legend in bazaar workshops throughout Hindustan. Painters of Delhi, Agra, and Jaipur covered reams of paper with ever duller versions, which could be bought singly or in complete sets, often including apocryphal portraits of Nur-Jahan and Mumtaz-Mahal. By 1820 the same bazaar workshops turned out shinier Baburs, Humayuns, and Akbars on ivory for carriage-trade visitors.

Like the paintings, the borders are nicely worked archaisms, with scrolling arabesque vines as languid as wilted flowers.

SCW

THE SURROUNDING verses in rather bad nasta'liq, not cutout, are from Nizami's *Iskandarnama*.

AS

THE POETRY of the innermost border is written directly on the album leaf but simulates a seventeenth-century cutout border. This is surrounded by another narrow border with frayed palmettes and leaves in gold on blue identical in style to those in the recto outer border. The outer border is made up of leaf and palmette scrolls in gold with dark red outlines on a buff ground.

MLS

242

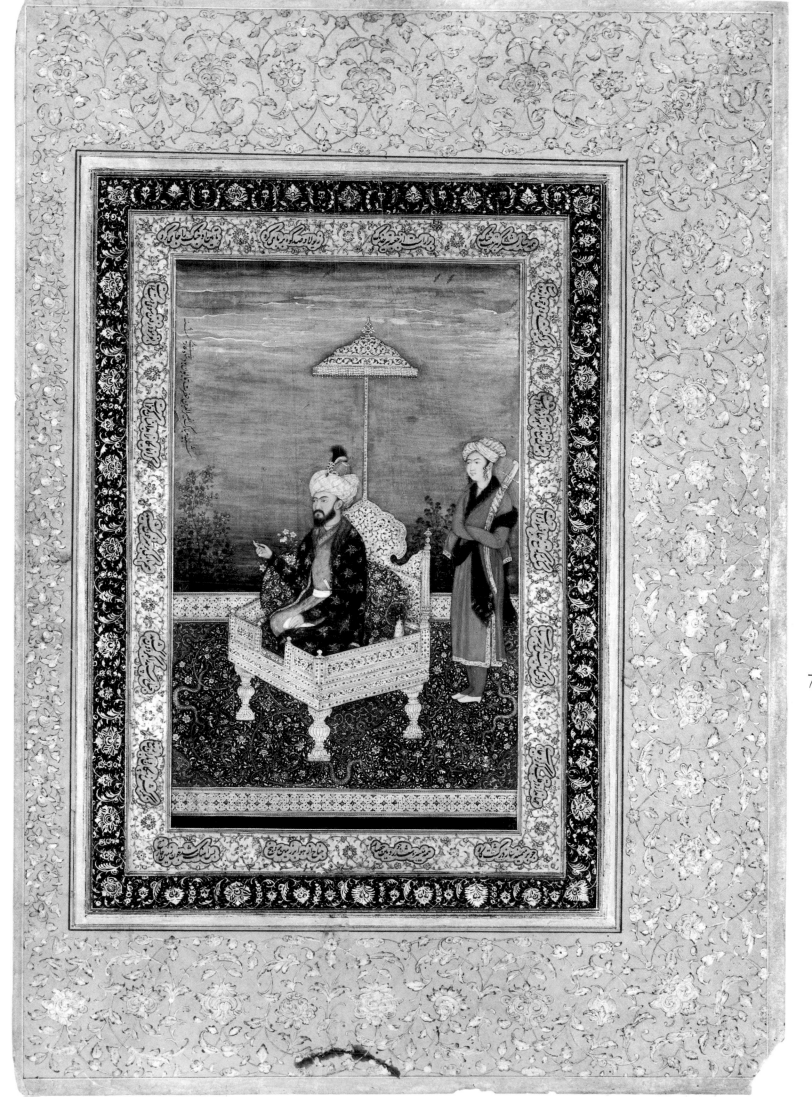

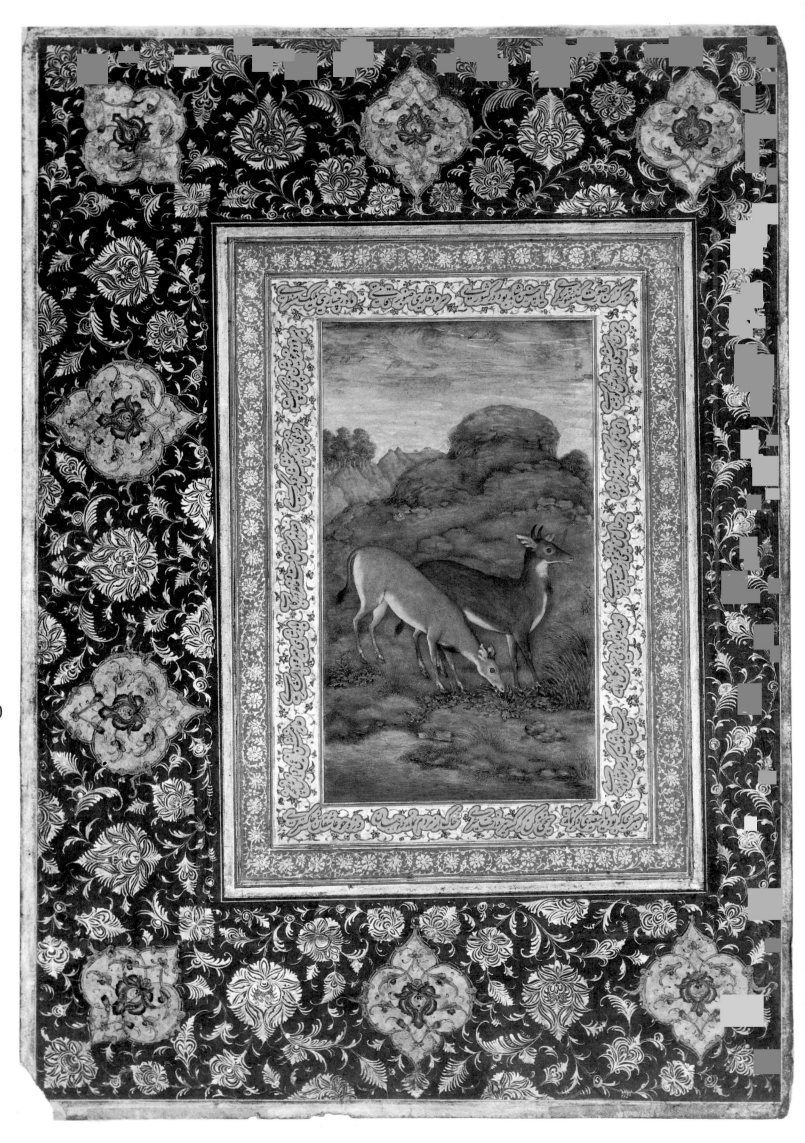

80

80. A Nilgai and a Sambar

Early nineteenth century

INSCRIBED (in minute nasta'liq): (on right) "work [*kar*] of Mansur-i Jahangiri"

FGA 39.48a

ALTHOUGH none of the seventeenth-century folios of the Kevorkian Album bears miniatures on both sides, many of the later additions are thus enriched. On the recto side of the portrait of Humayun is this study of two deer grazing in a landscape. It hints perhaps at a lost original by Mansur, Jahangir's chief animalier (see pls. 41, 44, 45, 47, and 50). But if such a picture existed, the copyist "boned" his venison with the skill of a Parisian butcher; the unsentimental animals of the seventeenth-century miniatures have been transformed into sweet-eyed Bambis. From top to bottom the miniature oozes green and tan mush, the soil having been turned to mud and the foliage reduced to overcooked spinach.[1]

SCW

1. During the early nineteenth century similar pictures were painted at Alwar, in Rajasthan, by émigré Delhi artists.

THE VERSES, in flighty, artless calligraphy, written on the paper and not cutout, contain a full ghazal by Sa'di.

AS

THE ANIMALS have been identified as a nilgai (*Boselaphus tragocamelus*) and, on its near side, a sambar (*Cervus* sp.?). The innermost border, as on the verso, has simulated cutout poetry, followed by a border with a gold flower-head design on a harsh pink ground. The outer border has cartouches in gold and red and green with frayed palmette and leaf shapes in gold, all on a dark blue ground. Neither of the borders is of much artistic merit.

MLS

81. Emperor Jahangir on a Globe, Shooting an Arrow at the Severed Head of Malik ʿAmbar

Early nineteenth century

INSCRIBED: (beside stand) "God is greatest/ work [ʿamal] of the smallest . . . with sincerity, Abuʾl-Hasan"

FGA 48.19b

ABUʾL-HASAN'S original version of this startling miniature (Chester Beatty Library, Dublin)[1] is one of several wish-fulfilling fantasies painted for Jahangir, which show the influence of Northern European High Renaissance and Mannerist engravings. Although neither patron nor artist was likely to have understood the meaning of these Western works, they did admire their hyperbolically sensuous drama.[2]

The intriguing "surrealism" of the original version of this miniature is clumsily laughable in the copy, which was concocted piecemeal from *charbas* of its parts. Bold and sharp-eyed Jahangir has been reinterpreted as a puffy, slightly tipsy boulevardier in bedroom slippers, scarcely maintaining his footing on a symbolic globe. Malik ʿAmbar, ghoulishly villainous in Abuʾl-Hasan's rendering, has become a sideshow travesty; the great fish, an obliging support in the original, now heaves a sigh of despair (perhaps because there is a cat in the center of the globe). Overhead, the once-efficient angels who offered a serviceably straight sword and arrows have now taken on the coloration of a Neapolitan wedding cake while bringing a stunted, bent sword and knitting-needle shafts.[3]

SCW

THE GLOBE is inscribed with the Timurid family tree. At the left there are two lines of poetry; then there is a minute Persian inscription identifying the event; beneath, between the scales, a Persian verse:

The justice of Emperor Nuruddin Jahangir
Makes milk flow from the teats of every lion . . .

Two more lines of poetry seem to complete the uppermost verse.

AS

THIS VERSO page has the usual inner border in gold on blue and an outer border of a palmette-and-leaf scroll in gold on a pale buff rather similar to that of MMA fol. 25r (pl. 90) and is probably by the same artist.

MLS

1. Arnold and Wilkinson, *Beatty Library*, III, pl. 62.
2. Striking proof of Jahangir's and Abuʾl-Hasan's enthusiasm for this genre is found in the vividly colored interpretation in the Institute for the Peoples of Asia, Leningrad, of Johannes Sadeler I's *Dialectics* (after Martin de Vos [1532–1603] and other engravings). The allegorical miniature shows a muscular woman on a throne of books, with a bird on her head, surrounded by animals and with a snake coiling around her arm. While arguing with a bearded man standing in the middle distance, she turns for support to a wise owl, taken by Abuʾl-Hasan from some other source. Not only the eccentricity of placing a bird atop a head but the actual owl perched on Malik ʿAmbar seem to have been borrowed via Abuʾl-Hasan's Leningrad extravaganza from Northern European Mannerist prints. Landscape elements appear to have been taken from a print such as Sadeler's *Litterae*. For the miniature, see Ivanov, Grek, Akimushkin, *Alʾbom*, no. 12 and also no. 13. For the engravings, see Scheffer, *Hollstein's Dutch and Flemish Etchings*, nos. 547 and 535.
3. For another late version, surrounded by ancestral portraits, see *Loan Exhibition of Antiquities*, no. C. 115, pl. XXXIX.

246

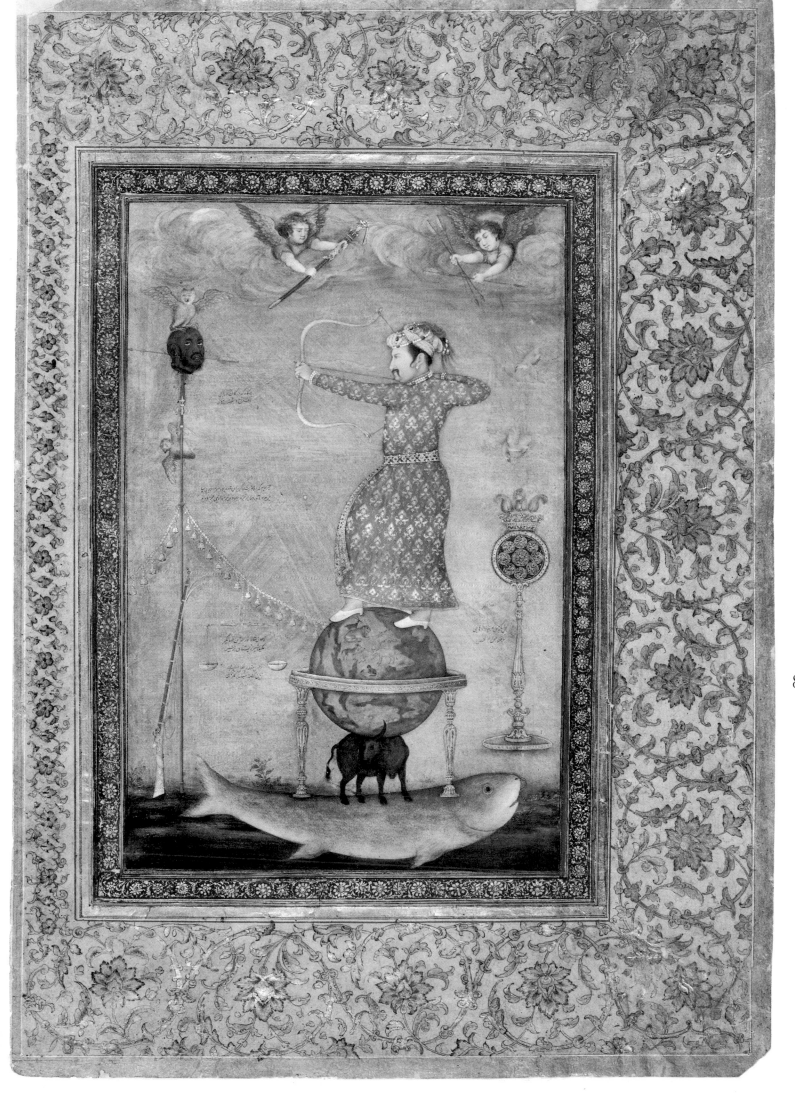

81

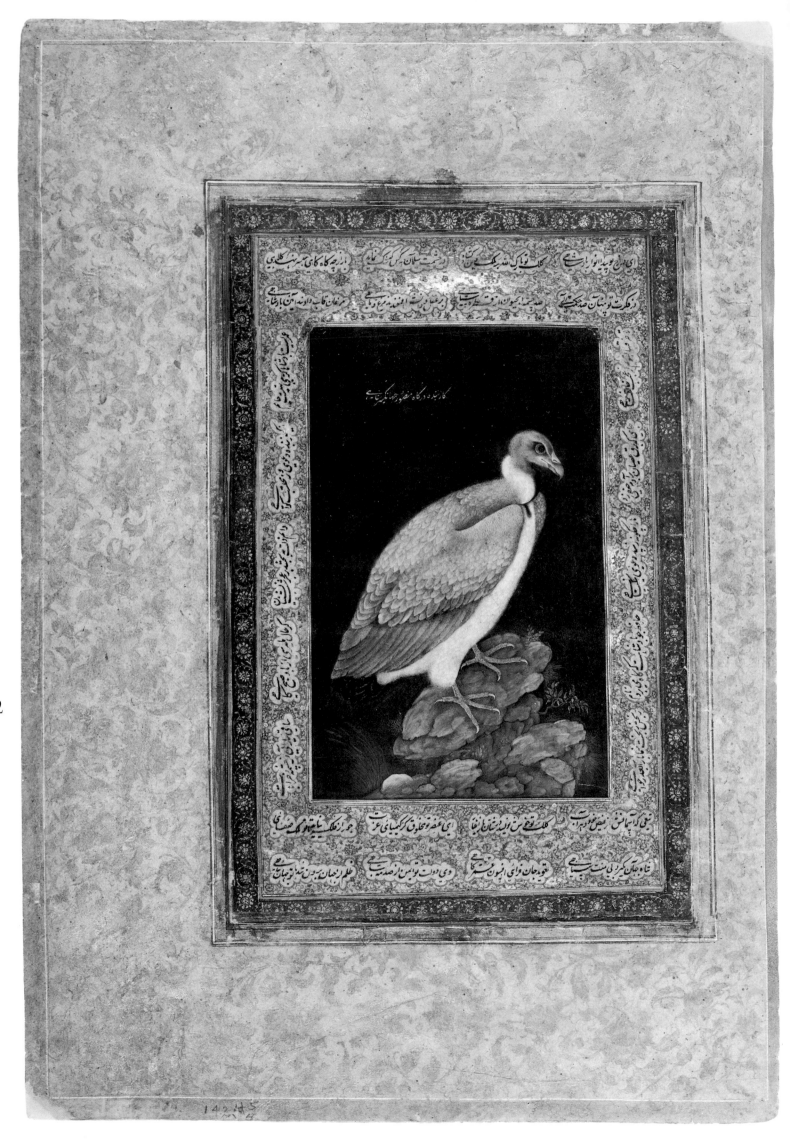

82

82. Long-Billed Vulture

Early nineteenth century

INSCRIBED (in fine nasta'liq): "work [*kar*] of the slave of the palace, Mansur-i Jahangirshahi"

FGA 48.19a

THE EARLY nineteenth-century artist did not take his bedraggled vulture (*Gyps indiens*) from Mansur's early seventeenth-century miniature in the Kevorkian Album (MMA fol. 12v; pl. 45) but from a study in the Chester Beatty Library of a more compact and hunched bird with ruffled feathers.[1] Although the Beatty vulture dates from the seventeenth century, its awkward imbalance, lack of spirit, and less than fine handling suggest that it was copied from a lost picture by Mansur. In the present copy —further removed from the original —the bird's health and humor seem to have declined even more.

SCW

THE VERSES around the picture, in mediocre writing, are a panegyric for a king, with the name of Hafiz in the last verse (right side).

AS

THE BORDER of this page has an all-over pattern in gold on buff. It is similar to that surrounding the nineteenth-century copy of the red-headed vulture (MMA fol. 25v; pl. 89), confirming that one artist was responsible for the borders of both these two later folios.

MLS

1. Arnold and Wilkinson, *Beatty Library*, III, pl. 80.

83. Ghiyath Beg, I'timaduddaula

Early nineteenth century

INSCRIBED (in fine nastaʿliq): "good likeness of
I'timaduddaula, work [ʿamal] of Balchand"

FGA 48.20b

MANOHAR'S EXCELLENT portrait of Jahangir's
father-in-law with the emperor (MMA fol. 23r; pl. 16)
must have been the basis for this slack portrait. After
copying Manohar's pose, the painter reattired the old
gentleman for winter and added a curling flourish to the
folio he carries, borrowed it seems from a portrait by
Manohar in the Victoria and Albert Museum. To tease
attributionists, the nineteenth-century artist credited
his slipshod work to Balchand. If, at fifty yards, the
folio resembles one made for Jahangir, closer inspec-
tion confirms one's worst suspicions. The palette has
become hot and sooty, courtier and flowers have gone
limp, and the floral borders have been made into a dec-
orative jumble suited to a Valentine's Day card.[1]

SCW

THE SURROUNDING verses in mediocre calligraphy
in which many dots were omitted contain a fragment
of a Persian *mathnavi* in the *hazaj* meter. On the scroll
are the words of I'timaduddaula's alleged prayer.

AS

IN THE INNER border the verses surrounded by scrolling
vines are separated by quatrefoil cartouches. The sec-
ond border is made up of cartouches with flower-head
scrolls in gold on blue. The outer border, with flower-
ing plants in strident colors and gold on a pink-beige
ground, has a very spiky quality in the drawing which,
combined with the peculiar coloring, is disturbing.

MLS

1. For another late portrait, probably made from the same tracing,
lent to the Coronation Durbar exhibition of 1911 by L. Bulaki Das of
Delhi, see *Loan Exhibition of Antiquities*, no. c.151, pl. XLIIIa.
The likely source of the curling folio is seen in Clarke, *Indian Draw-
ings*, no. 12, pl. 11.

83

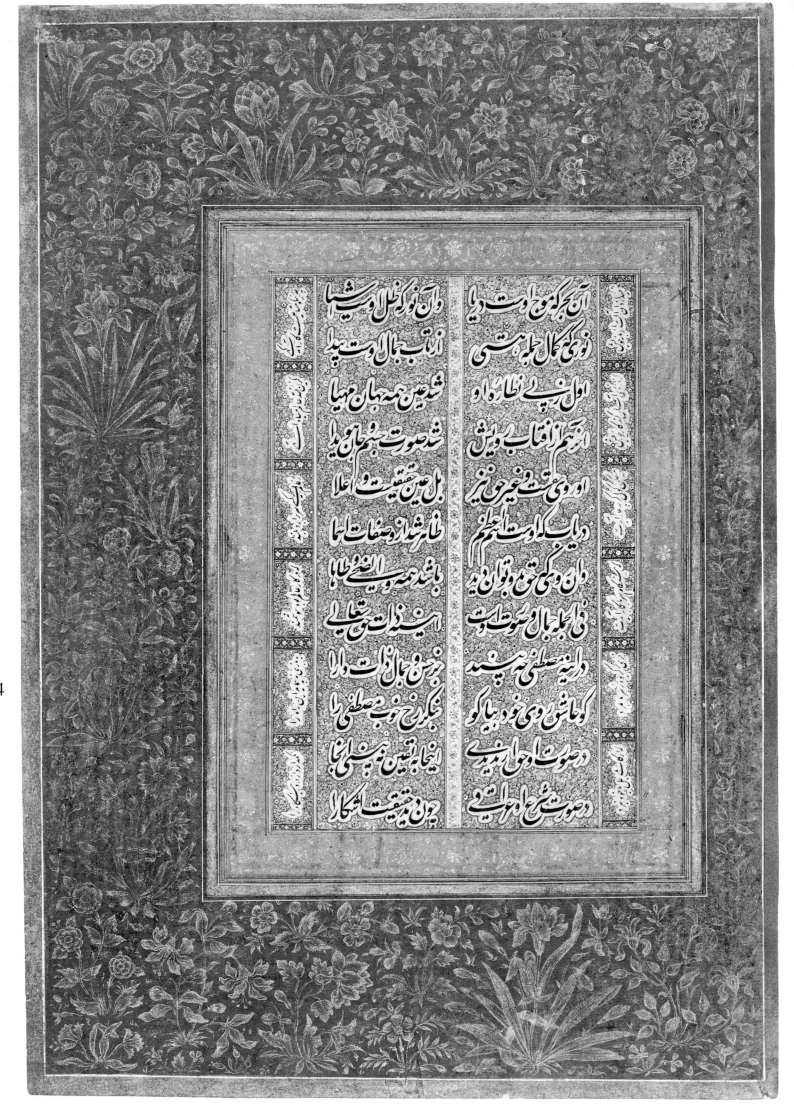

84. Calligraphy

Later copy from sixteenth-century original

FGA 48.20a

THE POEM, with the rhyming letter -*ā*, contains a highly interesting hymn in honor of the Prophet Muhammad, who is praised as the primordial light through which God manifests Himself in the world. It was composed, as the last line shows, by Fakhruddin 'Iraqi, a Persian mystical poet who lived for a long time in Multan (now Pakistan) and died in 1284 in Damascus.

That ocean, whose wave is the [visible] sea, and that light,
 whose shadows are the things—
[That is] the light from the radiance of whose beauty [*jamal*]
 the perfection [*kamal*] of all existence becomes evident.
First, in order to see it, the eye ('*ayn*; also "essence") of the
 whole world was prepared,
And in the end, likewise, the form of body and soul appeared
 from the sun of its face.
It is the face [or aspect] of the Divine Truth [*haqq*] but is also
 different of the Divine Truth; rather, it is the essence of
 Truth [*haqiqat*] and even higher.
Discover, that this is the Greatest Name [of God]; from it
 the qualities of the names become evident.
And that aspect through which you can see the Truth [*haqq*]
 is all *Waʾd-duha* [1]
"By the morning light" [Sura 93/1] and *Taha* [Sura 20/1].
Altogether, his [the Prophet's] beauty and form are a mirror
 for the essence of the Truth, Most High.
What else does one see in the mirror of Mustafa [one of the
 names of Muhammad] but the beauty and loveliness of
 the essence of the Lord?
The one infatuated with his own face may come and see
 the lovely countenance of Mustafa.
If you do not see the Truth in his outward form, you have
 not yet found here the certainty of the Beyond [i.e., if you
 do not see him as the vessel through which the Divine
 Truth shines, you cannot understand the spiritual world],
As 'Iraqi sees the Truth openly in the [outward] form of his
 law [the *shariʿa*, the divinely inspired law which the Professor brought].

This mystical poem, which contains the most important elements of the idea of the primordial Light of Muhammad, is surrounded by minute Persian verses from a didactic *mathnavi*.

<div align="right">AS</div>

THE CALLIGRAPHY panel has smaller calligraphies on either side with the verses separated by rectangular panels bearing a floral scroll. The inner border contains the usual flower-head scroll, here in gold on pink. The outer border is filled with flowering plants in gold on a blue ground.

<div align="right">MLS</div>

1. *Waʾd-duha* is used as an epithet for the Prophet Muhammad, whose radiant countenance is the appearance of the sun of truth, and the mysterious letters *ta-ha* at the beginning of Sura 20 are usually considered to be one of the Prophet's secret names.

85. Spotted Forktail

Early nineteenth century

INSCRIBED: "picture of a spotted animal; work [*kar*] of the servant of the palace, Mansur-i Jahangirshahi"

FGA 39.46b

IN MAKING his version of Abu'l-Hasan's *Spotted Forktail* (MMA 15r; pl. 40), the copyist used a *charba*, reversing the image. All that was lively and lovingly observed in Abu'l-Hasan's study has become flaccid and weak in this lackluster rehash.

SCW

IN THE INSCRIPTION the words "spotted animal" are written incorrectly, as if they had been copied from a text which the copyist did not completely understand.

The picture is surrounded by verses from a *mathnavi* in the *mutaqarib* meter, perhaps from Sa'di's *Bustan*.

AS

THE NINETEENTH-CENTURY artist has added two peculiarities of his own to this copy. Notches appear to have been cut out of the wing feathers just before the tail; the reason for this is unknown. The later artist has also given the bird a slightly hooked bill which in nature it does not possess. The treatment of feathers on the breast and upper back differs strikingly from that of the earlier painting. Here they are painted as a succession of overlapping arcs as in a wave pattern, while in the seventeenth-century painting it is quite clear that the dark feathers in this area of the body have white tips.

This leaf has an inner border of verses set against a floral-scroll ground that is not found in the earlier painting. The second border contains a scroll of flower heads and palmettes in gold on a blue ground instead of the pink ground of the earlier leaf in which the border is also wider. The outer border has a flower-head and leaf scroll in colors on a buff ground with abundant outlining in gold, seemingly closely patterned on the seventeenth-century border by Harif.

MLS

254

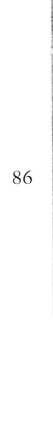

86. Shahjahan Riding a Stallion

Early nineteenth century

INSCRIBED (in small nastaʿliq): "work [ʿamal]
of Govardhan"

FGA 39.46a

DISINCLINED to make a precise copy, the painter
began with a tracing of Payag's majestic portrait of
Shahjahan astride a favorite stallion (MMA fol. 21v;
pl. 59) and then let his imagination ramble. Horse and
rider face right rather than left, requiring that reins
and lance change hands; the animal's markings are
playfully different; and the flowered turf has been
transformed into a riverside landscape, with trees and
palaces. Chitarman's refulgent depiction of Shahjahan
(MMA fol. 24r; pl. 58) also inspired the pasticheur. De-
termined to improve the original, the artist enlarged
all the jewels and brightened the colors. He hennaed
the white yak tail hanging from the horse's neck and
trimmed Shahjahan's coat, pajamas, and saddlecloth
with a green of ferocious hue.

SCW

THERE IS NO surrounding poetry, and the inner bor-
der is made up of a palmette and flower-head scroll in
gold on a bright pink ground. The outer border con-
tains flowering plants in colors heavily outlined in gold
on a buff ground. Among them a tulip, a narcissus,
and an iris can be identified.

MLS

87. Muhammad ʿAli Beg

Early nineteenth century

INSCRIBED (in fair nastaʿliq): *shabih-i Muham-mad ʿAli Beg ilchi, ʿamal-i Hashim* (portrait of Muhammad ʿAli Beg, the ambassador, by Hashim)

MMA 55.121.10.27v

MUHAMMAD ʿALI BEG was sent by Shah Safi of Iran as ambassador to the court of Shahjahan in 1631. The first mention of him in the court histories occurs when he leaves Agra to come to Shahjahan at Balaghat. Makramat Khan is dispatched with a robe of honor for the ambassador and charged with escorting him to Malwa, whence Muʿtaqid Khan, the governor of Malwa, would accompany him to Shahjahan.[1] When he was presented to the emperor in March 1631 and Shah Safi's letter of congratulation was read in court, the ambassador was presented with a robe of honor, a turban ornament, a bejeweled dagger, golden trays, a betel-leaf box, and a gold-plated goblet set worth twenty thousand rupees. Amanat Khan was deputed to accompany him to Burhanpur.[2]

In April 1632 the ambassador's envoy, Amir Beg, made the official presentation of Shah Safi's gifts to the Mughal emperor, including "fifty fleet-footed, hot-blooded, Iranian-born, Arabian-bred horses and other rarities of that land, such as the costliest of fabrics and rarest of goods, which his agents had sent from Iran; and all of these, by way of presentation, were dispatched, delivered and passed before the most glorious gaze [of the emperor]. Out of the extreme favor that had chanced to fall upon him, they were approved and the rays of the sun of acceptability shone upon them."[3] The following month the ambassador himself, having been granted permission to proceed from Burhanpur to Agra, was received at court.[4]

In October 1633 the ambassador was presented with a robe of honor of gold cloth, a jewel-studded belt, a pair of elephants, and a silver bowl and was given leave to return to Iran.[5] The last mention of him in the Mughal histories occurs in the description of a mission on which he was sent by the Persian shah to accompany Nazr-Muhammad Khan, the deposed Uzbek ruler, to court at Isfahan.[6]

WMT

THINLY PAINTED, in colors wholly lacking the radiant purity admired by Shahjahan, this miniature is a line-for-line copy of the original painting by Hashim from the Minto Album (V&A 25–1925). Hashim's sympathetic response to the sitter is apparent even in this replica, which also conveys the original artist's innovative success in depicting the ambassador's portliness and characteristic stance. Although both original and copy have floral borders, no attempt was made to imitate the "planting" of the original in the copy. The copyist added pleasing birds to the inner border.[7]

A miniature attributable to Laʿlchand in the Windsor *Padshahnama* (fol. 97v) shows Muhammad-ʿAli Khan received in audience by Shahjahan, who is also attended by his four sons. In the foreground Iranian servants bear trays laden with imperial gifts, presumably some of those presented at the time of the ambassador's leave-taking in 1633.

SCW

THE PAINTING is surrounded by a fragment from a narrative *mathnavi* in the *mutaqarib* meter; the script is contemporary with the miniature.

AS

THE VERSES surrounding this portrait are written directly on the page but outlined as if cut out. The palmette and flower-head border in gold on blue is not as sloppy as those of other late copies, but the blue is too dark. In the outer border the second plant from the bottom has a rose-type flower and the plant above it a cyclamen-type flower. Above that again is a primula. There are two plants above the primula; above these is a narcissus-type flower, but the rest is wrong for a narcissus. These plants are again not as badly drawn

258

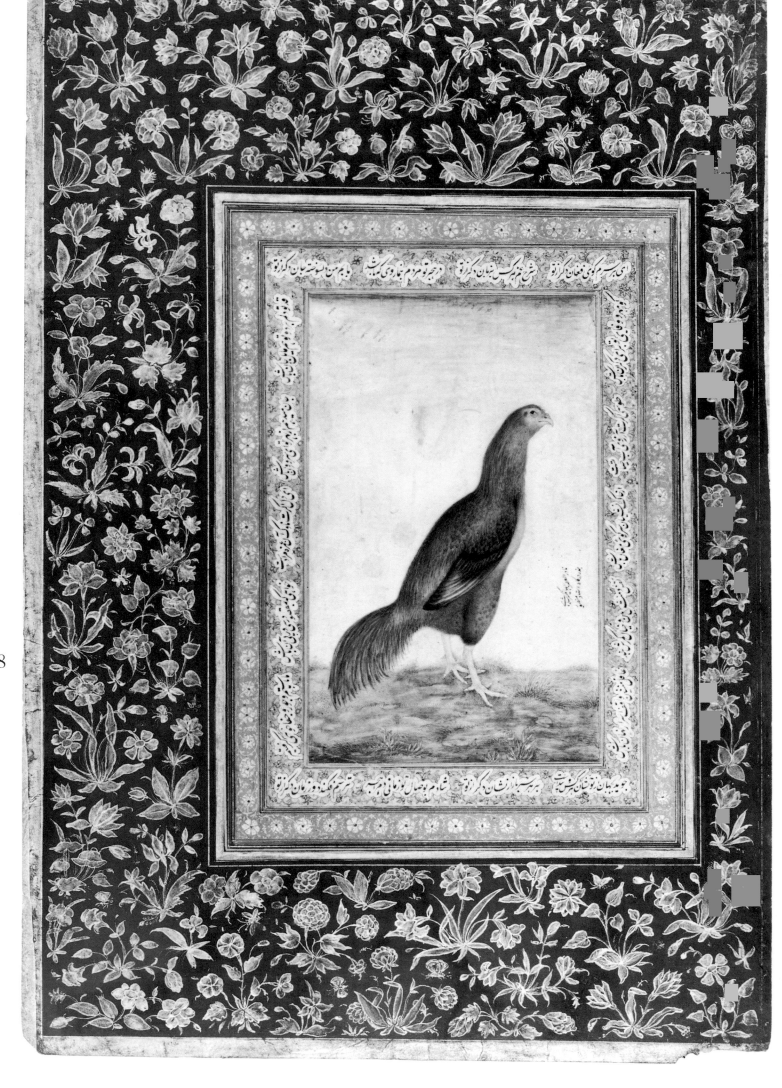

as in other late borders but are still very weak when compared with seventeenth-century borders. Of the birds in the medallions separating the poetry, an egret (*Egretta* species?) can be identified in the lower corner medallions.

<div style="text-align:right">MLS</div>

1. Muhammad-Salih Kanbo, *'Amal-i salih*, I, p. 425.

2. Muhammad-Salih Kanbo, *'Amal-i salih*, I, p. 427.
3. Muhammad-Salih Kanbo, *'Amal-i salih*, I, p. 480.
4. Muhammad-Salih Kanbo, *'Amal-i salih*, I, p. 487.
5. Muhammad-Salih Kanbo, *'Amal-i salih*, I, p. 504, and 'Abd al-Hamid Lahawri, *Padshahnama*, I, p. 440.
6. Muhammad-Salih Kanbo, *'Amal-i salih*, II, p. 528. There is another portrait of Muhammad 'Ali Beg in an album page in the Victoria and Albert Museum (25–1925); see Beach, *Grand Mogul*, p. 74.
7. See Pinder-Wilson, *Paintings from the Muslim Courts of India*, no. 130.

88. Jungle Fowl

Early nineteenth century

INSCRIBED (in small nasta'liq): "Nadir al-'asr Jahangirshahi, servant of the palace, Ustad Mansur"

MMA 55.121.10.27r

Was this skimpy copy of a pugnacious bird (*Gallus gallus*) intentionally placed on the reverse of the Persian ambassador's portrait when it was added to the album in the early nineteenth century? Marie L. Swietochowski has pointed out that a livelier and finer seventeenth-century version of this miniature, perhaps Mansur's original, shows the bird isolated against bare paper.[1]

<div style="text-align:right">SCW</div>

The picture is surrounded by a poem by Tusi and another love poem without a signature. The calligraphy appears contemporary with the painting but seems to have been copied from another page with cutout fragments—perhaps the original page with the bird.

<div style="text-align:right">AS</div>

This page's blue-and-gold outer border is by the same hand as that of the verso. Although the border is not as poor as several of the other early nineteenth-century copies, the drawing here is weak, as it is on the verso, and the background color is dead and dull in both. In the upper left corner is perhaps a cyclamen-type plant. The third plant in from the left has a rose-type bud. Below it and further right is a tulip, while above the tulip and slightly to the right is perhaps a narcissus and to the right and slightly below it, possibly a cyclamen. At the left edge of the outer border, slightly below the middle, is an iris-type plant.

<div style="text-align:right">MLS</div>

1. See Wilkinson, *Mughal Painting*, pl. 1, p. 24.

89. Red-Headed Vulture

Early nineteenth century

INSCRIBED: "work [*'amal*] of the servant of the palace Mansur Nadir al-'asr Jahangirshahi"

MMA 55.121.10.25V

APPROPRIATELY placed on the verso of a gory portrait of 'Abdullah Khan Bahadur-Jang bearing the severed head of the traitorous Khan-Jahan Lodi, this vulture (*Aegypius calvus*) was copied from Mansur's original in the Kevorkian Album (MMA fol. 12v; pl. 45). Although the brushwork is meticulous, the copy fails to capture the menacing elegance of Mansur's superb miniature.

SCW

THE VERSES surrounding the picture are not cut out but written as a whole around the painting. They contain an ode to the Prophet Muhammad, "the one buried in Yathrib [i.e., Medina]," whose help the poet implores.

AS

THIS DEPICTION of a red-headed vulture has a furriness and fuzziness not present in the original (MMA fol. 12v; pl. 45). The inner border is a sloppily painted blue-on-gold scroll, while the outer border is an all-over design of palmette scrolls.

MLS

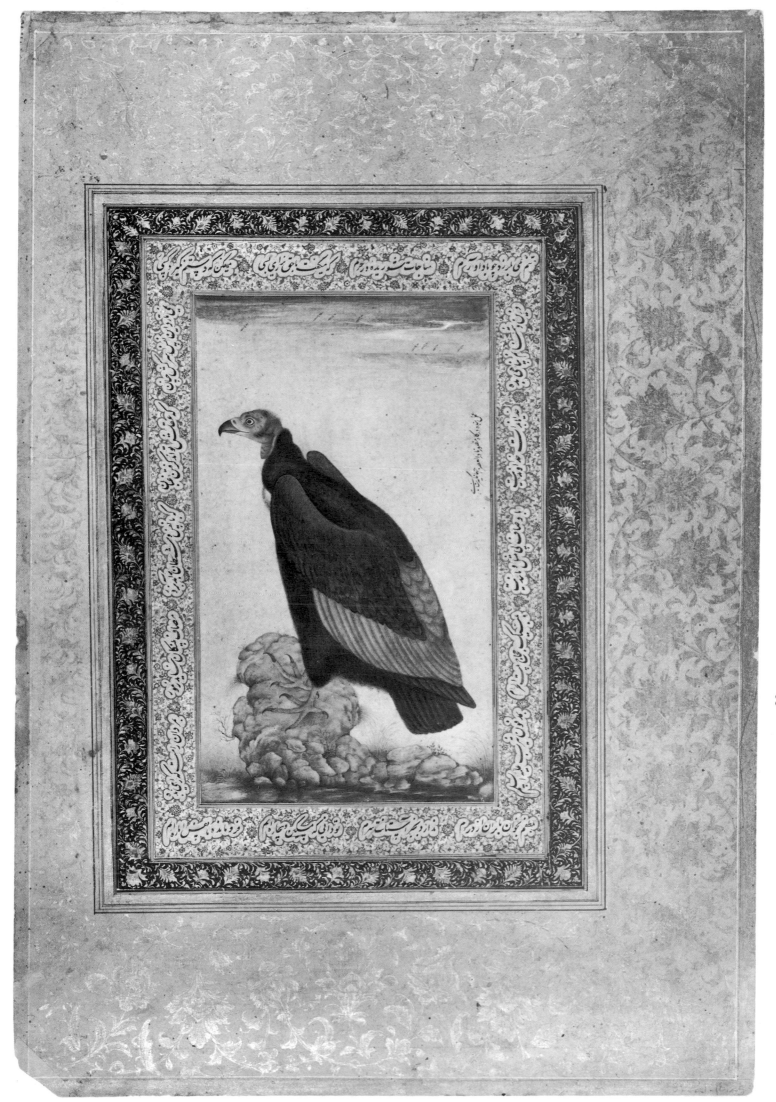

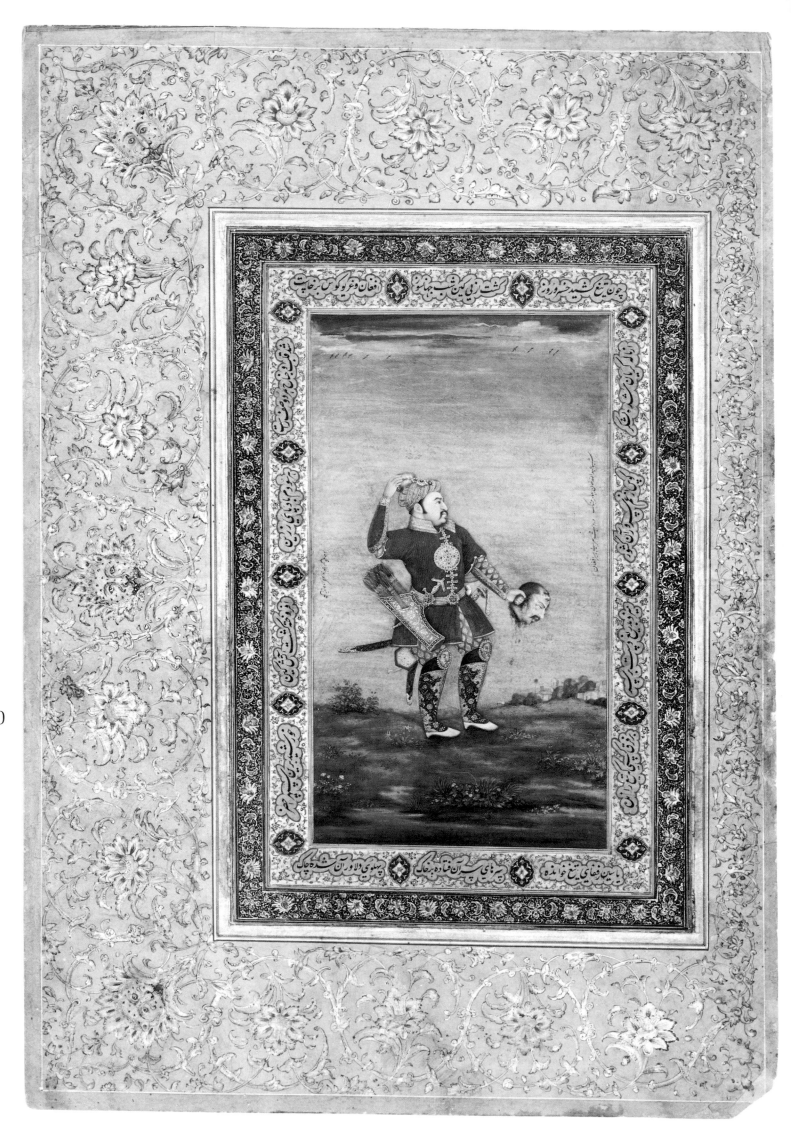

90. 'Abdullah Khan Bahadur-Jang

Early nineteenth century

INSCRIBED (in very small nasta'liq): (at right) *shabih-i 'Abdullah Khan Bahadur-Jang; dar dast sari Pir-i Afghan* (a portrait of 'Abdullah Khan Bahadur-Jang; in his hand he holds the head of Pir the Afghan [Khan-Jahan Lodi]): (at left) *'amal-i banda-i dargah ba-ikhlas Muhammad 'Alam* (done by the devoted slave of the court Muhammad 'Alam)

MMA 55.121.10.25r

A DESCENDANT of the Naqshbandi saint Khwaja Ahrar (d. 1490) of Central Asia, Khwaja 'Abdullah came to India during Akbar's reign and served as a soldier in the Deccan under one of his relatives. He then joined Prince Salim (Jahangir) in Lahore, but since he could not get along with the prince's agent Sharif Khan, he went into Akbar's service, where he was given the rank of 1000 and the title Safdar-Jang. Jahangir later writes of him: "Khwaja 'Abdullah, who is of the Naqshbandi order, was initially a footsoldier [in my service], and little by little his rank reached the 1000 mark. Without ostensible reason he went over to my father's service. Although I realized that it was to my own benefit for my retainers and men to go into his service, since he had done this without permission I was extremely annoyed. Nonetheless, despite such faithlessness, I confirmed him in the rank and fief my father had allowed him. The truth of the matter is that he is an ambitious fellow and brave fighter. Had he not committed this fault, he would have been flawless."[1]

Under Jahangir, 'Abdullah Khan was promoted eventually to the rank of 5000, given the title Bahadur-Jang, and made the governor of Gujarat. As a general in Jahangir's service he had his ups and downs and was in and out of favor many times, but he was well received by Shahjahan upon his accession and was in charge of many military campaigns.

During the long and difficult pursuit by Shahjahan of Pir-Muhammad the Afghan, known as Khan-Jahan Lodi, and his fellow rebel Darya Khan, 'Abdullah Khan and Sayyid Muzaffar Khan Barha were in charge of the troops that finally caught up with and killed Khan-Jahan. The rebel's head was dispatched to court by 'Abdullah Khan (the subject of this portrait), who was given the rank of 6000 and the title Feroz-Jang. Toward the end of his life he was given the governorship first of Bihar and later of Allahabad. He died in 1644, aged nearly seventy.

In summing up his character, the author of the *Maasir al-umara* says that although 'Abdullah Khan had a streak of cruelty and tyranny in him, his men believed him capable of working miracles and used to make offerings to him.[2] He is also reported to have once boasted that whereas the Prophet of Islam had to go to a cotton-carder's house to beg him to become a Muslim, he ('Abdullah Khan) had once taken prisoner five lacs of men and women and forced them all to convert to Islam, and from their progeny "there will be krors by the time of Judgment Day."[3]

WMT

A FINER than usual copy, perhaps because the artist found the subject so compellingly dramatic, this miniature expresses some of the horror of Abu'l-Hasan's original.[4] Here, however, 'Abdullah Khan looks less than victorious, while Khan-Jahan Lodi smiles for no apparent reason. As usual, the nineteenth-century copyist did not strive for accuracy, employing a *charba* and incomplete and generalized color notations. Abu'l-Hasan's picture differs in many details. Although quiver and turban are orange, and pajamas and sleeves are crimson, the hues differ markedly. Moreover, the pectoral ornament in the earlier picture is adorned calligraphically rather than with jewels, and 'Abdullah Khan's boots and leggings are silver, gold, and red, with silver instead of gold knee-guards. The ascription to Muhammad 'Alam, an artist otherwise unknown, may be an actual signature by one of the early nineteenth-century Delhi copyists.

The disturbing moment of Khan-Jahan Lodi's death was lugubriously depicted for the Windsor *Padshahnama* (fol. 93v) by 'Abid, who signed himself as the brother of Nadir az-zaman.[5]

SCW

THE SCRIPT around the picture is not cut out but is written on the sheet. The poem is suitable for the picture—a battle scene—and begins with the line:

When the Khusrau [Day] drew his sword [i.e., when the Sun killed the Night]...

The mediocre calligraphy and the appropriateness of the poetical theme indicate that the poem was done at a later time, to give the painting an ancient look.

AS

THE INNER border of this recto page is an outlandish version of the palmette, flower-head, and leaf scroll with additions of red and blue to the gold; there are so many squiggles on the scroll that the blue ground is virtually obscured. The outer border is no better, with its palmette-scroll pattern, with lion masks in the center of the corner palmettes and outer center palmette. There is another portrait of the youthful ʿAbdullah Khan (inscribed by Jahangir) in the Berlin Album (fol. 46), although there he is dressed differently and does not hold a severed head.[6]

MLS

1. Jahangir, *Jahangirnama*, p. 16.
2. Shahnawaz Khan, *Maasir*, I, p. 104.
3. Shahnawaz Khan, *Maasir*, I, p. 105.
4. Abu'l-Hasan's painting is in the Minto Album (V&A 16–1925).
5. See Welch, *Art of Mughal India*, fig. 4.
6. See Kühnel and Goetz, *Indian Book Painting*, pl. 6.

91. Shaykh Hasan Chishti

Early nineteenth century

INSCRIBED (in fine nastaʿliq): (at right) "blessed likeness of Hazrat Shaykh Hasan Chishti Jahangirshahi"; (at left) "work of the servant of the palace Bichitr"

MMA 55.121.10.26v

ESPECIALLY fine in detail, muted in coloring, and forceful in its characterization, this is the most impressive of the later copies in the Kevorkian Album. Nevertheless, the shaykh's garb is a muddle of form-concealing wrinkles and folds; the cut flowers and vases are prettified; and the arabesques of the carpets are typically nineteenth century in their undisciplined meanders.

Like the other copies in the Kevorkian Album, the technique of this picture differs from that of seventeenth-century works. No longer are colors applied in painstaking, burnished, enamel-like layers. Instead, in imitation of English watercolors, fine strokes of opaque as well as transparent color are brushed on in minute dashes and stippling to lend roundness of form. Far less time-consuming and less prone to flaking off—except in large areas of white, as in the textiles here—the imported method resulted in a less jewel-like color and a matte surface. It also tended to discourage the sharp outlining that lent articulate crispness to traditional miniatures.[1]

SCW

THE CALLIGRAPHY, of mediocre quality, is written directly on the miniature. The poem is a didactic *qasida* in which the reader is reminded that "healing and health come after illness, and happy spring after winter" and that everything will be ultimately changed into its contrary, for whatever begins has of necessity an end.

AS

THE INNER border of this picture is a palmette and flower-head scroll in gold on a rather grayish blue ground; the outer border is made up of flowers and leaves in an arabesque pattern. Both colors and drawing betray its late date.

MLS

1. This was published in 1955 as a seventeenth-century picture; see Dimand, "Exhibition," p. 99.

266

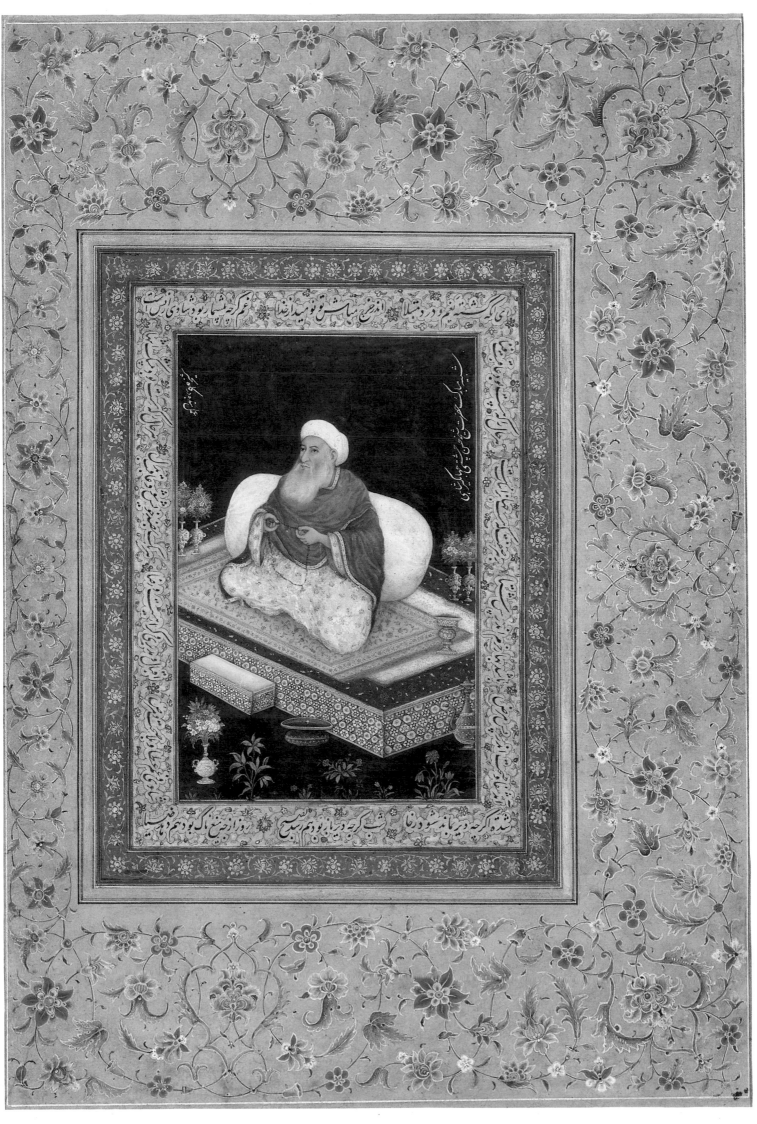

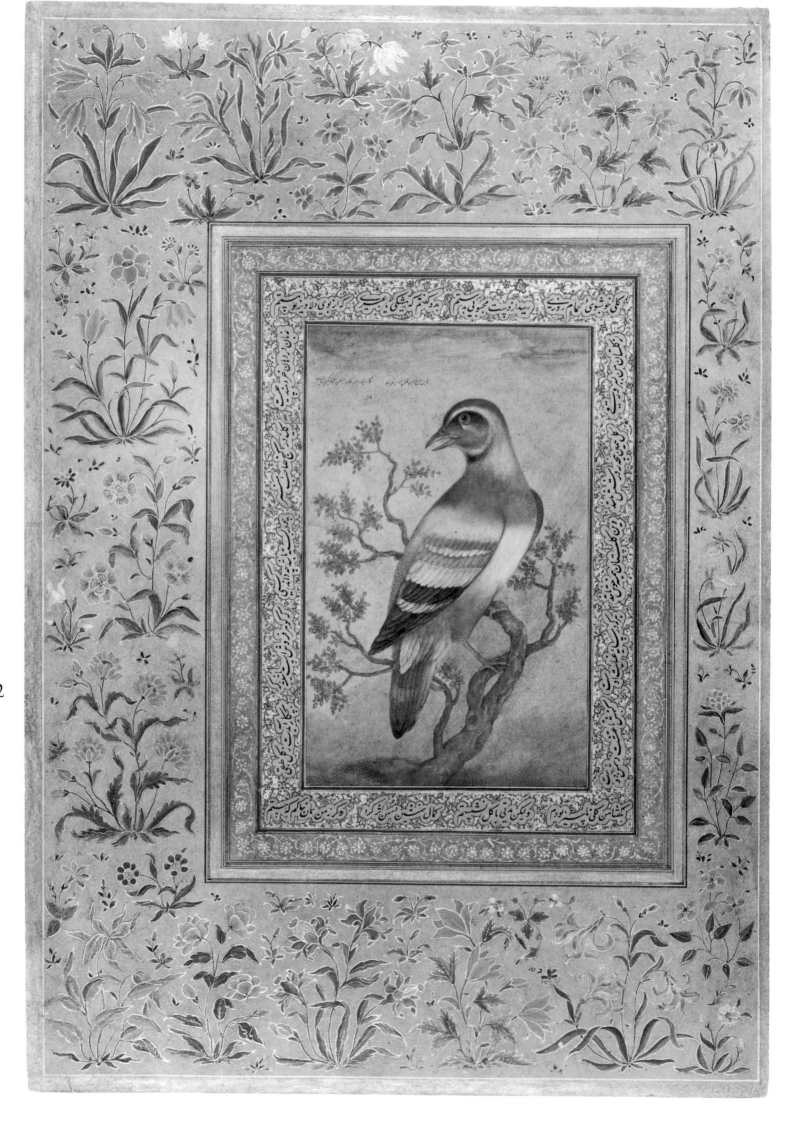

92

92. A Fantastic Bird

Early nineteenth century

INSCRIBED (in fine nasta'liq): "This bird is called *bu qalamun*. Work [*kar*] of the servant of the palace Mansur Jahangirshahi"[1]

MMA 55.121.10.26r

UNKNOWN TO ornithologists, this bird is a pleasing fantasy and an amiable companion to the holy man on the verso. Bright-eyed and chirping, the *bu qalamun* sports every hue in the spectrum, as well as gold. However soft and inarticulate the forms, this artist took pride in his work; when he inscribed this picture to Mansur, he probably did so less to deceive than to render homage to the renowned master.

SCW

THIS PICTURE is surrounded by a pleasant *qit'a*. The poet finds in his bath a piece of clay (used for rubbing the body), which is extremely fragrant. Asked the reason for its delightful odor, the clay replies that it has been sitting close to a rose and has become valuable thanks to this precious company.

There are also a fragment of a short *mathnavi* about the rose and the rose garden and two verses about the "tongue" (that is, the manner of speaking), which is the "key to the treasure of the virtuous" and can reveal whether a man is a jeweler or a glassmaker.

The mediocre calligraphy is contemporary with the picture.

AS

THE BORDERS around the painting of this pigeon-like bird follow those of the verso, although the inner one is on a pink rather than a grayish-blue ground, while the outer one has flowering plants in the same color scheme as the verso border. The borders are rather better than those of some of the other nineteenth century copies.

MLS

1. Annemarie Schimmel has pointed out that the term *bu qalamun* usually refers to a chameleon, not a bird; it is, however, also used to describe various colorful items, such as silk.

93. Calligraphy

Later copy of a sixteenth-century original

MMA 55.121.10.28v

THIS LEAF bears the same Persian quatrain as pl. 12; the latter is, however, signed "By its scribe, ʿAli," while here only the signature of Mir-ʿAli appears. The writing perhaps is by Mahmud Shihabi Siyavushani. The opening words *Huwa al-ʿAziz* (he is the mighty) may be understood as an allusion to the name of the Bukharan prince ʿAbdul-ʿAziz in whose service both Mir-ʿAli and Mahmud Shihabi were employed. This folio is written in a more elegant style than that of MMA fol.19r (pl. 12), but the possibility of its being an imitation—dating perhaps even as late as the eighteenth century—cannot be excluded as it is found on the reverse of a late miniature.

The calligraphy is surrounded by a story of a youth who recites in every *rakʿa* (unit) of his morning prayer the Koranic verse: "Do you not see how your Lord dealt with...."

This can be either Sura 89/6 ("...dealt with the people of ʿAd") or Sura 105/1 ("...dealt with the people of the elephant"). Both verses speak of God's wrath toward the enemies of the true faith. It appears that this verse was considered very powerful against misfortune for, as the story tells us, the youth was blessed with the "sun of happiness."

AS

THE GOLD garland-like scroll of the border, made up of overlapping leaves with a palmette and floral scroll beneath it, was patterned on the border of MMA fol. 24v (pl. 57). Not only is the drawing and handling of the brush not nearly so fine here, but there are also differences in the design. Here the scroll gives a slightly unpleasant impression—it brings to mind a congregation of snakes, partly because the undulating ribands do not come together pleasingly, as in the other folio, but appear to have separate lives of their own. The palmettes and flower heads in the background are somewhat heavy and awkward, lacking the delicacy and grace of the seventeenth-century model.

MLS

270

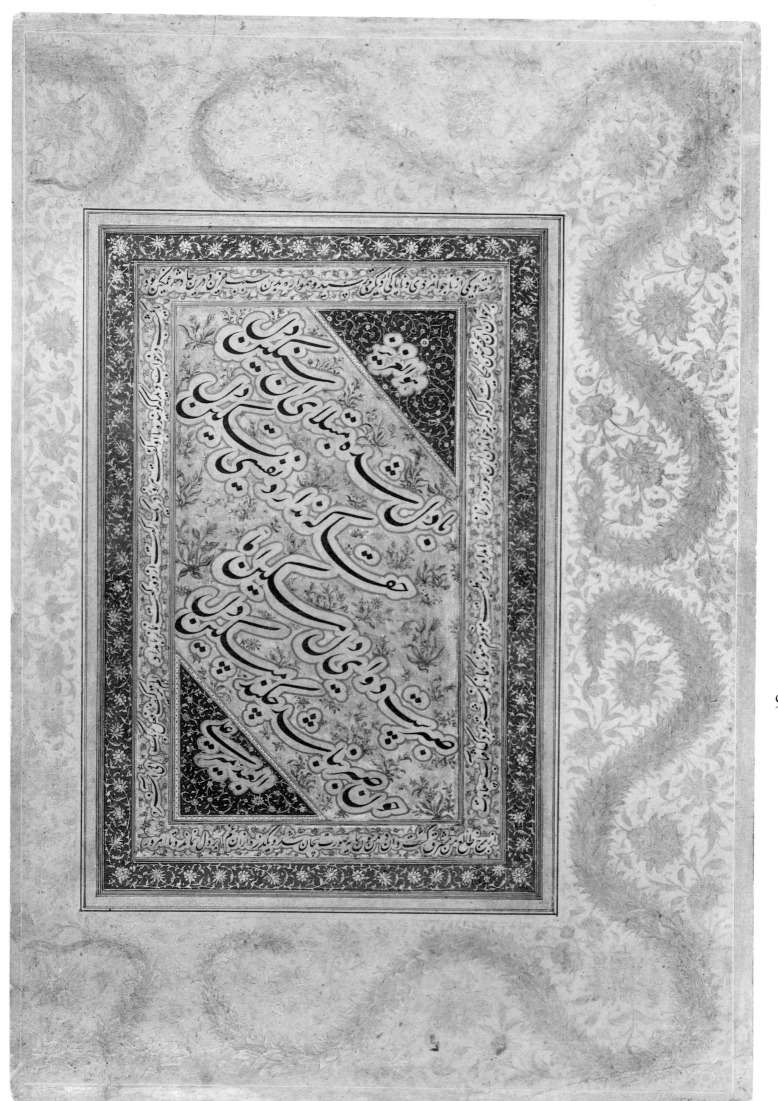

93

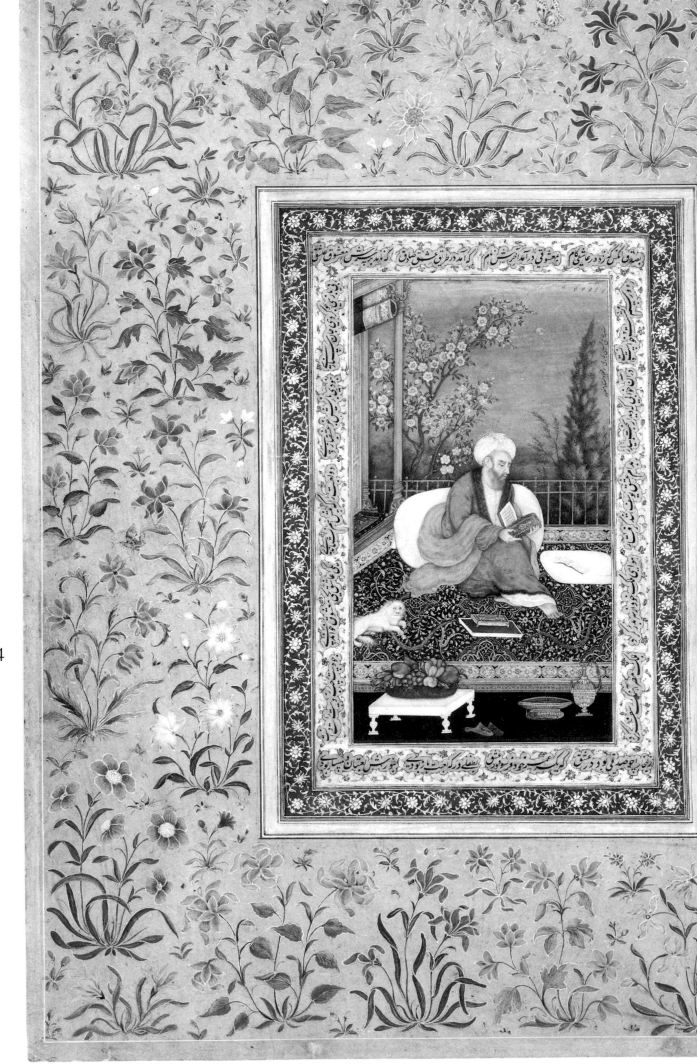

94

94. Hajji Husayn Bukhari

Early nineteenth century

INSCRIBED (in small nasta'liq): *shabih-i Hajji Husayn-i Bukhari, raqam-i Ustad Mansur* (a portrait of Hajji Husayn Bukhari, done by Master Mansur)

MMA 55.121.10.28r

THE ONLY person with whom this portrait can be identified is the Hajji Husayn who was a disciple and successor to Shaykh Salim Chishti at Shaykh Salim's *khanaqah* in Sikri.[1] Hajji Husayn's epitaph, carved above a veranda doorway in the structure at Fatehpur-Sikri known as the Jama'atkhana, gives the date of his death chronogrammatically as A.H. 1000 (A.D. 1591).[2]

The Chishti saint Shaykh Salim, who was greatly revered by Akbar, had predicted that the emperor would have three sons, as Jahangir describes in his memoirs: "During those days when my exalted father was desirous of having a son, there was a great dervish by the name of Shaykh Salim, who had traversed many of the stages of life, and who dwelt on a mountain near Sikri, a village dependency of Agra, and whom the people of that area held in the greatest reverence. Inasmuch as my father used to apply to dervishes, he held converse with this one too. One day, while meditating, he inadvertently asked [the shaykh], 'How many sons will I have?' He answered, 'The Giver who bestows without obligation will grant you three sons.' My father then said, 'I vow that I will entrust my first son to your care and will give him into the lap of your love and affection to protect and preserve him.' The shaykh accepted this and said, 'May he be blessed. We shall give him our own name.'"[3]

In fulfillment of this vow Akbar sent Jahangir's mother to Shaykh Salim's residence shortly before the delivery, and there, on August 30, 1569, she gave birth to the future emperor, who was named Sultan-Muhammad Salim and whose regnal name later became Jahangir. Partially in tribute to Shaykh Salim, Akbar built the imperial city of Fatehpur at Sikri and moved his capital there.

WMT

LIKE THE portrait of Shaykh Hasan Chishti (MMA fol. 26v; pl. 91), this portrait was painted in a reverent mood, presumably by a devout Muslim. To emphasize that Husayn Bukhari had made the hajj (pilgrimage to Mecca), the artist brought out a brilliant green for the robe and set it against a sky of even more visionary green. Lest his point be missed, he lavished the picture with more greens—in the dark foreground, in the electrifying greens of the arabesques in the carpet, and in those of the still life and tree. And to make these hues seem even greener, he wrapped the devotee in a contrasting pink-purple shawl—reddish hues being typical of the Chishti order—and sat him beneath a flowering rosebush.

Although not even the devotee's small white cat (a favorite animal of Sufis) can be related to the work of Mansur, the nineteenth-century pasticheur ascribed his work to him.

SCW

THE PICTURE is surrounded with script that is contemporary with it and contains lines from Jami's epic *Yusuf and Zulaykha*.[4]

AS

THIS RECTO portrait has an innermost border of simulated cutout poetry; the inner border has a palmette and flower-head scroll in gold on a blue ground rendered in a rather slapdash fashion. The floral border has lost the harmony of both color and drawing evident in the seventeenth-century borders. Its gold outlines are not very precise, and it gives an overall impression of agitation.

MLS

1. Badaoni, *Muntakhab al-tawarikh*, II, p. 344.
2. Begley, *Monumental Calligraphy*, p. 89.
3. Jahangir, *Jahangirnama*, p. 1f.
4. Jami, *Haft Aurang*, p. 728.

95. Calligraphy

Later copy of a sixteenth-century original

MMA 55.121.10.9v

Oh pity! Grief has made my face like straw [i.e., pale].
Lament! The days of life became so short!
Your lack of favor made me die from grief—
If you would show some favor, it's high time.
 The poor [*faqir*] Mir-ʿAli

The poem is surrounded by a ghazal by Saʿdi and two verses, which are not found in Furughi's edition.

The calligraphy looks somewhat too crisp for Mir-ʿAli. Found on the verso side of a nineteenth-century miniature, it is also probably of a later date.

<div align="right">AS</div>

THE SCHEME here—flowers in colors on a buff ground —matches a seventeenth-century leaf (MMA fol. 10v; pl. 75). Here a lily (*Hemeroulia* cult.) is identifiable in the lower right, and the large plant next to it is a chrysanthemum. An iris can be seen just below the center of the inner border. The borders of this leaf are considerably finer than most of the later copies, and the leaf follows the proper scheme of a portrait on one side and calligraphy on the other.

<div align="right">MLS</div>

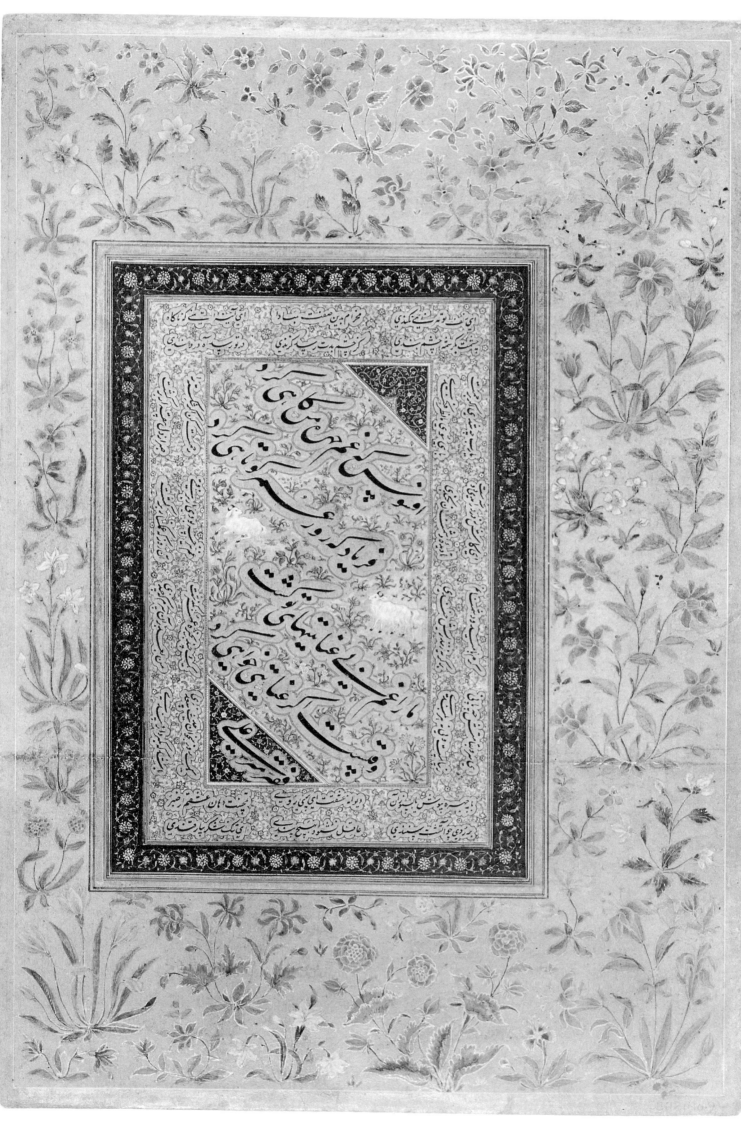

95

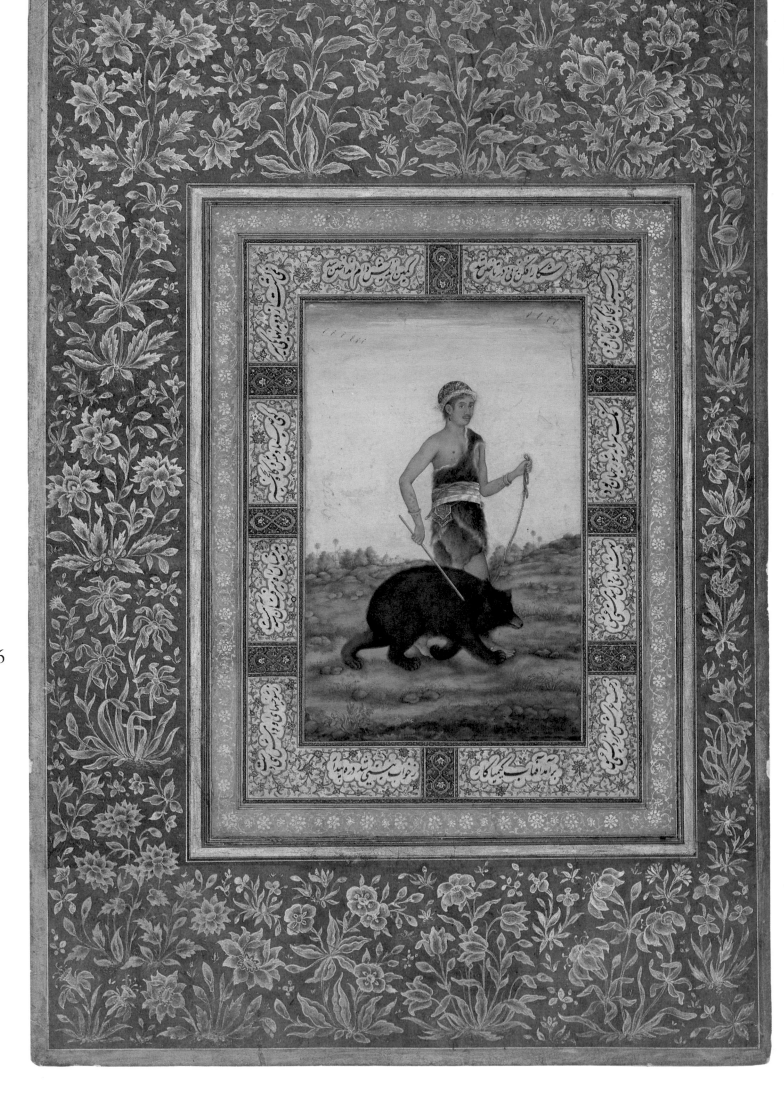

96

96. Dervish Leading a Bear

Early nineteenth century

INSCRIBED (in almost faded nastaʿliq): (on the
left side) "work [ʿamal] of Govardhan"

MMA 55.121.10.9r

Because the original by Govardhan is also in the
Kevorkian Album (MMA fol. 10r; pl. 76), it is conve-
nient to compare this version to it. As usual in India,
where it was traditional for later artists or musicians
to re-create or reinterpret earlier themes rather than to
reproduce them exactly, the early nineteenth-century
painter merely based his work on a *charba* of the orig-
inal. This tracing provided the theme and assured a
degree of accuracy of silhouette, proportion, and col-
oring (the last was usually noted by small blobs of pig-
ment or by words). Once the later artist had laid in
the outlines and determined the essential colors, he
was free to improvise. Since it was not his intention to
make a precise copy, he put away the original (if it
was available to him) and allowed his brush and spirit
to wander.

The nineteenth-century Delhi artist's characteriza-
tion of the dervish differs greatly from Govardhan's.
The painfully introverted figure has become healthily
optimistic and outgoing. His scabs have healed; cheek
and chin are no longer stubbled; his hangdog mouth
has taken on a welcoming, even coy smile. If the trou-
bled young man once averted his glance, now reborn
he looks the viewer manfully in the eye. He seems to
have exchanged moods with the bear, which in the
seventeenth century trotted along with a smile but
now expresses sullen disapproval. Perhaps it resents
being moved from a remote heath into a picturesque
landscape dotted with flowers, succulents, and quaint
buildings—an ambience better suited to a young man
dressed for a costume party.

SCW

The surrounding verses, which are fragments from
a *mathnavi* in the *hazaj* meter, are not cut out but
written on the paper.

AS

Simulated cutout verses occupy the innermost bor-
der; the second border has an oval palmette scroll in
gold on pink. The outer border of gold plants on a blue
ground is as densely arranged as seventeenth-century
borders but lacks their graceful proportions and felici-
tous placement of elements. A tulip can be recognized
in the upper right, with an iris lower down and a nar-
cissus near the lower right corner. The larger plant next
to the narcissus may be a lily, while the plant in the
lower left corner is a narcissus variant. In the outer
border the second large plant from the top may be a
lily, and in the upper border the second large plant
from the right is a cyclamen variant.

It is unclear why the compiler of the Kevorkian
Album would have inserted a late copy of a seventeenth-
century painting in the same album as the original.
The motivation for the copies would seem to have been
a wish to expand the existing Mughal albums in order
to have more albums for the art market. While some
of the later copies were made with considerable care,
one can only surmise that the reassembling of the al-
bums was done with unseemly haste or the reassem-
bling was repeated at a still later date when the origi-
nal motive was forgotten.

MLS

277

97. Bird

Early nineteenth century

INSCRIBED: "work [*ʿamal*] of the sincere servant of the palace, Farrukh Beg"

FGA 48.21b

THE SAME painter who ascribed his fanciful *bu qalamun* (MMA fol. 26r; pl. 92) to Mansur has offered this brightly tinted bird as homage to Farrukh Beg, another great imperial old master.[1] Trained in Shiraz during the sixteenth century, Farrukh Beg migrated to Khurasan before going to India and entering the service of Akbar. He later painted at Bijapur in the Deccan for the notable patron Sultan Ibrahim ʿAdilshah, before returning to the Mughal court, where Jahangir honored him as one of the three artists known as "wonders of the age." Other than this highly questionable attribution, there is no evidence of his work as a natural history painter.

SCW

IN THE SIGNATURE the word *ikhlas* (sincerity) is written with a *sin* instead of the correct *sad*, a mistake that reveals an ignorant copyist.

The picture is surrounded by a *mathnavi* in minute script in the *khafif* meter about the wedding of an ugly girl to a beautiful boy.

AS

THE BIRD in this painting is not identifiable. The inner borders resemble those on the recto page, with an additional row of verses at the bottom of the inner border. The main border contains flowering plants in colors and gold on a buff ground in the same nervous staccato style as the recto border.

MLS

1. For Farrukh Beg, see Skelton, "The Mughal Artist Farrokh Beg"; Welch, *India*, no. 147, pp. 221–25.

278

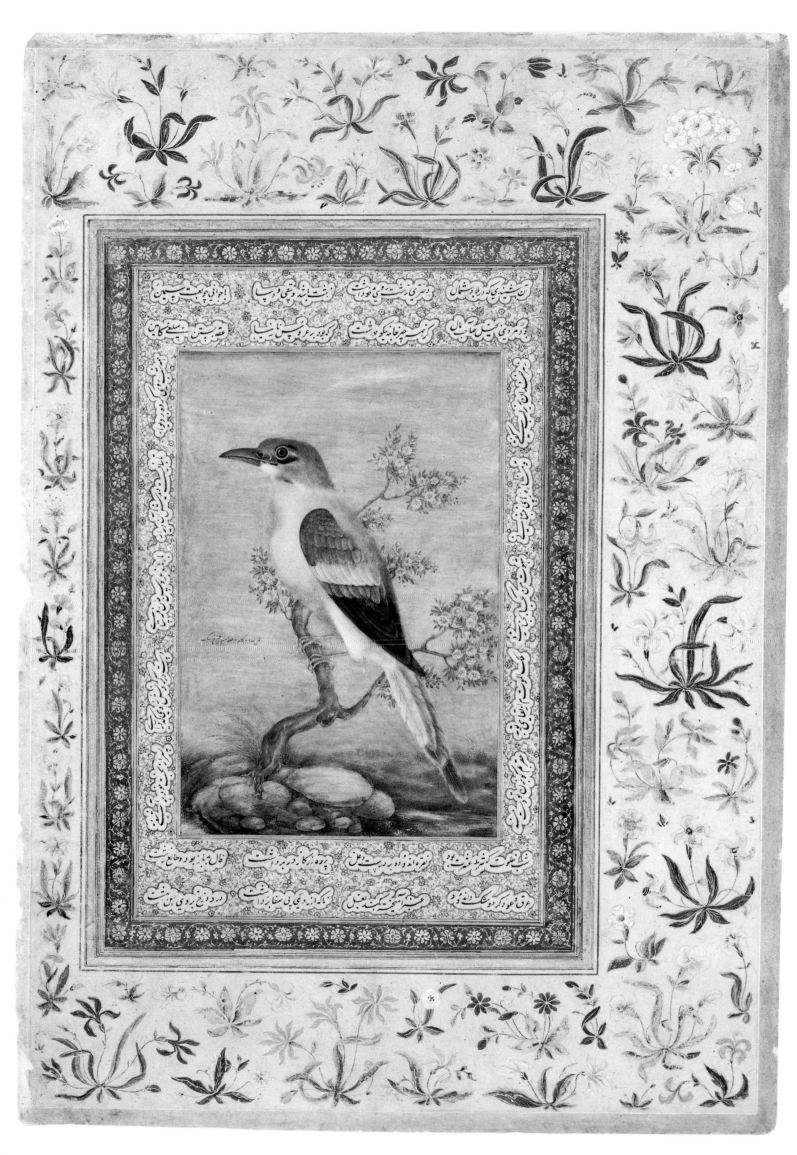

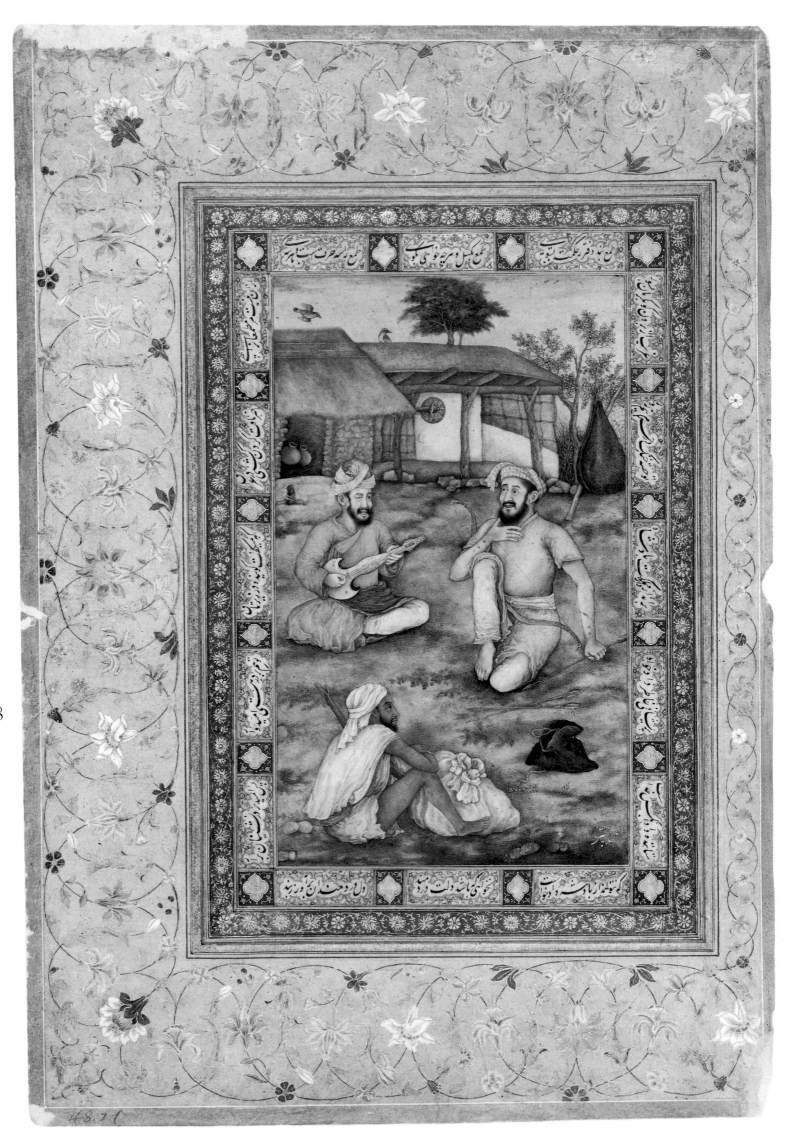

98

98. Archer, Musician, and Dervish

Early nineteenth century

Inscribed to Bichitr

FGA 48.21a

THE EARLIEST version of this picture (Victoria and Albert Museum) was painted during the 1630s by Bichitr in response to Govardhan's specialized genre scenes. Indeed, in a virtual companion picture by Govardhan in the Chester Beatty Library, the figure in the upper right is shown in reverse and without a bow, which suggests that the pictures were commissioned (perhaps by Prince Dara-Shikoh) in tandem, conceivably as a competition.[1] Despite their similarity of subject and sensitivity to nuances of personality, the pictures accentuate the artists' profound stylistic and spiritual differences. Govardhan's vision is ethereal. His forms and washes move sinuously and are as transparent as mist or water. More earthbound, Bichitr depicted the world as architectonic and crystalline. Govardhan's textiles are light and diaphanous, while Bichitr's are weighty, crisply outlined, and stiffly starched. Both artists painted nature's truths, but one did so through feelings and intuitive insight, the other with rigorous logic. Both offer mysteries, one interior, the other exterior. Govardhan's sensitive mind and brush gently beckoned characterizations from inner depths; Bichitr netted personalities with studied, wiry outlines and froze his catch.

The nineteenth-century artist intensified the subtle palette and lavished additional gold on the bowstring and arrows. Reinterpreting Bichitr's Govardhanesque theme, he summarily traced its rigid hands and facial expressions, adding his own dense network of crinkles and mottlings. He seeded the dusty tan ground with grass and weeds and, misled by the tracing, transformed the twisted curtain or tent wall (upper right) into a dented buffalo-skin waterbag.

SCW

THE VERSES around the picture, written in very sloppy nasta'liq, are from a didactic *mathnavi* in the *mutaqarib* meter.

AS

THE FLYING birds in this picture are not identifiable. The inner border has verses written directly onto the paper, separated by rectangles containing cartouches. The second narrow border has a gold flowerhead scroll on a pale blue ground. The main border contains a very regular and not very graceful floral scroll in colors on a buff ground.

MLS

1. For Bichitr's picture, now in the Minto Album (V&A 27–1925), see Stchoukine, *La Peinture indienne*, pl. XLIV; for Govardhan's picture, see Arnold and Wilkinson, *Beatty Library*, III, frontis., or Welch, *India*, no. 159.

99. Black Partridge

Early nineteenth century

INSCRIBED (in nastaʿliq): "work of the slave of the threshold, Muhammad ʿAlam Akbarshahi"

FGA 39.47b

THE BLACK partridge, or francolin (*Francolinus francolinus*), ranges throughout Northern India except in Sind and Baluchistan where a similar partridge of paler hue is found. Once a resident of Southern Europe, it is now extinct there. It is one of the favorite game birds of Northern India, and its loud and familiar call note "with its ring of pride and well-being"[1] is especially memorable.

On the subject of the black partridge Jahangir wrote in his memoirs: "I got a black partridge caught by a falcon, and ordered its crop to be cut open in my presence. A mouse was found which it had swallowed whole and had not as yet undergone any change. It was astonishing to see how, its oesophagus, being so narrow, could have admitted a full mouse. Without exaggeration, if somebody else had said so, it was impossible to believe. Since I have personally witnessed it I record it as an unusual thing."[2]

This painting is presumably an early nineteenth-century copy of an original seventeenth-century picture of a black partridge, with the original inscription also reproduced. It is not known whether or not the original has survived. Muhammad ʿAlam's name does not appear among the known Akbari or Jahangiri painters, and his style cannot be accurately determined from the copy if indeed he was a seventeenth-century artist and not, as has been suggested, an early nineteenth-century one. (For another nineteenth-century copy signed "Muhammad ʿAlam," see MMA fol. 25r [pl. 90].)

The border of this page and that of the recto are by the same hand. The only difference between the two is the additional panels of verse here above and below the bird.

MLS

ON THE TOP is an Arabic quatrain whose Persian translation appears beneath the picture. It admonishes the reader to be faithful to God's orders for then God will protect him. The inner border contains verses from a heroic *mathnavi* in the *mutaqarib* meter, probably from Nizami's *Iskandarnama*.

AS

1. Whistler and Kennear, pp. 430–32.
2. Alvi and Rahman, *Jahangir the Naturalist*, p. 54, quoting from the *Tuzuk*.

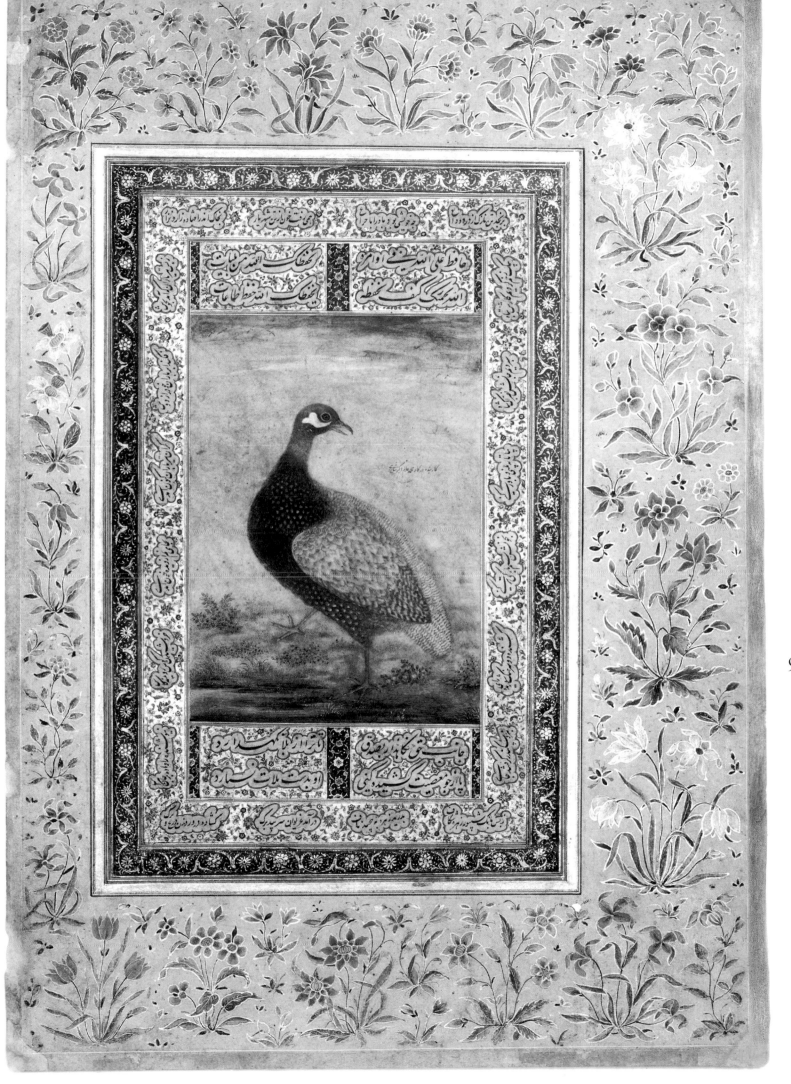

99

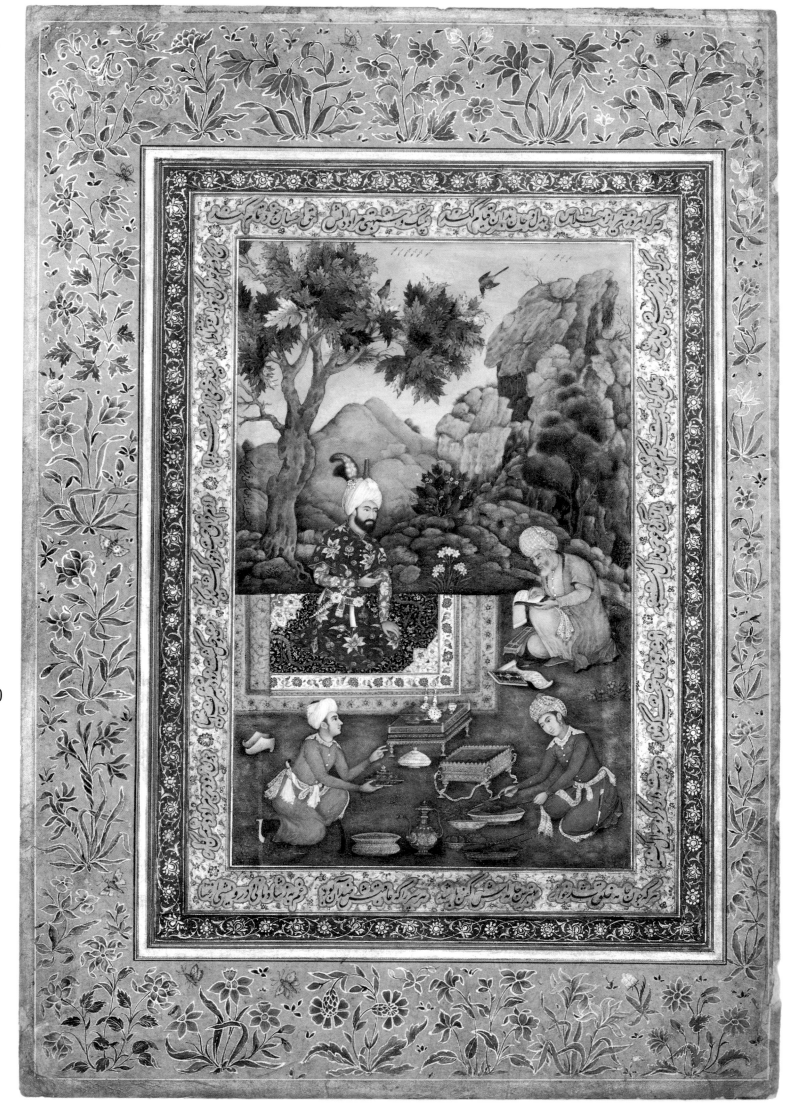

100. Shah Tahmasp in the Mountains

Early nineteenth century

Inscribed to Farrukh Beg

FGA 39.47a

THIS ARCHAIZING portrait of Shah Tahmasp (1514–76), the great Safavid patron who reigned in Persia from 1524 until his death, brings to mind historical films in which legendary beings are forced into "period" settings. The baton of his turban has been truncated; the landscape is trumped up from late sixteenth-century Mughal rather than Iranian sources; and the kebabs evoke flavors that are more traditional than the costumes of their cooks. It may have been inspired by a portrait painted for Jahangir by Sahifa Banu, the best-known woman artist of the Mughal court.[1] Her fine but amateur accomplishment was deemed worthy of one of the richest of all seventeenth-century Mughal borders, adorned (by Mansur himself?) with drawings in gold of flora and fauna. This early nineteenth-century pastiche bears no relationship to the work of the eminent artist Farrukh Beg, to whom it was inscribed.

SCW

THIS PORTRAIT is surrounded by Persian verses in apparent disorder. The reader is urged to turn to God and is told that "death is better than a life in misery."

AS

HERE AGAIN is the familiar nineteenth-century border of verses simulating the cutout ones of seventeenth-century albums, with a second border of a flower-head and palmette scroll in gold on blue. The main border is in colors heavily outlined in gold on a buff ground.

MLS

1. For Sahifa Banu's portrait, see Clarke, *Indian Drawings*, no. 27, pl. 18. It is in the Wantage Album (V&A 177–1921).

Appendix: Comparative Illustrations

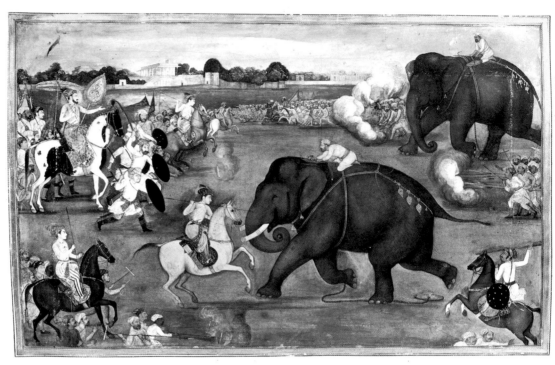

FIG. 15 Attributed to Govardhan, *Prince Aurangzeb Spearing an Enraged Elephant*. Windsor *Padshahnama*, fol. 133r. Her Majesty Queen Elizabeth II, Royal Library, Windsor Castle

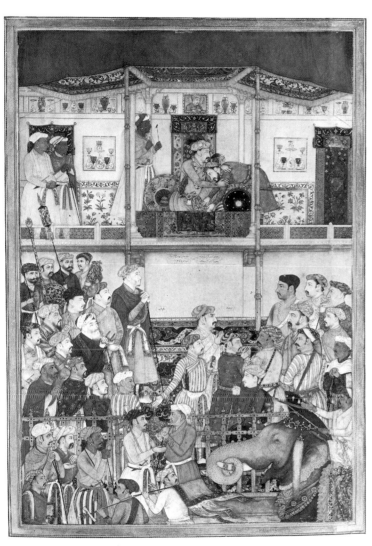

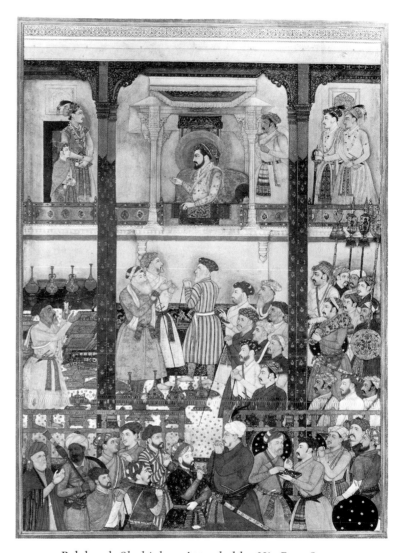

FIG. 16 Balchand, *Jahangir Receiving Shahjahan Prior to His Departure to Attack Mewar*. Windsor *Padshahnama*, fol. 43v. Her Majesty Queen Elizabeth II, Royal Library, Windsor Castle

FIG. 17 Balchand, *Shahjahan Attended by His Four Sons*. Windsor *Padshahnama*, fol. 72v. Her Majesty Queen Elizabeth II, Royal Library, Windsor Castle

FIG. 18 Balchand, *Shahjahan Attacks a Lion That Had Thrown Down Anup Singh*. Windsor *Padshahnama*, fol. 134r. Her Majesty Queen Elizabeth II, Royal Library, Windsor Castle

FIG. 19 Attributed to Hashim, *Malik 'Ambar*. Deccan, 1610–20. Museum of Fine Arts, Boston, Ross-Coomaraswamy Collection, 17.3103

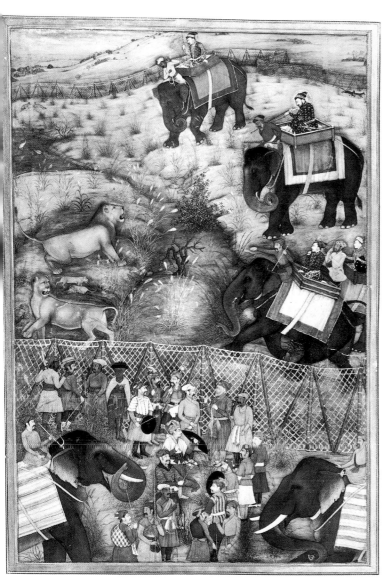

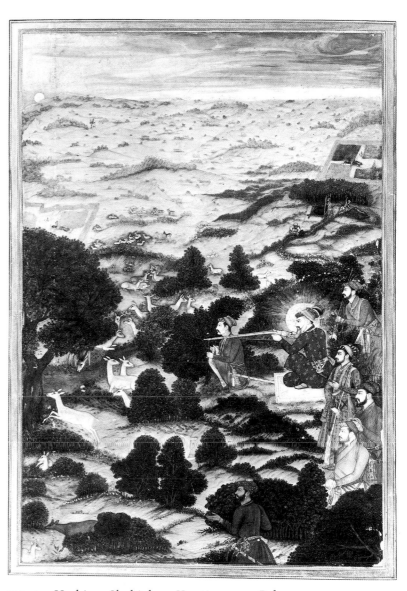

FIG. 20 Attributed to Hashim, *Shahjahan Shooting Lions with Shah Shuja⁶ and Dara-Shikoh near Palam*. Windsor *Padshahnama*, fol. 219v. Her Majesty Queen Elizabeth II, Royal Library, Windsor Castle

FIG. 21 Hashim, *Shahjahan Hunting near Palam*. Windsor *Padshahnama*, fol. 164r. Her Majesty Queen Elizabeth II, Royal Library, Windsor Castle

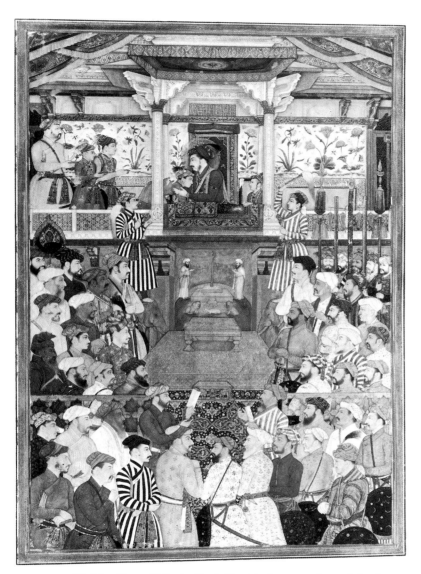

نگاه کرد برهمنی دید قدم تجرید درعالم تقرب نهاده و شقّه علم حقا
درمیدان دقایق جلوه داده سیرتی ملکی بصورت بشری او
ظاهر و نظافت چشمش برلطافت برهانی باهر رای بفراست

FIG. 22 Bichitr, *Dara-Shikoh, Shah Shuja', Aurangzeb, and Asaf Khan Received at Court*. Windsor *Padshahnama*, fol. 50v. Her Majesty Queen Elizabeth II, Royal Library, Windsor Castle

FIG. 23 Abu'l-Hasan, *King Dabshalim and the Sage Bidpai*. Leaf from a manuscript of the *Anwar-i Suhayli* (Lights of Canopus). British Museum, Add. 18579

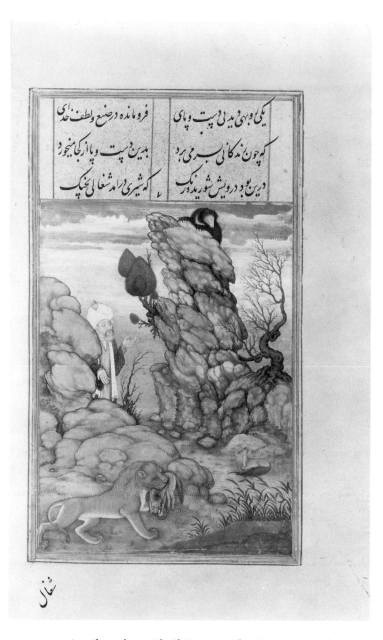

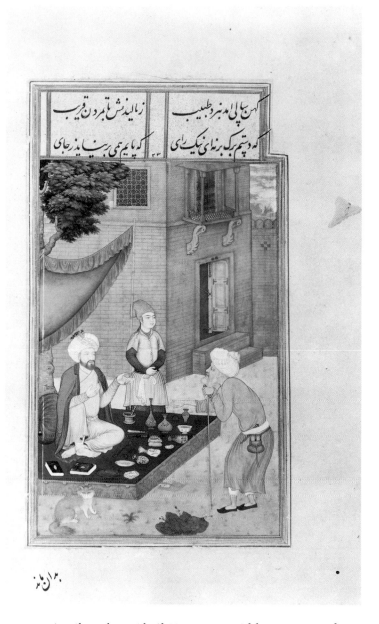

FIG. 24 Attributed to Abu'l-Hasan, *The Devotee and a Fox.* Leaf from a manuscript of Saʿdi's *Bustan*, copied for Jahangir and dated A.H. 1014/A.D. 1610–11. Collection Aboulala Soudavar

FIG. 25 Attributed to Abu'l-Hasan, *An Old Man Consults a Doctor.* Leaf from a manuscript of Saʿdi's *Bustan*, copied for Jahangir and dated A.H. 1014/A.D. 1610–11. Collection Aboulala Soudavar

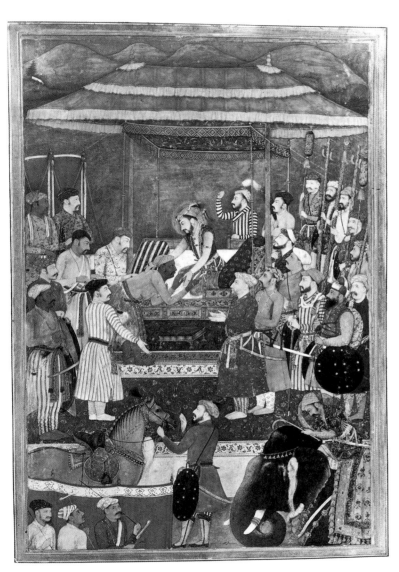

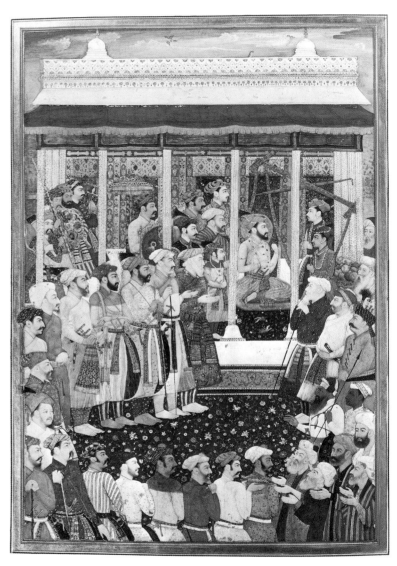

FIG. 26 La'lchand, *Prince Khurram Receiving the Submission of Maharana Amar Singh of Mewar.* Windsor *Padshahnama*, fol. 46v. Her Majesty Queen Elizabeth II, Royal Library, Windsor Castle

FIG. 27 Bola, *Shahjahan Being Weighed Against Sacks of Coins or Gems While Receiving His Sons and Courtiers.* Windsor *Padshahnama*, fol. 70r. Her Majesty Queen Elizabeth II, Royal Library, Windsor Castle

294

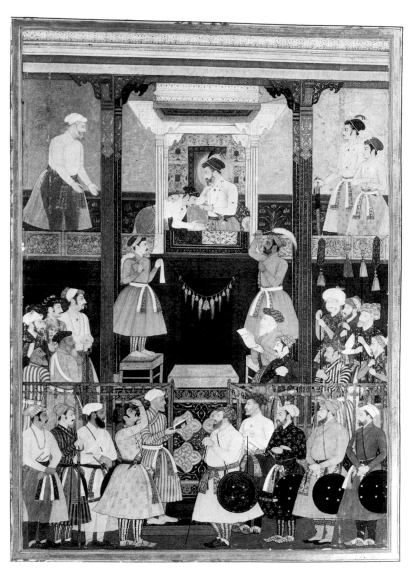

Murad, *Departure of Prince Muhammad Shah Shujaʿ for the Conquest of the Deccan* (Khan-Dauran Bahadur Nusrat-Jang is shown at the bottom center). Windsor *Padshahnama*, fol. 146v. Her Majesty Queen Elizabeth II, Royal Library, Windsor Castle

CHRONOLOGY

1504

Zahiruddin Muhammad Babur (1483–1530), descended from Tamerlane (Timur) and Genghis Khan, occupies Kabul, where his son and successor, Nasiruddin Muhammad Humayun (ca. 1508–1556), is born four years later.

1526

Babur defeats Ibrahim Lodi, last sultan of Delhi, at Panipat. A year later, Babur's armies crush the combined forces of Rana Sangram Singh of Mewar and a confederacy of other Rajputs. Characteristically, one of his first deeds in India is to design and plant a garden at Khanua; but no miniature paintings, manuscripts, or albums made for him are known.

1530

Babur dies; Humayun (r. 1530–42, 1555–56) succeeds him, as second Mughal emperor.

ca. 1530

Earliest miniature of the Kevorkian Album (pl. 52), *Dancing Dervishes*, painted at Tabriz by Aqa-Mirak, the great Safavid master.

1539–40

Sher Shah Sur, an ambitious Afghan officer, turns against Mughals and defeats Humayun in Bihar and later at Kanauj. He takes Delhi, ascends the throne, and forces Humayun into exile in Iran.

1542

Abu'l-Fath Jalaluddin Akbar (1542–1605) is born at Umarkot in Sind.

1544

Humayun is received by Shah Tahmasp at the Safavid court, where he meets major artists of the court atelier.

1545

Humayun, with military and financial support from Shah Tahmasp, captures Qandahar and Kabul.

1549

Safavid artists Mir Sayyid-'Ali and 'Abd as-Samad join Humayun at Kabul. Mir Musavvir, father of Mir Sayyid-'Ali, and Dust-Muhammad arrive later.

Humayun's extremely active patronage is displayed in surviving works like the seminal *Muraqqa'-i Gulshan* (Gulistan Library, Teheran), several miniatures of which retain contemporary borders. The Berlin Album, virtually a continuation of the Gulshan Album and similar in size, contains several of Humayun's miniatures; it was expanded under emperors Akbar and Jahangir (see Kühnel and Goetz, *Jahangir's Album in Berlin*; see also under 1609).

1555

Humayun returns to India; defeats Sultan Sikandar Shah Sur, son of Sher Shah who had been slain during a siege, at Sirhind.

Mir Sayyid-'Ali, 'Abd as-Samad, and Mir Musavvir establish ateliers. Mir Musavvir contributes three min-

iatures to a *Khamsa* of Nizami (Kasturbhai Lalbhai collection, Ahmedabad), which also contains work by indigenous and Uzbek artists (see Welch, "A Mughal Manuscript," pp. 188–90, pls. 97–104).

1556

Humayun trips on library staircase in Delhi; he dies and is succeeded by his fourteen-year-old son, Akbar, whose armies defeat the formidable Hindu general Hemu at Panipat.

1557

Akbar defeats Sikandar Shah Sur.

1560

Akbar establishes his authority as emperor by dismissing his powerful and effective regent, Bayram Khan, a major force in the restoration of Mughal power.

1561

Akbar annexes Malwa, Central India.
Bayram Khan assassinated.

1562

Akbar marries Maryam uz-zamani, the daughter of the raja of Amber, establishing close ties with a major Rajput dynasty.

Tansen, the inspired musician from Gwalior, arrives at Akbar's court.

1562–68

Birth of Akbar's twin sons and of other infants, all of whom die.

1564

Akbar abolishes the *jizya* tax levied on all non-Muslims, marking new conciliatory policy toward Hindus and others. (It remains abolished until 1679, when it is reimposed by the highly orthodox Emperor 'Alamgir.)

1564–65

Akbar begins building a palace near Agra.

1565–70

Akbar reconstructs the fort at Agra.

ca. 1567–82

Presumed dates of Akbar's crucial series of fourteen hundred large, dynamic, and fantastic paintings on cloth illustrating the *Dastan-i Amir Hamza* (Story of Hamza), carried out by Mir Sayyid-'Ali, 'Abd as-Samad, and the emerging indigenous masters of the imperial ateliers.

1568

Mughal conquest of Chitor, a major fort of the Sesodias of Mewar, proudest and most independent of Rajput dynasties.

1569

Mughal capture of Rajput fort at Ranthambhor, northeastern Rajasthan.

August 30: Birth of heir, Prince Salim (1569–1627; Em-

peror Jahangir, r. 1605–1627) at Sikri to Maryam uz-zamani. Akbar, now twenty-seven, endows a shrine there in gratitude for the intercession of Sufi saint Shaykh Salim Chishti.

1570

Akbar's second son, Prince Murad (1570–99), is born.

1570–71

Manuscript of Husayn Vaʿiz-i Kashifi's *Anvar-i Suhayli* (The Lights of Canopus; School of Oriental and African Studies, University of London, ms. 10102) is mostly illustrated by recruited Indian artists closely directed by the Iranian masters of Humayun (see Welch, *India*, pp. 154–57).

1571

Fatehpur-Sikri (Fatehpur, City of Victory) begun near Chishti shrine. A major intellectual and artistic as well as governmental center, it is expanded and enriched until 1585/86, when the court moves to Lahore.

Abuʾl-Fazl, in the *Aʾin-i Akbari* (Statutes of Akbar), discusses the emperor's views on painting: "His Majesty, from his earliest youth, has shewn a great predilection for this art, and gives it every encouragement, as he looks upon it as a means, both of study and amusement. Hence the art flourishes, and many painters have obtained great reputation. The works of all painters are weekly laid before His Majesty by the Dároghahs and the clerks; he then confers rewards according to excellence of workmanship, or increases the monthly salaries. Much progress was made in the commodities required by painters, and the correct prices of such articles were carefully ascertained. The mixture of colours has especially been improved. The pictures thus received a hitherto unknown finish. Most excellent painters are now to be found, and master-pieces, worth of a *Bihzád*, may be placed at the side of the wonderful works of the European painters who have attained world-wide fame. The minuteness in detail, the general finish, the boldness of execution, &c., now observed in pictures, are incomparable; even inanimate objects look as if they had life. More than a hundred painters have become famous masters of the art, whilst the number of those who approach perfection, or of those who are middling, is very large. This is especially true of the Hindus: their pictures surpass our conception of things. Few, indeed, in the whole world are found equal to them."

Abuʾl-Fazl continues: "I have to notice that the observing of the figures of objects and the making of likenesses of them, which are often looked upon as an idle occupation, are, for a well regulated mind, a source of wisdom, and an antidote against the poison of ignorance. Bigoted followers of the letter of the law are hostile to the art of painting; but their eyes now see the truth. One day at a private party of friends, His Majesty, who had conferred on several the pleasure of drawing near him, remarked: 'There are many that hate painting; but such men I dislike. It appears to me as if a painter had quite peculiar means of recognizing God; for a painter in sketching anything that has life, and in devising its limbs, one after the other, must come to feel that he cannot bestow individuality upon his work, and is thus forced to think of God, the Giver of life, and will thus increase in knowledge'" (*Aʾin-i Akbari*, pp. 107, 108).

1572

Prince Danyal (1572–1605) born. Mir Sayyid-ʿAli departs for Mecca.

1573

Mughal conquest of Gujarat.

1574

Office of Records and Translation Bureau set up at Fatehpur-Sikri. Arts ateliers burgeoning. Major manuscripts and albums in progress: for an illustration from one of the latter, see *A Cow and Calf* by Basawan (Welch, *A Flower from Every Meadow*, no. 55, pp. 94–95).

1575

Akbar sends emissaries to Portuguese settlement at Goa (established in 1510).

Akbar sets up House of Worship at Fatehpur-Sikri for religious debates among members of Muslim sects, Christians, Hindus, Jains, and others.

ca. 1575

Akbar, according to Abuʾl-Fazl, "himself sat for his likeness, and also ordered to have the likenesses of all the grandees of the realm. An immense album [long since scattered] was thus formed: those that have passed away have received a new life, and those who are still alive have immortality promised them" (*Aʾin-i Akbari*, pp. 108–109).

1576

Bengal conquered by Mughals.

1577

Akbar's mission returns from Goa.

The artist ʿAbd as-Samad appointed director of mint at Fatehpur-Sikri.

1578

Father Pereira, Jesuit vicar-general of Bengal, arrives at Fatehpur-Sikri.

Akbar experiences a transforming vision during *qamargah* (ring) hunt at Bhera. He makes a resolution against hunting; there are lavish donations to holy men and the poor.

1579

Akbar reads Friday sermon in mosque at Fatehpur-Sikri.

1580

First Jesuit mission of Father Rudolf Aquaviva arrives at Fatehpur-Sikri from Goa. Akbar and his artists admire European religious prints, which are copied by Mughal painters (Welch, *India*, pp. 164–65).

1581

Akbar leads army to Kabul, defeats his half brother Mirza Muhammad Hakim.

1582

Akbar establishes *Din-i-ilahi*, his new code of religious behavior, intended to unify disparate religious groups of the empire.

Akbar commissions illustrated translation of Hindu epic, the *Mahabharata*, to increase understanding of Hinduism by Muslims. He also commissions an illustrated copy of the Iranian epic, the *Shahnama* (Book of Kings).

1583

Akbar reorganizes the imperial government; his three sons head the main departments.

1584

Illustrated historical manuscript, the *Tarikh-i Khandan-i Timur* (History of the House of Timur), in progress.

1585

Prince Salim (Jahangir) marries daughter of Raja Bhagwan Das of Amber.

Akbar moves to the northwest to control crucial area following the death at Kabul of his half-brother Mirza Muhammad Hakim, whom he had defeated in battle in 1581 but allowed to continue there as ruler.

Akbar annexes Kashmir.

1586

Lahore becomes the new capital of the Mughal empire.

1587

Birth of Prince Khusrau (1587–1622), eldest son of Prince Salim (Jahangir), at Lahore.

1587–88

Illustrated translation of Hindu epic of *Ramayana* (Story of Rama) in progress.

Abu'l-Fazl writing *Akbarnama*, official history of Akbar's reign.

1588

Intimately scaled, masterfully illustrated divan of Anvari (Fogg Art Museum) copied and illustrated in Lahore, where Akbar—abetted by Prince Salim—commissions a series of superb illustrated manuscripts of Iranian and Indian classics (see Schimmel and Welch, *Anvari's Divan*).

1588–89

Birth of Abu'l-Hasan (Nadir az-zaman), son of Aqa-Riza Jahangiri and one of Emperor Jahangir's favorite painters (for a summary of his career and work, see Beach, *Grand Mogul*, pp. 86–92).

1589

Death of Tansen, Akbar's most inspired musician.

Translation of *Baburnama* presented to Akbar by 'Abd-ar-Rahim, the Khankhanan, great statesman, soldier, and poet (see pl. 19).

Birth of Prince Parviz (1589–1626), son of Prince Salim (Jahangir).

1592

Eastern province of Orissa annexed by Mughals.

Birth of Prince Khurram (1592–1666; Emperor Shahjahan, r. 1628–58), son of Prince Salim (Jahangir).

ca. 1595–96

Khamsa of Nizami, a particularly deluxe manuscript, illustrated only by major masters, now in the British Library (Or. Ms. 12208) and in the Walters Art Gallery, Baltimore (see Losty, *Art of the Book in India*, pp. 90–91;

Welch, "The Emperor Akbar's *Khamsa* of Nizami," pp. 86–96). It contains latest datable work of 'Abd as-Samad, who must have died soon thereafter.

1596

Akbar conquers Berar in the Deccan, but in spite of almost a century of campaigning, the region would not be annexed until the later seventeenth century.

Abu'l-Fazl presents the first volume of *Akbarnama*, probably the splendid manuscript illustrated by Akbar's many masters, usually working with their assistants, of which 117 folios are in the Victoria and Albert Museum, London (see Sen, *Paintings from the Akbar Nama*).

1598

Agra reinstated as Mughal capital.

1599

Death of Prince Murad, while leading Mughal armies in the Deccan. He is replaced there by his brother Danyal.

1600

English East India Company granted charter by Queen Elizabeth I (r. 1558–1603).

1601

February: While Akbar is in the Deccan, Prince Salim (Jahangir) rebels, assumes the title of king, takes Oudh and Bihar, and establishes his own imperial court—and ateliers—at Allahabad.

Akbar captures Khandesh in the Deccan.

Date of earliest Jahangiri inscription in *Muraqqa'-i Gulshan*, on a border by Aqa-Riza Jahangiri (see Beach, *Imperial Image*, p. 156).

1602

Rebellious Prince Salim (Jahangir) saddens and outrages his father by arranging the assassination of Abu'l-Fazl, Akbar's close friend and historian, and author of the *Akbarnama*.

Dutch East India Company granted charter under Maurice of Nassau (r. 1587–1625).

1605

March: Prince Danyal dies from consuming alcohol—an imperial family weakness—smuggled in a rusty gun barrel to him at Burhanpur in the Deccan.

October 24: Akbar dies after a reign of 41 lunar years, 9 months, at the age of 64 lunar years, 11 months. Prince Salim succeeds as Emperor Nuruddin Muhammad Jahangir (r. 1605–27), the World Seizer; he ascends the throne, Thursday, October 24. He soon releases most of his father's painters, who spread the Mughal style by finding employment in urban bazaars and at Rajput courts, and retains only the most admired masters and apprentices.

Beginning of the lively and candid *Tuzuk-i Jahangiri* (Memoirs of Jahangir), Jahangir's autobiography from his accession to 1622, after which, through 1624, it was transcribed by Mu'tamid Khan. It was paralleled by a series of historical miniatures of noteworthy episodes, presumably intended to illustrate a copy—or copies. Most of these are sparklingly immediate and highly detailed, by artists who sketched the scenes from life. In keeping with Jahangir's beguilingly idiosyncratic mind, the subjects include such

trivia as the emperor stopping a royal progress to observe a snake fighting a spider (Brown, *Indian Painting*, pl. xix; Beach, *Imperial Image*, pp. 172–73, provides a useful list of surviving miniatures from this extraordinary volume).

November: Husayn Khan Shamlu of Herat, on Akbar's death, besieges the strategic fort of Qandahar. It is bravely defended, relief is sent, and Shah ʿAbbas Safavi orders the siege to be raised.

1606

April 6: Rebellious Prince Khusrau escapes from the fort in Agra on the pretext of visiting his grandfather Akbar's tomb. He is joined by fellow conspirators on the way to Punjab. Jahangir dispatches troops, then follows in person. Council of Regency is formed, headed by Prince Khurram (Shahjahan); this is his first contact with public affairs.

Khusrau's rebellion is over less than a month later. His life is spared, but he is forced to ride an elephant down a street lined with stakes upon which his supporters have been impaled.

May 9: Jahangir enters Lahore, where he remains for the next eleven months to watch over the Iranian frontier. Intending to visit Kabul as soon as conditions calm, he summons Prince Khurram, Maryam uz-zamani (his mother), and other ladies. Another son, Prince Parviz, also comes to Lahore.

1607

March 21: At Lahore Prince Khurram is assigned his first military *mansab* (rank) of 8,000 *zat* (personal troops) and 5,000 *suwar* (horsemen) together with a *tuman-i tugh* (standard), a flag, and kettle drums. A week later, amid much rejoicing, he is betrothed to Arjumand Banu Begum, daughter of Iʿtiqad Khan (Asaf Khan) and niece of the soon-to-be empress Nur-Jahan.

Prince Khusrau rebels again; he plunders near Lahore but is defeated. On June 10, he is brought captive before his father, is partly blinded, and is imprisoned.

Arjun, fifth Sikh guru, is charged with aiding Khusrau and is executed.

Jahangir leaves Lahore, journeys to Kabul, where he arrives on June 4. Urtabagh (Garden of Urta) is given to Prince Khurram, which he redesigns, to Jahangir's delight. When the prince, known familiarly to his father as Baba Khurram, feels unwell, he is weighed against assorted metals and other valuables.

November 23: After a great *qamargah* (ring) hunt at Hasan Abdal, in which Princes Khurram and Parviz join their father, the royal party returns to Lahore, whence they proceed to Agra, arriving on March 12, 1608.

1608

Prince Khurram, now sixteen, is given a separate house and establishment in the Agra fort. His first experience as patron of architecture is remodeling it, which his father warmly approves.

1609

Earliest date (latest is 1618) found in the so-called Berlin Album (State Library, Berlin; see above, under 1549).

Khan Jahan Lodi loses heavily in a battle against Malik ʿAmbar, now master of the Deccan.

Malik ʿAmbar invades Gujarat, plunders Surat and Baroda, and retires. Mughal force stationed at Ramnagar to protect Gujarat.

April: Captain William Hawkins arrives at Agra from Surat as envoy of King James I (r. 1603–25) to Jahangir, to the dismay of the Portuguese. Hawkins stays until November 1611.

May: British East India Company granted a second charter by King James I (original charter granted in 1600).

Dutch build a fort at Pulikat, twenty-four miles north of Madras, their earliest settlement in southern India.

September: Prince Khurram's taste for jewels is whetted when Jahangir gives him a valuable ruby with two single pearls.

Four months later, Prince Khurram—although already engaged to Arjumand Banu—is also betrothed to the daughter of Mirza Muzaffar Husayn Safavi, a lineal descendant of Shah Ismaʿil, founder of the Safavid dynasty. He marries her on October 29, 1610.

Malik ʿAmbar Habashi (ca. 1546–1626; born a slave), the dynamic Abyssinian of the Deccan, conciliates Murtaza Nizam-Shah of Ahmadnagar and assumes rule of kingdom.

ca. 1609

Folio of *Muraqqaʿ-i Gulshan* (Gulistan Library, Teheran) containing detailed and animated portraits by Daulat of Abuʾl-Hasan, Manohar, Bishan Das, and Govardhan, as well as a self-portrait. Identical in style to a figural border by Daulat in the same album dated to 1609, it must have been painted in the same year (see Godard, "Les Marges du Murakkaʿ Gulshan," pp. 11–33, esp. 18–33; see also Beach, *Grand Mogul*, for reproductions from Godard of individual portraits).

1610

Malik ʿAmbar founds new capital, Kharki (now Aurangabad), and recovers Ahmadnagar and Berar districts.

During a hunt Prince Khurram and his father save the life of Anup Rai, who was attacked by a lion.

1610–11

May 25: Jahangir marries Mihr un-Nisa (1573–1645), the ambitious daughter of Iranian émigré Iʿtimaduddaula (see pl. 16) and greatly accomplished widow of Sher Afkan. She is entitled Nur-Jahan (Light of the World) by the devoted Jahangir, and she gains formidable power. Her family and fellow Iranians flourish at the imperial court.

1611–12

Date (A.H. 1020) inscribed in Prince Khurram's album (now scattered), which contained specimens of the prince's own calligraphy and brilliant, mostly early Akbari sketches and portrait miniatures (presumed gifts from Akbar), shows evidence of the prince's discerning interest in pictures (see Welch, *Indian Drawings and Painted Sketches*, no. 7; Beach, *Grand Mogul*, p. 74).

1612

January 21: Sultan Muhammad-Quli Qutb-Shah of Golconda dies; his brother ʿAbdullah Qutb-Shah succeeds.

March 12: Jahangir grants a firman permitting the English to establish factories at Surat, Gogha, Ahmedabad, and Cambay: thus Surat forms the first established settlement of the English in India.

March 27: At Nur-Jahan's urging, Prince Khurram is elevated to *mansab* (rank) of 12,000 *zat* and 5,000 *suwar*. Now entitled sultan, he is married to Nur-Jahan's niece, Arjumand Banu Begum, entitled Mumtaz-Mahal (Chosen One of the Palace) daughter of I'tiqad Khan (Asaf Khan). Month-long celebrations at Agra.

Rana Amar Singh of Mewar is defeated by Mughal general Mahabat Khan (see pl. 24), but he retains independence.

Malik 'Ambar forces the retreat of the imperial army led by 'Abdullah Khan.

1614

Early in the year, Prince Khurram (now *subadar*, or governor, of Malwa with a *mansab* of 15,000 *zat* and 8,000 *suwar*) leads 12,000 men against Mewar. After terrible battles, Rana Amar Singh surrenders Mewar's independence. Though not required to attend court, where he is to be represented by Kumar Karan, he comes in person to wait upon Prince Khurram, and he promises never again to fortify Chitor. Karan is received by Khurram, who gives him "a superb dress of honor, a jewelled sword and dagger, a horse with a gold saddle, and a special elephant." Jahangir, pleased by Khurram's victory, embraces him, kisses his head and face, and favors him with "special kindnesses and greetings" (Jahangir, *Tuzuk*, pp. 276, 277). Prince Khurram's campaign earns the devoted friendship of several noblemen, including Sundar Das (pl. 32) and Sayf Khan Barha (pl. 21).

March 20 or April 2: Birth of Jahanara Begum, accomplished, beautiful, and heroic daughter of Prince Khurram (Shahjahan), who would attend him during his imprisonment in the fort of Agra from 1658 until his death in 1666.

Raja Man Singh of Amber dies at Bidar in the Deccan.

1615

February 7: William Edwards, British East India Company's agent, presented to Jahangir. He obtains a general and perpetual firman for trade with Mughals.

Jahangir's troops suppress rebellion of Ahmad the Afghan, who had long held out in the mountains of Kabul.

March 19: birth of Prince Dara-Shikoh, son of Prince Khurram.

Victory gained in the Deccan by Prince Khurram against the united armies of Malik 'Ambar and the sultans of Bijapur and Golconda.

June 7: Treaty between Jahangir and the Portuguese in order to expel the English and the Dutch. Spain and Portugal for the first time unite against common rival, the Dutch.

July: Louis XIII of France (r. 1610–43) grants letters to a third French company to trade with the Indies.

September 18: Sir Thomas Roe, ambassador from James I of England to Jahangir, arrives at Swally Roads. Leaves for Agra, October 30; arrives at Ajmer, December 23. He accompanies Jahangir to Mandu and Gujarat.

1616

January 10: Roe is received by Jahangir in darbar. On March 26, Roe presents Jahangir with nineteen articles of Amity,

Commerce, and Intercourse. Some concessions are granted in September, but not full assent.

February 1: Solar birthday of Prince Khurram, now twenty-four, celebrated at Ajmer. His *mansab* is raised to 20,000 *zat* and 10,000 *suwar*, and he replaces Prince Parviz —removed for incompetency—as *subadar* of the Deccan, "as the signs of rectitude and knowledge of affairs were evident in him" (Jahangir, *Tuzuk*, p. 329).

June 23: birth of Prince Shah Shuja', son of Prince Khurram.

July–August: Sir Thomas Roe shows an English miniature portrait to Jahangir, who admires it. There ensues a bet stipulating that Roe give Jahangir's brother-in-law Asaf Khan "a good horse" if one of Jahangir's painters can make a copy "so like, that you shall not knowe your owne." One night a month later, Roe is summoned to see "6 Pictures, 5 made by his [Jahangir's] man, all pasted on one table, so like that I was by candle-light troubled to discerne which was which.... At first sight I knew it not, hee was very merry and Ioyfull and craked like a Northern man" (Roe, *Embassy*, 1, pp. 224–25).

'Abdul-Baqi's *Ma'athir-i Rahimi* (Memoirs of 'Abdur-Rahim, Khankhanan) completed.

October 6: Prince Khurram leaves Ajmer for the Deccan and marches straight to Burhanpur. According to the *Tuzuk-i Jahangiri*: "The time for the leave-taking of Baba Khurram had been fixed as Friday, the 20th (Aban). At the end of this day he paraded before me the pick of his men armed and ready in the public hall of audience. Of the distinguished favours bestowed on the aforesaid son was the title of Shah, which was made a part of his name. I ordered that thereafter he should be styled Shah Sultan Khurram. I presented him with a robe of honour, a jewelled *charqab*, the fringe and collar of which were decorated with pearls, an Iraq horse with a jewelled saddle, a Turki horse, a special elephant called Bansi-badan, a carriage, according to the English fashion, for him to sit and travel about in, a jewelled sword with a special *pardala* (sword-belt) that had been taken at the conquest of Ahmadnagar and was very celebrated, and a jewelled dagger" (pp. 338–39).

1617

March: Prince Khurram enters the Deccan and detaches Bijapur from the confederacy, whereupon Malik 'Ambar makes peace on behalf of the Nizam-Shah. Ahmadnagar and the reconquered territory are restored to Mughal control.

August 23: While in the Deccan, Shahjahan marries his third wife, daughter of Shahnawaz Khan, son of 'Abdur-Rahim, Khankhanan. Shahjahan's court at Burhanpur is becoming a significant artistic center (see Welch, *India*, pp. 229–32, 370).

October 12: Prince Khurram returns to his father at Mandu, where, in the Hall of Audience, he is called over to the *jharoka* (window of appearances). "With exceeding kindness and uncontrolled delight [Jahangir] rose from [his] seat and held him in the embrace of affection" (Jahangir, *Tuzuk*, p. 394). Prince Khurram is given a seat near the throne and receives the unprecedented rank of 30,000 *zat* and 20,000 *suwar* together with the title of Shahjahan. Gifts are showered upon him by his father, and Nur-Jahan

organizes a great feast in his honor. Other officers of the Deccani campaign—Khan-Jahan Lodi, Mahabat Khan, Raja Bhao Singh, Darab Khan, son of the Khankhanan, Sardar Khan, brother of ʿAbdullah Khan, Dayanat Khan, Shahbaz Khan, Muʿtamid Khan Bakhshi, and Uda Ram Decanni —offer presents to the emperor.

A month and a half later, Shahjahan brings the rich treasures from the Deccan to his father. On November 20, these are arranged in the Hall of Audience before the *jharoka*, together with horses and elephants in gold trappings. Jahangir comes down to inspect them, and five elephants of mountainous size please him most. The presents are valued at 2,260,000 rupees; and of these, presents worth 200,000 rupees are given by the prince to his stepmother Nur-Jahan.

In recognition of Shahjahan's success, the province of Gujarat is also assigned to him.

1618

May: Both Jahangir and Shahjahan ill with fever.

September: Jahangir leaves Gujarat for Agra after a sojourn of nearly a year. Sir Thomas Roe leaves Ahmedabad for Surat, having obtained firmans putting the English on a better footing in India than either the Portuguese or the Dutch.

October 24: Birth of ʿAlamgir, surnamed Abuʾz-Zafar Muhyiʾddin Aurangzeb (1618–1707; r. 1658–1707), third son of Shahjahan, born at Dohad during imperial progress from Gujarat to Ujjain. His mother is Mumtaz-Mahal.

The great fort at Kangra in Punjab having withstood Mughal sieges since 1615, Shahjahan takes upon himself the responsibility of capturing it. He deputes Raja Bikramajit (pl. 32) to reduce the fort, which surrenders in 1620.

1619

January 7: Jahangir enters Fatehpur-Sikri, and Shahjahan celebrates his twenty-eighth solar birthday. Nine days later, Jahangir shows him Akbar's buildings at Fatehpur, explaining them in detail.

Friday, April 8: Shahjahan's mother dies. The next day Jahangir goes to his house to console him; a day later the emperor makes a state entry into the capital, where he remains for six months.

October: Jahangir leaves for Kashmir, stopping for hunting and diversions on way, but disquieting news from the Deccan causes him to leave Kashmir.

November 15: Capitulation of Kangra Fort to the imperial troops.

December: While Jahangir and Shahjahan are in Kashmir, Malik ʿAmbar of Ahmadnagar joins with Sultan Muhammad ʿAdilshah of Bijapur and Sultan Muhammad Qutb-Shah of Golconda in a renewed campaign against the Mughals. Recently organized Maratha horsemen harass imperialist troops with guerilla tactics, and the imperialists fall back to Balapur, then to Burhanpur and Ahmadnagar, both of which are under attack. A message from the Khankhanan (pl. 20) says that unless help comes at once, he will sacrifice his men, then perform *jauhar* (self-immolation). Moved, Jahangir decides to send Shahjahan who leaves Kashmir to command the Mughal army. How-

ever, Shahjahan fears an alliance between the partially blinded but still treacherous Prince Khusrau and Empress Nur-Jahan and feels insecure at being away from the imperial court at a time when Jahangir's health seems to be failing. Shahjahan requests that Khusrau be handed over to him, which is done.

Shahjahan prepares for an arduous campaign in the Deccan. He renounces alcohol and orders that his stock of wine be thrown into the Chambal River and that his gold and silver cups be broken and distributed among the poor.

At Mandu Shahjahan hears from the Khankhanan that Burhanpur is under attack by sixty thousand men. With eighteen thousand men, Shahjahan leaves Mandu on March 25, 1621; the Khankhanan, fearing attack if he emerges with his army, meets him alone outside Burhanpur.

1621

April 4: Shahjahan enters Burhanpur, unnoticed by the Deccanis. He orders that the army be augmented with help from *jagirdars* (landowners) who had suffered at the hands of the Deccanis; thirty thousand men respond. Raja Bhim (pl. 33) and Raja Bikramajit (pl. 32) lead Shahjahan's two regiments; three others are led by Darab Khan, ʿAbdullah Khan, and Abuʾl-Hasan. Raja Bikramajit is in command.

Imperialists force their way into Balaghat, then destroy Kirki, and march toward Daulatabad in hope of defeating Malik ʿAmbar. But Deccani armies attack from all sides and the attempt is given up.

New Mughal plan is to relieve Ahmadnagar, but the path is barred and retreat blocked. Fortunately Shahjahan's armies recover Berar and Khandesh, both of which provinces had been occupied. When these Mughal troops attempt to restore lines of communication with main imperial army, Malik ʿAmbar sends eight thousand men against the imperial army. Shahjahan dispatches reinforcements. Malik ʿAmbar sues for peace, surrenders territories once held by Mughals in the Deccan, and withdraws his men. Treaty concluded by Raja Bikramajit.

Malik ʿAmbar, aided by the Marathas led by Shahji Bhonsla, again revolts against the Mughals. Shahjahan gains the upper hand, and the Marathas desert to the Mughals, receiving posts of distinction.

Empress Nur-Jahan withdraws her support from Shahjahan and betroths her daughter to his youngest brother, Prince Shahryar (1605–1628), whose cause she espouses.

November: When Shah ʿAbbas Safavi's armies besiege Qandahar, Shahjahan refuses to lead relieving army, whereupon his *jagirs* (land holdings) and troops are transferred to Prince Shahryar.

1622

January 26: Prince Khusrau dies in the Deccan—said to have been strangled by order of Shahjahan, whose fear of Nur-Jahan's intrigues has increased.

May 9: Shahjahan rebels openly against the emperor. He proclaims himself emperor of Hindustan and marches on Delhi, where he is defeated and forced back to the Deccan. Beaten again by Prince Parviz and Mahabat Khan, he rallies at Golconda and invades Orissa. He later takes Bardhwan and increases the size of his army.

Shah ʿAbbas Safavi captures Qandahar, which remains in possession of Persia until 1637.

Shahjahan marches from the Deccan for Agra. His army, under Darab Khan, son of the Khankhanan, is defeated at Biluchpur, whence he retires to Mandu. Prince Parviz and Mahabat Khan are sent after him, and the latter persuades many of Shahjahan's followers to desert. Shahjahan crosses the Narbada and occupies Asirgadh and Burhanpur.

The Khankhanan then also deserts, and Shahjahan escapes into Golconda territory.

1623

Shahjahan invades Orissa, defeats the governor of Bengal and masters the province, before being defeated by the imperial army. He sends his family for protection to Rohtas, and in 1624 he retreats to the Deccan.

October–November: Malik ʿAmbar joins Shahjahan in an unsuccessful siege of Burhanpur.

1624

Birth of Murad-Baksh, Shahjahan's fourth son.

1625

Shahjahan—known by Jahangir as *be-daulat* (the Wretch) since his rebellion—submits to his father and is pardoned. His sons Dara-Shikoh and Aurangzeb are sent to court as hostages.

Mahabat Khan (pl. 24) incurs the hatred of Nur-Jahan and is summoned to court. He complies but arrives with a bristling force of five thousand Rajputs.

1626

Mahabat Khan, embittered by Nur-Jahan's intrigues, seizes Emperor Jahangir at his camp on the Jhelim. The following day Nur-Jahan attempts to free her husband but is defeated with great loss and joins him in captivity for six months.

Malik ʿAmbar Habashi dies at the age of eighty and is succeeded as minister of the Deccan by his son Fath Khan.

September: Nur-Jahan's schemes at last succeed in rescuing Jahangir from Mahabat Khan, who is pardoned on releasing Asaf Khan, Nur-Jahan's brother. Mahabat Khan agrees to campaign against Shahjahan who continues to rebel. But Mahabat Khan again breaks with the emperor, and Shahjahan escapes through Gujarat to the Deccan, where he is soon joined by Mahabat.

November 7: Prince Parviz dies at Burhanpur, where he was *subadar* with a *mansab* of 40,000 *zat* and 30,000 *suwar* —higher than Shahjahan had ever ranked under his father.

Sultan Ibrahim ʿAdilshah II of Bijapur dies. Muhammad, his son, succeeds.

1627

Shahjahan enters Rajasthan, where Rana Karan Singh, a foe turned friend, comes to pay homage. They meet at Gonganda on January 1, 1628, with much cordiality. The rana presents horses, elephants, pearls, and diamonds. Shahjahan gives him a gold belt studded with twenty-one rubies, originally property of the house of Bijapur. The rana puts one thousand Rajput horsemen at Shahjahan's disposal. But the rana soon dies and is succeeded by his son, Jagat Singh.

November 8: Jahangir dies, probably of heart disease, in camp at Rajapur on his way from Kashmir to Lahore. Although Asaf Khan favors Shahjahan as successor, he outwardly espouses Dawar Bakhsh, son of Prince Khusrau. Nur-Jahan's candidate, Prince Shahryar, is also proclaimed king. Rival forces meet near Lahore; Shahryar's troops are routed.

1628

February: Prince Dawar-Bakhsh, his brother Garshasp, Prince Shahryar, and the sons of Prince Danyal are put to death, leaving the field open to Shahjahan.

February 14: Shahjahan (1592–1666; r. 1628–58) arrives at Agra and ascends the throne.

March: Princes Dara-Shikoh and Aurangzeb are removed from the care of Nur-Jahan by her brother Asaf Khan, their maternal grandfather, who sends them to Shahjahan at Lahore.

Shahjahan's illustrations for an official history of his reign are probably commissioned soon after he ascends the throne, although those that were ultimately bound into the great manuscript of the *Padshahnama* of Muhammad Amin Qazwini and ʿAbdul-Hamid Lahori must have been incorporated into the volume between 1635, when the manuscript was commissioned, and 1646, when the first section of the project was presented to the emperor. The majestic volume, now in the library of Her Majesty Queen Elizabeth II at Windsor Castle, is dated A.H. 1067 (A.D. 1656–57). Its latest miniatures, including the frontispiece portrait of Shahjahan, are of approximately this date or even a bit later (see Losty, *Art of the Book in India*, pp. 99–100; Beach, *Imperial Image*, pp. 174–77).

1629

November: An imperial army led by Aʿzam Khan pursues the rebellious Khan-Jahan Lodi to the Deccan. Aided neither by the sultan of Bijapur nor at Ahmadnagar, Khan-Jahan takes flight to the Punjab.

1631

February 3: Khan-Jahan Lodi and his followers are trapped and slaughtered by an advance guard of the imperial army under Madho Singh, son of the Hara Rajput chief of Bundi.

Murtaza Nizam-Shah of Ahmadnagar, threatened by Asaf Khan and the imperial army, liberates Fath Khan, son and successor of Malik ʿAmbar; but Nizam-Shah is put to death by Fath Khan, who raises to the throne Nizam-Shah's ten-year-old son, Husayn.

The rains fail and famine and pestilence break out in the Deccan.

July 7: The empress Mumtaz-Mahal dies at Burhanpur on the birth of a daughter, her fourteenth child. Shahjahan, deeply mournful, turns from active life as military commander to a more contemplative one, spending much time planning and supervising architecture.

1632

Shahjahan initiates designing and building the tomb of Empress Mumtaz-Mahal, the renowned Taj Mahal at Agra.

Shahjahan orders the destruction of Hindu temples recently begun, and seventy-six are razed at Benares. Religious orthodoxy is gaining the upper hand.

The Mughals attack the Portuguese at Hooghly in Bengal. After a three-month siege, the Portuguese are defeated

—10,000 men, women, and children are slain; 4,400 prisoners are taken.

1633

March 13: Mahabat Khan, now Khankhanan, lays siege to Daulatabad Fort which, in spite of the Maratha Shahji Bhonsla's efforts to relieve it, is finally surrendered to the Mughals by Fath Khan on June 28. He becomes a pensioner of the emperor, and young Husayn Nizam-Shah is imprisoned at Gwalior.

July 18: Christian prisoners taken by the Mughals at Hooghly are brought before the emperor. A few who accept Islam are liberated; most are imprisoned.

1634

September 28: Prince Aurangzeb is appointed to supreme command of the forces against Jujhar Singh Bundela, chief of Orchha.

November: Shahjahan wages successful war against Ahmadnagar and Golconda but fails to reduce Bijapur.

1635

The Peacock Throne, the quintessential symbol of Mughal power, is finished in time for the New Year Festival after seven years' work and a cost of 100 *lakhs* of rupees (see Welch, *India*, pp. 232–34).

1636

February 15: Khan-Dauran, Shayesta Khan, and Khan-Zaman sent to Bijapur, Golconda, and Ahmadnagar to continue the subjugation of the Deccan.

March 14: Golconda submits to the Mughals.

April 13: Khan-Zaman invests and takes Kolhapur; other successes against Shahji the Maratha are gained.

May 10: Shahjahan enters into treaties with the Deccani rulers, and Prince Aurangzeb is appointed *subadar* of the Deccan. On July 25 he proceeds to headquarters at Daulatabad.

June 4: Khan-Dauran takes Kalyan fort. Others capitulate and two thousand Bijapuris are defeated near Bidar on June 27. The forts of Udgir and Usa are besieged.

1637

April 27: Aurangzeb, whose *mansab* is 12,000 *zat* and 7,000 *suwar*, returns from the Deccan with the Nizam ul-mulk of Ahmadnagar who is imprisoned at Gwalior.

May 19: Aurangzeb is married to a daughter of Shahnawaz Khan; his brother Dara-Shikoh is married to his cousin Nadira.

'Ali-Mardan Khan, Persian governor of Qandahar, yields that town to Shahjahan's army. He is rewarded by being appointed Amir al-umara and subsequently made governor of Kabul and Kashmir.

1638

Raja Gaj Singh Rathor of Marwar is killed in Gujarat. His son Jaswant Singh succeeds, Amar Singh being passed over because of his violent temper.

1639

April 29: The foundations of the fort of Shahjahanabad (Delhi) are laid. It is completed on May 13, 1648.

Shah Shuja' is made governor of Bengal; Bihar is separated and placed under command of Shayesta Khan.

December 29: Muhammad Sultan, eldest son of Aurangzeb, is born at Mathura.

1640

June: The chief of Gondwana, a vast tribal area in eastern India, is subdued by Aurangzeb.

August 13: Asaf Khan, Khankhanan, brother of Nur-Jahan, dies.

Jagat Singh, a son of Vasu, raja of Kangra in the Punjab Hills, rebels. An expedition is sent into his territory; Nurpur and other forts are taken. Taragarh surrenders, and Jagat Singh submits.

December 24: Father Manrique, an Augustinian friar, arrives at Agra and proceeds to Lahore.

1642

Prince Dara-Shikoh gives his wife, Nadira Banu Begum, a splendid album of calligraphies, portrait groups, idealized figures, and natural history studies. (British Library, formerly India Office Library, Ms. Add. Or. 3129; see Brown, *Indian Painting*, pls. XXII, LV: figs. 1, 2; Binyon and Arnold, *Court Painters*, pls. XXXI, XXXIII; *Indian Heritage*, no. 58a, b).

1643

June: Aurangzeb declares his intention to withdraw from the world as a recluse. He is deprived of his government of the Deccan and of his honors and income. Later, on the intercession of his sister, Jahanara Begum, he is restored to favor and to his former rank.

1644

'Ali-Mardan Khan, with Murad-Bakhsh, the emperor's fourth son, recovers Balkh and Badakhshan. But the army returns with singularly little result.

1645

January: Gabriel Boughton, surgeon to the *Hopewell*, is sent to Agra by the Surat Council as surgeon to Shahjahan. He succeeds in saving the life of the emperor's favorite daughter, Princess Jahanara Begum, who had been severely burned. He is given permission for his countrymen to trade throughout the empire free of customs, a privilege extended to the East Indies Company.

February 27: Prince Aurangzeb is appointed viceroy of Gujarat, where there is trouble between Hindus and Muslims.

Raja Jagat Singh, brother of the raja of Kotah, invades Badakhshan and Balkh with fourteen thousand Rajputs.

December 17: Nur-Jahan Begum, widow of Jahangir, dies at the age of seventy-two.

1646

February 17: Prince Murad-Bakhsh, with 'Ali-Mardan Khan, leaves for Balkh. In June he takes Balkh, conquers the country, and puts Nazr-Muhammad to flight. The prince then insists upon returning to India.

1647

January: Great famine in Madras.

January 31: Prince Aurangzeb is appointed governor of Balkh and Badakhshan provinces. On February 20 he leaves for the post, then overrun by Uzbeks, reaching Kabul in April. He proceeds toward Balkh, opposed by the Uzbeks

and Alamans, arriving June 4, and defeats the armies of 'Abdul-'Aziz Khan, the son of the dispossessed king Nazr-Muhammad, who fails to enlist help of Safavids. But Shahjahan does not press for conquest, and Aurangzeb is recalled in September.

Shah Shuja' is recalled from Bengal and appointed governor of Kabul.

The *Padshahnama* or *Tarikh-i Shah Jahani Dahsala*, of Muhammad Amin Qazwini, comprising the history of the first ten years of Shahjahan's reign, is completed.

1648

Prince Dara-Shikoh is appointed twenty-seventh viceroy of Gujarat, with a *mansab* of 30,000 *zat* and 20,000 *suwar*.

December 26: Shah 'Abbas II of Persia arrives at Qandahar and invests the city. Aurangzeb is dispatched with an army but is unable to reach it because of snowstorms.

The Taj Mahal—the tomb of Mumtaz-Mahal, who died in 1631—is completed under Shahjahan's direction at Agra.

Shahjahan transfers the capital—and the Peacock Throne —from Agra to Shahjahanabad (Delhi).

1649

February 25: The Persians recover Qandahar from Daulat Khan, the Mughal governor. Aurangzeb arrives on May 25 with an ill-provisioned army, and after an indecisive battle the imperial troops withdraw.

Shah Shuja' is again made governor of Bengal.

The Venetian physician Manucci arrives at Agra for a forty-eight-year stay at the Mughal court, where he writes his chatty memoirs (*Storia do Mogor*).

ca. 1650

Shahjahan's later album (now scattered) is completed; it contains portraits, miniatures, calligraphies, and illuminations set in borders containing golden flowers and appropriate figures.

1651

July 1: An expedition is sent off from Kashmir to Little Tibet (Baltistan), to subdue a rebel, Mirza Jan, and to capture Fort Skardu. By August 15 Little Tibet is annexed to the Mughal empire.

1652

May 16: Prince Aurangzeb and his armies again arrive before Qandahar and invest the fortress. Shahjahan had reached Kabul on April 14, but after a siege of two months and eight days, he withdraws the army and retires to Hindustan.

Prince Dara-Shikoh, governor of Gujarat since 1648, is succeeded by Shayesta Khan.

1653

Dara-Shikoh sent with a large force against Qandahar. All efforts failing to take it, a retreat is begun on October 7.

October 4: Mughals chastise Jagat Singh, rana of Udaipur, for fortifying Chitor. Rana sends expressions of humility; the fort is demolished.

Prince Murad-Bakhsh appointed viceroy of Gujarat.

1655

Prince Aurangzeb intrigues with Mir Jumla, minister at Golconda, for the downfall of Sultan 'Abdullah Qutbshah.

1656

January: Aurangzeb treacherously attacks Golconda. 'Abdullah Qutbshah flees to the fortress of Golconda and agrees to give one of his daughters in marriage to Aurangzeb's son Muhammad Sultan, with dowry and territory, to pay a *kror* of rupees (a *kror* equals one hundred *lakhs*, i.e., ten million rupees), and to become tributary.

April: Shah Shuja' grants letters of patent to the English East Indies Company to trade duty-free in Bengal and Orissa.

The Koh-i-nur diamond, found at Kolhapur, is presented by Mir Jumla to Shahjahan.

November: Sultan Muhammad 'Adilshah of Bijapur dies. His son 'Ali's succession is disputed, and a Mughal force is sent to occupy the country.

Shahjahan is seriously ill, and the princes are anxious about succession. Aurangzeb hurries to Aurangabad. Dara-Shikoh takes the defensive against him. Shuja' marches on Agra but is defeated by Sulayman, Dara-Shikoh's son, and returns to Bengal. Murad-Bakhsh proclaims himself emperor, kills 'Ali Naqi, his minister, but afterward joins Aurangzeb, and marches against Jaswant Singh, leader of the imperial troops.

1657

January 7: An expedition under the Khankhanan leaves Khizrpur for the conquest of eastern Bengal. The city of Kuch Bihar taken.

April 1: Aurangzeb prosecutes war with Bijapur, reaches Zafarabad, Bidar, on April 10, and Kalyani on May 14; the latter is captured September 22. A hasty peace with Bijapur is arranged.

May: Sivaji, the Maratha leader, commits his first acts of hostility to the Mughals, plundering Junnar and partially looting Ahmadnagar.

1658

April: Mokand Singh of Kotah and three brothers fall in defense of Shahjahan at the battle of Ujjain. Kishor Singh survives and ascends the Kotah throne.

April 25: Princes Aurangzeb and Murad-Bakhsh defeat the imperial army under Jaswant Singh at Dharmatpur, near Ujjain, and march to meet their brother, Dara-Shikoh.

June 8: Aurangzeb and Murad-Bakhsh defeat Dara-Shikoh at Samugarh (Fathabad), between Agra and Dholpur. Dara flees via Agra and Delhi to Lahore. Aurangzeb enters Delhi on June 11. He imprisons Shahjahan in Agra Fort.

June 23: Aurangzeb and Murad-Bakhsh pursue Dara-Shikoh. At Mathura on July 5, Aurangzeb proposes to celebrate Murad's accession to the throne; but after filling him with drink, he seizes and fetters him, and sends him to prison in Salimgarh fort. Murad-Bakhsh is later sent to Gwalior, where he is put to death in December 1661.

July 30: Aurangzeb openly assumes government at Delhi and is formally proclaimed Emperor 'Alamgir (r. 1658–1707). An orthodox Sunni Muslim, he is nevertheless an inspired patron of painting—especially of the work of Hashim—and of the other arts during the early years of his reign. When the album known as the Kevorkian Album came into his possession, the second of its rosettes was stamped with a seal bearing his name and titles (pl. 5).

The fort and palaces of Shahjahanabad are completed.

On reaching Lahore, ʿAlamgir learns that Dara-Shikoh has gone via Multan to Bhakkar in Sind and thence to Gujarat; but hearing that Shah Shujaʿ is advancing on Agra, he leaves an officer to besiege Bhakkar and hurries back.

Har-rai with his Sikh army joins Dara-Shikoh in the Punjab, but when Dara is beaten he withdraws, sending to ʿAlamgir an apology and his eldest son as a hostage.

1659

January 15: Shah Shujaʿ and his Bengal army are defeated by ʿAlamgir near Allahabad. On February 2 Shah Shujaʿ's governor gives up Allahabad and Shah Shujaʿ retreats to Bengal.

Dara-Shikoh is acknowledged emperor in Gujarat, but after a desperate two-day battle (March 22 and 23) at Ajmer, he is defeated by ʿAlamgir and flees to Ahmedabad, where the gates are shut to him. He then crosses into Sind, seeks help from the chief of Shadar, who betrays him and his son to ʿAlamgir's foster brother, Bahadur Khan. They are sent to ʿAlamgir; Dara-Shikoh is tried as a heretic and put to death in prison by order of ʿAlamgir.

June 8: Prince Muhammad Sultan temporarily defects to his uncle, Shah Shujaʿ, but returns February 19, 1660, to the imperial camp.

Shah Shujaʿ flees with his family to Arakan, where he and his family and a few loyal retainers disappear from history.

1661

January 13: Prince Sulayman-Shikoh is given up to ʿAlamgir by the raja of Srinagar. He, his brother Sipihr-Shikoh, and the young son of Murad are put to death at Gwalior.

Bombay acquired by King Charles II as part of the dowry of his Portuguese wife, Catherine of Braganza.

December 14: Prince Murad-Bakhsh is put to death at Gwalior.

1662

May–August: ʿAlamgir is dangerously ill. The plot to restore Shahjahan fails. ʿAlamgir recovers in early December, goes to Kashmir until October 1663.

1665

Emperor ʿAlamgir's birthday is celebrated in Delhi with immense splendor and pomp. According to M. de Thévenot, he "has a special care to give orders, that the best dancing women and baladines [dancing girls], be always at court (*Indian Travels of Thévenot and Careri*, pp. 66–67).

1666

February 2: After seven years of imprisonment in Agra Fort, Shahjahan, attended by Princess Jahanara, dies at the age of seventy-five.

1668

Puritanism triumphs: ʿAlamgir forbids the writing of histories of his reign (along with historical paintings), as well as music at court, dandified styles of dress, alcohol, and dancing girls.

1671

Daughter of Shahjahan, Princess Raushanara Begum, ever loyal to ʿAlamgir, dies.

1679

After spending seven months quelling Rajput revolts, Emperor ʿAlamgir reimposes the *jizya*, the tax on all non-Muslims, which had been done away with by Akbar, a sign of intensifying Mughal religious orthodoxy.

1680

September: Princess Jahanara, who had shared her father's imprisonment, dies and is buried near the tomb of Sufi saint Nizamuddin Auliya at Delhi. The inscription on her cenotaph reads: "The perishable faqir Jahanara Begum, daughter of Shahjahan, and the disciple of saints of Chishtu, died in the year of the Hijra, A.H. 1092."

1691

Job Charnock founds Calcutta, which becomes center of British East India Company power in India.

1707

February 21: ʿAlamgir, the sixth Mughal emperor, dies at Aurangabad, aged 90 lunar years and 17 days. He is buried in the shrine of Shaykh Zayinuddin, in Khuldabad.

1719–48

Regnal years of the Mughal emperor Muhammad Shah (1702–1748), known as Rangeila (the Pleasure Loving). The last powerful emperor, he is also the one under whom the empire is seriously weakened.

1739

Nadir Shah of Iran (1687–1747; r. 1736–47), aware of the failing Mughal central government, invades India and takes Delhi. Two hundred thousand people are slain, and Nadir Shah sacks the royal treasury before returning to Iran with caravan loads of manuscripts and albums as well as other works of art, gold, and jewels, including the Peacock Throne.

In the aftermath of Nadir Shah's invasion, Mughal power continues to wane. The governors of Oudh, Bengal, and the Deccan establish central states more powerful than imperial Delhi. The emperors become pawns in the hands of rising forces—the Marathas, Rohilla Afghans, and the British.

1757

The East India Company, its forces led by Robert (later Lord) Clive, defeats the nawab of Bengal; and in 1765 authority over Bengal is transferred to the British.

1759

Shah ʿAlam II (1728–1806), a talented Urdu poet, ascends the throne after the murder of his father, only to become the puppet at Allahabad of the English, who deprive him of such privileges as the performance of ceremonial music.

1771

Shah ʿAlam returns to Delhi. In 1786 he falls into the hands of Ghulam Qadir Khan, a vengeance-seeking Rohilla Afghan chief, who cuts out his eyes. Nevertheless, Shah ʿAlam reigns, largely under British control, until his death in 1806.

1799

William Fraser (1784–1835) comes to India at the age of fourteen, settling not in Calcutta or Bombay but in the *mofussil* (provinces) of Delhi. While serving as English agent, he develops friendships with Indians of all sorts; he

hires two Mughal-trained artists of the sort responsible for the later copies and pastiches in the Kevorkian Album. They record his Indian world in animatedly detailed watercolors—that would have pleased Jahangir—for his albums.

1806

Akbar Shah II (1760–1837; r. 1806–37), becomes king, rather than emperor, of Delhi. He is also a puppet of the English.

1835

William Fraser is brutally assassinated by agents in the employ of an embittered Muslim aristocrat who believed he had deprived him of an inheritance. Fraser's albums are sent to his family in Scotland where they remain until 1980.

1837

The last Mughal emperor, Abu' l-Muzaffar Sirajiiddin Muhammad Bahadur Shah II (1775–1862; r. 1837–58, died in exile), succeeds Akbar Shah II. By now the empire has so shrunk that Bahadur Shah scarcely reigns in his own palace, where the English maintain him as a figurehead until the Indian Mutiny (Sepoy Rebellion, or War for Independence).

Mirza Asadullah Khan Ghalib (1797–1869), perhaps the most esteemed of all Mughal poets, not only serves Bahadur Shah II but also continues to write when Mughal India had succumbed wholly to the British. A talented poet in Urdu, Bahadur Shah used the pen name "Zafar."

1858

Eighty-three years old at the time of the Sepoy Rebellion, Bahadur Shah accepts its nominal leadership, for which he is tried after it is crushed by the British. He is deposed, deprived of property and revenues, and exiled to Rangoon, where he dies four years later.

1980

Fraser albums are admired and catalogued by the India Office Library and sold at Sotheby's, London, July 7. A second sale follows, at Sotheby Parke Bernet, New York, December 9.

SCW

GLOSSARY

abjad arrangement of the Arabic alphabet in old Semitic style, with a numerical value for each letter: a = 1, b = 2, j = 3, d = 4, and so on; used frequently for chronograms

alif first letter of the Arabic alphabet, formed like a slim, vertical line; has a numerical value of one; used as cipher for the slender beloved or for the Divine Unity

ʿamal work (Arabic); often precedes an artist's signature

bismillah the formula *Bismiʾllahiʾr-rahman-ʾr-rahim* (In the name of God the Merciful the Compassionate), which opens every chapter of the Koran and should be used at the beginning of every undertaking

bulbul nightingale; always appears in poetry with the *gul* (rose)

dal fourth letter of the Arabic alphabet; cipher for the bent posture of the suffering lover

divan collection of poetry, arranged alphabetically according to the rhyme; a divan usually contains ghazals, *qasida*, *muqattaʿat*, and *rubaʿiyat*

ghazal poem with monorhyme, usually five to twelve verses long; vehicle for love poetry and also poems on divine love. The oscillation of meaning between heavenly and worldly love is the most delightful aspect of these poems, which developed from the erotic introductions of longer poems (*qasida*) and became the favorite form of Persian, Turkish, and Urdu poets. The poet usually mentions his pen name in the last line of the ghazal.

ghubar "dust" script; a minute style of Arabic writing, first used for pigeon post, but later for poetry and religious texts

harrarahu "... wrote it"; formula used by calligraphers at the end of a text. *Harrara* is sometimes used for "clean copying."

hasb-i hal explanation of one's situation; poems in which the poet complains of bad luck, ailments, or similar sadnesses

hazaj Arabo-Persian meter in which each foot consists of a short and three long syllables (˘ - - -). The foot is repeated three or four times; for epic poetry a shorter version is used.

kar work (Persian); used by painters in their signatures (interchangeable with *ʿamal*)

katabahu "... has written this"; the usual formula preceding the signature of a calligrapher

khafif Arabo-Persian meter often used in epics, especially in Sanaʾi's *Hadiqat al-haqiqa*: ˘ ˘ - - | ˘ - ˘ - | ˘ ˘ -

kufic ancient angular style of Arabic writing; used in early centuries for Korans and for decorative purposes and inscriptions

mashq exercise, especially calligraphic exercise in which letters or words are frequently repeated

mathnavi poem in rhyming couplets

matlaʿ first verse of a poem

muʿamma riddle; especially connected with proper names. The art of *muʿamma* flourished in the late fifteenth century in Iran.

mujtathth Arabo-Persian meter of the form ˘ - ˘ - | ˘ ˘ - - | ˘ - ˘ - | ˘ ˘ -; often used in lyrical poetry

muraqqaʿ patchwork; album of miniatures and calligraphies

mutaqarib Arabo-Persian meter in which each foot consists of a short and two long syllables (˘ - - | ˘ - - | ˘ - - | ˘ -); it is the meter of Firdosi's *Shahnama*, Nizami's *Iskandarnama*, and Saʿdi's *Bustan*.

naskh normal cursive hand in Arabic

nastaʿliq "hanging" style of Arabic calligraphy; used mainly for Persian, Urdu, and Turkish; developed around 1400 in Iran

naʿt-i sharif poetic description of the Prophet Muhammad

nim qalam half pen; drawings in fine lines, heightened with very little color

nun Arabic letter *n*, which is formed like a horseshoe; hence, the cipher for something rounded or crooked

qasida long poem in monorhyme, usually in praise of a patron, but also used for satires, descriptions, and praise of God. The *qasida* can comprise more than a hundred verses; it usually begins with a romantic introduction (love story, description of spring, or the like) and then turns to the praise of the patron; it often ends with the wish that a handsome reward be granted. A *qasida* in praise of God ends with a prayer for forgiveness or for the Prophet's intercession.

qitʿa piece (single manuscript leaf) or a topical poem in which descriptions, chronograms, etc. are found

qiyamat resurrection; thought to be very lengthy and full of horror and confusion

ramal Arabo-Persian meter in which each foot consists of three long and one short syllable: - ˘ - - | - ˘ - - | - ˘ - (-). It was used for didactic *mathnavi*.

raqam drawing; the drawing of a miniature

rubaʿi quatrain with the rhyme scheme *aaba*, used for epigrams; made famous in the West by Edward Fitz-Gerald's *Rubaiyat of Omar Khayyam* (1859), a very free translation

safina boat; a small book, usually with poetry, sewn together at the narrow side; anthology

shabih likeness

shamsa sunburst; round ornament, often with highly complicated elaboration

tarkib composition

tartib arrangement

ʿunwan frontispiece or title page, often beautifully illuminated

BIBLIOGRAPHY

A

'Abd al-Baqi Nihawandi. *Ma'athir-i Rahimi.* Ed. Muhammad Hidayat Husayn. 3 vols. in 4. Calcutta, 1931–64.

'Abd al-Hamid Lahawri. *Padshahnama dar ahwal-i Abu'l-Muzaffar Shihab al-Din Muhammad Shahjahan Padshah.* Ed. Mawlawi Kabir al-Din Ahmad and Mawlawi 'Abd al-Rahim. Calcutta, 1867–78.

Abu'l-Fazl 'Allami. *The A'in-i Akbari.* Trans. H. Blochmann and Col. H. S. Jarrett. 3 vols. Calcutta, 1873–94.

Abu'l-Fazl. *The Akbarnama.* Trans. H. Beveridge. 3 vols. Calcutta, 1897–1939. Reprint, Delhi, 1972.

'Ali Efendi. *Manaqib-i hunarvaran.* Ed. Ibnülemin Mahmud Kemal. Istanbul, 1926.

Alvi, M. A., and Rahman, A. *Jahangir the Naturalist.* New Delhi, 1968.

Amir Khusrau Dihlawi. *Divan-i kamil.* Ed. Mahmud Darvish. Teheran, 1965.

Ansari, Mohd. Azher. "Palaces and Gardens of the Mughals." *Islamic Culture* 33 (1959), pp. 50–72.

Arber, Agnes. *Herbals: Their Origin and Evolution, a Chapter in the History of Botany, 1470–1670.* Cambridge, 1912.

Arberry, A. J.; Blochet, E.; Minovi, M.; Robinson, B. W.; Wilkinson, J. V. S. *The Chester Beatty Library: A Catalogue of the Persian Manuscripts and Miniatures.* 3 vols. Dublin, 1959–62.

Archer, Mildred. *Company Drawings in the India Office Library.* London, 1972.

Arnold, Thomas W., and Wilkinson, J. V. S. *The Library of A. Chester Beatty: A Catalogue of the Indian Miniatures.* 3 vols. London, 1936.

The Art of India and Pakistan: A Commemorative Catalogue of the Exhibition Held at the Royal Academy of Arts, London, 1947–48. Ed. Leigh Ashton. London, 1950.

Azad Bilgrami, Ghulam 'Ali. *Khizana-i 'amira.* Lucknow, [ca. 1890].

B

Babur, Zahiruddin. *The Babur-nama.* Trans. A. S. Beveridge. London, 1922. Reprint, 1978.

Bada'oni, 'Abd-ul-Qadir ibn-i-Muluk-Shah. *Muntakhabu-t-tawarikh.* 3 vols. Ed. William Nassau Lees and Ahmad Ali. Trans. George S. A. Ranking, W. H. Lowe, and Wolseley Haig. Calcutta, 1865–89. Reprint, Patna, 1973.

Barthold, Wilhelm. *Mir 'Ali Shir; A History of the Turkman People.* Vol. 3 of *Four Studies on the History of Central Asia.* Trans. V. and T. Minorsky. Leiden, 1962.

Bayani, Mehdi. *Tadhkira-i khushnivisan: nasta'liqnivisan.* 3 vols. Teheran, 1966–69.

Beach, Milo Cleveland. *The Grand Mogul: Imperial Painting in India, 1600–1660.* Williamstown, Mass., Sterling and Francine Clark Art Institute, 1978.

Beach, Milo Cleveland. "The Gulshan Album and Its European Sources." *Museum of Fine Arts, Boston, Bulletin* 63 (1965), pp. 63–91.

Beach, Milo Cleveland. *The Imperial Image: Paintings for the Mughal Court.* Washington, Freer Gallery of Art, 1981.

Begley, Wayne E. *Monumental Islamic Calligraphy from India.* Villa Park, Ill., 1985.

Beni Prasad. *History of Jahangir.* London, 1922.

Bhattacharya, Sachchidananda. *A Dictionary of Indian History.* Calcutta, 1967.

Binney, Edwin, 3rd. *Indian Miniature Painting from the Collection of Edwin Binney, 3rd: The Mughal and Deccani Schools.* Portland, Ore., Portland Art Museum, 1973.

Binyon, Laurence, and Arnold, T. W. *The Court Painters of the Grand Moguls.* London, 1921.

Blochet, E. *Catalogue des manuscrits persans de la Bibliothèque nationale.* 4 vols. Paris, 1905–1934.

Böwering, Gerhard. *The Qur'anic Hermeneutics of the Sufi Sahl at-Tustari (d. 293/896).* Berlin, 1979.

Brown, Percy. *Indian Painting Under the Mughals.* Oxford, 1924.

Browne, Edward Granville. *A Literary History of Persia.* 4 vols. Cambridge, 1902–1924. Reprint, Cambridge, 1959–64.

C

Chandra, Pramod. *The Tuti-Nama of The Cleveland Museum of Art and the Origins of Mughal Painting.* 2 vols. Graz, 1976.

Clarke, C. Stanley. *Indian Drawings: Thirty Mogul Paintings of the School of Jahangir (17th Century) and Four Panels of Calligraphy in the Wantage Bequest.* Victoria and Albert Museum Portfolios. London, 1922.

Colnaghi, P. and D., & Co. Ltd. *Persian and Mughal Art.* London, 1976.

Coomaraswamy, Ananda K. *Catalogue of the Indian Collection in the Museum of Fine Arts, Boston. Part VI: Mughal Painting.* Cambridge, Mass., 1930.

308

Crill, Rosemary. "A Lost Mughal Miniature Rediscovered." *The V&A Album* (London), 4 (1985), pp. 330–36.

D

Das, Asok Kumar. *Mughal Painting During Jahangir's Time.* Calcutta, 1978.

Daulatshah. *Tadhkirat ash-shuʿara.* Ed. Edward G. Browne. Leiden and London, 1901.

Davidson, Marshall B. "Notes." *The Metropolitan Museum of Art Bulletin*, n.s. 14 (1955), p. 84.

Dickson, Martin Bernard, and Welch, Stuart Cary. *The Houghton Shahnameh.* 2 vols. Cambridge, Mass., 1981.

Dimand, Maurice S. "An Exhibition of Islamic and Indian Paintings." *The Metropolitan Museum of Art Bulletin*, n.s. 14 (1955), pp. 85–102.

Divan-i Asafi-yi Haravi. Ed. Hadi Arfaʿ. Teheran, 1964.

Duda, Dorothea. *Islamische Handschriften I. Persische Handschriften.* 2 vols. Reihe I, Die illuminierten Handschriften und Inkunabeln der Österreichischen Nationalbibliothek, Bd. 4. Vienna, 1983.

E

Eckmann, Janos. "Die tschagataiische Literatur." In *Philologiae Turcicae Fundamenta*, II, pp. 304–368. Wiesbaden, 1960.

Ethé, Hermann. *Catalogue of Persian Manuscripts in the India Office Library.* London, 1903. Reprint, London, 1980.

Ethé, Hermann. "König und Bettler. Romantisch-mystisches Epos vom Scheich Hilali." In *Morgenländische Studien*, pp. 197–282. Leipzig, 1870.

Ethé, Hermann. "Neupersische Literatur." In *Grundriss der iranischen Philologie*, ed. Wilhelm Geiger and Ernst Kuhn, II, pp. 212–368. Strasbourg, 1896–1904.

Ettinghausen, Richard. *Paintings of the Sultans and Emperors of India in American Collections.* New Delhi, 1961.

Ettinghausen, Richard. "Pre-Mughal Painting in India." In *Trudy Dvatcatʾ pjatogo Mežunarodnogo Kongressa Vostokovedov, Moskva, 9–16 avgusta 1960* [Proceedings of the Twenty-Fifth International Congress of Orientalists...], IV, pp. 191–92. Moscow, 1963.

Ettinghausen, Richard, and Schroeder, Eric. *Iranian and Islamic Art.* The University Prints: Oriental Art, series O, section IV. Newton, Mass., 1941.

F

Fakhri Haravi. *Raudat as-salatin.* Ed. Sayyid Hussamuddin Rashdi. Hyderabad, 1968.

Falk, Toby, and Archer, Mildred. *Indian Miniatures in the India Office Library.* London, Delhi, Karachi, 1981.

G

Gascoigne, Bamber. *The Great Moghuls.* London, 1971.

Godard, Yedda A. "Un album de portraits des princes timurides de l'Inde." *Athar-e-Iran* II.

Godard, Yedda A. "Les Marges du Murakkaʿ Gulshan." *Athar-e-Iran* I (1936), pp. 11–33.

Gonda, J. *Aspects of Early Vishnuism.* Utrecht, 1954.

Goswamy, B. N.; Ohri, V. C.; and Singh, Ajit. "A 'Chaurapanchasika Style' Manuscript from the Pahari Area: Notes on a Newly Discovered *Devi Mahatmya* in the Himachal Pradesh State Museum, Simla." *Lalit Kala* 21 (1985), pp. 9–21.

Gray, Basil, and Godard, André. *Iran: Persian Miniatures —Imperial Library.* New York, 1956.

Gupta, Narayan. *Delhi Between Two Empires, 1803–1931.* Bombay, Calcutta, Madras, 1981.

H

Habib. *Hatt u hattatan.* Istanbul, A.H. 1305/A.D. 1887.

Hafiz, Muhammad Shamsuddin. *Divan-i Hafiz.* Ed. Nadhir Ahmad and S. M. Jalali Naʾini. Teheran, 1971.

Hafiz, Muhammad Shamsuddin. *Die Lieder des Hafiz.* Ed. Hermann Brockhaus. 3 vols. Leipzig, 1854–60. Reprint, Osnabrück, 1969.

Hambly, Gavin. *Cities of Mughul India.* New York, 1968.

Hatton, Richard G. *Handbook of Plant and Floral Ornament.* Reprint, New York, 1960.

Havell, E. B. *Indian Sculpture and Painting.* 2d ed. London, 1928.

Heeramaneck, Alice N. *Masterpieces of Indian Painting from the Former Collections of Nasli M. Heeramaneck.* New York, 1984.

History of Medieval Deccan. Ed. H. K. Sherwani and P. M. Joshi. 2 vols. Hyderabad, 1973–74.

Hollander, Barnett. *The International Law of Art.* London, 1959.

Huart, Clément. *Les Calligraphes et les miniaturistes de l'Orient musulman.* Paris, 1908. Reprint, 1972.

Husayn Bayqara. *Divan-i Sultan Huseyin Mirza Baykara.* Ed. Ismail Hikmet Ertaylan. Istanbul, 1946.

I

The Indian Heritage: Court Life and Arts Under Mughal Rule. London, Victoria and Albert Museum, 1982.

Indian Travels of Thévenot and Careri. Ed. Surrendranath Sen. New Delhi, 1949.

Indische Albumblätter: Miniaturen und Kalligraphien aus der Zeit der Moghul-Kaiser. Ed. Regina Hickmann. Leipzig and Weimar, 1979.

Iskandar Beg Turkuman. *Tarikh-i ʿAlam-ara-yi ʿAbbasi.* 2 vols. Teheran, A.H. 1350/A.D. 1972.

Ivanov, A. A.; Grek, T.; and Akimushkin, O. F. *Alʾbom indiyskikh i persidskikh miniatyur XVI–XVIII v.v.* Moscow, 1962.

J

Jahangir Gurkani, Nur al-Din Muhammad. *Jahangirnama: Tuzuk-i Jahangiri.* Ed. Muhammad Hashim. Teheran, A.H. 1349/A.D. 1970.

Jahangir. *The Tuzuk-i-Jahangiri; or Memoirs of Jahangir.* Trans. Alexander Rogers. Ed. Henry Beveridge. 2 vols. London, 1909–1914.

James, David. *Islamic Masterpieces of the Chester Beatty Library.* London, 1981.

Jami, ʿAbdur-Rahman. *Baharistan.* Lith.

Jami, ʿAbdur-Rahman. *Divan-i kamil.* Ed. Hashim Riza. Teheran, 1962.

Jami, ʿAbdur-Rahman. *Haft Aurang.* Ed. Aqa Mustafa and Mudarris Gilani. Teheran, 1958.

Jouher. *Private Memoirs of the Moghul Emperor Humayun.* Trans. Major Charles Stewart. London, 1832. Reprint, San Juan de Campostella, n.d.

K

Kühnel, Ernst. *Islamische Schriftkunst.* Berlin, 1942. Reprint, Graz, 1972.

Kühnel, Ernst, and Goetz, Hermann. *Indian Book Painting from Jahangir's Album in the State Library in Berlin.* London, 1926.

L

Leach, Linda York. *Indian Miniature Paintings and Drawings.* Cleveland Museum of Art, 1986.

Loan Exhibition of Antiquities: Coronation Durbar, 1911. Delhi Museum of Archaeology, [1911].

Losty, Jeremiah P. *The Art of the Book in India.* London, British Library, 1982.

M

Maggs Bros. Ltd. *Oriental Miniatures and Illuminations.* Bulletin No. 34. London, 1981.

Marteau, Georges, and Vever, Henri. *Miniatures persanes tirées des collections ... et exposées au Musée des arts décoratifs, juin–octobre 1912.* 2 vols. Paris, 1913.

Martin, F. R. *Miniatures from the Period of Timur in a Ms. of the Poems of Sultan Ahmad Jalair.* Vienna, 1926.

Massé, Henri. "Quinze poésies de Qasim-ol-Anvar." In *Charisteria Orientalia praecipue ad Persam pertinentia.* Ioanni Rypka ... hoc volumen sacrum, ed. F. Tauer, V. Kubíčková, Iv. Hrbek, pp. 164–78. Prague, 1956.

Mauquoy-Hendrickx, Marie. *Les Estampes des Wierix conservées au Cabinet des Estampes de la Bibliothèque Royale Albert Iᵉʳ: Catalogue raisonné.* Brussels, 1978–79.

Mehta, Nanalal Chamanlal. *Studies in Indian Painting: A Survey of Some New Material Ranging from the Commencement of the VIIth Century to Circa 1870.* Bombay, 1926.

Mirza Muhammad-Tahir Nasrabadi. *Tadhkira-i Nasrabadi.* Ed. Wahid Dastgardi. Teheran, n.d.

Muhammad-Salih Kanbo Lahawri. *ʿAmal-i salih.* Ed. Ghulam Yazdani. 3 vols. Calcutta, 1923–39.

Murrell, Jim. *The Way Howe to Lymne: Tudor Miniatures Observed.* London, Victoria and Albert Museum, 1983.

Mustaqimzada, Suleyman Sadettin. *Tuhfet el-hattatin.* Ed. Ibnülemin Mahmud Kemal. Istanbul, 1928.

N

Navaʾi. *Divan-i Amir Nizamuddin ʿAlishir Navaʾi.* Ed. Ruknaddin Humayun-farrukh. Teheran, A.H. 1342/A.D. 1963.

Navaʾi, Mir ʿAli-Shir. *Majalis an-nafaʾis.* Persian trans. ʿAli Asghar Hikmat. Teheran, 1945.

P

Pinder-Wilson, Ralph H., with Smart, Ellen, and Barrett, Douglas. *Paintings from the Muslim Courts of India.* London, British Museum, 1976.

Purinton, Nancy, and Newman, Richard. "A Technical Analysis of Indian Painting Materials." In Ellen S. Smart and Daniel S. Walker, *Pride of the Princes: Indian Art of the Mughal Era in the Cincinnati Art Museum,* pp. 107–113. Cincinnati, 1985.

Q

Qadi Ahmad. *Calligraphers and Painters: A Treatise by Qadi Ahmad, Son of Mir-Munshi (circa. A.H. 1015/A.D. 1606).* Trans. V. Minorsky. Washington, D.C., 1959.

Qatiʿi-i Haravi. *The Majmaʿ al-shuʿ ara-i Jahangiri.* Ed. Muhammad Saleem Akhtar. Karachi, 1979.

R

Robinson, B. W.; Grube, E. J.; Meredith-Owens, G. M.; and Skelton, R. W. *Islamic Painting and the Arts of the Book [in] the Keir Collection.* London, 1976.

Roe, Thomas. *The Embassy of Sir Thomas Roe to the Court of the Great Mogul, 1615–1619.* Ed. William Foster. 2 vols. London, 1899.

Rückert, Friedrich. *Grammatik, Poetik und Rhetorik der Perser.* Ed. Wilhelm Pertsch. Gotha, 1874. Reprint. Wiesbaden, 1966.

Rypka, Jan. *History of Iranian Literature.* Prague, 1956. Rev. ed. Dordrecht, 1968.

S

Saʿdi, Muslihuddin. *Kulliyat,* from the manuscript of Muhammad ʿAli Furughi. 4 vols. Teheran, 1963.

Safadi, Yasin H. *Islamic Calligraphy.* Boulder, Co., 1978.

Salar Jung Museum and Library, Hyderabad. *A Catalogue of the Persian Manuscripts in the Salar Jung Museum and Library.* Comp. Muhammad Ashraf. 5 vols. Hyderabad, 1965.

Sanaʾi, Abuʾl-Majd Majdud. *Hadiqat al-haqiqa wa shariʿat at-tariqa.* Ed. Mudarris Rizavi. Teheran, 1950.

Sarkar, Jadunath. *History of Aurangzib.* 5 vols. London and New York, 1920.

Scheffer, Dieuwke de Hoop, comp. *Hollstein's Dutch and Flemish Etchings, Engravings, and Woodcuts, ca. 1450–1700.* Vols. 21, 22. Ed. K. G. Boon. Amsterdam, 1980.

Schimmel, Annemarie. *Calligraphy and Islamic Culture.* New York, 1984.

Schimmel, Annemarie. *Islamic Calligraphy.* Iconography of Religions XXII, 7. Leiden, 1970.

Schimmel, Annemarie. *Islamic Literatures of India.* New numbering vol. VIII, 1, of *A History of Indian Literature.* Ed. Jan Gonda. Wiesbaden, 1973.

Schimmel, Annemarie. *Islam in India and Pakistan.* Iconography of Religions XXII, 9. Leiden, 1982.

Schimmel, Annemarie. *Mystical Dimensions of Islam.* Chapel Hill, N.C., 1975.

Schimmel, Annemarie. "Some Notes on the Cultural Activities of the First Uzbek Rulers." *Journal of the Pakistan Historical Society,* 1960, pp. 149–66.

Schimmel, Annemarie, and Welch, Stuart Cary. *Anvari's Divan: A Pocket Book for Akbar.* New York, Metropolitan Museum of Art, 1983.

Sen, Geeti. *Paintings from the Akbar Nama.* Calcutta, 1984.

Shahi. *Divan.* Lith. Istanbul-Beyazit, A.H. 1288/A.D. 1872.

Shahnawaz Khan, Samsam al-Dawla, and ʿAbd al-Hayy. *Maasiru-l-umara; Being Biographies of the Muhammadan and Hindu Officers of the Timurid Sovereigns of India from 1500 to About 1780 A.D.* Trans. H. Beveridge. Vols. 1, 2. Rev. ed. Calcutta, 1941–52.

Shams-i Hoseyni Anwari. *Moʿamma and Loghaz.* Berlin, 1986.

Skelton, Robert. "A Decorative Motif in Mughal Art." In *Aspects of Indian Art: Papers Presented in a Symposium at the Los Angeles County Museum of Art, October 1970,* ed. Pratapaditya Pal, pp. 147–52. Leiden, 1972.

Skelton, Robert. "The Mughal Artist Farrokh Beg." *Arts Orientalis* 2 (1957), pp. 393–411.

[Skelton, Robert]. In "Recent Acquisitions." *The V& A Album* (London), 4 (1985), pp. 16–17.

Soucek, Priscilla P. "The Arts of Calligraphy." In *The Arts of the Book in Central Asia, 14th–16th Centuries,* ed. Basil Gray, pp. 7–34. Paris, 1979.

Staude, Wilhelm. "Contribution à l'étude de Basawan." *Revue des Arts Asiatiques* 8 (1933–34), pp. 1–18.

Staude, Wilhelm. "Muskine." *Revue des Arts Asiatiques* 5 (1928), pp. 169–82.

Stchoukine, Ivan. "Un Bustan de Saʿdi illustré par des artistes moghols." *Revue des Arts Asiatiques* 11 (1937), pp. 68–74.

Stchoukine, Ivan. *Les Miniatures indiennes de l'époque des Grands Moghols, au Musée du Louvre.* Paris, 1929.

Stchoukine, Ivan. *La Peinture indienne à l'époque des Grands Moghols.* Paris, 1929.

Stchoukine, Ivan; Flemming, Barbara; Luft, Paul; Sohrweide, Hanna. *Illuminierte Islamische Handschriften.* Vol. 16 of *Verzeichnis der orientalischen Handschriften in Deutschland.* Ed. Wolfgang Voigt. Wiesbaden, 1971.

Strong, Roy. *Artists of the Tudor Court: The Portrait Miniature Rediscovered, 1520–1620.* London, Victoria and Albert Museum, 1983.

Strong, Roy. *The English Ikon: Elizabethan and Jacobean Portraiture.* London, 1969.

Subtelny, Maria Eva. *The Poetic Circle in Herat at the Court of the Timurid Sultan, Husain Baiqara, and Its Political Significance.* Ph.D. diss. Harvard University, 1979.

Subtelny, Maria Eva. "A Taste for the Intricate: The Persian Poetry of the Late Timurid Period." *Zeitschrift der Deutschen Morgenländischen Gesellschaft* 136, 1 (1986), pp. 56–79.

T

Tandan, Raj K. *Indian Miniature Painting, 16th Through 19th Centuries.* Bangalore, 1982.

W

Waheed Mirza. *Life and Works of Amir Khosrau.* Calcutta, 1935. New ed. Lahore, 1975.

Welch, Anthony. *Calligraphy in the Arts of the Muslim World.* Austin, 1979.

Welch, Anthony, and Welch, Stuart Cary. *Arts of the Islamic Book: The Collection of Prince Sadruddin Aga Khan.* Ithaca and London, 1982.

Welch, Stuart Cary. *The Art of Mughal India: Painting and Precious Objects.* New York, Asia Society, 1963.

Welch, Stuart Cary. "Early Mughal Miniature Paintings from Two Private Collections Shown at the Fogg Art Museum." *Ars Orientalis* 3 (1959), pp. 133–46.

Welch, Stuart Cary. "The Emperor Akbar's *Khamsa* of Nizami." *The Journal of the Walters Art Gallery* 23 (1960), pp. 86–96.

Welch, Stuart Cary. *A Flower from Every Meadow.* New York, Asia Society, 1973.

Welch, Stuart Cary. *Imperial Mughal Painting.* New York, 1978.

Welch, Stuart Cary. *India: Art and Culture, 1300–1900.* New York, Metropolitan Museum of Art, 1985.

Welch, Stuart Cary. *Indian Drawings and Painted Sketches.* New York, Asia Society, 1976.

Welch, Stuart Cary. *A King's Book of Kings: The Shah-nameh of Shah Tahmasp.* New York, Metropolitan Museum of Art, 1972.

Welch, Stuart Cary. "Mughal and Deccani Miniature Paintings from a Private Collection." *Ars Orientalis* 5 (1963), pp. 221–33.

[Welch, Stuart Cary]. "A Mughal Manuscript of the Reign of Humayun." Appendix E in Chandra, *Tuti-Nama of The Cleveland Museum,* pp. 188–90.

Welch, Stuart Cary. "The Paintings of Basawan." *Lalit Kala* 10 (1961), pp. 7–17.

Welch, Stuart Cary. *Room for Wonder: Indian Painting During the British Period, 1760-1880.* New York, American Federation of the Arts, 1978.

Welch, Stuart Cary. *Wonders of the Age: Masterpieces of Early Safavid Painting, 1501–1576.* Cambridge, Mass., 1979.

Welch, Stuart Cary, and Beach, Milo Cleveland. *Gods, Thrones, and Peacocks.* New York, Asia Society, 1965.

Wellesz, Emmy. *Akbar's Religious Thought Reflected in Mogul Painting.* London, 1952.

Wellesz, Emmy. "Sultan Ali Meschhedi" and "Sultan Mohammed Nur." In Thieme-Becker, *Allgemeines Lexikon der Bildenden Künstler, XXXII,* pp. 287–88 and 289. Leipzig, 1938.

Whistler, Hugh, and Kinnear, Norman B. *Popular Handbook of Indian Birds.* Rev. and enl. 4th ed. London, 1949.

Wilkinson, J. V. S. *The Lights of Canopus.* London, n.d.

Wilkinson, J. V. S. *Mughal Painting.* London, 1948.

Wilson, Horace Hayman. *The Vishnu Purana: A System of Hindu Mythology and Tradition.* 1840. Reprint of 3d ed. Calcutta, 1972.

Z

Zebrowski, Mark. *Deccani Painting.* London and Berkeley, 1983.

LIST OF KEVORKIAN FOLIOS
BY ACCESSION NUMBER

MMA Folios

MMA ACC. NO.	PLATE NO.	TITLE	MMA ACC. NO.	PLATE NO.	TITLE
55.121.10.IV	31	Calligraphy	12v	45	Red-Headed Vulture and
1r	32	Sundar Das, Raja Bikramajit			Long-Billed Vulture
		Margin number 58			Margin number 39
2v	33	Maharaja Bhim Kunwar	12r	46	Calligraphy
		Margin number 57	13v	47	Nilgai
2r	34	Calligraphy			Margin number 25
3v	23	Calligraphy	13r	48	Calligraphy
3r	24	Zamana Beg, Mahabat Khan	14v	41	Great Hornbill
		Margin number 6			Margin number 43
4v	21	Sayf Khan Barha	14r	42	Calligraphy
		Margin number 5	15v	39	Calligraphy
4r	22	Calligraphy	15r	40	Spotted Forktail
5v	65	Calligraphy			Margin number 44
5r	66	Sayyid Abu'l-Muzaffar Khan,	16v	43	Calligraphy
		Khan-Jahan Barha	16r	44	Diving Dipper and Other
		Margin number 36			Birds
6v	73	Calligraphy			Margin number 40
6r	74	Jadun Ray	17v	49	Calligraphy
		Margin number 18	17r	50	Black Buck
7v	27	Calligraphy			Margin number 26
7r	28	Raja Suraj Singh Rathor	18v	51	Calligraphy
		Margin number 4	18r	52	Dancing Dervishes
8v	29	Rup Singh			Margin number 46
		Margin number 3	19v	11	Jahangir and His Father,
8r	30	Calligraphy			Akbar
9v	95	Dervish Leading a Bear			Margin number 36
9r	96	Calligraphy	19r	12	Calligraphy
10v	75	Calligraphy	20v	53	A Youth Fallen from a Tree
10r	76	Dervish Leading a Bear			Margin number 17
		Margin number 11	20r	54	Calligraphy
11v	77	Dervish with a Lion	21v	59	Shahjahan Riding a Stallion
		Margin number 10			Margin number 11
11r	78	Calligraphy			

MMA ACC. NO.	PLATE NO.	TITLE	MMA ACC. NO.	PLATE NO.	TITLE
55.121.10.21r	60	Calligraphy	32v	17	Calligraphy
22v	9	*Akbar with Lion and Calf*	32r	18	*Prince Danyal*
		Margin number 26			Margin number 52
22r	10	Calligraphy	33v	35	*Ibrahim ʿAdilshah II of Bijapur*
23v	15	Calligraphy			Margin number 51
23r	16	*Jahangir and Iʿtimaduddaula*	33r	36	Calligraphy
		Margin number 37	34v	37	Calligraphy
24v	57	Calligraphy	34r	38	*Mulla Muhammad Khan*
24r	58	*Shahjahan Nimbed in Glory*			*Wali of Bijapur*
		Margin number 8			Margin number 45
25v	89	*Red-Headed Vulture*	35v	63	*Shah Shujaʿ with a Beloved*
25r	90	*ʿAbdullah Khan Bahadur-Jang*			Margin number 44
26v	91	*Shaykh Hasan Chishti*	35r	64	Calligraphy
26r	92	*A Fantastic Bird*	36v	55	*Shahjahan and Prince Dara-*
27v	87	*Muhammad ʿAli Beg*			*Shikoh Toy with Jewels*
27r	88	*Jungle Fowl*			Margin number 7
28v	93	Calligraphy	36r	56	Calligraphy
28r	94	*Hajji Husayn Bukhari*	37v	67	*Jahangir Beg, Jansipar Khan*
29v	25	Calligraphy			Margin number 35
29r	26	*Four Portraits*	37r	68	Calligraphy
		Margin number 12	38v	4	Calligraphy
30v	69	Calligraphy	38r	2	*ʿUnwan*
30r	70	*Qilich Khan Turani*	39v	3	*ʿUnwan*
		Margin number 3	39r	1	*Shamsa*
31v	71	*Khan-Dauran Bahadur*	40v	7	*ʿUnwan*
		Nusrat-Jang	40r	5	*Shamsa*
		Margin number 2	41v	8	Calligraphy
31r	72	Calligraphy	41r	6	*ʿUnwan*

FGA Folios

FGA ACC. NO.	PLATE NO.	TITLE	FGA ACC. NO.	PLATE NO.	TITLE
39.46b	85	*Spotted Forktail*	48.19b	81	*Emperor Jahangir on a Globe,*
39.46a	86	*Shahjahan Riding a Stallion*			*Shooting an Arrow at the*
39.47b	99	*Black Partridge*			*Severed Head of Malik*
39.47a	100	*Shah Tahmasp in the*			*ʿAmbar*
		Mountains	48.19a	82	*Long-Billed Vulture*
39.48b	79	*Emperor Humayun*	48.20b	83	*Ghiyath Beg, Iʿtimaduddaula*
39.48a	80	*A Nilgai and a Sambar*	48.20a	84	Calligraphy
39.49b	61	Calligraphy	48.21b	97	*Bird*
39.49a	62	*Shahjahan, Master of the*	48.21a	98	*Archer, Musician, and*
		Globe			*Dervish*
		Margin number 27	48.28b	13	*Jahangir as the Queller of*
39.50b	19	Calligraphy			*Rebellion*
39.50a	20	*Khankhanan ʿAbdur-Rahim*			Margin number 8
		Margin number 8	48.28a	15	Calligraphy

INDEX

NOTE: All numbers refer to plates. Titles of plates are in italics.